# ART

## of the 20th Century

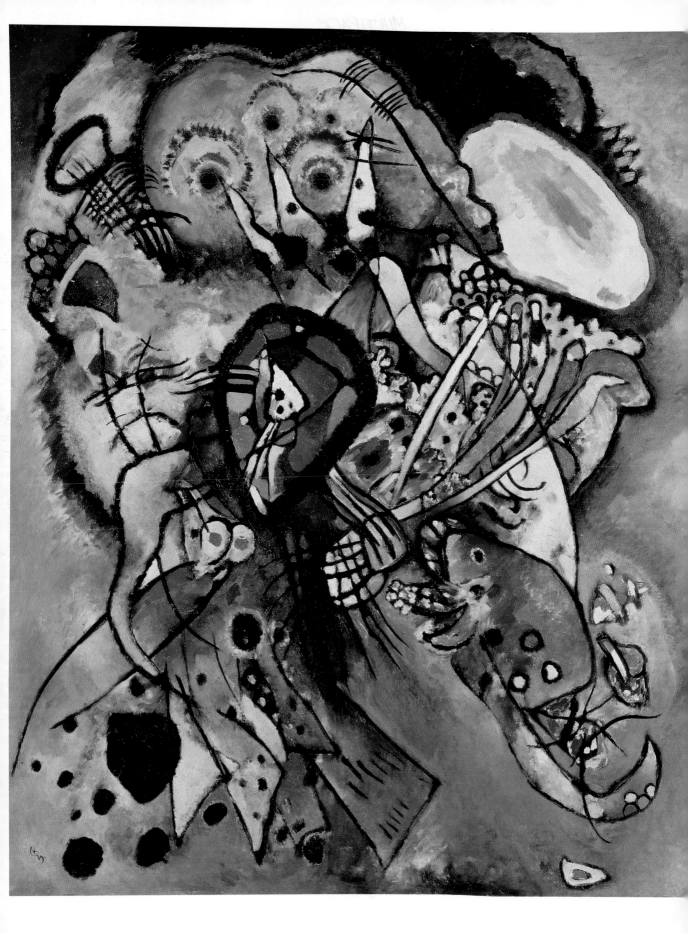

Ruhrberg · Schneckenburger · Fricke · Honnef

# ART
## of the 20th Century

*Edited by Ingo F. Walther*

**Volume I**

**PAINTING**

*by Karl Ruhrberg*

**TASCHEN**

KÖLN LONDON LOS ANGELES MADRID PARIS TOKYO

**Ingo F. Walther**, born 1940 in Berlin, edited this volume and wrote the biographies in the lexicon of artists. Studied literature and art history in Frankfurt am Main and Munich. Author and editor of numerous monographs on the art of the Middle Ages and of the 19th and 20th centuries, including *Vincent van Gogh* and *Pablo Picasso* (together with C.-P. Warncke), both published by TASCHEN

**Karl Ruhrberg** born 1924 in Wuppertal. Worked initially as a journalist, then enrolled in Cologne for drama, art history and German. 1956-1962 cultural editor; 1962-1964 chief dramatic advisor at the Deutsche Oper am Rhein. 1965-1972 founding director of the Kunsthalle Düsseldorf. 1972-1978 director of the DAAD's Berlin artists' programme. 1978-1984 director of the Museum Ludwig in Cologne. Since 1984 freelance writer on the arts, exhibition curator and consultant. Numerous publications on 20th century art, including *Kunst im 20. Jahrhundert*, Stuttgart, London, New York 1986, *Malerei in Europa und Amerika 1945-1960*, Cologne 1992.

*Front cover and slipcase:*
**Mark Rothko**
White Cloud over Purple, 1957
Oil on canvas, 143 x 158 cm
Private collection
© Kate Rothko-Prizel & Christopher Rothko/VG Bild-Kunst, Bonn 2005

*Illustration page 2:*
**Wassily Kandinsky**
Two Ovals (Composition No. 218), 1919
Oil on canvas, 107 x 89.5 cm
St. Petersburg, Russian State Museum

To stay informed about upcoming TASCHEN titles, please request our magazine at www.taschen.com or write to TASCHEN America, 6671 Sunset Boulevard, Suite 1508, USA-Los Angeles, CA 90028, Fax: +1-323-463.4442. We will be happy to send you a free copy of our magazine which is filled with information about all of our books.

© 2005 TASCHEN GmbH
Hohenzollernring 53, D–50672 Köln
**www.taschen.com**

Original edition:
© 1998 Benedikt Taschen Verlag GmbH
© 2005 for the illustrations: VG Bild-Kunst, Bonn, the artists and the heirs of the artists
Edited by Ingo F. Walther, Alling
Project management: Juliane Steinbrecher, Cologne
Translation: John William Gabriel, Worpswede; Ishbel Flett, Frankfurt; Fiona Elliott, Edinburgh; Frances Wharton, Cologne
Cover design: Angelika Taschen, Cologne

Printed in India
ISBN 3–8228–4089–0

# Contents

## Painting
*by Karl Ruhrberg*

# Prologue to Modernism

## The Magic of Light
### The Janus Face of Impressionism

A balloon floated over the Paris World Fair of 1867 and perched in its gondola was a man named Nadar, photographer, aeronaut, and caricaturist. In Oslo one can still see the captive balloon, floating in the upper right-hand corner of a painting that was executed the same year by Edouard Manet, *View of the World Fair* (ill. below), a painting which now hangs in the National Gallery in the Norwegian capital. Nadar's real name was Gaspard Félix Tournachon; the *nom de plume* reflected an awareness of his worth and mission. He was befriended with the artists who, as a group, would later be known as Impressionists. This term was meant to ridicule the apparently haphazard and half-finished character of their "snapshots" in painting, whose significance the photographer Nadar intuitively recognized. Seven years after the World Fair, from April 15 to May 15, 1874, Nadar made his premises at 35, Boulevard des Capucines, on the right bank of the Seine near the Opera, available to the painters for an exhibition.

The previous year, 1873, Claude Monet had depicted the boulevard from a window high above, giving the crowds hurrying along the pavement the blurred, schematic look of an early photograph. Here, in the midst of sophisticated nineteenth-century Paris, where Nadar enjoyed a reputation in high society, his painter-friends at last had an opportunity to show their pictures. These pictures had been repeatedly rejected by the jury of the official Salon exhibitions, or had been hung so disadvantageously that their fresh, bright colors blossomed in obscurity. Nadar's Impressionist show was the first unjuried exhibition ever. Admission cost fifty centimes, the catalogue one franc. The artists themselves had made the selection of paintings on display; no carping art expert was permitted to exclude anyone in the name of an academic tradition betrayed.

It was no coincidence that a photographer was among the few people who realized the artistic rank of these painters and their new approach to reality. Like his artist-friends, Nadar attempted with the means of his metier to capture the excitement of the unique, unrepeatable moment on a photographic plate. He, too, saw the world from a long, all-encompassing view, probably encouraged by his flights in the balloon.

All early photographs had a coarse-grained texture that very much resembled the brushwork of Impressionist paintings. This is seen to good effect in the very first photograph in the world, the picture taken in 1826 of the town of Châlons-sur-Saône by Nicéphore Niepce,

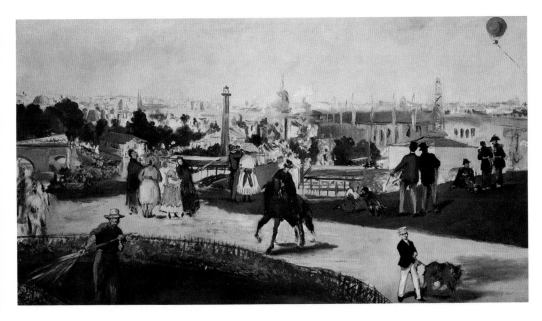

**Edouard Manet**
View of the World Fair 1867, 1867
Oil on canvas, 108 x 196 cm
Oslo, Nasjonalgalleriet

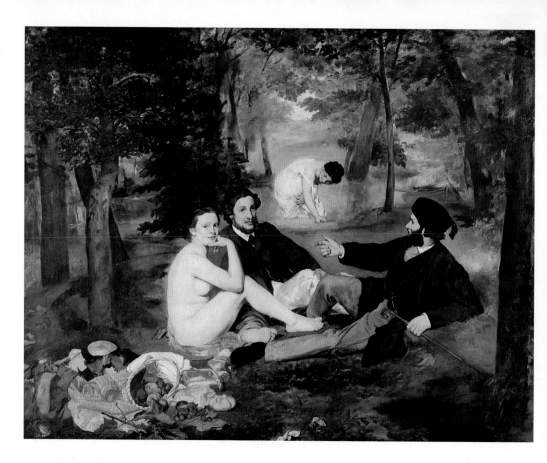

**Edouard Manet**
Le Déjeuner sur l'herbe, 1863
Oil on canvas, 208 x 264 cm
Paris, Musée d'Orsay

a landowner and amateur scientist. Niepce made the photo from the window of the chemical laboratory he had installed at his estate, Gras, outside his home town. The image was made on a zinc plate covered with light-sensitive asphalt. When the plate was rinsed with lavender oil and petroleum, the portions of the surface that had not been hardened by exposure to light were washed away. This lent the image a grainy irregularity, a sort of visual vibration which, though unintended, recalled the sketchy rendering of vegetation and sky combined with solidly depicted houses found in the similar motifs of a painter like Camille Pissarro.

The final decade of the waning century witnessed preparations on all hands for a revolution in the visual arts, a conscious revolt against tradition and established taste. Vincent van Gogh painted under the searing sun of Arles; Paul Gauguin and Emile Bernard, working at Pont-Aven in Brittany, founded a movement they called "Synthetism" the Norwegian painter Edvard Munch showed his work at the Association of Berlin Artists; James Ensor completed his provocative *Entry of Christ into Brussels in the Year 1889;* Parisian art dealer Ambroise Vollard showed the paintings of Paul Cézanne; and the Impressionists by this time had made their public breakthrough. Thus began what has come to be known as the "Heroic" epoch in the history of modern art.

The prologue to this chapter had been prepared in the spring of 1874, when Monet, Alfred Sisley, Pierre-Auguste Renoir, Edgar Degas, Armand Guillaumin,

Berthe Morisot, and Cézanne joined forces in Nadar's studio. But one important name was missing. Manet, though venerated by his colleagues as the painter of *Le Déjeuner sur l'herbe* (ill. above) and *Olympia* (Paris, Musée d'Orsay), though he had shown fifty works in his own pavilion at the 1867 World Fair, was not an Impressionist of the first hour. His once-rejected paintings had since found entry to the official Salon, where even Renoir (ill. right), with his still quite conventional *Lise with a Sunshade* (Essen, Museum Folkwang), and Monet with his Honfleur seascapes, had also enjoyed first recognition.

### The Bourgeois Geniuses

While Manet's colleagues admired him, they also were envious of his public success. In a sense they were revolutionaries against their own will, for most of them were honest, upstanding citizens from humble backgrounds. Only Manet and Degas were born into the upper-middle class, and represented the type of the educated, urbane, quick-tongued Parisian. Henri de Toulouse-Lautrec's family belonged to the French aristocracy. None of these artists could be called social revolutionaries or barricade fighters like Gustave Courbet, the great realist who was jailed after the smashing of the Vendôme Column during the Paris Commune. Although those who could avoided military service during the Franco-Prussian War of 1870/71, Monet, for one, later became a close friend of Minister President

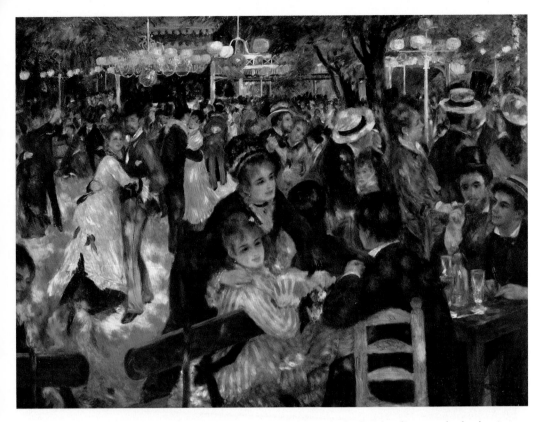

*"I used to find enough girls at the 'Moulin de la Galette' who were willing to come to me as models, like the two at the front of the picture. One of them wrote to me on gold-edged paper, offering herself as a model, even though I had been meeting her quite frequently when she was carrying milk at the Montmartre."*
PIERRE-AUGUSTE RENOIR

**Pierre-Auguste Renoir**
Le Moulin de la Galette, 1876
Oil on canvas, 131 x 175 cm
Paris, Musée d'Orsay

Georges Clemenceau, whose militancy earned him the nickname of "The Tiger." It was the rejection, scorn, and derision poured upon them by press and public that transformed this loose group of artists into secessionists. They had a simple message to convey, and wanted to be understood. The fact that they were absolutely misunderstood struck them as an embarrassing misfortune. The notion of purposely shocking the bourgeoisie was far from their minds. It was Monet's picture *Impression – Sunrise* (p. 10), a depiction of the sun shimmering

*"In art, nothing should look like chance, not even movement."*
EDGAR DEGAS

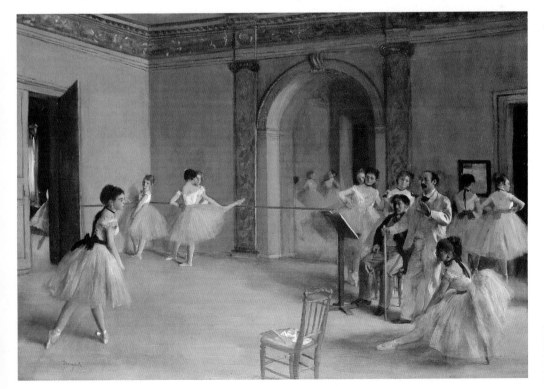

**Edgar Degas**
Dance Studio of the Opera, Rue le Pelletier, 1872
Oil on canvas, 32 x 46 cm
Paris, Musée d'Orsay

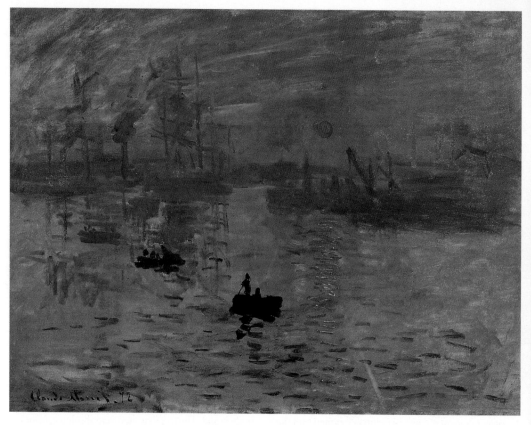

**Claude Monet**
Impression – Sunrise, 1872
Oil on canvas, 48 x 63 cm
Paris, Musée Marmottan

*Page 11 above:*
**Lovis Corinth**
The Lake of Lucerne in the Afternoon, 1925
Oil on canvas, 57.5 x 75.5 cm
Hamburg, Hamburger Kunsthalle

*Page 11 below:*
**Max Liebermann**
Munich Beer Garden, 1884
Oil on canvas, 95 x 69 cm
Munich, Bayerische Staatsgemäldesammlungen,
Neue Pinakothek

through dawn mists, that gave Louis Leroy, critic of *Le Charivari,* the opportunity to deride the group as "Impressionists," although this term actually says very little.

Like the Roman god Janus, guardian of gates and doorways, Impressionist painting has two faces. It makes no attempt to plumb the meaning of existence. It reflects the colorful surface of life, strives to record the beauty of surface appearances as seen in changing lights and seeks, to capture the charm of the moment. It is very much of this world, secular rather than transcendental. Impressionism represents the culmination and end-point of illusionistic painting, which since the beginning of the age of perspective in Renaissance Florence had dominated European art and habits of perception. But as every style has the tendency to flip over into its opposite when it reaches its apex, Impressionism at the same time represents the root of modernity in art. It had already begun to reflect the vagaries of human perception and its relativity to times of day and changes of place; it provided the materials for an anti-illusionistic art, the technical, formal, and, tentatively, even the theoretical underpinnings for advances to come. Impressionism liberated color to the point of autonomy, and it took the dissolution of traditional form to the verge of an atmospheric, shimmering veil behind which the objects depicted vanished, ushering in a "non-objective" art.

Cézanne, a loner who obstinately worked *sur le motif* in and around the southern French town of Aix-en-

Provence, sought a harmony of color and form in a self-contained art "parallel to nature." Gauguin left his family and his stockbroker's career for the South Sea island of Tahiti, where he hoped to find a lost paradise and a new, unspoiled innocence in painting. Georges Seurat and Paul Signac developed with scientific acumen and great patience a style called Pointillism, in which the subject was rendered in tiny dots of unmixed paint which came together in the eye of the spectator to reveal figures and scenes.

In the work of the Impressionists and their successors painting was once again taken back to its original sources: pure color *and* pure form. It was liberated from every literary and allegorical reference. With the addition of van Gogh's obsessive passion for subjective expression, Impressionist painting laid the groundwork for all that was to come.

### "I Paint What I See"

Impressionism marked the birth of subjective art. Not the "what" of the motif but the "how" of its depiction came to decide the rank and value of a painting. "I paint what I see and not what others deign to see," said the young Manet when he was still a pupil in the atelier of Couture. It was no longer the individuality or originality of the subject that counted but the personality of the artist who rendered it, with his own, unique and specific touch. A portrait by Manet, said the writer André Malraux, contained more of the painter than of the person portrayed.

Impressionism in painting conveyed a certain view of life that was also reflected and refracted in the music of the period (Claude Debussy), in its literature (Marcel Proust), and in its philosophy (Henri Bergson, Friedrich Nietzsche), all of which bore witness to the increasing secularization of art.

Despite its worldly, seemingly rational character, Impressionist painting was the result not of systematic research but of spontaneous experience. The example had been set long ago, by the great Spanish masters Diego Vélazquez and Francisco de Goya, by French artists Eugène Delacroix and "Père" Corot and the Barbizon masters of the *paysage intime* (intimate landscape) who had taken their cue from 17th-century Dutch art, foremost among them Charles Daubigny, the first painter to work primarily out-of-doors. Yet even they were overtopped by the dynamic figure of Gustave Courbet, whose realism swept the brown gravy of complacent studio painting off the canvas once and for all time. Among many others, Courbet too was an immediate precursor of Impressionism.

The history of Impressionism has yet to come to an end. Not only the triumphant success of recent retrospectives – 960,000 people saw the 1996 Monet exhibition in Chicago – indicates the continuing currency of the style, which, like all great art, resists the tooth of time. More importantly, Impressionism has continued to influence the development of 20th-century painting down to the present day. The term "abstract Impressionism," coined to describe the abstract landscapes of a Jean-Paul Riopelle or a Jean Bazaine, is only one of countless examples.

## From France into Germany

The full-fledged German Impressionism of the trio Max Liebermann, Max Slevogt, and Lovis Corinth (ill. right and p. 12) cannot be said to have brought any crucial innovations, perhaps with the exception of Corinth's late work. The style reached Germany with a delay of fifteen years, when artists in France had long begun to distance themselves from a stream that had since found widespread acceptance. While German artists enthusiastically adopted the vibrant illumination of French Impressionism, they apparently did not feel comfortable with it until it was toned down by an admixture of Dutch ninteenth-century landscape painting. The Mediterranean *joie de vivre*, the brilliantly orchestrated palette found in the best paintings of the French Impressionists are sought in vain in the work of their German followers.

German art nevertheless owes a debt of gratitude to the trio of Liebermann, Slevogt, and Corinth. Inspired by the naturalistic and unliterary landscapes of the Worpswede and Dachau groups, and by the relaxed brushwork of Hans Thoma, Wilhelm Leibl, Carl Schuch, and Wilhelm Trübner, the German Impressionists mounted a concerted attack on the chauvinism of academic art during the Wilhelminian era. That

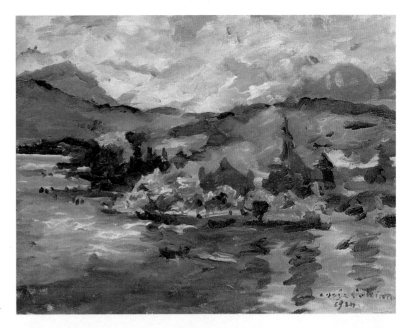

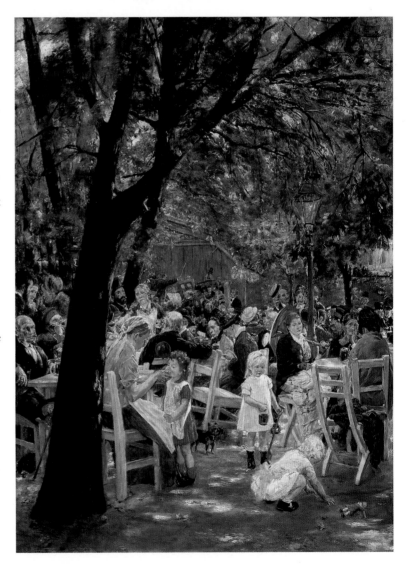

**Max Slevogt**
Flowering Lilacs, c. 1921
Oil on wood, 54 x 66 cm
Frankfurt/Main, Städelsches
Kunstinstitut und Städtische
Galerie

*Paris* (Berlin, Nationalgalerie), which reflects a view of the typical German soldier as a hero with a heart who, when he happens not to be occupied in defeating the French, sings Schubert, plays the "Appassionata", or just muses on the deeper meaning of life.

It was against such sentimental idealization that the shrewd and skeptical intelligence of Liebermann revolted. A realist in both his art and life, he was instrumental in the founding of the Berlin Secession, which reflected his critical opposition to the official art policies of the day more than his acceptance of innovative alternatives. The uproar caused by the exhibition of Edvard Munch's symbolic, but shockingly honest paintings in the Architects' Building of the Association of Berlin Artists in 1892 was only a secondary cause. Liebermann did not make avant-garde artists of the secessionists. They were not progressive, only open to the new and unusual, convinced that it had to be given a chance, and to fight for it if necessary. Being Germans, these artists naturally cleaved to the idea of a deeper meaning which art must make visible. Content and message were just as important to them as form. This is why they remained basically conservative, all except for Corinth, whose dramatic late work – culminating in the self-tormenting, psychologically penetrating, Rembrandesque self-portraits, the incredibly impassioned Walchensee landscapes, and the religious depictions in the manner of an *Ecce homo* – shows at least as many Expressionist as Impressionist traits. The Expressionists themselves were soon to have ominously nationalistic arguments marshalled against them, even by Corinth himself, and to feel the brunt of Liebermann's *grand seigneurial* obstinacy.

Berlin, upstart younger sister of the French capital, produced the outstanding personality in this development, Max Liebermann, should come as no surprise, for Impressionism was essentially a metropolitan art. And in the German metropolis, the middle class was experiencing a growing democratic sense of its importance which led it to rebel against the court and its apologists. First among these was Anton von Werner, the highly praised painter of the Foundation of the German Empire in the Hall of Mirrors at Versailles, and of *Base Quarters outside*

# The Painting of Pure Reason
## Seurat and the Neo-Impressionists

Although Georges Seurat died at a young age, he was the most significant of those artists who are lumped together in art-history books as Post- or Neo-Impressionists. Seurat himself would have preferred to have his and his friends' style known as "Chromo-Luminarism," or painting in color and light. The terms Pointillism (painting in dots of color set next to one another) or Divisionism (painting in separated areas of color) are likewise more precise than Neo-Impressionism, a term coined by the critic Félix Fénéon, which the young painters accepted out of respect for their erstwhile mentors. "Once again artists appear with books under their arm," wrote the eminent German critic Julius Meier-Graefe around the turn of the century, implying that it was theoretical writings by artists and physicists that had sparked the new departure. Seurat learned from the great colorist Delacroix, who had already strongly influ-

enced the Impressionists, that dabs of different colors, when seen from a certain distance, would merge into *valeurs* of great brilliance and freshness in the eye of the viewer.

Other stimuli came from the color theories of the scholars Dave, Blanc, Helmholtz, Sutter, and Rood, but especially from Michel Eugène Chevreul's doctrine of "simultaneous contrasts." The artists gathered to discuss such theories in the branch of the Goupil art dealership headed by van Gogh's brother, Theo. Seurat, just over 25, argued with Signac, four years his junior, his most faithful follower and soon to become the spokesman for the movement. The debate was occasionally joined by Toulouse-Lautrec, Gauguin, or Bernard, and by the always receptive and open-minded patriarch Pissarro. Cézanne, however, had to be admired largely at a distance.

## The Haughty Cartesian

There can be no doubt that the artists gathered around the young, taciturn, aloof and almost haughty Seurat, a disciple of Cartesian philosophy, believed themselves to be the heirs and continuators of Impressionism. Yet is is equally clear that their investigations and meditations unavoidably led them ever farther from the source. Impressionist spontaneity, the naive abandonment of a Renoir or a Monet to the joys of the sensuous life, were not for Seurat. Manet and Degas appealed to him more. Like him, they had made untiring studies in an attempt to detect the formal canon, the hidden geometries, the intellectual framework beneath the surface of the paintings of a Hans Holbein, a Raphael, Nicolas Poussin, or Jean Auguste Dominique Ingres, and to precisely analyze the complimentary contrasts and tapestry-like brushwork of Delacroix.

The more instinctive than rationally controlled division of light into the colors of the spectrum practiced by the Impressionists ran counter to Seurat's rigorous intellectuality and to his belief in the benefits of the natural sciences, which he shared with his contemporaries and which was so characteristic of the latter half of the nineteenth century, with its deep mistrust of the irrational. Also, something within Seurat revolted against the tendency of Impressionist painting to destroy form. He strove for a permanence in art, an art that was decorative in the best sense of the word, an "art in function" which did not retire to the easel painting as the be-all and end-all of art. We are witnesses to the exciting spectacle of a painting technique that had fully matured into a style, which then, thought through to its logical end and taken in practice to the extreme limits of its

possibilities, suddenly turned into its opposite. Seurat completed the process begun by Théodore Géricault, continued by Delacroix, and brought to maturity by the Impressionists – the gradual dissolution of planes of color into ever tinier color particles. But what with the Impressionists was the result of spontaneous visual experiences became with Seurat an exact scientific method.

The effects of this systematization were to extend all the way to the abstractions of the Netherlandish group, "De Stijl," headed by Piet Mondrian. Seurat did not paint outdoors any more. He reverted to the age-old tradition of sketching outdoors and painting in the studio, which in Seurat's case was a study and laboratory in one. But his approach to color was anything but traditional. Instead of mixing paints on the palette (with the exception of the adjacent colors of the spectrum), he would place them carefully, dab by dab, side by side on the canvas, based on scientific analyses of light and the doctrine of simultaneous contrasts.

The mixing of pigments practiced by the Impressionists appeared to the Neo-Impressionists to make the colors seem too material, too "dirty." By keeping them pure, they hoped to dematerialize them, make them convey the disembodied brilliance of the light spectrum. The process of mixing was now to take place on the retina of the viewer's eye, and thus the viewer was cautioned not to approach the canvas too closely. This radical formulation of the Impressionist approach once again demanded an alteration of visual habits. And in this case, too, the result was that an unknowing public stuck their noses right into these curious pictures and were blinded by their brilliant luminosity. Fénéon, the

*"Art is Harmony. Harmony is the analogy of contrary and of similar elements of tone, of color and of line considered according to their dominants and under the influence of light, in gay, calm or sad combinations.*
*The contraries are: for tone: a more luminous or lighter, shade against a darker; for color: the complementaries, i.e. a certain red opposed to its complementary, etc.: for line: those forming a right angle.*
*Gaiety of tone is given by the luminous dominant; of color by the warm dominant; of line, by lines above the horizontal. Calm of tone is given by an equivalence of light and dark; of color, by an equivalent of warm and cold; and of line, by horizontals. Sadness of tone is given by the dominance of dark, of color by the dominance of cold colors and of line, by downward directions."*
GEORGES SEURAT

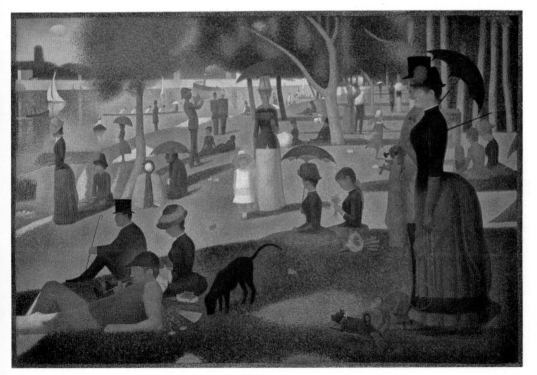

**Georges Seurat**
A Sunday Afternoon on the Ile de la Grande Jatte, 1884–1886
Oil on canvas, 206.4 x 305.4 cm
Chicago (IL), The Art Institute of Chicago

Neo-Impressionists. Through optical mixture (mixture in the eye of the observer) of these pure colors, whose relationship to one another can be varied at will, an infinite number of hues can be obtained, from the most brilliant to the greyest. Every brushstroke that is taken pure from the palette remains pure on the canvas."

These words have a cool, scientific tone that reflects as much detachment from the artists' own activity as from the vociferous attacks of their opponents. One was too sure of one's mission to be unsettled by criticism. The finished painting was the result of patient work, which, in Seurat's case, sometimes extended over a full year's time; it was "constructed" according to laws which stood on a level with the most advanced physics of the day, laws which could be confirmed by any one who cared to. The process of painting was no longer subject to the vagaries of emotional sensations or personal temperament. The subjectivity of Impressionism had flipped over into objectivity. Now, colors were *set* like the notes in music.

The vibration of Impressionist colors was linked to form, and the resulting compositions once again possessed stability. In a painting like Seurat's famous *Sunday Afternoon on the Ile de la Grande Jatte* (p. 13), a moment in time is lent permanence, instead of passing in a fleeting impression. The figures of the strollers, composed of thousands of dots that congeal into shapes, take on a almost symbolic meaning, for despite their period clothing, they also represent a certain human prototype. There is nothing naturalistic about their depiction. In this picture a silent happiness takes on painterly form: "L'art c'est l'harmonie," art is harmony. Later artists' aspirations would extend, in Mondrian's words, to making art contain a "universal harmony."

critical apologist of the new movement, accordingly reminded his readers that it was not advisable to sit in the middle of the brass section if one wished to hear a symphony.

### The Neo-Impressionist Conception

"With these colors, mutually tinged and lightened with white," Seurat's friend and heir Signac described the Neo-Impressionist method, "an attempt is made to achieve the richness of the sunlight spectrum with all of its tones. An orange that blends with yellow and red, a violet that tends towards red and blue, a green between blue and yellow are, with white, the sole elements of the

### Creative Intelligence

Seurat died of meningitis at the age of 31. His early death prevented the compilation of his ideas and studies into a coherent theory. His friend Signac (ill. above), who lagged far behind him as a creative artist, made up for this lack with his 1899 book, *From Delacroix to Neo-Impressionism*. Decades before speculations about painting machines, computer art, and holography, this book only served to show, however, that no theory, no matter how perfect, and no method, no matter how sophisticated, could replace the creative human being. It was precisely, this, which Signac and his colleagues and followers had hoped would be possible. Neo-Impressionism in its most logical, didactic form aimed at establishing a binding doctrine, a normative aesthetic, those notorious "objective criteria" which do not exist and cannot exist as long as art remains alive. Once Neo-Impressionism itself became a dogma, its vitality was inevitably sapped.

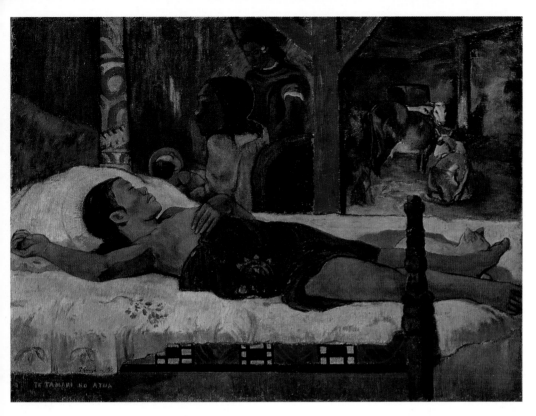

**Paul Gauguin**
The Birth of Christ
("Te Tamari No Atua"), 1896
Oil on canvas, 96 x 128 cm
Munich, Bayerische Staats-
gemäldesammlungen, Neue
Pinakothek

# In Search of a Lost Paradise
## The Work and Legend of Paul Gauguin

No greater contrast is conceivable than that between the cool-headed, bourgeois, scholarly Seurat and the adventurer, speculator, and prophet of art, Paul Gauguin. The only thing they shared in common was a quest for lucid form in painting, which they believed had been lost and which they attempted, by quite different methods, to restore.

Gauguin was not only a great painter, he was also a great actor. The play in which he performed the leading role was the legend of his own life. When in 1902 he considered returning to Paris from the Marquesas Islands in the South Pacific, his friend Daniel de Monfreid, for whom Gauguin had painted his famous, deeply resigned self-portrait in 1896, replied with merciless frankness: "You must not come back. You enjoy the immunity of the great dead .... You have gone down in art history." The year after, on May 8, 1903, at about eleven o'clock in the morning, Gauguin died in Atuona, on Hiva-Oa, in the South Pacific. His dissolute life, extreme poverty, a heart condition, alcohol, and finally, the "French disease," had broken the spirit and ruined the body of this seemingly indomitable, athletic man.

Born in 1848 in Peru, the son of an opposition journalist and a French-Peruvian mother, Paul spent a restless childhood in the country where some of his ancestors on his grandmother's side had served as viceroys. His father had died on the passage from Europe. Gauguin entered the merchant marine, became, like the poet Charles Baudelaire and the painter Monet, steersman's mate, discovered in Rio de Janeiro the exotic charm of the South American landscape, and finally, returning to Paris, entered the employ of a renowned Parisian financing firm on Rue Lafitte, the same street on which the famous and clever art dealer, Vollard, would later reside. Successful market speculations made Gauguin a prosperous man. He married the lovely daughter of a respected Danish family, Mette Gad, and had money enough to amass a significant collection of Impressionist art. Twelve years later the amateur painter, the stockbroker and father of five who had been smitten by Impressionism, threw everything to the wind and decided to live only for art. Disgusted by the satiety and complacence of European civilization, Gauguin set off on his quest for a paradise lost, first going to Panama and Martinique, then to villages in Brittany (Pont-Aven and Le Pouldu), and finally to Tahiti and the Marquesas Islands.

Gauguin died indigent and alone, banned from the memory of his respectable wife, who was unable to forgive him the fate he had brought upon her and their children.

*"With this painting, I tried to make everything breathe faith, quiet suffering, religious and primitive style and great nature with its scream."*
PAUL GAUGUIN

**Paul Gauguin**
Exotic Legends
(Contes barbares), 1902
Oil on canvas, 131.5 x 90.5 cm
Essen, Museum Folkwang

*"Painting is the most beautiful
of all the arts; in it all feelings are
summed up, looking at it each viewer
can, through his imagination, create
a novel; one single glance can engulf
the soul in the most profound memo-
ries, a slight effort of memory and
everything is summed up instantly.
A complete art that sums up all the
other arts and completes them."*
PAUL GAUGUIN

### The Clandestine Classicist

This story of an artist's life, as if right out of a Holly-
wood movie, has long distracted attention from the aes-
thetic qualities of Gauguin's work. Nor was he himself
entirely without blame for this. Gauguin called himself
a barbarian or wild Indian once too often for us not to
believe him, particularly in view of the exotic milieu
depicted in his South Pacific paintings. In truth he was
never a primitive at all; nor was he an amateur, even in
his earliest attempts. For all their awkwardness in detail,
his Impressionist works evince an astonishingly high
degree of sophistication, and a fine sense of the deco-
rative. Formally speaking, Gauguin is a clandestine
classicist, albeit without the perfectionistic smoothness
usually associated with this term.

Gauguin's compositions have a strictly balanced
framework of horizontals and verticals to which the har-
monious rhythms of the groups of figures remain sub-
ject. The sensuous curves of the many bronze-skinned
Maori girls he depicted (ill. above) are stylized into flat,
unmodelled forms which reflect the "Cloisonnism"
developed in Pont-Aven, a style based on the leaded
contouring between the panes of stained-glass windows,
which lends the figures their solidity of outline.

More important to us today than his ambitious but
vain attempt to combine the innocent sensuality of the
heathen world with the ascetic humility of Christianity
into a new, "synthetic" myth, is Gauguin's genius for
planar composition. *Te Tamari No Atua* (p. 15), a depic-
tion of an island girl lying on her cot, a manger with
oxen and a dog behind her, two helpers in the back-
ground, mother and child encompassed by a gleaming

aureole, is still as moving today as when it was painted.
Yet its charm does not lie alone in the shifting of the
manger from Bethlehem to Tahiti, nor in the some-
what sentimental idea of "Virgin Mary among the
Natives."

More important is the transformation of the touch-
ing story into a grand, classically serene composition,
based on horizontals and verticals and a balanced har-
mony of colored planes, and supplemented by abrupt
shifts in perspective which lead to a unification of
various levels of reality within a *single*, coherent image.
This principle, soon to be taken to its extreme by Pablo
Picasso in *Les Demoiselles d'Avignon* (p. 69), would
become a crucial element in 20th-century art.

### The Would-Be Fresco Painter

Gauguin's talent predestined him to be a painter of
frescoes, but it was a talent that went unused. It was the
Symbolist Pierre Puvis de Chavannes, whose attenuated
figures inspired Gauguin (and from whom he later
attempted to distance himself), who received the mural
commissions for which Gauguin waited in vain. This
was really his fundamental artistic tragedy. "Be con-
cerned with the silhouette form of each object," Gau-
guin had written, very much in line with turn-of-the-
century tastes, and, "One must always feel the plane,
the wall; tapestries need no perspectives."

Gauguin's ideas of form are independent of the
exotic South Pacific milieu. They come out just as
clearly in the paintings from Brittany, where Gauguin
and Bernard (p. 14), who would later bitterly claim prior-
ity, announced their theory of "Synthetism". This term
implied a return to the basic elements of all visual cre-
ation, including the intrinsic value of the material used
for the painting. The artists sought a new, ornamental,
two-dimensional arrangement of simplified forms and
figures with emphasized contours. By express analogy to
music, they experimented with pure, unmodelled, col-
ored "notes" or "sounds," which, like line, were to be
independent of the natural model. Above and beyond
this, they wanted to fill their paintings, once again, with
poetic content.

Gauguin's œuvre, too, bore traits of the poetic
symbolism of the period, but he was outspoken in his
advocacy of representing sensations and emotions
solely through abstraction, through line, form and
color. The analogies between music and painting were
more important to Gauguin than to the Neo-Impres-
sionists.

Georg Wilhelm Friedrich Hegel's concept of the
musical in *all* of the arts, his emphasis on the absolute,
non-representational character of art in general, found
its painterly realization in the art of Gauguin, who envi-
sioned making "music in colors." Where this could not
help but lead in artistic terms becomes clear from deci-
sive passages in Gauguin's letters and writings: "I am no
painter after nature." – "There is only drawing." – "Pure
color, one must sacrifice everything to it." – "The artist

may deform if his deformations are expressive and beautiful." Or even more concisely: "Do not work after nature. Art is abstraction."

## No Art without History

The art of Gauguin points as far back into the past as it does forward into the future. Javanese art and Egyptian reliefs, the Buddha figures of India and the Parthenon frieze, Japanese woodblock prints and medieval church windows, Melanesian sculpture and Oriental ceramics, Breton crucifixions scenes and Aztec idols, Early Renaissance Italians and the early Manet, Puvis de Chavannes and Degas – all contributed to the formation of Gauguin's style. By the time of his mature period he had diverged from the strict flatness of his Breton motifs and begun arranging the composition in layers, from foreground to background, in the manner of a bas relief. As

these historical references indicate, not even a "revolution" in art can come about by arbitrary decisions made in a historical vacuum. Such revolutions generally make an appeal to traditions which have been forgotten or have not received their proper due.

Gauguin's immediate influence can be seen in the arabesques of a Toulouse-Lautrec, and the path he opened led to the art of the "Nabis," from the ecclesiastically-minded Maurice Denis and Paul Sérusier to the more secular Pierre Bonnard and Edouard Vuillard. His legacy was taken up by Art Nouveau and by Munch, and through Munch it was passed on to the graphic art of the German Expressionists. Gauguin's commitment to the musical quality of pure color anticipated Henri Matisse and the Fauves, even Wassily Kandinsky; his abstract-organic forms were taken up and developed by Hans Arp and Joan Miró.

# Truth beyond Beauty
## Van Gogh: Painting as Dramatic Action

Van Gogh's paintings now fetch prices reaching into the two-digit millions. During his lifetime, however, this man sold only one picture, from his mature period, *Red Vineyard* (Moscow, Pushkin Museum). It was bought while it was part of an exhibition of a group known as the "Les Vingt" (The Twenty) in Brussels, for 400 francs. The purchaser was Anna Boch, who was herself an artist, and the sister of a Belgian poet-painter whom van Gogh had portrayed in Arles. Van Gogh's career certainly does fit the popular notion of the "neglected genius", and its exploitation in movies and novels has reduced it to a cliché.

The year of the artist's death, Albert Aurier described him and his career in the *Mercure de France* in understanding, if quite pathetic, words. Even in the

eyes of his painter-friends – from Gauguin to Toulouse-Lautrec and Signac – he was basically a stranger, whose greatness remained concealed behind his wooden, ungainly peasant exterior. Only his younger brother, Theo, recognized Vincent's genius and understood the alienation it entailed from the world around him. An employee of the Paris art dealership Goupil, Theo fought for his brother's recognition where he could. But it was in vain. Vincent's artistic and human tragedy was too much for his reserved, sensitive brother to bear. Despite a first public success at the "Salon des Indépendants" and the congratulations of Pissarro and Gauguin, Vincent ended his life in summer 1890 with a pistol shot. Six months later, on January 29, 1891, Theo followed him.

*"I experience a period of frightening clarity in those moments when nature is so beautiful. I am no longer sure of myself, and the paintings appear as in a dream."*
VINCENT VAN GOGH

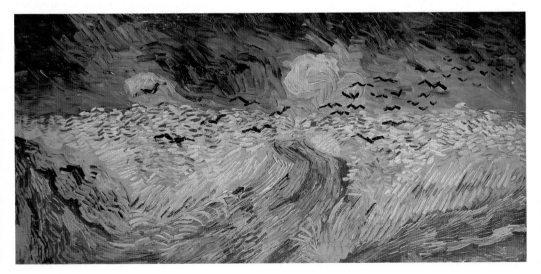

**Vincent van Gogh**
Wheat Field with Ravens, 1889
Oil on canvas, 50.5 x 103 cm
Amsterdam, Rijksmuseum Vincent van Gogh, Vincent van Gogh Foundation

## Speaking in Pictures

The son of a Dutch pastor, Vincent became a painter because he had failed as a preacher. Because speech would not obey him, in about 1880 Vincent began to draw, and then to paint. Despairing of the coldness of civilized life, he was one of those artists who were condemned to an existence in the hell described by Arthur Rimbaud. Van Gogh's unfulfilled longing led to that panic fear of life which is at the bottom of the "speech-lessness" of modern man. His urgent need to communicate broke through in a precipitate series of visual statements. From the dark, earthy tones of *The Potato Eaters* (Amsterdam, Rijksmuseum Vincent van Gogh) to the sinuous arabesques and luminous colors of the Arles, Saint-Rémy-de-Provence, and Auvers-sur-Oise series, van Gogh's life's work was done within the incredibly short period of five years.

It was a superhuman effort that destroyed him. At the apex of one of his creative spells, which gripped him as if in a delirium, he attacked his idolized friend, Gauguin, with a razor, and immediately thereafter turned the blade on himself and severed his right ear lobe. Van Gogh was committed to the mental asylum in Saint-Rémy, then transferred to Auvers, where he came under the care of his eccentric benefactor, Dr. Paul Gachet. His suicide brought to a close the tragedy of an artist whose attempts to find himself ended in self-destruction.

## Between Order and Anarchy

With van Gogh, for the first time in the history of the early modern movement, we come upon an artist who was not a Frenchman. Though far from achieving the painterly perfection of his compatriot, Rembrandt, van Gogh was filled with a comparable passion and depth of feeling. In fact his expressive urge was so strong that traditional forms could not contain it, so he changed and bent them to his will. The expressiveness of his excited, writhing lines, a brushwork so violent that it sometimes verges on brutality, the rustic roughness of his art distinguished it fundamentally from that of Gauguin, the Parisian, who tempered his conscious primitivism with the rules of classical harmony.

The incessantly moving, agitated forms in van Gogh's painting correspond to the processes of nature, ever in flux. Its sometimes harsh dissonances, its precariously maintained balance between order and anarchy, are very Germanic in character, despite the fact that van Gogh took his point of departure in French Impressionism and also occasionally used a flat, as it were spaceless composition inspired by Japanese woodblock prints. But the dynamic quality of his art was definitely Nordic as opposed to Mediterranean in origin. Van Gogh looked "into the heart of the people" for his motifs, as he wrote to his painter-friend Anton van Rappard. His ideal in this regard was Jean François Millet, who in turn had been influenced by Honoré Daumier.

In contrast to Impressionism, van Gogh's painting was not an art of acceptance but an art of protest, not indifferent to society and its ills but critical of them, especially in his early period of depictions from the milieu of the poor and underprivileged. Apart from the Provençal landscape, on which he did not yet exclusively focus, van Gogh painted people at their humble repast, denizens of poorhouses, old men, mail carriers, women neither beautiful nor rich, barges, worn-out boots, cane-seated chairs, dreary night cafés "where you can go insane and commit crimes," third-class waiting rooms, hospitals, and, of course, the mental asylum. The anxiety of the rootless, homeless human being, born of a sense of the emptiness and meaninglessness of life, found lasting visual expression in van Gogh's work.

For van Gogh, painting a person or object no longer meant giving a faithful reproduction of appearances. His concentration of form, agitation of line, and intensification of color not only suggested an exterior world shaken to its foundations, but also reflected his own, extreme experience of the anxieties and fears of the period, which broke out of him with explosive force. This is the source of the tremendous disquiet that permeates van Gogh's œuvre. Unlike Impressionism, his is an art that radically questions the culture from which it emerged, that transcends the traditional value system of moral and aesthetic categories. And unlike the Impressionists, and even Gauguin, van Gogh is no longer concerned with beauty, but with truth alone. Truth is found neither in palaces nor on Tahiti; it is found on the streets of Arles, in the faces of plain people, even in the mental asylum.

## The Last Dutch Master

The imagery of this last of the "Dutch masters" in the wake of Rembrandt has none of the static calm of the art of his friend, Gauguin. It is dynamic. Everything seems in perpetual motion. The process of painting becomes a dramatic act, and its record is still there on the canvas for all to see. An early example of Action Painting, in other words, though done under quite different circumstances from the "dripping" of a Jackson Pollock or the gesticulations of the latter-day Wild Painters or Neo-Fauves. The traces of making remain evident in the finished work, since van Gogh made no attempt to smooth down his convulsive brushstrokes or sweeps of the palette knife, or to blend the pure colors squeezed out of the tube direct onto the canvas. His pictures are unretouched. For him, technique and mastery of the craft were a means to an end: "Let us try to plumb the mysteries of technique so deeply," van Gogh wrote to van Rappard, "that people will crowd around and swear to heaven that we have no technique."

Such words illustrate the stance of this extremely unclassical artist to whom perfectionism was entirely foreign. His attitude is also reflected in the commonplace, disregarded things he chose as motifs. As he wrote in 1883, he even considered using materials from a junk

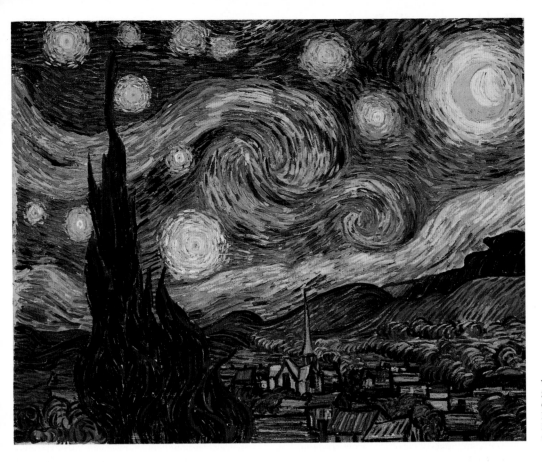

**Vincent van Gogh**
Starry Night, 1889
Oil on canvas, 73.7 x 92.1 cm
New York, The Museum of
Modern Art, Acquired through
the Lilly P. Bliss Bequest

pile "as models." A direct path leads from such decisions to the present-day treatment of materials in art. Van Gogh's humble, empty wooden chairs are distant relatives of Joseph Beuys's *Fat Chair* (p. 553). Not virtuosity but expression, the communication of subjective emotion, was the aim of van Gogh's work. The passionate individualism of a great and lonely man beset by self-doubt shaped this œuvre. Every slashing stroke of the brush or pen eloquently attests to this.

Despite the unleashed color in his paintings, to which he gave an unprecedented luminosity, van Gogh was above all a gifted draftsman. It is primarily the energy of his line that lends his work its eminently expressive force. Especially in his later years he drew and "spoke" with color, and not only in the black of the contours. Now, line, as it has no volume, can be called the abstract element in visual art. Any painting style that is dominated by line will tend to abstraction. Even van Gogh once toyed with abstraction, though he soon abandoned the idea. "When Gauguin was in Arles," he wrote to Emile Bernard, "I let myself, as you know, be tempted into abstraction once or twice, in the 'Berceuse' and the 'Woman Reading a Novel.' At the time abstraction seemed an interesting path to me. But that is bewitched ground, my friend! And in no time you run up against a wall."

It was not such fleeting experiments in abstraction that marked the significance for the future of van Gogh's art and personality. Rather, it was the autonomous, formative and deformative power of his line, his ability to combine untrammelled expression with decorative appeal, that strongly influenced his followers (sometimes to their own detriment) from Jugendstil to the social-critical artists of the 1920s and 1930s. Perhaps the most moving homage ever paid to a father of modern art was that paid to him by Francis Bacon. The British artist's series of van Gogh variations is painterly evidence of a rare affinity of spirit that overleaps the barrier between past and present centuries (p. 331).

Van Gogh's yearning for redemption, his suffering from the world as it is, his final yielding to the self-destructive forces that lurk within us, what Paul Klee called his "exemplary tragedy," the fire of his palette – all these made the Dutch artist a forebear of European Expressionism. "When no one else knew how to go on, he found a wide road for the future," said Pablo Picasso. This future is our present day.

*"It is the excitement, the honesty of a man of nature, led by nature's hand. And sometimes this excitement is so strong that one works without noticing it – the strokes of the brush come in quick succesion and lead on from one to the next like words in a conversation or letter. Yet one should not forget that is not always so and that in the future too many despondent days without any inspiration will follow."* VINCENT VAN GOGH

# World Art from the Provinces
## Paul Cézanne: the Primitive of a New Art

One of the pioneers of international modern art was a man who lived in the provinces of southern France, and who only left the country once – to visit western Switzerland just across the border, in 1891. His name was Cézanne. The decisive phase of his career, whose effect is still undiminished today and whose influence hardly any major twentieth-century artist was able to avoid, played itself out largely at a distance from the busy metropolis of Paris. It was the period when Cézanne painted in the rural seclusion of Aix-en-Provence, outdoors, "in front of the motif": Mont Sainte-Victoire (ill. right), which he had in front of his eyes every day; at the country estate of his parents, Jas de Bouffan, which he inherited and later sold (ill. below); in the immediate vicinity of his house in the Château Noir; outside his studio in the Lauves hills north of town; and in the Bibémus quarry. Cézanne painted Provencal peasants and petty bourgeois, and painstakingly arranged still lifes.

In early years Cézanne travelled widely through France. That his work found no favor with the academic judges was almost obligatory for a pioneer of the new vision at the end of the nineteenth century. It hurt him as deeply as the continual rejection of his pictures by the selection committees of the official Salon exhibitions, as the end of his friendship with the author Emile Zola, or the denial of the Cross of the Legion of Honor. The naturalistic writer instinctively rejected the aesthetic, anti-illusionistic tendency of the new approach that emerged ever more clearly in Cézanne's work.

In the figure of the painter Lantier in his novel *L'Œuvre* (The Work), a counterpart to Balzac's *Chef-d'œuvre inconnu* (The Unknown Masterpiece), Zola gave a scarcely veiled portrayal of his former friend as a negative hero, a failed artist whose theorizing had ruined his creative powers. The author's misunderstanding precisely marked the break between an illusionistic art that conscientiously describes reality and a non-illusionistic painting "parallel to nature" as envisioned by Cézanne. In coming decades his approach would paradoxically lead, as Walter Hess notes, "from the most humble inquiry into nature … to 'abstract' painting." Cézanne himself sensed the profound changes that were soon to take place in art. "Perhaps I came too early," he said to his friend, the young writer Joachim Gasquet. "Someone else will do what I have been unable to do. Perhaps I am only the primitive of a new art."

### The Painter as Constructor

"Réalisation" was the concept most crucial to Cézanne – the realization or achievement of his own ideas of form, inspired by an immediate confrontation with nature, but without slavish reproduction of appearances. His aim was to achieve harmony, but not a harmony that was given *a priori*. The harmony Cézanne strove for had first to be "constructed," and instead of denying the existence of tensions between divergent forces, it would reconcile such contrasts by means of "the right placement of color gradations," or in other words, through conscious design.

By his own testimony, Cézanne wanted to be a "classical" artist. Yet it would be mistaken to view his retiring personality and the time-transcending serenity of his art, which was intended to make visible "a timeless existence divorced from genesis and decay," as evidence of a lack of feeling or temperament. His wild and uncontrolled early work, influenced by the southern French painter Adolph Monticelli, with its depictions of murder, revolt, rape, and orgiastic wish-dreams, reveals that Cézanne was basically a Baroque, passionate man. At the mercy of a overrich imagination and tormented by an inferiority complex, he was incapable of overcoming his innate shyness and difficulty in meeting people. It took an incredible amount of self-discipline for Cézanne to subject these chaotic impulses to the order of his will. As so often in art history, the originality of his style was able to develop only in resistance to an apparently predestined path. The Baroque component in Cézanne's character becomes entirely clear when he enthuses, in face of the pictures of the great Venetians, especially Tintoretto and Paolo Veronese, "All tones interpenetrate, all forms revolvingly interlock. This is coherence."

No one after the Venetians of the 16th century was more exclusively a painter than this college-educated, middle-class, patois-speaking citizen of Aix. Drawing

**Paul Cézanne**
House with Red Roof. The Premises of Jas de Bouffan, c. 1887
Oil on canvas, 73.5 x 92.5 cm
Germany, private collection

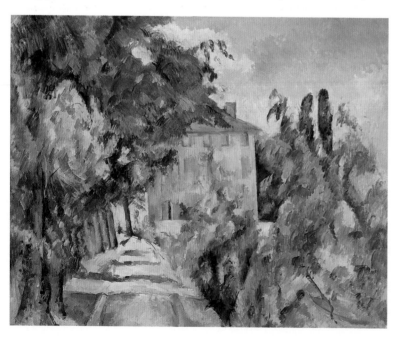

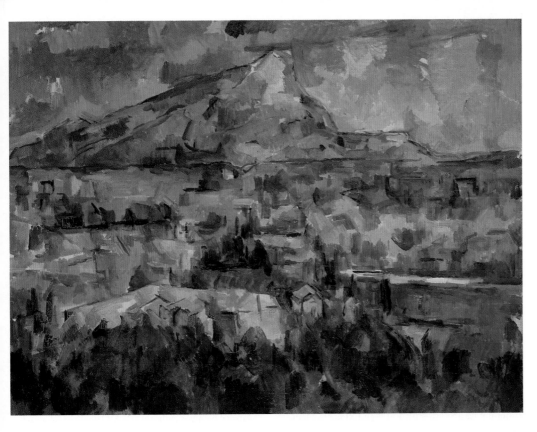

**Paul Cézanne**
Mont Sainte-Victoire, Seen from
Les Lauves, 1902–1904
Oil on canvas, 69.8 x 89.5 cm
Philadelphia (PA), Philadelphia
Museum of Art, George W. Elkins
Collection

interested him only in so far as it contributed to painting. Cézanne's aim was nothing less than to transform the world into an image on canvas. The means to this end was not line but color. "Nature is... not on the surface," he said, in a typical and compelling blend of sober objectivity and pathos, "it is in the depths. Colors are an expression of these depths on the surface. They rise from the roots of the world."

## "My Canvas 'Joins Hands'"

In order to give shape to the world in a landscape, in a bowl of fruit, a group of anonymous people, or in a portrait, Cézanne first had to organize color according to strict laws. In contrast to the Impressionists, he did not attempt to visualize the reflection of light *from* the surface of things but light itself as manifested *in* the colors of things. The charm of atmospheric effects left Cézanne cold. His art was devoted not to the changing appearances of the outside world but to its unchanging being or essence; instead of capturing the fleeting moment it strove for permanence.

Although his brushwork, like the Impressionists', had a finely articulated "molecular structure," it did not dissolve forms, having the effect not of nervous dispersion but of calm concentration. Cézanne built up his pictures with infinite patience, in a process, according to Gasquet, in which twenty minutes might pass between one brushstroke and the next. He gradually brought contrasts into harmony, until a dense, gapless weave of colors had emerged. When he was satisfied

with the result, "My canvas 'joins hands,'" he would say. "It holds firm."

This wonderfully characterizes Cézanne's deductive working method, progressing gradually from the small to the large. A fine texture now replaced the hitherto usual composing of a picture by establishing contours, volumes, and spatial relationships. Cézanne's pictorial architecture provided the source of abstract art, from the Platonistic geometry of the Cubists to the monochrome painters of recent days, who like Cézanne, do not compose a painting but weave it out of fine textures, like a tapestry. Every one of the French artist's pictures is like a world unto itself. Crossed tree branches, a boulder, a wall, or a house facade mark the limits of this world; we as viewers remain outside. We are not drawn into the image as we are into pictures based on an illusion of perspective depth. This fact points to the autonomy of Cézanne's painting. It is not dependent on nature, but, as he himself said, exists "parallel" to it, a creation of equal value, based on its own laws. Such visual barriers as the ones just mentioned even occur in the still lifes and portraits. The edge of a table, an easel, or a palette shut off the world of the picture from the world of the viewer. The effect is further underscored by Cézanne's waiver of depth relationships and plastic modelling. The pictorial space is defined solely by rich and subtle gradations of incorporeal color. Instead of using paint to *model* figures and objects, he *modulates* the paint with the aid of half and quarter tones as a composer modulates his theme by changes of key.

*"Look at Saint-Victoire. What a sweep! What a commanding thirst for sunshine! And what melancholy in the evening when all that heaviness settles upon it. Those blocks were fire. The fire is still in them. The shadow, the day, seems to recoil from them in awe, to be afraid of them... when great clouds pass over you will notice that their shadows tremble on the crags as if scorched, as if they were being quaffed by fiery mouth at the same time."*
PAUL CÉZANNE

# 2 The World as Symbol

## The Art of the Initiates
### Symbolism and its Consequences

*"Art is no longer a purely visual experience that we simply record nor is art a photograph of nature, not even a particularly sophisticated photograph. No, art is a work of our intellect, a work that is merely triggered off by nature. Rather than working through the eye, we concentrate our studies, as Gauguin said, on the secretive center of the mind. This is what Baudelaire had in mind, for in this way, the imagination again becomes the queen of our strengths and we liberate our sensitivity."*
MAURICE DENIS

Artistic styles that were heavily dependent on content, on ideas, were long out of fashion after the last war. It was not until the rediscovery of the Pre-Raphaelites, of the Nabis, of Gustave Moreau and Arnold Böcklin, that symbolism in the widest sense began to gain a more just appreciation. Despite its sources in the Romantic era, the Symbolist movement met with great distrust on the part of a generation that had been surfeited with ideology in art, especially in Germany. Although the reaction is understandable, it is not just. For without Symbolism and its practitioners modern painting would look very different; nor, in fact, would there be an autonomous art of the kind we know.

Symbolist painting goes back to two disciples of Gauguin, Paul Sérusier (ill. right) and Maurice Denis (ill. below). It was anticipated in the work of the idealizing neoclassicist Puvis de Chavannes, and in that of Odilon Redon, the first "modern" painter of supernatural and subconscious themes. From Paris and France Symbolism spread to Switzerland, informing the work of Ferdinand Hodler, and to Norway, influencing that of Munch. The notion of a pure and absolute art cropped up as early in Symbolist painting as it did in the

poetry of a Mallarmé or Verlaine. The visual image was considered independent of reality, self-contained and self-explanatory; that is, reflecting nothing but the subjective ideas of its maker. Color and form were used to translate thoughts and sensations into visual terms. It is one of the numerous paradoxes of art history that it was precisely this bond between idea and image that lent the painting a previously unprecedented degree of autonomy and independence of the natural model.

It was also a Symbolist, of all people, who said, "One must remember: a picture, before it is a warhorse, a nude woman, or some anecdote or other, is first and foremost a flat surface covered with colors in a certain order." These revolutionary words were uttered by Maurice Denis as early as 1890. Art therefore need not, as the German naturalistic poet Arno Holz maintained, have "the tendency to be nature again." It can be a creation based solely on intrinsic principles, corresponding to the artist's imagination and subject to his will to form.

Historically, Symbolism was a reply to the increasingly materialistic and mechanized life of the burgeoning Industrial Age and to the empirical, naturalistic art that uncritically reflected this development. The visual "nationalism" of Impressionist art was countered by the Symbolists with an emphasis on spirituality and an acceptance of the mysteries of existence. *Intuition*, introspection and inspiration, became the new magic word of the *Initiés*, the initiates of Symbolism, who rejected mere *artistry*. The major group in the movement, founded by Sérusier in 1888, called themselves "Nabis," a Hebrew word meaning "enlightened one" or "prophet". The creative power of imagination once again came into its own. The Romantics had earlier believed in it.

The practice of art again received a metaphysical consecration. William Blake and Philipp Otto Runge, in close contact with the poets and philosophers of the period, had already spoken of "symbolic color" and "pure forms." Runge, like the poets Novalis and Ludwig Tieck, realized that interrelationships existed between mathematics, music, and color in art. His painting *The Lesson of the Nightingale* (Hamburg, Kunsthalle) was intended to be the same thing "as a fugue in music." In his studies for the unfinished cycle on *The Times of Day*, Runge developed an enigmatically coded picture-writing, symbolic hieroglyphs, which would be taken up

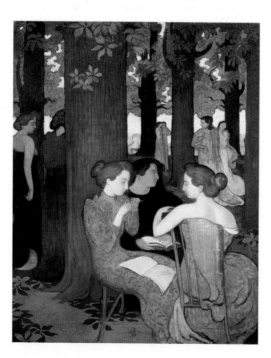

**Maurice Denis**
The Muses or In the Park, 1893
Oil on canvas, 171.5 x 137.5 cm
Paris, Musée d'Orsay

by later artists. Already in the early 19th century the Romantics sought a way to bridge the gap between mind and matter, the spiritual and the perceptual, between ideal and reality.

The alienation of the individual from society had begun. Gifted and dissatisfied loners withdrew ever further from an increasingly commercialized world; artists, who saw themselves as belonging to the elect, set themselves off from "the madding crowd." The gap between artist and audience grew apace.

## The Enigmatic World

All of this was a consequence of an increasing sense in the 19th century of the inadequacy of scientific explanations of the workings of nature and society. Too much still remained an enigma. Previous bases of social consensus, from religion to common sense, had begun to crumble away. Only the individual could hope to find some solution for the problems of life, alone in his study or studio. This was the source of the private, even hermetic character of art and the artist's life in the Romantic period. The artist came to be seen, and to see himself, as an elect person, a seer or prophet; and consequently art became a surrogate religion, a development that sooner or later could not help but lead to art for art's sake. Capar David Friedrich painted a ghostly ship, called *Hope,* stranded in a sea of icefloes (Hamburg, Kunsthalle).

European nihilism and the melancholy of the modern artist had their roots in Romanticism, which in in turn largely anticipated the philosophy of Symbolism and the course of its representatives' lives. With Gauguin the night thoughts of the Romantics burgeoned into a nausea with civilization. Rimbaud no longer mourned the loss of paradise, instead offering his readers the experience of *A Season in Hell.* Baudelaire wrote a book of poems called *The Flowers of Evil.* With him the Romantics' sufferings at the state of the world turned into a surfeit, a deadly ennui in face of it all.

The Symbolist painters, rediscoverers of the Romantic arabesque, the music of color, the symbolic form, developed in different directions. Some, like Sérusier and Denis, although they were artistic disciples of the heathen Gauguin, became the founders of a new ecclesiastical art in a Catholic vein. Another, the Belgian painter Jan Verkade, joined the artists' brotherhood in Beuron Monastery. Hodler, the Swiss, adopted a more secular artistic ethic, beholding solely to the human individual, the society in which he lived, and the history that had shaped it. Art, he believed, should fill existence with beauty, which would make people better and more capable of living in peace with each other.

Hodler embodied the idealistic strain within Symbolism, for he believed with unshakeable naivety that art could be a universal language, understandable to all and therefore capable of reconciling nations. For artists like Hodler, art was meaningful only when it fulfilled a social function, not when it attempted to be self-sufficient. Other painters, such as the incomparable colorist Bonnard and his colleague Vuillard, although they too originally belonged to the Nabis circle, took a less sentimental, more skeptical view of the mission of art.

Attempts to improve the world and religious zeal were equally foreign to them. And they were foreign to Marquis Henri de Toulouse-Lautrec. On withered legs that had been injured in a fall from a horse as a youth, Lautrec explored his personal version of Rimbaud's hell in the bordellos and sleazy cabarets of Montmartre. The scope of Symbolist art originally reached from Toulouse-Lautrec's reports from the demi-monde to Sérusier's devoutly spiritualized imagery. It cannot be gainsaid that the painters who turned most radically away from the original Symbolist idea of redemption through art produced work which, in terms of quality and significance, outstripped the meaningful but often sweetly decorative paintings of their religious counterparts. Today Sérusier, whose brilliant philosophical mind was already appreciated by his fellow-students at the Paris Academy, and Denis, the co-leader of the Nabis, are valued perhaps less as painters than as thinkers and theoreticians who sparked a renascence of ecclesiastical art.

**Paul Sérusier**
The River Aven at Bois d'Amour
(The Talisman), 1888
Oil on wood, 27 x 21.5 cm
Paris, Musée d'Orsay

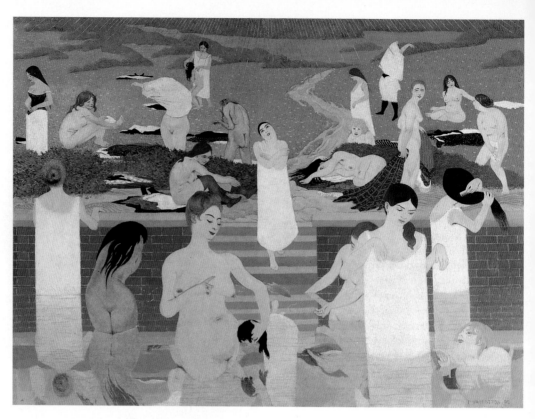

**Félix Vallotton**
Bath on a Summer Evening, 1892
Oil on canvas, 97 x 131 cm
Zurich, Kunsthaus Zürich

Symbolism, unlike German Expressionism or French Cubism, was not a movement striving for stylistic unity, but a mental and spiritual attitude that permitted many variants. It stands as proof of the absolute superiority of France – that is, of Paris – in the art-historical situation at the close of the 19th century. The French metropolis was not only the production plant and market for the naturalistic, empirically oriented arts but the center of the Symbolist reaction against their hegemony. The movement began in 1891, with the first exhibition of Impressionist and Symbolist painting at a newly opened gallery, the Le Barc de Boutteville.

### Art becomes Literary
Again the pendulum swung back to a literary art. Symptomatic of this development was the cooperation of visual artists with a spate of new and important journals, *Plëiade, Décadent, Vogue, Plume, Mercure de France*, and *La Revue Blanche*, which published the graphic art of the Symbolist painters. The art dealer Vollard published a series of now-famous deluxe books, limited editions to which both the worldly and pious Symbolists alike contributed illustrations. Henry van de Velde, Dutch artist and Art Nouveau architect, he too an adept of dynamic, sinuous line, ornament and arabesque, designed the editorial offices of the *La Revue Blanche*. An occasional visitor there, by the way, was a taciturn man from the far north of Europe by the name of Edvard Munch.

The sharp contrast between Impressionist and Symbolist art theory is well-illustrated by the statements of Albert Aurier, an admirer of Gauguin, published in *Mercure* in 1891: "The work of art must be, firstly, 'ideational'; secondly, symbolistic, because it expresses an idea in forms; thirdly, synthetic, because it describes these forms and these signs in a generally understandable way; fourthly, subjective, because the object is never considered an object per se but rather as a sign for an idea which is expressed through the object; fifthly, decorative, because the original decorative painting, as practiced by the Egyptians and very likely also by the Greeks and primitive peoples, is nothing other than a simultaneously subjective, synthetic, symbolistic, and ideational manifestation of art."

One can see that the Symbolists too had their venerated ancestors. Under the generic heading of "traditionalism" they interpreted Egyptian, ancient Greek, and early Italian Renaissance art in an arbitrary manner suited to their own needs. The concept of the decorative, understood to mean simplified forms enlivened by arabesque contours and a color harmony of pure and broken hues, received a considerable re-evaluation. Again artists, true to Verlaine's demand that poetry be "music above all else," began speaking of "notes" and "chords" in painting, as Gauguin had done before them and as Kandinsky would subsequently do. Unlike many a later purist, the Symbolists were not ashamed to admit that art could be ornamental, even though it was primarily idea. Thus it was very much in conformance with the Symbolist aesthetic that the applied and graphic arts, not highly valued by the academies, experienced a new flowering.

The long forgotten and only recently rediscovered Swiss artist Félix Vallotton (ill. left), a highly intelligent man with a fine sense of design whose style combined a moderated Art Nouveau sinuosity with a subtle color range, helped revive the technique of the woodcut. The art of lithography was brought to an unprecedented peak of perfection by Toulouse-Lautrec and others, the tradition of tapestry-making was revived, and poster design became an art in its own right. Surpassing the fly-sheets and copper engravings of earlier days, the new graphic arts brought greatly improved possibilities of producing and distributing quality works of art and publications.

Moreover, the Nabis and Symbolists now received the mural commissions for which a Gauguin had waited all his life in vain. Vuillard was asked to decorate the Palais de Chaillot in Paris, near the Eiffel Tower, and the Palace of the League of Nations in Geneva, a project to which Denis also contributed. The formal approach of the Symbolist artists was perfectly suited to fresco painting: a simplification of form to the point of conscious "primitiveness," and a preference for expansive, two-dimensional, depthless planes of the kind found in Japanese prints or Egyptian art. Despite their emphasis on heightened color and arabesque contour, which they took to the verge of Expressionist distortion, the Symbolists strove for aesthetic harmony, an "abstract" order within the depiction. To this extent they kept the heritage of Cézanne and Seurat alive in their art, despite the very different aims they pursued. Gauguin's former Pont-Aven disciples Sérusier and Denis announced their return to the religious wellsprings of art: mysticism, legend, allegory and dream. They also maintained ties with the more or less dubious sects and groupings of the period, whether cabbalist, theosophical or occult, including the Rosicrucians and their Richard Wagner cult. As in the preceding Romantic era, the wisdom of the East once again attracted followers, and artists proclaimed their allegiance to the *Elan vital* described by philosopher Henri Bergson, the superiority of intuition over intellect.

In sum, the entire epoch yearned for redemption. Many artists and poets, like the drinker Paul Verlaine, fled into the saving arms of the Catholic church. Yet Symbolist painting in France managed to escape a "gothic" look, with its proliferation of detail and vagueness. Its structural framework remained lucid, coherent, and disciplined. This was due not least to the artists' adoption of mystical numerology, their revival of the "sacred proportions" which already in the Middle Ages had led to a combination of clarity of thought with meditative absorption, and which appeared to the devout artists to represent the ideal form of an *imitatio dei*, or imitation of God. Their reverence for the right angle, the horizontal and vertical as "pure axioms of the spirit," anticipating Piet Mondrian and the aesthetic of De Stijl, also played a key role in the maintenance of pictorial order.

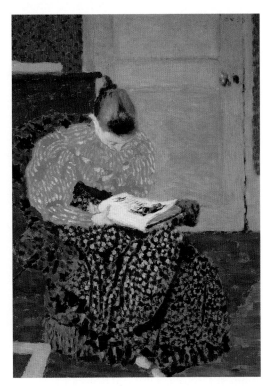

**Edouard Vuillard**
Woman Reading, 1893
Oil on cardboard, 35 x 25 cm
Private collection

**Edouard Vuillard**
Mother and Child, c. 1899
Oil on cardboard, 50.8 x 58.5 cm
Glasgow, Glasgow Art Gallery
and Museum

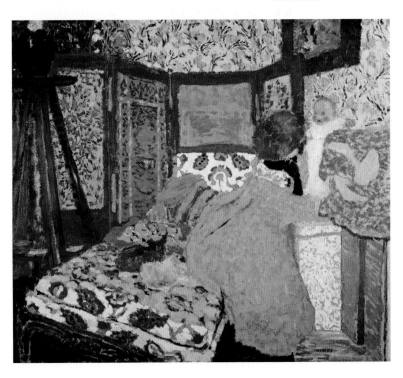

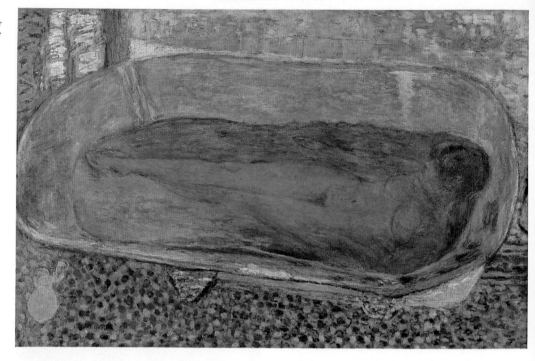

**Pierre Bonnard**
Female Nude in the Bathtub,
c. 1937
Oil on canvas, 94 x 144 cm
Germany, private collection

**Pierre Bonnard**
The Breakfast Room, c. 1930/31
Oil on canvas, 160 x 113.8 cm
New York, The Museum of
Modern Art

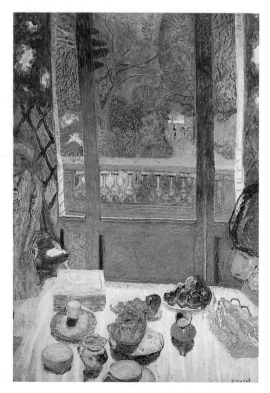

*Page 27:*
**Pierre Bonnard**
The Toilette, c. 1908
Oil on canvas, 119 x 79 cm
Paris, Musée d'Orsay

### Painterly Finesse and Pictorial Framework

Bonnard and Vuillard, who founded the Nabis after Sérusier's visit to Gauguin, have best withstood the test of time precisely because they soon ceased to conform to the group's doctrinaire principles. Their compositions are highly daring, revealing the influence of Japanese prints – indeed Bonnard was titled the "Nabis très japonard." They love apparently random but actually carefully calculated overlappings of form, and often cut off objects and even the limbs and heads of figures at the canvas edge. This lends their pictures the charm of the accidental, without jeopardizing the harmony of an art of extreme sophistication and exquisiteness.

Vuillard's style is consciously two-dimensional (p. 25). Its planar decorum and rich ornamentation, emphasizing the rare and exquisite, often lends his paintings the appearance of a fine tapestry. Bonnard, taking his cue from the late Monet, developed Impressionist color to the peak of refinement. His palette is subdued yet retains a vibrant intensity. Landscapes, figures, and objects appear as if behind a diaphanous veil, their shimmering contours rendered in subtle gradations of hue, the whole suffused by an incredible range of values, an exciting glissando of color. A wonderful cool blue, a richly gradated white are contrasted to luminous warm color chords. The art of Bonnard, the retiring former lawyer, has a tantalizing grace, exudes an irresistible but never cloying perfume, which is counterpointed by a decisive and daring composition derived from Degas and rife with significance for developments to come. In contrast to the Impressionists, Bonnard did not paint spontaneously (pp. 26 f). He corrected his pictures again and again, sometimes working for years on a single painting or series of paintings without ever being satisfied with the result. Yet his art has all the carefreeness and seeming effortlessness of a Mozart symphony. It celebrates leisure, the pleasures of the good life; it shows beautiful people surrounded by beautiful things, a world apparently unburdened by cares or labor. But again, the lyricism and charm of these idyllic "moods" were the result of endless, self-critical, even pedantically obsessive effort.

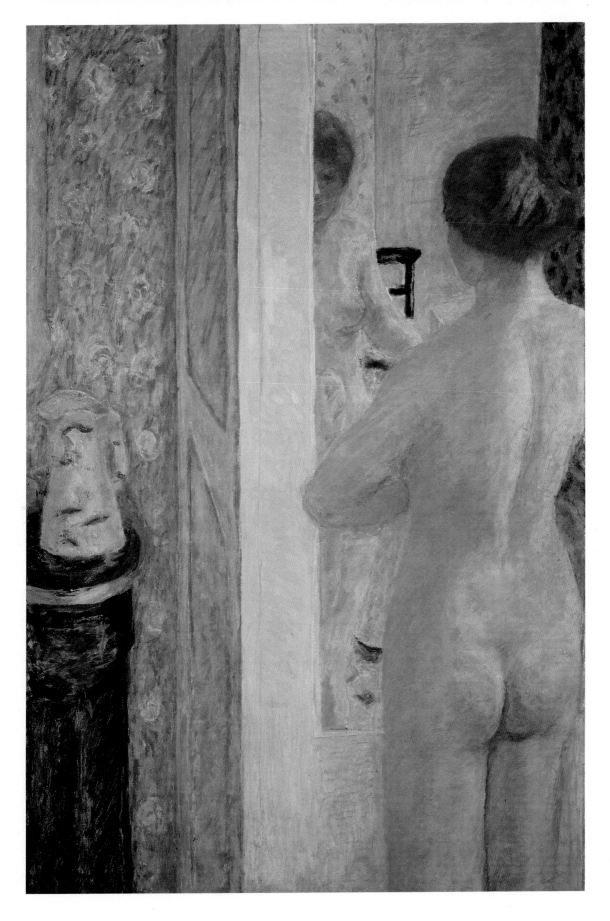

Bonnard did not stop at correcting pictures that already hung in exhibitions or even museums, clandestinely, if necessary. His apparently so unrevolutionary, unobtrusively tranquil painting was a late blossoming of the French cultivation of the medium, and yet it was also full of potential for the future, as the shy, retiring artist was evidently aware. "The abstract is a component of art," Bonnard said, and summed up his experiences in the proud yet modest statement, "The path is open, but the work of art still remains to be created." This bourgeois *intimiste* was not the unoriginal Post-Impressionist successor which for decades he was considered to be. In the quality of their *peinture*, Bonnard's pictures need not fear comparison with those of the great Matisse, and in their visualization of ideas by means of a balanced asymmetry of pictorial framework, they early anticipated things to come.

## A Closed Society
### Henri de Toulouse-Lautrec and the World of Montmartre

*"Nothing for it, nothing for it, I must play the deaf mute and batter my head against the walls – yes – and all for an art that eludes me and will never encompass all the terrible things I have endured for its sake … Ah, dear grandmother, you are wise not to give yourself over to painting as I do. It is worse than Latin if you take it as seriously I do."*

HENRI DE TOULOUSE-LAUTREC

The lives of most of the Symbolist painters took a different course from those of the poets of the period – the morbidly melancholy Baudelaire, the Rimbaud who abandoned poetry for the active life, the alcoholic Verlaine. But for one painter, Henri Marie Raymond de Toulouse-Lautrec (ill. below), life was truly "A Season in Hell". Much as the label would have angered him, he too was a Symbolist, if not in the sense of holding to any rigid aesthetic or ideological doctrine. He was a Symbolist in the sense that all of the figures he painted or drew – prostitutes, *grisettes*, singers, dancers, dandies, apaches, pimps, gentlemen about town – we "representative" of a certain type of person, products of an era that was on the verge of discovering the dubious, absurd aspect of human existence. In the feeling of having been abandoned by God, people let themselves go, plunged into sin and licentiousness, for a greed for life is the reverse of a fear of life.

The painting of this man, who suffered by proxy the fate of his own and the succeeding generation, is great, precise, and clairvoyant art. In it the expressive force of the linear arabesque was put in the service of the depiction of human character. Toulouse-Lautrec jettisoned the historical and mythological ballast that had

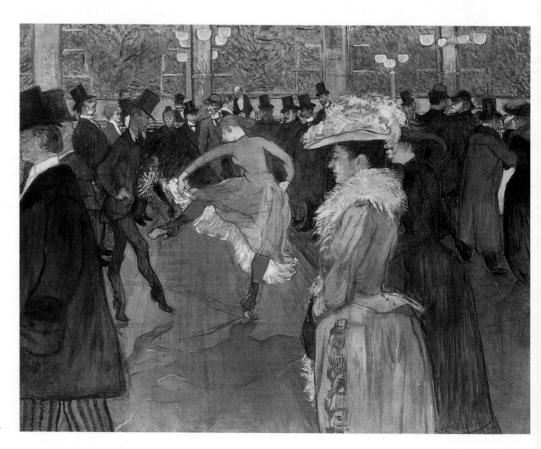

**Henri de Toulouse-Lautrec**
A Dance at the Moulin Rouge,
1889/90
Oil on canvas, 115 x 150 cm
Philadelphia (PA), Philadelphia
Museum of Art, The Henry
P. McIlhenny Collection in
Memory of Frances P. McIlhenny

**Ferdinand Hodler**
Night, 1890
Oil on canvas, 116 x 299 cm
Bern, Kunstmuseum Bern

encumbered previous figurative art. He was inspired by the Modern Style, the English source of Art Nouveau and Jugendstil, but he far transcended its self-conscious play of line, its tendency to the sheerly ornamental, and its programmatic symbolism. Toulouse-Lautrec's paintings, drawings, and posters are suffused with reality, based on precise observation. In his skilled hands the denizens of Montmartre, the cabaret and circus people, the habitués of bars and bordellos, are transformed into symbols of themselves. Toulouse-Lautrec's art is simultaneously realistic and symbolic. The figures are stripped of accidental detail and reduced to the essence of character. Though sometimes verging on caricature or even overstepping the line, these figures, for all their individuality, have an emblematic presence. They are an essence distilled from reality by a great artist.

## Art as a Philosophy
## Ferdinand Hodler: Swiss Symbolist

Born into a tradesman's family in Gürzelen, canton of Bern, Hodler left home at the age of 19 and went to Geneva, in French-speaking Switzerland. His art, intellectual, laden with problems, and rather heavy-handedly symbolic, was destined to have almost no echo in France. In Germany, on the other hand, it was readily taken up, especially by the Munich Circle of Symbolists around the poet Stefan George. This is not surprising in view of the fact that in the land of poets and thinkers, painting has always involved a deal of cerebration. Hodler occasionally went too far in this regard. His depth of thought, his penchant for allegory and tendency to mystify life and organic processes, almost spoiled the effect of the very paintings he considered his best: *Spring* (Essen, Museum Folkwang), *Eurythmy, Dialogues with Nature, The Chosen One* (all Bern, Kunstmuseum), and *Gaze into the Everlasting* (Basel, Kunstmuseum).

This was the entire impressive series that had begun in 1890, with *Night* (ill. above). In an extreme heightening of the Romantic notion of symbolic form, Hodler here transformed form itself into an ideology. Through symmetry of composition, a parallel arrangement of figures in vertical or horizontal rows, a palette rife with symbolic meaning, a rhythm of dignified movements, a contained passion of facial expression, and a serene pathos, he attempted to achieve a new and convincing monumentality. Hodler sought to unify the sensual with the spiritual in his art.

"Parallelism," the technique Hodler developed to create monumental effects by sparing means, without having to resort to masses of figures, perhaps cannot entirely convince a contemporary eye, which tends to see only the forced look of the poses. Nonetheless, the Swiss artist demonstrated that monumental history painting free of academic sentimentality was indeed possible at the beginning of the twentieth century. Also significant are Hodler's portraits and his light-flooded late landscapes, melancholy views of Alpine nature without a sign of human life. The soaring mountain ranges, the parallel bands of water, land and sky that seem virtually to continue beyond the canvas edge, convey the grandeur of the wide open spaces and possess the force of form and line reduced to the essence and cleansed of all anecdotal detail.

*"Light in the evening is a harbinger of the night. In a picture, one can add to this light and I act according to the logic of this law of a unified light. I did not want to render a night effect, but rather a more general, deeper feeling."*
FERDINAND HODLER

# 3 The Break with History

## Youth Wipes the Slate Clean
### The End of the Historical Definition of Art

No one would think of judging the artistic style of our own period by looking at the design of the subway entrance on the next corner. Around 1900 people did just this. Those who visited the Paris World Fair at the start of the new century and prepared to descend the stairs to the Métro had before their eyes an example of the formal language of a new art. The cast-iron ornamentation of the recently installed Métro entrances contained in a nutshell the unified opposites out of which the style had been shaped. Known as Art Nouveau in France, the Modern Style in England, its country of origin, and Jugendstil in Germany, where it came to full flower, the style combined a playful use of plant-like, intertwining lineatures with an appreciation of the fitness of the materials to the design. Floral ornament burgeoned during the early phase of Art Nouveau. The later, more geometric phase, dominated by the outstanding personality of the Belgian artist, designer and architect Henry van de Velde, marked its end. The generic term for the style in the German-speaking countries derived from an important illustrated magazine, *Jugend* (Youth), published from 1896 by Georg Hirth in Munich. The name is itself a kind of statement of principle. It embodies the carefree freshness of the innovative stream of art that set out to expose what Friedrich Ahlers-Hestermann called the "stylistic masquerade" of the 19th-century Historical Revival styles. All over Europe it wiped the slate clean, sweeping away knick-knacks and furbelows of the Victorian variety in England, of the Wilhelmine variety in Germany, and

of the post-Napoleonic variety in France. In Spain, with Antoni Gaudí, it brought forth a neo-Baroque renascence in architecture. Everywhere it cast off the burden of traditions to proclaim a new beginning. The link between art and publishing points to the literary element in this youth movement in art, which laid claim to creating not only a new aesthetics but a new ethics as well.

### Social Reformers

Art Nouveau set itself the task of radically changing the human environment. The young artists wanted to fill the world with beautiful things, and to fight for the maintenance of individuality in the face of an increasingly technologized society. Technology was to be "humanized," machines were to be made the servants, not the masters, of man. At the beginning of the century the protagonists of Art Nouveau already tackled an issue that still concerns us today: how to bridge the gap between artist and audience, between individual and society. They too showed a penchant for the Gesamtkunstwerk, a comprehensive work of art that would take effect on everyday life, indeed that would make life itself a work of art, an idea from which a direct path leads to Joseph Beuys's postulate that everyone is an artist.

The pacemakers of the Art Nouveau movement were originally painters. But indicatively they soon turned to architecture or to the previously so belittled arts and crafts, in order to facilitate the dissemination of their ideas. They became builders and designers, van de Velde of Belgium, Joseph Maria Olbrich of Vienna, August Endell of Munich (whose influence led beyond Art Nouveau to Kandinsky), the northern German Peter Behrens, the southern German Richard Riemerschmid, and their many followers. Hermann Obrist, a natural scientist who studied sculpture, even found his specific form of expression in embroidery. This choice of medium illustrates the paradoxical blend of social utility and elitist exclusiveness that characterizes the style. "We must use the snob in order gradually to reach the people," stated the painter Otto Eckmann. His credo sheds light on the problematic nature of the entire movement, for by the time Art Nouveau actually came "to the people", it had been distorted almost to the point of unrecognizability by manufacturers of mass products who speculated on its popularity.

**Adolf Hoelzel**
Abstraction II, c. 1913/14
Oil on canvas, 52 x 61 cm
Stuttgart, Staatsgalerie Stuttgart

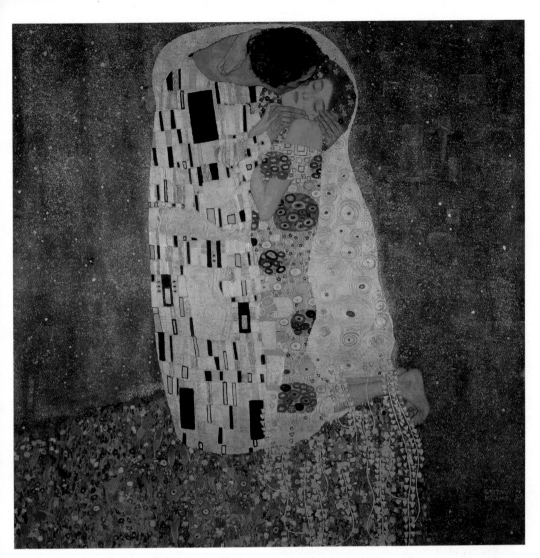

**Gustav Klimt**
The Kiss, 1907/08
Oil on canvas, 180 x 180 cm
Vienna, Österreichische Galerie
im Belvedere

Yet even more than in painting and drawing, Art Nouveau came into its own in architecture and interior design. With the Darmstadt artists colony of 1899, the first Gesamtkunstwerk encompassing city planning, architecture, sculpture, painting, and applied art was conceived and realized. The most original talents of Art Nouveau would have nothing to do with the easel painting, which to them seemed the quintessence of an elitist and hermetic art for art's sake. Similar considerations would later be aired in the program of the Weimar Bauhaus. Indicatively, it was an architect, Walter Gropius, who was nominated as director of the new school of art, and that on recommendation of van de Velde.

### Art as a Surrogate Religion

In Germany especially the ideological weight that Art Nouveau was expected to bear finally brought it to its knees. What was basically an honorable and well-meaning attempt to completely redesign the human ambience, including finding the best possible form for household appliances, ultimately issued in a development that, for all its beneficial results, proved incapable

of resisting the onslaught of kitsch. The movement finally ended in a mass production of pseudo-Art Nouveau products that discredited the style for decades to come. However, this should not be allowed to blind us to the immense historical significance of the Modern Style and its continental offshoots. Not only did it give the *coup de grâce* to the endless historical revivals of the late 19th century (what Karl R. Popper terms "historicism"), but it replaced them by a new, independent sensibility to form, born of the spirit of the contemporary age, and by so doing it paved the way for revolutionary directions in modernism. In England the development, inspired by John Ruskin and William Morris, who themselves revived aspects of past art, especially Gothic, had already come to a standstill by the time it was peaking in Germany. British artists, perhaps more conservative in attitude, sought a compromise between tradition and innovation; the reformers remained at bottom artisans, and they rejected the machine as the destroyer of handcrafted quality goods. In consequence, the English aesthetic reforms petered out before they had hardly begun.

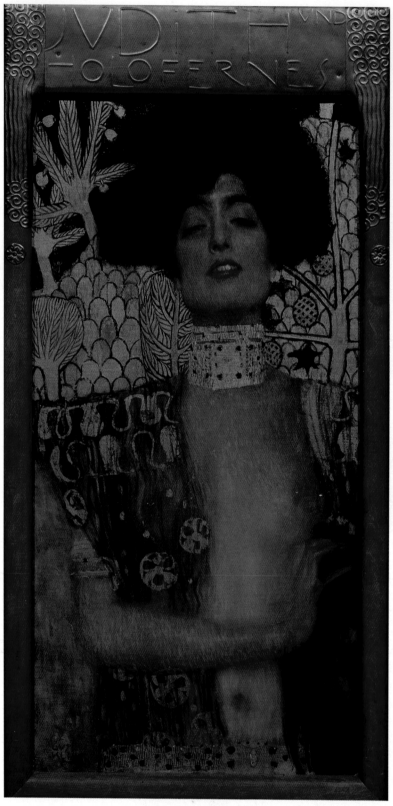

They invented a new brand of planar ornamentation, which initially depended largely on the natural forms of plants and flowers but which gradually developed towards abstraction and autonomy, while at the same time taking on more sculptural volume. Van de Velde provided a tectonic structure for the style. In general, Art Nouveau described a path from a contemplative and amusing glass bead game with free forms to a constructivist seriousness and utility. It would lead to the stark buildings of Adolf Loos, the Viennese Secession architect, who proclaimed that ornament was a crime. Other artists of the movement had begun to dream of a public that no longer asked about the "motif" or "subject matter" of a picture but were ready to lose themselves in the mellifluousness of line as in the melodies of music. The painter Adolf Hoelzel (p. 30) began to think about a theory of harmony as applied to colored forms, and he also experimented with black and white figurations transformed entirely into ornament.

The affinities of Art Nouveau with contemporaneous French painting are obvious. The formal language of the style was not exhausted in the sophisticated, hothouse late Mannerism of the English illustrator of Oscar Wilde's *Salome*, Aubrey Beardsley. It also appeared, as suggested above, in the sinuous flamelike play of line in van Gogh's cypresses, and in Seurat's and Toulouse-Lautrec's arabesques. Many major artists of the late 19th and early 20th century were influenced by Art Nouveau.

### The Perfume of the Vamp

An important and highly idiosyncratic variant of the new style emerged with the Viennese Secession, founded in 1898 by Gustav Klimt, who was the most gifted painter in the group (pp. 31 f). This great decorative artist, whose proliferating paintings and subtle, supple, erotic drawings stood in sharp contrast to the purist architecture of his fellow-Secessionists Loos and Otto Wagner, was the first and most significant depictor of the manhunting vamp, the *femme fatale* of the *fin de siècle*. Klimt's sensuous female figures embedded in rich ornamentation studded with gold and jewel-like colors represented the type of the courtesan, which would find widespread dissemination with the advent of film. One might even say that if Renoir created the popular image of the Parisian woman, that of the vamp was created by Klimt.

Yet Klimt's depictions entirely lack the existential seriousness, the passion sometimes pitched to the point of hate, which the theme "woman" took on with an artist like Munch. Klimt's sophisticated world, with its atmosphere of drawing-room wildness, influenced the young Oskar Kokoschka, the Austrian Expressionist and belated heir of the Baroque. Art Nouveau prepared the ground for the growth of many considerable talents and a few major painters, but it did not itself really produce any. This fact points up the greatness and the limitations of the movement that emblazoned on its banners "Youth!" and "New!"

**Gustav Klimt**
Judith I, 1901
Öl auf Leinwand, 84 x 42 cm
Wien, Österreichische Galerie
im Belvedere

In the other countries of Europe the movement away from tradition took place all the more rapidly and radically, if with varying results. Artists discovered the expressive potential of the organic, freely curving line.

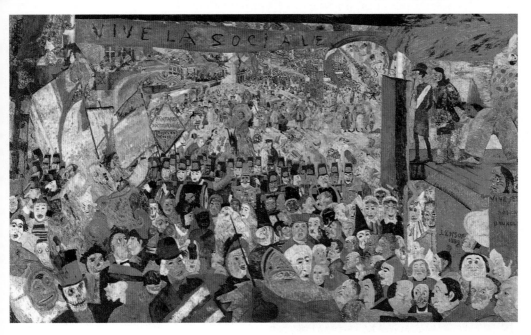

# Masquerades
## The Haunted Realm of James Ensor

In November 1949, a lonely old man died at the age of almost ninety in the attic of his house in the fashionable Belgian resort Ostend. James Ensor, son of a Flemish mother and an English father, had outlived the major phase of his work by nearly five decades. By the time the once-derided painter of ghostly masquerades, a latter-day heir of the Netherlanders "Hell Breughel" and Hieronymus Bosch, received a knighthood from the Belgian royal house at the age of seventy, Ensor's visionary force had long deserted him, and he had become a reclusive eccentric.

Ensor's fantasies are records in painting of a profound anxiety that pervaded the art and lives of many artists around the turn of the century. His work is suffused by deep skepticism in the face of a materialistic world. With the sensitivity of a seismograph Ensor registered the cracks in the glossy surface of a prospering bourgeois society which would soon tumble into the abyss of the First World War. His demons, grinning skeletons, and eerie masks were omens of approaching disaster. In *The Entry of Christ into Brussels in the Year 1889* (ill. above), the apocalypic imaginings of the artist, translated from personal experience into general terms, take on exemplary form. Like the painter himself in many of his portraits (ill. right), the figure of Christ is surrounded by masqueraders who attempt to pull him along with them as the crowd streams towards us out of the picture. These are bourgeois ghosts, normal everyday citizens revealing the brutal, snobbish, demonic or macabre side of their nature, accompanied by a skeleton, a mummer of the devil with his retinue in train.

Reality dons a mask, becomes wierd and strange, the ground is pulled out from under the artist's feet – isolating him, leaving him alone with his mistrust of the real world around him, and with an anxiety that causes him to see nothing but death and decay everywhere. The

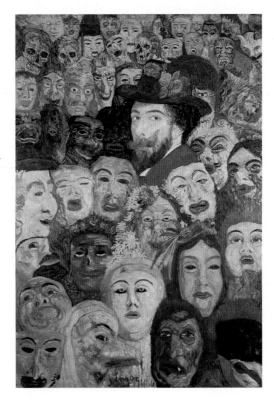

*"Oh, one must see them, the masks beneath our great opal sky! Smeared with horrible colors, moving wretchedly, their backs crooked, pathetic figures, horrified figures, outrageous and shy at the same time, scolding and bickering."*
JAMES ENSOR

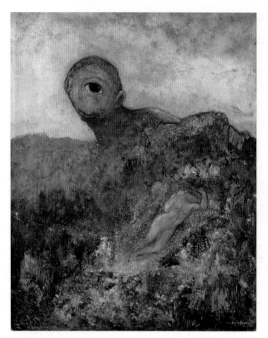

hues and prismatic reflections of Impressionism, intended to give a perfect illusion of real appearances, were made to serve the ends of a non-illusionary, and disillusioned, art. As the world around him grew darker, Ensor's palette grew brighter. But if we look more closely, we see that this brightness consists of myriad gradations of opalescent hues that suggest the colors of decay and putrefaction, processes that are also evoked by the increasingly loose, disintegrated texture of the painting surface. The light in these pictures seems bleached, producing a pastel tonality that is occasionally heightened by accents of bright, disturbing yellow and harsh, toxic red. Even in face of Ensor's most beautiful paintings and etchings, whose technical mastery recalls Rembrandt and whose themes recall Goya or Jacques Callot, one doubts the wisdom of one's first reaction of spontaneous pleasure. This doubt is justified. Signs of dissolution are even found in Ensor's landscapes. A print like "Peculiar Insects," which the artist has given his own and a woman-friend's faces, anticipates Kafka's nightmarish tale *The Metamorphosis*, in which a sales-man, Gregor Samsa, wakes up one morning to find himself transformed into a giant beetle.

Ensor was neither an Impressionist nor a Symbolist. Nor did he found a school, though many Expressionist and Surrealist artists learned a great deal from him. Emil Nolde's ecstatically religious imagery, at least in terms of color scheme, goes back to Ensor just as much as does the masquerade realm in many paintings by Karl Hofer or the invocation of overwhelming inhuman forces in the visions of graphic artist Alfred Kubin. Ensor's hallu-cinatory art was continually threatened by an influx of dissolution, his brushstrokes disintegrated beneath his hand. Like Monet's *Haystacks* and Turner's watercolors, such paintings as Ensor's *Crushing of the Rebel Angels* (Antwerp, Koninklijk Museum voor Schone Kunsten) belong to the forerunners of Abstract Expressionism and L'art informel.

Redeemer is at the mercy of the raving crowd, a Don Quixote, a tragic fool whose approach is watched with veiled curiosity by the actors on the market stage, for someone *this* unworldly is hard to believe.

As early as Redon (ill. above), an artist saw reality, nature turn demoniacal, as eerie, phantasmagorical creatures emerged from apparently innocuous bouquets of flowers. But what the French artist achieved by "liter-ary" means, Ensor translated into pure line and form. He unmasked society by letting it don the masks of its own choosing, revealing the underlying attitude to life of the epoch in compelling and disturbing imagery.

Ensor employed painterly means developed in Impressionism. This adds another paradox to the many that characterize his art. The luminous, shimmering

## Life unto Death
### The Crisis of Modern Consciousness in the Work of Edvard Munch

Anxiety can be a spur to creativity, as the work of Ensor shows. That of Munch reflects the crisis of modern con-sciousness with even greater intensity. In his case, too, the personal experiences of a depressive nature corre-sponded with the pessimistic basic mood of the era.

Already as a boy Munch was confronted by the death that inevitably closes life's cycle. He was only five when he lost his mother to tuberculosis. A sister died a short time later, and a third became insane. Edvard's father, a melancholy man, was a doctor who treated the poor of Oslo, so misery was a continual guest in the Munch household. The sensitive young man feared to

succumb to the family fate; an aunt suggested that painting would be a good way to take his mind off such depressing ideas. She thereby showed him the way to articulate his oppressive anxiety.

It cannot be denied that Munch's artistic unique-ness, the factors in his work that made him a pioneer of modern painting, were closely linked with his personal circumstances. For confirmation we need only compare the works of his early period, up to 1908, with those he painted after the Danish physician, Dr. Daniel Jacob-son, had cured him in a Copenhagen clinic of the obses-sions that had led to a near-fatal nervous breakdown.

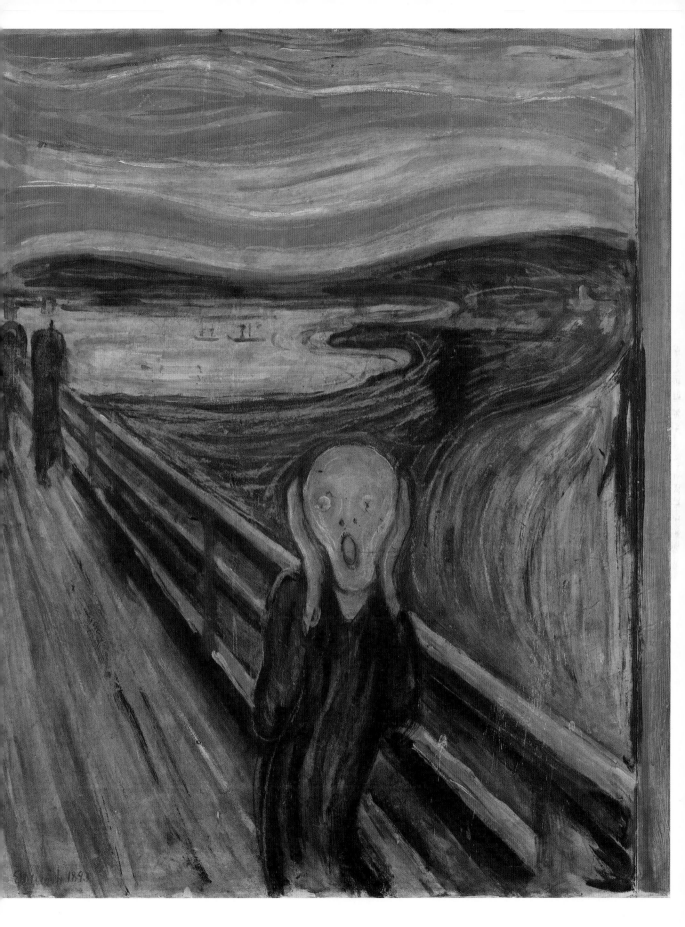

Suddenly his paintings showed no more despairing young girls on *The Day After*, no panic-stricken men and women, no sick children, no dead and dying, no storm-whipped, darkly ominous landscapes. From then on Munch depicted only scenes from normal, everyday life, farmers, fishermen and workmen, horses before the plow, peaceful stretches of countryside.

Munch had recovered his health and his ability to cope with life, but this regained power also entailed a loss of hallucinatory vision and nervous sensibility. Yet to the end he remained an artist of remarkable expressive force. The caesura in his development did not lead, as it did with Ensor, to an abrupt decline in imaginative capacity. Even at an advanced age Munch produced works as compelling as the self-portrait in which he depicts himself, tall and emaciated, his face seemingly already beyond the grave, standing shaky-kneed and with arms dangling helplessly at his sides next to a grandfather clock that shows his hour has come (Oslo, Munch-Museet).

### La Boheme in Oslo

Munch had his first lessons with Hans Olaf Heyerdahl and Christian Krogh in Oslo. Then, in 1885, he travelled to Paris for a three weeks' stay. By the time he returned home he had learned the Impressionist technique of painting in brilliant colors on a white canvas, instead of on the traditional dark ground. His association with Hans Jäger, a writer who had shocked the good citizens of Oslo with a novel so sexually explicit that it was promptly banned, brought Munch into contact with Oslo's Bohemian scene. (The city was at the time still known as Christiania.) The artists there had distanced themselves as far from the self-satisfied bourgeoisie as they had in Paris, and they protested against the commercialization of industrial society in a life-style as unconventional as they could manage.

This period saw a second incident that emotionally injured Munch so deeply that he never recovered, and in fact that made him incapable of marriage. The unfaith-

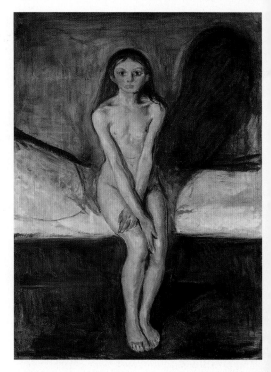

fulness of a girl he loved led him, the tall man with the chiselled features whose looks fascinated women, to view females as vampires, and love for them as a fatal attraction.

The year 1889 found Munch in Paris for the second time. He went to exhibitions of Impressionist, Neo-Impressionist, and Symbolist art, and frequented the editorial offices of *Revue Blanche*, where he met Tou-louse-Lautrec. Munch discovered the magic of line, admired Gauguin's ability to compose in flat planes of musically modulated color, but did not imitate his approach. Instead, he transposed the aesthetic insights gained in Paris into his own, Nordic realm of "nocturnal brightness," as Werner Haftmann has put it. For Munch, form was not an end in itself but a means to translate his visions into painting, to make them manifest on canvas. Munch turned his most intimate and private feelings outwards. But his Paris experiences did provide him with the formal framework within which his revelatory, confessional art could unfold. French painting saved him from sentimentality, self-pity, and from submersion in the sheerly literary.

Munch had an especially strong influence on German art. The arabesques of Jugendstil went back to the curvatures in Munch's painting, such as the waves of color surrounding the panicked figure in his *Scream* of 1893 (p. 35), which would subsequently be translated into graphic ornaments. The German Expressionists learned from Munch to transform their inmost sensations into painting, to reduce the human figure and the landscape to essentials shorn of all superficial detail, to subordinate form, at the price of deformation, to the artist's urge to expression, and to reveal the reality hidden beneath the surface of things.

**Edvard Munch**
Puberty, 1894
Oil on canvas, 151.5 x 110 cm
Oslo, Nasjonalgalleriet

**Edvard Munch**
The Dance of Life, 1899/1900
Oil on canvas, 125.5 x 190.5 cm
Oslo, Nasjonalgalleriet

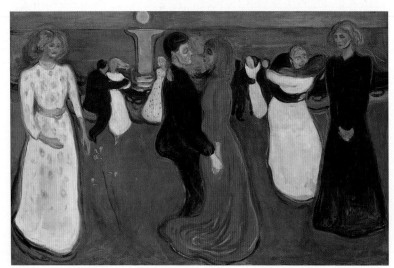

# Expression and Form

## The Fauves and their Classic Representative
### Matisse and his Circle

They used colors like "bombshells" that would discharge light, said André Derain, one of the painters who figure in histories of 20th-century art under the heading "Fauves", Savages or Wild Men. No wonder Parisians shielded their eyes in horror when they saw the Fauves' first group show, in 1905, in the main room of the Salon d'Automne, or Autumn Exhibition, which had started two years previously.

It was Louis Vauxcelles, the by no means hostile critic of *Gil Blas*, who made the legendary quip, *Donatello parmi les fauves* (Donatello among the savages). By "Donatello" he meant a bland neoclassical sculptor by the name of Marque. The savages whose pictures threatened Monsieur Marque's Florentine-style torso of a child were Henri Matisse, Albert Marquet, Derain, Maurice de Vlaminck, Othon Friesz, Henri-Charles Manguin (ill. right), Charles Camoin, Jean Puy, Louis Valtat, and Georges Rouault. A year later the earnest, always somewhat secretive Georges Braque and the insouciant Raoul Dufy, the Rossini of art, became the final members of the group.

Its spokesman and undisputed master was Matisse. In 1909, four years after the scandal at the Autumn Salon, he formulated his credo: "What I dream of is an art of balance, of purity and serenity devoid of troubling or depressing subject matter, an art which might be for every mental worker, be he businessman or writer, like an appeasing influence, like a mental soother, something like a good armchair in which to rest from physical fatigue." The title of one his early key works, which summed up the experiences of Neo-Impressionism, was borrowed from Baudelaire: *Luxe, calme et volupté* (a title whose literal translation is misleading, and might better be paraphrased as *Beautiful Things, Peace of Mind, and Sensual Pleasure*). These aims can be seen to characterize Matisse's entire œuvre, because they represent a program: creation of art as the highest mental and spiritual form of luxury.

### A Culinary Art

How was it possible that a style of painting that had, in Bertolt Brecht's term, "culinary" aims, an art intended not to be "troubling" but to "appease," should have provoked contemporary viewers and critics to such an extent? Their anger was directed not only at the two

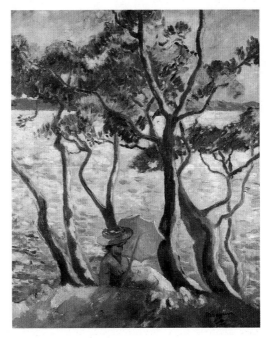

**Henri-Charles Manguin**
Jeanne with Sunshade, 1906
Oil on canvas, 61 x 50 cm
Bielefeld, Kunsthalle Bielefeld

painters who outdid the savages in savagery – Derain shooting his "bombshells" of color into the audience, Vlaminck, the "barbarian," squeezing the paint straight out of the tube onto the canvas. It was also and equally aimed at Matisse and his paintings *Open Window at Collioure* (New York, John Hay Whitney Collection) and *Woman with Hat* (private collection; both 1905). It was the Fauves' reliance on the elemental, on the effects of pure color independent of natural appearances and on a radical simplification of form, that struck the public as primitive and wild. The exquisite sophistication of the style was beyond their perception.

The blue-violet hat worn by the lady in the portrait (Madame Matisse), topped by a colorful, fantastic feather ornament, the brick-red and cobalt blue hair, the green, yellow and pink face, red and orange neck, green skirt and glove, the upper part of the dress glowing in variations of green, violet, pink and yellow, then the echo of all of these combinations in the expansive, loosely rendered planes of the background – all of this went so far beyond Impressionism, which people had only recently become accustomed to. The wings of the *Open Window* and the bluish-green and reddish-violet

*"Fauvism shook off the tyranny of Divisionism. It could not live in too orderly a household. So they broke out into the wild, to use simpler means that would not suffocate the spirit. At this moment, the influence of Gaugin and van Gogh came into play. These were the ideas of the time: constructing with coloured surfaces, searching for intensity through colour effects – the material is unimportant. Light is no longer smothered but finds release in the vibrant interaction of the brilliantly coloured surfaces."*

HENRI MATISSE

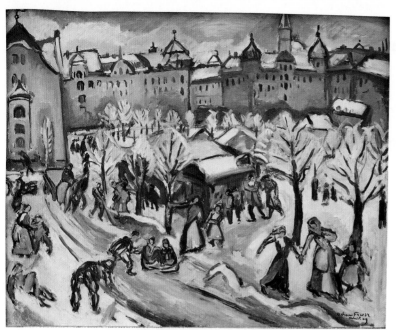

**Othon Friesz**
Snow in Munich, 1909
Oil on canvas, 64 x 80 cm
Moscow, Pushkin Museum

*"This woman, symbolising the eternal woman: a flighty, often fatal bird, going through life with a flower in her hand, in quest of a vague, mostly terrible ideal. Always moving on, treading everything underfoot, even geniuses and holy men. This dance is danced, these mysterious wanderings played out before the staring eyes of gaping death and the executioner with his sword."* GUSTAVE MOREAU

**Gustave Moreau**
The Apparition (Salome),
1874–1876
Oil on canvas, 142 x 103 cm
Paris, Musée Gustave Moreau

walls clearly show how Matisse draws together the dabs and touches of Impressionist renderings of things into broad, comprehensive planes. By the same token, the twining ivy is no longer depicted in a Neo-Impressionist technique but with a loose, ornamental brushwork that presages the arabesques of the artist's late work. The view of the sea with light playing across its surface and the boats on the beach likewise shows a tendency to generous flat planes and concentration of form.

Matisse's admiration for Signac, spokesman of the Neo-Impressionists and president of the Salon des Indépendants, led him to follow him to Saint-Tropez in 1904. The town, yet to be discovered by high society, was at that time still a reasonably-priced idyll for artists with little money. The brilliant sunlight and the luminosity of the sea, they felt, could no longer be depicted by naturalistic means, nor could the means of the now-accepted Impressionism do them justice. "One must give a correspondence to sunlight through a rich, polychrome orchestration, through passionate translations which must always begin with the experience of nature and whose results and theories emerge from an enthusiastic search," Othon Friesz (ill. above) here described the essence of Fauvism. The transformation of reality into aesthetic form merged with the sensibility of the artist. As Matisse emphasized again and again, "I am unable to distinguish between the feeling I have for life and my way of expressing it."

It was their youthful enthusiasm that distinguished the Fauves from their somewhat pedantic Neo-Impressionist predecessors. They painted with greater verve, infusing form with expressiveness. The harmony which Matisse above all, but also the young Derain, strove for even in their storm-and-stress period, was achieved not by subduing color values and combinations but by lending colors emotional values and reducing forms to the

simplest terms. A sense of depth and space was now engendered by the color juxtapositions themselves, rather than by perspective devices or *trompe l'œil*. "That was the point of departure of Fauvism," stated Matisse. The paintings of Cézanne provided key impulses. Beginning with Impressionism, the Provencal artist had given color an independent status, while at the same time – in contradiction to the Impressionist aesthetic – pulling the strokes of paint together to form colored fields, and thus preventing it from dissolving into a vague atmospheric evocation.

### "I Am the Bridge…"

Gustave Moreau (ill. below), a Symbolist long scorned as a *décadent* and only recently rediscovered, was a hallucinatory dreamer like Redon, but his dreams were inspired not by nature but by the gaslights in his own studio. Moreau is not only recognized as the mentor of the young talents who came to be known as Fauves, but highly regarded as a predecessor of Surrealism. He quickly realized what the work of his pupils Matisse, Rouault and Marquet held in store. "They will simplify painting," Moreau stated, and precisely defined the role his imaginative, anti-positivist stance would play: "I am the bridge over which some of you will go."

Simplification of form did not imply a simplistic approach. Gauguin had shown this with his decorative planes of color, and even Manet, long before, had already ended the compromise between painting and sculpture by emphasing the two-dimensionality of the canvas. The painters gathered around Matisse were, in addition, inspired by the early French "Primitives" and their brilliant color schemes.

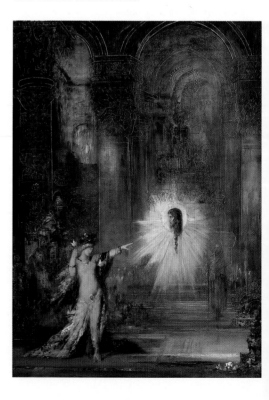

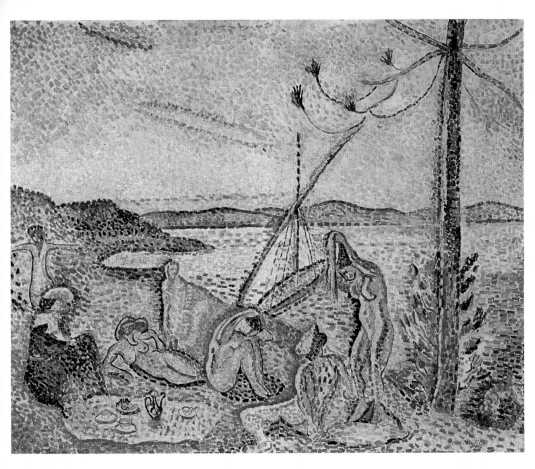

**Henri Matisse**
Luxe, calme et volupté, 1904/05
Oil on canvas, 98.3 x 118.5 cm
Paris, Musée d'Orsay

Matisse and Marquet began to paint in pure colors as early as 1898. For a time the overweening figure of Signac suppressed all other influences. Convinced of his mission to provide a normative aesthetic for painting, he took the fledgling Fauves firmly under his wing. But Matisse, in paying his reverence to Signac's doctrines, simultaneously overcame them. *Luxe, calme et volupté* is a good example (ill. above). The placement of the dabs of paint seems Pointillistic only on first glance. Looking more closely, we see that Matisse's coloration is much more intense and luminous than that of Signac, the silvery shimmer of whose paintings Matisse initially so admired. The greater freedom of his paint application is also evident. Matisse subjects Seurat's and Signac's scientific thoroughness to imagination, breaks the objective rules by putting them to the test of his subjective, personal view. The pastoral scene of the painting – six nude women and a clothed man on a beach – evokes not a timeless Arcadia but a very up-to-date, localizable idyll in the vicinity of Saint-Tropez just after the turn of the century. The composition has nothing in common with Nicolas Poussin's dark, Greco-Roman style arcadias of death. It does, however, possess classical harmony, the horizontals on the far shore replying to the emphatic vertical of the slender tree trunk in the foreground, which in turn is echoed by the mast of the sailboat in the center. The diagonal of the beach in the foreground ties the oppositions together; the counterpoint of the standing or seated, reclining or moving figures finds an echo in the curves of the bay and in the flowing lyrical rhythm of the hills in the background. This diagonal is repeated several times, in the branches, bands of light, and an inclining mast.

The brilliant mosaic of color is firmly locked in a carefully designed framework, in the spirit not only of Seurat but, and especially, of Cézanne, who literally built his paintings. It was his example that saved the French "Expressionists," with their need to give emotion free rein and their trust in intuition, from falling into sentimentality or formlessness. When the Fauves distorted things or figures, they did so for decorative reasons, not for the sake of sheer emotional expression. They knew very well that Oceanic and Black African sculpture was not a "primitive" art in the sense of being unskilled, but that the distortion found in it was a conscious device.

## Cézanne and van Gogh

With Matisse and Marquet, aesthetic discipline was innate. A wonderful early example of this in Marquet's work (p. 40) is his treatment of a theme popular since Monet's days and also addressed by Manguin – that of the flag-decorated streets of France on July 14th, Bastille Day. The nervous rush and bustle of Monet's picture, the ecstatic palette-knife sweeps of van Gogh, have here given way to quiet, lucid planes. The only "savage" fea-

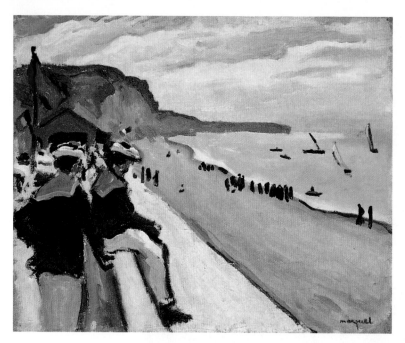

**Albert Marquet**
The Beach of Fécamp, 1906
Oil on canvas, 51 x 61 cm
Paris, Musée National d'Art
Moderne, Centre Georges
Pompidou

ture – from a contemporaneous point of view – is the brilliant colors of the flags, especially the vermilion gleaming against the dark house walls. The composition, on the other hand, is almost geometrically rigorous. (The theme would have to wait for Raoul Dufy to recover the character of a fleeting "impression".)

The case is different with the two Fauves from Chatou, André Derain and Maurice de Vlaminck. Their idol was not Cézanne but van Gogh. The admiration they felt for the Dutch artist for a few years united their very different temperaments, Derain, was the scion of a rich merchant family and humanistically educated, Vlaminck, was a rough fellow, born near Les Halles, whose parents were itinerant musicians. Vlaminck earned his living as a street fiddler, farmhand, novelist and professional cyclist before his paintings began selling well enough to support him. He was the only real "wild man" among the Fauves, and Derain, equally energetic but much more sensitive, found his stormy temperament irresistible. In Chatou color did not blossom, it veritably exploded, in unmixed vermilion, cobalt, chrome yellow, and Veronese green. Throughout his long life – Vlaminck died in 1958 at the age of 82 – he evidently never suffered an attack of self-doubt. In his memoirs, paraphrasing a famous saying of Louis XIV, he coolly declared, "I am Fauvism." Vlaminck had apparently forgotten that, as mentioned, Matisse and Marquet had already begun in 1898 to work in pure colors, and that Matisse was respected by his colleagues as a superior mind who had given Fauvism its aesthetic and intellectual foundation. Painterly instinct played a

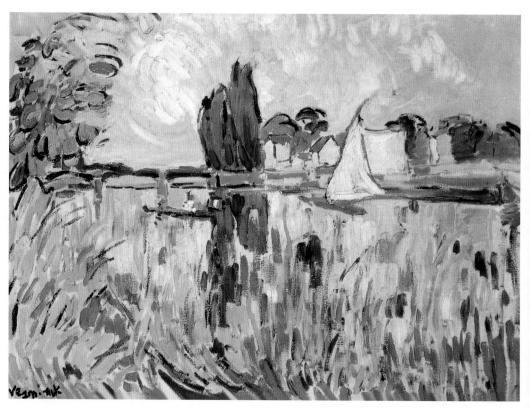

**Maurice de Vlaminck**
Sailing Boat on the Seine, 1906
Oil on canvas, 54.5 x 73.5 cm
Private collection

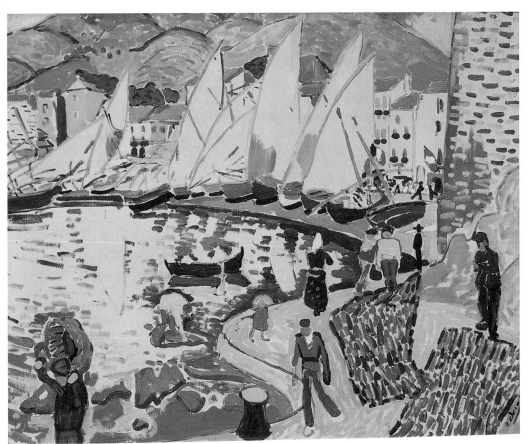

*"Do you know a painter who has invented a color different from those that compose the solar spectrum?"*
ANDRÉ DERAIN

**André Derain**
Drying Sails, 1905
Oil on canvas, 82 x 101 cm
Moscow, Pushkin Museum,
I. A. Morosov Collection

greater role than intellect in Vlaminck's art. And his unpolitical character led to his sympathizing with the Nazis during the Occupation.

## "Raphael is the Greatest"

Derain was too astute and well-educated to remain a Fauve for ever. This becomes apparent when we compare his *Boats in Collioure* (ill. right) with the *Rhône Barques* of his idol, van Gogh. Van Gogh addresses the subject with all the rustic directness of a Dutchman; Derain's picture, for all the vitality of its palette, its daring perspective, and simplification of form, reveals a nervous sensibility and a sure taste. The ease and fluency of the brushwork is a fine example of French painting culture. Derain's Fauvist paintings combine the vehemence of a Vlaminck with the culture of a Matisse. The Pointillist technique of dividing colors and the Fauvist technique of making them cohere are blended into a high-spirited and joyous style. Derain's landscapes of Saint-Tropez, Collioure, and London not only belong to the masterpieces of his relatively brief Fauvist period; they also represent the apex of his œuvre. In contrast to the Impressionists, Derain always concerned himself with "the solid, the eternal, the whole", and resisted the Impressionist temptation to be satisfied with shimmering atmospheric effects. This covert classicism, even present in the pictures in which color is completely unleashed, is typical of Derain's art.

**André Derain**
Boats in Collioure, 1905
Oil on canvas, 60 x 73 cm
Düsseldorf, Kunstsammlung
Nordrhein-Westfalen

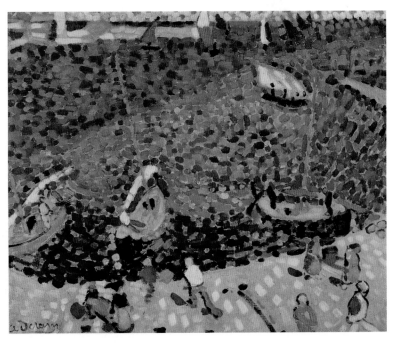

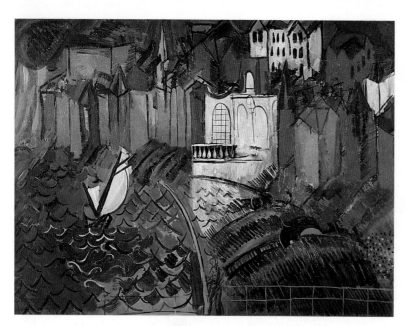

**Raoul Dufy**
Sailing Boat at Sainte-Adresse,
1912
Oil on canvas, 86.4 x 114.3 cm
New York, The Museum of
Modern Art

**Georges Braque**
L'Estaque, 1906
Oil on canvas, 50 x 61 cm
Private collection

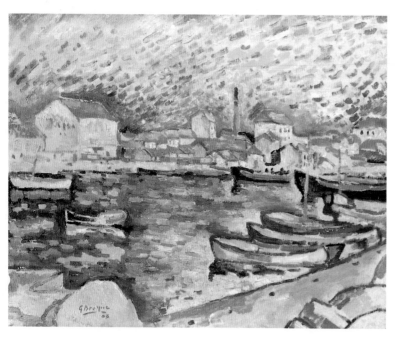

His classical tendencies, if not his final turn to a stylized realism, are already recognizable in Derain's brilliant early work. Like Cézanne to Poussin, Derain professed his allegiance to Raphael. "Raphael is the greatest of misunderstood artists", he declared, "Raphael alone is divine." Following his wild years Derain became a preacher of moderation, proportion and harmony, turning from a revolutionary into a conservative, even into a political conformist who, during France's darkest hours, betrayed not only his artistic but his humanistic principles by sympathizing with the Nazis. But one crucial point is essential to make: Derain was the first European artist to discover the expressive power of African sculpture, which he collected and to which he drew Picasso's attention. This, as we know, opened a new and far-reaching path for modern art.

## Music in Colors and Architecture in Painting

Moreau's students and the Castor and Pollux of Chatou were joined in 1905 and 1906 by three further painters: Georges Braque, Raoul Dufy, and Othon Friesz. In the year of scandal, 1905, Dufy saw Matisse's *Luxe, calme et volupté* at the Salon des Indépendants, and thereupon immediately forswore Impressionism, deciding in favor of form over "mood." Dufy went with Marquet to paint in the Le Havre vicinity, while Braque joined Friesz in Antwerp. Dufy's charming art, which in later years would become overly ingratiating and elegant, combines in its best examples the virtues of Impressionism with those of Fauvism. *The Beflagged Street* (ill. right) shows this combination to good effect. The solid arrangement of lucid, carefully juxtaposed planes of color is counterpointed by the lissom depiction of the ebb and flow of life on the street. Dufy's style is always evocative of motion, invariably retaining something of the Impressionist snapshot. It exists on the sunny side of life, reflecting uncomplicated, mundane situations and sophisticated social gatherings and sports with equal ease.

Braque is deeper and has more substance. As decisively as he reveled in pure color at the beginning, he just as determinedly never allowed color to shake his control of his craft. Every brushstroke was carefully considered, every accent of color precisely placed; his compositions, for all their painterly freedom, had a classical balance and harmony. He was more ascetic and rigorous than his friends, and he used his enormous skills with more circumspection. Braque's pictures are always *built*, even when, as in *L'Estaque* (ill. left), he lavishly scatters flecks of color like jewels over the surface. In view of such paintings the transition to Cubism is not as surprising as it would seem when comparing brilliantly colored Fauvist paintings with the reserved greyish-brown hues and formal regularity of Cubist compositions. The possibility of thinking in painting, an idiosyncrasy of the athletic ex-boxer Braque, had indeed been demonstrated by the Fauves, especially by Braque's idol, "Professor" Matisse.

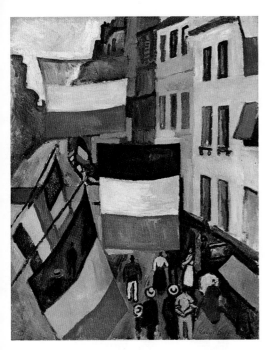

**Raoul Dufy**
The Beflagged Street,
Le Havre, 1906
Oil on canvas, 81 x 65 cm
Paris, Musée National d'Art
Moderne, Centre Georges
Pompidou

barous era. Living a simple life in the midst of post-war prosperity and luxury, Matisse drew sustenance and joy from his art even in an old age marked by sickness and frailty. When his brush hand would no longer obey him, he began cutting his arabesques with scissors out of paper, as if immersed in a glass bead game.

"I no longer ask whether and how long my works will outlast me," Matisse told Gotthard Jedlicka, who visited him in his hotel room in Cimiez, in the hills above Nice, his retirement home. "What I create, what I shape, has its meaning in the fact that I create it, that I shape it; is fulfilled in the enjoyment my work gives me – my work? My play. I play, and fulfil myself in play; and must a game outlast the player? Isn't its meaning to fulfil itself in itself? The purest player is the child, because it is one with the game. I too play, with the scissors, like a child, and I ask just as little as a child does what will become of the game that gives me such delightful hours." Out of this game, begun because he was no longer able to paint, grew a late work, a manifestation of an outstanding genius independent of medium and tools, his *gouaches découpées*, among the purest and most beautiful imagery in the art of all time (p. 44).

**Kees van Dongen**
Nude of a Young Girl, c. 1907
Oil on canvas, 100 x 81.5 cm
Wuppertal, Von der Heydt-
Museum

## Intelligence and Sensibility

The same clarity of thought, the same "fervor," as Braque used to call his contained passion, informs the work of by far the most outstanding Fauvist and one of the very greatest artists of the 20th century: Henri Matisse. The scope of his creativity only became apparent after the "pioneer period" at the start of the century, at a time when the force of his Fauvist friends' work was not increasing. Without the encouraging atmosphere of the group and its collaboration, the other talents – like most of the German Expressionists in a similar situation – began gradually to produce work of less substance. This is true of the cultivated Marquet, and of the significant loner, Rouault. Another fine talent, Dutch artist Kees van Dongen, even eventually became a fashionable portraitist to Parisian society (ill. right).

For Matisse, on the other hand, the "wild" days were only the overture to a life's work in painting, drawing, printmaking, and sculpture that is one of the supreme manifestations of Western art in the 20th century. Intellectuality and sensuality, inspiration and artistry, color and form, decoration and expression, tradition and contemporaneity, all exist in an exemplary balance in Matisse. He achieved something that only the greatest in art can achieve: Like a tragedy by William Shakespeare or a comedy by Molière, like a Michelangelo sculpture or a Rembrandt painting, Matisse's art speaks equally to the layman and to the connoisseur. It lends pure, spiritual form to the gratuitous beauty of things. Working untiringly down to the final days of his long life, Matisse demonstrated in this century of catastrophes that painting, even after 1900, is still capable of giving people joy. If Renoir can be called the painter of an "unconscious" happiness, Matisse is the painter of a conscious happiness, maintained in the teeth of a bar-

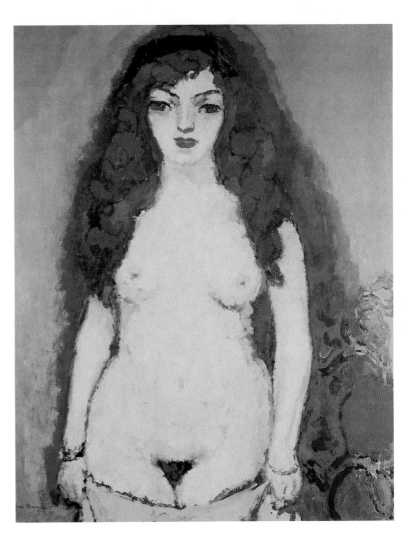

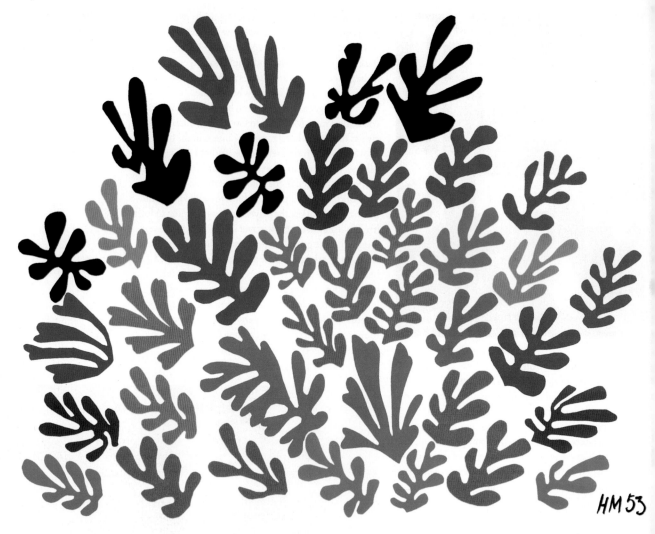

HM 53

**Henri Matisse**
Spray of Leaves, 1953
Gouache cut-outs, 294 x 350 cm
Los Angeles (CA), Wight Art
Gallery, University of California

**Henri Matisse**
Spanish Woman with
Tambourine, 1909
Oil on canvas, 92 x 73 cm
Moscow, Pushkin Museum,
S. I. Shchukin Collection

### Old Truths in a New Light

As described in Heinrich von Kleist's essay, *On the Marionette Theater*, Matisse's work and personality followed a path from knowledge through infinite experience to emerge as a second naivety. The quiet revolutionary never denied the influence that the great masters of the past and non-European cultures had had on his style. In his Paris apartment hung paintings by Renoir and Cézanne, and Courbet's *Young Women on the Banks of the Seine* (Paris, Musée du Petit Palais). He admired El Greco and Rembrandt, the Sienese artists Duccio di Buoninsegna and Piero della Francesca, Japanese woodblock prints, and Manet. Matisse knew that the liberation of color was primarily the achievement of the Impressionists, the heirs of Delacroix. He early recognized the significance of Gauguin for his own development. He paid his respects to the Pointillists Seurat and Signac, he admired Cézanne and revered Redon, whose influence is seen in many a Matisse still life of flowers. Matisse frankly admitted the importance of his confrontation with Islamic art, with Persian miniatures in particular, which helped determine the decor and arabesques of his mature work.

"The artist only sees old truths in a new light," stated Matisse, "because there are no new truths."

Matisse loved to study and to learn from others. He took Moreau's advice literally, going both to the museums and into the streets. When he was already a well-known painter, reports his German student Hans Purrmann, Matisse continued to attend night courses at a school of decorative art. This stupendous assiduity was the source of his outstanding craftsmanship. Matisse's drawings are like shorthand records of reality. A few contours allowed him to capture the essence of his model. Out of a handful of colored planes and sparing arabesques he would evoke the figure of a musing girl, an interior, the view through a window. In paintings like these the tension between self and world seems to have been overcome. *Joie de vivre*, the title of a painting that made Matisse undisputed leader of the Fauves when it was shown at the Salon des Indépendants in 1906, might stand as a motto over his entire œuvre (Merion, Barnes Foundation). In canvases such as *The Dance, Spanish Woman with a Tambourine, Harmony in Red, Lady in Blue* (pp. 45 f.) and many others from all phases of his career, sensations are raised to an art form in its own right.

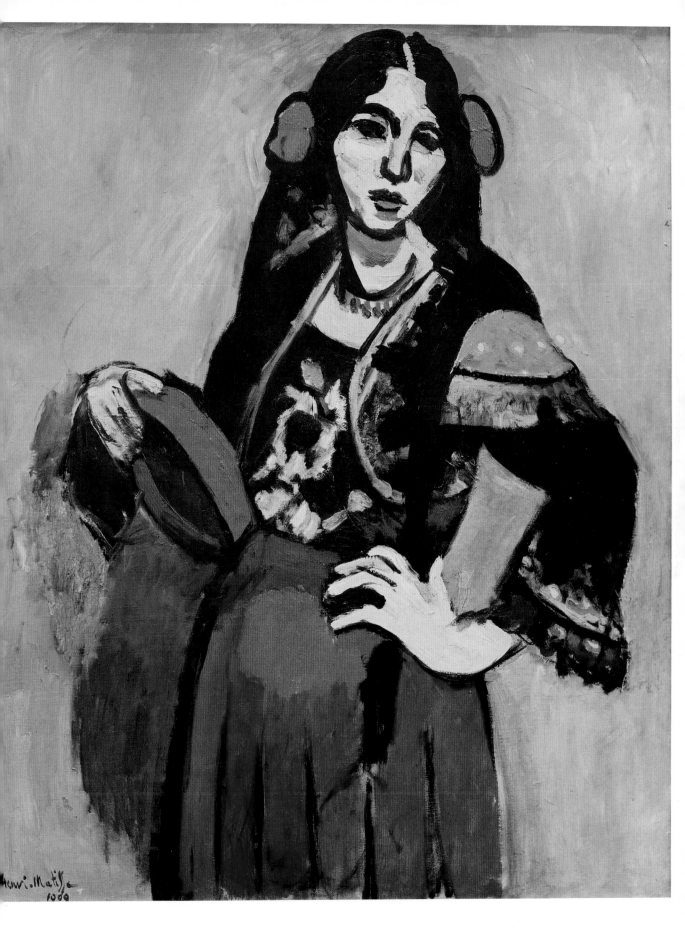

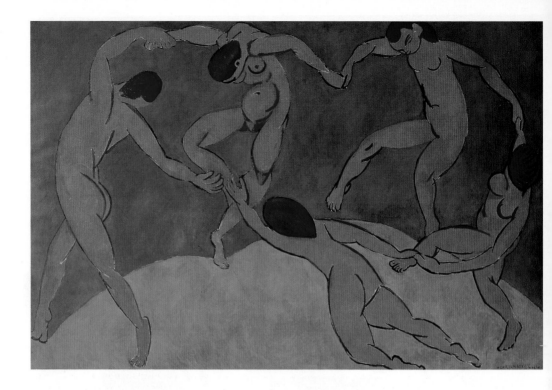

**Henri Matisse**
The Dance, 1909/10
Oil on canvas, 260 x 391 cm
St. Petersburg, Hermitage

**Henri Matisse**
Harmony in Red –
The Red Dining Table, 1908
Oil on canvas, 180 x 220 cm
St. Petersburg, Hermitage

**Henri Matisse**
Lady in Blue, 1937
Oil on canvas, 92.7 x 73.6 cm
Philadelphia (PA), Philadelphia
Museum of Art, Gift of Mrs. John
Wintersteen

### "I am the Model"

Maurice Denis recognized the originality and rank of
Matisse's art at an early date. "What we have here,"
he wrote in 1905, "is a painting wrest away from all
randomness, painting per se, pure painting … . What
is going on here is the quintessential search for the
absolute."

Matisse found "the absolute" in the ornamental
designs of an oriental carpet or in a bouquet of flowers,
in a seascape or in the face of a girl, in the sensual, ani-
mal magnetism of his odalisques (from whom, by
his own admission, he would have taken to his heels
had he met them in real life). Matisse already played
with abstract form. In this regard he went much further
than his German students Hans Purrmann, Rudolf
Levy, and Oskar Moll. They adhered closer to the motif,
their lyricism was more direct, and they had no qualms
about evoking "moods." "I am the model" – this self-
confident declaration of Matisse's would never have
occurred to them.

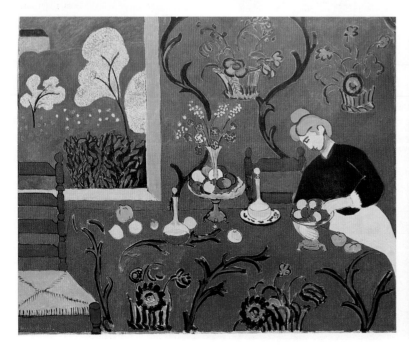

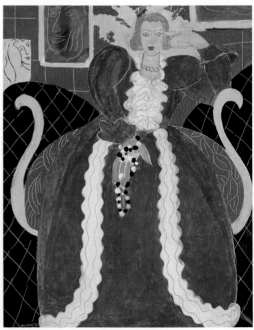

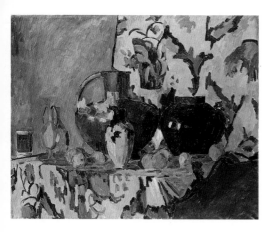

**Hans Purrmann**
Still Life, 1908
Oil on canvas, 80 x 99.5 cm
Berlin, Nationalgalerie,
Staatliche Museen zu Berlin –
Preussischer Kulturbesitz

Purrmann's style combined the decorative with the structural, Matisse with Cézanne (ill. above). The artistic substratum of his career – apart from the superb paper cut-outs – is the Chapel of the Rosary in Vence, the building of which was partially funded by the artist himself. It, too, is a Gesamtkunstwerk, for Matisse not only decorated the chapel but designed it as well. From an early age, the artist did speak of a "kind of religious feeling" he had about life. This feeling found its artistic expression in the symbolically abbreviated wall-paintings of the Matisse chapel, which depict the Passion of Christ, the Virgin and Child, and St. Dominic in contour drawings.

Artistic reason and a Romanistic sense of order and proportion came to fulfillment and reached the limits of their potential in the œuvre of this scholarly artist, who enjoyed talking about art almost as much as painting.

With the Fauves and their classic representative Matisse, "the solar adventure of modern art", as Jean Leymarie emphatically calls it, began an adventure which nevertheless, as we know, had its dark, penumbral side as well. Before leaving Matisse, a brief note on his sculpture is in order (p. 428). Few as the number of his works in this medium is, they represent much more than a marginal note to his œuvre. In fact, the only major twentieth-century painter to have surpassed Matisse as a sculptor was Picasso.

## Victory over "Satan's Sun"

The quintessential painter of the dark side of man, of evil, despair, and decay, but also of pity and redemption, the prophesy of a victory over *Satan's Sun* – the title of a famous novel by Georges Bernanos – was Georges Rouault. He exhibited with the Fauves at the 1905 Salon d'Automne, but despite the aggressiveness of his early work he was not really one of them. He had no wish to be a "renowned luminary of revolt and negation." Like Matisse and Marquet a student of Moreau's, in fact his favorite student, Rouault was the most passionate religious artist of the twentieth century. His protest against the hypocrisy of pre-First World War society and the dry, boring art of the academies was not an exuberant revolt against tradition, no cheerful firing-off of colored bombshells à la Derain or Vlaminck. Rouault's resistance to the status quo had other reasons, rooted in his profound Christian faith.

"Anybody can rebel. But to obey in silence an inner calling, to search lifelong without impatience for the means of expression adequate to us – that is much more

*"If there had been beautiful church windows as in the Middle Ages, I might not have become a painter."*
GEORGES ROUAULT

**Georges Rouault**
The Holy Face, 1933
Oil and gouache on paper,
91 x 65 cm
Paris, Musée National d'Art
Moderne, Centre Georges
Pompidou

**Georges Rouault**
The Old King, 1937
Oil on canvas, 76.8 x 54 cm
Pittsburgh (PA), The Carnegie
Museum of Art

difficult," said Rouault, and he did not speak lightly. He lived and worked according to this insight. The formal concentration and the expressiveness of Rouault's painting were modelled on the late Rembrandt. His seemingly self-illuminated phosphorescent colors, shining through thick relief-like layers of impasto and heavily contoured as if with leading, were oriented towards the stained-glass windows of Gothic cathedrals.

### Slatterns instead of Seraphim

Rouault was still far from the religious themes of his later period when he exhibited with the Fauves. At least it appeared so. His paintings, in acid, cool bluish-greens counterpointed by a livid greyish-red and overlaid with brittle grids of blackish-grey, depicted prostitutes, clowns, and – taking his cue from Daumier – the malicious faces of philistines and corrupt judges. Nausea and anger suffuse these significant early canvases of Rouault's, not the cool detachment or indifference with which a Toulouse-Lautrec dissected society. The light that would illuminate the later paintings was still concealed, the artist was still polemicizing, mounting an

attack on the venality and vices of humankind. In this phase of his work Rouault was still more of a social critic in the vein of Goya or Daumier than a proclaimer of Christian redemption.

### Icon Painter of a Late Civilization

Rouault's painterly invocation of an ideal early Christianity did not begin until 1930. In a process that frequently extended over years, he applied layer after layer of paint to the canvas until he felt that the right hue had been found. The primary – and primal – hues of green, blue, red and yellow, gripped within black contours like the colored panes of church windows within leading, strive for metaphysical sublimity. Their lavish impasto seems pervaded by deep melancholy. Evening shadows lie over silent landscapes; the faces of the figures are careworn, marked by life's sorrows. The hope of redemption is not announced with the jubilation of glad tidings, but simply stated as a humble expectation. The Christianity proclaimed in Rouault's paintings is a burdensome one, chiliastic, borne up by the belief in the coming of the millennium (p. 47).

# Sensation and Ecstasy
## Northern German Expressionism

A protest against academic art stands at the beginning of art history in the 20th century. The first revolutionary phase came to an end when many erstwhile rebels were offered teaching posts and themselves became professors at art schools. The eminent German critic Werner Haftmann already cautioned, at mid-century,

against the danger of the emergence of an "abstract academy," implying that abstract art could not be taught without a basis in painting craft, and that any attempt to do so would only lead to a pseudo-revolutionary eclecticism. Similar warnings were expressed by American critic Harold Rosenberg in his essays, "The Tradition of the New".

Many a student was astonished when his or her teacher, an acknowledged pioneer of modern art, assigned drawing from life as the first step towards becoming an artist. But though the fact has long been overlooked, the teachings and practices of the past were not without meaning for the leading personalities in late-19th and early-20th-century art. They learned from them, and their protest against them – or against their all-too dogmatic application – formed the precondition for their life's work. This statement holds not only for art since the Impressionist period. It holds for the realist, Courbet, in France, as it does for the German idealist who worked in Rome, Hans von Marées. It also applies especially to Käthe Kollwitz, the socially critical, expressively naturalistic denouncer of proletarian mass poverty, genocide, and chauvinism. Kollwitz's passionate empathy, her motherly yet harsh commitment, lends her graphic art an affinity with Munch. Her expressive style, for all its naturalism, points forward to German Expressionism, at the beginning of which stands the figure of another, very young, motherly woman, who, a few weeks after the birth of her long-awaited first child, left

*"A great simplicity of form, that is something wonderful. I always tried to give the heads that I painted or drew the simplicity of nature. Now I have a deep empathy for how I can learn from the heads of antiquity."*
PAULA MODERSOHN-BECKER

**Paula Modersohn-Becker**
Self-Portrait with an Amber Necklace, 1906
Oil on canvas, 62.2 x 48.2 cm
Basel, Öffentliche Kunstsammlung Basel, Kunstmuseum

this world at the age of only 31 with the words, "How sad." This was Paula Modersohn-Becker (p. 48 and ill. right).

Though a native of Saxony, Paula Modersohn-Becker belongs for art historians in the context of the artists' colony of Worpswede, a village near Bremen in northern Germany. It was here that a new, lyrical landscape painting emerged, in reaction to the hectic and increasingly inhumane milieu of the industrial cities of the period. The artists' protest took the form of a retreat. In the midst of the noise and smoke of a world in the making, they sought an island of calm, accepting reality only in those aspects that conformed to their romantic, youth-movement ideals.

One of the artists active in Worpswede was the landscapist Otto Modersohn. Paula Becker would marry him in 1901. Modersohn, at the time more famous than she, was the only one who recognized her talent at an early date. Paris, as it had for the young poet Rainer Maria Rilke, became the second pole of Modersohn-Becker's life. She marvelled at the lucid planes in Gauguin's paintings, at the energy of the contours, the musicality and glow of his palette. Yet despite her admiration for him, for the self-taught painters of Brittany, and for Böcklin's nature symbolism, Modersohn-Becker felt intuitively drawn to the formal rigors of Cézanne. Little by little she worked to make the forms in her painting cohere into flat planes, inexorably turning away from romantic charm and Impressionist "atmosphere". She reduced the "natural" appearances of landscape and figure to their formal essence; she emphasized her tectonic planes of color with strong outlines. Modersohn-Becker had ceased to describe things and had begun to express them. The aspects of the Worpswede style that remained alive in her work reflected the caring side of her nature, her love of the simple life and of plain people, of whom she felt herself one. Her personal feelings, her love, her desire for a child, and the universal themes of fertility and motherhood, accordingly became the principal subjects of her art. "Sensibility" was transposed into painting, albeit in a more subjective way than Matisse envisaged. Thanks to her unsentimental, generous, rigorous sense of form, the subdued glow of her colors, and an honesty of feeling that prevented her work from ever growing cloying, the small number of major paintings that Paula Modersohn left to posterity, especially her self-portraits and pictures of children, have a simplicity and immediacy of presence that sometimes recalls the magic of Egyptian portraiture.

## The Northern German Eccentric

Emil Nolde was the outstanding representative of a new, expressive art that emerged in northern Germany. Not that he himself attached any importance to such labels. A farmer's son from Schleswig-Holstein, the most northern of the country's provinces, all he wanted to be was a painter, and obstinately to go his own way. It was destined to be a long and rocky road, and when it

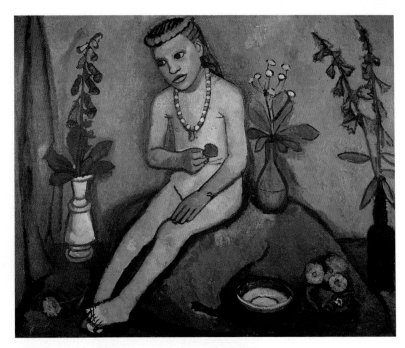

seemed that every obstacle had been overcome, Nolde himself erected new ones. He had arguments with the influential art dealer Paul Cassirer and the eminient critic Meier-Graefe; he missed no opportunity of making himself disliked. Nolde railed at the French and the Jews, despite his own depictions of Christ, his disciples and figures of the Old Testament as Jews in his religious paintings, and he let his German nationalism be known at every opportunity. Yet Nolde felt ill at ease among people. At the same time he suffered under his own isolation, which only his first wife, the Danish actress Ada Vilstrup, shared with him tenaciously despite protracted illness. Not even the company of like-minded artists was something Nolde could stand for long. He left the Dresden Brücke group after only a year and a half. His naive hope that the National Socialists would appreciate his art, which he felt was truly and essentially German, rooted in the soil and nourished by the lifeblood of his rural homeland, was cruelly disappointed. In 1937 Nolde found himself in the company of the "degenerate artists" vilified by the Nazis. His paintings were removed from public collections and sold off for a pittance. Finally he was officially forbidden to paint at all.

There is no other German painter whose medium for the depiction of appearances and emotions was so exclusively color. Emil Hansen, a native of the village of Nolde, took on the name of his birthplace after his marriage in 1902. Nolde pretended to despise the Impressionists who came after Manet. Yet his first major paintings of flowers and gardens were little else than a dramatized and intensified continuation of the Impressionist treatment of color, a translation into German, as it were, in which van Gogh played the role of intermediary. This implied a turning away from the decorative

**Paula Modersohn-Becker**
Seated Nude with Flowers, 1907
Oil on canvas, 89 x 109 cm
Wuppertal, Von der Heydt-Museum

*"I want the to give colors intoxication, fullness, excitement, power By trying to forget Impressionism, I wanted to conquer it. In the process I was conquered. We must work with assimilated, digested Impressionism."*
PAULA MODERSOHN-BECKER

**Emil Nolde**
Whitsun, 1909
Oil on canvas, 87 x 107 cm
Berlin, Nationalgalerie,
Staatliche Museen zu Berlin –
Preußischer Kulturbesitz

*"Colors, the painter's material. Colors in their essence, crying and laughing, dream and happiness, hot and holy, like songs of love and eroticism, like hymns and magnificent chorales. Colors vibrate like the silvery pealing of bells and bronze tones. They herald happiness, passion and love, soul, blood and death."* EMIL NOLDE

outward charm of Impressionist painting in favor of a passionate introversion, or, in psychological terms, a cathexis with the things that struck his eye. Yet Nolde would have to become almost 40 years old before he had developed his technical means to the point of being able to paint what moved him and be satisfied with the results.

At the beginning of his path towards an original style stood an interior, sumptuously painted in delicate gradations a little in the manner of Bonnard and showing Ada reading in the center, a surprisingly tender homage to his beloved wife with the allusive title of *Spring in the Room* (1904; Neukirchen, Stiftung Seebüll). In the subsequent period Nolde's color, not uninfluenced by his "Brücke" friends, experienced an extreme heightening of intensity. His floral pictures contained final reminiscences of the subdued, tone-in-tone values of the Dachau "landscapists" with whom Nolde had worked, and of Franz von Stuck, the idol of Munich, whose allegories, however, now ceased to interest him. But even these works represented only a transition. Nolde's finest achievement, as he himself knew, came with his series of religious depictions. It began in 1909, and with two major works at that: *The Last Supper* (Neukirchen, Stiftung Seebüll) and *Whitsun* (ill. above). The nine-part altar painting *The Life of Christ* (1912; Neukirchen, Stiftung Seebüll) and the triptych *Maria Aegyptiaca* (1912; Hamburg, Kunsthalle) marked the cul-

mination of the theme. By way of *The Tribute Coin* (1915; Kiel, Kunsthalle), *The Philistines* (1915; Essen, private collection), *That Ye May Not Become as the Children* (1929; Essen, private collection), the series led to *The Great Gardener* of 1940 (Hanover, Sprengel Museum), which brought a surprisingly lyrical note into the late work.

### Ecstatic Religiosity

In these canvases an ecstatic religiosity breaks through, an emotion whose fervor goes back to the influence of Matthias Grünewald and whose psychological penetration derives from Nolde's admiration for Rembrandt. The sublime and the grotesque, the sacred and the profane, despair and transfiguration exist side by side in these works as in the paintings of the medieval "Primitives."

Nolde's violent and conscious barbarism comes out even more strongly in the secular figurative compositions, which depict dancers and pierrots, dubious characters from Berlin nightlife (ill. right), and men and women living out their animal instincts. Demonic masks, inspired by Ensor, lend destructive primal forces visual presence. The compelling power of Nolde's approach is also manifest in the paintings of lonely marshes, dunes, clouds and sea. His express aim was "a new evaluation of nature, with the infusion of personal soul and spirit." The medium for this was heavy impasto

paint, which embodied that "primal-utterance character" of nature spoken of by Wilhelm Worringer, a leading German art historian, in connection with Expressionism in general. What took shape here was not "beautiful, purified nature but the enigmatic, unarticulated reality which never loses the threatening character of being haunted by spirits."

The blood-and-soil miasma rising from some of Nolde's paintings still awakens unpleasant associations. Not all of his works give a satisfactory answer to the question of artistic mastery of the forces of chaos. Yet the most beautiful imagery this artist gave to the world will certainly survive: his watercolors painted on damp Japan paper, with their diaphanous veils of interflowing colors. In the best of these, floral subjects and landscapes, Nolde's strength blends perfectly with aesthetic delight and a masterful technique.

## Christian Rohlfs

Late watercolors also marked the culmination of the work of another artist from Holstein, Christian Rohlfs (ill. right). His long career, which belonged both biographically and artistically as much to the late nineteenth as to the early 20th century, is an indication of the fact that Expressionism was not the result of arbitrary individual decisions but represented a Europe-wide movement.

**Christian Rohlfs**
House in Soest, 1916
Tempera on canvas, 80 x 100 cm
Private collection

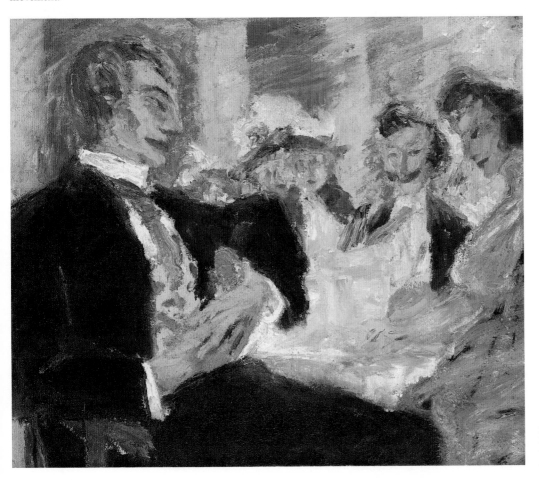

**Emil Nolde**
In the Café, 1911
Oil on canvas, 73 x 89 cm
Essen, Museum Folkwang

A fall from a horse, tormenting years of being bedridden, followed by the amputation of his right leg, made Rohlfs incapable of taking up farming. His father finally agreed to let him try to make his way as an artist. Rohlfs's earliest work was in the *plein-air* mode, a very noble and solidly crafted landscape art in the tradition of the *paysage intime* of the school of Barbizon in France and The Hague in the Netherlands. This was the favored style around the turn of the century in Weimar, where the young artist came of age.

Rohlfs was 48 years old when he discovered his interest in Impressionism. The ensuing paintings were suffused with dramatic passion in the manner of van Gogh. The "script" of his brushwork grew grainier, heavier, more dynamic – in a word, more expressive. *Birch Woods* of 1907 (Essen, Museum Folkwang), done at the age of 58, records the artist's transition from the rendering of an *impression* to a striving for *expression*, from Impres-

sionism to Expressionism. Though here the borderline was still vague, soon the decision would be made. The impulse came from Nolde, whom Rohlfs had met in Soest in 1905. There emerged a series of vibrantly colored cityscapes with church spires, depictions of farmhouses, and – again influenced by Nolde – compositions with Biblical figures. Though Rohlfs never succumbed to Nolde's fervency, he did often similarly distort figures to the point of grotesqueness. As he grew older, his work gained in artistic discretion in proportion to its decline in visionary force. Rohlfs's paintings possess a strange, shimmering translucency. Towers and walls seem no longer able to rely on their own stability, begin to waver, to disintegrate. This instability corresponds to the vibrato of the color. It embodies a striving for spirituality, but at the same time it represents a sign of growing doubt about the solidity of the foundations on which the world rests.

# The Struggle for a New World
## The "Brücke" Painters and their Utopia

In 1905, the same year as the public uproar over the Fauves in Paris' Salon d'Automne, four young men in Dresden founded a group called "Brücke" (Bridge), planting the seed of German Expressionism. Their names were Fritz Bleyl, Erich Heckel, Ernst Ludwig Kirchner, and Karl Schmidt. They were later joined by

**Ernst Ludwig Kirchner**
Potsdamer Platz, 1914
Oil on canvas, 200 x 150 cm
Berlin, Nationalgalerie,
Staatliche Museen zu Berlin –
Preussischer Kulturbesitz

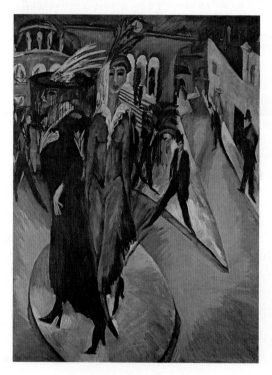

*Page 53:*
**Ernst Ludwig Kirchner**
The Red Tower in Halle, 1915
Oil on canvas, 120 x 90.5 cm
Essen, Museum Folkwang

Max Pechstein and Otto Mueller, and, for a time, by Nolde. The four had come to Dresden to study architecture at the college of technology there. In their spare time they painted and drew, with an enthusiasm inspired by Nietzsche and his *Zarathustra* (from which the group's name also derived) that initially stood in for solid training in art. They started from scratch, refusing to consider attendance at an academy. On the other hand, they had no Moreau as mentor to support them, nor a Pissarro to provide understanding and encouragement. Just the opposite: Corinth, who was more of an Expressionist than an Impressionist even in his mature years, denounced the new style with a complete misjudgement of its essence as "un-German" and "intellectualist".

What brought the Brücke painters together and kept them together for eight years, until they dispersed in 1913, was a belief in a new brotherhood of man, a solidarity which only young people, artists in particular, could bring about. Only in a commune, by collective effort, thought the Brücke artists, could the storms of the period be weathered, could a plan for a new and better world, indeed a new type of human, be conceived and implemented. Van Gogh had already dreamed of such an artists' commune, and had temporarily been able to interest Gauguin in the idea. But finally the obtuseness of his contemporaries, the strong individualism of French artists, and the eccentricity of his own personality, doomed his attempts to failure.

What van Gogh and Gauguin had not succeeded in doing 17 years previously in Arles came to pass in an

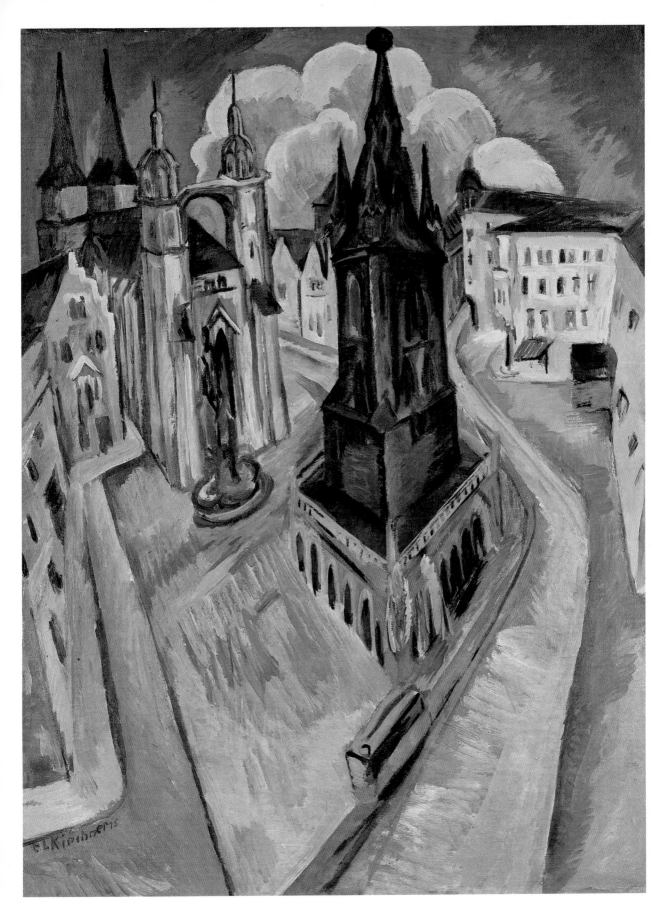

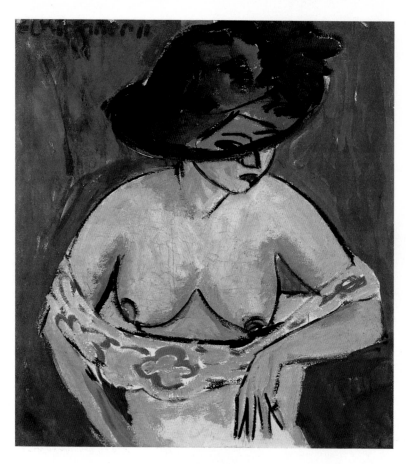

**Ernst Ludwig Kirchner**
Female Half-Length Nude
with Hat, 1911
Oil on canvas, 76 x 70 cm
Cologne, Museum Ludwig,
Haubrich Donation

*"My wife always says that I never
again accomplished another
painting like this of a woman, and
here jealously plays a slight role,
because there are also some very
beautiful nudes of her. But perhaps
she is right insofar as in this painting
for the first time a profound love
for the female figure comes forward,
and such a thing can happen only
once."*

Ernst Ludwig Kirchner

visual arts, it was closely allied with the revolutionary socialist movement. In contradistinction to most Neo-Expressionists of the 1980s, the original Expressionists not only wanted to create art, they set out to create a new ethics.

In other words, German Expressionism was political at its source. This statement holds especially for the poets and writers who strove for reconciliation and cried in the face of a spreading barbarity, "Oh, Humanity!" But it also holds in the wider sense of the term "political" for the Expressionist painters. Admittedly their commitment was less ideologically defined than that of the writers, not linked with any doctrinare world view, and for that reason less subject to perversion by party-political considerations. The utopian ideals of the Brücke artists were expressed in the visionary terms of the contemporary youth movement. Kirchner later desired his name not to be mentioned in connection with this "silly youth stuff," but in 1906 he thought differently. "Putting our faith in development and in a new generation of creators and art lovers," he wrote in the Brücke manifesto, "we call upon all youth to unite. We, who possess the future, want liberty of action and thought with respect to the hidebound older generation. Anyone who honestly and directly expresses what urges him to create is one of us." These words clearly indicate what distinguishes the German Expressionists from their French counterparts, the Fauves, despite all they share in common. It is a far cry from this militant youthful idealism to Matisse's epicurean idea of an "art of balance, of purity and serenity devoid of troubling or depressing subject-matter."

Where Matisse wished to convey tranquillity and "detached pleasure," the German Expressionists set out to excite and incite the public; where the former avoided the problems of modern life, the latter plunged into them. The balance for which Matisse strove, the Expressionists set out to upset. Purity seemed suspect to them. They empathized with the "impure," the miserable and downtrodden of the earth. They wanted to smash the old world in order to build a new one from its ruins. Instead of a new aesthetic, they proclaimed a new, ethically founded stance. They sought a new and immediate relationship to reality. Their art strove for inward truth rather than for outward beauty.

The Brücke artists were carried along by the current of an agitated and exciting era in which one artistic sensation, one discovery followed on the heels of the next. They admired Munch, especially his woodcuts, though Munch's pessimism and Strindbergian misogyny held no appeal for them. Even more they admired the early medieval German masters, whom Kirchner, as the first, had seen in Nuremberg. Van Gogh's luminous impasto colors and sinuous contours confirmed the Brücke artists in their own expressive urge. From Art Nouveau they had learned that line was an independent element with the aid of which subjective feelings and personal temperament could be visualized. Gauguin's escape

empty shoemaker's shop on Berliner Strasse in Dresden-Friedrichstadt, which Heckel had converted into a studio. The four friends not only collaborated in their work, they lived together and shared their daily chores and cares. The impetus that bore them up had its source in this sense of community. Left to themselves, none of them would have had the power to touch off this powerful movement. For decades, admittedly, observers and critics abroad, whether French or American, considered German Expressionism a Gothic-Teutonic aberration, a violent would-be art that lacked every sense of fine execution and formal balance. Now that this view has been honorably corrected on both sides of the Atlantic, the enthusiasm for the *Furor teutonicus* in painting has reached such a level that for a time even the generation that could have been the Expressionists' grandchildren, the Wild or Neo-Expressionist painters, were swept up in it.

Expressionism in the broader sense is a timeless phenomenon in art. It is found among the Pacific islanders and the Aztecs, in Africa and in Gothic cathedrals, in medieval manuscript illuminations, in Grünewald and El Greco. Spiritual depth and a link with the metaphysical, the invisible and intangible, have characterized German painting and sculpture from its earliest days. But this is only part of the story. German Expressionism at the beginning of the century was a committed art. In literature even more than in the

from civilization corresponded to the scorn they felt for a satiated and hypocritical turn-of-the-century society, and his undoctrinaire handling of color and plane impressed them as much as the Neo-Impressionists' analysis of the spectrum. The Brücke painters found their Tahiti in the Dresden Museum of Ethnology, embodied in Black African and Polynesian sculpture. The experience gave them courage to employ distortion as an artistic means.

## "For a Humane Culture"

The rapidity with which the characteristic Brücke style emerged is astonishing. The paintings of these temperamentally so different men initially looked very much alike. Their common program obscured the individuality of the Brücke members, whose full freedom and originality would unfold only in the course of the years. Out of the passionate brio of their brilliant, occasionally somewhat slapdash concert of color the personal idiosyncrasies of the players gradually emerged. There were the dynamic, primitivistic compositions of Karl

Schmidt, who called himself Schmidt-Rottluff after the town near Chemnitz where he was born. There was the hieroglyphic formal canon of Kirchner, the sensitive professor's son from Franconia. There was the more gentle, lyrical and introspective imagery of Heckel; Mueller's "earthly paradise", which the reticent loner found in Bohemia and Eastern Europe; Pechstein's powerful figurations; and the religious visions of the Nordic Nolde.

No one can remain a revolutionary for life. As Kirchner emphasized as early as 1913, in his chronicle of the Brücke, disagreement over which finally broke up the group, it struggled for a humane culture "uninfluenced by the current streams, Cubism, Futurism, etc." Almost unnoticed by themselves the Brücke artists had become increasingly conservative, and each now decided to stick to the path he had disovered and felt was right. Similar to the Fauves, the elan of storming the barricades of convention could not hold the Brücke together for more than a few years. Agreeing to disagree, the artists went their own ways.

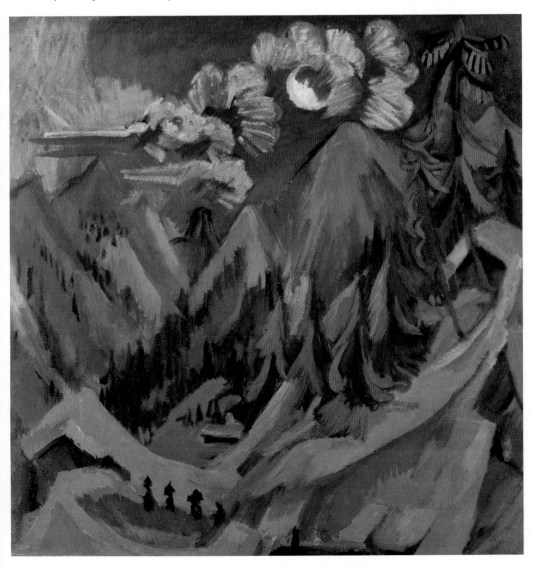

*"It is not right to judge my pictures according to the standard of what is true to life, for they are not depictions of certain things or beings but rather are themselves independent organisms, comprised of lines, planes and colors. They only contain natural forms insofar as these are a necessary key to understanding them. My pictures are allegories, not portraits."*

ERNST LUDWIG KIRCHNER

**Ernst Ludwig Kirchner**
Winter Moon Landscape, 1919
Oil on canvas, 120 x 121 cm
Detroit (MI), Detroit Institute of
Arts, Gift of Curt Valentin

## Loners

Kirchner had set off on his own long before the Brücke disbanded, following a path none of the others could, or wished to take. He was the only one in the group who was not satisfied with the autonomy of color and form they had achieved, despite the fact that for a few years he was strongly influenced by the Fauves and had antedated some of his paintings to prove the innate tie between French Fauvism and German Expressionism. Kirchner's development eventually led him far from what is generally understood under the blanket term "German Expressionism". His art, rife with tensions, contradictions, and audacities, eludes every stylistic label. Despite his temporary identification with the collective, Kirchner was fundamentally a loner. The continual mental strain under which he lived, compounded by the dashing of his hopes in the First World War, the postwar years, and the Nazi terror, brought about a series of nervous breakdowns. In the end, illness and despair caused Kirchner to take his own life in 1938, in Switzerland.

Kirchner's mental state is reflected in the proliferating abundance of visions and configurations in his art, its obvious tendency to the apocalyptic, the harsh incisive "barbarian" of its palette, and in the use of distortion as a means to express passionate emotion. The conscious primitivism is combined in a remarkable way with sophistication of technique and enigmatic, hieroglyphic symbolism. Kirchner's angular, hatched or restlessly sweeping contours, nervous and as if charged with electricity, reveal a tremendous strain between intellectuality and sensuality, a trait that distinguishes his major work very clearly from that of his friends. His career can

be seen in terms of two main phases, marked on the one hand by his fascination with the "inferno" of the big city, and on the other by the idyllic if precarious balance between man and nature seen in the forbidding Alpine landscapes of Switzerland, where, after a serious breakdown, Kirchner temporarily found peace of mind in 1915. These two phases were those of his preceding "street scenes" and of his Swiss imagery from 1917 onwards.

### Between Heaven and Hell

A key trait of Kirchner's œuvre is its formal reconciliation of opposites and contrasts. His is not a literary or illustrative art. What Kirchner does is translate reality, overt and covert, into forms and colors on the painted surface. In early years, inspired by his somewhat naive belief in the social efficacy of art, he set out to destroy illusion and penetrate to the core of appearances. Superficial beauty was anathema to him. "How fundamentally different is Germanic from Romanic art," he said, falling into the vocabulary of Teutonism. "The Romanic artist obtains his form from the object, from the natural form. The German artist creates his out of imagination, inner vision, and the forms of visible nature are to him only symbols.... For the Romanic artist, beauty lies in appearances; the other sees it behind things."

Kirchner's beginnings still stood under the spell of van Gogh's agitated brushwork and palette-knife technique. As with all of the Brücke artists, Neo-Impressionism, Art Nouveau arabesques, the Nabis Vuillard and Vallotton, even Toulouse-Lautrec, as well as Polynesian sculpture left their traces on his style. Munch also played a role, but less in terms of form and design than in terms of his disquieting moods. All of these influences were amalgamated very early on with Kirchner's own personal approach. Sooner than his friends he found himself, and together with them, out of the ruins of academic conventions, developed the Brücke style with its luminous, expansive passages of color, its emphasized contours, and its lapidary simplifications of form. Kirchner's nervous hieroglyphics began to emerge at an early date. His abrupt changes in perspective, changes of vantage point, sharp overlappings, and compositional audacities in the form of characteristic V, N and X-shaped configurations, also announced themselves. In his renowned 1914 painting of cocottes on *Potsdamer Platz* in Berlin, these features were brought to full mastery (p. 52).

### Metropolis and Mountains

The street scenes reveal Kirchner to have been a fascinated and precise observer of big-city life. These paintings, which include the impressive cityscape *The Red Tower in Halle* of 1915 (p. 53), belong to the most superb accomplishments of his career, ranking alongside such masterpieces as *Female Half-Length Nude with Hat* of 1911 (p. 54), the ambiguous *Circus Rider* wonderfully

**Karl Schmidt-Rottluff**
Farm in Dangast, 1910
Oil on canvas, 86.5 x 94.5 cm
Berlin, Nationalgalerie,
Staatliche Museen zu Berlin –
Preussischer Kulturbesitz

**Karl Schmidt-Rottluff**
At the Station, 1908
Oil on canvas, 70 x 92 cm
Vienna, Österreichische Galerie
im Belvedere

inscribed in an ornamental oval (1914; Saint Louis Art Museum), and the scathingly frank self-portrait, probably influenced by Heckel, *The Drinker* (1915; Nuremberg, Germanisches Nationalmuseum). A second culmination came later with Kirchner's monumental depictions of the Alpine environs of Davos, Switzerland. His *Stafelalp in Moonlight* of 1919 (Dortmund, Museum am Ostwall) is suffused by a tantalizing magic. Nature becomes demonic, a symbol of itself. The spiritual affinity to Romantic art, especially that of Caspar David Friedrich, is obvious.

This is equally true of *Winter Moon Landscape* (p. 55) of the same year, whose expressive color scheme is very compelling. After the mid-1920s many of Kirchner's paintings begin to take on a rather cheerful air that calls to mind posters or children's book illustrations. Here the limitations of his art become apparent, as does his dogged attempt to visualize in painting such phenomena of the physics of light waves as interference and polarization. The result is a disjunction of forms that inadvertantly recalls Picasso, much as Kirchner himself resisted such comparisons; the difference being that Picasso achieved double the artistic effect with half the intellectual effort. The all-too emphasized cheerfulness of some of the late canvases is not entirely convincing, in view of Kirchner's medical history and psychological state. He suffered from a progressive intestinal illness, increasingly oppressive apocalyptic visions ("The angels strewing the plagues from their bowls – aren't they the airplanes dropping gas bombs?"), and recurrent premo-

nitions of death. "Have a lot planned for this summer," he wrote in 1937. "Maybe it will be my last?" It was his last.

Of equal rank with his major paintings are Kirchner's watercolors, drawings, and above all, his graphic art. The woodcuts are among the finest imagery in his entire œuvre. With the aid of this technique Kirchner attempted to curb and lend valid form to the unique, nervous lineatures of his drawings, which had a spontaneous flow akin to handwriting. Kirchner's extraordinary craftsmanship and his love of experiment served him well in this regard, as they did in every graphic medium he employed.

## Monumental Landscape

The graphic art of Schmidt-Rottluff, the first in the Brücke group to make lithographs, likewise stands on a level with his painting. The woodcut technique compels an artist to simplify, to eliminate superfluous detail and concentrate on the essentials of a face or a landscape. This is why the woodcut was so well adapted to the Expressionist style in general, and to the energetic character of Schmidt-Rottluff in particular. The one who suggested the name for the group and convinced Nolde to join it, Schmidt-Rottluff had perhaps the most consistent career of all of the Brücke artists, although it cannot be denied that, like them, he did his best work during the early *Sturm und Drang* period of critical engagement with the ills of the era. Beginning with a dramatized version of Pointillism, Schmidt-Rottluff

*"I really feel a pressure to create something that is as strong as possible. The war has really swept away everything from the past. Everything seems weak to me and I suddenly see things in their terrible power. I never liked the type of art that was simply appealing to the eye, and I have the fundamental feeling that we need still stronger forms, so strong, that they can withstand the force of the crazed masses."*

KARL SCHMIDT-ROTTLUFF

developed a monumental, cohesive, symbolic style of landscape painting in which a new sense of nature, derived from a protest against modern urban civilization, found expression (p. 57). Instead of the interesting motif he sought an unsullied natural environment, and found it, with the other Expressionists, in the village of Dangast on the North Sea, in the Dangaster Moor, in Norway, on the Baltic island of Fehmarn, in the hamlets of Alsen and Nidden near the seacoast.

After the First World War Schmidt-Rottluff produced work suffused by deep melancholy and embittered resignation. His *Self-Portrait with Hat* (1919; private collection) is a key painting of Expressionism. The artist has no qualms about extending distortion to include his own features. One eye is large, the other small; one is open, the other as if blind; the face is skewed; the colors are violently dissonant, translating the disturbed harmony into aggressive contrasts. The man depicted here has lost all illusions. He is a marked man, struck to the core by the experience of the first great catastrophe of our century. The optimistic faith in the future of his rebellious years has vanished, to be replaced by disappointment and skepticism. In the

course of the years Schmidt-Rottluff's style would grow increasingly tranquil, as a strong tendency to the decorative, influenced by Fauvism, came to the fore. His compositions grew more serene, reflecting a striving for a balance of opposing forces, a harmony. Thus Schmidt-Rottluff gradually became a classical modernist.

## Expressionism and Dostoevsky

The retreat into a natural idyll took on even clearer form with Erich Heckel, the most sensitive and melancholy of the Brücke friends. The idea of "vicarious" suffering, rooted in Christian ethics and ecstatically heightened under the influence of Fiodor Dostoevsky, was one of the essential traits of Expressionist literature and art, and it found perhaps its most concise embodiment in Heckel's imagery. The *Two Men at a Table* (Hamburg, Kunsthalle), confined in a tiny room, tormented, mutually distrustful, and suffering, behind them the image of Christ stretched out supine on the cross, is a compelling document of this mental attitude.

The lyrical side of Heckel, whose palette rarely rose to the fanfare of the other Brücke artists, came out most purely in the early landscapes suffused with morning light, as in Crystalline Day (p. 58 below). Heckel perhaps belonged to Expressionism more by historical contingency than by virtue of his personality. Yet a painting like the deserted Canal in Berlin (Cologne, Wallraf-Richartz-Museum) shows that Kirchner was not the only one to master the nervous touch, the "hieroglyphics" of form, and that influence among the Brücke artists during their collaborative years was certainly mutual.

The tranquillity of Heckel's late work in painting and graphics, which, by way of the Neue Sachlichkeit and a decorative Fauvism took on an increasing restraint and balance, seems to confirm the assumption that even the Futurist-influenced passion of the early period reflected little more than a youthful revolt on Heckel's part.

As so often happens in art history, the Brücke artist who enjoyed most contemporaneous success later came to be considered one of its lesser exponents: Max Pechstein. In his paintings the brashness and crudeness of Expressionism seem to lack metaphysical reference, being more straightforward, direct, and intellectually less demanding. Though Pechstein's art has elemental force, it is more decorative than that of his friends, despite the fact that some of the superb achievements of his Brücke and post-Brücke periods can certainly

stand beside theirs. Examples are *Girl in Red under a Sunshade* (Darmstadt, Hessisches Landesmuseum), *The Fishing Boat* (p. 58 above), and *The Green Sofa* (Cologne, Wallraf-Richartz-Museum).

## "Gypsy" Mueller

More significance attaches to the thematically limited but formally interesting work of Otto Mueller, whose lyricism enriched the brass band of Brücke color by the haunting notes of a shepherd's flute. Mueller's origins were long shrouded in obscurity. His mother was rumored to have been an "abandoned gypsy child," and he himself, wrote Werner Haftmann, was "short and slender" with the "melancholy eyes of the gypsy." The artist's sister was less prone to mystification. Mueller's mother, she wrote in her memoirs, was "born out of wedlock to a Bohemian servant girl" and later put up for adoption. She was described as a "pretty, brown-skinned Bohemian woman" with "black hair and dark eyes" – no mention of gypsies here.

In 1924 Mueller travelled with his divorced wife and his new wife through Dalmatia and Bosnia. Three years later found him wandering alone through Hungary and Romania. It was here that he made his personal contribution to the time-honored theme of German Romanticism, "man and nature." He lived among the homeless and portrayed their girls in the midst of the countryside, giving them something of the grace of plants, awkwardly innocent and lascivious at once, like

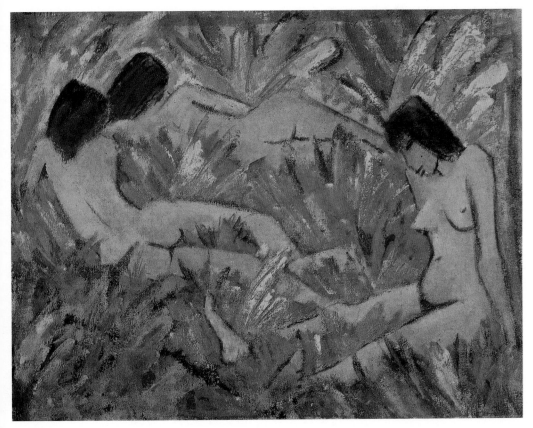

*"My art cannot be bought. I will not exchange my feeling for any earthly treasure. Other people might run themselves ragged for money, fame and honor, but I am not taking part in this. I would rather lie on the grass under blooming flowers, let the wind caress me, listen to the hustle and bustle of the people – this gives me strength and amuses me – and dream away the day."*

OTTO MUELLER

**Otto Mueller**
Female Nudes in Open Air,
c. 1920
Distemper on burlap, 86 x 111 cm
Wuppertal, Von der Heydt-Museum

**Erich Heckel**
Windmill at Dangast, 1909
Oil on canvas, 70.7 x 80.5 cm
Duisburg, Wilhelm Lehmbruck
Museum

Gauguin's Maori women. Sensibility and gesture arise from a simple, unbroken feeling for life and an elemental sensuality. Unburdened joy fills these images of naked children of nature, playing among the dunes, in the reeds, under trees, in the water. Mueller painted with distemper on rough burlap, in subdued, matte

colors. This gives his pictures their strangely muted atmosphere (p. 59).

In later years Mueller's palette grew darker. Now he began to portray his gypsies as outcasts and pariahs, dispossessed by destiny and society. In the pictures of lovers the coexistence of sexuality and death, happiness and damnation is emphasized. Gypsy mothers with child and their "providers" are given a nimbus, and thus characterized as relatives of poor Mary from Nazareth in the Bethlehem stall. Religious ideas are transposed into a secular, proletarian context – not always successfully, it must be admitted.

One of the happier results of the Neo-Expressionist wave of the 1980s was that attention was drawn to the sculptures of the original Expressionists, not only to those by sculptors such as Ernst Barlach (p. 413) or Wilhelm Lehmbruck (pp. 414 f) but to those by painters, like Kirchner (p.423) and Schmidt-Rottluff (p.424). Though the great expressive force of these works was pointed out as early as 1931 by Alfred H. Barr, Jr., founding director of the Museum of Modern Art, New York, they had been almost completely forgotten for decades.

# A Belated Heir of the Baroque
## Oskar Kokoschka: Viennese Expressionist

*"How do I define a work of art? It is not an asset in the stock-exchange sense, but a man's timid attempt to repeat the miracle that the simplest peasant girl is capable of at any time, that of magically producing life out of nothing."*

OSKAR KOKOSCHKA

Oskar Kokoschka grew up among the circle of Klimt and the Viennese Secession, and owed his first advancement to the architect Loos. He developed into one of the finest portrayers of human beings the century has seen. His early portraits were of an eerie clairvoyance, justifying commentators to describe them, perhaps a bit pathetically but at bottom correctly, as X-ray pictures of the human soul and character. No doubt the artist's own self-tormenting disquiet, a reflection of the disquiet of the age, played a role here, but this alone cannot explain why the portraits have the appearance of painted hallucinations.

Kokoschka's models often refused to recognize their likenesses. "One day he asked me whether he could draw me," reported one of his "victims" in the journal *Kunstblatt* in 1918. "The picture was finished in twenty minutes – but what a picture it was! Three months in jail would not have been too much for the 'damage to my good name and reputation' he caused me. The drawing was published in *Sturm* which was the leading German avant-garde art journal of the day. It was published by Herwarth Walden, a passionate advocate of modernism of every variety who had begun his career as a poet and composer. Walden had brought Kokoschka to Berlin in 1910. It was probably also he who coined the generic

term "Expressionism," the first time a new movement had been given a name that was not derogatory in intent.

### Kokoschka's 'Second Sight'

Professor Auguste Forel, the famous Swiss natural scientist of whom Kokoschka painted a still more famous portrait in 1910, was another dissatisfied sitter. Neither he nor his family accepted the portrait, and they refused to purchase it. It was especially the "dead" right eye in the scholar's careworn face, and his "convulsed" hands, which gave cause for indignation. Two years later Forel suffered a stroke, which resulted in paralysis of one side of the brain. Kokoschka, with the "second sight" of his nervous sensibility, had quite unconsciously anticipated the disaster. Another man he portrayed, the reviewer and essayist Peter Scher, reported that during the sitting Kokoschka's brush penetrated the surface of his face, producing a "pretty grim-looking" convict's mug. Years previously Scher had actually "sat" in a more unpleasant context, namely in jail, where he had been put for insulting a government minister and where he had had to weave reed mats. Scher had told Kokoschka nothing of this episode, but the artist found out about it nonetheless, as the portrait was being done.

when Kokoschka was a professor at the Dresden Academy. He had a life-size artificial dummy manufactured, based precisely on the principles of the female anatomy. It was to serve as his "life's companion," accompanying him wherever he went, even to the theater. A maid was hired to work the doll. Yet hardly had the doll been delivered, that the whole affair was over. Anyone who has seen the portraits of the young Kokoschka will realize that the episode represented an extravagant outbreak of despair, rooted in bitter disappointments in love and in a feeling of terrible loneliness. The background was as follows: Though a pacifist, Kokoschka had volunteered for war service. It was the only way he saw to escape from Vienna and from the tantalizing Alma Mahler, artists' muse and later the wife of architect Walter Gropius and writer Franz Werfel. The daughter of the Viennese landscape painter Emil Jakob Schindler, Alma was married at the time to Gustav Mahler. Her relationship with her much older, greatly admired husband, who moreover died prematurely, did not fulfil the beautiful, passionate woman. Then she met Kokoschka. The years with him "were a single violent love-battle," wrote the companion of so many great men in her candid memoirs.

At the time, Gustav Mahler was composing his monumental, brilliantly disjunctive symphonies, which both quoted the past and anticipated the future. Hugo von Hofmannsthal was sadly but presciently invoking the downfall of the Austro-Hungarian monarchy at the heart of Europe. Arthur Schnitzler, in Sigmund Freud's footsteps, was describing the "vast land" of the human psyche. Arnold Schönberg's ecstatic early work was emerging, while on the other hand, the public were suppressing their anxieties about the moribund state of the empire in the charming company of "sweet maidens" at the operetta. An awareness of this historical background is necessary to understand Kokoschka's idiosyncracies, which distinguished him from all the other Expressionists.

The psychological penetration and nervous agitation of the early portrait masterpieces correspond to the technique employed (ill. above). The paint application is thin, the color schemes are subdued. The handle of the brush has been used to inscribe intertwining, eerily gleaming lines into the wet paint surface, and entire areas have been applied with the fingers and hands – Kokoschka got beneath the skin in more senses than one. That the result is an "expressive art" goes without saying. But the sophisticated quality of Kokoschka's style, which is also evident in the linear webs of the lithographs, stands in sharp contrast to the neo-primitivism and merciless distortion of the German artists.

The Austrian was a passionate painter. The extent to which he suffered from his own failings and the fragility of the era, from the struggle between eros and reason, is indicated by the affair of the doll, which began in 1920,

**Oskar Kokoschka**
Portrait of Herwarth Walden, 1910
Oil on canvas, 100.6 x 69.3 cm
Stuttgart, Staatsgalerie Stuttgart

## "The Bride of the Wind"

The results of this love-battle were depicted by Kokoschka, distilled into a symbol of the eternal struggle between the sexes, which he considered preordained by fate. The picture is called *Die Windsbraut*, or *The Bride of the Wind*, the German term for "whirlwind" or "hurricane" (p. 62). The woman, who bears a portrait likeness to Alma Mahler, lies asleep, her body half beside, half over that of the sleepless man. His eyes gaze emptily from deep sockets; the face is sunken, the skin stretched like parchment over the skull and hanging in shreds from the body, which seems to be decaying, almost a skeleton. The uncanny scene plays itself out in an infinite, indeterminate space through which the

**Oskar Kokoschka**
Dresden Neustadt, 1922
Oil on canvas, 80 x 120 cm
Hamburg, Hamburger Kunsthalle

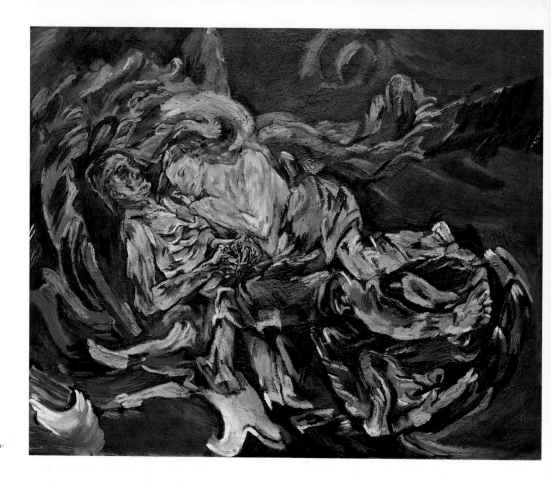

**Oskar Kokoschka**
The Bride of the Wind, 1914
Oil on canvas, 181 x 221 cm
Basel, Öffentliche Kunstsamm-
lung Basel, Kunstmuseum

*"I myself see no cause to retrace my steps. I shall not weary of testifying by the means given to me by nature and expressed in my art, in which only vision is fundamental, not theories. I consider myself responsible, not to society, which dictates fashion and taste suited to its environment and its period, but to youth, to the coming generations, which are left stranded in a blitzed world, unaware of the soul trembling in awe before the mystery of life."*   OSKAR KOKOSCHKA

couple is whirled as if caught in a vortex. As in Romantic art, love and death appear here as siblings, but the underlying message is not "death and transfiguration" but horror and damnation. As the feverishly sweeping forms and curving brushstrokes show, this artist is indeed a belated son of the Baroque, an era that was more conscious of the equivocal nature of human existence, its fragility and mortal dread, than a public familiar only with the worldly opulence of Baroque festivities and operas is perhaps aware. Not only El Greco's spiritual Mannerism but also Symbolist art contributed to this major work of Kokoschka's, which anticipates significant stylistic changes. From now on the paint would be used in a more definitely painterly way. Linear, graphic elements would lose importance, and the paint, instead of being diluted to watercolor thinness, would be applied in thick impasto, though the brilliance of French and German Expressionist paintings was neither equalled nor desired. Kokoschka's color chords have more of a Symbolist subtlety and reserve.

## Cities Portrayed

For a time Kokoschka continued to work in this allegorical vein, but suddenly he gave up his professorship in Dresden and vanished without a word of farewell. His profound restlessness impelled him to a vagabond life, and as he explored the world, he painted its great cities, whose feverish confusion mirrored the state of his own mind. Kokoschka generally depicted cities from a high vantage point, which permitted him to gain an overview, a comprehensive image of their physiognomy and character as a whole. Thus his city views, the glory of his mature period, are themselves a species of portrait. And they, too, like every great work of art, contain an element of the autobiographical. The overcharged tension of Kokoschka's early period is released, the colors gain in intensity. This development began early, with the views of Dresden and the Elbe River painted after 1920 (p. 61). But now the impassioned expression that invoked heaven and hell gives way to an impression, although it is one dramatically suffused with the energies of the restless wanderer and his adventurous life.

Denounced by the Nazis as degenerate, Kokoschka emigrated to England, where he found himself almost as misunderstood as during his early years in Vienna. He painted passionate appeals to the conscience of mankind, which are humanly deeply moving but aesthetically not always convincing. After the war, Kokoschka attained a calm and serene late style. But though his technical mastery remained as strong as ever, his visionary force diminished. The innovative paths marked out by younger artists Kokoschka declined to follow.

# Universal Anxiety and a New Acquiescence
## Meidner, Morgner, Schiele and Late Expressionism

Thirty years ago, during the opening ceremony of an art festival in Recklinghausen, Germany, the speaker was interrupted by a loud remark from the audience. It came from the artist whose work was being discussed, and who wished to draw attention to the fact that he was still alive: "I'm here – Meidner!" Apparently the speaker was unaware that the subject of his obituary was in the room. Ludwig Meidner (ill. right) was born in 1884 in Bernstadt, Silesia. An eccentric and willful man, Meidner continually swam against the stream, and his later years were overshadowed by loneliness and poverty. Expressionist pathos and a veritably manic compulsion to self-depiction, despair at the state of the world and at his own situation, embittered criticism and hate of man's inhumanity to man, marked the work of this restless Jewish artist. Although his œuvre is not flawless, it certainly represents a significant document of recent history.

Meidner experienced the first half of the 20th century as an apocalyptic age. Ensconced in his humble attic-studio in Berlin before the outbreak of World War I, he painted visions of the Last Judgement and the end of the world. "Sometimes I feel like hopping out of the window, down four storeys," Meidner wrote in his autobiography. "When I'm half awake I die many terrible deaths, but I know that I shall come into divine bliss again nevertheless . . . . I'm going to throw myself under a train, so its wheels can run screaming into my serene skull – ! Into a momentous, grand death – !" Even down to the punctuation, such statements are suffused with an ecstatic acceptance of the "twilight of humankind", "fall and scream," an apocalyptic mood, and also a touch of self-pity, are reflected in Meidner's words. As a painter he stood under the spell of van Gogh, and affinities with the early Kokoschka are also apparent. Wildly sweeping lines, extreme distortion of features in the portraits, jumbled perspectives in the cityscapes, where the buildings seem shaken by an earthquake and on the verge of collapsing, where the ground is pulled out from under our feet and the sky goes up in flames or disintegrates before our eyes – and in the midst of this chaos, man, alone and forlorn: Meidner himself.

### Tragic Fragments: Egon Schiele

A universal anxiety and a deep mistrust of one's fellow men likewise suffuse the work of Egon Schiele, who, like Kokoschka, emerged from the orbit of the Viennese Secession. Schiele transposed the hot-house eroticism of Klimt, who was twenty-eight years his senior, into a more aggressive and tragic mode. In his hands the suave ornamentation of the Viennese variant of Art Nouveau became nervous and agitated, and finally, with Expressionist heightening, it took on an angular sharpness.

While Schiele's palette remained subdued, the broken hues were often interspersed with glaring accents of red. Like Kokoschka, Schiele was a hypersensitive personality and a prophet of the imminent European catastrophe. For him, as for the allied soul of the visionary poet, Georg Trakl, life was constantly lived in the face of death. Even Schiele's mercilessly frank erotic depictions reflect this state of mind. Especially in the drawings, as Wolfgang Fischer notes, the "burning unfulfilled sexual-

**Ludwig Meidner**
The Burning City, 1913
Oil on canvas, 66.5 x 78.5 cm
St. Louis (MO), St. Louis Art Museum, Bequest of Morton D. May

**Egon Schiele**
Summer Landscape (Krumau), 1917. Oil on canvas, 110.3 x 138.9 cm. Private collection

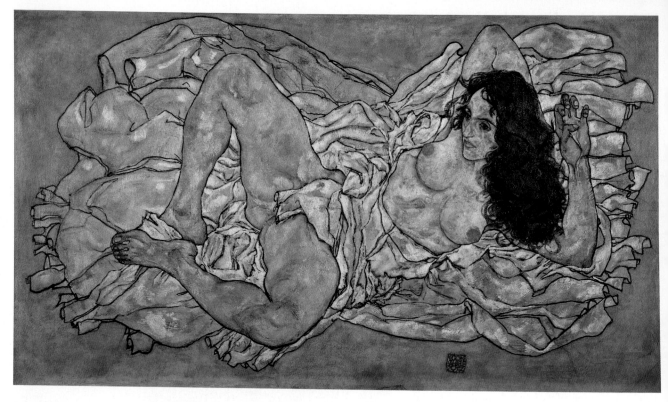

**Egon Schiele**
Reclining Woman, 1917
Oil on canvas, 96 x 171 cm
Vienna, Leopold Collection

ity of the nudes and embraces" finds expression. It seems grotesque, but these depictions caused Schiele to be labelled a "pornographer," on which charge he even spent almost four weeks in jail in 1912. What they in fact embody is the suffering involved in sexuality, the night

side of the relations between male and female, as described in the work of Freud (ill. above and below).

A more tranquil contrast to the figurative work is seen in Schiele's cityscapes, with their idiosyncratic perspectives and enigmatic, melancholy mood (p. 63). Here the borderline to abstraction is reached, if not overcome. "Painting is not enough for me," the artist wrote, "I know that one can create qualities with colors." Schiele's grandiose œuvre was destined to remain a fragment. He died on October 28, 1918, of Spanish influenza, the same illness to which his pregnant wife, Edith Harms, had succumbed three days previously, and which had taken the life of Klimt before them.

Like Schiele, the life and work of Wilhelm Morgner, born in Soest, Westphalia, in 1891, were prematurely cut short. The artist was killed in action near Langemarck in 1917. Morgner was not a precocious artist like August Macke, from whose carefree brilliance he was worlds apart. He was a contemplative, melancholy man whose path vanishes into obscurity. Influenced by van Gogh, Morgner depicted rural subjects, such as farmers working in fields stretching to a far horizon. As regards technique, he initially employed an ornamentally based, somewhat heavy-textured Pointillism in compositions reminiscent of Hodler. The "Sonderbund" exhibition, held in Cologne in 1912, brought a decisive confrontation with the work of the Brücke, the Cubists, and the Blauer Reiter. The despairing invocation of humanity that suffuses Expressionist poetry is also found in Morgner's fervently religious imagery. Passionate color combinations – culminating in the illuminated glow of the figurative ornament in his major work, *Entry into*

*"My existence, my decay, transposed to enduring values, must bring, sooner or later, my strength to other strongly or more strongly developed beings, like a living revelation of religion… I am so rich that I must give myself away."*

EGON SCHIELE

**Egon Schiele**
Lovers, 1913
Pencil, tempera and oil on paper, 48 x 32 cm
Turin, Galleria Galatea

*Jerusalem* (ill. right) – a swirling agitation of forms, and trenchant critique of human failings, are characteristic of Morgner's art. His *Astral Landscape* recalls the adoration accorded to a monstrance. Morgner was on the path to abstraction, although how far he would have travelled it had he lived, no one can say.

## Man as a Lump of Clay

The principal representative of Flemish Expressionism, an earthy version of the style that took its point of departure in the early van Gogh of *The Potato Eaters*, was Constant Permeke, a Belgian. In his dark-hued paintings of plain people and rural life, human beings seem formed of the same clay they work, predestined to bear the burden of a laborious life (ill. below). Permeke's forceful, brusquely simplified style divests Expressionism of its usual aggressiveness and turns it into a medium to convey monumental calm. Influences of Cubism, of the French neoclassical realism of Derain and followers, and of Picasso's neoclassical period, are all detectable in the original and powerful paintings of Permeke.

Unlike the work of the Fauves, that of the German Expressionists called the real world in question, for it had its origin in protest. Over the years the force of this protest diminished, partly out of disappointment, but partly from a newly felt need for acquiescence with the status quo. Ultimately this turn to the positive led, with the Brücke painters – and in an Impressionist variation

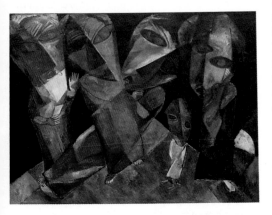

with Kokoschka – to a brand of realism characterized by heightened colors and reduced forms, a style in which years of experience found application. This path, marked out by the original protagonists of Expressionism, was taken by their followers as well. Among them was Lasar Segall, a Jewish artist born in Vilna who spent his later years in Brazil (ill. above); Werner Scholz, who adopted Expressionism under the influence of Nolde and the Brücke; and César Klein, who gained his reputation especially as a designer of theater sets.

A special case is that of the Rhenish Expressionists, a group of artists that originally referred to themselves as "Young Rhineland". The style reached a sort of culmination in the vociferously socially critical work of Gert H. Wollheim, who later emigrated to the United States; the

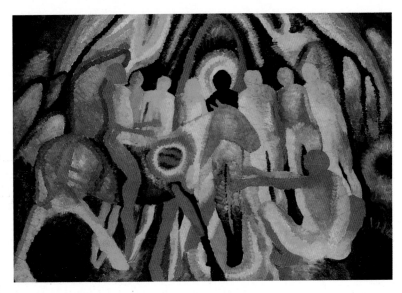

stark, black and white visions of Otto Pankok; and the work of artists who were temporarily part of the scene, such as Otto Dix, Max Ernst, and the Cologne "Progressives" around Heinrich Hoerle and Franz Wilhelm Seiwert in Cologne.

It was a Dutchman, Jan Thorn-Prikker, who established the first links between the Rhineland and international contemporary streams in art. At the time the region was still provincially preoccupied with its illustrious past, represented by the Düsseldorf School of the nineteenth century, whose influence had spread to Scandinavia, Russia, and even to New York (Hudson River School). Thorn-Prikker's symbolistic, semi-abstract murals and window designs translated influences of early Christian art, the Nabis, the Orphic Cubists, and the Blauer Reiter into a formal language of considerable originality (p. 66).

Mention should also be made of Jankel Adler, a Polish Jewish artist who, before persecution drove him into exile, lived for an extended period in Düsseldorf, where he met Paul Klee (p. 66). His style initially oscillated between Klee and Picasso, until expressive renderings of the natural scene and a subjective depiction of

**Wilhelm Morgner**
Entry into Jerusalem, 1912
Oil on canvas, 119 x 170.5 cm
Dortmund, Museum am Ostwall

**Lasar Segall**
The Eternal Vagabonds, 1919
Oil on canvas, 138 x 184 cm
São Paulo, Museu Lasar Segall

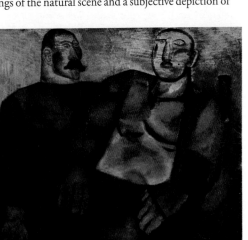

**Constant Permeke**
The Two Sailor Brothers, c. 1923
Oil on canvas, 128 x 151 cm
Basel, Öffentliche Kunstsammlung Basel, Kunstmuseum

his personal experiences helped him develop a more rigorous, nobly hierarchical approach to composition. Individual traits were reduced to the prototypical, while subjective feelings were objectified. Adler's later paintings possessed a reserved earnestness that brought an Eastern European note into the generally decorative tendency of French-inspired Rhenish art.

### An Attempt to Break through to God

"Paintings have their time," wrote Carl Linfert. Put differently, pictures and their styles are by no means random, ahistorical products. Expressionism was a European movement whose conceptual source lay in the feverish unease of the years preceeding the First World War, and in the optimism with which parts of the younger generation reacted to this malaise. All over the continent artists began to revel in pure color and dynamic composition – in Paris and Dresden, in Berlin and Vienna, even in the provinces far from the acknowledged centers of art. Key aesthetic and artistic streams and developments do not take place in a vacuum; they are embedded in actual, historical circumstances.

Expressionism, which we shall confront again under very different premises and in a different form in the Munich artists group Der Blaue Reiter, was not only a temporary direction. It represented an artistic and human stance which was to prove lastingly viable despite

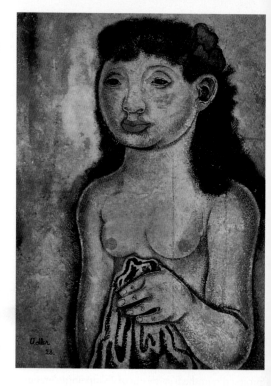

the vicissitudes of time. In Expressionism the imbalance between emotion and reason was righted, the claim of the creative mind to make independent artistic decisions beyond all questions of utility, social conformity, and scientific principles, was strongly confirmed. The expressive art of the early century was an initial attempt to mount resistance to the automatism of industrial and commercial life, to set a dynamic lawlessness against the ossified laws, rules and regulations of the era. The Expressionists' distortion or deformation was not an attack on human dignity, just the opposite. All of their critique of the times, all of their distortions and screaming colors aimed at one thing only: "The most profound, presciently sensed meaning of all Expressionist art is… an attempt to break through to God, through all of the barbed wire entanglements of the laws of nature," as Wilhelm Worringer put it in 1919, with the pathos of a war-torn period.

However, it should not be overlooked, especially in the case of Expressionist architects, that their preference for the grand gesture and monumental demonstration contained a certain latent danger, which continues to exist to this day. Their pathos had ideological underpinnings, and the vocabulary of their theoretical writings in part anticipated the big words which a quite different political movement was soon to mobilize. Today, with the advantage of hindsight, certain crypto-fascist traits can be detected in the pithy pronouncements of the Expressionists, though one cannot in justice hold their spokesmen responsible for the terrible vulgarization to which their ideas were subsequently subjected. We are approaching a discussion, which is by no means closed even today.

**Jankel Adler**
Woman, 1928
Gouache, watercolor, sand and distemper on cardboard, mounted on wood, 62 x 46 cm
Tel Aviv, Adam Eyal Collection

**Jan Thorn-Prikker**
Madonna among Tulips, 1892
Oil on canvas, 146 x 86 cm
Otterlo, Rijksmuseum Kröller-Müller

# Classicism and Imagination

## The Calm after the Storm
## Cubism, or Classical Modern Art

"Action equals reaction" – this axiom of physics also holds in a general way for art. We have seen how Cézanne attempted to rescue form from complete disintegration into Impressionist dots and commas of paint. Though the Fauves never forgot Cézanne's example, their prime concern was to liberate color, to use it in its purity and brillance. This concern, initially at least, forced considerations of form into the background. With the Expressionists outside France, the urge to turn their inmost feelings outwards, to exorcise their ghosts, even led to a destruction of form. The reaction to this came with Cubism, in which not feeling and sensation, but reason and design predominated. Yet the two opposing tendencies shared something in common – an elimination of traditional *trompe l'œil* effects. Instead of fooling the eye, the Fauves and Expressionists sought subjective truth in color, and the Cubists sought it in form. The fundamental problem they faced was how to depict three-dimensional objects on the two-dimensional plane of the canvas without resorting to perspective illusion.

A little over a year after the great Fauves show at the 1905 Salon d'Automne in Paris, Pablo Picasso tackled this problem for the first time. He began in spring 1907 and that same summer presented the result to his friends: *Les Demoiselles d'Avignon* (p. 69). The now-legendary painting depicts five nude female figures with rough-hewn, angular bodies and schematic faces in the manner of primitive Romanistic Catalan frescoes. The Picasso noses of the four figures shown frontally or in three-quarter profile are bent to the side, pressed into the plane; the bodies are unmodelled, devoid of volume. This exoticism had no formal significance as such; Picasso always defended himself against the inference that he had been influenced by African art, which the Fauves had discovered. The fact is that in May or June he had visited the Ethnographic Museum at the Palais du Trocadéro, and – like Matisse and Derain before him – he had been impressed by the African sculpture there. Whether he actually later altered three figures in *Les Demoiselles* (two on the right, one on the left) or even repainted them or changed their sequence under the influence of this experience, remains uncertain. Nevertheless, the similarities to African art reflect an inner affinity, which was confirmed, at least, by the artist's visit to the Trocadéro. In addition, the expressive ugliness of the masks points to something else: the innate expressive traits in Picasso's personality. Among other things, he was heir to the tradition of Spanish Realism, whose combination of harshness and ecstatic mood strongly shaped the Andalusian artist's approach.

Picasso was the most significant "expressionist" painter of the century, in the sense of the dramatic events that played themselves out on canvas after canvas. Yet this circumstance is not central to *Les Demoiselles*. More crucial are the technical means with which the artist forces the masks (which in this regard diverge from African sculpture) into the two-dimensional plane and elicts an impression of volume and mass not by means of light-dark contrasts, or chiaroscuro, but through long parallel strokes of green or blue-black. These parallel hatchings are found only in the faces of the two figures on the right. They amount to the earliest document of Cubism. This feature was so radical and strange that even Picasso's friends, the poets and writers Guillaume Apollinaire, Max Jacob, and André Salmon (who eventually suggested the picture's title) did not initially understand the painting, and Braque was prompted to say that Picasso apparently wanted to give people "kerosene to drink." Nevertheless, this shock ultimately led to Braque's conversion: the Saul of the Fauves became the Paul of the Cubists.

### Picasso and his Crew

*Les Demoiselles*, by the way, had initially been conceived in quite different terms. It was to include figures of men, a student and a sailor, dining in the company of ladies from the Carrer d'Avinyo (Avignon Street) in Barcelona. The fruit in the foreground – grapes, pear, apple, melon – remain over from the original composition. Its scene was a Barcelona brothel well known to Picasso and his friends. "Le Bordel d'Avignon" was accordingly Picasso's chosen title, which shifted the events depicted from Avignon Street to the town of Avignon itself. But André Salmon, reportedly to the artist's displeasure, decided a title less offensive to genteel ears would be better. As Picasso later told his friend and dealer Daniel-Henry Kahnweiler, he and his confreres made ribald jokes about the whole affair, and

*"In 1908, Picasso showed a few paintings in which there were some simply and firmly drawn houses that gave the public the illusion of these cubes, whence the name of our youngest school of painting. This school has already aroused passionate discussion. Cubism can in no way be considered a systematic doctrine; it does, however, constitute a school, and the painters who make up this school want to transform their art by returning to original principles with regard to line and inspiration, just as the Fauves – and many of the cubists were at one time Fauves – returned to original principles with regard to color and composition."*
GUILLAUME APOLLINAIRE

assigned starring roles to Max Jacob's grandmother, the artist Marie Laurencin, and his current girlfriend Fernande Olivier as "The locked-up ladies of Avignon". This anecdote reveals the faunlike and clowning side of Picasso's nature, though of course it says little about the significance of the painting in the history of Cubism.

The "Bateau-Lavoir" (Laundry Barge), a dilapidated studio building located at Rue Ravignan 13 between Place Pigalle and the top of Butte Montmartre, was a Noah's ark for Picasso and his Bohemian "crew" between 1903 and 1912. "Painters, sculptors, writers, humorists, actors, laundresses, seamstresses, and itinerant vegetable dealers" lived there, reports Fernande Olivier in her memoirs. "It was an icebox in winter and a sweatbox in summer, and the tenants met at the only water faucet with pitcher in hand." The artists worked and partied, loved and starved there, until finally an angel of grace appeared, in the figure of Gertrude Stein, rich American poetess and exacting muse of so many artists of the first third of the century, from Matisse and Picasso to Sherwood Anderson and Ernest Hemingway. But what above all appeared at the Bateau-Lavoir was a

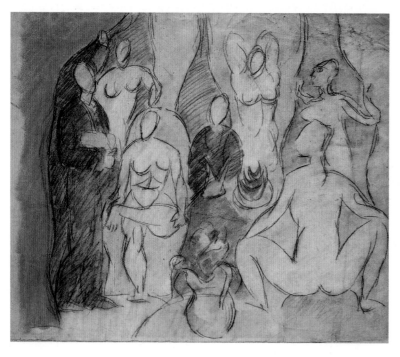

**Pablo Picasso**
Study for "Les Demoiselles
d'Avignon", 1907
Watercolor on paper, 17.5 x 22.5 cm
Philadelphia (PA), Philadelphia
Museum of Art

form of painterly expression that can be considered the classical art of the 20th century.

Cubism reacted in a way quite different from Expressionism to the anxiety and disquiet, the crisis of faith and lack of roots that emerged from European nihilism. It raised no protest and staged no revolt, nor did it naively proclaim "back to nature" as the way to salvation. In the face of chaos, Cubism set out to create a new order, an arrangement of silent signs on canvas. An extreme degree of objectivity was combined in this early form of "conceptual art" with a strange, brooding,

intellectually tempered mysticism, which nevertheless had something fanatically determined about it. A cold flame burned the breasts of these artists. They behaved like the members of a religious order, a brotherhood that knew that it was far in advance of the times, and therefore that its thinking and the results of its inquiries would not be understood by its contemporaries. "Philosophers of form," Klee termed the Cubists.

This is why the protagonists of the style, Picasso and Braque, kept their products out of the public discussion as long as they could. They initially showed their pictures only with Kahnweiler, a young German-Jewish dealer from Mannheim who had come by way of England to Paris, opened a gallery on Rue Vignon, and, with somnambulistic sureness, had taken up the Cubists in an exclusive choice he never would have reason to regret. At Kahnweiler's gallery they could expect connoisseurs or at least interested viewers, and avoid the obloquy that had been poured on the heads of the Impressionists and Fauves. Kahnweiler made the Cubists' retreat from the public eye possible by agreeing to take their entire production, without stipulating fixed periods for delivery. Thus their intellectually reflected conceptual art was enabled to come to maturity slowly, more or less in peace and quiet, in a process of hard, concentrated work. This indicates how entirely different the artists' daily lives were from their activity in the studio. As members of the wild Montmartre *bohème* they were part of "Picasso's crew," but as painters they labored with extreme concentration and persistence to find solutions to the tasks they had set themselves.

### Cézanne, the "Protective Mother"

At the beginning of this development stood Cézanne, whose paintings had made a deep impression on the future Cubists at the memorial exhibition held in the 1907 Salon d'Automne. "He was like a protective mother to us," Picasso admitted in a conversation with Kahnweiler. Cézanne had once said, "The eye absorbs… the brain produces form." Still, it would be mistaken to consider the outsider from Aix the only ideal of the Cubists. It is true that his canvases "joined hands," that is, were composed of a dense interweave of strokes that resisted Impressionist dissolution of form. But it is important to remember that Cézanne, despite mentally preconceiving the forms in his paintings, ultimately derived them from color. The Cubists approached this problem from a different angle, and with different means. As Kahnweiler said, they wanted "simply to give a precise image of bodies on a flat plane, without illusion of any kind." In contrast to Cézanne, and in even greater contrast to the fanfare colors of the Fauves, the Cubists subdued their palette. In the early years it was comprised of only greys, ochers, browns, a dark saturated green, and an occasional accent of bright red. The forms were abbreviated, geometrically simplified, condensed. At first, plastic volume was not dispensed with, but instead of being suggested by illusionistic

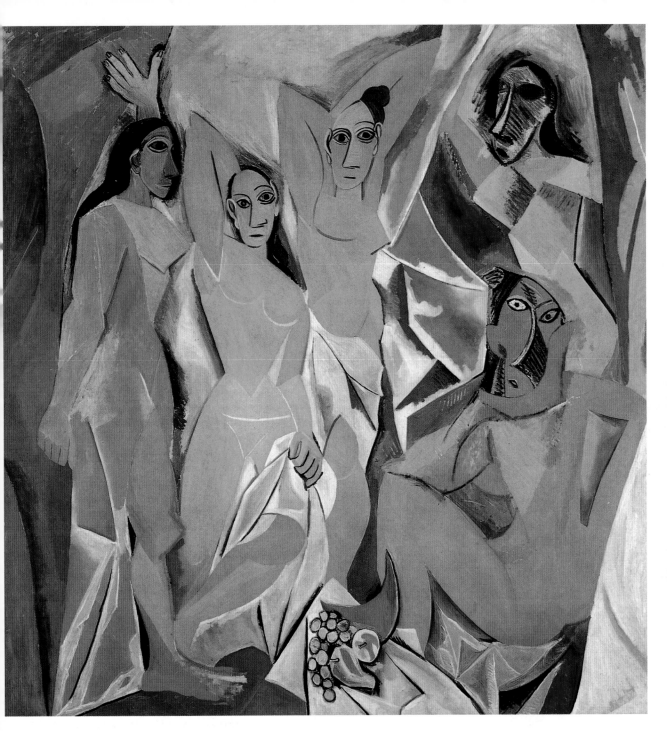

shadowing it was evoked by passages of flat modelling. Braque came back from L'Estaque with paintings from which the bright Mediterranean atmosphere had vanished, but which contained what were clearly cubic shapes (p. 70). These were the elements that gave the style its name, and it was again the critic Vauxelles who coined it, when he described the unusual works as "cubistic bizarreries." (Albert Gleizes pointed out to Daniel Robbins that another critic, Louis Chasserent, spoke as early as 1906 of "cubism," but this was in connection with Jean Metzinger and Gleizes.)

The magic of light and atmosphere was sacrificed to clarity of form, as everything unreal, vague and undefined was banned from Cubist pictures. Their subjects were quite commonplace: houses, trees and rocks, bowls, fruit, vases and musical instruments. "The vase gives emptiness a form, as music does silence," said Braque. Instead of seeking the particular, the Cubists concentrated on the general, on the unchanging essence of things rather than on their transient appearance.

The compositional planning this involved went far beyond Cézanne, who wished to dispense neither with

**Pablo Picasso**
Les Demoiselles d'Avignon, 1907
Oil on canvas, 243.9 x 233.7 cm
New York, The Museum of
Modern Art, Acquired through
the Lillie P. Bliss Bequest

**Georges Braque**
L'Estaque, 1908
Oil on canvas, 60.3 x 50.2 cm
New York, The Museum of
Modern Art

light nor with the bluish hues things take on when seen from a distance. Picasso's paintings of the Spanish village Horta de Ebro of 1909, like Braque's concurrent landscapes, showed buildings and setting in terms of highly reduced, cubic configurations. The terracing of hills and houses perfectly suited the pictorial architecture for which Picasso and Braque strove. The forms of nature, subjected to man's needs, played an only marginal role.

In Braque's hands even the elaborate ornamentation of Sacré-Cœur cathedral was transformed into a monument of tectonic rigor and formal logic. *Chiaroscuro* returned to Cubist painting for a while, but not in order to produce striking effects of illumination, but to emphasize the sculptural modelling of the simple cubic forms. Interruptions of contour at the meeting-point of two planes provided transitions, softening the harsh light-dark contrasts at the edges of the outlines. The separate shapes, despite their reduction to geometric blocks, seemed to interpenetrate like

**Georges Braque**
Fruit Bowl and Glass, 1912
Charcoal and papiers collés,
62 x 44.5 cm
Private collection

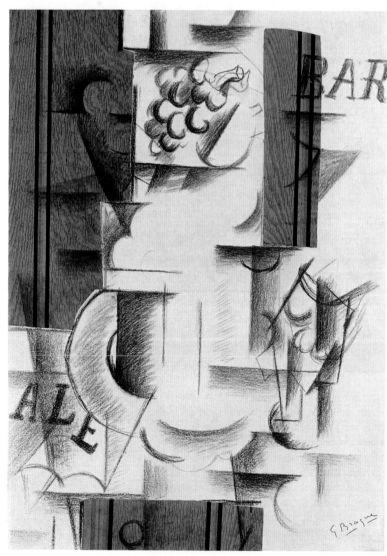

crystalline growths. This mitigated the rigidity of the compositions and lent them a painterly vibrato which already anticipated the facetting of Analytic Cubism. The well-nigh monotonous colors, limited to ocher, reddish-yellow, and greenish-grey, also represented a feature very typical of early Cubism – a puristic rigor of palette. Color was not allowed to detract from the principal theme. That theme was form.

## The Silent Revolution

In the following period, from 1910 to 1912, the large, simplified, condensed form began to be divided into smaller and smaller parts that resembled the facets of a crystal. Figures were taken apart, then reassembled on the plane and made to cohere by pulling together the light reflections on various parts of the body. In the famous *Girl with a Mandolin* (New York, The Museum of Modern Art), done in 1910, the corporeal character of the figure is still retained, despite the formal disassembly of figure and instrument and their integration in the geometrical facetting of the picture plane. This analytical procedure gave the development a direction that could not help but lead to a final break with traditional habits of perception.

What occurred during these years was the silent revolution of Cubism, apparently unsensational but rife with consequences. Anti-illusionism was taken by the Cubists to its logical end, producing results that became obligatory for European art for a long time to come. In keeping with the great self-consciousness of a late culture, Cubism was an intellectual art. The theory on which it rested is no easier to understand than the analytical paintings themselves. But a brief outline might be of help. We shall set aside the scholarly debate on whether the theory came first or the artists, progressing from insight to insight in the course of painting.

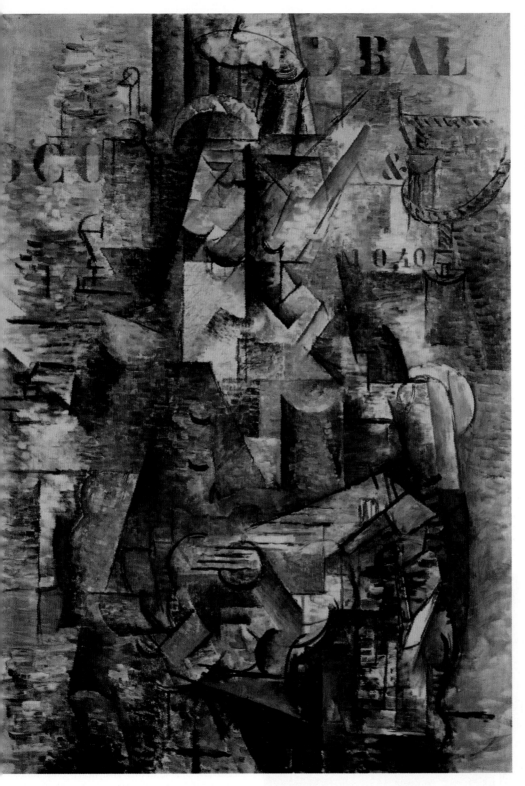

**Georges Braque**
The Portuguese, 1911
Oil on canvas, 116.5 x 81.5 cm
Basel, Öffentliche Kunstsamm-
lung Basel, Kunstmuseum

Probably both views are correct, because in an art as conceptually oriented and technically difficult as Cubism, it is almost impossible to separate idea from realization, perceptual critique – influenced by the new perceptual physiology and psychology of the 19th century – from the practical struggle with problems of form.

Their restless search very clearly reflected the episte-mological doubt over truth of sensory perception which was characteristic not only of early Cubism but of the entire century, including its science. The evidence of the eye came to be considered only an "optical illu-sion", unreliable, a misrepresentation of facts. The eye

recorded only external appearances, and could not penetrate to the core of things. But it was this core with which the painters were concerned, an essence which they hoped to define and represent in paint on canvas – which amounts to the same thing. "Writing does not mean describing, painting does not mean copying," said Braque. But according to the Cubists it was precisely copying, to put it simply, which illusionistic painting in all its varieties since Giotto had done. Picasso and Braque now proceeded to draw their conclusions. They ceased painting objects "as they saw them" and began painting them "as they thought them," as Maurice Raynal put it in his essay "What is Cubism" of 1913. "This is precisely the law which the Cubists have taken up again and expanded and codified under the heading of 'the fourth dimension'." They broke objects open, flattened them out and deprived them of volume and the illusion of a surface skin; they no longer looked at a table, a chair, a vase, a glass or even a human being from a single vantage point only but from several vantage points. They walked, as it were, around things, and what they saw in the process was supplemented by what they knew about these things, and their knowledge, in turn, was supplemented by experience.

This process ultimately led to the simultaneous depiction of various aspects of reality. Different views of the same object seen at different points in time were represented together, as in a multiple exposure photograph. This amounted to bringing the factor of time into an art that intrinsically was very static and intended to emphasize permanence, a principle that – under other conditions and with different aims – would soon be adopted and ramified by the Futurists. The painted image, as Carl Einstein put it, now developed "out of a cadence of tectonic planar forms." Apollinaire spoke of a pictorial space with a "reversed perspective." The light

sources in these paintings were not detectable, light and shade remained ambivalent in nature. The image was capable of accepting anything that could be translated from three-dimensional volume into two-dimensional surface, while dispensing with an illusion of depth. Compositional harmony was engendered by a well-considered juxtaposition of contrasts, which led to the "plastic," relief-like effect Kahnweiler described. The Cubist method was akin to that of counterpoint in music.

## The Thing in Itself

In this way the Cubists, instead of reproducing the appearance of an object, hoped to penetrate to what Plato (and Picasso) called the underlying "idea" and what Kant called "das Ding an sich," or the thing in itself. Instead of representing more or less accidental or partial aspects of reality, in other words, they strove to represent reality itself, based on a new conception of space and time. Optical illusion would be replaced by "true vision," the "lie" of visual perception by the definition of a new, comprehensive reality. "Defining a thing means putting the definition in its place," was Braque's terse equation.

So the definition of a thing was the thing itself. By means of exact analysis, these artists attempted to bring back into painting a reality that had grown so complex and ramified that it could be stated only in terms of formulae. In making such statements, color would only stand in the way. It would have brought a sensuous factor into this strict, logical art, in which something of Kant's philosophical rigor was revived. "The senses deform, the mind forms…. There is no final certainty except that the mind grasps," stated Braque. Thus Picasso and Braque, in their analytical period, limited themselves largely to grey, ocher, and brown. But these *grisailles* were so subtly gradated, so rich in intermediate tones, that they took their place among the most exquisite manifestations of European painting.

The implicit purism of this radically anti-perceptual, in a way even iconoclastic art that hermetically sealed itself off from sensation-hungry curiosity, can be

**Georges Valmier**
Abstract Composition, c. 1920
Oil on canvas, 116 x 82.5 cm
Private collection

**Georges Braque**
Atelier II, 1949
Oil on canvas, 131 x 163 cm
Düsseldorf, Kunstsammlung
Nordrhein-Westfalen

as little denied as the purism of its life-long prophet and brilliant interpreter, Kahnweiler. The famous art dealer early on stated the opinion that painting was a written language that invented symbols or characters which it was the task of the viewer to decipher. Truly, the hermetic language of Cubist pictures is not easy to read. The painters themselves sensed this, and as simplicity is often a sign of maturity, as soon as they felt certain of their technical means they began to give the public visual hints, suggestions of recognizable things, which at the same time served to interpret the subject matter of their paintings. For example, Picasso's *Souvenir du Havre* (Basel, private collection) of 1912 contains a number of references to reality, memories of an apparently enjoyable and somewhat "wet" journey with Braque – boats' rigging, seashells, rippling waves, and above all, drinking glasses.

The introduction of letters of the alphabet into their paintings emphasized the Cubists' fundamentally anti-illusionistic stance. These characters served as orientation points within the non-perspective space. In their search for the true, unadulterated local color of objects, the painters' fanatical love of truth led them to begin to imitate the textures and colors of materials, and soon even to insert actual materials such as wood, marble, or printed wallpaper into their works. This supplemented the painted surface by new, tactile values. These works, collages and *papiers collés*, were not intended ironically or meant to disparage past art as were those of the Dadaists and Surrealists of a later period. Rather, they represented visible and tangible elements of reality,

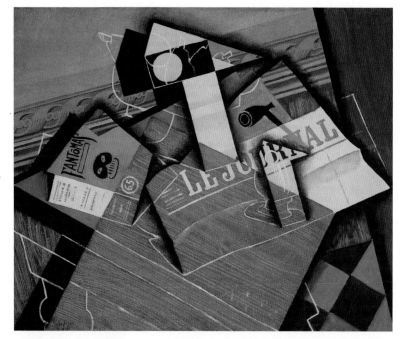

"things in themselves," which in this way were introduced into art. In addition, non-aesthetic materials – Braque soon began using sand, wood shavings, and twine – offered a chance to elicit effects of depth without recourse to tabooed perspective, because a surface could be built up in the manner of a low relief, in which the planes advanced or receded solely by dint of the contrast between their color or textural values.

### "Don Juan, or The Love of Geometry"

With these works, into which brilliant colors again entered, began a turn away from Analytic Cubism. The new direction led to what is known as Synthetic Cubism, a style just as intellectual but less complicated than its predecessor, and therefore more easily accessible. In this new phase a third artist joined the pioneers Picasso and Braque. This was Juan Gris, actually José Victoriano Gonzáles, like Picasso a Spaniard, and one of the most sympathetic figures in the history of modern art, a "minor" painter but a great one. Gris was a handsome man who loved to dance. His friends nicknamed him "Don Juan Gris" because women found him almost irresistible. Nevertheless, no scandalous stories about him have come down to posterity, for the same discretion that is such a signal trait of his art characterizes his life as well. Of all the Bateau-Lavoir artists Gris had the hardest time. He was so poor that he had to draw cartoon series in order to survive. This cost him a great deal of time, but he watched and waited. When he was finally in a position to concentrate on his own work, Gris first oriented himself towards Analytic Cubism, concentrating, as in his famous 1912 portrait of Picasso, on the form-engendering and form-dissolving qualities of reflected light. Yet soon Gris developed an original approach. Unlike his friends, he did not take Cézanne as

**Juan Gris**
Still Life with Pipe and Newspaper (Fantomas), 1915
Oil on canvas, 60 x 72 cm
Washington, National Gallery of Art, Chester Dale Fund

*"I work with the elements of the intellect, with the imagination. I try to make concrete that which is abstract. I proceed from the general to the particular, by which I mean that I start with an abstraction in order to arrive at a true fact."*
JUAN GRIS

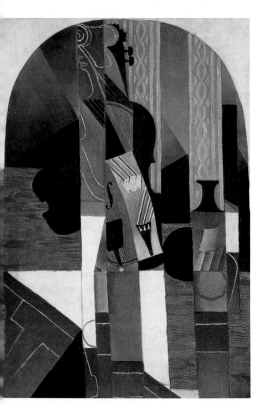

**Juan Gris**
Still Life (Violin and Inkpot), 1913
Oil on canvas, 89.5 x 60.5 cm
Düsseldorf, Kunstsammlung Nordrhein-Westfalen

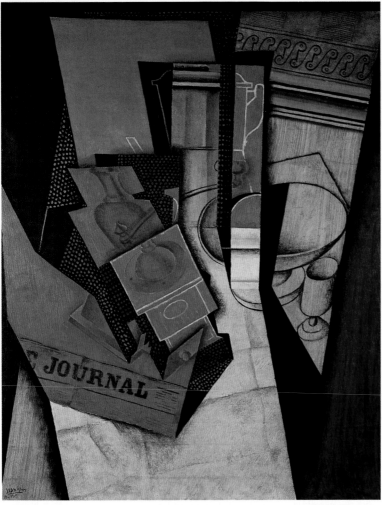

**Juan Gris**
Le déjeuner, 1915
Oil and charcoal on canvas,
92 x 73 cm
Paris, Musée National d'Art
Moderne, Centre Georges
Pompidou

**Fernand Léger**
The Stairway, 1914
Oil on canvas, 130 x 100 cm
New York, The Museum of
Modern Art

combining parts into a whole (synthesis). What was retained from the earlier approach was the purely planar character of the painting, whereby three-dimensional objects were tilted up into the two-dimensional plane. This was the final consequence of Cézanne's perspective distortion, in which the composition was subject to the laws of form alone. It is a feature of Cézanne's still lifes that still strikes the naive observer as awkward, because the fruit bowls, knives, pitchers and jugs seem on the verge of slipping down the inclined plane of the table and falling to the floor. The ascetic, brooding greyish-browns of the Analytic paintings remained a memory. Though the palette of Synthetic Cubism did not reach the brilliance of Impressionism, not to mention Fauvism, its subtle, subdued hues presented a feast for the eye, and the compositions were understandable without undue intellectual effort. Gris – until his premature death – and Braque set out to explore the new style in all its variants.

Braque in fact became the classical representative of late Cubism, a man whose work reflects the culture of French color and form in an incomparable harmony. Only an occasional misjudgement in format, or a discrepancy between still-life calm and the agitated movement of sometimes life-sized figures, made slight smudges on the lucid mirror of Braque's œuvre. Its intellectual stance is closely allied with that of the great French still-life painters from Chardin to Cézanne. "I am not a revolutionary painter," admitted Braque. "I do not seek exaltation – excitement is enough for me." After the stormy years of his beginnings, Braque became one of the great and profound conservatives of the age.

### The Sunny Side of Technology

Cubism was originally suffused with mistrust of human perception of the reality of the visible world. In the work of Fernand Léger, it became an art of acceptance (pp. 75–77). The heavyset, awkwardly charming grandson of Norman farmers and son of an animal breeder, Léger praised the glories of the technological world in a quite unintellectual, somewhat naive way. His favorite shape was the tube or pipe, which led Vauxelles, godfather to so many major artists, to nickname Léger a "Tubist." For a time Léger was a convinced communist, and dreamed of a popular art for all. His late, prototypical style, perhaps the purest formulation of socialist realism because it was entirely without ideological blinders, represented the utopia of a "proletarian Olympus." That it was destined not to be understood by the people for which it was meant was a personal disappointment for Léger, but one he shared with many avant-garde artists.

Léger, too, was helped by Cézanne out of the dilemma that faced the successors of Impressionism. But as the early *Nudes in a Forest* (Otterlo, Rijksmuseum Kröller-Müller) already shows, Léger's reading of Cézanne differed greatly from that of the other Cubists'.

a point of departure. He turned the Aix master's methods upside down, as it were, first designing an abstract, tectonic pictorial structure and then inserting objects into it. Instead of creating abstractions, Gris rendered the abstract concrete. "Cézanne made a cylinder out of a bottle," he once stated; "I make a bottle out of a cylinder."

In the still lifes done by this method, mathematics and poetry are combined, as in music (p. 73 and ill. above). Gris's palette is completely liberated and independent of the local colors of things, strong and at times brilliant. This reconsideration of the importance of color had also taken place with Picasso and Braque, initially in their collages. As regards form, the ideal configuration of an object or figure was now no longer arrived at in a long process of analytical investigation and division into component parts, but projected according to the artist's imaginative idea. In contrast to Cézanne's method of working "in front of the motif," or from life, this process involved and relied on memory. Perceptual experience was no longer conceptualized; rather, a mental conception was rendered perceptible. Instead of dividing a whole into parts (analysis), the artists began

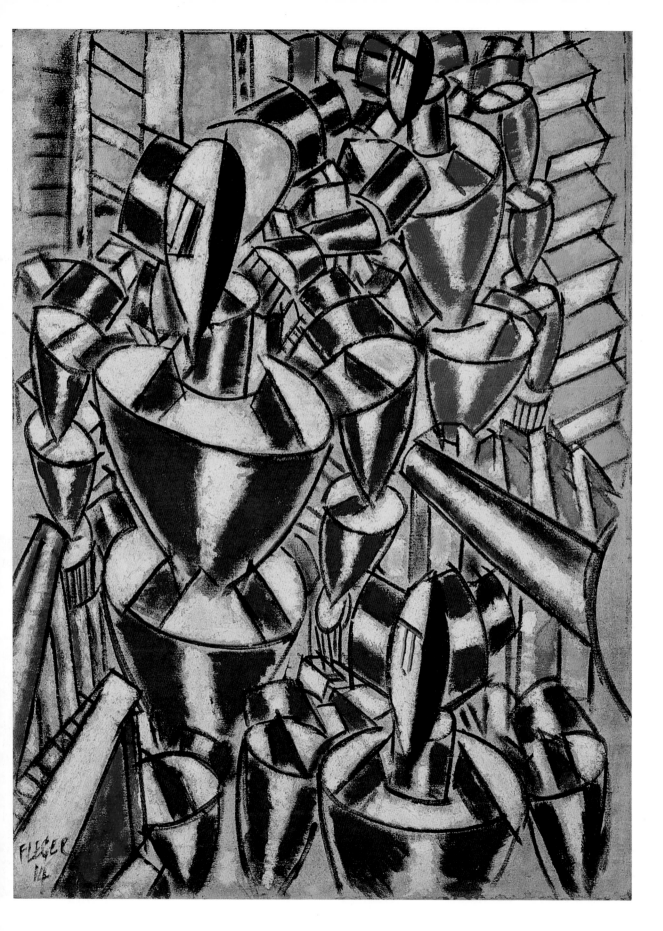

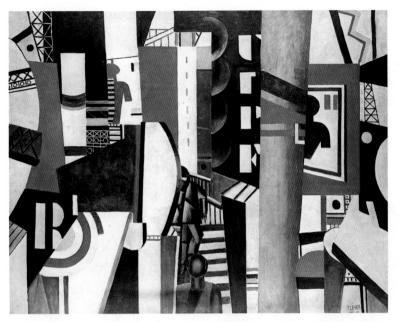

**Fernand Léger**
The City, 1919
Oil on canvas, 230.5 x 297.8 cm
Philadelphia (PA), Philadelphia
Museum of Art

*"A work of art must be significant in its own time, like any other intellectual manifestation, whatever it may be. Painting, because it is visual, is necessarily the reflection of external conditions, not psychological ones. Every painting must allow for this momentary and eternal value, which will make it last beyond the period of its creation."*
FERNAND LÉGER

As he himself said, the painting is "a battle of masses," in which giant, robot-like figures move through a proliferating jungle of tubular trees. This dynamic approach to composition would continue to inform subsequent paintings, which in addition had large areas of bright color inserted between the abstracted, tubular figures. The landscapes, figurative compositions, still lifes, and stair motifs of the pre-World War I period were all reduced to strongly contrasting, geometric bodies whose volumes, instead of being flattened out, are especially emphasized. The palette of bright blue, red, yellow, and green was employed as a constructive rather than a coloring factor, and the hues possessed a metallic hardness. The early Léger took Cézanne's famous saying literally, transforming everything that came into his hands into cones, spheres, and cylinders. Whatever he painted took its place in a mechanized world.

Nor did this change in the coming years, during which Léger became the founder of a *nouveau réalisme*. His formal discipline, the binding logic of his pictorial architecture – or rather, structure – made this engineer among artists into a classic. "One of his pictures is titled 'Homage to Louis David'," remarked Kahnweiler; "that says everything." He was right, for David, the painter of "The Horatian Oath," was a revolutionary who metamorphosed into a neoclassical court artist to Napoleon. David's perfect execution expunged every trace of painterly luxuriance. But that disturbed the socialist Léger as little as did David's change of camp. All he was interested in was his great predecessor's ability to construct a painting. The admiration of the self-confessed proletarian artist for the extoller of the French Revolution and then of the tyrant who brought it to bay, indicates how little aesthetic issues have to do with philosophy or political stance.

**Fernand Léger**
Woman with Book, 1923
Oil on canvas, 116.2 x 81.5 cm
New York, The Museum of Modern Art, Nelson A. Rockefeller Bequest

## The Proletarian Olympus

The work of this great French artist leads, by many byways, far away from Cubism and very close to the concerns of the present day. During his time of service in the First World War, Léger felt a brotherly attachment towards the farmers, navvies, miners, and sailors in his unit, saying "their plain-spokenness and their argot were my language." But as an artist what intrigued him the most were the guns and equipment that the soldiers used. He saw clearly that in this merciless realm, human beings were degraded to a marginal role.

This changed fundamentally during the postwar years, as Léger began to project his "proletarian Olympus." The gods with whom he populated it were plain, even vulgar, earthbound, apparently insentient figures, which nevertheless possessed a strange greatness and dignity that were more than superficial. Humanity, the people in their simplest, typified form, were celebrated by a man who permitted himself no emotion, no attempt at psychological penetration. "Psychic expression was a too sentimental affair for me," Léger commented in a note of 1917. Yet it was precisely his waiver of the heroic pose and the superhuman factor that enabled him to create imagery of compelling force in which people and things are reduced to brief, lapidary signs.

The way in which Léger carried out this reduction and condensation was initially still influenced by his "Tubism." The human body continued to be treated as a machine, a configuration built of pipes and levers. In subsequent years, however, organic forms began to play an increasing role, particularly in his paintings of aver-

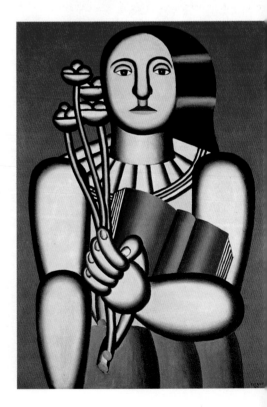

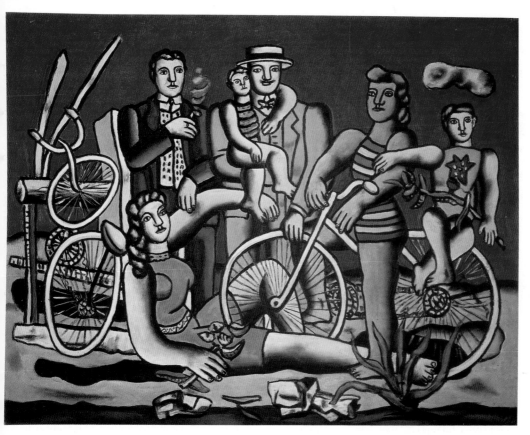

*"I worked for two years to make 'La Grande Parade'. I study everything ponderously. I work extremely slowly. I don't know how to improve. The more I examine myself, the more I see that I am a classical artist. I undertake lengthy preliminary work. First I make a number of drawings, then I make gouaches and finally I turn to the canvas, but when I start on it, I am 80% certain. I know where I'm going."*
FERNAND LÉGER

**Fernand Léger**
The Pause, on a Red Ground, 1949
Oil on canvas, 114 x 148 cm
Biot, Musée National Fernand
Léger

age people involved in leisure-time activities. Léger depicted them at the circus or on an excursion into the country, among flowers and trees and clouds like fluffs of cotton wool which were just as graphically simplified as the expressionless faces and chunky figures. The subdued lyricism of these scenes stands in contrast to the harsher mood of depictions from the realm of labor, showing farmers and workers and engineers to whom the machine is not alien but familiar. Solidarity among simple people, anticipating the brotherhood of man in a classless society, are the themes of this phase. Thanks precisely to their restraint and understatement, these paintings represent an epic eulogy to the advantages of a technological existence.

As this implies, Léger attempted to refute the supposed incompatibility of nature and machine. In still lifes of incomparable formal simplicity he juxtaposed flowers and bolts, clouds and cogwheels, dichotomous elements and symbols of one and the same world. Pop artists like Roy Lichtenstein learned much from these paintings. To Léger, to fall into cultural pessimism or protest against the status quo would have seemed an escape from reality.

Thus, without becoming unfaithful to himself, Léger developed from a Cubist into a realist. He also went through an abstract phase when he designed murals in collaboration with his friend, the architect Le Corbusier, and others. But for him abstract art had a serving function. It was "applied art", a means of deco-rating large surfaces, perfectly suited to interpreting and heightening architecture, what Léger himself termed "architectonic" art. Because of his great simplification of form and the brilliance of his color planes – the transparency of the flowing colors behind the contours was inspired by Broadway's neon signs – Léger was predestined to be a muralist. It is no accident that his influence on Mexican mural painters such as Diego

**Fernand Léger**
La Grande Parade, 1954
Oil on canvas, 299 x 400 cm
New York, Solomon R.
Guggenheim Museum

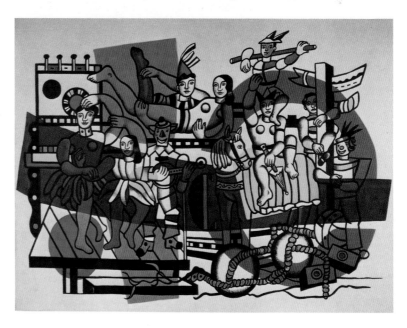

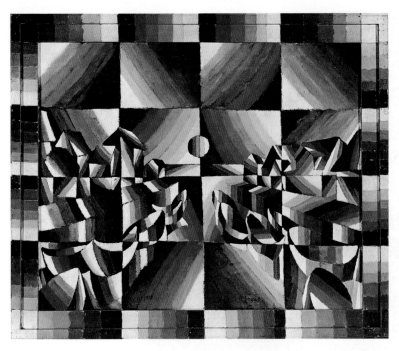

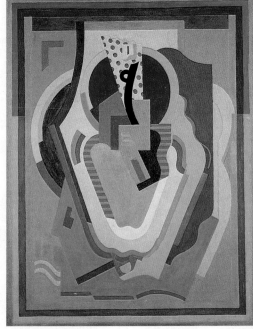

**Arthur Segal**
Harbor in the Sun, 1918
Oil on canvas, 91.5 x 109.5 cm
Zurich, Kunsthaus Zürich

**Albert Gleizes**
Composition
(Madonna and Child), 1930
Casein on canvas, 146.4 x 114.6 cm
Private collection

Rivera and José Clemente Orozco, as well as on Pop Art and poster design, was second to none. But Léger was too straightforward and honest not to realize that abstract art was beyond his scope.

However, he respected those who thought differently: "Only a few creative artists and knowledgeable connoisseurs can maintain the high level of this art," he said. "In this height also lies its danger. But make no mistake: This form of art arose from an inner necessity. It had to emerge, and it will endure."

## Reaction against Picasso and Braque

Like Léger, Robert Delaunay's painting led far from Analytic Cubism. An admirer of Kandinsky as representative of the "great abstract," Delaunay was the restless, rebellious spirit of Section d'Or, (golden mean), a group of Cubist heretics founded by Jacques Villon. Meeting on Place de l'Alma or in Villon's studio, the group discussed the golden mean and – based on Platonist ideas revived by Symbolism – ideal proportions of measure and number on which a "pure painting" could

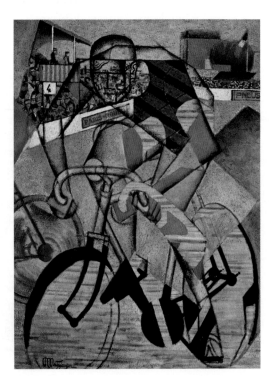

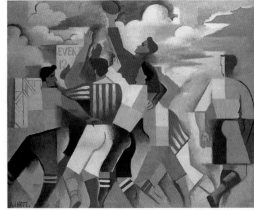

**Jean Metzinger**
At the Cycle Race Track, c. 1911/12
Oil and collage on canvas,
130.4 x 97.1 cm
Venice, Peggy Guggenheim
Collection

**André Lhote**
The Rugby Players, c. 1917
Oil on canvas, 148 x 179 cm
Private collection

be based. Above all, color again became a key issue. These concerns reflected a decided opposition to the primacy of form and abstention from color in the work of the Cubist grand masters Picasso and Braque. They did not attend the group's gatherings, but Gris did. He must have been interested in the formal considerations aired there with regard to new subject matter. The others present were mostly Cubists of the second

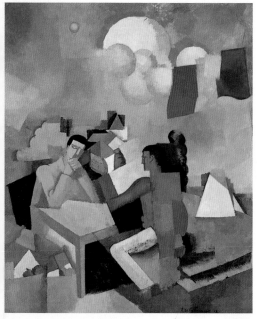

hour, who developed more or less personal versions of the style and above all popularized it. These included Jean Metzinger and his associate Albert Gleizes, a metaphysician who linked up with Symbolism and finally, like Delaunay, arrived at abstraction. Also active in the group were Gleizes's friend, Henri Victor Le Fauconnier, the estimable Polish artist Louis Marcoussis, and the intelligent André Lhote (ill. below and p. 78).

For other artists such as the great Dada chief Marcel Duchamp, Francis Picabia, František Kupka, and Léger, the Section d'Or was only a waystation. Also occasionally present was Marie Laurencin, the painter

of a sophisticated yet sensual, joyful Arcadia populated by charming girls, an Arcadia which entirely lacked the fateful shadows of Poussin's (ill. above). The sensitive Jacques Villon, actually Gaston Duchamp, a brother of Marcel Duchamp, adopted an axiom of Leonardo da Vinci's, according to which the imaginary lines that connect a subject with the artist's eye form a pyramid. This pyramid determined Villon's compositions, which were just as reserved and lyrical as the pastel, translucent bloom of his palette (p. 78).

Delaunay (pp. 80, 81) attacked the new aesthetic issues with much greater energy than Villon. He began by studying the structural laws of Gothic architecture,

as reflected in his paintings of Saint-Séverin, the church of Parisian professors and students. In 1909 Delaunay arrived at a theme that would concern him through long series of paintings: the Eiffel Tower. He discovered the hidden dynamism of this apparently so static structure. By means of shifting and overlapping vantage points, by disassembling and reassembling the bril-

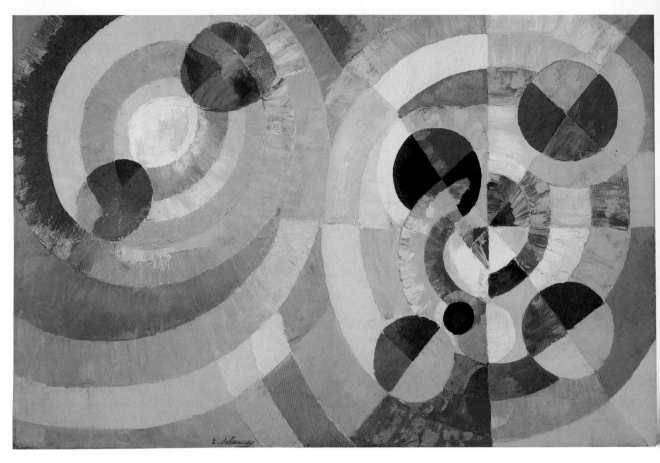

**Robert Delaunay**
Circular Forms, 1930
Oil on canvas, 128.9 x 194.9 cm
New York, Solomon R.
Guggenheim Museum

liantly engineered giant toy, Delaunay achieved a vital pictorial rhythm that wonderfully embodies the skyward thrust of this symbol of modern engineering. The dramatic effect is heightened by the simple geometry of the buildings staggered around the tower, and by the rounded cloud formations interpenetrating the iron web. With this series Delaunay vehemently broke out of the hermetically sealed still-life world

of Analytic Cubism, and brought color back into its own. It is as if he had grown tired of the philosophizing and visual riddles of the analysts and thrown himself head-first into the pulsating life of the big city.

### Hymn to the Sun

This is actually overstating the case, for Delaunay was actually a clear, exact thinker. His great achievement was to have discovered a way to compose a picture using color, a way diametrically opposed to formal analysis. Color became Delaunay's principal theme. He investigated its intrinsic laws, allowing him to engender rhythm and movement simply by juxtaposing complementary colors, red against green, blue against orange, yellow against violet. These colors then reproduced the effects of light on canvas. Delaunay was the first painter to play the color spectrum as if it were a musical scale. Though a practical application of Chevreul's speculative color theory and its doctrine of "simultaneous contrasts," Delaunay created painted poetry. Apollinaire suggested a name for it, "Orphism." Delaunay's palette reached a degree of luminosity unprecedented in art. Light, the rays of the sun, the disembodied glow of the colors of the rainbow, suffused Delaunay's entire œuvre. The world of the first technological revolution, with its towers, airplanes, and balloons, appeared there flooded with light and filled with hope for the future.

**Robert Delaunay**
The Windows, 1912
Oil on canvas, 92 x 86 cm
Chicago (IL), Morton G.
Neumann Collection

Delaunay's brilliant art found its loveliest and most delicate formulation in his *Window Paintings*. The compositions are determined by prismatic colors, luminous and transparent, rich in gradations and transitions. This abstract Cubism, as the artist himself termed it,

**Sonia Delaunay-Terk**
Electric Prisms, 1914
Oil on canvas, 250 x 250 cm
Paris, Musée National d'Art
Moderne, Centre Georges
Pompidou

**Robert Delaunay**
Eiffel Tower (The Red Tower), 1909
Oil on canvas, 133.7 x 90 cm
New York, Solomon R.
Guggenheim Museum

eventually led to complete abstraction. This point was reached with the *Formes circulaires*, the circular forms of the following two years. The circular or rotating movement of colors ultimately became Delaunay's sole theme. "As long as art does not detach itself from the object, it remains description," he wrote in an essay, "Concerning Light" (Über das Licht), published in 1913 in Herwarth Walden's *Der Sturm*. Delaunay drew his conclusions from this subjective insight. The liberation of color he achieved between 1910 and 1916 must have filled him with indescribable joy. The artist's triumphant happiness conveys itself to anyone who sees this imagery, pure and seemingly divested of all earthly ties.

Subsequently Delaunay returned to objective depiction. But in his late years, not without the influence of his wife, Sonia Terk (ill. above), geometry once again triumphed. The paintings became flatter, more ornamental, sometimes even slightly poster-like. The period in which Delaunay, according to an unpublished manuscript by Gleizes, played "with sun and moon like an amazed child," was over. The predominant shape was now the disk, as the fundamental model of the simultaneity of light and motion. The compositions were lent a dynamic character by means of dissolving the spectrum of the color wheel. "A painting formed according to the laws of this organization is a microcosm adapted to the rhythms of the macrocosm," Delaunay explained. The rays of his brilliant palette extended even to the neighboring countries, where they influenced, among many others, the artists of Der Blaue Reiter. Their effect has been felt down to the threshold of the present day, especially in the work of major American painters.

The range of Cubist influence, including that of its "Orphist" opposition, may be seen in the work of František Kupka (ill. below and p. 82), a native of Czechoslovakia. After beginning in a style allied with Art Nouveau and Symbolism, he too produced compositions of abstract color wheels, then later advanced to architectural structures of rectangular shapes arranged in a way that recalls musical fugues. For Kupka the work of art represented "an abstract reality," which "demands that it be formed of invented elements. Its concrete meaning derives from the combination of

*"Simultaneous contrast ensures the dynamism of colors and their construction in the painting; it is the most powerful means to express reality."* ROBERT DELAUNAY

**František Kupka**
Cathedral, 1913
Oil on canvas, 180 x 150 cm
Washington, Jan and Meda
Mladek Collection

morphological primal images and the architectonic conditions intrinsic to its own organism." Kupka went to France at an early date. Yet in Prague, too, a group of artists developed a relatively independent variant of Cubism, surely influenced by visits to Kahnweiler, Picasso, and Braque. Miroslav Lamac designated it "Cubo-Expressionism," and quite aptly so. For unlike classical Cubism of the French variety, Czech Cubism combines an expressive tendency with the crystalline forms which would come to represent its basis. This is particularly evident in the work of Otokar Kubin and Emil Filla, but also in that of the early, Futurist-influenced Antonín Procházka, and in that of Josef Čapek and his writer-brother Karel, who refused from the start to be pinned down to Braque's and Picasso's Cubism of the pioneer years. This led in 1912 to a break with Filla and his followers.

Francis Picabia, who would experiment in virtually the full gamut of avant-garde styles, was at the time producing ornamental abstractions in a subdued color range from which every memory of the things and experiences that had inspired them had been expunged. Picabia demanded "a painting based on pure imagina-

tion, which recreates the world of forms on its own strength." Marcel Duchamp, in contrast, depicted a *Melancholy Boy in a Train* (Venice, Peggy Guggenheim Foundation) and his renowned *Nude Descending a Staircase* (p. 129), later spoofed in America as an "explosion in a brickworks." These are dark, dreamlike images in which the movement of the young man being shaken by the vibration of the train and that of the woman walking down stairs are depicted in an eerie simultaneity of their separate consecutive phases. In terms of formal approach, these paintings of Duchamp's should be viewed in the context of Italian Futurism, as should, incidentally, Villon's *Marching Soldiers* (Paris, Musée National d'Art Moderne).

## More Ascetic than the Ascetics

Many artists of the twentieth century, obsessed with the idea of purity of means and truth of depiction, fought not only illusion in visual art but everything that smacked of sensuality, emotion, or individualism. They crusaded against these with all the zeal of Martin Luther against the Pope. Their goal was a supra-individual, absolute painting, which subjected all phenomena

*"The creative ability of an artist is manifested only if he succeeds in transforming natural phenomena into 'another reality'. This part of the creative process, can be considered an independent element, and if conscious and developed, it hints at the possibility of creating a painting. It can thus charm or move the onlooker without disturbing the organic color of natural phenomena."* FRANTIŠEK KUPKA

**František Kupka**
Amorpha – Fugue in Two Colors, 1912
Oil on canvas, 211 x 220 cm
Prague, Národni Galeri

**Le Corbusier**
Menace, 1938
Oil on canvas, 162 x 130 cm
Switzerland, private collection

**Amédée Ozenfant**
Accords, 1922
Oil on canvas, 130 x 97 cm
Honolulu, Honolulu Academy of
Arts, Gift of John Gregg Allerton

that rested on deceptive visual perception to a rigorous, rational order. This visual order, as Kupka already demanded, must realize itself independently of nature. Thus Cubism produced its fundamentalist reformers. These were Amédée Ozenfant (ill. above right) and Edouard Jeanneret, who, as an architect, became famous under the name Le Corbusier (ill. above left). The two joined battle against what they considered the "degeneration" of classical Cubism into the merely decorative.

Like all apostates Ozenfant and Jeanneret were even stricter than the church founders. From now on, they declared, verticals and horizontals were to be the sole bases of a pictorial geometry controlled by reason, precise, and capable of validation like a scientific experi-

ment. Their ideal was the perfection of the machine, an instrument of modern civilization produced and mastered by the human mind. Acceptable subjects were few – everyday mundane things rendered in straight-forward colors, to ensure that no sensuous charm, deco-rative fillip, or insinuating motif should detract from the mathematical harmony. The aim of this abstinence was a sort of normative visual poetics, its result an austere, didactic art out of a test-tube – "Purism" in painting. This was the name attached to the entire stream. Its cool harmonies – thanks not least to Le Corbusier – soon took effect in architecture, but its underlying ideas also remained vital in painting. In 1938 Ozenfant opened an art school in the United States which would prove extremely influential.

# Assault on Tradition
## The Brief but Violent Earthquake of Futurism

The intellectual roots of the "art of the future" con-ceived in Italy can be traced back to the European nationalism of the years prior to 1914, which inexorably led to the disaster of World War I.

The rigorous attitude of the Futurists, iconoclasts and image-makers in one, had its source in the feeling of being excluded from the European art discussion. Since the 18th century and Giovanni Battista Tiepolo, Italy had produced no artist of truly European rank. Its young intelligentsia, unable to explain the sudden decline of creative powers in a country that had led the

world for centuries, were enraged. From the art journals flourishing in neighboring nations and the Venice Biennale, established in 1895, they knew of the advances being made elsewhere. An urgent need to play a role, to regain international importance in art, heightened to fever pitch by chauvinism and a naively positivistic faith in progress, produced the brief but far-reaching blos-soming of Futurist art. "Italy has been the great market-place for old-junk dealers long enough," declared the author Filippo Tommaso Marinetti in his *Futurist Manifesto* of 1909, which was followed the next year by

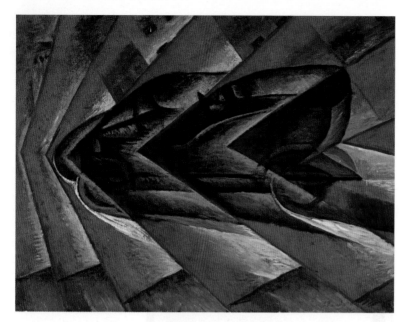

**Luigi Russolo**
Dynamism of a Car, 1912/13
Oil on canvas, 106 x 140 cm
Paris, Musée National d'Art
Moderne, Centre Georges
Pompidou

*"We declare that the world's magnif-
icence has been enriched by a new
beauty: the beauty of speed. A racing
car whose hood is adorned with
great pipes, like serpents of explosive
breath – a roaring car that seems to
ride on grapeshot is more beautiful
than the Victory of Samothrace.-
We stand on the last promontory of
the centuries!… Why should we
look back, when what we want is to
break down the mysterious doors of
the Impossible? Time and Space died
yesterday. We already live in the
absolute, because we have created
eternal, omnipresent speed."*
F. T. MARINETTI

**Gino Severini**
Dancer + Ocean =
Bouquet of Flowers, 1913
Oil and collage on canvas,
91 x 60 cm
New York, private collection

an artists' manifesto signed by Giacomo Balla, Umberto Boccioni, Carlo Carrà, Luigi Russolo (ill. above), and Gino Severini. An excerpt: "We want to liberate [Italy] from the countless museums that blanket it like countless churchyards."

The ground for the movement was prepared, in Italy as elsewhere, by literary men – Giovanni Papini, the author-artist Ardengo Soffici, and above all, Marinetti – as well as by committed journals such as *Leonardo* or *Voce*. It was through the latter that the Futurists became familiar with Cubism. Their uncompromising desire to give Italy a new cultural self-confidence made any means to this end seem justified. Long before Mussolini, the Futurists and those who paved the way for them sung the praises of imperialism, and extolled war as a sublime and purifying bath in bullets – "the sole hygiene for the world." Besides advocating war, they celebrated the cruelty and harshness of an unjust life, which was a battle in which the strong would prevail over the weak, and sought adventure for its own sake. Even art, stated the Futurists, could "only be violence, cruelty."

Naturally this led them to believe in intuition as the source of all art, a doctrine that, in Italy, went back to Benedetto Croce. The Futurists revelled in the heady feeling produced by the powers of technology, especially an intoxication with speed, which led to Marinetti's proverbial saying that a racing car was more beautiful than the Nike of Samothrace. Dynamism, motion, speed were the incantatory formulae of the Futurists, and not surprisingly, this very dynamism would lead with the velocity of a racing car to the fascism of the amateur race-driver Mussolini. Other traits the Futurists shared with the future *Duce* were the extravagance of their demands, and a propagandistic celebration of force that completely misjudged the actual power relationships of the day. Artistically the movement came to an end the moment it compromised itself by collaborating

with fascism. By that time its key surviving representatives, Severini and Carrà (Boccioni had died in 1916, after a war injury and a subsequent fall from a horse) had long turned to aims of an entirely different nature.

## Orgy of Destruction

Such considerations might well ruin one's pleasure in the pictures produced by this aggressive movement, which was unscrupled in both its methods and aims. Yet Futurism also engendered a number of major works which are capable of making one forget the well-nigh terrorist boasting of the manifestos. Then, too, things look different after the bitter experiences of a century than they did in 1909. This was the year of Marinetti's publication of the *Futurist Manifesto* in the then still progressive *Le Figaro* of Paris. In the name of the future, Marinetti advocated that libraries, museums, and universities, and by implication, the entire European tradition, be destroyed at the earliest possible date. The trauma of an undigested past, in this case the great Italian artistic tradition, lay heavy on the minds of its descendants and provoked a – fortunately only theoretical – orgy of destruction. Freed of the invisible chains in which their ancestors had fettered them, they strode optimistically into the future. Their intoxication was short-lived. Yet it remains an historical fact that while Futurism throve, Italy again became a serious partner in the European art discussion. In 1912, the Bernheim-Jeune gallery in Paris gave the Futurists not only an opportunity to show their work but a chance to describe

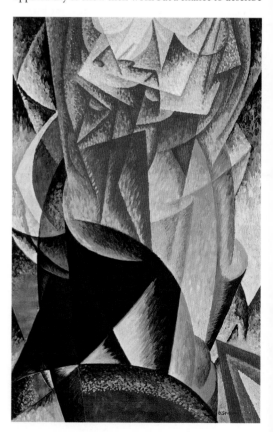

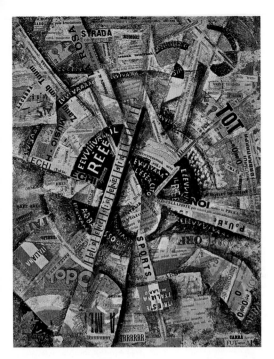

what distinguished their position from that of Cubism. Put briefly, this amounted to stasis (Cubism) versus dynamic movement (Futurism). As this exhibition travelled to London, Herwarth Walden organized, that same year, a Futurist retrospective in his Berlin gallery, Der Sturm.

Noise and confusion, provocation and excitement at all costs, were the characteristic traits of Futurist agitation. In the long run they began to grate so on the nerves of the sensitive Gino Severini, who was initially influenced by Seurat's Pointillism, that he repeatedly exhorted his comrades to please calm down. Their obtrusive vitalism was not only verbal but visual. Inspired by Analytic Cubism, the Futurists focussed on the simultaneity of various views of a motif, but instead of depicting it in a state of immobility they showed it in rotating, plunging, or thrusting motion. Motion itself, or rather, the various phases of its process, were to be immediately visualized in a painting or sculpture. This intention was achieved in its mildest form by Severini, a cultivated colorist who, even in his Futurist work, never entirely lost touch with Neo-Impressionism in his many paintings of balls and ballerinas. The dynamism of his very effective compositions is lyrically subdued, formally disciplined, and, to this extent, clearly influenced by the aesthetic of classical Cubism. No wonder that, in the 1912 show, it was Severini's work that most appealed to the French audience (p. 84 and ill. right).

### Dynamism and the Fourth Dimension

A more energetic embodiment of Futurist ideas was achieved by Umberto Boccioni. "I wish to paint the new, the fruit of our industrial age," he noted in his diary. Boccioni employed powerful, plastic forms that eventually led him to sculpture, and an expressive palette that far transcended Neo-Impressionism. He also developed what he termed a "dynamics of the human body," which however was impressively contained in controlled form. Cézanne and Cubism stood at the beginning of this style. States of excitement and emotional moods entered the picture in Boccioni's renderings of *The Street Revolts* (New York, The Museum of Modern Art) or *The Street Penetrates the Building* (p. 86 above). Here the forms grow transparent, interior and exterior interpenetrate, are depicted in simultaneous overlaps, as are the events taking place in the building and the street. The fourth dimension, time, enters the scene – or at least this was the artist's intention. The viewer was to be spirited "into the midst of the picture." A tumultuous unrest, the hectic nervousness of urban life, but also the intoxication of speed, become painterly events in Boccioni's work. And this even though the striving to depict motion – before the invention of "moving pictures" and long before kinetic art – was ultimately foiled by the immutable stasis of the painting surface.

Though Futurism was able to represent the course of a motion diagrammatically, in a way similar to multiple-

**Carlo Carrà**
Interventionist Demonstration
(Patriotic Celebration), 1914
Tempera and collage on cardboard,
38.5 x 30 cm
Milan, Mattioli Collection

**Gino Severini**
Portrait of Paul Fort, 1913/14
Collage on canvas, 81 x 65 cm
Paris, Musée National d'Art
Moderne, Centre Georges
Pompidou

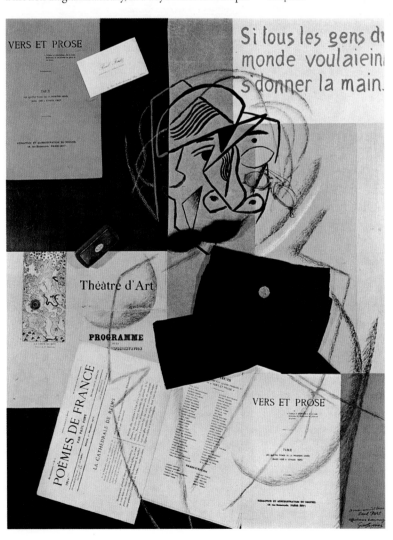

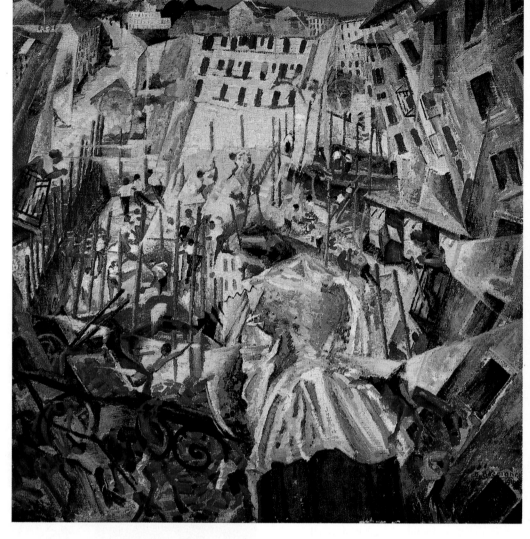

**Umberto Boccioni**
The Street Penetrates the Building, 1911
Oil on canvas, 100 x 106.5 cm
Hannover, Sprengel Museum
Hannover

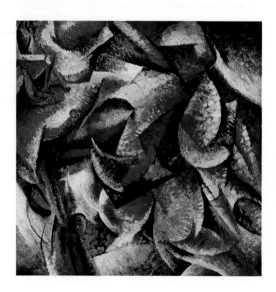

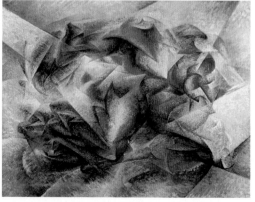

**Umberto Boccioni**
Dynamism of the Human Body, 1913
Oil on canvas, 100 x 100 cm
Milan, Civico Museo d'Arte Contemporanea

**Umberto Boccioni**
Dynamism of a Soccer Player, 1913
Oil on canvas, 193.2 x 201 cm
New York, The Museum of Modern Art, Sidney and Harriet Janis Collection

exposure photographs, the depiction motion itself escaped its means. Faithful depiction of motion had to wait for the film, which had been pointed the way by the instantaneous sequential photographs of Eadweard Muybridge and the "chronophotography" of Etienne-Jules Marey, also of key significance to the Futurists. To today's eyes a runner with ten legs or a horse with twenty might seem rather jejune, especially as the Futurists' express aim was to render reality more closely than their predecessors. But being surfeited with flickering electronic media imagery, we realize that such criteria are beside the point. What counts, apart from the continuing effects of Futurism's elan, is above all the degree of its aesthetic success.

Futurist work that still deserves undivided attention includes the relatively static and often almost entirely abstract paintings of the oldest protagonist of the movement, Giacomo Balla (ill. right and below); the *Dancers* by his pupil, Severini; and especially the energy-charged compositions of Boccioni with their dynamic distortions. Severini came, by way of a return to Cubism, to the neoclassical style so widespread in the 1920s and 1930s, before, in old age, he began to recapitulate Futurist motifs. Carlo Carrà authored a manifesto of *Total Painting*, a sort of multimedia art comprising colors, tones, noises, and odors. Yet basically he was a covert classicist, whose roots in Giotto and Paolo Uccello are evident in his superb metaphysical paintings.

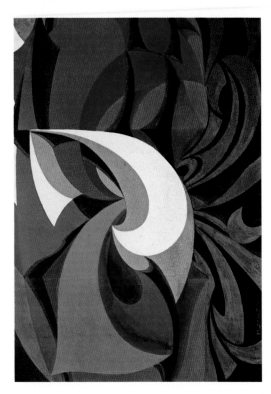

**Giacomo Balla**
Form Cries "Viva Italy", 1915
Oil on canvas, 134 x 188 cm
Rome, Balla Collection

*"Futurism, predestined force of progress and not of fashion, creates the style of flowing abstract forms that are synthetic and inspired by the dynamic forces of the universe."*
GIACOMO BALLA

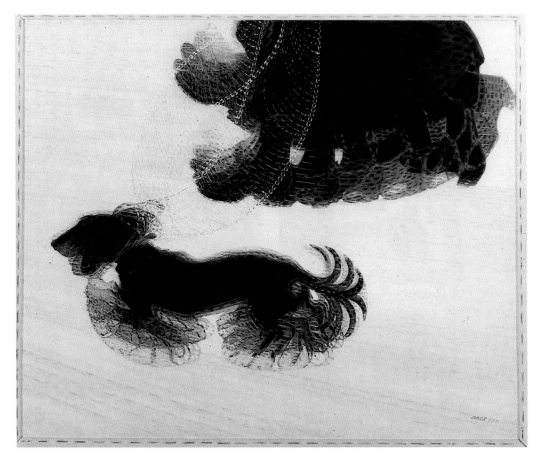

**Giacomo Balla**
Dynamism of a Dog on a Leash
(Leash in Motion), 1912
Oil on canvas, 90.8 x 110 cm
Buffalo (NY), Albright-Knox Art
Gallery, Bequest of A. Conger
Goodyear

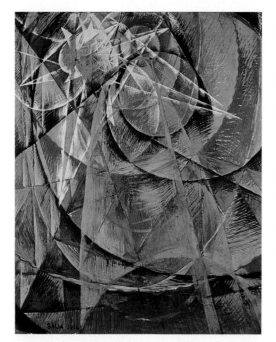

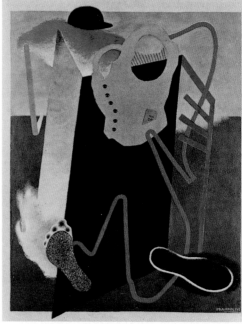

**Giacomo Balla**
Mercury Passing Before the
Sun, 1914
Oil on canvas, 120 x 100 cm
Milan, Mattioli Collection

**Enrico Prampolini**
The Mundane Robot, 1930
Oil and collage on wood,
10 x 80 cm
Rome, private collection

His friend, Giorgio De Chirico, though he was among the founding fathers of Futurism, likewise retained a stronger allegiance to *Pittura metafisica*. This phase brought forth his finest works, before he turned to a more realistic style shot through with occasional references to earlier approaches.

Total or multimedia art, simultaneity, dynamism, depiction of movement and speed, an interlocking of interior and exterior worlds, a painterly interpretation of feelings – these are the Futurist ideas which survived the movement itself, whose only direct follower of any significance was Enrico Prampolini, a skilled theater painter and later abstractionist (ill. above). These ideas lastingly inspired not only Italian art but spread throughout Europe and beyond. Far-reaching innovations and a number of good paintings were all that remained of the revolt of chauvinistic intellectuals, of which some later distanced themselves from the militancy of their early years. Everything else vanished, like ostensibly dynamic fascism and its ephemeral *aeropit-*

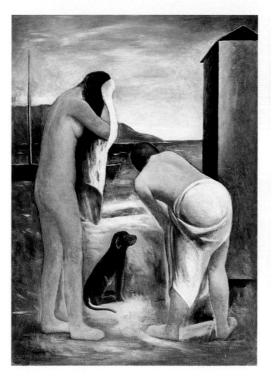

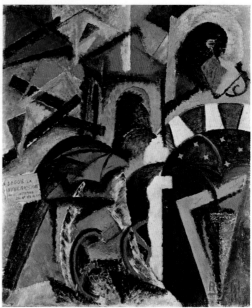

**Carlo Carrà**
Summer, 1930
Oil on canvas, 166 x 121.5 cm
Milan, Civico Museo d'Arte
Contemporanea

**Ottone Rosai**
Dissection of a Street, 1914
Oil and collage on canvas,
63 x 53 cm
Milan, Mattioli Collection

*tura*, or painting in an airplane, which today is little more than a curious footnote to art history.

"Standing on the top of the world, we once again fling our challenge to the stars," the Futurists declared in their manifesto. Their great exhibition of 1986 in Venice not only documented the vital force of the movement in every medium of art (painting, sculpture, poetry, music, theater, and dance), it also pointed out its intellectual and aesthetic wellsprings (for instance, in the Pointillism of Seurat) and its far-reaching consequences from Russian Cubo-Futurism to the Op Art and Kinetic Art of our own day.

The consequences, too, were multi-disciplinary. They related to music, in the form of *musique concrète*, to the theater, as well as to attempts to link art with technology and life with art. "Power to the artists!" demanded Marinetti in 1919, because they had the ability to "artistically suffuse life and make life itself into a work of art." The affinity with the later demands of a Lucio Fontana or a Joseph Beuys is obvious, as is the attempt to infuse visual art, especially sculpture, with energy and dynamism. As regards sculpture, the Futurists were the first artists ever to advance the notion that all materials were fundamentally of equal value. The inclusion of the factor of time in art likewise went back to Futurist conceptions. Kurt Schwitters's proliferating "MERZ" structure (p. 461) would have been as unthinkable without them as the dynamic sculptures of Norbert Kricke (p. 495) or the accumulations of the Nouveaux Réalistes.

# "Paris, You, My Second Vitebsk!"
## Marc Chagall and the Jewish Outsiders

One is the hero of sentimental artists' legends; the second is extremely popular; the third was unjustifiably almost entirely forgotten until a just few years ago. All three shared in common a Jewish background and an artistic home, Paris. They were an Italian and two Russians: Amedeo Modigliani, of Livorno; Marc Chagall, of Vitebsk, and Chaïm Soutine, of Smilovich, near Minsk. The three were linked with Cubism by the circumstance of sharing, with Léger, a dismal studio in the vicinity of the Paris stockyards in Vaugirard. Other links with Western European streams in art were more or less accidental, although it cannot be gainsaid that formal and technical skills acquired in Paris gave them the means to express their feelings, indeed to overcome the traditional Jewish ban on image-making. All three elude stylistic classification; each stands as an original figure alongside the mainstream of developments. For all three men, as Chagall said, art was foremost a state of mind, and only secondarily a problem of form. What the very different pictures of these three Jewish artists share in common is an overabundance of emotion, which in Modigliani and Chagall is accompanied by a lyrical charm that is hard to resist.

Modigliani, son of an upper-middle class family, kept alive the Tuscan tradition of *disegno*, masterful drawing, which Vasari described as the "active creative principle in the visual arts." (ill. right and p. 90). Like the Picasso of the pre-Cubist Blue and Rose periods, Modigliani was fascinated by Lautrec's arabesques, traces of which are found in his early work. The great Romanian sculptor Constantin Brancusi encouraged him to create idol-like, elongated figures. Modigliani was also influenced by the expressive force of Black African sculpture, and ultimately he submitted himself to the gentle yoke of Cézanne's formally concentrated figurative painting. Cézanne's color also gave him pointers. Modigliani's art was rooted in a brotherly love for social outcasts and outsiders, one of whom he felt himself to be. The eccentric friends with whom he debated and drank, his girlfriends, poor, half-starved children of

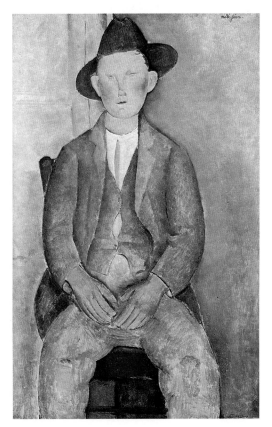

*"By the way, I try to formulate with the greatest clarity the truth about art and life, in the way that I experienced it occasionally through the beauties of Rome and since I saw the inner connection, I will try to reveal it…"* AMEDEO MODIGLIANI

**Amedeo Modigliani**
The Peasant Boy, c. 1918
Oil on canvas, 100 x 65 cm
London, Tate Gallery

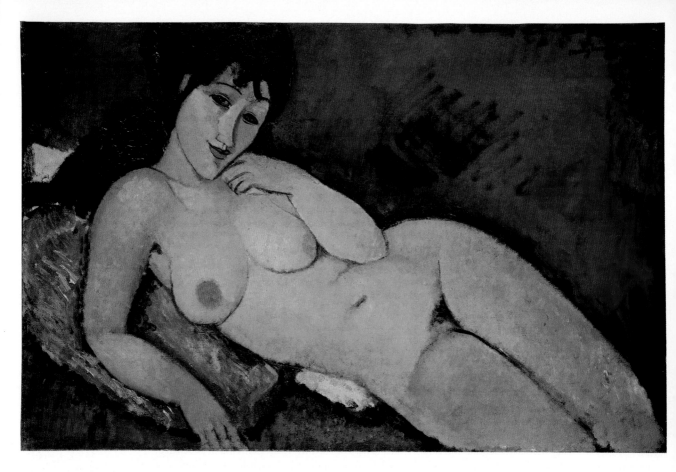

**Amedeo Modigliani**
Nude on a Blue Cushion, 1917
Oil on canvas, 65.5 x 100.9 cm
Washington, National Gallery
of Art

**Amedeo Modigliani**
The Bride and Groom, c. 1915/16
Oil on canvas, 55.2 x 46.4 cm
New York, The Museum of
Modern Art

*Page 91 below:*
**Marc Chagall**
The Cattle Dealer, 1912
Oil on canvas, 97 x 200.5 cm
Basel, Öffentliche Kunstsamm-
lung Basel, Kunstmuseum

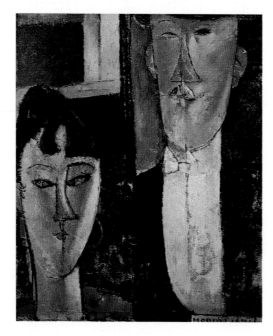

the Montmartre and later Montparnasse milieu, were
Modigliani's models. He depicted them with the clair-
voyant vision of the drinker and drug-taker, one of the
last Bohemians of the century – a tall, handsome man to
whom women were magnetically attracted, but also a
sick and wasted man, unable to manage the money his
family sent him.

Modigliani was a latter-day Mannerist, the painter
of overelongated, willfully distorted figures with long
necks and close-set, introspective, sometimes empty
eyes in masklike faces. The charm of his art lies less in its
palette than in its drawing. Modigliani's line has a lyrical
beauty that occasionally verges on the overelegant. In
what one commentator calls his "human still lifes" the
finest tradition of Sienese-Florentine art survives, some-
thing of the melancholy grace of Sandro Botticelli,
heightened by a touch of Matisse.

A far cry from the aura of lasciviousness that sur-
rounds Modigliani's nudes is the art of Marc Chagall.
The shy, stuttering son of a Russian clerk from Vitebsk,
in 1910 he came to the bustling avant-garde center of
Paris, his head full of colorful dreams and tales from the
village and ghetto. Chagall's art drew sustenance from
this humble world, where his memories and desires
were at home, continually returning to the great events
of little lives: birth, love, marriage, death. The highest
praise Chagall could think of affording Paris was to
exclaim, "There it is! Paris, you, my second Vitebsk!"

Apart from his meeting with the famous theater designer Léon Bakst, Russian schools had little to offer Chagall. Like many Western prophets of a new art, he was refused entry to the state art school. Yet in Paris he found immense inspiration. Chagall made friends with the author of "simultaneous poetry," Blaise Cendrars, with Max Jacob and Apollinaire. He became acquainted with Modigliani and above all with Delaunay, whose brilliant Orphism confirmed his own, folkloristic, colorful approach. Chagall delved into the aesthetic issues of Cubism, which helped give his painting a solid structural framework. But despite the abundance of impulses from outside, Chagall remained true to his own origins, which were rooted in the Chassidic love of storytelling, in Jewish pantheism with its faith in the indissoluble link between God and men, which makes believers capable of working miracles.

Chagall's paintings accordingly evoke a world full of miracles that happen every day – in lovers' bedrooms, at the inn, on the streets of Vitebsk, even under the Eiffel Tower. Even though he adopted a Cubistically austere style and employed simultaneous effects, he basically remained a Russian-Jewish storyteller. Yet Chagall cannot be called a narrative artist, at least during his best years, for he had the ability to transmute his fantastic tales directly into pure painting. This is why the Surrealists revered him as a predecessor, the artist who introduced the metaphor into modern painting, as André Breton said. The austere still-life subjects of the Cubists, their tables, glasses, bowls, and guitars, held little interest for Chagall.

Even his famous Cubist composition *The Drinking Soldier* (ill. right) tells a story. The soldier is so tipsy that he feels his cap is flying off his head, as he sees a vision of a couple dancing on the table in front of him. This is

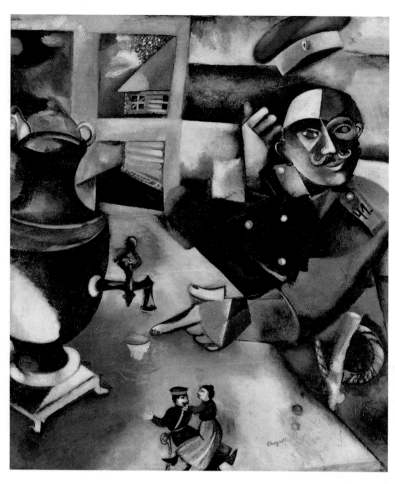

**Marc Chagall**
The Drinking Soldier, 1911/12
Oil on canvas, 109 x 94.5 cm
New York, The Solomon
R. Guggenheim Museum

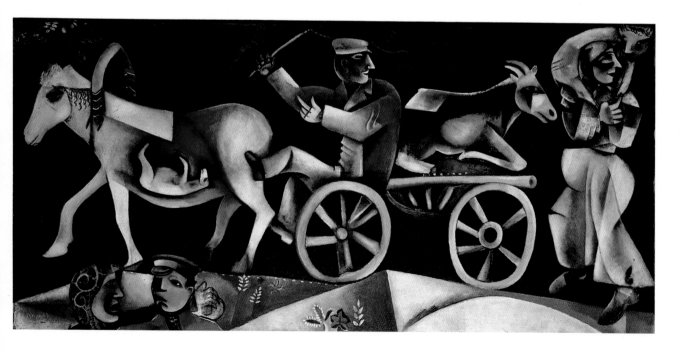

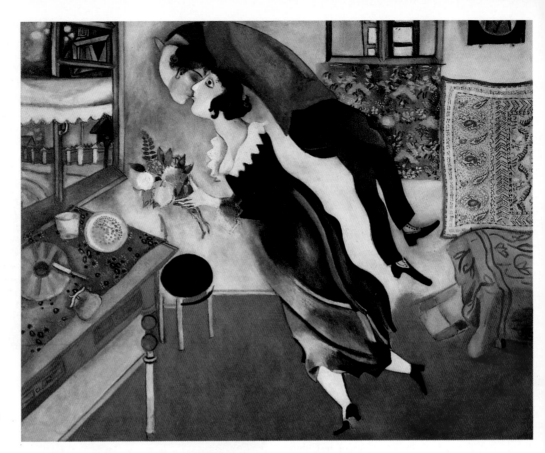

**Marc Chagall**
The Birthday, 1915
Oil on cardboard, 80.6 x 99.7 cm
New York, The Museum of
Modern Art

*"We all know that a good person
can be a bad artist. But no one will
ever be a genuine artist unless he is a
great human being and thus also a
good one."* MARC CHAGALL

Chagall himself and a Russian girl – an image of remembrance. Chagall made the mundane appear "miraculous". That was the aim of his estranging effects, which include physical manifestations of sheer joy. An example is the picture in which he and his fiancée and later wife, Bella, float blissfully through the air; another is the wellwisher at *The Birthday* (ill. above), who is filled with such joy that he leaves the floor, his back to his girl, his head bent backwards at an angle only love could permit, offering a kiss. Then there is the *Violinist*, hovering over the rooftops of Vitebsk as he plays, in the background a haloed figure passing across the sky, watched by a man with three heads in the foreground – a saint's legend in modern embodiment. Finally, there is the face of Chagall's *Rabbi*, enigmatic and inscrutable, broodingly spiritual, marked by the millennia-old torments of his people and its divine revelations.

Chagall's painting and his very painterly graphic, illustrations to Gogol, Lafontaine, and the Bible, transgress the borderline of the visible and tangible realm. To that extent his art is surreal, as few similarities it otherwise bears to the intellectual, consciously shocking juxtapositions of Surrealism proper. Color is used symbolically, especially the all-pervading, mystical violet, but also Chagall's luminous red, shimmering green, cerulean blue, or blue-green oxide. This exciting color range intrigued the Expressionists, who, like the Surrealists, and to a lesser degree the Cubists, considered Chagall their brother in spirit.

In 1914 his paintings were shown at Walden's Sturm gallery in Berlin, and had a resounding success. The poet Ludwig Rubiner even went so far as to tell the artist, "Your paintings have initiated Expressionism. They draw high prices. But don't expect to receive the money Walden owes you. He is not going to pay you a thing, because he maintains that fame should be enough for you."

### "I Am Certain that Rembrandt Loves Me"

Evidently Chagall did not bother much about the commercial side of art. "I am certain that Rembrandt loves me," he wrote in his autobiography. Chagall admired Cézanne almost as much as the great Netherlandish artist. His involvement with Cézanne helped him develop a formal framework to contain his apparently freely and spontaneously composed imagery, a rational check on the irrational tendency of Chagall's visions.

He was an extremely prolific painter, and constantly recapitulated certain themes around which his thinking and feeling revolved. Rarely did anything new or unprecedented enter this circumscribed world. In the 1930s and 1940s, horrified by the fate of the Jews under Nazi terror, Chagall's form and color grew agitated and wild, and he depicted a number of crucifixions. The *White Crucifixion*, done in 1938, evoked evils perpetrated and anticipated those to come. It is a key image of the epoch.

**Marc Chagall**
The Violinist, 1911–1914
Oil on canvas, 94.5 x 69.5 cm
Düsseldorf, Kunstsammlung
Nordrhein-Westfalen

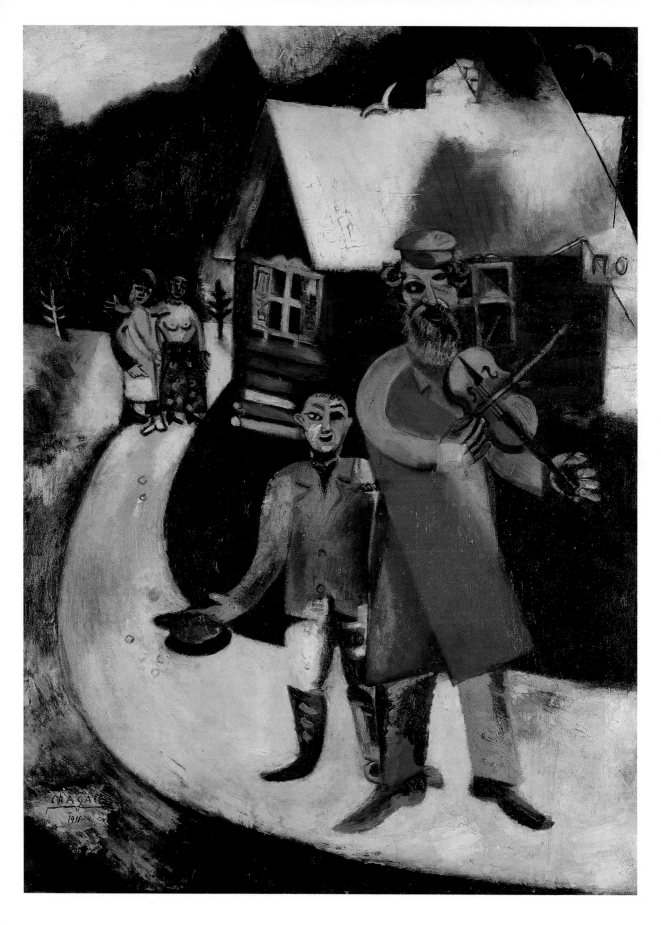

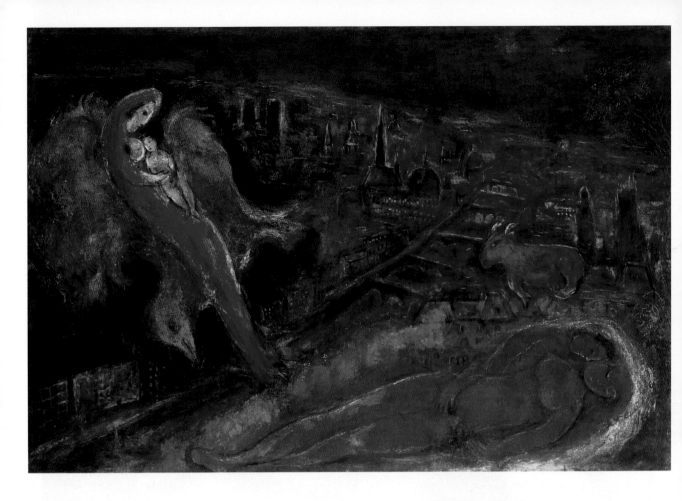

**Marc Chagall**
The Seine Bridges, 1954
Oil on canvas, 115.5 x 163.5 cm
Hamburg, Hamburger Kunsthalle

The death of Chagall's first wife, Bella, in 1944, triggered a series of paintings charged with memories of the past. Previously, in the 1930s, the artist had discovered the beauty of flowers in southern France. Not all of the resulting paintings were of equal quality. Especially in his late years, Chagall was not always able to avoid the pitfalls of sentimentality, the anecdotal, and the all-too ingratiating.

### Apocalyptic Landscape

The art of Chaïm Soutine (p. 95), still not accorded the respect it deserves, is darker and more ambiguous than Chagall's. One of many children born into a tailor's family in a hamlet near Minsk, Soutine basically remained a homeless wanderer throughout his life. The wild fire that suffused the shy, hypercritical painter broke out in a series of apocalyptic landscapes blazing with Expressionist-Fauvist color, in depictions of slaughtered oxen, in portraits and paintings of choirboys transfused with melancholy and forlornness, but also sometimes partaking of sly humor. Soutine's art is nourished by the heavy, glowing sumptuousness of the paint, which he applied to the canvas spontaneously, almost without preliminary drawing, sometimes directly from the tube. Werner Haftmann has pointed to Soutine's

**Moïse Kisling**
Kiki of the Montparnasse, with
Red Sweater and Blue Scarf, 1925
Oil on canvas, 92 x 65 cm
Geneva, Musée du Petit Palais

**Jules Pascin**
Reclining Female Nude, 1925
Oil on cardboard, mounted on
wood, 73.4 x 60.3 cm
Private collection

**Chaïm Soutine**
Page Boy, 1925
Oil on canvas, 98 x 80 cm
Paris, Musée National d'Art
Moderne, Centre Georges
Pompidou

**Chaïm Soutine**
Carcass of Beef, c. 1925
Oil on canvas, 140.3 x 107.6 cm
Buffalo (NY), Albright-Knox Art
Gallery

affinities with the visionary aspect of German Expressionism. But even more relevant is his position between two artists separated by decades in time: van Gogh, and the great American from Holland, Willem De Kooning.

The high-strung erotic art of Jules Pascin, born in Bulgaria to a Spanish-Jewish father and an Italian mother, also belongs in this context (ill. above). His sexual themes and celebration of *la dolce vita* were only the other side of a deeply depressive character. Pascin's mental torment came to a head when he realized that he had sacrificed his eminent gifts as a draftsman to the demands of fashionable society. Seeing no way out, Pascin hanged himself in his studio on the eve of a vernissage.

With these artists, among whom must be counted the realistic Polish painter Moïse Kisling (p. 94), began the Jewish contribution to figurative painting in the 20th century. Paris brought to light the imagery slumbering in the depths of a people whose religion precluded the making of images. Modern Israel, though eager to close the gap, for a long period had little to set beside the early contribution of the Jewish members of the Ecole de Paris and that of two major American artists of Eastern Jewish origin, Mark Rothko and Barnett Newman. However, as developments in recent decades indicate – from the influential work of the former Klee student Ardon to Yaacov Agam, Kadishman, and younger artists such as Rafi Kaiser, Zvi Goldstein, Serge Spitzer, et al. – a great deal has changed since then.

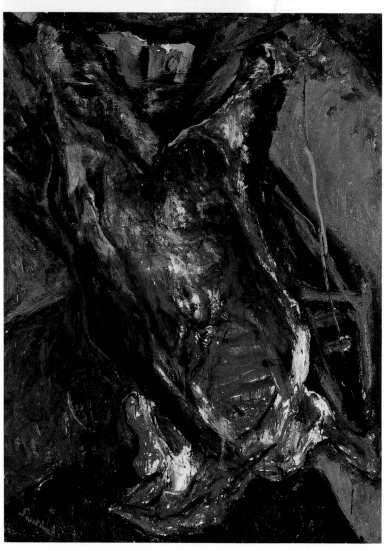

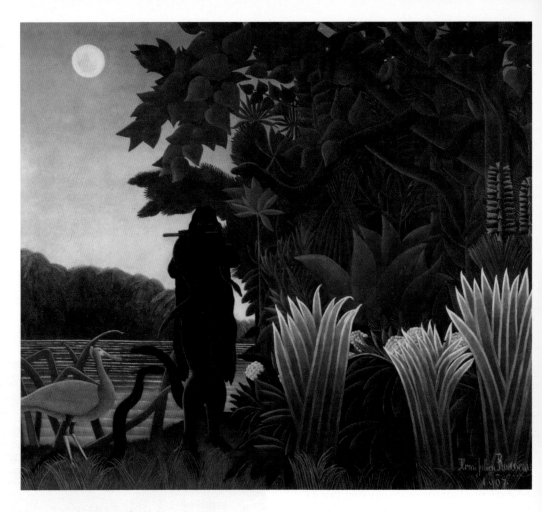

**Henri Rousseau**
The Snake Charmer, 1907
Oil on canvas, 169 x 189.5 cm
Paris, Musée d'Orsay

## Dreams of Compelling Magic
### Henri Rousseau, his Contemporaries and Followers

*"I don't know whether you feel the way I do, but when I am in these hothouses and see the strange plants from exotic lands it seems to me that I am entering a dream. I feel like a quite different person."*
HENRI ROUSSEAU

When eager amateurs open a paintbox, every day becomes a Sunday. And what charms us about the works of these Sunday, weekend, or naive artists is the carefree, holiday mood they lend to reality. "For your true, dyed-in-the-wool Sunday painter, art is not a heartfelt concern, it is heartily indifferent to him," as someone aptly said. Naive artists have saved for our problem-laden era something of the innocence of the anonymous folk art which was submerged by the great European styles in fine art. The fact that such outsiders have even been noticed at all is a consequence of that search for a lost innocence that began with the discovery, in the early years of the century, of the supposedly primitive art of exotic peoples and distant times. It was so much public interest as that of intellectuals and artists that brought to light the imaginative masterpieces of unassuming amateurs.

This first happened, like so many other firsts of the period, in Paris. There resided a man by the name of Henri-Julien-Félix Rousseau, an employee of the *Douane*, or municipal customs bureau, whose life,

despite the many legends that have grown up around it, lies largely in obscurity. He stood at the inception of the history of what Kandinsky termed the "great reality", as whose representative in an era growing increasingly unreal Kandinsky described Rousseau. But he was also a dominating figure whose art remains unsurpassed in its poetic abundance and visionary force.

Rousseau's personality combined naivety with great intelligence; his simplicity was that of a prophet of the people, a seer. The exotic atmosphere of his tropical forests was once thought to reflect memories of a trip to Mexico, though this is now disputed. More probably, Rousseau's vegetation originated from the exhaustive studies he made in the Jardin des Plantes. A police report alludes to sinister affairs, and due to actively abetting fraud on the part of a bank official, Rousseau narrowly missed actually being sent to an exotic land: Cayenne and its penal colony. We know that he gave lessons in recitation and the violin, in order to keep his head above water after an early retirement. Also on record is the legendary banquet which Picasso gave

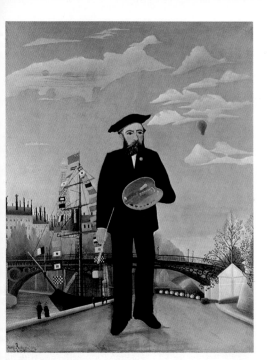

"You and I [to Picasso] are the greatest painters of our times, you in the Egyptian style, I in the modern."
HENRI ROUSSEAU

scenery is spirited into a timeless intermediate realm, where dream and reality merge indistinguishably. This is a picture by the eccentric Douanier Rousseau, called *The Snake Charmer*, an incunablum of pure realism (p. 96). The late jungle paintings, visions of compelling magic, are the major works of Rousseau, some of them, incidentally, executed with amazing sophistication. Yet his less fantastic motifs, mundane suburban landscapes and figure groups, are reduced in the same way to essentials, concentrated into monumental emblems. The process lends the group pictures, stiffly posed like family photos in an album, a timeless aspect, such that the humor of the awkward rendering flips over into sublime dignity. Rousseau's works are archetypes, images from the source of all imagery. An incredible instinct for the expressive power of color, for the arrangement of planes in space, and for formal structure, lends them their outstanding quality. Hermann Broch once justifiably spoke of Rousseau's "mythical naiveness."

Another extraordinary talent, more obsessive than naive, was Séraphine Louis. She was Wilhelm Uhde's cleaning lady, and he discovered her talent more by chance. A rare case among amateur artists, Séraphine showed little concern with the outside world, painting only her visions – phantasmagorical shrubbery, foliage, flowers and fruit, partaking of both heaven and hell, with angels' and devils' eyes meeting our gaze. Beset by voices and ghosts, Séraphine escaped the coils of evil lusts in painting and prayer. Her works are the traumatic

**Henri Rousseau**
Myself, Portrait-Landscape, 1890
Oil on canvas, 143 x 110 cm
Prague, Národni Galeri

in honor of the *Douanier* at the Bateau-Lavoir. Rousseau took the occasion to insure his host that both were great painters, he, Rousseau, in the modern style, and Picasso in the Egyptian style. According to a report by Gertrude Stein, who was present with her entourage, as were Max Jacob, Apollinaire, André Salmon, Marie Laurencin, and others, the gratified Rousseau slept through most of the boisterous party.

This odd fellow was revered almost as a household saint by the artists and writers of Bohemian Montmartre as the great primitive of a late era, despite the fact that his pronouncements often made them laugh. Apollinaire inscribed a farewell poem on his gravestone with an engraving tool, and Constantin Brancusi and the painter de Zarate later deepened the lines and made them weatherproof. It was a well-earned honor for Rousseau, who lived his entire life in poverty and whose paintings, hardly had he passed away, began to fetch astronomical prices. He far surpassed every *peintre naïf* who went before him, nor has any matched him since. Except for his artist-friends, who recognized him as one of their own, Rousseau's rank was initially appreciated only by Wilhelm von Uhde. It was the German collector and tireless discoverer and his 1928 exhibition of Rousseau, André Bauchant, Camille Bombois, Séraphine (Louis), and Louis Vivin finally sparked public interest in naive art.

Strolling through the Impressionist collections in the Musée d'Orsay in Paris, one may suddenly stop short, transfixed by eyes as if from a dream, gleaming among tropical vegetation. Snakes coil in the trees, on the lakeshore, around the shoulders of a dark-skinned woman. The forms of everything are very precisely rendered, yet still unreal, surreal, fixed like symbols. The

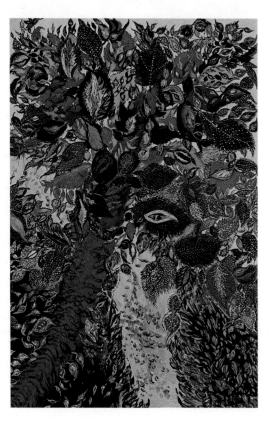

**Séraphine**
Paradise Tree, c. 1929
Oil on canvas, 195 x 129 cm
Paris, Musée National d'Art
Moderne, Centre Georges
Pompidou

visions of a woman who suppressed carnal desires and devoted her life to the Virgin Mary (p. 97).

The other painter to whom Uhde drew the attention of Paris and the world was less complex and more down to earth. André Bauchant (ill. below left) depicted Greek landscapes and allegories, in which "the village postman cheerfully marches alongside Vercingetorix." Camille Bombois brushed flat planes and brilliant colors next to one another on canvas with the hard grip of a veteran wrestler (ill. right). Louis Vivin, conscientious as a diligent boy, painted his churches stone by stone, and if the result did not look natural enough, he added a little more plaster to the paint (p. 99 below).

The five Parisian artists have since been joined by a great company, in France as elsewhere. To list only three of the more serious European *naïfs*: first, Adalbert Trillhaase, a depictor of scurrilously demonic, fanatically pious hunting scenes and Bible stories. Second, a respectable Dutch hotel owner, horse breeder, and rider called Jan van Weert, who started painting when he was seventy because the pictures he had bought had gotten lost and the walls looked so bare. His specialty was Dutch mail coaches in landscapes of the changing seasons. Third, there was Stepan Generalíc, whose military subjects soon, unfortunately, became all-too routine. These three were accompanied by scores of others, known and unknown, not to mention the increasing numbers of *faux naïfs* that came in their wake. Active on the other side of the Atlantic were a

**Camille Bombois**
The Athlete at the Fair, 1930
Oil on canvas, 89 x 130 cm
Paris, Musée National d'Art
Moderne, Centre Georges
Pompidou

**André Bauchant**
The Gardener, 1922
Oil on wood, 94 x 61 cm
Zurich, private collection

**Grandma Moses**
The Dead Tree, 1948
Oil on canvas, 40.6 x 50.8 cm
Paris, Musée National d'Art
Moderne, Centre Georges
Pompidou

number of American folk artists, whose tradition began in the 19th century with the sign-painter and itinerant preacher Edward Hicks. Morris Hirshfield, who was born in Poland, had a careful technique and his paintings – particularly of female nudes – were rich in ornament. This is apparent, for example in *Girl in the Mirror* (p. 99 above). Grandma Moses, an original who lived to be 100, was for the time being the last famous link in the chain (ill. above). Like van Weert, the rugged farmer's wife was over seventy when she first picked up a brush, to depict memories from which ugliness and evils may be expunged, but which celebrate the glories of the simple life with great humility and peace of mind.

## A Painter of Montmartre

Some of the same qualities are found in the best paintings of a resident of Montmartre, Maurice Utrillo. He stands at the borderline that separates the "naive" from the "professional" artist. Ultimately he was something of both. Maurice was a shy, weak, and above all neglected boy, to whom his love-hungry mother was not always able to devote enough time. A feeling of being abandoned, shut off from the world, augmented his hereditary propensity. Maurice drank and painted. He became the portraitist of Montmartre (ill. below). In keeping with his background he began with Impressionism, under the tutelage of his mother, whom Degas had taught to paint. But Utrillo had a heavy hand. His division of colors was not methodical, and his art, at least in the early years, lacked all perfectionistic fluency. Artistic problems did not interest him much anyway. Utrillo simply wished to realistically paint the environs in which he lived, not to create art. Impressionism struck him as the best way of approaching reality – apart from the fact that he knew no other. But reality includes the feelings and moods of the person who perceives it. Utrillo projected such sensations into his pictures. This is the source of their melancholy, occasionally somewhat sentimental poetry, and of the mellowness of their color, especially in the "white period" with its subtle gradations between white and grey. "White and silence are what one must paint," Utrillo told Florent Fels, "the color of the barracks, the hospitals, the prisons. My life has run its course in these houses of the lost, in the midst of the white of misery…. It is not jolly being a cursed painter [*un peintre maudit*]."

**Morris Hirshfield**
Girl in the Mirror, 1940
Oil on canvas, 101.9 x 56.5 cm
New York, The Museum of Modern Art

*"Montmartre, with your small town corners and your alleys of the Bohème – how may stories could b written about this quarter… I will always feel well when I am close to you, when I sit my my room and paint a picture with whitewashed houses."* MAURICE UTRILLO

**Louis Vivin**
The Cathedral of Reims, 1923
Oil on canvas, 65 x 50 cm
Paris, Musée National d'Art Moderne, Centre Georges Pompidou

**Maurice Utrillo**
The Church Saint-Séverin in Paris, c. 1913
Oil on canvas, 73 x 54 cm
Washington, National Gallery of Art, Chester Dale Collection

# The End of Illusion

## Painting as an Inner Necessity
### The Blauer Reiter, Kandinsky, and the Spiritual in Art

The most radical revolution in painting since the Renaissance was set underway not by a fiery young rebel but by a distinguished middle-aged man, who at thirty would have become professor of national economics at Dorpat University had he not decided for a career in art instead. His name was Wassily Kandinsky, born in 1866 in Moscow, died in 1944 in Neuilly-sur-Seine. Though his intellectual and artistic life came to fulfillment in Western Europe, a very Russian yearning for the "great mother," Moscow, and the golden glow of her domes never left him. It is idle to debate the question whether or not Kandinsky was the inventor of the abstract painting which dominated the art scene for a full fifty years of the century. Other artists could justifiably claim priority: Kupka, the Lithuanian painter Mikolajus K. Čiurlionis, Adolf Hoelzel of Germany, the American Arthur Dove (ill. below), Katharina Schäffner of Prague, not to mention the Art Nouveau practitioners Henry van de Velde, Hermann Obrist, or August Endell. Surely the earliest theoretical and practical approaches to abstraction can be found in the streams represented by the above names, if we disregard even earlier but ephemeral examples that lead from Leonardo da Vinci and the perspective manuals of the 16th century down to Lawrence Sterne's *Tristram Shandy* illustrations,

Victor Hugo's gouaches, and certain Italian examples in the 19th century.

Čiurlionis, who began as a musical prodigy, was primarily a Symbolist painter of dreamlike fantastic landscapes, but he also translated symphonic sounds and structures into "abstract" paintings (ill. right). The first picture of this type emerged in 1905. Hoelzel transformed landscapes and figures into free, rhythmic ornaments, while Schäffner expressed moods and passions through lines alone. Kupka, who came out of Symbolism, painted his first abstract picture, based on Art Nouveau ornamentation, in 1910/11, certainly without knowing of Kandinsky's concurrent experiments. Yet none of the attempts named really went beyond the experimental stage, transcended the merely ornamental, or, most importantly, had a logical theory behind them. This ultimately holds for Hoelzel as well, who, with Kupka, was among the most significant of the forerunners of abstraction. His work was a prelude to the transition, which remarkably began at a number of different places almost simultaneously, without the painters' initially being aware of each other's development – with Delaunay and Kupka in Paris, with Kandinsky in Munich, and with Mikhail Larionov in Moscow.

The time was ripe for an art of signs and symbols in a world that was growing more complex seemingly by the day. Any attempt to cope with or explain this complexity had to fall back on formulae. In this regard, the

**Mikolajus Konstantinas Čiurlionis**
Star Sonata. Allegro, 1908
Tempera on cardboard,
72.2 x 61.4 cm
Kaunas, Museum Čiurlionis

**Arthur Dove**
Holbrook Bridge, Northwest, 1938
Oil on canvas, 63.5 x 89 cm
New York, Roy R. Neuberger Collection

*Page 100:*
**Wassily Kandinsky**
Two Ovals
(Composition No. 218), 1919
Oil on canvas, 107 x 89.5 cm
St. Petersburg, Russian State Museum

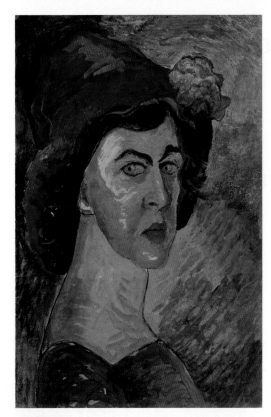

**Marianne von Verefkin**
Self-Portrait I, c. 1908–1910
Tempera on paper, 51 x 34 cm
Munich, Städtische Galerie im
Lenbachhaus

**Wassily Kandinsky**
Murnau – View with Railway and
Castle, 1909
Oil on cardboard, 36 x 49 cm
Munich, Städtische Galerie im
Lenbachhaus, Gabriele Münter
Foundation

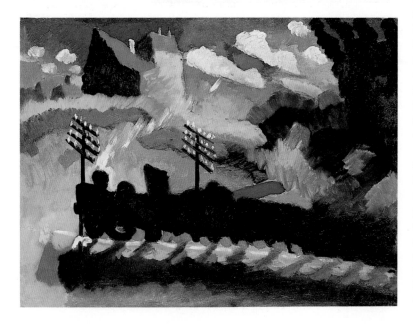

artists' experiments paralled developments in other
fields, particularly science and technology. These
included, on the one hand, color theory, emerging in
the wake of Newton, Euler, Huyghen, and the early
"color piano" of Castel; light theory, cosmology,
morphology, and quantum mechanics. On the other,
there was the development of photography and meth-
ods of reproduction, continuations of the Romantic
artists' investigations into correspondences between

painting and music, color and sound. Psychology and
psychonanalysis had more importance for Surrealism,
which was emerging almost concurrently with abstrac-
tion.

It was Kandinsky's historical achievement to have
recognized these interrelationships both as an artist and
as a theoretician, and to have been the first to methodi-
cally investigate them. The Russian was the undisputed
leader of the group of Munich artists who called them-
selves "Der Blaue Reiter," (Blue Rider), not Franz Marc,
the now-popular painter of creaturely fates, not the
radiant boy August Macke, and certainly not Klee, who
was still at the beginning of his development. With the
Blauer Reiter, German Expressionism entered its
second, as it were aristocratic, phase. This loose union of
very different temperaments and diverse personalities
was not concerned, as the Brücke artists of Dresden ini-
tially were, with improving the world and reforming
society. Their aim, as announced in the title of the essay
Kandinsky wrote in 1910 and published in 1912, was
*On the Spiritual in Art* (Über das Geistige in der Kunst).
As Franz Marc wrote to his wife from the front, "Pre-
cisely 'pure' art concerns itself so little with the 'others',
bothers so little about the 'purpose of unifying man-
kind', as Tolstoy says, pursues no purposes at all, but
is simply a metaphorical act of creation, proud and
entirely 'of and for itself'." This amounted to a clear
rejection of the positivistic, materialist thinking of the
19th century.

### The Hour of Pure Abstraction
Nothing could be more mistaken than to consider these
artists, who wished to be neither reformers nor revolu-
tionaries, a group of level-headed intellectuals. Kandin-
sky and Marc in particular, much like the Romantics
before them, saw art as being closely related to religion.
Kandinsky's thinking was rooted in an emotional Chris-
tianity of the Slavic variety, and Marc's thinking and
feeling grew out of a highly imaginative and decidedly
Romantic sense of nature, which prompted a yearning
for purity and redemption. The most important crite-
rion of all artistic activity for the Blauer Reiter members
was – in Kandinsky's phrase – "inner necessity." With
their art they hoped to set the viewer's mind in sympa-
thetic vibration, not upset it by distorting and radically
reducing their motifs like the rebellious architecture stu-
dents in Dresden.

Far from the Brücke's converted railroad station
and the scene of their famous and riotous "Dresden
Fests" at the Baroque Fürstenhof, the artists in sophis-
ticated Munich preached not neo-primitivism but
profound contemplation and sensibility. In Kandinsky's
eyes, fundamental emotions such as love, lust, and
anxiety were "material," that is, vulgar emotions, and as
such had no place in art. He intended to strike more
sensitive chords in the human soul. The art of the Blauer
Reiter, with the exception of the uncomplicated and
worldly Macke, tended to the transcendental, meta-

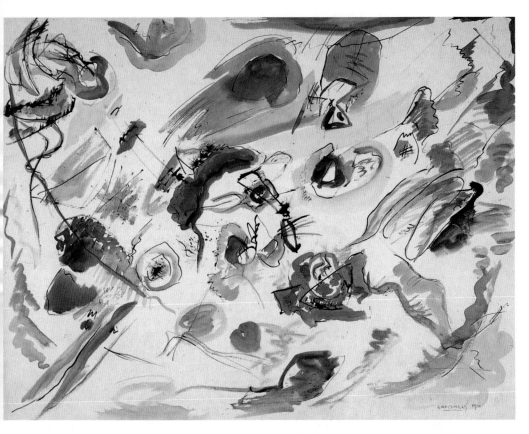

**Wassily Kandinsky**
Untitled, 1910 (1913)
Pencil, watercolor and India ink on
paper, 49.6 x 64.8 cm
Paris, Musée National d'Art
Moderne, Centre Georges
Pompidou

physical, the realm of pure mind. Despite all its emotionality, it was informed by a philosophical strain. It was an art of thinking painters for twentieth-century man. Inspiration was subjected to rational control; no attempt was made to pretend that innocence and naivety had not been irrevocably lost. Pure realism could be found only among a few, truly naive sorcerers of painting like Henri Rousseau. For the others, above all Kandinsky, the hour of pure abstraction, what he called the "great abstract," had come.

The aesthetic revolution did not break out suddenly. It was prepared for over a long period, and Kandinsky was almost 45 years old when, between 1910 and 1913, he advanced to abstraction. His famous "first abstract watercolor," dated by the artist to 1910, was long considered the incunabulum of abstract painting (ill. above). However, it was likely not rendered until about 1913, as recent stylistic and technical investigations appear to prove.

Other members of the Blauer Reiter were Alexei von Javlensky, a former lieutenant in the Russian hussars, and his painter-wife, Baroness Marianne von Verefkin (p. 102); Kandinsky's pupil and long-time companion Gabriele Münter; Adolf Erbslöh; Alexander Kanoldt, who later developed a neo-classically tinged, sharp-focus "magic" realism; the graphic artist Alfred Kubin; the French Cubist Henri Le Fauconnier; Karl Hofer for a time; and finally, Macke and Marc. If we include Heinrich Campendonk and Lyonel Feininger, who participated in the 1913 "Deutscher Herbstsalon" (German

Autumn Salon) the ranks of the late Blauer Reiter are complete. Kandinsky also introduced the composer Arnold Schönberg, who occasionally painted, to the group.

## A Bavarian Coffee Party

The differences of character, and of intellectual and aesthetic goals, were too great for the group to last long. For a few years conservative Munich witnessed a phalanx that, picking up where Jugendstil left off, strove for a new European art. They mounted significant exhibitions of the great French artists, were attacked as "un-German" and "pro-Western" by the pious and patriotic Vinnen of the Worpswede artists' colony (and sadly also by Käthe Kollwitz), and suspected of "wheeling-dealing" by no less than Meier-Graefe. In the meantime the critics took their usual potshots at "incurable madmen," "shameless bluffers," and "boom profiteers," thereby enriching the vocabulary of the brown-shirted iconoclasts soon to come.

Then an event occurred which is not uncommon amongst contentious artists – a great and resounding quarrel. When Erbslöh and Kanoldt decided they could no longer follow Kandinsky's innovations, he and his Bavarian friend Marc drew their conclusions. They resigned, and began planning an almanach to explain their secessionist views to the public. As a title they chose *Der Blaue Reiter*, after a motif of Kandinsky's. It was collaborative work on the almanach, co-edited by Kandinsky and Marc and published in 1912, that brought the group into being. In addition to pictures

*"As has been said often enough, it is impossible to make clear the aim of a work of art by means of words. Despite a certain superficiality with which this assertion is leveled and in particular exploited, it is by and large correct, and remains so even at a time of the greatest education and knowledge of language and its material. And this assertion – I now abandon the realm of objective reasoning – is also correct because the artist himself can never either grasp or recognize fully his own aim."*
WASSILY KANDINSKY

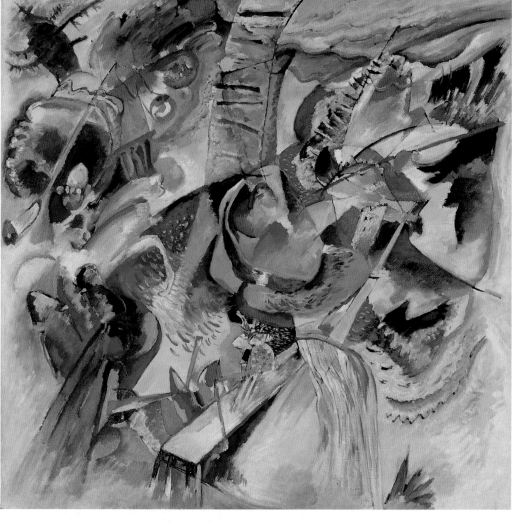

**Wassily Kandinsky**
Improvisation "Klamm", 1914
Oil on canvas, 110 x 110 cm
Munich, Städtische Galerie im
Lenbachhaus

and articles by Kandinsky, Marc, and Macke, reproductions of work by Klee, Kubin, Cézanne, Matisse, Delaunay, Picasso, Rousseau, Kirchner, Nolde, Kokoschka, and Hans Arp, the almanach contained compositions by Schönberg, Alban Berg, and Anton Webern. As the participation of composers indicates, the group viewed the issues of form and expression in the visual arts in connection with music. What Gauguin had intuitively sensed, was now methodically investigated – the process of synesthesia. "Music and painting are basically the same – you only have to have the organ" to detect it, Marc wrote home from the war.

Rarely have conversations over the coffee table had more momentous consequences than those concerning the almanach, which took place at Marc's house and of which he gave an excited and somewhat subjective report. From that point on, Germany became an equal partner with France on the European art scene for twenty years. Though the First World War brought a painful caesura, and Macke and Marc were killed, the development continued until the rise of the Nazis to power in 1933 abruptly ended it.

The anecdote about how Kandinsky arrived at abstract painting has often been told, not lastly by the artist himself. He came home in the evening twilight, saw one of his paintings, turned ninety degrees and standing on its side, and did not recognize it. It seemed to him, that this was the work of a stranger, but he liked what he saw. What Kandinsky saw were only colors and forms, "suffused by an inner glow." He realized that painting had to become independent of material objects, that representations of them would be detrimental to his art. Yet abstraction was at first no dogma for him. Suggestions of objects break through again and again in the paintings of subsequent years: horses and riders, boats, angels with trumpets, church cupolas, hills and valleys, above them the sun or moon. These are fragments of memory, abbreviated signs, but they do originate from the visible world. A strong tension arises between the objective forms and the free composition of amorphous shapes and colors, making these works among the most beautiful the great Russian artist ever did, and giving them a place of prominence in his œuvre.

## Moscow and "Lohengrin"

Kandinsky had to travel a long path before achieving this breakthrough. In Russia, he had been deeply impressed by Rembrandt in the Hermitage in St. Petersburg, and by Claude Monet's *Haystacks* and Richard Wagner's *Lohengrin* in Moscow. Wagner's opera seemed to him to musically reflect the resplendent colors of the Russian capital. For the first time he realized the pos-

every naturalistic and impressionistic detail. Byzantine splendor intermingled with European design in color. Other impulses came from Bavarian glass painting with its simple forms and strong colors. The motif was now only the occasion, not the theme of the painting, whose means – form, color, plane – grew increasingly autonomous. By reducing outward appearances to their essence, Kandinsky hoped to bring out the character of their

*"Every work of art is the child of its time, often it is the mother of our emotions. Thus, every period of culture produces its own art, which can never be repeated. Any attempt to give new life to the artistic principles of the past can at best only result in a work of art that resembles a stillborn child."* WASSILY KANDINSKY

**Wassily Kandinsky**
In the Blue, 1925
Oil on cardboard, 80 x 110 cm
Düsseldorf, Kunstsammlung
Nordrhein-Westfalen

sibility of expressing such sounds through color and form, an idea that basically made him decide to take up art and abandon what was a very promising academic career. Kandinsky began painting very novelistic, narrative pictures of a Romantic character which went back to Russian folk art. They teemed with figures, were ornamental and colorful as fairy tales; many were infused with the Romantic charm of the Middle Ages, to which was later added the influence of European Symbolism and Art Nouveau. These works, sentimental in the best sense, hardly suggest the revolutionary developments to come.

The final liberation of color came at Murnau, a Bavarian village on a lake, Staffelsee, where Kandinsky lived with his pupil, Gabriele Münter. His pictures, still very Impressionistic in approach, gradually grew ever more passionate, as the impasto strokes merged to form planes of color. The subject matter – landscapes and figures – was increasingly simplified in the manner of the German Expressionists and the French Fauves, whose work Kandinsky had seen in Paris. The artist submitted to the principle of the flat surface, gradually expunging

painting as an entity independent of the natural model. Through the psychological effects of color even more than through its physical effects, Kandinsky hoped to touch the soul of the viewer. In his own words, "In general, then, color is a means to exert a direct influence on the soul." Using the analogy of a piano, he went on, "Color is the key. The eye is the hammer. The soul is the piano, with many strings."

Kandinsky envisaged playing on the piano of the soul. In his programmatic treatise, *On the Spiritual in Art*, of 1912, he outlined a tablature of the inherent values of colors and forms. These were fundamental patterns capable of infinite variation and combination, studies for a sort of thorough bass of painting, which Kandinsky considered desirable and possible as a supplement to Goethe's color theory. Colors, he explained, could be cold or warm, light or dark, bristling or smooth, soft or hard. The tension between blue and yellow represented the poles of cold and warm, spirituality and passion. When the tension was released by mixing them, the result was green, the color of calm. White had the effect of "great silence," black sounded like "a dead nothing-

ness after the extinguishment of the sun," grey was "soundless and immobile," Saturn red coveyed the impression of power, energy, joy, and triumph, and cinnabar or vermilion was "like a constant, glowing passion." Forms, too, had their intrinsic character and mood. The circle, one of Kandinsky's favorite shapes, represented perfection or wholeness, while a semi-circle resting on its straight edge signified tranquillity and an upright triangle represented energy. Yellow was the "triangle color," blue the color of the circle. In the case of forms, direction played a key role. For instance, a triangle pointing upwards had a very different significance, and elicited a very different mood in the viewer, from a downward-pointing triangle. The same was true of lines: horizontality meant calm, an upward course meant joy, a downward course meant sadness. The energy with which lines were drawn, their width and direction of taper, also had their psychological connotations. Kandinsky's theory marked the beginning of the development of an entirely new vocabulary for talking about art. In turn, painting became a sort of written language that had to be learned to appreciate it. Its words were colors and forms, its punctuation marks lines. In the course of time, Kandinsky envisaged, these symbols would call forth in the viewer's mind images or conceptions as precise as those elicited by common every-day words, like tree, sky, man, flower, and sea.

Like speech, but above all like music, painting was seen to possess rhythms, a certain mathematical precision, repetitions, and leitmotifs. A hierarchy of artistic means no longer existed, each being of equal value, like the twelve tones of the musical scale of Schönberg, whose formal theory confirmed the artists' investigations. The Russian composer Alexander Skriabin attempted to heighten the effect of musical notes by supplementing them with the corresponding colors. Macke had notes played on the piano to match the hues of his palette. As in music, inspiration and structuring, feeling and calculation came together in painting. Kandinsky's goal was to make the viewer's soul vibrate, like a sounding board, by means of the sounds of colors. He remained true to this aim even in his later, more dogmatic period, when during his years of teaching at the Bauhaus his paintings grew ever less expressive and more rigorous, controlled, and mathematical.

Before this phase of artistic development lay years spent in Russia during and after the First World War, from 1915 to 1921. The works of the period, not least as a result of Kandinsky's intellectual and aesthetic involvement with Constructivism, were initially very contradictory and heterogeneous. Kandinsky's own ideas and theory made little impression on his Constructivist colleagues, such as Alexander Rodchenko and Ivan Puni. The invitation to return to Germany and teach at the Bauhaus came as a godsend.

Kandinsky was convinced that the world of colors and forms rose from the depths of the human soul, like music. Although ordering colors and forms into a composition was a rational and necessary process, the source of the artist's means and activity was subconscious. His work was neither pure ornament, lacking in content, nor was it the result of pure calculation. Kandinsky energetically denied the accusation of formalism, nor would he condone talk about abstract wallpaper patterns or of meaningless, dry geometry. "Every means is sanctified, as long as it is inwardly necessary," he explained, in the moral categories of the German phrase, *Der Zweck heiligt die Mittel*, which were very typical of him. "Every means is sinful, as long as it does not stem from the wellspring of inner necessity.... Nothing is more detrimental and sinful than seeking form violently." For Kandinsky every form had its "inner content," and was "the expression of this content." Content was made up, firstly, of the personality of the artist, and secondly, of the spirit of the epoch in which he lived. Thus Kandinsky painted pictures of the "world within," mental images he saw with unusual vividness and clarity, the eidetic gift.

**Wassily Kandinsky**
Sky-Blue, 1940
Oil on canvas, 100 x 73 cm
Paris, Musée National d'Art
Moderne, Centre Georges
Pompidou

## Painting and Physics

Another development that found entry into his imagery was the revolutionary new physics and its view of the universe, a development Kandinsky followed passionately and very knowledgeably. The results of this interest are best seen in the paintings of his "period of genius," from 1910 to the First World War, many of which are in the collection of the Städtische Galerie im Lenbachhaus, Munich. These *Improvisations*, *Compositions*, and – more rarely – *Impressions*, with their swirling, streaming, form-engendering and form-dissolving brushwork, their sometimes controlled and sometimes explosive outbreaks of unleashed color, their nervous, microbelike webs of line, represent Expressionism taken to its logical conclusion.

It is difficult not to see a primary and conscious connection between the atomization of the pictorial plane and the findings of atomic physics, just as a perhaps unconscious link can be detected with the political catastrophe then coming to a head in Europe. Marc wrote while in the army that such pictures should be painted before a war, whereas in its aftermath, the thing was to confront chaos with a constructive order. Kandinsky did both.

Kandinsky's later compositions reflected his conviction that the ultimate abstract form in any art was number, an idea related to medieval and symbolist numerology. Yet while they were methodically designed and calculated, the best of these paintings temper mathematics with poetry. The artist's "inner necessity," that is, his creative gift, transfuses even their rigorous shapes and arrangements, rendering them transcendent, raising them to the level of signs and symbols capable of pointing beyond themselves. In the late years following upon Kandinsky's emigration in 1933 to Neuilly, near Paris, his work began to be populated with playfully biomorphic shapes that recalled Surrealism and the imagery of Miró, and whose lyric joyfulness pointed back to Kandinsky's early predilection for Russian folk art.

## The Popular "Cultural Bolshevik"

A less hermetic, less encoded world opens up before us in the work of a painter of whom, in a reversal of Klee's lament, it could be said that "A people supported him." This is Franz Marc, whose paintings the Nazis had to remove from their "Entartete Kunst" (Degenerate Art) exhibition because their "degeneracy" attracted crowds of admiring Aryans. Marc's continuing popularity, however, rests largely on a misunderstanding. Everybody enjoys his motifs, animals, and the lyrical, metaphysical aspect he lends them. We appreciate him emotionally and sentimentally, and tend to overlook his aesthetic gifts (ill. above and p. 108).

Marc was more than one of the most sympathetic figures in the history of modern art. He was an uncompromising artist who, with Kandinsky and his other Blauer Reiter friends, threw himself wholeheartedly into the campaign against public incomprehension. "The writers, at least, have managed to make the public accept that the moon can very well stroll into a room," he wrote in a note concerning *The Limitations of Art*. "One is even permitted to wear a sun in one's heart,

**Franz Marc**
Large Blue Horses, 1911
Oil on canvas, 102 x 160 cm
Minneapolis (MN), Walker Art Center, Gift of the Gilbert M. Walker Fund

*"In this time of the great struggle for a new art we fight like disorganized 'savages' against an old, established power. The battle seems to be unequal, but spiritual matters are never decided by numbers, only by the power of ideas."*

FRANZ MARC

**Franz Marc**
In the Rain, 1912
Oil on canvas, 81 x 105 cm
Munich, Städtische Galerie im
Lenbachhaus

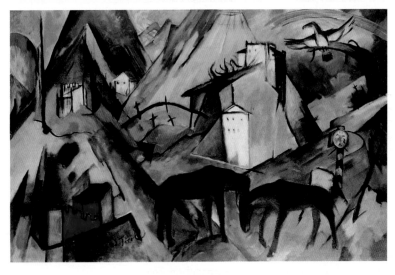

**Franz Marc**
The Poor Land of Tyrol, 1913
Oil on canvas, 131.5 x 200 cm
New York, Solomon R.
Guggenheim Museum

Platonic notion by which Marc understood neither conceptual art nor allegories but meaningful symbols or signs which contained reality in distilled form. And the ideas represented, he hoped, would be capable of encouraging community. In view of Marc's present worldwide popularity, such visions are easily misunderstood, as if he had conceived of an "art for all," in anticipation of certain agitprop slogans to come. Any such inference would miss the point entirely. It is enough to quote a statement of Marc's, made in the spirit of Kandinsky: "The coming art will be our scientific principles become form .... We will live in the 20th century in the midst of strange faces, new images, and unheard of sounds. Many who do not possess the inner fire will freeze, and feel nothing but a coldness, and escape into the ruins of their memories."

## A Dreamer's Pathos

Marc's notion of a "community" was an elite receptive to "the spiritual in art," a sort of worldly brotherhood which would carry its ideas into the future without regard for the real, social ills of the day. His pathos was more fanatical, less tempered by intellect, than that of his older friend, Kandinsky. Marc's dream of a better, purer world, which he saw prefigured in the insentient creaturely life of animals, is a notion to which we owe many of his wonderfully crystalline, luminously colored paintings, which hover between objectivity and abstraction. But of course this visionary enthusiasm, like all overheated idealism, contained within itself the danger of a blindness to reality. Marc considered the First World War, whose victim he became in 1916, as Macke had before him in 1914, to be an unavoidable inferno through which men had to pass before entering the better world he dreamed of.

Marc learned from Delaunay's color theories, from the Cubists' distillations of objective form, and from the Futurists' prismatic facetting of form and inclusion of the element of time in painting. But it was under Kandinsky's all-powerful influence that he arrived at an abstract order, if one that appeared somehow unfinished and occasionally still too beholding to the ornamental. Marc's œuvre remained a promising fragment, cut short by his untimely death. He pursued the pure, crystalline form, but was not given enough time to find it. The series of his major works began in 1911, only three years before his death, with *Three Red Horses* (Cincinnati, private collection), in which he succeeded for the first time in employing color as a symbolically expressive device. In *Tower of Blue Horses*, a 1913 composition now lost, Marc approached very closely to his crystalline ideal.

From this point on his style became increasingly differentiated. The forms began to overlap, were prismatically divided, became ever farther removed from nature. The motif was subordinated to the arrangement of forms on the plane, and only the colors were still suffused with that "mystical inwardness" which the artist

bring the stars down to earth, etc. But just let a painter try to hang the moon up in a drawing room, lay it on a table, etc. Some things have been allowed by decree, such as putting wings on a horse; but you have to write 'patented by Berceuse' underneath it." Marc, too, sought a "universal painting" in which the dilemmas of life would be resolved in a harmony of creation. But he took a different path from his Russian friend, who at least had studied with a comparative outsider on the Munich scene, Franz von Stuck. Marc's background was in the academic painting of the city, and his father had been an artist before him. At bottom, Marc was a brooding, melancholy man, a religiously inspired idealist who suffered from the imperfection, or – as he himself would have said – from the impurity of the world and its loss of metaphysical meaning. This was the source of his conviction that the *Nur-Bild*, or painting in itself, was not sufficient. Rather, artists should represent "ideas," a

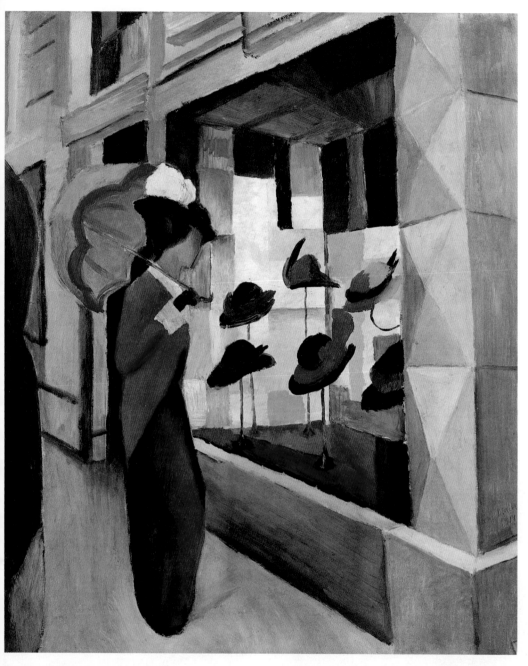

"It is a tremendous effort for me to paint and I exert so much energy when I am painting that I am always very tired afterwards. I tear the paintings stroke for stroke from my brain. Really. I am actually very lazy. If I have torn out my nerves, however, then these canvas rags should also be worth something, at the very least my energy has been spent on them. They can be appreciated by whoever pleases.
I paint, paint, paint and am deeply happy when my eye sinks with the light into the darkness of the forest or trembles above the meadows and finally dreamily follows the clouds in the distance. Every day a new happiness is experienced, a new joy.
I want to use the days now as much as I can. I always feel the urge to work." AUGUST MACKE

**August Macke**
Hat Shop, 1914
Oil on canvas, 60.5 x 50.5 cm
Essen, Museum Folkwang

attempted to make visible. *The Poor Land of Tyrol* (p. 108 below) is a harsh, forbidding landscape with bare, rugged mountains, humble dwellings, martyrs' crosses, emaciated, shaggy horses, and a ruffled eagle perched on a bare limb – Marc's apocalypse, an ominous, depressing picture. It proves that Marc was no innocuous painter of pastoral idylls.

### Ariel among the Expressionists

The most radiant and vital figure among the Blaue Reiter artists was August Macke, born in Meschede, Westphalia, in 1887, active in Düsseldorf and Bonn in the Rheinland, and at Tegernsee in Bavaria, died in action in Champagne, France, in 1914 (ill. above and

p. 110). Macke was not metaphysically interested like his friends, to whom he was introduced by his bride's uncle, the collector and art patron Bernhard Koehler. As time went on he grew increasingly alienated from Kandinsky, nor was he sparing of criticism with respect to the "intellectual painting" of his older friend, Marc. More important to Macke than the spiritual in art was sensuousness of color and harmony of form; he remained true to the beauties of this world. Macke had a great lust for life, and attempted to project it into his art. Influences worked on him through the eye, not the intellect. Macke involved himself in the pre-1914 directions in painting in an entirely carefree, open way, tirelessly experimenting, accepting and rejecting. The brilliancy of his palette was

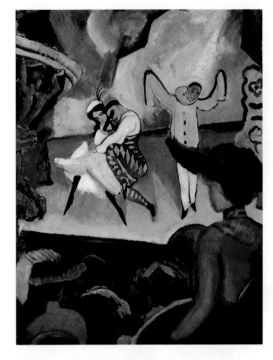

of forms to tubular shapes. Macke even tried abstraction, though it certainly suited his temperament least of all approaches.

Macke's style combines the insouciance of Impressionist art with the formal logic of a Seurat. His unmythical, worldly approach made him the most romantic of German painters in the 20th century. Unlike Marc, Macke was not still struggling to find himself when he died – he had reached early maturity. Macke's gifts came to full flower within the space of only two years, in marvellous landscapes with figures, his favorite theme. His finest accomplishment then came with the Tunesian watercolors, the fruit of a trip to Africa undertaken with Klee and Louis Moilliet in 1914. There is nothing in 20th-century German art to compare with the transparent beauty of these works, the unprecedented, luminous major key of their palette, their melodious grace of form. Macke's paintings are the final reverberation of a period from which he took leave in a depiction of the mobilization, presciently titled "Farewell."

### A Modern "Old Lower Rhinelander"

Inhabitants of the Lower Rhine region are known for a temperament almost as meditative and melancholy as the peoples of Eastern Europe. Heinrich Campendonk, a native of Krefeld, is a case in point. Recruited by Marc for the Blauer Reiter in 1911, Campendonk came by way of Cézanne to Cubism, whose formal clarity he adopted, but not its subject matter or subdued palette.

inspired by Marc and the early Kandinsky, but even more strongly by Delaunay's color-circles and window paintings. In terms of form, Macke was intrigued by the lucid logic of Cubist composition, for a time by the dynamics of Futurism, and finally, by Léger's reduction

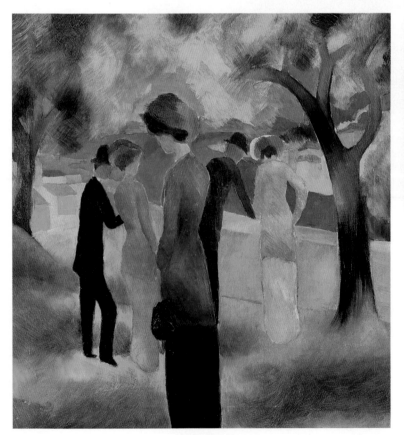

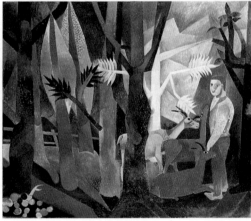

Campendonk's work blends a tendency to narrative, relating folk legends in a popular tone, with a strongly ornamental bent. Yet despite this narrative character his pictures are static, as if all movement were caught in suspended animation. The colors in the early work are brilliant and luminous, but later their fire is subdued, and they sometimes verge on the saccharine (ill. above). Campendonk was more naive than his friends; basically he remained a conservative, in the tradition of Lower Rhine landscape art. Driven out of his post at the Düsseldorf Academy in 1933, he died in Amsterdam in 1957, a highly honored but embittered and lonely man.

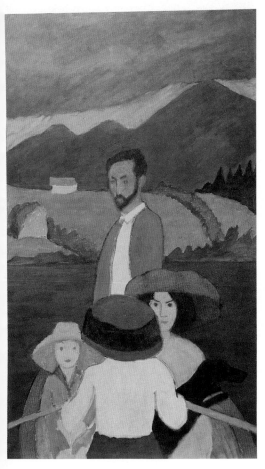

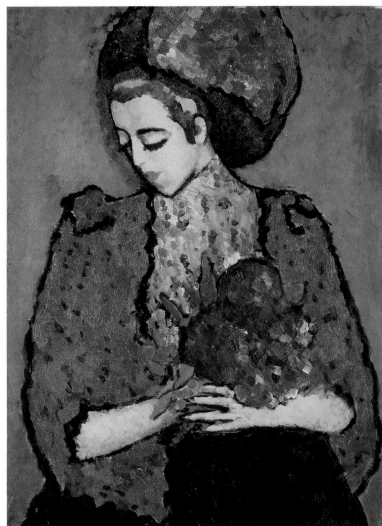

## Cavalry Officer and Mystic

More important to the group than Campendonk was Alexei von Javlensky, a former Russian cavalry officer with a great zest for life who gradually discovered the contemplative, mystical side of his nature. Javlensky's prime theme was the human face, into which he projected all the intensity of his sensibility. As the glowing colors and heavy, simplified contours indicate, the artist was concerned not with the individual but with the general in the human aspect. The wide-open eyes, filled with a melancholy ecstasy reminiscent of medieval manuscript illuminations, transfix the viewer. "I am less interested in searching for new forms," said Javlensky; "but I do wish to become more 'profound'." This he achieved with the aid of color, which, more definitely than with the other Expressionists, was infused with a symbolic character. Javlensky envisioned heightening the luminous chords of Fauvism and the passionate fire of van Gogh's palette into a metaphysically expressive color. As regards form, by the end of his career he had reduced it to a few, sweeping contours, and to horizontal and vertical strokes to indicate the facial features. The

face became an apparition, with all sensation and emotion as it were turned inwards. Javlensky's long series of "Meditations," variations on this single theme, can have a slightly wearying effect, but this should not prevent us from admiring his exquisite still lifes and his few landscapes. The involvement with landscape led, during the First World War and thereafter, to impressive compositions of lapidary simplicity and ingenious lyricism (ill. above right and p. 112).

Another member of the Blauer Reiter, as well as of its predecessor, the "Neue Künstlervereinigung," was the graphic artist Alfred Kubin. His reputation as an invoker of the demonic, dark side of human nature was already established when he joined the group. Compared to his drawings and prints, Kubin's work in painting was less significant. More important was the work of Kandinsky's pupil, Gabriele Münter. She represented the rare case of a naive artist who attended an art school and whose work nonetheless retained a wonderful freshness and unaffectedness. Münter's early paintings were primarily landscapes and still lifes done during the years spent with Kandinsky in Murnau. Their instinctive dis-

**Gabriele Münter**
Boat Trip (Kandinsky, Javlensky's
Son Andreas, Marianne von
Verefkin on Staffel Lake), 1910
Oil on canvas, 122.5 x 72.5 cm
Milwaukee (WI), Milwaukee Art
Museum, Gift of Mrs. Harry
Lynde Bradley

**Alexei von Javlensky**
Girl with Peonies, 1909
Oil on cardboard, mounted on
plywood, 101 x 75 cm
Wuppertal, Von der Heydt-
Museum

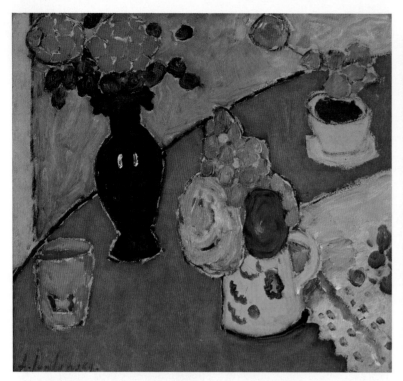

**Alexei von Javlensky**
Still Life with Vase and Jug, 1909
Oil on cardboard, 49.5 x 43.5 cm
Cologne, Museum Ludwig,
Haubrich Collection

**Alexei von Javlensky**
Evening, 1929
Oil on cardboard, 53 x 32.7 cm
Private collection

tillation of form and brilliant colors were inspired as much by Javlensky as by Kandinsky, to whom Münter owed her artistic development but whose intellectual approach remained foreign to her (p. 111). She is said to have discovered the indigenous glass paintings whose bright, folkloristic colors gave so much to the Blauer Reiter. Münter's best works stand on a level with those done concurrently by her friends.

    With the outbreak of the First World War, the his-

tory of the Blauer Reiter came to a close. Macke and Marc were killed in action; Kandinsky, threatened with internment as an enemy alien, fled by way of Switzerland to Russia; Münter, driven by her own demons, wandered restlessly through Europe. The final reverberation came with the founding in 1924 of "The Blue Four" – Kandinsky, Klee, Javlensky, and Feininger, all of whom were masters at the Weimar Bauhaus and by that time internationally known.

## Design of a Possible World
### The Exemplary Art and the Exemplary Life of Paul Klee

*"At one time, people used to paint things that could be seen on Earth, things they liked looking at and would have liked to see. Now we make the reality of visible things apparent and in doing so express the belief that, in relation to the world as a whole, the visible is only an isolated example and that other truths are latently in the majority. Things appear in their extended and manifold sense, often seemingly contradicting yesterday's experiences. The aim is to reveal the fundamental idea behind the coincidental."*
PAUL KLEE

Among the circle of writers and poets who gathered in Jena during the early Romantic period, Friedrich Hardenberg-Novalis was the most thoughtful and imaginative, and yet also the most reserved. In his writings reality was transformed into a symbolic cypher; to speak with Klee, he was "not graspable this side of the grave." For all his personal kindness, Novalis was surrounded, like Klee, by an aura of unapproachability. Existing in his "intermediate realm," he remained in closer touch with the wellsprings of creativity than his colleagues. The purity of his nature, the ineffable profundity of his writings, and the precision of his thought made Novalis the tacit moral authority for his friends, a man who set standards, just as, in our own century, Klee set standards for the artists of the Blauer Reiter, the Bauhaus, and many others in their wake. In Klee's work, the Enlight-

enment and early Romantic era were revived, with an authentic zeal that had nothing in common with the lip-service paid by so many to that movement. Klee was a "Romantic with an exact, conscientious sense of form," who, as Werner Haftmann has shown, admired not only Novalis and Friedrich Schlegel, Runge and Friedrich, but also Goethe and the philosophical painter and physician Carl Gustav Carus. Klee's world was no idyll. He was not a painter-poet who told fairy tales in miniatures with a Surrealist touch. We should not allow ourselves to be deceived either by his generally small formats or by his conscious primitivism, which was merely a reflection of that extreme sparingness of means which marks "ultimate professional insight." In Klee's case, too, Cézanne was the mentor par excellence.

    As in Novalis's texts, we find a unification of opposi-

**Paul Klee**
Revolution of the Viaduct, 1937 (153)
Oil on oil ground on cotton on a
stretcher, 60 x 50 cm
Hamburg, Hamburger Kunsthalle

surpassed that of many a specialist. He was a scholarly artist, a *pictor doctus*. What with Novalis remained a fragment, life and work, Klee brought to fulfillment. When he died in 1940 at the age of 60, of cardiac paralysis brought on by a terrible disease, a hardening of the skin caused by measles, Klee had accomplished his life's work.

Two writers have been mentioned with whom the artist felt allied and whose different characters he in large part embodied within himself. It might have been even more to the paint, however, to speak of two composers. For Klee not only possessed a great literary gift, as his writings show; he was also an outstanding connoisseur and performer of music. Born in 1879 in Münchenbuchsee, near Bern, to a German music teacher and his music-loving Swiss wife, Klee long vacillated between a career in music and art. According to his own record, he finally decided on painting because as its development was not so far advanced as that of music, his own contribution might be more important and necessary to painting. In music he loved Mozart and Bach above all. Bach's sense of form, the strict principles of his musical architecture, are as present in Klee's work as the grace of Mozart and the suggestion of something demonic just beneath the surface. As in Mozart's case, connoisseurship alone does not suffice for an understanding of Klee, who was

**Paul Klee**
Villa R, 1919 (153)
Oil on cardboard, 26.5 x 22 cm
Basel, Öffentliche Kunstsamm-
lung Basel, Kunstmuseum

tions in Klee's work. Mysticism and logic, poetry and mathematics, day and night, metaphysical and physical realms, the visible and the invisible, the conscious and the unconscious, childlike naivety and aesthetic sophistication, death and life, the organic and the inorganic, East and West, order and anarchy, irony and commitment, are often simultaneously present.

For Klee, the making of art was a simile for the creation of the world. Like Goethe, whom he considered the "only bearable German," and whose experience of nature seemed allied to his own, Klee attempted to capture nature in terms of primal images; and like the poet, the artist discovered "analogies to the universal design in the tiniest leaf." On an early trip to Italy, undertaken with the Swiss sculptor Hermann Haller, Klee was intrigued less by the legacy of visual artists – with the exception of Leonardo – than by the structural principles of Italian architecture, which he saw as a continuation of natural laws by human hands, and by the fantastic aquatic flora and fauna in the Naples aquarium. Between these two poles lay the garden, organic nature domesticated and shaped by man, which inspired many of Klee's finest pictures. And it was between these two poles, those of construction and imagination, that his rich œuvre slowly and continually developed.

## The Scholarly Artist

Klee's personality was informed as much by Novalis' striving for wholeness, the endlessness of an undivided creation, as by Goethe's sense of harmony, proportion, and perfection. Like the poet, Klee was artist and scientist in one. "An artist must be so much – poet, natural scientist, philosopher," he noted in an early diary entry. Nor was this said lightly. Klee's precise knowledge in the fields of natural science, world literature (he read the Greek classics in the original), in philosophy and music,

**Paul Klee**
The Goldfish, 1925 (86)
Oil and watercolors on paper,
mounted on cardboard,
49.6 x 69.2 cm
Hamburg, Hamburger Kunsthalle,
Gift of the friends of Carl Georg
Heise

comparably able to retain artistic quality despite an
enormous productivity that was almost unprecedented
in modern art – his own catalogue of works encom-
passes nearly nine thousand items.

Klee's talent was soon recognized. His first Munich
teacher, Heinrich Knirr, already prophesied that he
would achieve something out of the ordinary. The
famous "Böcklin-German," Franz von Stuck, also
thought highly of Klee. Alfred Kubin, the draftsman of
the wierd and ghostly, was his first purchaser. Kubin felt
a kindred spirit in the drawings and prints of Klee, who
had yet to begin to paint. Although Kubin was right, he
recognized only part of the younger man's personality,
his tendency to the bizarre and eerie, to the sarcastic and
ironic. Kandinsky, long a co-teacher with Klee at the
Bauhaus, was proud of having recognized Klee's genius
at first sight, although around 1910 Klee had produced
only a thin œuvre consisting almost entirely of drawings
and graphic works. Also, he had destroyed many of his
early attempts. Klee needed a long time in which to find
himself: "There should be no hurry when one wants so
much," he noted in his diary. For a time Klee even toyed
with the thought of devoting himself to sculpture. He
actually did produce a few idol-like, grotesquely wierd
sculptures, but this was to remain an episode.

### Strict Rites

Klee's drawings and etchings showed an early propensity
towards a unique, Manneristic lineature which varied
reminiscences of Symbolism and Jugendstil in a very
personal way. They were satirical not for the sake of

being satirical but out of "distaste in view of the higher
things." Klee's humor is often acid and cruel, and the
laugh it prompts is uneasy. Many of the distorted,
insect-like creatures contain a half-digested "Gothic"
aspect. Some of them are perhaps too intellectual, too
indirect, requiring translation and a knowledge of liter-
ary allusions in order to understand them.

In the course of time Klee overcame his latent illus-
trative tendency. For years he had devoted himself to
illustrating Voltaire's *Candide*, intrigued as he was by its
clarity of diction and well-turned plot. When people
later asked him for illustrations, he usually requested
them to choose something suitable from among those
he had already done. Glass paintings, many in a negative
process, and white drawings on a black ground, a few of
them colored, were the next of Klee's areas of study. In
the course of his career he was so tirelessly to investigate
every nook and cranny of art that in the end there was
no unexplored territory, no problem of craft, that found
him without a solution, no theme to which he could not
apply the perfect technique. The material side of art was
indeed just as important to him as the ideal. Nor did he
ask himself the idle question as to the priority of form or
content. With Klee, the two always remained in balance.
Down to carefully prepared patina and artificial mildew
marks on the paper, there was nothing uncalculated or
uncontrolled about Klee's art.

### "The Call of Color"

For many years the watercolor technique served Klee
primarily as a means to define the entire color scale with

**Paul Klee**
Untitled, 1940, [001]
Oil on canvas on a stretcher,
100 x 80.5 cm
Switzerland, private collection

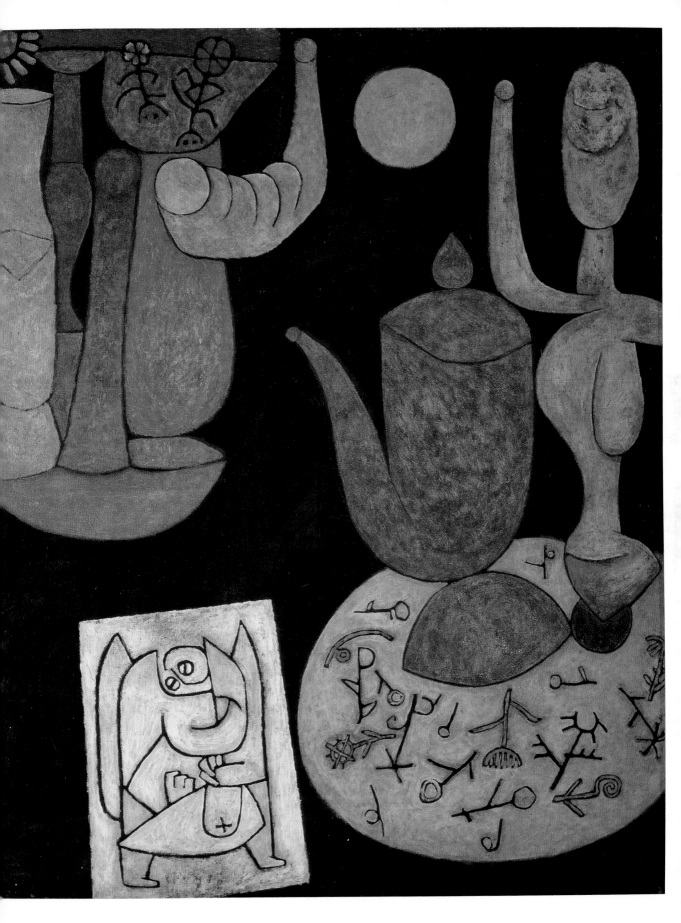

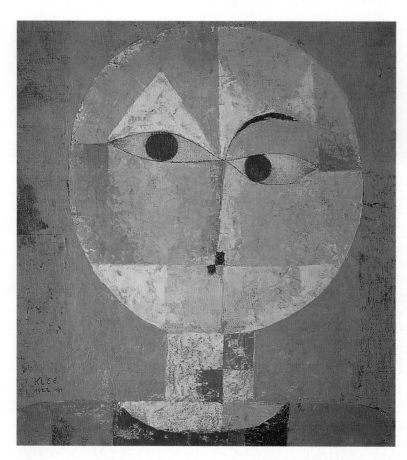

**Paul Klee**
Senecio, 1922 (181)
Oil on gauze with chalk ground;
original yellow frame, 40.5 x 38 cm
Basel, Öffentliche Kunstsamm-
lung Basel, Kunstmuseum

*Page 117 above:*
**Paul Klee**
Highroad and Byroads, 1929 (90)
Oil on canvas on a stretcher,
83.7 x 67.5 cm
Cologne, Museum Ludwig

*Page 117 below:*
**Paul Klee**
Insula dulcamara, 1938 (481)
Colored paste and oil on
newspaper, mounted on burlap
on a stretcher; original frame,
88 x 176 cm
Bern, Kunstmuseum Bern,
Paul Klee Foundation

all its transitions and gradations between black and white, and to explore the influence of color and light on effects of depth. This was self-abnegating laboratory work, which Klee performed with great conscientiousness and superhuman patience, trying and testing, musing and meditating like a medieval craftsman, lost to the world and not expecting immediate, tangible results because he had no definite goal. Only a man of great self-assurance could have undertaken such labors. Quietly confident of his mission, after a stormy youth Klee consciously brought order into his private life by marrying Lilly Stumpf, a Munich pianist, creating an atmosphere conducive to the development of his art.

The artist was well-prepared when, at the age of 34, while travelling in Tunisia with his painter-friends Macke and Moilliet, "the call of color" reached him. This was not coincidentally in Africa, to which his ancestry on his mother's side extended back. Klee felt at home there. Those who knew him said that in his young and middle years he had something of the appearance and gaze of an Arab about him. The cubic, both austere and fantastic architecture of the Arab settlements, the brilliance of the Mediterranean light, the intense colors of Tunisia, struck Klee with the force of a revelation. "Arabian Nights as an extract with ninety-nine percent reality content," he decided. Spontaneously he discovered a way to create a synthesis between actual and pictorial architecture.

The path to his liberation of color had been theoretically paved by Delaunay, whom Klee had met in Paris. The influence of Orphism is evident in many of the watercolors done in Kairouan and other places. *South Wind in Marc's Garden* (1915; Munich, Städtische Galerie im Lenbachhaus), for instance, was clearly stimulated by Delaunay's window paintings. Klee has loosened the Cubist rigor of the composition by introducing slight irregularities and hardly detectable shifts, a method he would retain, particularly in the incomparable major work, *Highroad and Byroads* (ill. right), a fruit of his trip to Egypt in 1928/29. Even during his years of collaboration with Kandinsky, Oskar Schlemmer, and Feininger at the Bauhaus, Klee's idiosyncrasies always remained somewhat beyond the law, as it were. For "genius is the defect in the system," stated the conscientious systembuilder, who knew that genius was the only thing that could neither be taught nor learned. This is why Klee's pictures, no matter how constructed they seem to be, are never lifeless. The "defect in the system" keeps them vital.

### Orient and Occident
Kairouan made Klee into a painter. The experience of the holy Moslem city moved him so deeply that he returned home through southern Europe as it were with his eyes closed, in order to retain his impressions unblurred. Klee had found a second artistic home in Tunisia. The strange mixture in his painting of sophisticated Western and exotically Oriental elements is one source of its charm. This blend began to take shape in Tunisia, the significance of which is only comparable to that of Egypt, where Klee, as mentioned, travelled in 1929. Kairouan gave him color and pictorial architecture; Egypt gave him the experience of a timeless coexistence of permanence and transience.

Klee's work did not begin to develop in full freedom until 1914. But it led to an œuvre that, second only to Picasso's, profoundly influenced contemporary art all the way down to Conceptual Art. Klee's imagery teems with symbols, which with time grew increasingly simplified and essential, condensing like crystals. Although he always proceeded from a visual experience of plants, animals, or humans, of the natural or man-made environment, and ultimately of death – which for him was always present in life – Klee's art, like his elusive personality, exists on a plane beyond the everyday. It reflects nothing visible, but – to use the artist's most famous phrase – it makes visible.

### Painting is Script
His art is a very original creation, a both imagined and carefully calculated design of a possible universe beyond the one we know. From there, Klee hoped, perhaps the imperfection of all previous art could someday be overcome, and a work created "of a really great scope, covering the entire elementary, objective, substantive and stylistic territory." Similarly to Cézanne, Klee considered

himself the "primitive of a new sensibility." He passed through many way stations on the road to his distant destination. In keeping with his temperament, he depicted not so much being as becoming, not the blossom but the process of blossoming, not the river but the process of flowing, not the tree but its growth, as Haftmann said. Arrows, punctuation marks, numbers and arabesques facilitate the reading of Klee's pictures; they provide orientation, point out directions, set signals, but without entirely answering the pictorial riddle. One is put in mind of Kahnweiler's early remark to the effect that painting was script, hieroglyphics.

In the last years of the artist's life his formats grew larger and the imagery starker, more monumental. This was partially the result of Klee's illness, which began in 1935. The drawings grew increasingly lapidary and more like writing, frequently recalling Chinese or Japanese calligraphy. "Variations on the theme of drawing the final line," Georg Schmidt once called Klee's last series of works. The theme of death indeed comes strongly into the foreground, as seen in the compelling *Angel of Death* (Basel, Kunstmuseum), done in the final year of his life, as well as in many other paintings and drawings. The late works represent a summing-up not only in autobiographical terms but in aesthetic ones as well. For the dark, threatened nature of human existence was always present in Klee's work. His very last painting (p. 115) was a still life with vases, pitcher, a sculpture, a flower-decorated table, and a moon. At the lower left, on a white field, one sees Jacob wrestling with the angel and a cross, as if Klee himself had decided, now it is enough.

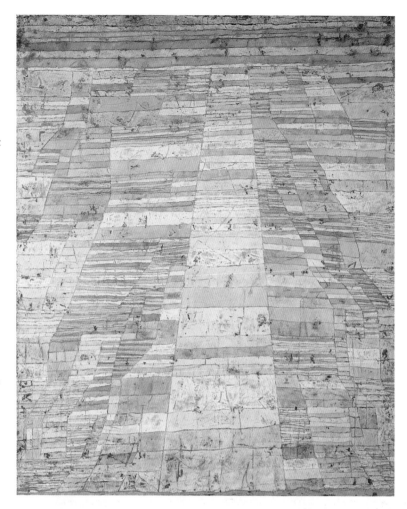

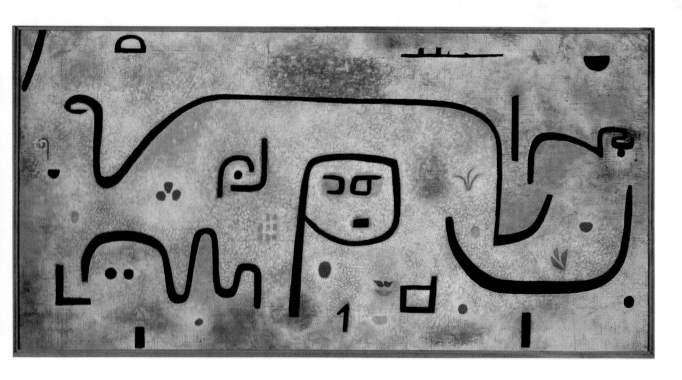

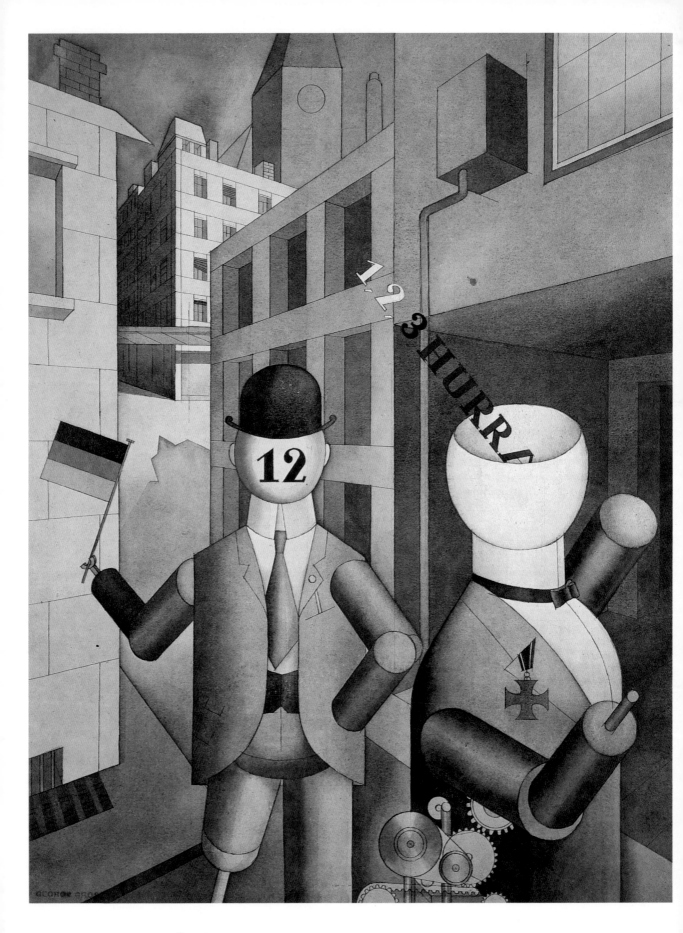

# Revolt and Poetry

## "Scarecrows against Reason"
### The Dadaist Revolt

Even today many people still look upon Dadaism as a nihilistic monster, sheerly destructive in intent. This is an over-simplification. The European cataclysm of the First World War made it impossible for artists, in so far as they were committed and felt responsibility, to escape into philosophy, because the war had made all big words and resounding phrases seem suspect. The only possible reaction was a radical one. Dada, even in its negation, was an offshoot of Western bourgeois thinking. The movement had nothing to do with Bolshevism, despite certain parallel, ephemeral, and soon suppressed streams in Eastern Europe and in Soviet Russia immediately after the October Revolution. As for nihilism, most Dadaists did not propagate it but merely registered its existence.

Their revolt unified a range of international artists and writers of solid middle-class origin, free-thinking individuals from New York to Zurich, from Cologne to Paris, from Berlin to Hanover, with reverberations felt in London, San Francisco, Moscow, Budapest, and Tokyo. No stream of 20th-century art was as global as Dada. Dada journals were published in Switzerland, Italy, the Netherlands, Germany, Austria, Hungary, Serbia, Romania, Poland, and the United States.

The Dada revolt was an expression of disgust, anxiety, and despair in face of a world in which "everything works fine, but people don't any more," as author Hugo Ball put it. Ball was one of the spiritual fathers of the Zurich branch of the movement and, indicatively, later a convert to Catholicism. The mass slaughter of mechanized warfare had far outstripped anything envisaged by the pessimism of the preceding age. Dada drew its conclusions from the insanity of an unquestioning faith in progress, and proceeded to celebrate the triumph of the absurd. Dada was more than the horseplay in which it occasionally manifested itself. It was a revolt of vitality against ossification, of liberty against doctrine, of the irrational against the "reason" of politicians and war speculators, a despairing attempt to survive destructiveness by destroying. As Max Ernst said, during his period of activity as "Minimax-Dadamax" in Cologne, Dada was a profoundly pacifist reaction to "the mess of this idiotic war." It was a frontal attack on "the civilization that produced it," including the language and visual imagery of that civilization, including its "eternal values," including the Venus de Milo and Mona Lisa, whom Duchamp embellished with a moustache. Subsequently Dada made attempts at reconstruction, which were viewed with skepticism by Ernst, because, as he said, you cannot "glue parts of an exploding grenade together."

All thinking, writing, and painting that side-stepped the hopelessness of the historical situation, attempted to ignore it, prettify it, or even to justify it, became the target of ruthless criticism, which did not stop short at the artists' own bourgeois heritage and the art it stood for. Dada was not a style, not a philosophical or aesthetic program; it was a series of individualistic, anarchic acts made in reply to a collective and terroristic world, "an outbreak of joy in life and fury," to again quote Ernst. It was an outbreak full of aggressiveness, of elan, activity, and movement, whose vitality put the entire past in question. Declaring "the best of all possible worlds" to be an old wive's tale, Dada stuffed it into the garbage can of a pre-Beckett "End Game," without being able to offer an alternative or even wishing to. Dada was the manifestation of a despairing attempt of free individuals to maintain their integrity in a regimented world whose regimentation had led straight to Armageddon.

Each Dadaist fought a lonely battle, even as member of a group, whether in Zurich or Berlin, in Cologne or Budapest, but especially in Hanover (Kurt Schwitters) and New York (Man Ray). This was both the movement's strength and its weakness, for it finally led to a dispersion of forces (which in any case never had a real chance of preventing the lemmings from throwing themselves into a new and even deeper abyss). By definition, Dada could never have become a mass movement. This is why it is completely mistaken to accuse these artistic individualists, as some have, of having unwittingly paved the way for political terrorism. Ultimately, the intellectual elite remained isolated. "The cynicism of the Dadaists is a mask," said the painter, sculptor, and poet Hans Arp; "the Dadaist suffers from the delirium of the human delusion of grandeur that began with the

*"jolifanto bambla ô falli bambla*
*grossiga m'pfa habla horem*
*égiga goramen*
*higo bloiko russula huju*
*hollaka hollala*
*anlogo bung*
*blago bung*
*blago bung*
*bosso fataka*
*ü üü ü*
*schampa wulla wussa òlobo*
*hej tatta gôrem*
*eschige zunbada*
*wulubu ssubudu uluw ssubudu*
*tumba ba – umf*
*kusagauma*
*ba – umf"*      HUGO BALL

**George Grosz**
Republican Automatons, 1920
Watercolor, ink and India ink on cardboard, 60 x 47.3 cm
New York, The Metropolitan Museum of Art

World War of 1914." This mask often bore the grimace of the slanderer, joker, or clown, the agent provocateur who – as in Beckett's plays – proclaims his truths under cover of a fool's cap.

Nevertheless, with the aid of elements of Futurism (and of its Russian version, Ego-Futurism), of Expressionism, Duchamp's first "ready-mades," Kasimir Malevich and Alexei Alexeivich Morguniov's promenade of wooden spoons, and Alfred Jarry's *Ubu Roi*, Dadaism did attempt to make a new beginning from its lost outpost. This could only succeed if first the past was smashed to smithereens.

### The Debunking of Western Civilization

The official date of the birth of Dada was December 5, 1916. It was on this day, in respectable Zurich, that the "Cabaret Voltaire" opened, an "association of young artists and literary men," as an innocent newspaper article put it, "whose aim it is to establish a center for artistic entertainment." The word "dada," which first appeared in April of that same year in Ball's diary, was reputedly discovered by him and Richard Huelsenbeck, poet and later psychiatrist. As the two were leafing

through a German-French dictionary in search of a striking stage-name for a female singer, they came across the children's word "dada," which means "hobbyhorse" or "giddyup," but also "Hottentot." And it was like Hottentots, at least in the eyes of the good citizens of Zurich, that the artists behaved – Ball, Huelsenbeck, Tristan Tzara, Arp from Alsace, and Marcel Janco, an artist from Romania. They had all been driven to Zurich by the war, with which they wanted nothing to do, and they all refused to believe in the "meaning of history." They set up "scarecrows against reason," as Arp put it, and reacted to common sense with noisy and provocative nonsense: simultaneous poems, spoken or roared in unison; a "Bruitism" borrowed from the Futurists; performances accompanied by cacophonous musical entertainments; shocking manifestos; poetry composed of grunts and squeaks; Arp's profound tomfoolery in verse; attacks on the church; and an Expressionistic, sentimental appeal to the best in humanity. The primal, childish, primitive, and also the factor of random chance, were held up scornfully in the face of officially sanctioned culture.

During the sometimes boisterous, sometimes sarcastic activities undertaken by these critical and intellectual artists, activities which also reflected a radical self-criticism, something new came to light – what became visible now was the poetry of the absurd and grotesque, the charm of the illogical and paradoxical. These artists discovered the unconscious mind and the dream as sources of a new reality and artistic inspiration. In the course

of breaking down traditional forms and styles Dada obtained new materials for art. Though they rejected all perfectionism and wished to start with a clean slate, the Dadaists again and again made surprising finds, with the result that – as subsequently would often happen – their anti-art ultimately developed into a new art form. Despite repeated attempts, art in the 20th century has been unable to escape itself.

### Everybody Likes a Good Joke

Not everything about Dada was an expression of protest, reflected a philosophy, or better, an anti-philosophy; nor did Dada ever become an ideology. Many of the movement's explosions were touched off by nothing more than a sense of fun, the enjoyment of play innate to *homo ludens*. They were manifestations of a pure love of practical joking, subject to no rules or compulsions. "Dada is against the compulsory form of the German school essay," wrote Arp, the kindliest, most visionary, and most disciplined of the Dada leaders. "But Dada is for dreams, colorful paper masks, kettle drums, sound-poems, concretions, *poèmes statiques*, for things that are not far from picking flowers and making bouquets." Or, as a later artist associated with Pop, Claes Oldenburg, would put it somewhat more bluntly: "I am for an art that is political-erotical-mystical, that does something other than sit on its ass in a museum."

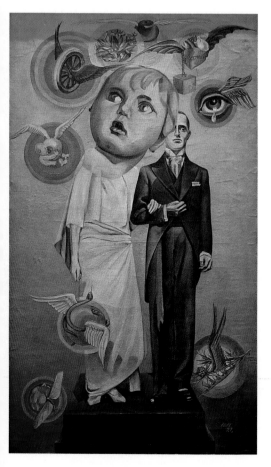

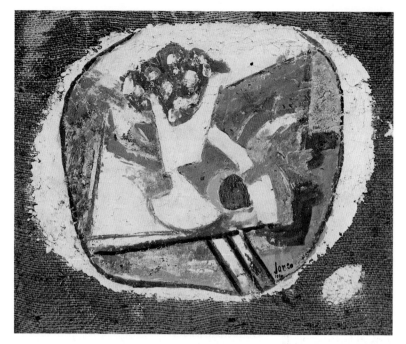

Marcel Janco
Still Life, Composition with
Flowers, 1920
Oil on plaster on burlap, 51 x 60 cm
Paris, private collection

Apart from Janco and from Arp's first wife, Sophie Taeuber, the poet, sculptor and painter was the only one of the Zurich group to develop a style which had a lasting influence on contemporary art, as well as on poetry in both the traditional and the Dadaist sense. Arp had his origins in abstract painting, knew Kandinsky, and had participated in the 1913 "German Autumn Salon." In Zurich he broke with geometric abstraction and took up impulses from Cubist collage, but in place of rigorous design he set "controlled chance." Arp put together existing things made of various materials as they came into his hands, mixing organic with geometric shapes, and mounted them on the surface, as it were in the order of their appearance (p. 120). His montages of unaltered fragments of *objets trouvés* have the strangely tantalizing magic of a chaos contained. In the playful relief-compositions of free-form colored shapes we already find the plantlike, organic configurations and the formal concentration that would become characteristic of Arp's work in painting and sculpture. Aesthetic and natural forms have become one in this imagery, which has "grown like a fruit."

Sophie Taeuber-Arp was likewise a mild and kindly person (p. 120). Though her imagery was strictly geometrical, it was filled with a cheerful mood. Using circles, squares and rectangles in light to luminous colors, she played a sensitively poetic glass-bead game. Janco (ill. above), who would later emigrate to Israel, where he made a considerable contribution, at the time concentrated on watercolors, crayon drawings, and mostly varicolored reliefs of a great richness and harmony of form, an abstract pictorial architecture built up of fragments of objects and natural phenomena. Seen from today's vantage point, Janco's art has mellowed, now appearing more appealing than provocative.

Hannah Höch
The Bride, 1927
Oil on canvas, 114 x 66 cm
Berlin, Berlinische Galerie

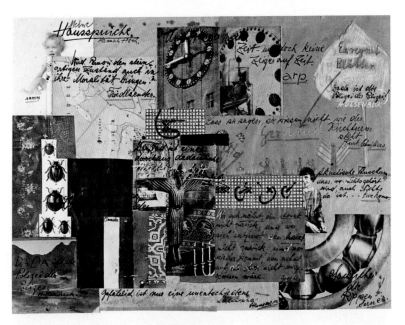

**Hannah Höch**
My Home Mottoes, 1922
Collage and India ink on paper,
32 x 41.3 cm
Berlin, Galerie Nierendorf

## On the Barricades

In Berlin, Dada took on the aspect of a revolutionary uprising. The members of the group uncompromisingly expected to make an immediate effect on politics. They attacked Church and State in no uncertain terms. "Chief Dada" Johannes Baader, while attending a service in Berlin Cathedral, replied to the pastor's rhetorical question, "What does Jesus Christ mean to us today?" by announcing loud and clear, "To your sort, He doesn't mean a damn thing!" Raoul Hausmann wrote a

*Manifesto Against the Weimar Approach to Life,* George Grosz scoffed in biting drawings at the "home front," at war profiteers and brothel frequenters, militarists and speculators, before turning to more idyllic subjects after his emigration to America. Grosz's art of the period was more realistic to the degree that the Dadaists' striving to make a difference in day-to-day Berlin politics was more direct than in Zurich. But in Berlin, too, artists and especially writers explored the realms of the unconscious and automatism, polemicizing at Freud the while. In the visual arts, a group gathered around Hausmann (ill. below), Hannah Höch (p. 121 and ill. left), Grosz, the brilliant agitator John Heartfield (ill. below) and his brother Wieland Herzfelde, aimed at what they termed a "satirical hyper-realism" and carried considerably more weight than the abstractionists. Aesthetic consequences arose especially from their experiments in photomontage, by means of which a theme could be represented from various vantage points, in different perspectives, and with daring juxtapositions of form and content. These devices alienated reality so strongly that the shocked viewer was confronted with the mundane transmuted into the extraordinary, in a sense even into the surreal, and was forced to cope with it whether he accepted or rejected what he saw. This new technique, often used in combination with pithy, satirical texts, has retained its revolutionary effect down to the present day, and that not only in an aesthetic sense. Photomontage remains the strongest weapon in the hands of the politically committed artist. A straight line runs from John Heartfield to Klaus Staeck.

**John Heartfield**
Hjalmar, or the Growing
Deficit, 1934
Photomontage, 54 x 38 cm
Berlin, Akademie der Künste,
John-Heartfield-Archiv

**Raoul Hausmann**
Tatlin at Home, 1920
Collage and gouache, 41 x 28 cm
Stockholm, Moderna Museet

*Page 123 below:*
**Max Ernst**
Fruit of a Long Experience, 1919
Painted wood relief, 45.7 x 38 cm
Geneva, private collection

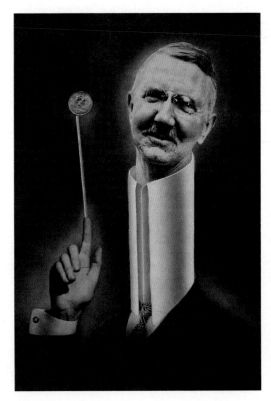

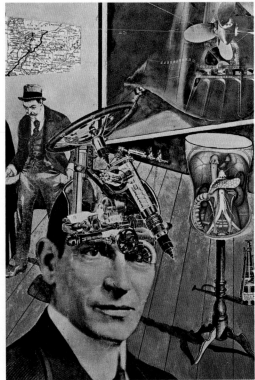

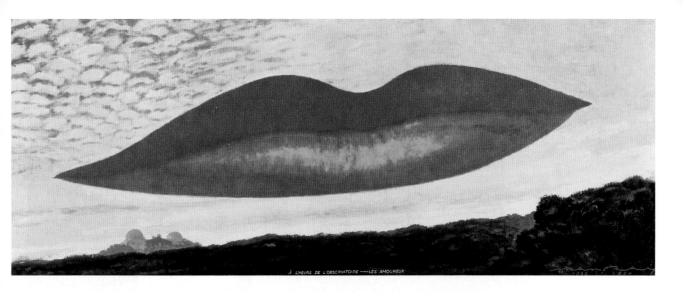

## Dadamax of Cologne

In Cologne, Max Ernst was the outstanding Dada figure (ill. below and pp. 138, 139, 141). In his early collages he arbitrarily pieced together fragments of reality, rearranged separate elements taken from technical drawings into an astonishing, unreal but convincing mechanical world, created a completely new system of references among things, and by so doing, paved the way for Surrealism. "Deranged!" people cried, and they were right in a sense they perhaps did not realize. By dictionary definition, Ernst truly "upset the arrangement, order, or operation" of these painstakingly rendered machines, removing the components from their normal context and placing them in a new one, and giving them a new meaning which is often underscored by the title of the collage.

The literary factor so crucial to Surrealism was anticipated by Ernst as well. His early *Pietà, or Revolution by Night* (1923; London, Tate Gallery) depicts a boy with curly blond hair, clad only in shirt and trousers, perched on the arm of a moustachioed, derby-hatted gentleman standing in front of a wall out of which projects, at the right, a shower head. In the background is the outlined figure of a tall, bearded man at whom the boy gazes, and whose aristocratic air contrasts strongly to the frumpiness of the man in the hat, uncomfortable in the role of the Virgin. In *Saint Cecilia*, the figure of the title appears walled in, seated on a movable framework, as a dove shoots vertically into the air towards a triangle formed of three balls, open at the bottom and suspended at the top by a string from a fourth ball, which in turn is affixed to the sky. Dreamlike images without apparent logical coherence, unconscious associations, are made visible in such paintings. It was not symbols Ernst depicted, but magical signs. In the first post-war years he also depicted quite different subjects, openly intended to provoke. One was *The Virgin Spanking the Christ Child before Three Witnesses* (Cologne, Museum Ludwig), which was done in 1926 and caused a scandal in Cologne two years

later. With this visual satire, alluding to the "Chastized Cupid" of antiquity and to Christian depictions of the life of Jesus – the three witnesses, by the way, are Breton, Paul Eluard, and Ernst himself – the artist liberated himself from the traumatic memory of a "pious" spanking once received from his father. In addition to remi-

**Man Ray**
Observatory Time – The Lovers,
1932–1934
Oil on canvas, 100 x 250.4 cm
Longport-sur-Orge, William N.
Copley Collection

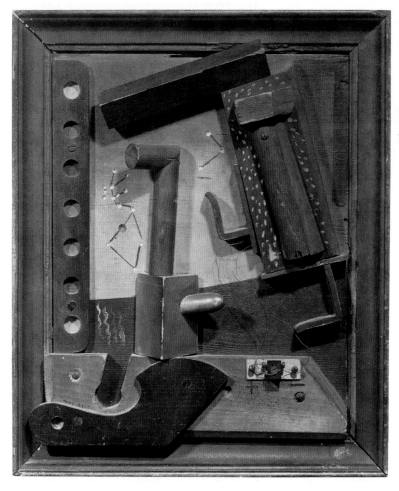

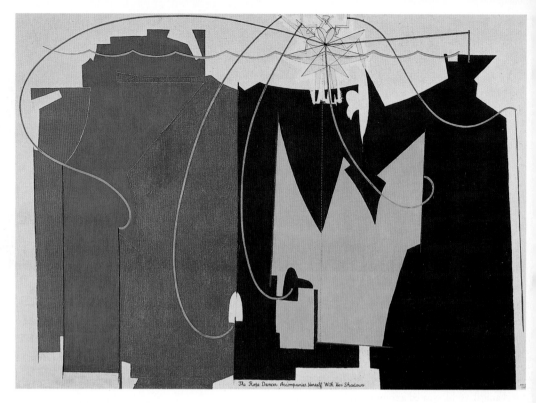

*"Throughout time painting has
alternately been put to the service of
the church, the state, arms, individ-
ual patronage, nature appreciation,
scientific phenomena, anecdote, and
decoration.
But all the marvellous works that
have been painted, whatever the
sources of inspiration, still live for us
because of absolute qualities they
possess in common. The creative
force and the expressiveness of paint-
ing reside materially in the color
and texture of pigment, in the possi-
bilities of form invention and orga-
nization, and in the flat plane on
which these elements are brought to
play."*
MAN RAY

niscences of the Mannerism of Pontormo or Parmi-
gianino and of De Chirico's metaphysical painting,
Ernst's work contains early anticipations of the Surreal-
ist scenario.

### From Dada to Merz

In business-like Hanover the movement produced a late
and marvellous blossom in the work of Kurt Schwitters.
"It was Schwitters who spoke the last Dada word," wrote
Georges Huguet in the catalogue of the unforgettable
exhibition "Fantastic Art, Dada, Surrealism," held in
1936-37 at the Museum of Modern Art, New York, which
had been founded seven years previously. The activities
of the "Société Anonyme," established by Man Ray
(p. 123 and ill. above) and Duchamp in 1920 and sup-
ported by the Schwitters enthusiast and tireless advocate
of European modernism in the United States, Katherine
S. Dreier, had laid the cornerstone for the early fame in
America of Schwitters' "one-man Dadaism", to use
Werner Schmalenbach's term.

Schwitters was also a poet, the author of *Anna
Blume*, which caused a scandal in 1919. Influenced by
Hausmann's consonant-poem *fmsbw*, the *Ursonata*,
(primal sonata), was the quintessence of all stammering,
roaring, yet wonderfully metrical, phonetic poems. This
experimental poet happened to be a tall, well-built man.
According to his friend, Hans Richter, after the war
Schwitters was even able to hold at bay a belligerent
group of officers of the guard in the still-militant garri-
son town of Potsdam solely through his eloquence and
the magnetism of his extremely gentlemanly, quite
unbohemian personality. During the war, in which he

had "upheld the Fatherland … in an office," Schwitters
used his desk job to jumble the files and thereby help
men accused of insubordination, defeatism, or deser-
tion to escape punishment.

Using a collage technique that employed objects
and materials of the most heterogeneous description,
Schwitters created a highly individual "world view," an
anti-ideology he called *Merz*. This word, like Dada, was
a chance find. It emerged in the course of making a col-
lage which included newspaper clippings, one of which
was an advertisement for the "Privat- und Com-
merzbank." After it had been torn and pasted over, all
that remained was the word-fragment "merz." Schwit-
ters's unconventional view was born and christened
simultaneously. Down to the last years of his career,
everything was transformed under Schwitters' hand
into *Merz*. He naturally also applied the term to the
fantastic structure he built in his Hanover house at 5,
Waldhausenstrasse. Made, like his pictures, of materials
found by chance, random remainders of everyday life
supplemented by lumber, plaster, and oil paint, the
*Merzbau* gradually proliferated upwards story by story.
Schwitters worked intensively from 1920 to 1936 on this
endless column of longing, whose full title was *Merzbau
with the Cathedral of Erotic Misery*. Schwitters considered
this fantastic architectural object to be the quintessence
of his life's work, or at least the bass that underlay the
melody of his œuvre. Nothing – except for the death
of his wife, Helma – hurt the artist more deeply than
the news that the *Merzbau*, which he had had to leave
behind on his escape from Nazi persecution, had been
destroyed in an air raid.

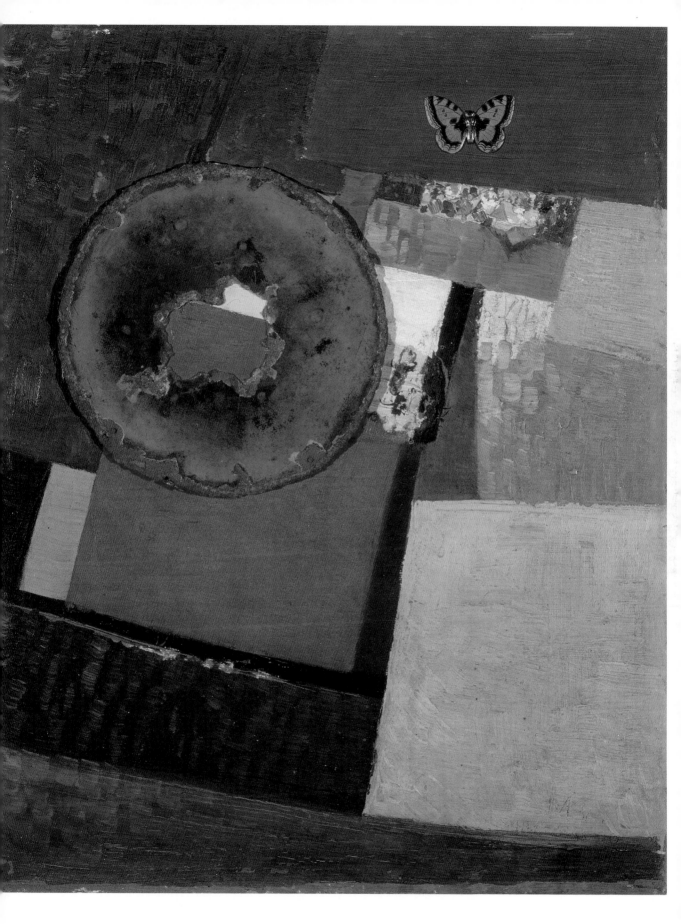

**Kurt Schwitters**
Merz Picture 9 b (The Big Me
Picture), 1919
Collage, oil and gouache on
cardboard, 96.8 x 70 cm
Cologne, Museum Ludwig,
Ludwig Collection

The reconstruction of the original *Merzbau* in
Hanover (p. 461), a visual and architectural manifestion
of Schwitters' life-long yearning for a unification of all
the arts, was one of the high points of Harald Szee-
mann's memorable 1983 exhibition "Der Hang zum
Gesamtkunstwerk" (The Penchant for the Total Work of
Art). Schwitters would surely have been gratified by this,
because the notable and notorious "penchant," a key
feature of the art of this century and the last, was just as
much a part of his work as *Anna Blume* and the long
series of pictorial collages. The *Merzbau*, in that it went
far beyond the use of previously scorned materials in art,
marked the ultimate transcendence of the traditional
borderlines of painting.

In spite of Picasso's significant sculptural work, the
approach introduced by Schwitters remained the excep-
tion in the first half of the century, gaining followers
only after mid-century. This is precisely why the early
example of the universal artist, prototype of *homo ludens*,
is so important. It was in keeping with Schwitters' per-
sonal penchant for the Gesamtkunstwerk that, being also
an excellent typographer and publicity man (on his own
behalf as well as others'), he not only produced the
*Merzbau* but envisioned a *Merz Revue* and a *Merz The-*

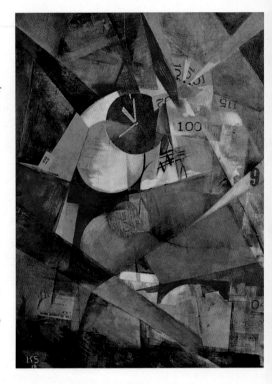

**Kurt Schwitters**
Construction for Noble
Women, 1919
Assemblage, 103 x 84 cm
Los Angeles (CA), Los Angeles
County Museum of Art

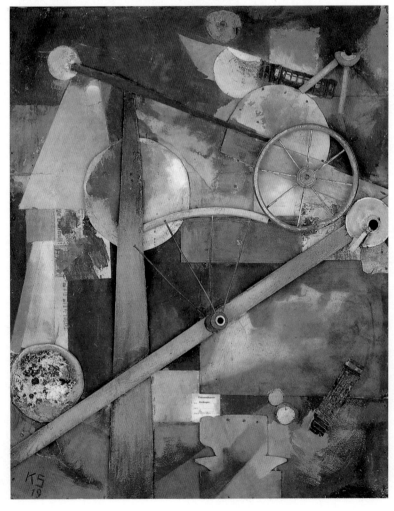

*ater* as well. *Merz* was nothing more than an identifying
word; it pointed to the irrational because it had nothing
substantial to designate and owed its discovery to
chance. Yet it became a fetish, like the nonsensical con-
sonant sequences of the sound-poems and the things
and materials of which Schwitters made collages – and
especially after his confrontation with the Dutch De
Stijl movement-reliefs and three-dimensional objects.
*Merz* is the signet of the unutterable that eludes lan-
guage.

"Art," explained Schwitters not without pathos, "art
is a primal concept, sublime as the godhead, inexplica-
ble as life, undefinable and gratuitous." Art has no mes-
sage; its message is the art itself: "Every line, color, or
form has a certain expression. Expression can only be
given by a certain combination, but it cannot be trans-
lated. One cannot formulate the expression of a picture
in words, just as one cannot paint the expression of a
word, such as the word 'and'." This amounts to a rejec-
tion of any attempt to translate visual realities into
verbal terms. A waiver of all illusion, including the ideo-
logical variety, and a commitment to abstraction are key
factors in Schwitters' otherwise traditional aesthetic.
Though his artistic products may have shocked the
bourgeoisie, he was basically a bourgeois at heart, for
whom art was art and nothing else. Socially or politically
committed art was a contradiction in terms for Schwit-
ters. "The art we strive for," he declared, of all places,
in an article on the subject of "proletarian art" in 1923
(other contributors were Theo van Doesburg, Arp,
Tzara, and the critic Spengemann, a friend of Schwit-
ters') – "Art is neither proletarian nor bourgeois.... .
What we are preparing... is the all-inclusive work of art,

which is exalted above every poster, be it made for champagne, Dada, or communist dictatorship."

As Schwitters' collages of paper, wood, fabric, tin, wire, and sackcloth show, the materials used in art are of little significance. This should be recalled when one feels irritated by Beuys's fat or felt, Dieter Roth's cheese, or by the wilted leaves, coal-dust or pollen employed in the work of the *Spurensicherer*, trace or cluefinding artists. Going far beyond the Cubists and their collages, Schwitters discovered the covert poetry of the trivial, of disdained and discarded everyday things, in a way that radically questioned traditional values. Under his hand street-car tickets, baby-carriage wheels, tin cans, yellowed newspapers, string, hair, nails, and rotten roots were transmuted into another reality, a visual reality of compelling magic (pp. 125–127).

The magical power of Dadaist objects reached a culmination in the work of this solo Dadaist, this brilliant junk collector who was a mediocre academic painter, a culmination that far transcended Dada as a movement out to *épater le bourgeoisie*. Schwitters rehabilitated, even nobilitated, enfranchised things. He possessed a childlike innocence, receptivity, and imagination, which enabled him to look at commonplace things with a fresh eye and be astonished by them. He discovered them anew, as if they had never existed before. But already as his eye took things in, he changed them, and by playfully manipulating them he infused them with a new meaning, an innate dignity. Combined with this candor was the shaping will of the intelligent artist, an extraordinary sensibility, and an inexhaustible imagination that accepted the existence of contradiction and paradox. Added to these, Schwitters was gifted with an innate sense of humor, which was never injurious and remained forgiving in the face of every provocation, and had its source in his basically melancholy nature.

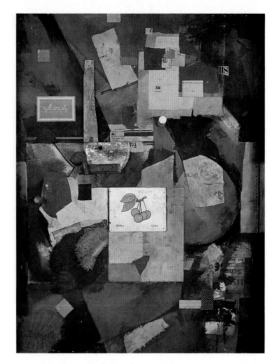

The works of later styles that relied on the autonomy of materials; styles such as L'art informel and Arte Povera, the many and various attempts to unite painting and sculpture, Pop Art, the neo-Dadaist streams of yesterday and today, typography, and literary experiments – all of these quite clearly owe key impulses to the direction taken by Schwitters'. Much of the art that emerged in the post-war period can be traced back to his inspiring example, not least the revival of the idea of the comprehensive, multi-disciplinary work of art, at which Schwitters aimed with his three *Merzbau* projects in the knowledge that they were destined to remain utopian.

*"I called my new way of creation with any material 'merz'. This is the second syllable of 'Kommerz' [commerce]. The name originated from the 'Merzbild', a picture in which the word 'Merz' could be read in between abstract forms. It was cut out and glued on from an advertisement for the Kommerz und Privatbank."* KURT SCHWITTERS

# Transcending Boundaries: an Interim Report
## Marcel Duchamp, Non-Conformist and Prophet

Just as, after 1945, there was a lively and varied neo-Dada scene whose effects are still being felt, there was a proto-Dada scene around the outbreak of the First World War. It emerged in New York, which at the time could not even dream of ever advancing to become the world center of visual art. With the Armory Show of 1913, the city was just beginning to bring the avant-garde movements of the day and their key works to the United States. However, there was one person who predicted the development that would reach its first culmination only three decades later: Marcel Duchamp. "If only America would realize," he said in an interview with the journal *Current Opinion*, that the art of Europe is over, dead –

and that America is the land of the art of the future, instead of trying to build all it does on the foundation of European traditions."

Although the American parallel to European Dada was over by the early 1920s, leaving deep traces but sinking no roots – causing Duchamp and his artist-friend Man Ray to return to Paris in 1921 – his vision of the future was something of a self-fulfilling prophecy. For hardly another artist did more for the art of the future through his public activity and inspiring influence behind the scenes than the war-weary visitor from France. Duchamp was originally part of a group of anti-war emigrés from various European countries, voluntary

*"The criticism of modern art is a natural result of the freedom given to the artist to render his individual view. I consider the barometer of the opposition to be a healthy indicator of the depth of the individual expression. The more hostile the criticism, the more encouraging for the artist."* MARCEL DUCHAMP

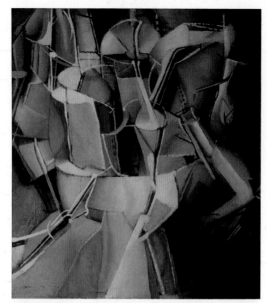

**Marcel Duchamp**
The Passage from Virgin to Bride,
1912
Oil on canvas, 59.4 x 54 cm
New York, The Museum of
Modern Art

**Marcel Duchamp**
The King and Queen Surrounded
by Swift Nudes, 1912
Oil on canvas, 115 x 128.3 cm
Philadelphia (PA), Philadelphia
Museum of Art, Louise and Walter
Arensberg Collection

*Page 129:*
**Marcel Duchamp**
Nude Descending a Staircase,
No. 2, 1912
Oil on canvas, 147.5 x 89 cm
Philadelphia (PA), Philadelphia
Museum of Art, Louise and Walter
Arensberg Collecion

photography of Etienne-Jules Marey, and perhaps also to visual ideas of the type that early appeared in Kupka's work. The significant series begins with *Dulcinea* (1911; Philadelphia Museum of Art), and leads by way of the *Portrait of an Actress* (Philadelphia Museum of Art) and the depiction of the veritably vibrating *Sad Young Man in a Train* (Venice, Peggy Guggenheim Foundation) to the various versions of *Nude Descending a Staircase* of 1912, the second version of which was a *succès de scandale* at the Armory Show (p. 129).

*The Passage from Virgin to Bride* (ill. left), done in autumn 1912 in Munich, already anticipates *The Large Glass,* just as the various versions of the *Chocolate Grinder* (p. 130) and the *Nine Masculine Forms* mounted between two panes of glass (1914-15; Milan, Arturo Schwarz Collection) point the way to the mechanical and anthropomorphic figures of the "bachelor Machine" with the irionic title, *The Bride Stripped Bare by Her Bachelors, Even* (p. 458). Duchamp worked on this key piece for eight years – or ten, counting the pre-

exiles who lived in the midst of the New York business world and apparently tried to numb their despair over a hopelessly corrupted humanity in a series of wild parties. The leaders of the group, in addition to the intellectual rigorist Duchamp, included his closest friend, Picabia of the ever-changing masks. Their American hosts were Alfred Stieglitz, photographer and art promotor from his gallery at 291 Fifth Avenue, and collector-poet Walter Arensberg and his wife, Louise.

Back in Paris, Duchamp had initially involved himself with Impressionism and the art of Seurat. The resulting Fauvist and especially the Cubist-influenced canvases already exhibited an extraordinary painterly talent, in terms of their sophisticated color values and their mastery of difficult compositional problems. Moreover, these works pointed to the intellectual independence of Duchamp, who immediately abandoned an approach as soon as he had understood it. Repetition wearied him to the point of disgust. With Duchamp, boredom always led to a decline in activity – or, as he himself termed it, to laziness, for what really impelled him was curiosity. The only thing that really interested the artist Breton called the most intelligent man of the period was *creatio ex nihilo*, creative work that started from zero, from scratch. This is why the most significant of his periods in painting, the productive involvement with Cubism, was soon at an end.

Duchamp's independence and willfullness were already apparent in the paintings that combined variations on Cubist design and color with depictions of phases of movement. These were not, as was long assumed, primarily influenced by Futurism, which Duchamp said he did not particularly value, although his dynamic canvas with the ironic title *The King and Queen Surrounded by Swift Nudes* (ill. right) was presumably painted after a visit to a Futurist exhibition. Rather, the approach relates to the motion-sequence

liminary studies – before he finally declared it "definitively unfinished."

By the same token, Duchamp's entire œuvre, complex and full of arcane allusions to his many and varied interests (literature, music, mathematics, physics, mechanics, folk culture), eludes final definition. Every attempt at interpretation – and there have been superb ones – has remained as incomplete as his major work, which impressively manifests Duchamp's final abandonment of painting (his last picture had been done in 1918, for Katherine S. Dreier, his most important patron apart from the Arensbergs). This residue of enigma, which remains just as inexplicable as the texts of the Symbolist outsider Raymond Roussel, which Duchamp read with passionate interest, points to the presence of two elements of early Romanticism. The first of these is Romantic irony, which Duchamp heightened to a Dadaist peak in works such as the reproduction of the Mona Lisa which he "improved" by adding a moustache and an obscene abbreviated title, *L.H.O.O.Q. (Elle a*

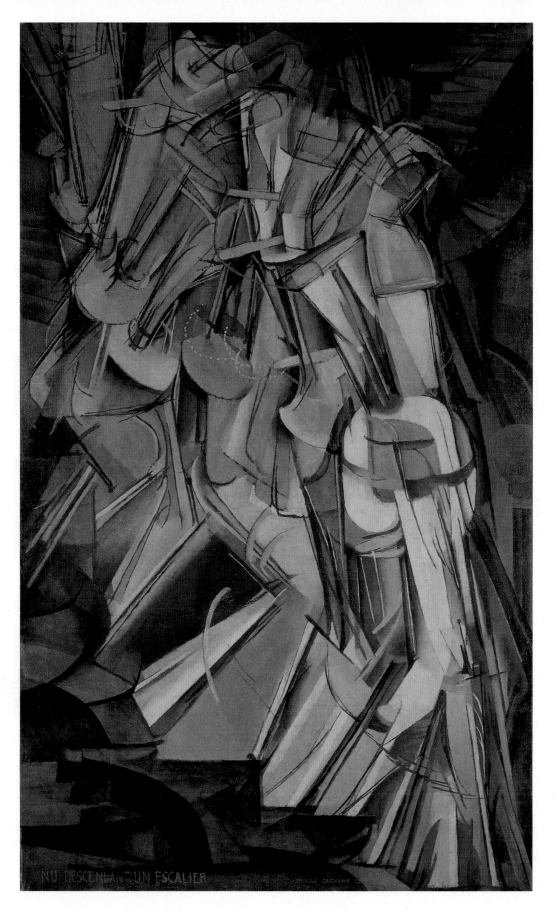

NU DESCENDANT UN ESCALIER

**Marcel Duchamp**
Chocolate Grinder, No. 1, 1914
Oil, thread and pencil on canvas
primed in black, 65 x 54 cm
Philadelphia (PA), Philadelphia
Museum of Art, Louise and Walter
Arensberg Collection

This ostensible anti-artist, as is well known, was also the inventor of the "ready-made": a *Bicycle Wheel* mounted on a stool (p. 457), a mass-produced *Bottle Rack*, a urinoir titled *Fountain* and signed "R. Mutt" (p. 459). Duchamp put these banal things in a gallery or museum environment and declared they were works of art. However, such acts did not mean he had ceased being an artist. He was "rien qu'un artiste," he himself said two years before his death. Duchamp was no iconoclast. What he attacked was not art but the abuse of art, the boredom caused by repetition, the emptying of all meaning caused by hypocritical pathos, and the decline of the work of art to the status of a commodity.

By the same token, Duchamp's radical critique had its source in an extraordinarily high, ambitious, even utopian conception of art, and in the ironically or sarcastically veiled insight into the impossibility of its realization. Only in a mental exchange between the work of art and the viewer, in Duchamp's imaginative "coitus," could an experience of beauty and of one's own individuality still be had. The fragmentary character, the unfin-

**Jean Crotti**
The Clown, 1916
Mixed media on glass, 35.1 x 23.2 cm
Paris, Musée d'Art Moderne de la
Ville de Paris

*chaud au cul*). The second Romantic factor is the fragmentary, provisional, open-ended nature of the artist's work. He radically questioned all supposedly eternal values, and was sadly yet cheerfully aware that all certainties and systems were nothing but speculation, if not a great swindle. Duchamp believed God was an invention of man; yet he nevertheless finally decided that it was better to believe in such things after all, because it would help one to die "happier".

The "eternal value" of painting was also suspect to Duchamp. During the ten years in which he devoted himself exclusively to playing chess – with some international success, even – he not only gave up painting but also gave up art of any kind. Nor did he do anything to quash the rumor that, since the mid-1940s, he had as good as given up art entirely, while in reality he had been working for twenty years on his legacy, an enigmatic environment of diverse materials (from wood, velvet and stones to plexiglass, a gas lamp, and a motor) visible only through two peepholes in a door. Its title: *Given: 1. The Waterfall, 2. The Illuminating Gas* (Etant donnés: 1° la chute d'eau, 2° le gaz d'éclairage). Forced into the role of voyeur, the spectator sees a naked female figure in three-quarter view, her pubic hair shaved off, holding a gas burner in her hand. Her arm is covered with dry twigs. In the background is a wooded landscape, with a lake and waterfall. All of the means Duchamp ever employed are present in this initially shockingly naturalistic, but actually allusively encoded scene, as is his latent eroticism, which culminated in the brash demand that a "visual coitus" should take place between viewer and painting or object of art. This postulate was truly the precondition for Duchamp's final work, which, despite its superficial naturalism, is even more complex, ambiguous, and enigmatic than the *Large Glass*.

ishability, if you will, of the major works are a clear indication of this belief. And so the question remains open whether the work of Duchamp's last twenty years represents a document of final success or of an ultimate failure to fulfil his own exacting demands.

Cushioned by the privileges of his upper-middle-class background, Duchamp persisted in his aim of resisting commercialization and rapid success. "When I think of all the young people," he told Pierre Cabanne, "who absolutely want to have a one-man show by the

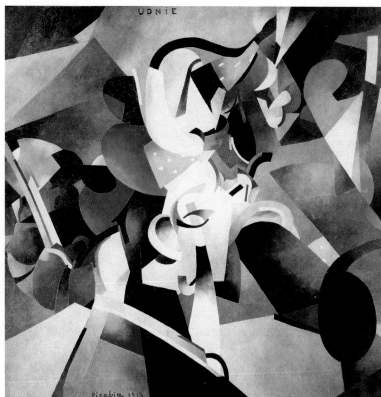

time they're twenty! And believe that that in itself would make you a great painter!" And the "consulting museum authorities," in Duchamp's eyes, were "the art dealers."

Duchamp inspired the art of his and our own times like no other. This holds equally for America and Europe, although he himself considered a society without art a possibility, "a state … perhaps not so nice … but conceivable". The move away from pure abstraction can be traced back largely to Duchamp's influence. Pop Art, which he liked because it waived distortion and abstraction and brought "finished things" into the picture, Op Art, Conceptual Art, all learned from Duchamp, and even the famous visualized statement of Beuys', "The silence of Marcel Duchamp is overrated," reflects an intensive involvement with his predecessor. Above all Duchamp demanded that art be intelligent, wrote Allan Kaprow, father of the Happening, which Duchamp by his own admission would like to have invented himself.

Duchamp was far in advance of his time. With him began what is known as "the expanded arts", the crossing of borderlines between media, the interdisciplinary approach that blurs the distinctions between painting, sculpture, artistically designed spaces ("installations" or "environments"), and object. But above all, Duchamp introduced a reflective art, an art of indirect allusion, including literary and philosophical allusion, which for a thinking artist like Duchamp – as for René Magritte in his footsteps – was just as naturally a part of the work as the mobilization of the viewer. The viewer was chal-

lenged to enter into a dialogue with the work, completing it with his imagination by giving mental associations free rein. With Duchamp began a chapter in contemporary art history that no one could have conceived of before him. In a dialectical shift unparalleled in modern art, Duchamp's years of relinquishing artistic production in favor of reflection triggered creative impulses on the part of great numbers of artists, down to the next and following generations. Hardly ever before or after has uncompromising analytical thinking had so far-reaching creative consequences.

## The Columbus of Art

If Duchamp was a systematic thinker, Francis Picabia was an eccentric experimenter. The quiet concentration of the chess player stood in sharp contrast to the unrest of his anarchic friend. As Picabia's early Orphic-Cubist canvases show, he was one of the most gifted painters of the early century. By conventional standards, he was also one who squandered his talents by sampling style after style and rarely taking enough time to bring any one of them to maturity. Picabia was unconcerned about such judgements, for his heart was in experimentation. What he had done yesterday held no interest for him today. After beginning in the purist style of Section d'Or, he had gone into Orphism. A stay in New York in 1915 was followed the next year by his founding, in Barcelona, of the journal *391*, an offshoot of the New York Dada journal *291*, which sparked discussions on Dada in the group and eventually led to contacts with Paris Dada. Picabia

**Francis Picabia**
Cacodylic Eye, 1921
Oil and collage of photographs, postcards, and papers on canvas, 148.6 x 117.4 cm
Paris, Musée National d'Art Moderne, Centre Georges Pompidou

**Francis Picabia**
Udnie, 1913
Oil on canvas, 300 x 300 cm
Paris, Musée National d'Art Moderne, Centre Georges Pompidou

*"Francis Picabia is the Christopher Columbus of art. His philosophical composure, his creative play and his technical cold-bloodedness have not been matched by anyone. He steers his ship without a compass. He has discovered the 'concrete islands' on which the 'abstract gentlemen' eat each other."*

HANS ARP

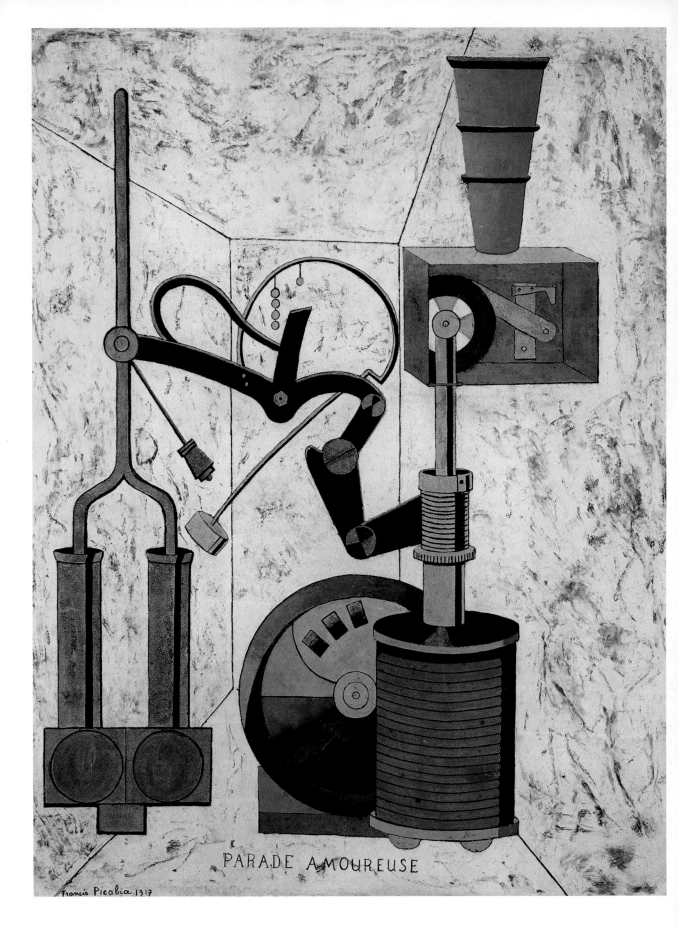

PARADE AMOUREUSE

Francis Picabia 1917

created female portraits out of hairpins and matches, landscapes with trees out of steel springs, painted female nudes on targets – the renowned *Spanish Night* (Cologne, Museum Ludwig) – or on black and white striped backgrounds. His colors were sparing, his materials unusual (pieces of wood, gold and silver powder). The *Portrait of an American Girl in a Naked State* (private collection) consisted of a spark plug. For Picabia and his colleague, Man Ray – as later for the French artist, Arman – the alarm clock was a "symbol of perfect humor."

Picabia, too, was a machine fetishist, as exemplified by *Love Parade* of 1917 (ill. left). The machine gave rise to a new mythology; the "sexual frenzy" of pistons and levers became a dynamic, erotic symbol. The new myths that grew up around technology were multifarious, extending even to the science-fiction legend of flying saucers. Picabia's versions of the myth represented an attempt to affirm the new world of the machine, more intelligent and less aggressive than the Futurists'. Literary quotations pointed to the foundations on which his art, or anti-art, rested, for it was intended to discredit the classical heritage. After the fallings-out among the Dadaists in 1921, Picabia shifted his allegiance to Surrealism, but his restless spirit soon took him down a different path. Later he even made essays in abstraction before returning to objective depiction

again, producing some imagery of a fashionable eroticism that bordered on kitsch. The experiments and youthful glee in discovery of the man whom Arp called a "Columbus of art," if one who always "sailed without a compass," led to successes and failures that have provided a lasting stimulus to younger generations of artists down to this day. A prime example is Sigmar Polke, who was strongly influenced particularly by Picabia's abstract "polka-dot paintings" of the late 1940s and early 1950s.

Picabia can be seen as a key Dadaist figure, despite the fact that a large part of his wilfully contradictory œuvre, inspired by movie magazines, emerged outside the Dada orbit, and that he practiced a hollow, trivial realism in the 1940s in a dubious political accord with the Vichy Regime, before turning to a style that approached abstraction and even, in the late dot-paintings, L'art informel.

Man Ray, painter-photographer and the most significant American Dadaist of the New York group, experimented with arrangements of objects placed on photographic plates and exposed in the darkroom. These "Rayographs" were taken up by László Moholy-Nagy at the Bauhaus, and provided key impulses to artistic photography to come. In cinema, the abstract films produced by the Berlin painter Hans Richter and the Swedish artist Viking Eggeling have lost little of their compelling force even today.

"Artists are afraid; they whisper in each other's ears about a boogey man which might well prevent them from playing their dirty little tricks! No age, I believe, has been more imbecilic than ours."

FRANCIS PICABIA

## Melancholy and Loneliness
### Giorgio De Chirico and Metaphysical Painting

The heyday of Futurism was brief. One of its leading advocates, Carlo Carrà, turned away from the movement in 1917, on the force of a meeting with Giorgio De Chirico at a field hospital in Ferrara. De Chirico was born in 1880 to Italian parents in Volos, Greece, the point from which the legendary Argonauts set sail. Celebrated by Apollinaire in Paris as one of the most astonishing young painters he had met, De Chirico, even before the war, had concerned himself with ways to overcome Impressionism, the art of lovely surfaces, and to penetrate to the "inward meaning of things." De Chirico and Carrà set out to formulate the aesthetic of a *pittura metafisica*, a painting that would project onto canvas metaphysical spaces suffused by deep melancholy, great loneliness, and lurking anxiety. The changeover from Futurist to Metaphysical painting was a radical one. Obtrusive dynamism was replaced by an oppressive, silent immobility, and a "materialistic" representation of subject matter by a metaphysical, arcane symbolism. Turning way from Impressionism, whose nervous, agitated surfaces had been adapted by Futurism, the Metaphysical painters looked back to the mas-

ters of the Early Renaissance in Italy, to Uccello, Masaccio, and Piero della Francesca and their precise delineation of figures and objects, their carefully calculated if perplexingly unreal perspectives.

At the time Carrà was in a clinic being treated for a nervous disorder. When the doctors saw his and De Chirico's paintings, they agreed that the two artists were direly in need of recuperation. This episode is symptomatic, for the traumatic anxiety of the period, the feeling of continual threat, of emotional emptiness and lonliness, found compelling expression in the work of Carrà and De Chirico.

De Chirico, who died in 1978 at the age of nearly 100, came to develop his style in almost complete independence from the different directions in painting that were most influential at the time. Indifferent to Impressionism, Fauvism and Futurism, he admired the then so belittled Arnold Böcklin and Max Klinger, the almost surrealistic painter, sculptor and graphic artist and author of the *Spaziergänge* (Perambulations) and the fantastic *Glove* series of etchings. De Chirico studied with Klinger during his early years in Munich.

"I remember one vivid winter's day at Versailles. Silence and calm reigned supreme. Everything gazed at me with mysterious, questioning eyes. And then I realized that every corner of the palace, every column, every window possessed a spirit, an impenetrable soul. I looked around at the marble heroes, motionless in the lucid air, beneath the frozen rays of that winter sun which pours down on us without love, like perfect song. A bird was warbling in a window cage. At that moment I grew aware of the mystery which urges men to create certain strange forms. And the creation appeared more extraordinary than the creators."

GIORGIO DE CHIRICO

**Francis Picabia**
Love Parade, 1917
Oil on cardboard, 96.5 x 73.7 cm
Chicago (IL), Morton G.
Neumann Collection

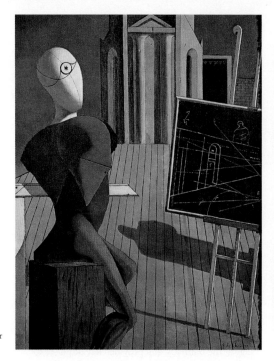

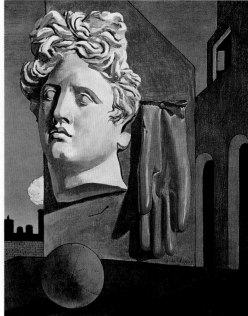

**Giorgio De Chirico**
The Seer, 1915
Oil on canvas, 89.6 x 70.1 cm
New York, The Museum of
Modern Art, James Thrall Soby
Bequest

**Giorgio De Chirico**
The Song of Love, 1914
Oil on canvas, 73 x 59 cm
New York, The Museum of
Modern Art, Nelson A. Rockefeller
Bequest

*"As for me, I am calm, and I deco-
rate myself with three words that I
wish to be the seal of all my work:
Pictor classicus sum."*
GIORGIO DE CHIRICO

The formal logic of De Chirico's pictorial architec-
ture goes back not to Cubism but to the early classical
period of Italian art. The scenes in his paintings are like-
wise classically Italian. They are inspired by the city
squares in Ferarra, a somber, melancholy town redolent
with memories of past celebrations, as well as by squares
in Turin and Florence, open spaces devoid of human
life, populated only by faceless sculptures that cast long
shadows. Monotonous arcades open out like gaping
maws of the void; the abrupt, exaggerated perspective
with its eerily foreshortened lines and close vanishing
points creates an ominous vacuum and a sense of un-
reality. On the horizon one sometimes glimpses a loco-
motive or streetcar, ghost trains from the underworld –
reminiscences of De Chirico's father, who was a railroad
engineer.

These are Kafkaesque scenes, suffused with melan-
choly colors, with green, ocher and grey predominating.
International tourist attractions take on a demonic cast,
things and objects develop a wierd and disturbing life of
their own. The expressive force of the empty, silent spaces
is further increased when the sculptures are replaced by
tailor's dummies, *manichini*, phantom figures made of
leather and wood. Shadows are cast across the squares by
unidentifiable light sources, and in the midst of this
emptiness the *manichini* take on an anonymous, idol-like
presence. The alienation from familiar scenes is com-
plete. De Chirico's displacement of real things into a new
context in which they appear incongruous and unex-
pected engenders a sense of shock and disillusionment.
The viewer is forced to perceive a dreamlike, secondary
reality, and to become involved in interpreting it. This
paradoxical, illogical juxtaposition of disparate things,
which De Chirico said was invented by Nietzsche,

would later become the foundation of the Surrealist aes-
thetic. Nietzsche and Schopenhauer, wrote De Chirico
in his programmatic essay, "We Metaphysicians" of 1919
"were the first to teach what a profound meaning the
non-sense of life has." Good artists, he added, were
"philosophers who have overcome philosophy."

In De Chirico's metaphysical interiors we find col-
lections of the most heterogeneous objects – fragments
of Greco-Roman sculpture, rubber gloves, plaster casts,
fruit, vegetables, cookies, and scientific apparatus, par-
ticularly of the mathematical variety. Behind or between
them there is empty space, which in the course of time
would grow increasingly cut off, bounded, as if the artist
had begun to fear the icy breath of nothingness he him-
self had invoked. The compositions became more com-
plex, but also less clear and more confusing. One senses
a touch of psychological insecurity in such pictures. In
fact, by 1925, when the Surrealists trimphantly caught up
with him, De Chirico had long passed beyond meta-
physical painting. As early as 1919 he had already advo-
cated a return to tradition, thus introducing a wide-
spread development in post-World War I art. De
Chirico began to copy Renaissance masters, especially
of the 15th century, and to praise the great colorists up to
Renoir, especially the Renoir of the pre-Impressionist
years. In the same year as his "We Metaphysicians", De
Chirico wrote an essay that would prove decisive for
things to come. Entitled "The Return to Craftsman-
ship", its penultimate sentence read "Pictor classicus
sum". With this De Chirico not only sealed his return to
the old masters but also his rejection of his epochal early
work. Nevertheless it disturbed him greatly that Carrà,
in his essays on pittura metafisica, neglected to give him
De Chirico, credit for helping to invent the style.

**Giorgio De Chirico**
Hector and Andromache, 1917
Oil on canvas, 90 x 60 cm
Milan, private collection

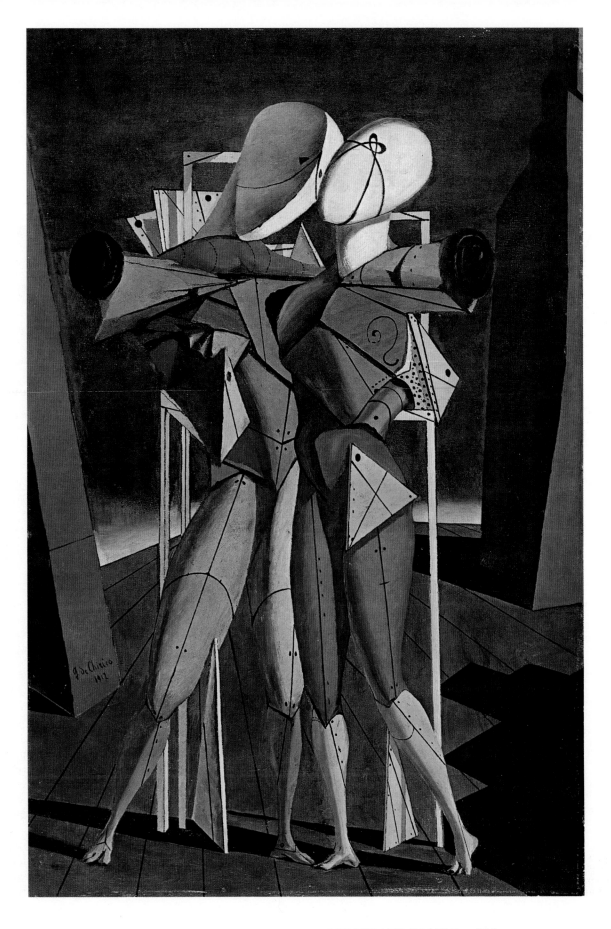

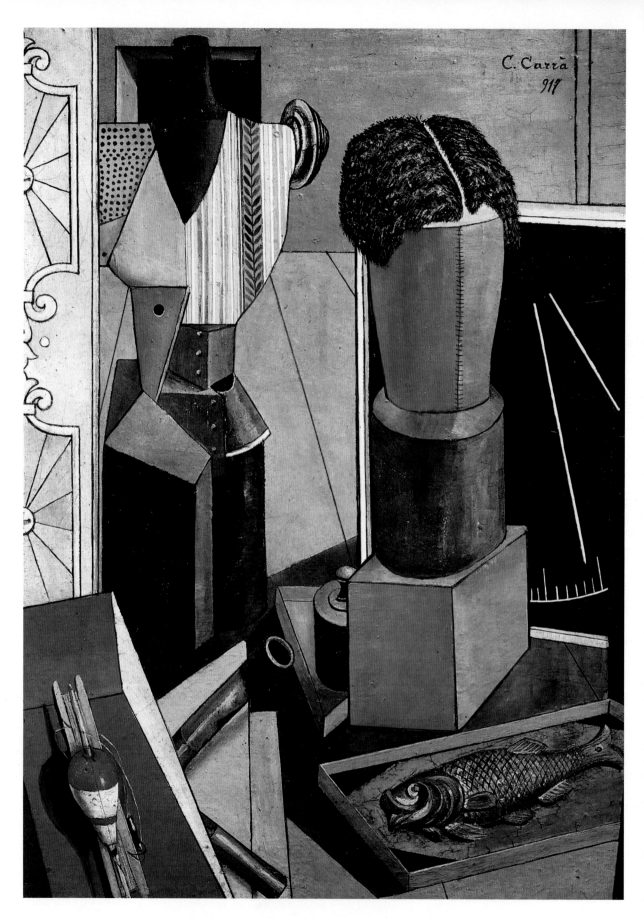

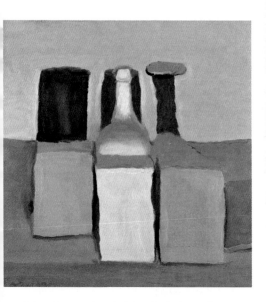

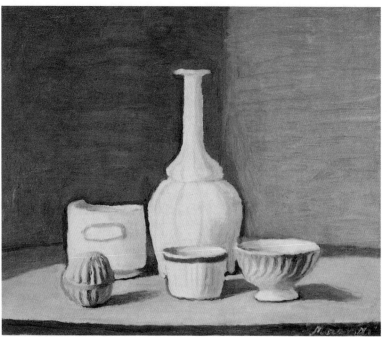

Although more skeptical than in the immediate post-war decades of the notion of a "will to art" as advanced by Alois Riegl, we have broken ourselves of the habit of reproaching artists for not practicing something they never intended. While De Chirico's best works of the 1920s, 1930s and beyond do have a restorative, retrospective tendency, they also possess a great, intrinsic originality. Carrà's "metaphysical" œuvre is closely allied to that of his friend of the early period, who later so bitterly denounced him as an ungrateful imitator. Yet while his work deserves all respect, it rarely achieves the aesthetic logic and compelling poetic force of De Chirico.

A significant variant on metaphysical painting was produced by the like-minded Bolognese artist Giorgio Morandi, whom the rigorous and autocratic De Chirico admired without considering him a true metaphysician. Even more than his landscapes, it is the masterful, enigmatic still lifes of this outstanding painter and draftsman, rendered in subdued colors against indeterminate backgrounds, that discover ever-new painterly and poetic aspects in the simple shapes of mundane things such as bottles, bowls, funnels, cups. Morandi's finest works need not fear comparison with those of Chardin (ill. above).

**Giorgio Morandi**
Still Life, 1956
Oil on canvas, 35.5 x 35 cm
Bologna, Galleria Comunale
d'Arte Moderna

**Giorgio Morandi**
Still Life, 1946
Oil on canvas, 37.5 x 45.5 cm
London, Tate Gallery

# The Omnipotence of Dreams
## Surrealism – From André Breton to the Present

With de Chirico, classical scenes were transformed into nightmarish visions. Surrealism raised this sort of visualization of the unharmonious, dissonant side of human existence to the status of a program. Their inclusion in literature and visual art of the irrational, paradoxical, and absurd had been prepared for by the Dadaist revolt. The Surrealists, led by the writers André Breton, Paul Eluard, and Pierre Reverdy, set out to bring system into anarchy. The first *Surrealist Manifesto* was published in 1924, the second in 1930. The Surrealists marshalled many and diverse ancestors to legitimate their endeavors: Bosch, Breughel, Giovanni Battista Piranesi, the creator of labyrinthine dungeons; the Swiss painter of nightmares Johann Heinrich Füssli (who later, in England, became Henry Fuseli); another Englishman, William Blake; the Goya of the *Caprichos* and the *Horrors of War;* the French artists Redon, Henri Rousseau, and Moreau, mentor of the Fauves; and finally the early Chagall, Klee, a few works by Léger, the Romanian sculptor Brancusi, and more. The *poètes maudits*, or condemned poets, from Rimbaud and Baudelaire all the way back to Lautréamont and Marquis de Sade, were also invoked. That Dada was also a key precursor was something the Surrealists tended to gloss over, despite the great influence of Duchamp. Recent research has brought to light the connections between Surrealism and historical Mannerism, drawing new attention to artists such as Giuseppe Arcimboldo, court painter to

*"Surrealism is based on the belief in the superior reality of certain forms of previously neglected associations, in the omnipotence of dream, in the disinterested play of thought. It tends to ruin once and for all all other psychic mechanisms and to substitute itself for them in solving all the principal problems of life."*
ANDRÉ BRETON

*Page 136:*
**Carlo Carrà**
The Enchanted Room, 1917
Oil on canvas, 65 x 52 cm
Milan, private collection

Rudolf II in Prague, who in a way anticipated the grotesque black humor of the Surrealists.

Max Ernst once said that his art was as unharmonious and inconsistent as his life. In fact for the Surrealists the notion of lending harmony to chaos, of idealizing reality, was a lie, and the idea of the creative artist as a *creator mundi* was a "superstition," in Ernst's view, a sad relic of the myth of creation. More, to limit artistic depiction to the realm of consciousness would be to curtail intolerably the abundance of existence. Citing the insights of psychoanalysis – despite the fact that its founder, Freud, did not appreciate their art – the Surrealists proclaimed the significance of the unconscious mind, of hallucination and dream and states of intoxication and ecstasy, which, they stated, were just as real as the experiences of conscious life. To bring to light previously repressed feelings and images, and thus to visualize the whole of human existence, including its absurd contradictions, its terrors and underlying humor, regardless of social taboos – that was the mission the Surrealists set themselves. They approached the task either passively, as a sort of medium, as in the case of Max Ernst; or actively, as a free-floating, all-knowing, self-styled genius, as in the case of Salvador Dalí.

Surrealism, pronounced Breton, was "pure psychic automatism." That is to say, the Surrealist artist would delve below the level of the conscious mind with its controls and inhibitions, and "automatically" reproduce what his subconscious inspiration dictated to him. He would submit to no morality, repress none of his deepest desires or instincts, because the Surrealist inhabited a value-free realm in which evil, ugliness, cruelty, instinct, paradox, the grotesquely comic, even the satanic, had as much right to exist as the good, true and beautiful. Such ambitious ideals could, of course, be put into practice only partially. The underlying principle was an acceptance of anarchy.

It was thus no wonder that the Surrealists' connection with the radical political Left, especially with the ex-communicated revolutionary Leon Trotsky, proved untenable in the long run. Although the Surrealists considered the existing social order outmoded and hypocritical, they set out, if not to overthrow it, at least to discredit it with every means at their disposal. But they had no desire to be pressed into a new ideological straitjacket. To these artists, with their anarchical love of liberty, their extreme individualism, and their fundamental refusal to submit to the rules of any collective, the humorless totalitarian doctrines took on an increasingly ominous aspect.

On the other hand, the free-floating attitude of Dalí, eccentric provocateur and immoralist, had quite different consequences. Despite his friendship with the Spanish poet Federico García Lorca, who was later mur-

**Max Ernst**
The Rendezvous of Friends, 1923/24
Oil on canvas, 129.5 x 193 cm
Cologne, Museum Ludwig

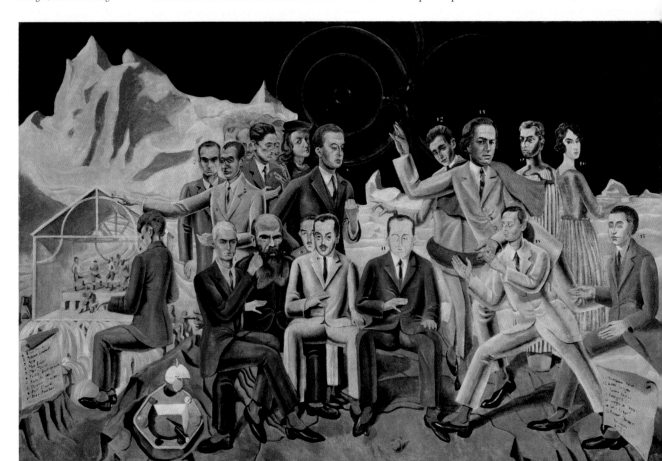

**Max Ernst**
The Entire City, 1935/36
Oil on canvas, 60 x 81 cm
Zurich, Kunsthaus Zürich

dered by the Fascists, and despite his visionary premonitions of the atrocities of the Spanish Civil war as a prelude to the cataclysm of 1939–1945, Dalí toyed for a time with the affinity he felt with the personality of Adolf Hitler. In Hitler's delusions of grandeur Dalí saw – perhaps naively, perhaps opportunistically – certain parallels to his own narcissistic, masochistic, and paranoiac tendencies. Even the apocalyptic visions of this superb mannerist and Surrealist eclectic were presented with a certain coquetry, with a demonstration of virtuosity from the exalted position of Dalí's "critical-paranoiac" stance, and entirely without moral commitment. Dalí was not even entirely unsympathetic to Generalissimo Franco, who was ultimately responsible for García Lorca's brutal execution, which long made the artist a controversial figure, even in his home town of Figueras in Catalonia. His Surrealist colleagues of the early period not only reviled Dalí, they cast him out of the group – at least personally. As far as his art was concerned, they did not like to do without it in their exhibitions.

The systematization of anarchy envisaged by Breton was a typical Surrealist paradox, a contradiction in terms, which was almost impossible to realize in practice. What could be realized, on the other hand, was a merging of the visual with the literary, of form with content, something which was much doubted at the time and later, with the triumph of pure painting and abstraction, was condemned outright as mere "illustration." The finest of the Surrealist painters were precisely those who were able to overcome Breton's contradiction in terms by translating their subconscious visions and dis-

coveries directly into a new pictorial structure with little loss of their fantastic character. This structure served to hold together an abundance of highly diverse mental associations and pictorial sensations. Max Ernst managed this difficult process in a more intellectual way, and Miró in a more playful, spontaneous way.

Other and lesser artists, especially among the following generation, were unable to solve this crucial problem of Surrealism, and remained bogged down in the indiscriminately destructive or the decoratively illustrative. This led to an underestimation of Surrealism that lasted for decades. For a time it even seemed as if Surrealist shock tactics had definitively lost their vitality. It also seemed that interesting after-effects of the kind that undoubtedly occurred in poetry, in the work of René Char and Paul Celan, for instance, were not to be expected in the visual arts. Dalí's virtuoso opportunism, his profitably toyings with the snob-appeal of sophisticated society, appeared to confirm this judgement, as did the platoons of unoriginal camp-followers of Surrealism in both Europe and the United States. In the meantime, however, we know that such sweeping generalizations are bound to be wrong. Gifted painters like Roberto Matta and Wifredo Lam were already at the peak of their powers, and younger artists like Konrad Klapheck, Rebecca Horn, and Jannis Kounellis were on the verge of developing innovative and wittily ironic variations on the Surrealist theme. That the transitions were gradual between Surrealism and Abstract Expressionism on both sides of the Atlantic is now also common knowledge.

"Therefore, when one says of the Surrealists that they are painters of an always changing dream reality, this does not mean that they paint what they have dreamed (that would be descriptive, naive naturalism) or that each one constructs his own little world out of dream elements, in order to behave amicably or in an evil way, (that would be a 'flight from time') but rather, that they move freely, bravely and naturally on what is physically and psychologically certainly a real ('surreal') – even if not yet adequately defined - border area between the inner and outer worlds."

MAX ERNST

kind, with a few additions from the artist's hand, were transformed into natural objects or phenomena. A pattern of parallel bands of grain might become a cleft in a rock-face, and a knothole might be seen as a bird hovering with outspread wings. The stripes of its body merged into a circular head, prompting a mental association with *The Origins of the Pendulum Clock*. Oil paintings, too, could be textured in a similar way, by contrasting various spontaneously rendered free forms. Ernst's images of forests composed of tubelike or serrated shapes were done in this manner. A variation known as grattage involved scratching textures into the painted surface; later pictures were done by "decalcomania," a technique discovered in 1935 and perfected by Oscar Dominguez (ill. below), a Surrealist from Teneriffe who took his own life on New Year's Eve of 1957/58. In this method, a surface covered with wet paint was pressed onto the painting surface, then removed, leaving fantastic, swirling patterns that evoked landscapes of moss, water, rocks, and coral reefs. These patterns set off a chain reaction of creative ideas in the artist's mind.

## Max Ernst's Phantasmagoria

A key part of the Surrealist catechism was Hippolyte Taine's dictum, "The painting, like the perception it reproduces, is hallucinatory by nature. The hallucination, abnormal as it may seem, is the essence of our mental life." Since no artist could continually have hallucinations or be cognizant of the hallucinatory nature of everyday perception, he had to provoke his imagination, inject into its oyster, as it were, the grain of sand which would become the pearl of inspiration. Only by this means could the process of "psychic automatism" Breton spoke of, the process of drawing or painting as if in a "state of trance," be set underway. Max Ernst, based on his Dada experiments, discovered new methods of inducing this enlightened state, techniques by which controlled chance was introduced into the creative process. Continuing the Cubist collage approach, and with an eye to Lautréamont's famous poetic confrontation of a sewing machine and an umbrella on a dissecting table, Ernst juxtaposed disparate, mutually alien visual elements within a new and strange context. His intention, as he once wrote to Franz Roh, was to "generate an electric or erotic tension. The result was discharges or high-tension currents. And the more unexpected the elements brought together [e.g., gun barrel, beetle mimicry, lace petticoat], the more surprising were the sparks of poetry that leapt the gap."

After collage came frottage, a technique based on Ernst's chance discovery of the charm of wood grain in the floorboards of a hotel room. Seeing strange images in the grain, the artist placed a sheet of paper on the floor and rubbed over it with a soft pencil or crayon. The resulting patterns might evoke waves on the sea, and when the sheet was placed over a phonograph record and rubbed again, its grooves became the rising sun on the horizon. Surprising configurations of this

Using these and similar invocatory formulae Ernst created an ambiguous world of imagery, eerie or joyful, dreamily romantic or magically grotesque, in which things of the most diverse description merged without transition: the human with the animal, the animal with the vegetable, the organic with the anorganic. Out of a protoplasm of moss-like forms emerged ominous giant figures that strode towards the dwellings of men: *The Horde* (Amsterdam, Stedelijk Museum). A collection of intertwining, polyp-like shapes, rendered with realistic precision and fitted with birds' heads, became a *Monument to the Birds* (1927; private collection).

An obscenely swelling configuration with three heads, a bird, human, reptile, and monster mammal in

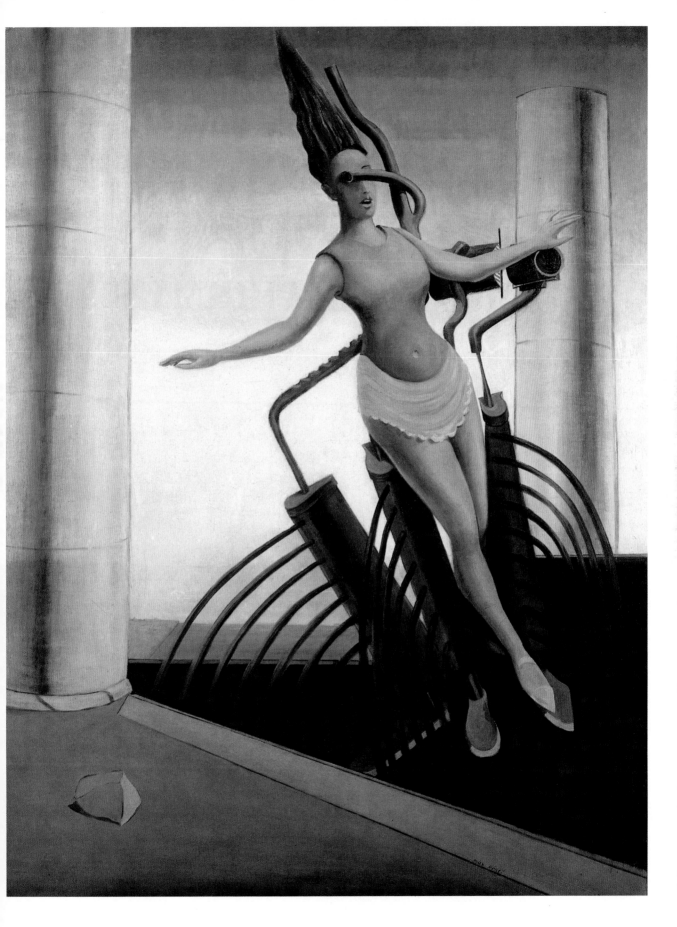

one, "automatically" paints a picture with a hand growing out of its polyp arm: *Surrealism and Painting* (1942; New York, CPLY Art Trust), a grandiose visual translation of Breton's programmatic essay of the same title. *Head, Egg, and Fish* (1925; private collection), painted as if in relief on a wall, is a metaphor for primeval evolution, the seed of life coming to light out of chaos. *Loplop, Chief of the Birds*, becomes a sort of controlling authority, the artist's alter ego, symbolic figure of the subconscious id and the conscious ego both, which in Ernst's case interpermeated and intermerged.

Ernst's phantasmagoria are quite realistic in detail, yet entirely unreal in their combination of disparate elements, their manneristic ambiguity, their inclusion of chance and subconscious imagery. The borderline between external and internal worlds, matter and mind, is transcended, as is the distinction between various periods, for in Ernst's work there is no such thing as development or progress from one phase to the next. The border-lines are vague, and they would remain so to the end of his career. Ernst's inventiveness surpassed that of any other artist of Surrealism, with which only a part of his œuvre was directly associated. A waiver of the traditional sources of artistic inspiration, an objective depiction, and fantasy are combined in a unique way, even in those works which at first sight seem so clear and real, such as the renowned *The Rendezvous of Friends* (p. 138). Only on second glance do we realize that past

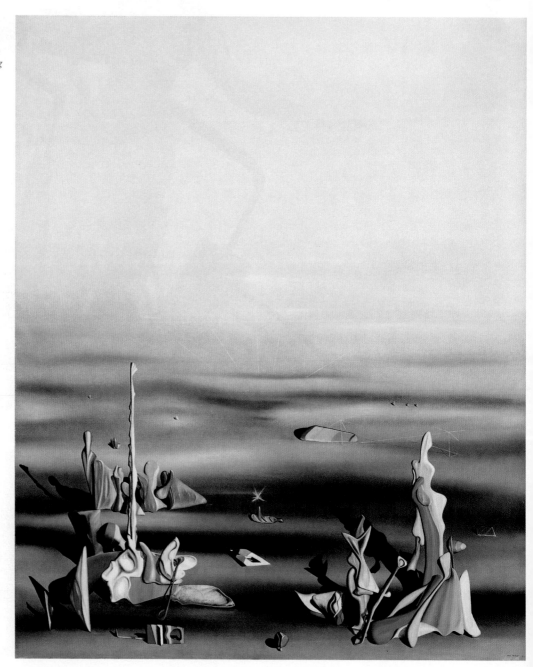

**Yves Tanguy**
The Five Strangers, 1941
Oil on canvas, 98.1 x 81.3 cm
Hartford (CT), Wadsworth
Atheneum, The Ella Gallup
Sumner Collection

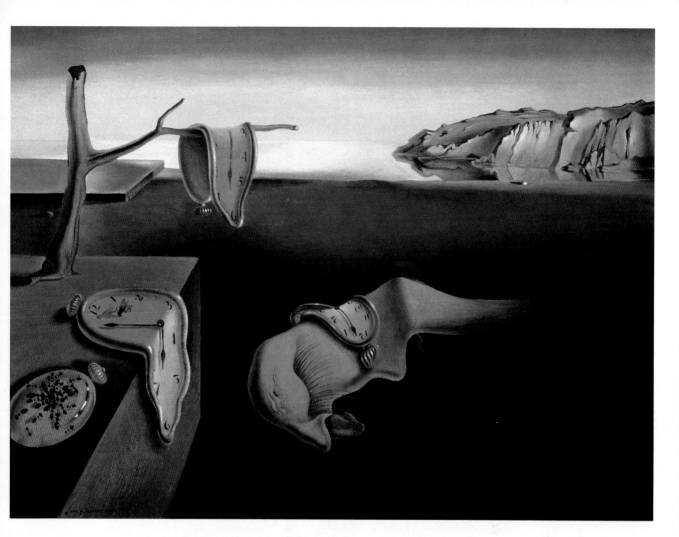

and present (Max Ernst and Dostoievsky, Raphael and De Chirico), real and unreal, day and dream, the living and the dead also have their rendezvous here in this ghostly, airless space.

Much more limited by comparison was the visual vocabulary of Yves Tanguy, a former seaman who decided to devote himself entirely to art after being deeply impressed by a De Chirico painting. Against milky, vague, misty or opalescent, unbounded backgrounds Tanguy set carefully rendered shapes, part animal, part mechanical, evoking things that do not exist in the real world, but which consciously or unconsciously surely reflect the artist's early fascination with menhirs. Tanguy depicted the dreamlike configurations brought forth by his imagination in an almost illusionistic manner, then abandoned them to the wastelands of an unbounded environment in dream landscapes of a high degree of abstraction (pp. 140, 142).

## The Obsessions of Salvador Dalí

Tanguy's seemingly infinite perspectives returned, in a later twist of the spiral, in the much more veristic and descriptive landscapes of Dalí. More than any other Surrealist, Dalí raised the factors of absurdity and simulated

insanity to a principle. The disgusting and obscene, the satanic and monstrous, were presented in a veritably theatrical way. Dalí's technique was brilliant, Old Masterly, correct to the point of pedantry. Yet he used the perfectly rendered naturalistic detail to convey content of a monstrous, unnatural nature. Bloated, decaying limbs form gates of horror, rattling skeletons stuck on posts, emaciated female figures with bellies like chests of drawers, stand starkly against ominous horizons. The essence of this art, what Dalí termed "paranoiac critique", was a hallucinatory exaggeration of sexual, sadistic, masochistic, and compulsively neurotic ideas. According to the artist, blood, decay, rot, and excrement were key components of a painting approach which – like Surrealism in general – continued and ramified the anti-aesthetic principles of Dada in that it was intended to be understood not in the traditional sense, but in the sense of a demonstration and analysis.

Yet Dalí's art in particular obviously displays an abundance of historical references and allusions, especially to Mannerist painting, and ultimately, it too was unable to escape the inevitable transformation of anti-art into a new, as it were "positive" form of art. The clownish, grotesquely comic traits in Dalí's art, intended

**Salvador Dalí**
The Persistence of Memory
(Soft Watches), 1931
Oil on canvas, 24 x 33 cm
New York, The Museum of
Modern Art

*"Soft clocks: they are nothing else than paranoiac-critical, gentle, and extravagant Camemberts outside of time and space."*
SALVADOR DALÍ

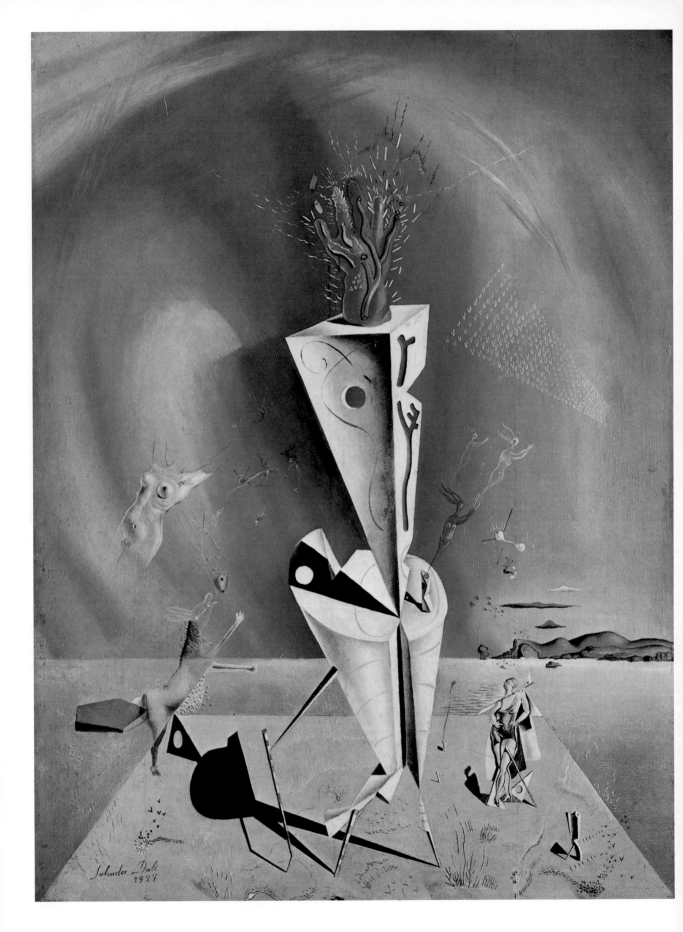

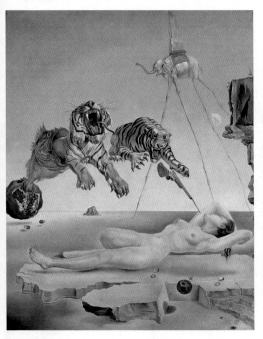

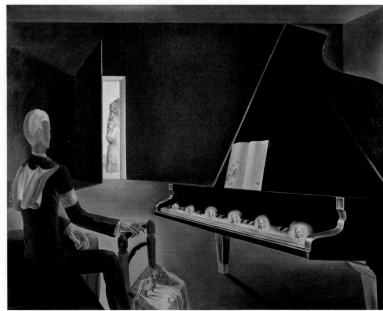

to provoke the complacent, whether of the middle-class or the ideological Left, should not be overlooked. They formed the humus in which the flowers of evil grow. In fact the "satanists," from de Sade through Lautréamont to Baudelaire and Rimbaud, provided as much material for Dalí's pictures as they did for Luis Buñuel's films.

Still, there is no doubting the originality of many of Dalí's pictorial inventions. Examples are the eerie and ironic depiction of soft and drooping clocks in the painting *Persistence of Memory* (p. 143), the apocalyptic figure of the *Burning Giraffe* (1936/37; Basel, Kunstmuseum), or the *The Enigma of Wilhelm Tell* (1933; Stockholm, Moderna Museet), which due to the resemblance to Lenin of the Swiss idol transformed into a cannibalistic anti-hero, caused a scandal among the left-leaning Surrealists – a typical instance of the inevitability of the conflict already mentioned between artistic individual and political collective. However, these and other masterpieces stand opposed to many paintings that exhibit more speculation and empty virtuosity than true obsession and intuition – not to mention the mass editions of facile to slipshod prints and faddish knick-knacks which Dalí sadly also produced.

The Catalan artist is a paragon example of the exhibitionistic self-actor who benefited for decades from brilliant career management. His chief manager was Gala, the woman Dalí took away from Paul Eluard and who jealously guarded over him for more than fifty years. It was only when, with increasing age, Gala began to loosen the reins a bit that her husband fell into the clutches of business-wise secretaries and dealers. That success is not always an insurance of rising quality becomes sometimes cloyingly obvious in the late work of the eccentric and knowledgeable eclectic, even though in middle and old age Dalí again and again pro-

duced a significant work, such as *The Temptation of St. Anthony* (1946; Brussels, Musées Royaux des Beaux-Art), executed in 1946 for a Hollywood competition. Another theme on which Dalí rang many and compelling changes was *The Angelus* by Jean François Millet, a theme whose pious to murderous complexity involved Dalí from his boyhood years to the very end.

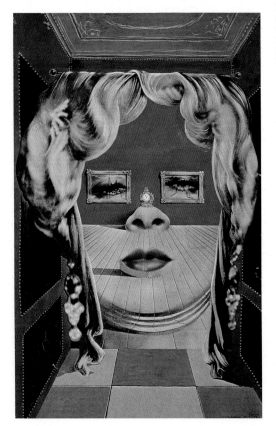

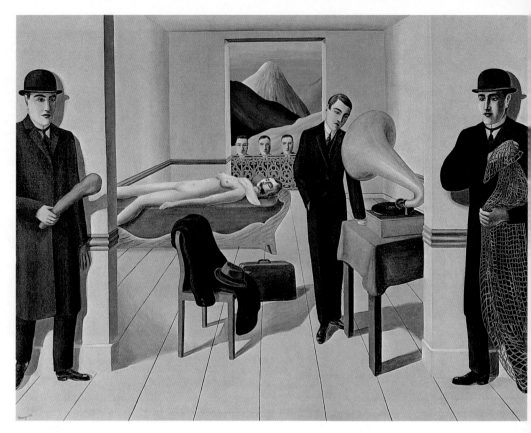

**René Magritte**
The Threatened Murderer, 1926
Oil on canvas, 150.4 x 195.2 cm
New York, Collection, The
Museum of Modern Art,
Kay Sage Tanguy Fund

**René Magritte**
Time Transfixed, 1939
Oil on canvas, 147 x 98 cm
Chicago (IL), The Art Institute of
Chicago

## Surrealism in Belgium

Surrealist pictures tell stories. This is why for many Surrealists a literary idea, an art-theoretical or philosophical commentary, were more important than the actual painterly execution. The intellectually most impressive example of this is the work of René Magritte, a Belgian artist who continued Duchampian notions in painted form. Instead of bringing the aspect of the surreal into his pictures, Magritte built riddles out of components of reality, pointing up its absurdity in the process. Magritte's picture-puzzles are intellectual games that at the same time call reality radically in question. Not an invocation of the unconscious is his theme but the discomfiting of the viewer and his habitual perception, by means of the confrontation, anticipated by Lautréamont, of disparate, uncompatible, mutually alien elements. By so doing Magritte intended to make us stop and think about the nature of reality and our tacit assumptions concerning it, as well as about art and processes of perception in general. Magritte admired the work of his great idol, De Chirico, he said, because of the "superiority of poetry over painting and the diverse painting styles" it evinced. The aesthetic device Magritte used to engender a magical, poetic transmutation of the mundane and to jog the viewer out of his complacency was that of surprise. This effect took the form, in the early, "criminalistic" paintings, of turning familiar situations upside down: in *The Threatened Murderer* (ill. above) the murderer is the victim; in *The Amusement* (Düsseldorf, Kunstsammlung Nordrhein-

"The images must be seen such as they are. Moreover, my painting implies no supremacy of the invisible over the visible."
RENÉ MAGRITTE

**René Magritte**
The Treachery of Images, 1928/29
Oil on canvas, 62.2 x 81 cm
Los Angeles (CA), Los Angeles
County Museum of Art

Westfalen) a girl consumes a bird; in *The Sleepwalker* (1927; Essen, Museum Folkwang) the title figure walks through a nocturnal room lit by a streetlamp.

Magritte's conception of an interplay of painting and poetry, subject and idea, magic and reflection, comes out most clearly in the works in which the subject depicted is verbally denied its identity. The most famous is the painted pipe captioned *Ceci n'est pas une pipe,* or This is not a pipe (ill. above). The prob-lem was redoubled and intellectually sharpened when Magritte repeated the theme forty years later, shortly before his death. This time the picture of the pipe with its negating caption was placed on an easel, within a larger picture containing a larger pipe floating in empty space. Its ironic title: *The Two Mysteries* (1967; New York, Mr. and Mrs. Terry Semel Collection). In both cases it is pointed out that a painted pipe is not a real one; the floating pipe in the later canvas refers

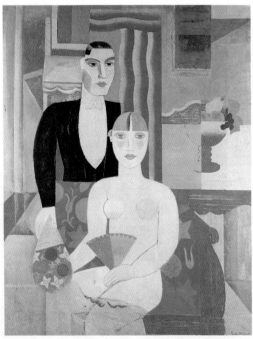

**Frits van den Berghe**
Le Beau Mariage I, 1928
Oil on paper on wood, 64 x 48.5 cm
Private collection

**Gustave de Smet**
The Blue Divan, 1928
Oil on canvas, 145 x 115 cm
Private collection

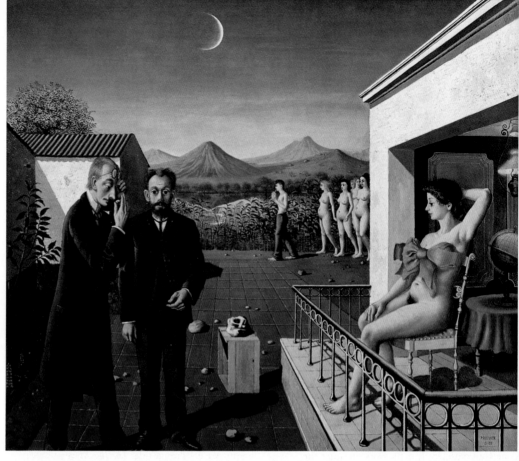

**Paul Delvaux**
Phases of the Moon, 1939
Oil on canvas, 139.7 x 160 cm
New York, The Museum of
Modern Art

once again to this fact, but it is not any more real or tangible than the original pipe, but only a two-dimensional depiction of it.

Similar trains of thought are evident in Magritte's pictures within the picture, such as that of a weightlifter whose bald head is apparently identical with one of the two weights he is lifting, or in the canvas *The Human Condition* (1933; Washington, National Gallery), where the "actual" view through a window merges with a painted section of the same view standing in front of the window on an easel. This picture within the picture effect corresponds to an ambiguous and ironic device that goes back to the Romantic era, that of the theater within the theater, in which the question as to reality and illusion is asked with the same, veritably philosophical force.

The other classical Surrealist of Belgian origin was born a year before Magritte: Paul Delvaux. Originally an

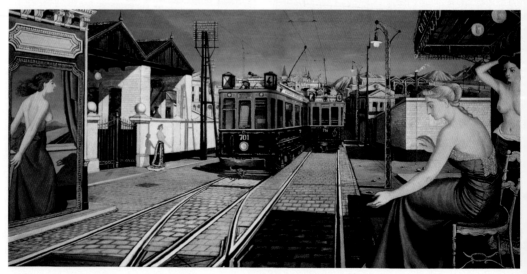

**Paul Delvaux**
The Blue Train, 1946
Oil on canvas, 122 x 244 cm
Private collection

Expressionist influenced by Permeke, Delvaux, like Magritte, had a confrontation with the painting of De Chirico that proved decisive. Yet unlike Magritte, Delvaux relied heavily on imagery from the subconscious mind, especially imagery of an erotic nature. His musing, pale nudes perambulate with empty gaze, sometimes observed by voyeurs alive or dead, through cool, moonlit, imaginary cityscapes in the neo-classical manner, occasionally set off by a De Chirico-like steam engine. The air seems to stand still in the silence of this imaginary realm, in which sexuality and death, ghostly life and waxwork petrifaction, community and loneliness, nightmare and ennui coexist (ill. left).

In this context a brief look must be taken at the so-called Surrealist phase of Picasso's work. After all, the Spanish artist did participate in 1925 in the first Surrealist exhibition at Galerie Pierre in Paris, because he sympathized with the aims of the group and its revolutionary elan, including its then-leftist ideology. It was a similar mood to that which produced Picasso's expressively magical symbolism, though unlike the Surrealists proper and despite his protean liberty in the choice of painterly and sculptural means, Picasso always cleaved closely to reality. Alienation effects and arbitrary combinations of disparate and contradictory elements, a submission to dream and the Freudian unconscious, were things that held no appeal for Picasso. The distortions in his work had a quite different meaning.

## Joan Miró's World

The "psychic automatism" of Breton, which continued to affect *informel* work of Georges Mathieu and the ecstatic drawings of the painter-poet Henri Michaux, found its purest expression in the work of another Spaniard, the Catalan artist Joan Miró, though his style was only partially Surrealist-influenced. Miró's paintings have since achieved considerable popularity. Though it would be cruel to ruin the naive pleasure people find in his fantastic universe of signs, it would be equally wrong to treat Miró as a decorative artist, a teller of lightheartedly grotesque tales populated by strange configurations in vivid colors. He not only painted canvases like the delightful *Harlequin's Carnival* (p. 150), but also the eerie *Head of a Woman* (Los Angeles, private collection) of 1938, a huge and belligerent insect who calls Kafkaesque metamorphoses to mind. Miró's world is not consistently cheerful and sunny; it is occasionally overclouded by something uncannily magical. What distinguishes him from the majority of his contemporaries – including Klee, to whom he owed much – is Miró's ease and originality of invention. He did not need to work through any oppressive visual compulsions in order to arrive at the "second naivety" of the modern artist. Although he oriented himself to historical models such as the Dutch masters, Miró, like the artists of aboriginal cultures, drew on a universe of signs and symbols that was essentially inborn.

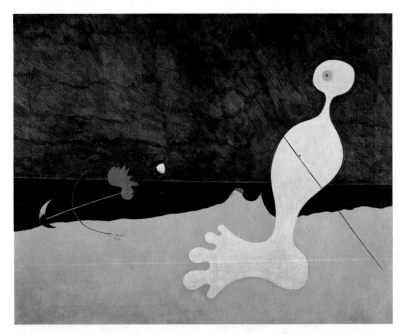

**Joan Miró**
Person Throwing a Stone at a Bird,
1926
Oil on canvas, 73.7 x 92.1 cm
New York, Collection, The
Museum of Modern Art

Miró's development was extremely logical. The early landscapes, done around 1920, reveal an unspoiled eye for reality and the freshness of vision of a Sunday painter. The compositions and rendering of details are rigorous and painstaking, but they already show a tendency to stylization in which the forms are sharply juxtaposed – a Spanish realism curbed by Cubism. Already one sees graphic lineatures beginning to snake playfully across the plane, and numbers appear like magic signs. Such pictures anticipate much of what is to come – a

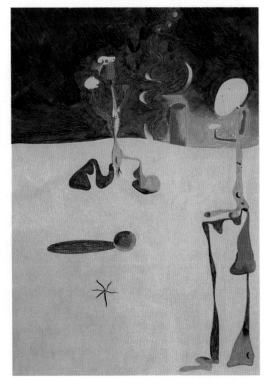

*"Immobility fascinates me. This bottle, this glass, a big stone on a deserted beach – these are motionless things, but they set loose great movements in my mind. I don't feel this with a human being who changes place all the time in an idiotic way. People who go bathing on a beach and who move about touch me much less than the immobility of a pebble."*          JOAN MIRÓ

**Joan Miró**
Nocturne, 1935
Oil on copper, 42 x 29.2 cm
Cleveland (OH), The Cleveland
Museum of Art, Mr. and Mrs.
William H. Marlatt Fund

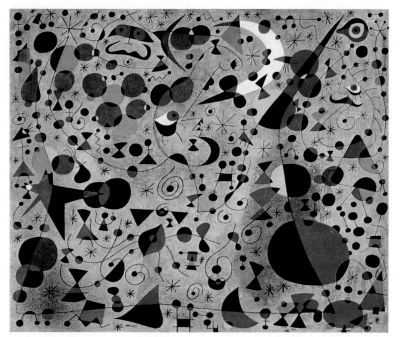

**Joan Miró**
The Poetess, 1940
Gouache and turpentine paint
on paper, 38.1 x 45.7 cm
New York, private collection

**Joan Miró**
Harlequin's Carnival, 1924/25
Oil on canvas, 66 x 93 cm
Buffalo (NY), Albright-Knox Art
Gallery

*Page 151:*
**Joan Miró**
Ladders Cross the Blue Sky in a
Wheel of Fire, 1953
Oil on canvas, 116 x 89 cm
Private collection

reduction of real objects to abstractions, of real scenes to excerpts, emblems. A tree trunk becomes a cone, a plowed field an undulating ornament. But unlike the rigorous paintings of the Cubists, this reduced reality contains an admixture of the fantastic. The crowns of trees sprout eyes, ears grow out of their trunks, a magical triangle is a pyramid, face, and treetop in one. Organic and anorganic forms are set in effective contrast to one

another. As the years go by, the organic elements, derived from the primeval forms of plasma, would come increasingly to dominate Miró's imagery. The circle, his favorite shape, took a place of prominence, whether in pure or irregular form. Human, animal, and vegetable configurations, sun, moon, and stars, began to whirl and intermingle until it became impossible to distinguish them.

Although these configurations are obviously far removed from the realm of everyday perception, they nonetheless retain an individual physiognomy. Their features cover a particular gamut of expressions, all the way from carefree, childlike joy to a barely concealed demonism. Sharp saw-teeth, pointed claws, grisly suction cups, and grasping, amoeba-like creatures point up the fact that one enters the realm of such hybrids of imagination and reality only at one's own risk.

A reliance on chance and on existing objects and materials also played a role with Miró. He learned these techniques from the sculptures of Arp, whose spontaneously engendered organic forms gave Surrealism its most decisive turn in the direction of abstraction. The Surrealist object became a fetish for Miró as well. In his later years he tended, not always advantageously for his painting, to the monumental, reducing forms to the utmost, to signets floating on an expanse of canvas. But that this emblematic art was ultimately nothing other than condensed reality, in both the physical and poetical sense of the word, is revealed by Ernest Hemingway's remark that everything he knew about Spain, Miró had painted – harsh landscape, hot sun, and the bullfight.

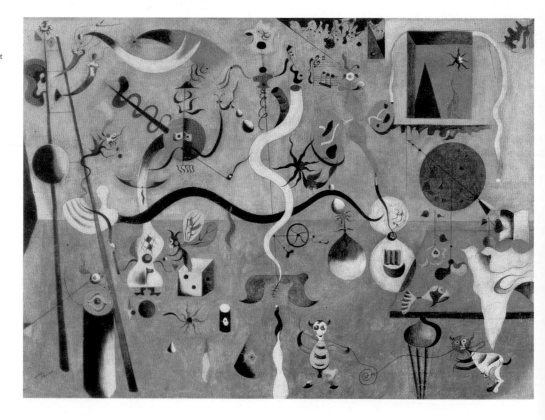

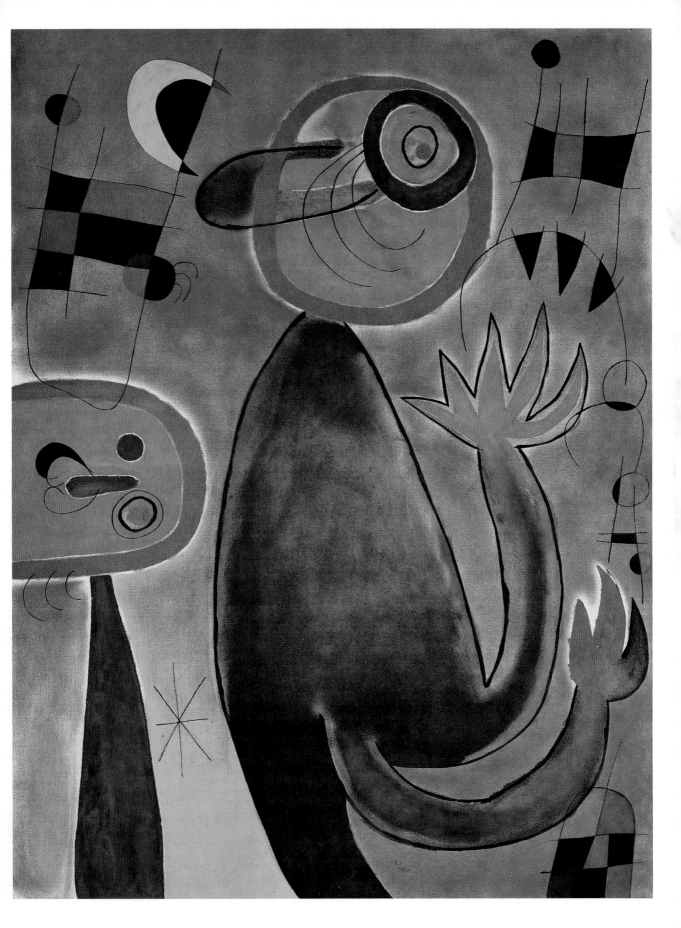

<em>"For me, a picture should be like sparks. It must dazzle like the beauty of a woman or a poem. It must have radiance, it must be like those stones which Pyrenean shepherds use to light their pipes."</em>

JOAN MIRÓ

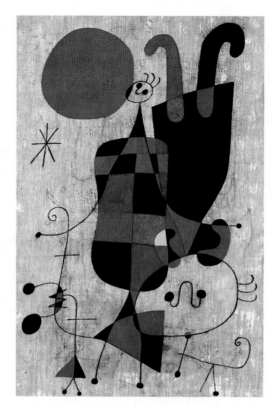

**Joan Miró**
Personages and Dog Before the Sun, 1949
Tempera on canvas, 81 x 54.5 cm
Basel, Öffentliche Kunstsammlung Basel, Kunstmuseum,
Emanuel-Hoffmann Foundation

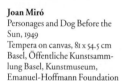

**André Masson**
In the Forest, 1944
Oil on canvas, 56 x 38 cm
Buffalo (NY), Albright-Knox Art Gallery

*Page 153 below left:*
**Léopold Survage**
Surrealistic Composition with Fish and Figures, 1917
Oil on canvas, 92 x 73 cm
Geneva, Musée du Petit Palais

*Page 153 below right:*
**Toyen**
Slumbering Woman, 1937
Oil on canvas, 81 x 100 cm
Private collection

## International Surrealism

Like Miró, André Masson was initially influenced by Cubism. His master was Gris. Yet the stringent composition of the Cubists with its lucid, structural emphasis was soon inundated by a nervous, passionately dynamic network of lineatures that was a direct expression of the artist's mental state (ill. right). This excited, emotionally agitated mood suffuses Masson's œuvre. The paintings of his most significant period, before and after 1930, read like a confirmation of Breton's Surrealist dictum: "Beauty will be convulsive, or it will not be at all."

Masson was highly receptive to the cataclysms and cruelties of the age. The battle of all against all, whether in the animal kingdom, among humans, or even between the sexes, became a trauma for him, and he painted in an attempt to rid himself of it. The result was a strange mythology of destruction: fish fighting one another, birds killing one another, and erotic confrontations that seemed to verge on murder. The experiences of Masson's youth, the First World War, the Spanish Civil War, the Second World War, escape and persecution, the inexorable chain of catastrophes shaped his automatic calligraphies, which during an American sojourn during the war, became feverish and garish. The incredible mental tension under which he stood was impossible to bear in the long run, which perhaps explains Masson's turn back to an Impressionist approach influenced by William Turner, in which he produced pictures of a surprisingly tranquil, reserved lyricism. Yet his earlier automatic technique continued to have an effect on other artists, down to Hans Hartung and

his "psychograms" and Jackson Pollock's drip paintings (pp. 268 ff).

Visions of massacre and inexorable destruction are likewise suggested by the excited and exciting canvases of Arshile Gorky, an Armenian born in Russia who, ill and disappointed, committed suicide in New York at the age of 44. Like Masson's, Gorky's significant and only belatedly appreciated work continued and transcended Surrealism, to take a key place within the Abstract Expressionism of the New York School (p. 278).

The paintings of Richard Oelze, born in Magdeburg, Germany, in 1900, are those of a loner who submitted to no Surrealist dogma. His *Expectation* (ill. right) caused a furor when it was shown in the famous exhibition, "Fantastic Art, Dada, Surrealism," held at the Museum of Modern Art, New York, in 1936. While Oelze's style drew on the lyricism of the German Romantic era, it was a lyricism grown ominous and ghostly. His landscapes show fantastic grottoes and caverns under clouded, endless skies, populated by bizarre, enigmatic figures, animals, plants and spirits with bloated or decaying forms, the whole suffused by subdued, as it were twilight colors, delicate gradations of grey, brown and rose. This hallucinatory realm appears as if behind veils, and over it lies a pall of decay. Like Masson's work, Oelze's macabre depictions of enchanted, romatically surreal locales reflect the anxieties of the age in visual terms.

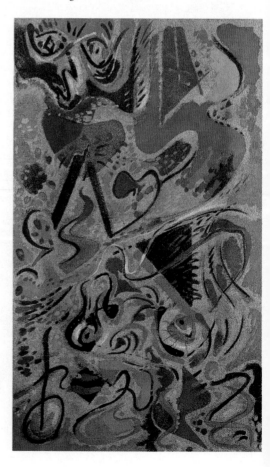

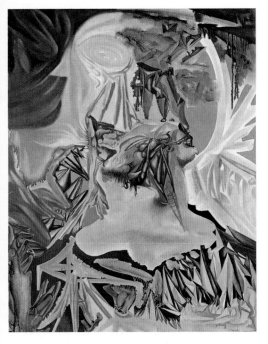

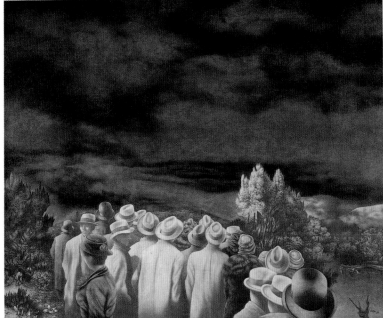

Surrealism, like the fantastic architecture of the Spaniard Antoni Gaudí, is an unclassical art par excellence, a protest against the norm. To that extent it represents a timeless human possibility, a further tributary of the romantic stream that runs through the history of ideas. With this introduction, we can turn to a loner who, though he had nothing to do with Surrealism as a programmatic movement, did apply an essential part of its methods and insights to his art. The English painter, Graham Sutherland transformed landscapes and naturally occurring forms into disagreeable objects, the *objets désagréables* so crucial to the Surrealists. Angular, thorn-studded configurations grow out of half-moon shapes or are imbedded in them; the two halves of a bare, broken branch become threatening elephant's tusks, and a distorted face appears at the point of the break. Sutherland's *Thorned Head* (done in several versions) has a bird's head with a half-open sickle shape containing spear-sharp configurations from another world, half evil birds in a thorny nest, half thistle. The nature mystique in the artist's best works engenders not familiarity but unfamiliarity, alienation, fear. Yet this creative phase was relatively brief. Sutherland also did a number of impressive portraits, including one of the author

**Jacques Hérold**
Heads, 1939
Oil on canvas, 81 x 65 cm
Paris, private collection

**Richard Oelze**
Expectation, 1935
Oil on canvas, 81.6 x 100.6 cm
New York, The Museum of Modern Art

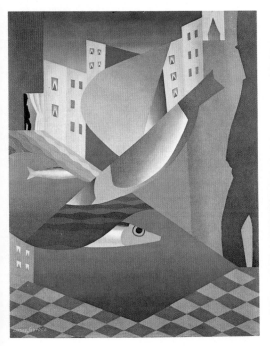

**Graham Sutherland**
Thorn Trees, 1945
Oil on cardboard, 105 x 99 cm
Buffalo (NY), Albright-Knox
Art Gallery

**Sergei Charchoune**
Sentimental Landscape, c. 1915
Oil on cardboard, on canvas,
36.5 x 33 cm
Paris, private collection

*"With respect to my thorn pictures,
I can say, that I was thinking of the
crucifixion… and that I was think-
ing about thorns, about wounds that
come from thorns."*
GRAHAM SUTHERLAND

**Graham Sutherland**
Portrait of Somerset Maugham,
1949
Oil on canvas, 137 x 65 cm
London, Tate Gallery

Somerset Maugham (ill. left). The most famous of his portraits was that of Winston Churchill, which achieved late fame for a rather sad reason – Lady Churchill burned it because it was not sufficiently "like" her husband.

If Sutherland was connected with Surrealism by elective affinity alone, two further artists took up its aggressive tendencies as immediate followers: Roberto Matta of Chile, and Wifredo Lam of Cuba. Matta's enormous canvas *Being With* of 1946 caused a sensation at documenta 2 in 1959, because it proved that supposedly moribund Surrealism still had a great deal of life left in it. The fact that the new wave ran in the opposite direction, no longer from Europe to America but vice versa, was no coincidence. In art as in literature we have repeatedly seen how America takes up European tendencies, emancipates and transforms them, then exports them back to the Old World. "Ping-pong," Pontus Hulten has aptly termed this process of exchange in the history of ideas.

In the work of Matta there is no attempt made to disguise either his critical engagement or his direct reference to current realities. Our technology-suffused existence, including missile launching pads and the experience of space travel, take on painterly presence. The industrialized world becomes a laboratory, an experimental station, with man delegated to playing the role of robot or test-tube product. The human figure in Matta's work appears surrounded by machines, piping and capsules which man himself has created. The machinery, in turn, seems to take on a creaturely life of its own, threatening or tormented, suspended in a mesh of steel rods and levers, the whole teeming with eerie, bristling, insect-like configurations. Matta's colors are cool and thinly applied, his compositions rigorous and graphic; yet at certain points hot, fiery hues in heavy impasto shine out (p. 155).

"I tried to pass from intimate imagery, forms of vertebrae, and unknown animals, very little known flowers to cultural expressions, totemic things,`civilizations."
ROBERTO MATTA

**Roberto Matta**
Bringing Light without Pain, 1955
Oil on canvas, 200 x 300 cm
Brussels, private collection

It is a long path from Duchamp's or Picabia's cult of the machine to Matta's critique of technology and its effects. His critique is radical, and its tone sarcastic and bitter. It is easy to see what side Matta stands on – that of the disadvantaged and dispossessed. The Chilean artist's themes make him a sort of "Hell Breughel" of our own age. Whether you take the serious, silent wall paintings (Matta worked for Le Corbusier as an architect for a few years) or the visions of outer space, the dramatic "paintings of anger and protest," Matta's attempt to face up to a complex and frightening reality and to change his and our lives through art remains impressive.

Wifredo Lam's Chinese father lived to the age of 108, when he died of a fall from a horse. His son inherited this vitality and invested it in a painterly œuvre of great puissance. Lam had Chinese, African, Indio, and European blood in his veins, which is as evident in his paintings as the influence of Picasso. They are populated by figures half-human, half-animal, armed with sharp implements and scythes, performing their dark rites in impenetrable jungles in which hybrid creatures and heads lurk at every turn. Like all of Surrealism, Lam's compositions are not without a touch of grotesquerie and black humor. In his paintings the myths of primitive African and South American tribes are reformulated for the contemporary age, for Lam's nocturnal beings symbolize the jeopardy of human life in a world echoing with war cries and the screams of innocent victims (p. 156 above left).

Another artist who belongs within the orbit of Surrealism is Josef Šima, a Czech painter who, like many Eastern Europeans, spent his formative years in France.

In 1935 he travelled with Breton and Eluard to Prague, establishing first contacts between Czech and French Surrealists. Sima's highly sensitive, poetic, dreamlike compositions delve into the secrets of the universe and also – under the influence of Carl Gustav Jung's psychology – explore the depths of the unconscious mind, whether the subject be "Europe," rendered as a double female torso, *The Fall of Icarus*, or a simple *Landscape* (p. 156 below).

**Roberto Matta**
Untitled, 1971
Oil on canvas, 206 x 160 cm
Private collection

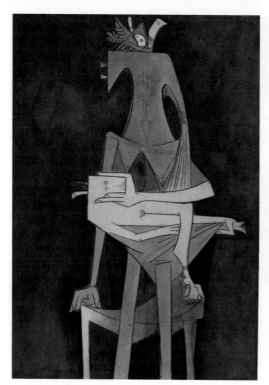

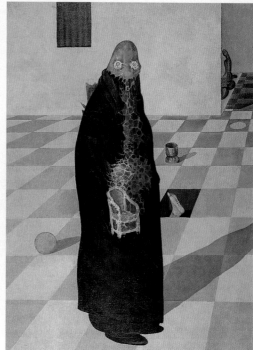

## On the Margins of Surrealism

Another, if less substantial variant of Surrealism was the now almost forgotten "fantastic realism" of the Vienna School, which emerged from the academy class of painter-writer Albert Paris Gütersloh. That this neo-manneristic style arose in Vienna was no coincidence, nor was the influence of nearby Prague and its history, particularly the phase represented by Rudolf II and Giuseppe Arcimboldo. That the group of five artists had as mentor an author who also painted is reflected in the literary bent of their work from the start. Apart from Arcimboldo, they drew inspiration from the art of the late Gothic period, from the Danube School, from the Venetians Gentile and Giovanni Bellini and Carlo

Crivelli, from the Netherlanders Hieronymus Bosch, Pieter Breughel and Joos van Cleve, from the Fleming Joachim Patinier, the Symbolist Moreau, and even the Pre-Raphaelites – indeed a large bite to digest from the history of art.

It must be said that the style of the Vienna School, whether of Ernst Fuchs, Erich (Arik) Brauer, Wolfgang Hutter, or Anton Lehmden, gradually became increasingly facile and superficial. There was "absolutely nothing… new about it," stated critic Uwe M. Schneede. "The ingredients of this marketable mixture of shallow mannerism, high-flown kitsch, and quasi-religious profundity were already musty when they returned in the works of these Viennese artists: a saccharine symbolism,

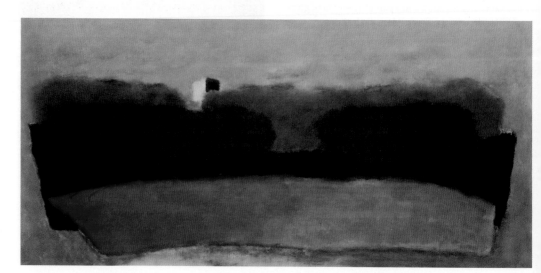

a defused Surrealism, a dolled-up mythology, and exhausted pictorial means." The only member of the group to make a name for himself in the serious art scene was Rudolf Hausner, a thoughtful and painstaking artist whose incessant self-investigations explore the borderline between reality and imagination, which, in Hausner's own words, "continually tend … to inter-merge" (ill. right).

More significant for the later history and effects of Surrealism was the work of Hans Bellmer, which, despite his early contacts with the Surrealists and his friendship with Max Ernst, Man Ray, Yves Tanguy, and Paul Eluard during the French emigration, did not find the attention it deserved until after 1945 (ill. below) – more precisely, until the participation of this brilliant graphic artist in the great Surrealism demonstration of 1947. Bellmer's erotic obsessions between dreaming and waking, his fantastic labyrinths out of which leads no Ariadne's thread, visualize, as Herbert Pée notes, "the inferno of the instincts" in a way that recalls Hieronymus Bosch.

The erotic theme appeared no less subtly, if much less directly in the paintings, collages, and objects of the fascinatingly beautiful Meret Oppenheim. In her case the aspect of the absurd was addressed straightforwardly, by means of a combination of disparate and contradictory realities, materials and iconographies that, strictly speaking, were mutually exclusive.

A quite different case is represented by Gerhard Altenbourg, an East German artist who died in an accident shortly before the reunification of the country in 1989. An isolated loner in the then GDR, Altenbourg anticipated the mode of the drawing as an autonomous work of art, a theme to which much space was justifiably devoted at documenta 6 in 1977. His profoundly romantic imagery bears as much affinity to Klee – who also relied on many Surrealist devices – as it does to programmatic Surrealism proper. The image, whether a head, a figure, or a landscape, was developed without a

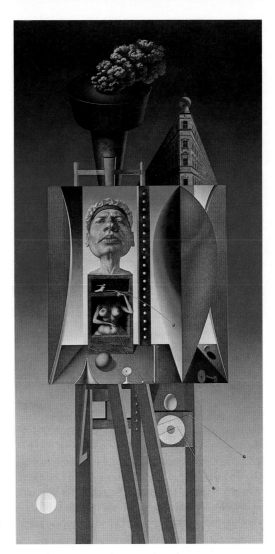

pre-conceived plan, if not entirely "automatically." The narrative or literary elements in Altenbourg's works, their enigmatically distorted, fundamentally indecipherable configurations, their mixture of conscious and unconscious promptings, and the poetic "christening" of spontaneously emerging imagery, all point back beyond Surrealism to the Romantic era – up to and including the scurrilous jesting of a Jean Paul. As the richly nuanced, indeed sometimes oversumptuous palette of many of Altenbourg's watercolors, gouaches, and tempera paintings indicates, this born draftsman was also a gifted colorist (p. 368).

In the United States, Surrealism never dominated the art scene as it did for a time in Europe, and this despite the 1937 exhibition "Dada, Fantastic Art, Surrealism," despite the presence of many war emigrés (including Ernst, who in 1946 married Gorky-student Dorothea Tanning), and despite the pioneering art of Gorky himself. Surrealist influences, which ranged from Gorky to C.G. Jung, were ultimately turned in a quite different direction, as seen for instance in Pollock or De Kooning. It should not be overlooked, however, that

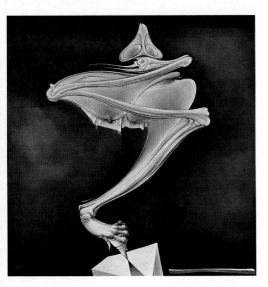

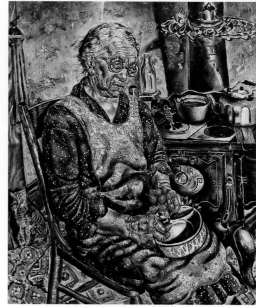

**Dado**
The Massacre of the Innocents,
1958/59
Oil on canvas, 194 x 259.5 cm
Paris, Musée National d'Art
Moderne, Centre Georges
Pompidou

**Ivan Le Lorraine Albright**
The Farmer's Kitchen, c. 1933/34
Oil on canvas, 91 x 76.5 cm
Washington, National Museum
of American Art, Smithsonian
Institution

infusions of Surrealism altered the style of precisionist, socially critical realists such as Ivan Le Lorraine Albright (ill. above right) or Peter Blume in the direction of the fantastic.

Surrealist tendencies in the art of the Eastern Bloc countries of the day were long subjected to political repression. As a result, to give only two examples, the Ukrainian artist Alexander Tyschler was unable to retain the visionary force of his early painting, and Dado felt himself compelled to abandon Yugoslavia for Paris (ill. above left). However, one need only take an even cursory look at the contemporary Eastern European scene

to realize that the love of the super-real and fantastic can never be entirely suppressed.

The imagery of Balthus, the brother of the esoterically erotic painter-writer Pierre Klossowski, whose family came from Poland, is situated in the twilight zone between Surrealism and an almost magical realism, which is not blatant but psychologically subtle. Indicatively the aging Rilke admired the young prodigy Balthus, who soon augmented the sensibility of a Far Eastern painter by a precision of detail and a logic of composition which went back to illustrious artists of the past, from Piero della Francesca in the Renaissance

**Louis Soutter**
Abel, 1937–1942
Gouache and India ink on paper,
64.8 x 49.8 cm
Napa (CA), Hess Collection

**Adolf Wölfli**
St. Adolf Diamond Ring, 1913
Pencil and crayon on paper,
98 x 74.7 cm
Bern, Adolf Wölfli Donation

**Balthus**
The Street, 1933
Oil on canvas, 195 x 240 cm
New York, The Museum of
Modern Art, James Thrall Soby
Bequest

to Courbet's 19th-century naturalism. Until the 1960s Balthus enjoyed the reputation of a rather decadent painter for a small coterie, who, however, paid well for his works. With their elegantly subdued palette, at first a bit on the dark side, but then becoming lighter, more pastel, these interiors and figures are marked by a silent, dreamlike tranquillity. The girls in Balthus' pictures are not yet women, but no longer girls; they possess an ambivalent sexuality between innocence and vice, which, often underscored by obvious devices, fills the scenes with a lasciviousness that recalls the salons of Marcel Proust. Balthus's sophisticated painting technique partakes of the surreal, though certainly not of doctrinaire Surrealism. It calls to mind theater scenes in suspended animation, tableaux in which the familiar grows strange and mundane reality takes on the vividness of dream (ill. above).

It is a far cry from this intelligent, sophisticated, high-strung erotic art to the works of those painters who occupied the twilight zone between delusion and reality, and in whom the Surrealists' interest was sparked by Hans Prinzhorn's collections and writings, foremost his 1922 book, *Bildnerei der Geisteskranken* (The Picture-Making of the Mentally Ill). Space permits reference to only three exemplary figures: Friedrich Schröder-Sonnenstern, Adolf Wölfli (p. 158 below right), and Louis Soutter (p. 158 below). The youngest of the three, who

styled himself "Friedrich the One and Only," was a restless if entirely benign wanderer, who later became the victim of unscrupulous forgers of his eccentric colored-pencil works. The second, Wölfli, was a compulsive sexual criminal. The third, Soutter, a failure in normal life, was committed to an asylum by his family when, bitterly disappointed and abandoned by wife and friends, he returned from America to Europe at an advanced age. For all three artists, spontaneous visual creativity served to help them overcome the speechlessness into which their inability to adapt to the norms of society had forced them. Their aggressive, anarchic allegories were a visible sign of the suffering of the social pariah from the coldness and indifference of the age, from unchanneled sexuality, from the lack of meaning in their own and others' lives, and from the plight of the poor and outcast. Schröder-Sonnenstern's garish drawings, Wölfli's visual rebuses, Soutter's fingertip-paintings emerged from the same subconscious depths that played such a key role in Surrealism. But in their case, there was no simulation of states of madness as advocated by Breton as a means to "reunite dream and waking states, insanity and reason" (T. Spoerri), no artificially induced intoxications or ecstasies. If their imagery moves us, it is because it emerged immediately and uncensored, without aesthetic calculation, from the depths of their troubled souls.

*"Every time that I have placed the last brushstroke on a painting, I am overcome by the idea that I have forgotten everything that I knew about my art and will have to discover everything anew. It is as if you wake up, have to write a speech, and then realize that you cannot recall the simplest rules of grammar."*
BALTHUS

**Kasimir Malevich**
Suprematism, c. 1917
Oil on canvas, 80 x 80 cm
Krasnodar, Lunatscharski-
Museum

# Abstraction and Reality

## Russian Revolutionaries and Dutch Iconoclasts
### Suprematism, Constructivism, and "De Stijl"

It is an age-old dream of artists, that the creation of a better and more beautiful environment will further the emergence of a new and more noble type of human being. This utopian idea has metaphysical roots, in that it is related to religious doctrines of salvation. Such dreams have retained their effect down to the present day, especially among architects. That 20th-century architecture was profoundly influenced by an anti-individualistic style of art which claimed to establish a new universal order is therefore not surprising. Russian "Suprematism" and its successor, "Constructivism," as well as the Dutch movement, "De Stijl," were rooted in an attempt to change the world and to create a functional, normative art. All the artists involved in both movements – with the exception of Kasimir Malevich – rejected the traditional concepts of the fine arts as being sufficient unto themselves. Both movements envisioned a universal, collective art for all, an applied art in the best sense, far removed from all individualism and subjectivity. No greater contrast to the fantasies and ecstasies of the Surrealists is imaginable. Russian Constructivism, especially its Suprematist phase, rooted in pre-revolutionary anarchism and later condemned by Lenin, might be characterized as the "romantic" side of the movement, while the Dutch variant represented the "classical" side with its idealistic and spartanic emphasis. Suprematism and Constructivism had a tendency to the infinite and absolute, Suprematism exhibiting a more mystical, pathetic strain and Constructivism a more futurological, technological one. The artists of De Stijl oriented themselves towards the exactly defined and delineated plane. But whether it was the dynamic pictorial structure of the Russians or the static one of the Dutch, all strove for the greatest good for the greatest number, a utopian striving which is symbolically reflected in the themes of their works.

The widespread belief that two different and mutually alien cultures existed in Europe was an untenable hypothesis long before the political upheavals of the late 1980s and early 1990s. It was disseminated as opium for the people on both sides of the Iron Curtain during the Cold War, which had been touched off in February 1945 by the notorious Yalta Conference. Art was enlisted by the opposing ideologies as an instrument of political propaganda, chauvinistic Socialist Realism on the one side, and on the other abstract art, which was touted as a symbol of Western freedom. One plain fact tended to be overlooked: that officially sanctioned art was not the only art that existed beyond the border, and that neither

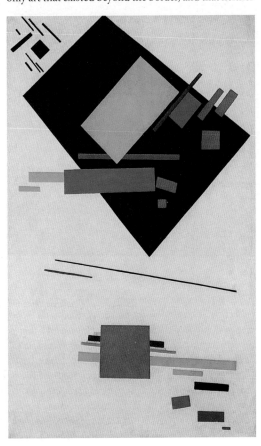

*"It has become clear to me that new frameworks of pure color-painting should be created, constructed at color's demand; and, secondly, that color should leave the painterly mixture and become an independent factor, entering the construction as an individual of a collective system and individual independence."*
KASIMIR MALEVICH

**Kasimir Malevich**
Suprematist Painting, 1915
Oil on canvas, 101.5 x 62 cm
Amsterdam, Stedelijk Museum

the Eastern European dictatorships nor the Soviet Union under Stalin had been able to completely suppress it. European art history in the 20th century, as Riszard Stanislawski points out, rested on "reciprocal inspiration," on a continual exchange of ideas between East and West. The question of priorities is moot, because they continually changed. This was first brought to widespread public attention in the late 1970s and early 1980s by "Paris-Moscow," an exhibition curated by Pontus Hulten and shown at the Centre Pompidou in Paris and at the Pushkin Museum in Moscow.

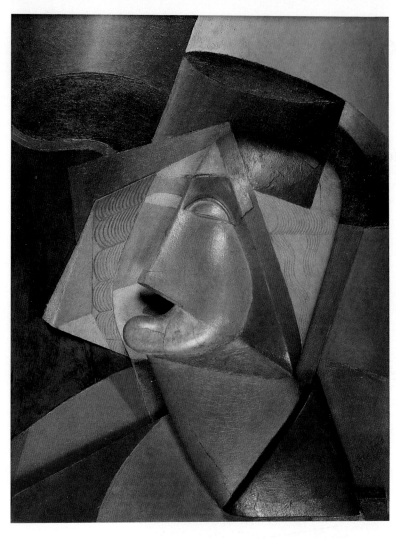

**Alexander Archipenko**
Woman with Hat, 1916
Oil, metal, papier maché and
gauze on wood, in wooden frame,
35.5 x 26.5 cm
Private collection

*"The forms of suprematism, the
new realism in painting, are already
proof of the construction of forms
from nothing, discovered by intu-
itive reason."*

KASIMIR MALEVICH

Not only the Jewish art tradition but also that of the Slavs, which was subjected to alien influences, Byzantine and European, for a millennium, attained a new self-awareness only in our own century. This liberating moment came suddenly, ten years before the October Revolution of 1917. Shchukin and Morozov brought paintings by Cézanne, Gauguin, the Fauves and Cubists to Russia; Russian artists travelled to France and Germany. These events could not remain without consequences. Kandinsky made the final step towards absolute abstraction; Chagall lent the imageless world of Jewish legends and myth visual concreteness; Leon Bakst made Russia's most significant contribution to the theme of the stage set as a work of art. Alexander Archipenko (ill. left) and above all Vladimir Tatlin, subsequent designer of the famous *Monument to the Third International* of 1919/20 (p. 444), created the first abstract sculptures, reliefs and objects, Tatlin as the result of an early involvement with Picasso's collages in space, which he transformed into three-dimensional works in wood, glass and metal.

The first programmatic art of Russian origin was practiced around 1911 by Mikhail Larionov, founder of "Rayonism" (French *rayonner* = radiate), a style based on Futurism and Cubism which sought to liberate color and form. Flecks and rays of color, corresponding to the Futurists' lines of force, were arranged into self-sufficient compositions entirely independent of the motif. Initially these works were completely free-form, with no trace of figurative allusion (p. 163 below).

The year 1913 marked the publication of the *Rayonist and Futurist Manifesto*. Working in collaboration with his wife, Natalia Gontsharova, who did not approach so closely to complete abstraction as he did (p. 163 above right), Larionov also continued to paint in a starkly simplified figurative vein and designed sets for Sergei Diaghilev's Russian Ballet. While Larionov's innovative ideas initially remained an episode, they, and his magnetic personality, nevertheless had a great influence on his Russian colleagues.

### On the Verge of Nothingness: Kasimir Malevich

Kasimir Malevich (pp. 160, 161, 164, 165), like Tatlin, fell especially under Larionov's spell, though he was destined to far outstrip his mentor in terms of audacity, influence, and gifts of design. Malevich has gone down in art history as the initiator of Suprematism. This awkward neologism was intended to express a very simple aim: to lend supremacy to the basic means of art, color and form, over the mere depiction of phenomena of the visible world. It is important to know that Malevich spoke in this connection of the "supremacy of pure sensation." This reveals the romantic tendency of his thinking and art, and excludes the possibility of considering his paintings the result of purely intellectual processes. Though Malevich was indeed fascinated by the beauty of mathematical forms, he wished to infuse them with passionate emotion, with a sense of what he

As surely as the French paintings bought by Russian collectors Mikhail Morozov and Sergei Shchukin greatly influenced the early Russian avant-garde, there is no denying that Western abstract painting would be an entirely different thing without Čiurlionis, Kupka, and Kandinsky, or De Stijl without Suprematism and Russian Constructivism. Also, the work of many emigrés who achieved fame in the West was clearly rooted in Eastern traditions. This is just as true of the Romanian sculptor Brancusi as of the Russian artist Chagall, or of the Polish-born painter Roman Opalka, not to mention Vitali Komar/Alexander Melamid and Ilya Kabakov, who years ago exchanged Russia for the blandishments of the American West. The long, in part politically conditioned absence of Eastern European art from Western museums has tended to blind us to this circumstance, as has the facile "naturalization" of the works of Eastern artists in Western cultural scenes. The question whether what Thomas Strauss calls the "avant-garde as idea" emerged in Eastern or Central Europe need not concern us. Western and Eastern avant-gardes simply cannot be separated.

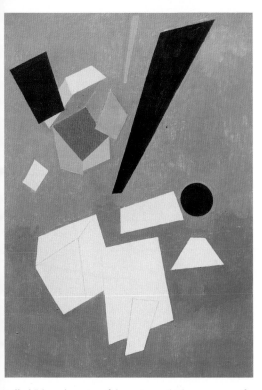

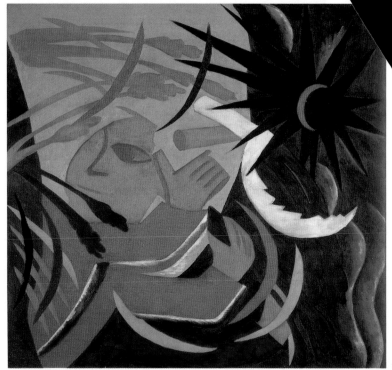

called "the solemnity of the universe." The expanses of the backgrounds in his paintings, the vibrating textures that seem to continue virtually into infinity and the concise visual signs that float in front of them, correspond to the amplitude of Malevich's sensibility. Passion and scientific accuracy (Malevich apparently drafted his trapezoids and ellipsoids under the influence of Tatlin's material constructions) combined in his work with an

ecstatic invocation of a New Age to come. Admittedly the Russian artist knew that this was a goal that could only be approached but never reached. The meaning of his revolutionary painting lay in the journey, the process of moving towards the infinite, towards that zone of "non-objective" perfection in which the oppositions between man and nature, mind and matter would be overcome.

**Ivan Puni**
Suprematist Composition, 1915
Oil on canvas, 94 x 65 cm
Amsterdam, Stedelijk Museum

**Natalia Gontsharova**
The Harvest, 1911
Oil on canvas, 92 x 99 cm
Omsk, Museum of Fine Arts

**Mikhail Larionov**
Rayonism, 1912/13
Oil on canvas, 52.5 x 78.5 cm
Ufa, Baschkirski Muzei

*"The square is not a subconscious
form. It is the creation of intuitive
reason. It is the face of the new art.
The square is a living, royal infant.
It is the first step in the pure creation
in art. Before it, there were naive
deformities and copies of nature."*
KASIMIR MALEVICH

Malevich was the first artist to seriously attempt to achieve absolute painting, cleansed of every objective reference and allusion. He aimed at "a new reality of color, understood as non-objective pictorial creation. The forms of Suprematism have the same life as the forms of nature. This is a new pictorial realism, purely pictorial, because the reality of mountains, sky and water is absent. Every real form is a world, and every pure painting surface is more alive than a painted or drawn face, out of which a pair of eyes and a smile stare." That Malevich was one of the first artists to discover the expressive potential of empty space, the void, was no coincidence – the experience of flying had opened his eyes to it.

Initially impressed by the Nabis, Vuillard, Bonnard, and Vallotton, Malevich later involved himself with Fauvist and Cubist art. An undertone of Russian folklore is present in all his early paintings, whether they represent a woman and man on a village street, a man carrying a heavy sack, or a couple dancing the polka. The colors are luminous and heavy, the forms ponderous and rustic, and the compositions are suffused with the humor of a Gogol. Then the artist began to bring his temperament under control. The forms of the human figure and natural scene were condensed, then subsequently geometrically abstracted to produce an autonomous pictorial order. Behind these pictures one senses the presence of Léger, as one senses that of Gris behind Malevich's superb *Head of a Peasant Girl* (1912/13; Amsterdam, Stedelijk Museum). This imagery laid the groundwork for Suprematism.

It was evidently in 1913 that Malevich painted his famous – and notorious – *Black Square on a White Ground* (cf ill. left), entirely independent of European developments and influences. First exhibited in 1915 at the latest, the canvas was the first in the long series of "last paintings" subsequently done in the course of the 20th century, symbols of artists' final detachment from the visible, exterior world. Malevich invoked the "naked, unframed icon of our age." His asceticism, driving him to the borderline of nothingness, reached its culmination in 1917 with the white-in-white painting *White Square on a White Ground* (New York, The Museum of Modern Art). These manifestations profoundly influenced modern developments down to Clyfford Still, Yves Klein, and monochrome painters such as Robert Ryman, Piero Manzoni, and Raimund Girke, all the way to the painterly œuvre of Jannis Kounellis, one of the key representatives of Arte Povera, which has since expanded into the mythical dimension.

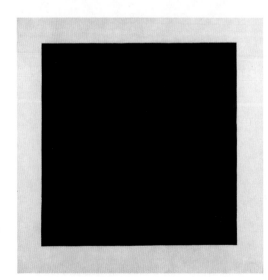

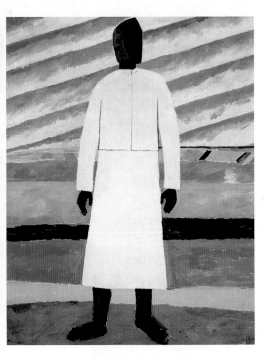

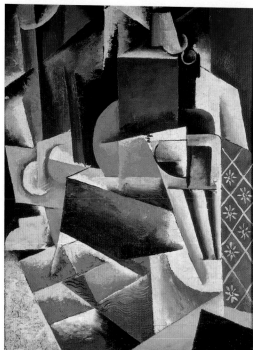

**Kasimir Malevich**
Peasant (with Black Face),
c. 1928–1932
Oil on canvas, 99 x 80 cm
St. Petersburg, Russian State
Museum

**Lyubov Popova**
Still Life, 1915/16
Oil on canvas, 54 x 36 cm
Gorki, State Art Museum

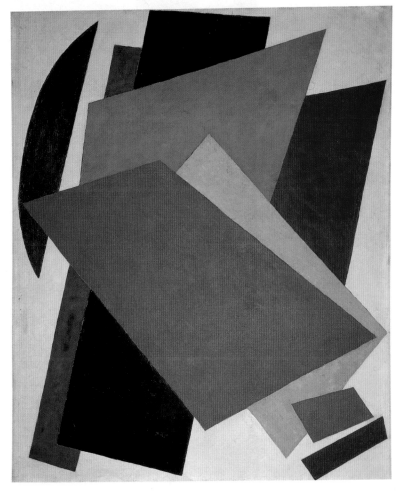

**Lyubov Popova**
Painterly Architectonics, 1917
Oil on canvas, 106 x 88 cm
Krasnodar, A. F. Kowalenko-
Museum

Malevich's triangles, rectangles, crosses and trapezoids are magic, dynamic signs that hover within seemingly infinite spaces. It is this tendency to endlessness and dynamic motion that distinguishes these works from those of the De Stijl group, which are composed by reference to the delimited plane surface. The meditative, even mystical lyricism of Malevich's paintings ("I didn't invent anything," he said, "I just felt the night within myself and sensed the new thing I call Suprematism") stands in contrast to the practical nature of his architectural models, which fundamentally influenced 20th-century architects, Frank Lloyd Wright among many others. Apart from Malevich, whose Suprematism temporarily or permanently cast its spell over many major Russian artists – his later wife, Nadeshda Udalzova, Nikolai Suetin, Ivan Kliun (p. 164), Ivan Puni (p. 163), Pavel Mansurov, Alexander Rodchenko (p. 166), Lyubov Popova (ill. right), the Cubo-Futurist Alexandra Exter (p. 166) and others – Tatlin and above all El Lissitzky emerged as key influences. Tatlin was the founder of Constructivism, in comparison to Suprematism, a much more worldly movement oriented towards technology and its applications. Tatlin's, Rodchenko's, Vassili Ermilov's and many others' abstract, mechanistic paintings and reliefs made of glass, wood, metal and concrete inspired the sculpture of the brothers Naum Gabo (pp. 406, 452 f) and Antoine Pevsner (pp. 450 f). Later "kinetic art," from Alexander Calder (pp. 468, 471, 473) to Jean Tinguely (pp. 499, 506–508) and Nicolas Schöffer (p. 582), can also be traced back to Constructivism. Its representatives felt a deep-seated disappointment with the existing world, its outmoded systems and unjust hierarchies;

they sensed the emergence of a new, technological age and expressly wished to help shape it. Their work is an impassioned profession of the beauty of technology, which in their eyes established new human values and represented a hope for the betterment of the lot of the proletarian masses.

### The "Proun" World of El Lissitzky

El Lissitzky (pp. 167f) joined the Suprematist-Constructivist group shortly before its historical exhibition of

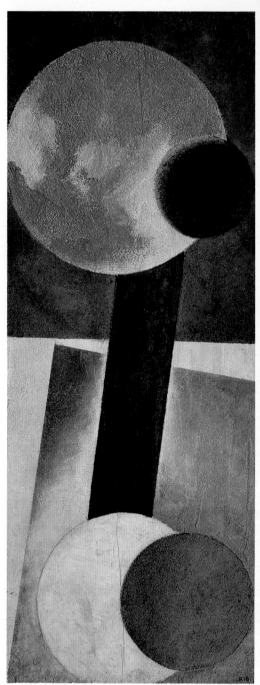

1919, which summed up its achievements to date and pointed towards a new, revolutionary future. Two years later, Lenin's announcement of a "New Economic Policy" abruptly, and quite unrevolutionarily, cut off this future before it could begin. Thus the cornerstone was laid for that simple-minded backwardness in which, cemented by Stalin's enthronement in 1932 of Socialist Realism as the only true proletarian mass art, official Russian art would find itself for decades to come. Heroic maidens, super-soldiers, and noble, self-sacrificing workers replaced genuinely revolutionary Russian Soviet art, which was outlawed and officially disap-

peared from the scene. Still, the undesirable works of art were not destroyed, as they were under the Nazis; they were put in storage, out of which they gradually began to re-emerge even before *glasnost* and *perestroika.*

Lissitzky, too, advocated a New World, but a "world of objects" which was to be created by the artist. He outlined an entirely new frame of reference in his pictures, which he called *Prouns* (Russian *pro unovis* = for a

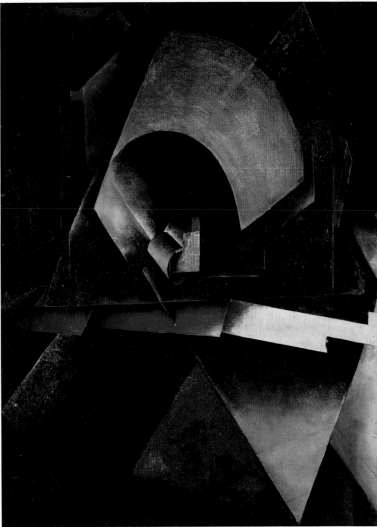

renewal of art). The forms in Lissitzky's compositions are rhythmically arranged, seeming virtually to move along different planes, horizontal, vertical, or diagonal, suggesting interlocking spaces. The intrinsic dynamism of these compositions is very striking, and quite different from the static orders of the Dutch artists. Also obvious is the revolutionary aim of Lissitzky's art. Despite being bitterly disappointed by Lenin's verdict, he remained convinced throughout his life that a revolutionary art could be realized within a revolutionary, proletarian society. This belief was shared by his friends, the film and theater directors Vsevolod Meyerhold, who was executed in 1940; Alexander Tairov, who adjusted to the circumstances before it was too late; and Sergei Eisenstein, whose films were suppressed. Another staunch believer in the cause was poet Vladimir Mayakovsky, whose disappointment over its forsaken ideals led him to commit suicide in 1930.

Lissitzky's emigration to Western Europe was a result of external compulsion. For him, art was ultimately nothing but a "way station to architecture." At

this point Russian Constructivist thinking overlaps with that of De Stijl, but even more so with the concept of architect Walter Gropius, the first director of the Weimar Bauhaus. It was an attitude Lissitzky tirelessly advanced in Western Europe, and not even the lung ailment which forced him to recuperate in Davos and eventually led to his pre-mature death was able to break his courage. Lissitzky influenced abstract film, typography, photography (László Moholy-Nagy), and finally – through the famous "Abstract Cabinet" in the Provinzialmuseum, Hanover, which was destroyed in the Third Reich, and through his design of the Soviet pavilion at the Pressa Exhibition in Cologne in 1928 – he furthered the creation of an innovative type of museum and exhibition: the "living museum".

Almost every major progressive artist in Europe of the 1920s, from Arp to Schwitters, from Piet Mondrian to the architects Ludwig Mies van der Rohe and Jacobus Oud, knew and valued the energetic Russian, who had introduced his and his friends' work for the first time in 1922, at Galerie van Diemen in Berlin. Yet despite the

**Olga Rozanova**
Composition without Objects, 1916
Oil on canvas, 62.5 x 40.5 cm
St. Petersburg, Russian State Museum

**El Lissitzky**
Composition, 1919
Oil on canvas, 71 x 58 cm
Kiev, Museum of Ukranian Art

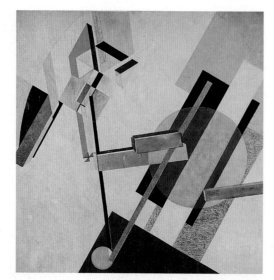

and was therefore essentially static. The paintings of the group are like blueprints for the design of a better future. Their art is limited to contrasts of horizontals and verticals brought into equilibrium; their palette is limited to the three primary colors, blue, red and yellow, augmented by the "non-colors" black, white and grey. In the context of architecture, according to Mondrian, space corresponds to the non-colors and materials to the colors. This implies total abstraction, the elimination of the last trace of memories of or references to the visible world, an overcoming of nature (Barnett Newman to the contrary. The American artist, whose European father-figure was Mondrian, once stated that the Dutchman's rigorous paintings were still too "naturalistic" for his taste, because their rectilinear composition, abstract as it might seem, was ultimately derived from nature).

strong impulses that proceeded from his work, Lissitzky ultimately did not succeed in planting the seed of Constructivism in the narrower sense in Western European soil. He was and remained a Russian; his friends, even the Socialists who politically sympathized with him, remained Western Europeans. For all the aesthetic rapprochement and mutual inspiration these kindred spirits shared, their differences remained stronger than their similarities. The conflict between pure form and a new class consciousness was, so to speak, intrinsic to the Constructivist project itself. The conflict between formalists and activists had already broken out in the young Soviet Union, and it continued until the disintegration of the empire.

Why this was so becomes rapidly apparent when we compare Constructivism with De Stijl, two directions which on first sight have the look of twins. De Stijl is not anarchistic but bourgeois in spirit. It represents an aesthetic reaction on the part of people conditioned by living in a countryside wrested from the encroachment of the sea, a symbol of the superiority of the ordering and building human mind over the brute forces of nature. Not a covert imitation of nature was the thrust of "Neoplasticism," as the new Dutch style in painting was known, but a creative activity out of the ordering spirit which is also embodied in nature. Peace, harmony, and discipline were the characteristic factors of this art, and a totally harmonious world its utopian goal. Mondrian, the greatest of the De Stijl artists, envisaged in art the formulation of a universal ideal of happiness, whose prophet he considered himself. "He spent his entire life in this utopian future," said H.L.C. Jaffé. Mondrian's essay, "Neoplasticism," was dedicated to "the man of the future."

Suprematism and Constructivism, in that they reflected revolutionary political thought in Russia, were essentially dynamic in character. The aesthetic of De Stijl, developed in 1917, at the peak of the European cataclysm of World War I, reflected a longing for peace,

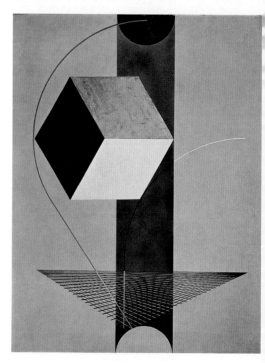

## The Harmony of Geometry: Piet Mondrian

For Piet Mondrian the elimination of the real and visible was not only an aesthetic requirement but a philosophical tenet. De Stijl set out to create a pure art composed of pure elements, whose man-made order would be set against the wild proliferation of nature and the twisting, curving or interrupted lines of natural forms. It is not surprising that this ascetic art emerged in Holland, the land of Calvinism and the Iconoclasts, the classic country of the bourgeoisie and its values. And in art, after all, Holland is not only the homeland of Jacob van Ruisdael and Rembrandt, but also that of Pieter de Hooch, Jan Vermeer of Delft, and the architecture painters Pieter Saenredam and Emanuel de Witte.

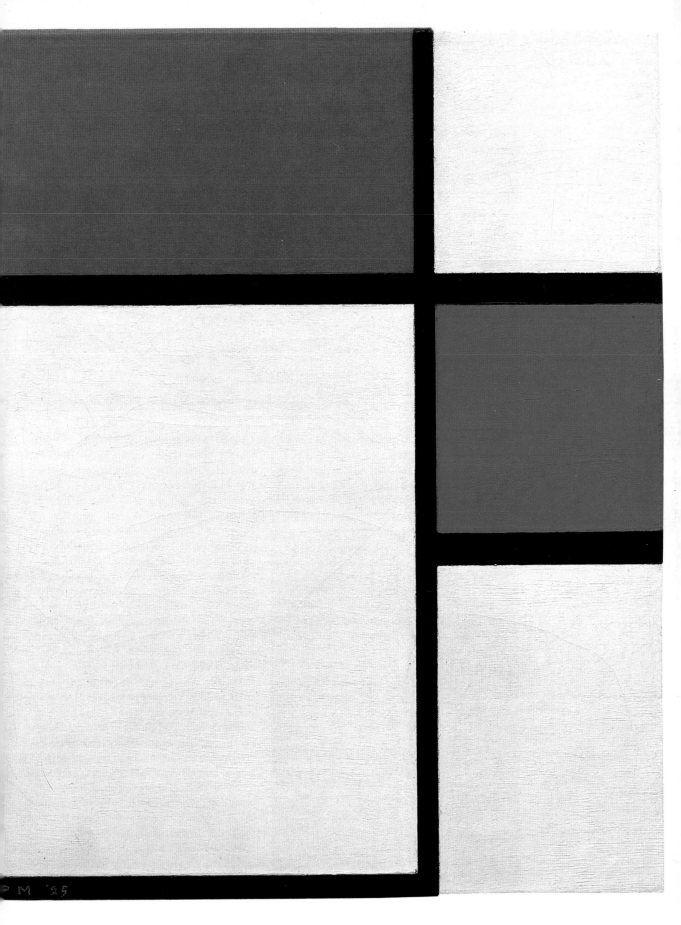

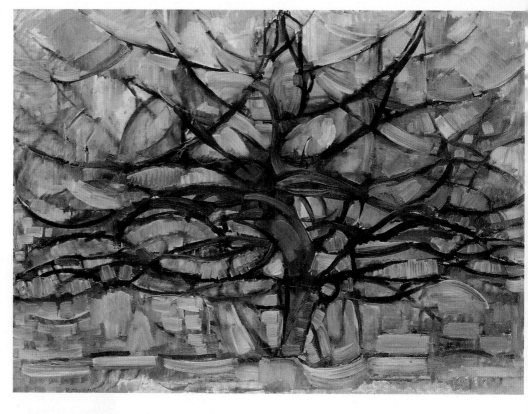

**Piet Mondrian**
Gray Tree, 1912
Oil on canvas, 78.5 x 108.5 cm
The Hague, Haags Gemeente-
museum

The protagonists of De Stijl, apart from Mondrian, were Theo van Doesburg (pp. 171, 172), who in 1917 founded the journal *De Stijl* and thus gave the movement its name; Bart van der Leck; the Hungarian artist Vilmos Huszár; and the Belgian painter and sculptor

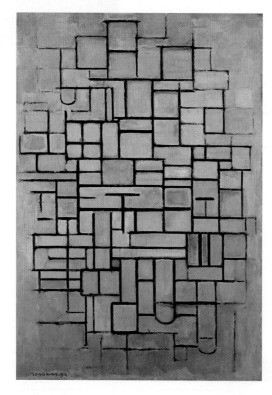

**Piet Mondrian**
Composition No. 6, 1914
Oil on canvas, 88 x 61 cm
The Hague, Haags Gemeente-
museum

Georges Vantongerloo (p. 171 above). They were later joined by César Domela (p. 172), by the German artist Friedrich Vordemberge-Gildewart (p. 173), by the architects J.J.P. Oud, Cornelis van Eesteren, Gerrit Rietveld, Jacobus van t'Hoff, and others. What the majority of these men shared in common was a pious Calvinist background. In personality and appearance they hardly conformed to the general notion of the revolutionary artist. They were disciplined men with a tendency to asceticism, in both their life and art. Mondrian's life and thought call to mind those of a Chinese sage, despite his very Western penchant for sarcasm, which helped him cope with self-abnegation, and an enjoyment of physical movement which inspired the passionate jazz dancer Mondrian in the syncopated, staccato rhythms of the *Boogie-Woogie* paintings he did in 1940, after fleeing from German air raids to New York (p. 171 below right).

In addition, a series of paintings emerged during the final years of Mondrian's life in America which are among the finest works he left to posterity. These are panels on which the conventional media of oil, pencil and charcoal are combined with apparently carelessly applied, partially thumbtacked strips of adhesive tape – a technique hard to reconcile with the image of the painstaking purist, but which brings a vitality into the strict classicism of the compositions that even surpasses the rhythms of the dance-inspired paintings. America, Mondrian once told his friend, Sidney Janis, an influential dealer and collector, America had permitted him to work more rapidly than in Europe. Yet the experimental spontaneity of the taped canvases was not achieved at

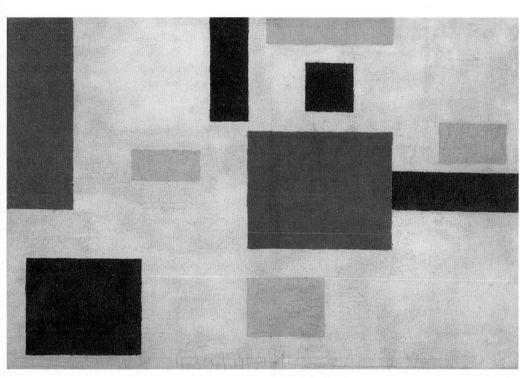

**Georges Vantongerloo**
Composition, 1917/18
Oil on canvas, 36 x 54 cm
Paris, Musée National d'Art
Moderne, Centre Georges
Pompidou

the expense of precision. Their relaxed, unroutine character points back to the material collages of the Cubists on the one hand, and on the other points forward to Robert Rauschenberg's or Jasper Johns's employment of mundane and trivial materials.

Personal vanity was unknown to the De Stijl artists; what they strove for was anonymity. Their attitude was

does develop powers that in turn determine culture as a whole."

The De Stijl artists felt their philosophy confirmed by the perfection of the machine, by the increasing tendency of modern man to live in groups and collectives (political parties, trade unions, associations), and by the anonymity of the modern labor and industrial process.

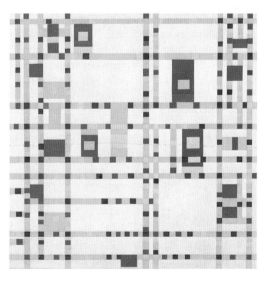

**Theo van Doesburg**
Simultaneous Counter-
Composition, c. 1929/30
Oil on canvas, 50.1 x 49.8 cm
New York, The Museum of
Modern Art

**Piet Mondrian**
Broadway Boogie-Woogie, 1942/43
Oil on canvas, 127 x 127 cm
New York, The Museum of
Modern Art

socialistic to the extent that they envisioned a collective art for all. Only such an art seemed capable of upholding universal harmony in the face of rampant individualism. Not that the Dutch artists saw themselves engaged in the class struggle, however. "Art, as we understand it," stated van Doesburg, "is neither proletarian nor bourgeois. Nor is it determined by social conditions; but it

Every form of imitative, naturalistic painting, in their eyes, had been taken ad absurdum by photography. As early as 1921, Rodchenko had drawn his conclusions from this insight and bid painting farewell with a monochrome *Triptych in Pure Colors*, that a revolutionary new architecture developed out of De Stijl's rectilinear, harmoniously proportioned compositions beholding to

**Theo van Doesburg**
Pure Painting, 1920
Oil on canvas, 130 x 80.5 cm
Paris, Musée National d'Art
Moderne, Centre Georges
Pompidou

**César Domela**
Neo-Plastic Composition, 1924/25
Oil on canvas, 82 x 67.5 cm
Private collection

old architecture painters, and in that of the Hague School, which itself looked back to the Golden Age of 17th century Dutch art, Mondrian painted Impressionist and Pointillist-influenced landscapes and still lifes. He then began to simplify the curving lines of such subjects until an abstracted, fundamental pattern emerged in which the interrelationships of form took precedence over the subject depicted. While he was aided in this process by the Analytical Cubism he had studied at the source, in Paris, Mondrian still adhered too closely to the subject to divorce his Cubist abstractions entirely from nature. Soon he had reduced his grey and ocher-hued compositions to a system of verticals and horizontals; but even these still seemed to relate too closely to the external world. Mondrian realized that pure, universal beauty could be achieved only by expunging every memory of subject matter, in a complete harmony of a small number of colors and shapes simplified to the utmost – in compositions that were not abstracted from nature but represented a counter-image to nature. Thus he proceeded from a practically monochrome Cubism, based on elliptical shapes, to compositions of rectangular planes that virtually continued beyond the canvas edge, compositions whose colors, in order to expunge every last trace of illusion, he began in 1920 to reduce to red, yellow, blue, and black and white.

the Platonic notion of an ideal, geometric beauty, seems a matter of course. The "pure" relationships discovered by the painters were applied to architecture and translated into three dimensions. "In view of Constructivism who would have predicted," asked Johannes Cladders, "that even the skyline of our old cities now no longer looks Gothic but Constructivist?"

Van Doesburg later turned away from painting in favor of architecture. The change was symptomatic. In 1920 he had visited the Bauhaus in Weimar, where he triggered a fundamental reorientation. It was due not least to Van Doesburg's influence that Gropius and the Bauhaus masters abandoned the mystical, speculative pathos of the founding years in favor of a new objectivity and sobriety, less ambitious but definitely more practically effective. Le Corbusier, too, concerned himself with the ideas of De Stijl, which provided him with essential stimuli and confirmation of his own approach.

When van Doesburg died in 1931, the optimistic movement lost impetus, as indeed its positivistic attitude and belief in the power of rational thinking to shape the future had already been shaken by revolutionary developments in science, especially in physics. Persecution and repression at the hands of the fascists brought the *coup de grâce*.

Any outstanding artist, despite a pledge to create an anti-individualistic, undramatically harmonious art for all, is bound to transgress the bounds of the collective. This holds for De Stijl as well, in which the outstanding artist was Mondrian. After preludes in the style of the

Mondrian once reported that he had first seen this method in the work of Bart van der Leck, who, however, applied the Neoplastic palette and formal repertoire to figurative subjects (p. 173 above right). With Mondrian, the canvas became an impersonal panel, conducive to meditation. The intellectual foundations for this development had been laid by the philosopher M.H.I. Schoenmakers, whose ideas were an odd mixture of

**Vilmos Huszár**
Composition – Human
Figure, 1926
Oil on canvas, 61 x 54 cm
Lódz, Muzeum Sztuki

**Bart van der Leck**
Composition, 1918–1920
Oil on canvas, 101 x 100 cm
Amsterdam, Stedelijk Museum

mysticism and mathematics. In his philosophical interpretations of vertical and horizontal lines, of figures and formulas, Schoenmakers attempted to explain the universe and make it understandable in concrete terms.

Mondrian's rejection of individual sensibility and the artist's personal touch was rigorous. Like Malevich with his squares, Mondrian not only reached but overstepped the extreme borderline of art as previously understood. At this point we come up against the inexplicable quality, the secret contained in this so rationally and rigorously calculated Neoplasticist style. For the seemingly so impersonal, collectivist artist Mondrian, the constructor of beautifully simple patterns of form and color, was not only a mystic like Schoenmakers, he was also a prodigy of technical uniqueness. That no one, not even the most brilliant of forgers, is capable of copying Mondrian's paintings is a ridiculous, if indicative, statement. But his works can easily be distinguished from the apparently so similar ones of the other De Stijl artists even by the layman. Mondrian was the only one of them who achieved that perfect proportion and harmony, divorced from all drama and sentiment, for which all of them strove.

### De Stijl's Continuing Influence

The aesthetic of De Stijl was adopted and ramified by Vordemberge-Gildewart (ill. right), the German member of the group, who resisted Mondrian's dogmatism. He escaped the tyranny of Mondrian's vertical-horizontal as well as van Doesburg's diagonal color-field borders and, inspired by the dynamic factor introduced by the latter, lent the rigorous style more freedom and sensibility despite retaining a great sparingness of means.

Carl Buchheister of Hanover also maintained close contacts with De Stijl (p. 174 above left). Yet his works of the 1920s, when Hanover was a center of Constructivist art, showed just as close ties to the Russians' concept of an art for the masses, as indicated by his reproduced

paintings of mid-decade. Also, Buchheister used a greater range of colors and shapes than the Dutch artists, lending his flat compositions a certain vibrancy. A few of his works, which were more diverse and full of contrasts than long assumed, even anticipated tendencies of Action Painting and monochrome art.

Outstanding specimens of the Constructivist approach were also produced by Erich Buchholz (p. 174

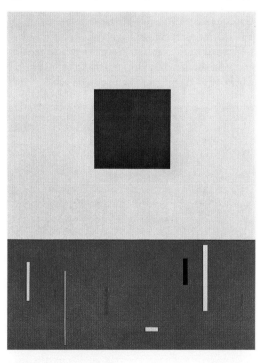

**Friedrich
Vordemberge-Gildewart**
Composition No. 211, 1958
Oil on canvas, 130 x 100 cm
Düsseldorf, Kunstsammlung
Nordrhein-Westfalen

below), who in the final phase of his long career distanced himself from his pre-1933 artistic activity and wasted much time in post-war Berlin launching cranky attacks on contemporary developments. In addition to paintings, painted reliefs, and sculptures based on the circle, square, and narrow rectangle, Buchholz too pro-

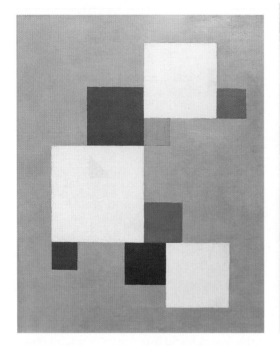

Carl Buchheister
Composition Blue Square,
1926–1933
Oil on plywood, 65.5 x 52.5 cm
Münster, Westfälisches Landes-
museum

Hans Richter
Autumn, 1917
Oil on canvas, 79 x 63 cm
Zurich, Kunsthaus Zürich

duced designs for architecture and the stage, did com-
mercial work and designed industrial products. Walter
Dexel (p. 175 above left) was a native of Munich who in
1933 gave up art for almost thirty years, as a result was
long forgotten, and only a few years before his death in
1973 was given the appreciation he deserved. By way of
Cubism and its German-American transformer,
Bauhaus master Feininger, Dexel arrived at sparingly
Constructivist cityscapes from which figurative refer-
ences did not entirely vanish until the artist finally
adopted a more stringently abstract approach.

Hans Richter, a Dadaist of the first hour in Zurich
(1916), became a protagonist of the abstract film.
Throughout his life one of the most intelligent and ener-
getic witnesses to 20th-century developments, Richter
returned late in his career to painting, in a style that
oscillated between strict, Cubist-influenced composi-
tion and suggestions of Surrealist anarchy (ill. above).

De Stijl remained viable not only in architecture but
in art as well. The line of development leads, with many
variations and changes of theme, from the Paris group
*Abstraction-Création*, founded in 1931, to which Vordem-
berge also belonged, through Auguste Herbin, Ben
Nicholson, and Victor Pasmore, to the kinetic art of
sculptor Nicolas Schöffer, the painting in light of *Zero*,
the monochrome painters, and finally to the Op Art of
Victor Vasarely and others. Also related to the De Stijl
context are the stringent squares of Josef Albers and –
in a creative reaction to Albers – American Color Field
painting, all the way down to diverse recent develop-
ments such as the work of Helmut Federle, Niele
Toroni, or Peter Halley (p. 390).

The influence of the German members of De Stijl,
in addition of course to contacts with neighboring Hol-
land, was important to Belgian artist Victor Servranckx,
whose monochrome grisaille *The Squarest Rectangle*
would have been unthinkable without Malevich's pio-
neering composition.

### A Glance at Eastern Europe

Even more important were the continuing effects of
Suprematism and Constructivism in Eastern Europe,
especially in Poland. In 1924, three years after Lenin's
verdict, a Constructivist group called "BLOK" was
founded there by Henryk Berlevi (who had met El
Lissitzky in 1921), Vladislav Strzemiński, and Henryk

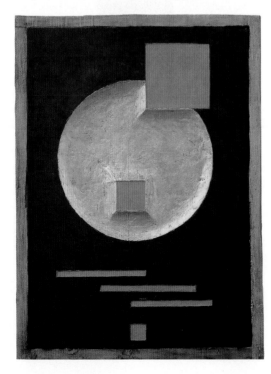

Erich Buchholz
Relief Painting, 1922
Oil on wood, 60.4 x 45 cm
Cologne, Museum Ludwig

Stazevski. Berlevi became known for his development of "Mechanofaktur," an ostensibly universal system, based on the ideas and works of the Russian Constructivists, with the aid of which art could be produced according to mechanical principles. Berlevi, too, soon went west, to Paris (1928), and he also returned repeatedly to Berlin (p. 176).

Strzemiński (ill. right), born in White Russia and seriously wounded in the First World War, was in 1919 already participating in the activities of the Moscow Constructivist avant-garde. In 1922, after his marriage to Katarzyna Kobro (p. 449), an important sculptress he went to Poland. There, Strzemiński not only became a founding member of BLOK but, later, with Stazevski and others, of the group "a.r."; he was also that rare case of an artist who established a museum. The Sztuki Museum in Lódz, which subsequently, under the directorship of the polyglot Riszard Stanislavski, would maintain contacts with the West under political conditions of the most difficult, owed its founding to Strzeminski's initiative.

In the mid-1920s, in parallel with Russian Suprematism, Constructivism, and Cubo-Futurism, he worked out the theory of "Unism," which "defines the image as a self-referential entity." There followed "Architectonic Compositions," pictures composed of elementary geometric forms, "based on a system," as Janini Ladnovska says, "of mathematical calculations, substrates of compositions in space for which Strzemiński developed his own theory." Subsequently, before being ostracized for his criticism of Socialist Realism, the artist executed his *After-Images of Light.*

likewise influenced by the art of Malevich and Lissitzky at an early date. His untiring search for new expressive potentials in many fields, from painting to photography, design, typography, and kinetic sculptures incorporating the element of light, will be discussed in detail in another context.

In the 1980s younger artists, who could have been their grandchildren, picked up the thread of the Constructivists' achievements in East and West. The first syllable of the abbreviation "Neo-Geo" (Neo-Geometry) points up the eclectic character of tendencies in post-modern art and its, so to speak, late-Hellenistic situation. In contrast to the pioneering avant-gardes, today's artists refer consciously to historical styles, not out of a belief in a new art capable of shaping the future but with a skeptical to cynical knowledge that such utopias are illusory.

Strzemiński's serial method, his equilibrium of color and line, and his resolution of the dualism of flat surface and three-dimensional form into a "unistic" entity, all had far-reaching consequences, not only for the international Zero movements of the 1960s but also for developments of a very recent date. The same holds, if to a lesser extent, for the work of Stazevski (p. 175 above right), who endeavored to combine the principles of Mondrian's Neoplasticism with those of Unism into a synthesis.

Turning to Hungarian abstraction, the pacemakers in the field during the 1920s were emigrés living in Vienna and Berlin, such as the painter-poet Lajos Kassák (ill. right), known as "steersman of the vanguard," and his temporary partner, Sándor Bortnyik, who was influenced by Popova.

Moholy-Nagy, the Hungarian Bauhaus master in Weimar and later in Chicago, at the New Bauhaus, was

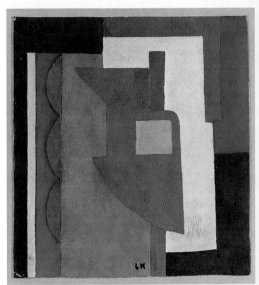

## Art with a Social Mission
### The Artists at the Bauhaus under Walter Gropius

*"Architects, sculptors, painters, we all have to return to the crafts. 'Art as a profession' does not exist. There is no real difference between the artist and the craftsman. The artist's task is an intensified version of the task of the craftsman."*
WALTER GROPIUS

The attempt to build a mystery cult around art is age-old. As Max Ernst already scoffed, art had been raised to the status of a religion, and the artist to that of a Chosen One whose inspiration represented an act of grace. It was under such conditions that art, especially since the 19th century, developed in a world apart, Elysian Fields far removed from the social realities, and in the process lost its social function and responsibility. This development culminated in an ominous, hybrid aesthetic idealism which bore a close relationship to the sense of mis-

sion felt by the statesmen and generals of the day, and thus ultimately if indirectly contributed to the justification of war.

The First World War, which even Franz Marc viewed as an inferno that must inevitably preceed the making of a better world, swept such ideas away in a carnage of a horror never before seen. The notion of an art sublime and exalted above reality proved to be a self-delusion. To re-establish art's "bond with society" – in Hugo von Hofmannsthal's phrase – to give it social tasks to per-

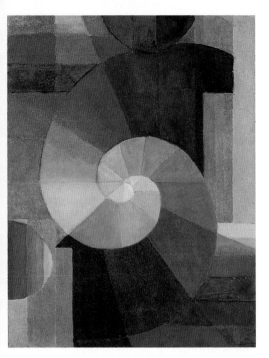

aesthetic usefulness in designing the environment. The Bauhaus teachers were no longer professors but "masters of form," that is, artisans, but artisans who in the design of prototypes included considerations of mass production from the start. The machine was no longer looked upon as a threat to art but a welcome helper. Free, applied, and industrial design enjoyed equal status at the Bauhaus; the hierarchy of the arts was overcome; functional art became teachable and learnable.

Many of the most significant artists of the day contributed to the realization of this conception. Klee taught glass painting and weaving, and while at the Bauhaus he wrote the *Pedagogical Sketchbook*, one of the most important theoretical and epistomological source texts in modern art. Kandinsky taught analytical drawing and developed out of this experience a normative, rigorously methodological textbook on composition, *Point and Line to Plane*, His path from the expressive idiom of his early period to a poetic geometrical style reflected not only Kandinsky's confrontation with Russian Constructivism, but also the development of pictorial thinking at the Bauhaus. Gerhard Marcks

**Johannes Itten**
Meeting, 1919
Oil on canvas, 105 x 80 cm
Zurich, Kunsthaus Zürich

form, and finally to overcome the division between fine and applied art, became the goals of the Bauhaus, established in Weimar in 1919 by the architect Walter Gropius. There was to be no more art for art's sake; art was to become a responsible activity. Painting, sculpture, the crafts, and industrial design were to become integral elements of architecture, the mother of all the arts which encompassed them all. The well-functioning building, designed to make people's lives easier and happier, became the focus of a utopian conception of a new and better world. As it had in Russia and Holland, the vision of a lucid and functionally beautiful environment for a classless society stood at the inception of developments in Weimar.

The young architect's enthusiasm was so infectious that everyone Gropius asked to participate in helping build the "cathedral of the future" agreed to take part. The historic model for the Bauhaus was the anonymous community of artists and craftsmen of the medieval building guilds; its immediate model was Jugendstil, and its offshoot, the "Deutscher Werkbund," founded in 1907. Influences from Constructivism and De Stijl also played a fruitful role. Van Doesburg, Lissitzky, Gabo, even Malevich came to Weimar; writings by Mondrian, van Doesburg, and Malevich were published in the series of "Bauhaus Books." At the beginning, the Bauhaus philosophy was a seemingly incompatible mixture of sober objectivity and romantic, Expressionist-style idealism, but gradually practical, functionalistic thinking gained the upper hand. One of Gropius' first acts, and main achievements, was to eliminate the hierarchic organization of the traditional academy. Classes were transformed into workshops, in which the students, starting from scratch, were asked to investigate materials of all types with an eye to their practical and

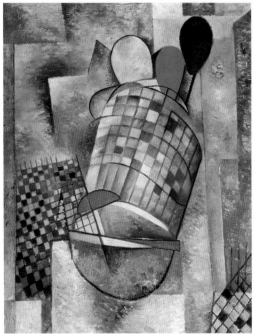

**Georg Muche**
Composition with Black and Green Form, 1920
Oil on cardboard, 71.5 x 53.8 cm
Bonn, Kunstmuseum Bonn

(p. 416), a relatively conservative sculptor, headed the ceramics department; painter and art teacher Johannes Itten (ill. above left) taught the basic preliminary course; and artist Oskar Schlemmer ran the workshop for wall painting (murals), and later also the sculpture workshop and the Bauhaus Stage. Feininger was nominated by Gropius as early as 1919 for the first masters' council, and headed the printing shop, if only for a brief period.

Gropius was not enough of a doctrinaire to share Klee's opinion that genius represented a "defect in the system." He was aware that the great individual, even

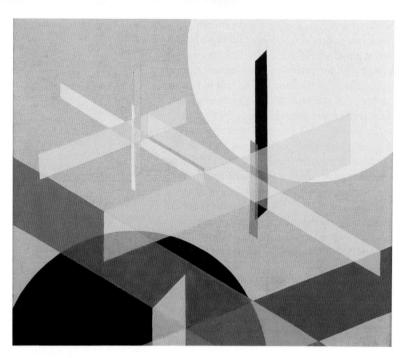

**László Moholy-Nagy**
Composition Z VIII, 1924
Distemper on canvas, 114 x 132 cm
Berlin, Nationalgalerie, Staatliche
Museen zu Berlin – Preußischer
Kulturbesitz

*"And I know now that if I develop
my best abilities in the manner
appropriate to them, – if I try to
come to an honest and thorough
understanding of the meaning of
my life – then it is right for me to
become a painter. My talent lies
in the expression of my life and
creative power through light, color
and form. As a painter I can convey
the essence of life."*

László Moholy-Nagy

**László Moholy-Nagy**
Composition A XXI, 1925
Mixed media on canvas, 96 x 77 cm
Münster, Westfälisches Landes-
museum

though he might subordinate himself and his activity
to service to the community, would still overstep its
boundaries, and that it was in fact the "defect" of genius,
unteachable and unlearnable, that justified the educa-
tional system by calling it into question. Gropius would
not countenance work at the Bauhaus being submitted
to any uniform style. He permitted Klee to tell his stu-
dents that quality in art could never be a norm, or be
pressed into a formula; rather, quality was something in
the process of becoming, and every artist had to create it
anew, as the product of aesthetic and intellectual effort.
Based on his insight, Gropius retained the great individ-
ualists on the faculty even when the decision to make
strict functionalism the guideline for Bauhaus work
became final, and thus the priority of architecture over
visual art was established. This decision prompted the
idealist Itten, the Expressionist and former member of
the *Sturm* theater Lothar Schreyer, the sculptor Marcks,
and the painter Georg Muche (p. 177) to leave the
Bauhaus, in that order.

The story of the Bauhaus' odyssee as a result of
political pressure from the Right is familiar. After being
forced to move to Dessau in 1925, it was driven in 1932
by the National Socialists to Berlin, where Hermann
Goering irrevocably closed the school as "a hothouse of
cultural bolshevism." But political pressures were not
the only reason for its demise. Internal dissolution had
begun much earlier. Gropius relinquished his office in
1928; other faculty members, including Moholy-Nagy,
architect Marcel Breuer, Schlemmer, and Klee followed
suit. Gropius's successor, Hannes Meyer, was a commit-
ted socialist and a strictly functionalist architect under
whose aegis the crisis deepened. The last director of the
school, architect Mies van der Rohe, a protégé of

Gropius, no longer had time to attempt to re-establish
the unity of the arts that had stood at its inception.

The importance of the Bauhaus for painting lay
above all in the systematic analysis of its means and the
basic research into its applications which the Bauhaus
achieved. The Bauhaus books were among the most sig-
nificant art-theoretical writings of the period. Their
authors represented the new type of the conscious and
methodical creative person who took responsibility for
his work and was almost as much of a scientist as an
artist. The influence of the teaching activities of
Kandinsky, Klee and Schlemmer was extraordinarily
great. It continues to this day, even though its effects
may not be so visible as those of the Bauhaus architects
on international building all the way down to the Post-
Modern reaction.

### The Man of the Day after Tomorrow

The fundamental premise of the Bauhaus, to experi-
mentally investigate the nature of materials, was put
into practice most thoroughly by Moholy-Nagy (ill. left
and below). Like Kassák and others of his countrymen,
Moholy-Nagy had emigrated from Hungary after the
counter-revolution, going initially to Vienna. He had
been called by Gropius to Weimar in 1923. A Construc-
tivist and founder of the group "MA", Moholy-Nagy
earned himself the title "man of the day after tomor-
row." Many a subsequent avant-garde artist was an heir
to Moholy-Nagy; many a light-show, many a rotating
kinetic wall-object dependent on the effects of shadow
and light, and many an image made of glass, was a
variant or continuation of what began at the Bauhaus.
Moholy-Nagy was the spiritual father of several genera-
tions of artists. A gentle man with a tendency to melan-
choly, he took seriously the hypothesis of Konrad

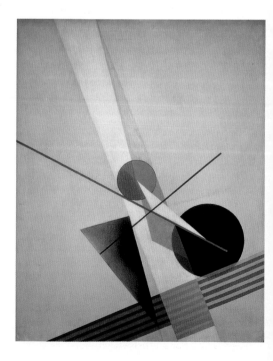

Fiedler, formulated in the 19th century and much in advance of its time, that the inception of all artistic activity was the creation (as opposed to the imitation) of reality. For Moholy-Nagy this meant the reality of the times and the environment in which he lived. He tested materials for their applications in art with the curiosity of a child and the experimental ardor of an aware intellectual. Things we take for granted and thoughtlessly use every day became in his hands the substance of aesthetic design: wire, paper, bits of fabric, razor blades. This activity went back to Cubist and Constructivist collage techniques, as well as to the Dadaist-Surrealist ready-made, but at the same time it went beyond these. As Giulio Carlo Argan says, Moholy-Nagy's materials became "the new primal matter of a formal construction" consisting of triangle, cube, circle, and rod-shape. The artist also continued Man Ray's photomechanical experiments, producing montages, negative prints, X-ray images, depictions of moving bodies by means of photographic series, photograms, etc.

Such experiments still play a role today in the attempts of many artists to capture reality by means of photographs altered by overpainting, extreme enlargement, or blurring, as in the case of the early Gerhard Richter, Chuck Close, or the Photorealists, who, so to speak, built their imagery over fragments of reality. These experiments were also fruitful for kinetic art, and art that relied on the effects of light. They eventually led Moholy-Nagy to begin experimenting in the medium of abstract film. As early as 1929 he had attempted to combine light, form and color, in an object entitled *Light Prop*. His series of experiments eventually led to the *Light Space Modulators* (p. 454) created in the United States, where in 1937, after his second emigration, the Hungarian artist founded the New Bauhaus in Chicago. The *Light Space Modulators* were three-dimensional constructions of transparent planes, among which light and shade played in wonderfully sophisticated and surprising ways. Moholy-Nagy "painted" with plastics, such as plexiglass, Galalith, and Neolith; but after the *Telephone Paintings* on enamel of 1922, which with the aid of color charts and graph paper he had executed in a factory according to his telephone instructions, the artist also "painted" with light – an art of far-reaching consequences, especially in the field of theater.

This combination of spontaneous experimentation with the materials of a new century, technical and artistic sophistication, and an intellectual, constructive method, quite aptly describes the range of all the work at the Bauhaus, whose poles were marked by a tendency to the folkloristic and naive on the one hand, and on the other by a commitment to the machine and technical perfection.

Besides Moholy-Nagy, it was especially Josef Albers whose activities definitively turned the Bauhaus, after it had sloughed off all remainders of Expressionism, towards a constructivist art in the service of architecture. Influenced by De Stijl, Albers's work exhibits an

extreme reduction of form to a lapidary, geometric idiom rendered with extreme painterly and technical perfection. And like Moholy-Nagy, he consciously did a great deal of commercial work and contributed significantly to the development of industrial design. Yet his major paintings, the series of *Homages to the Square* (ill. above and p. 180), have nothing at all to with applied art. Hardly another artist of our era demonstrated more compellingly than Albers that the most elementary things are ultimately inexplicable. As the philosopher Ludwig Wittgenstein said, everything we see could just as well be different. Everything we can describe at all could be different as well. There is no order of things *a priori*. Albers's œuvre corroborates Wittgenstein's insight, painting by painting. His works are like traps into which the viewer is repeatedly tempted to fall. The sense of insecurity they instill is great, and the proof they give of the fallibility of perception is irrefutable. This aspect of irritation, Albers's illustration of the existence of the irrational by rational means, his demonstration of the fact that there are no finally valid solutions but only permanent change, infinite variation, all indicate that at bottom Albers remained a European despite living and achieving his finest work in the United States. But he was no formalist who produced multiple art. He justifiably insisted not only on the originality but on the variety of his visual inventions. Every realization of an idea, he believed, was a one-off, unique work.

The combination of perceptual possibilities is as endless in Albers's structural constellations in painting as it is in his tectonic graphic art. The aggressiveness of

*"As 'gentlemen prefer blondes', so everyone has a preference for certain colors and prejudices against others. This applies to color combinations as well. It seems good that we are of different tastes. As it is with people in our daily life, so it is with color. We change, correct, or reverse our opinions about colors, and this change of opinion may shift back and forth."* JOSEF ALBERS

*"Practical exercises demonstrate
through color deception (illusion)
the relativity and instability of
color. And experience teaches that
in visual perception there is a dis-
crepancy between physical fact and
psychic effect."*   JOSEF ALBERS

these visual manifestations and the eye's inability to ulti-
mately fix them, are almost painfully evident, both phys-
ically and mentally. The economy of means, precision
and concentration of Albers's imagery stand in inverse
relationship to the effectiveness of each variant. The
same holds for the colors, whose values alter depending
on the adjacent colors, and are subject to a continual
temperature and climatic change from warm to cold,
cold to warm. Mixed with grey, they appear de-material-
ized, floating as if in a mist, the borderlines blurred; the
hues appear to advance and recede in space, and the eye
cannot hold them. In Albers' *Squares*, as in his prints,
plane and space are reciprocally perceived. This effect is
created entirely without personal touch, but with a high
degree of objectivity and sensibility. "I paint as thinly as
Breughel," Albers once told a visitor to his New Haven
studio, which he called the smallest workroom in the
world. Painting after painting was done here on a plain
deal table. He wanted to "realize," not "express" him-
self, the artist added, because while he had learned to
think and see, he had not learned "art." Albers never
took the second step before the first; his pictorial think-
ing was oriented towards practice. He did not formulate
his variations on the basis of any preconceived system,
or subject them to any *a priori* theory. Rather, his
approach and teaching were the result of experience,
empirical trial and error. To recognize the originality of
Albers's œuvre, a sensibility for nuances is required. It
was like with the cook, the artist once jocularly put it.
Sometimes she used more salt, sometimes less. That
made the great difference.

### The Human Being in Space

The Bauhaus theory of harmony and proportion was
related to that of the Renaissance, with the difference
that instead of positing a finite space defined by the laws
of perspective, it posited an infinite space for which
these laws no longer held. This distinction points up the
problem faced by another Bauhaus teacher, the painter
Oskar Schlemmer. Schlemmer was one of the last mas-

ters of perspective in art history. His major theme was
what he termed "the human being in space." The
strange mixture of constructive and sentimental, soberly
realistic and romantically expressive tendencies that
marked the early years of the Bauhaus, was also present
in the personality of Schlemmer. At happy moments, he
once said, he had to physically compel himself not to go
about indiscriminately "embracing people." In the face
of official Bauhaus doctrine, Schlemmer believed paint-
ings were "revelations of the divine through the medium
of man, known as 'the artist,' a language of forms and
colors mystical in origin." This stands opposed to the
diary entry, "Not laments over mechanization, but an
enjoyment of precision.... If the artists of today love
machinery and technology and organization, if they
want the exact instead of the vague and fuzzy, this is an
instinctive escape from chaos and a yearning to give
shape to our era...."

This wonderful and complex man, subsequently
defamed by the Nazis as a "cultural Bolshevik," kept
alive the heritage of the great Renaissance masters of
perspective, and in their wake that of Hans von Marées,
the German in Rome whose forte was the idealized
human figure in the landscape. Impressed by Seurat and
also by Cubism, whose analysis of form he, however, did
not adopt, Schlemmer reduced the human figure to its
basic geometric elements and set it in relationship to
the surrounding space. Every individual feature was sup-
pressed in favor of the prototypically human. Schlem-
mer's figures were representatives of a noble type, gener-
ally appearing in groups, part of a community yet
nonetheless alone, thoughtful, proud, and introspective.
The *Five Men in Space* (1928; Stuttgart, private collec-
tion) and the *Bauhaus Stairway* (ill. right) embody
Schlemmer's classically idealistic conception to perfec-
tion. His murals and reliefs in the workshop wing of
the Weimar Bauhaus were destroyed in 1930, by order of
the National Socialist government of Thuringia at the
behest of the notorious Paul Schultze-Naumburg, who
called them "exercises devoid of artistic value."

Schlemmer's murals strove for a harmony of actual and imaginary space, an absolute equilibrium. The wall surface, he believed, should be rendered transparent and thus be virtually eliminated, permitting the ambient space to be continued within the picture. The perspectives of actual and pictorial spaces would flow into and interpenetrate each other – an idea of indisputably utopian grandeur. Admittedly, the contradiction between objective imagery rendered in perspective terms and an architecture that was growing increasingly dynamic and flexible proved well-nigh impossible to

overcome. When Schlemmer turned to easel painting it was ultimately as a stop-gap, since all of his work and its tendency to monumental scale revealed the urge to design for the architectural setting.

Schlemmer's conception of "the human being in space" found its purest expression in his theater work. Here the space-creating imagination of the artist, who was also a talented amateur dancer, could freely unfold. Parts of his famous *Triadic Ballet* (1922), to which Paul Hindemith wrote a new score for mechanical organ in 1926, were already performed in Stuttgart during the war, at a regimental entertainment in 1916. He was inspired to the ballet, said Schlemmer, by Seurat's painting *Le Chahut* (Otterlo, Rijksmuseum Kröller-Müller). "In Seurat's painting the most vigorous movements of dance are achieved through stringent forms (straight-lined, decisive)," Schlemmer noted. An intellectual basis, or preliminary design, as it were, was provided by Heinrich von Kleist's essay "On the Marionette Theater". The

mechanical artificiality of the marionette became the model for Schlemmer's abstract dance, which attempted to avoid all sentiment because the expression of feelings, according to Oscar Wilde's ironic apercu, becomes further removed from art the more real the feelings are. With the aid of highly abstracted masks and costumes, that is, of sheer artificiality, Schlemmer hoped to unite the Dionysian aspect of dance with its Apollonian one, the sensual with the spiritual.

Another covert romantic with a superbly lucid mind was Lyonel Feininger (pp. 182, 183), born in New York to German parents who were both musicians, a child prodigy on the violin, and later a gifted player of Bach and composer of respectable fugues. Feininger began his career as a successful caricaturist, but, as he said, had no intention of being "condemned to create in perpetual travesty." In 1906 he discovered the quiet beauty of Thuringian villages and their architecture, which he would later depict in a famous series of paintings. That

**Oskar Schlemmer**
The Dancer – The Gesture, 1922/23
Oil and tempera on canvas,
200 x 130 cm
Munich, Bayerische Staats-
gemäldesammlungen,
Staatsgalerie moderner Kunst

**Oskar Schlemmer**
Bauhaus Stairway, 1932
Oil on canvas, 162.3 x 114.3 cm
New York, The Museum of
Modern Art, Gift of Philip Johnson

"Since my childhood, the church,
the mill, the bridge, the house – and
the cemetery – have aroused deep
and reverential feelings in me. They
are all symbolic..."
LYONEL FEININGER

**Lyonel Feininger**
Before the Rain, 1927
Oil on canvas, 45 x 80 cm
Hamburg, private collection

same year saw his second trip to Paris; in 1907 Feininger cancelled all his journalistic contracts to devote himself exclusively to painting from then on. His meeting with the circle of German students of Matisse (Levy, Purrmann, Moll) and with Delaunay, and his confrontation with the disciplined imagery of Seurat, brought first and strong impressions of the new developments in art. The crystalline compositions of the Cubists strengthened Feininger in his conviction that he was on the right track. He described his aim as "a passionate longing for rigorous spatial design – without painterly intoxication of any sort." This longing was one that was shared by Gropius and the Bauhaus, where Feininger's influence, by the way, was not so much in the capacity of a teacher as in that of a free artist whose example set standards.

From his experiences on the shores of the Baltic, that "tranquil sea," and of the landscapes of central Germany, through which he hiked and cycled, Feininger distilled a highly original pictorial architecture, reducing the forms of churches or sailboats to overlapping crystalline shapes rendered in increasingly translucent hues. A Latin lucidity and a Gothic-Romantic mystery, occasionally tinged with irony – especially in the accessory figures – entered into a unique blend in this imagery. Over the years Feininger heightened expression and form to monumentality. The thirteen *Gelmeroda* canvases of the 1920s, symbols of the church's striving towards heaven, metaphors of a longing for the infinite expressed in the finitude of crystalline form, have a logic of composition, a transparency of structure, that recall the fugues of Bach. These works were the culmination of Feininger's development. Many of the best and loveliest examples of his style are found among the delicate watercolors and prints, especially the woodcuts, the finest of which possess an intimacy, force, and quality of form quite on a par with the major oils.

**Lyonel Feininger**
Village Pond in Gelmeroda, 1922
Oil on canvas, 86 x 112 cm
Frankfurt/Main, Städelsches
Kunstinstitut und Städtische
Galerie

In later years, particularly after his return to the United States, Feininger's lucid crystalline style of the mature European period made way for a more romantic approach in which the contours grew vaguer, more blurred, recalling the work of Turner, which had impressed Feininger early in his career. The further removed in space and time he became from the land of Romantic art, the more romantic his painting grew. *Gelmeroda* continued to preoccupy Feininger's mind in America, where initially he felt out of place and was plagued by homesickness, until his work began to receive the honors it had enjoyed in Europe. It was characteristic that he should have translated the vertical gigantomania of Manhattan into a Gothic mode although he was here unable to achieve the lucid spirituality of the transparent compositions of the earlier years.

*Page 182:*
**Lyonel Feininger**
Gelmeroda IX, 1926
Oil on canvas, 108 x 80 cm
Essen, Museum Folkwang

# Return to the Visible World
## The Wave of Realism after World War I

**Mario Sironi**
Self-Portrait, 1913
Oil on canvas, 51.5 x 49 cm
Milan, Civico Museo d'Arte
Contemporanea

In the years following the Armistice many painters began to abandon the aesthetic speculations that had done so much to advance art during the pre-war period. An emphasis on the purely formal aspects of art suddenly appeared dubious to them, as if it represented a retreat, conscious or not, from a responsibility to society, a refusal to face up to the abuses of power. Many of these artists shared with their peers at the Bauhaus a sense of duty to society, even if they expressed it in quite different terms. Feeling themselves belated heirs to the Enlightenment, they used expressionistically heightened or caricatural means to unmask the ills of the post-war era and the venality or shallowness of its representatives. Abstraction was no help in this regard, since their aim was to "show" in the Brechtian sense, to record and document realities, and to penetrate beneath their surface to reveal the motives and mind sets that had led to the European disaster. These artists were filled with a sense of mission – to prevent such a war from ever reoccurring. They pointed accusing fingers, intervened in political affairs, in depictions of disabled veterans, trench warfare, profiteers and prostitutes and brutal crimes. They launched merciless Jeremiads in paint, yet all the while remaining skeptical of the efficacy of art to really make a difference.

Such was the background to the widespread return to realism in the early 1920s. It provided the impetus for

**Mario Sironi**
The Truck, 1917
Oil on cardboard, 90 x 80 cm
Milan, Pinacoteca di Brera,
Jucker Collection

Grosz's depictions of the post-war world in terms of the obscene scrawls on latrine walls, as it did for Beckmann's ballad of human cruelty, *The Night* (p. 195), an image that far transcended its temporal reference to become the period's most superb and horrifying evocation of the beast that lurks in man.

The war pictures of Otto Dix, in contrast, resist ideological definition, having more the character of a disillusioned analysis than a pillorying of society's ills. By the same token, the socially critical art of the realists and verists of the day is marked by a kind of inverted idealism, which perhaps never before in history had had so much reason for disillusionment with society. The pitfalls of a committed, polemical art are well known. They were frighteningly demonstrated in the socialist, fascist, and vulgar-Marxist pseudo-realism that flourished before and after World War II in both Western and Eastern Europe. Art of this ilk can easily degenerate into propaganda.

In Italy and France after 1918 a return to the visible world as a reaction to the storm and stress of the pre-war period set in as well. The shape it took, however, differed profoundly from the aggressive social criticism of German artists. The Latin countries witnessed an attempt to create a new order.

In Italy this development was encouraged by the neoclassicism of De Chirico and Carrà, but also by the classical Renaissance heritage which was an integral part of Italian artists' environment. Morandi's reinstatement of the transcendental dignity of commonplace things

also played a role. In 1918 the first issue of *Valori Plastici* (Plastic Values) appeared, with an editorial that programmatically demanded the revival of traditional values in art. "We want Italian painting to find its way back to order, method, and discipline, and to attain to solid, tangible form," wrote Carrà, the erstwhile Futurist. The mobility and dynamism of Italian art were suspended for years to come. The "noble simplicity and quiet grandeur" of the ancient Greeks, Johann Joachim Winckelmann's leitmotif for German classicism, well describes the efforts of Italian artists during the 1920s, which were largely conservative to reactionary in thrust. This regressive tendency was furthered by a group of artists who called themselves *Novecento Italiano* (Italian 20th Century), at whose first public showing Mussolini gave a speech.

**Felice Casorati**
Noon, 1922
Oil on wood, 119.5 x 130 cm
Trieste, Civico Museo Revoltella,
Galleria d'Arte Moderna

20th-century experience, these images from the distant past re-materialized in the Alexandrine world of Campigli's imagery.

The painting of Felice Casorati (ill. above) was inspired by the sophisticated Jugendstil eroticism of Klimt and disciplined by the idealistic symbolism of Puvis de Chavannes and the Pre-Raphaelites. Though he subsequently achieved a simplified planarity in the manner of Gauguin, Castorati's work, like that of many of his countrymen, points up the fact that Italian art in the wake of Futurism and *Pittura Metafisica* was long overrated. Another case in point is Gino Bonichi, alias Scipioni, a Roman artist who died at an early age. His expressionist style, inspired by El Greco, was infused

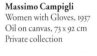

**Massimo Campigli**
Women with Gloves, 1937
Oil on canvas, 73 x 92 cm
Private collection

A return to the figure, to monumentality, to traditional values, coupled with a rejection of Impressionism and decadence, and of the supposed effeminacy and cosmopolitanism of critical art – all this seems very familiar, calling to mind as it does German art under Hitler or the anti-formalist ideology of Stalinism. Yet while Italian aims may have been similar, that country never developed the official, aggressive philistinism nor the merciless persecution of non-conformism that reached such horrifying levels in Germany.

Yet nothing revolutionary could be expected from Italian art from that point on, either. Mario Sironi (ill. left), the former Futurist and war volunteer turned metaphysical artist, attempted in the work of his postvanguard years to depict alienated man in an industrial landscape heightened to the point of archaic monumentality, a bleak world into which the pathos of Nordic Expressionism also entered.

Massimo Campigli (ill. above) brought buried realities back to light in a different, one might say culturalhistoric way. Beginning with Cubism, then influenced by the monumental, Ingresque and archaic figuration of Picasso, Campigli discovered the charm of defunct cultures – Etruscan and Arabian, the hieroglyphs of Egypt, the frescoes of Pompeii, and the mosaics of Ravenna. Ironically refracted, viewed through the spectacles of

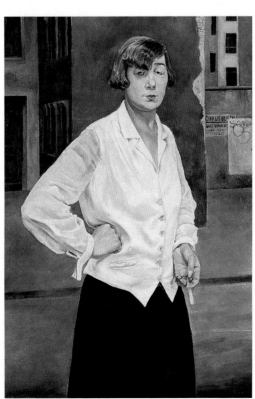

**Rudolf Schlichter**
Portrait of Margot, 1924
Oil on canvas, 110.5 x 75 cm
Berlin, Märkisches Museum

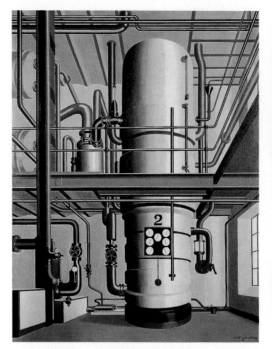

with religious ardor and suffused with the somber reds of Dante's Inferno. The vehement expressionist painting of Luigi Spazzapan, finally, bordered on abstraction and anticipated developments to come.

### Neue Sachlichkeit

The return of the Italian painters to a view of the real and tangible world through the veils of history had consequences throughout Europe, particularly in Germany. The aesthetic results, however, were more modest than

the achievements of the critically realist camp. Their style derived its name from an exhibition mounted in 1925 by G.F.Hartlaub, then director of the Mannheim Kunsthalle, to which he had been soliciting contributions since 1923. Neue Sachlichkeit – variously translated as New Objectivity, Sobriety, or Austerity – brought together 124 works by 32 artists. Their re-investigation of late medieval painting, of 15th-century Italian art, of the simplified, comprehensive plastic forms of Ingres' and David's neoclassicism, said Hartlaub, led to an emphasis

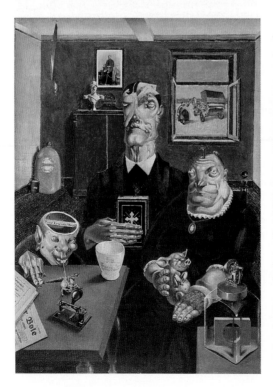

on the "autonomy of the objects in our environment." These things were depicted in sharp focus, with almost microscopic attention to detail, and often without regard to their interrelationships. All motion was brought to a stand-still. Painting reverted to a static state. "Magic Realism" was Franz Roh's term for this new austerity.

Viewed historically, Hartlaub's and Roh's names for the movement had a very different thrust, which sparked a terminological debate that has continued to the present day. The many attempts to find a common denominator for the diverse artistic personalities and aesthetic approaches involved finally resulted in a compromise. Their differences notwithstanding, art historians have agreed on the term "Neue Sachlichkeit". The exaggerated focus in which things and figures were rendered occasionally lent the paintings of the movement a well-nigh surreal look – that magical quality to which Roh referred. Christian Schad's portraits, or Alexander Kanoldt's bleak suburban landscapes punctuated by telegraph masts of 1930, are key specimens of the style, in whose orbit Dix and Grosz, inspired by Metaphysical Painting, also temporarily moved. At this period Grosz produced compelling depictions of the loneliness of mass man, de-individualized, lost in cold and empty urban ambiences, pictures that need fear no comparison with those of Carrà or De Chirico.

Some artists' fascination for the object – in the dispassionate dissections of a Schad (ill. right), even humans themselves became objects – led in the long run to immobility and even petrifaction, as is seen in the work of Kanoldt (ill. below) and of Georg Schrimpf (p. 186 below). With Kanoldt, this tendency even brought a dalliance with National Socialism, whose pseudo-classical aesthetic proved too tempting for the passionate admirer of Ingres. The kitsch-mongers of the Haus der Deutschen Kunst were already lurking in the wings, and their triumph would not be long in coming.

More progressive, and thus of more lasting importance, was the socially critical variant of Neue Sachlichkeit. Seeing reality through disillusioned eyes, it was to that extent anti-illusionistic. Its major representative,

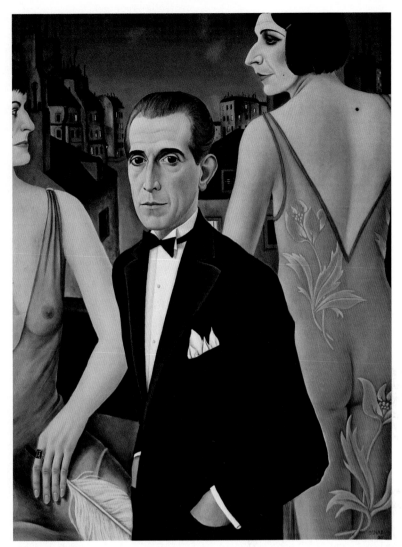

**Christian Schad**
Count St. Genois d'Anneaucourt, 1927
Oil on wood, 86 x 63 cm
Hamburg, private collection

Otto Dix, was born in 1891 into a laborer's family in Untermhaus near Gera. Like the other artists of the movement, Dix was inspired by a confrontation with the Old Masters, especially Albrecht Dürer, Lucas Cranach, Hans Baldung-Grien, Grünewald, Hans Holbein, and Botticelli, though his first key works, done in wartime, still showed a strong Futurist influence: *The Cannon* (1914; Düsseldorf, Kunstmuseum) and *Self-Portrait as Mars* (1915; Freital, Haus der Heimat). In his masterly portraits Dix combined painstaking attention to detail with a manneristic refinement, seen in the elongated figures and eloquent gestures. The intriguing thing about these pictures is the application of a grand, Old Masterly technique to banal, proletarian or prurient subject matter. Dix's portraits of children, depicted with crystal clarity and an infallible eye for character (and with a side glance at Runge), likewise evince a typical and paradoxical mixture of detached observation, empathy, and harsh irony. Though partaking of European nihilism in the wake of Nietzsche, this amalgam bears traits of early Romanticism as well. These traits would come to the fore later, when the aging Dix turned to

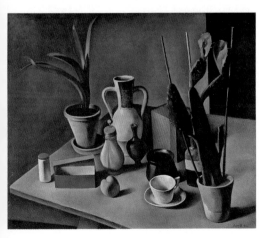

**Alexander Kanoldt**
Still Life with Jugs and Red Tea-Caddy, 1922
Oil on canvas, 77.5 x 88.5 cm
Karlsruhe, Staatliche Kunsthalle

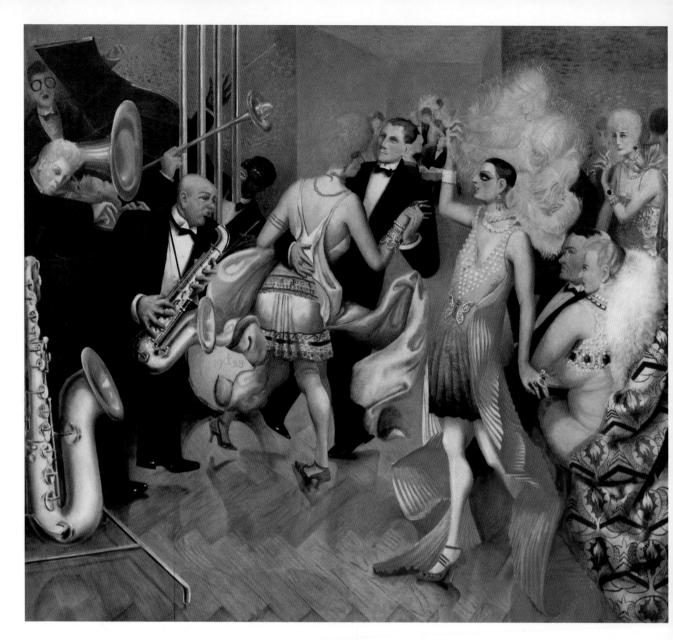

**Otto Dix**
Metropolis (triptych, central
panel), 1927/28
Mixed media on wood,
181 x 200 cm
Stuttgart, Galerie der Stadt
Stuttgart

*"Nobody wants to look at it. What is
it all supposed to mean... the old
whores and the old, worn out
women and all of life's cares? ... It
doesn't make anybody happy. No
gallery wants to exhibit it. Why do
you even bother to paint it?!"*
OTTO DIX

landscapes, flowers, animals, and figures, depicted in a
somewhat rough-hewn, expressively heightened style,
and in a range of bright colors. Works such as the *Por-
trait of the Artist's Parents* (ill. right), that of his brother-
in-law, Dr. Koch (1921; Cologne, Museum Ludwig),
or the portrait of the author Theodor Däubler (1927;
Cologne, Museum Ludwig), who is depicted as a
prophetic figure of veritably Old Testament propor-
tions, a tragic colossus looming up before the neoclassi-
cal columns of the Brühl Terrace in Dresden, belong
among the truly great works of the epoch.

  Despite such outstanding, absolutely frank and in
no way idealized portraits, which include that of
Johanna Ey, maternal protector of Düsseldorf artists
(1924; Kunstmuseum Düsseldorf), Dix gave his very best
in the unsentimentally analytical, mercilessly revelatory
imagery devoted to the First World War and its after-

math. In the etching cycle *Der Krieg* (War), as in *The
Trench* of 1923, an oil destroyed in the Second World
War, Dix depicted devastation, decay, and horror in
nightmarish, well-nigh surrealist visions that finally
buried the legend of the glory of dying for one's country.
The mood of the postwar period was embodied in the
*Metropolis* triptych of 1927/28 (ill. above), whose middle
panel shows tuxedo-clad heroes of the ambivalent
Golden Twenties dancing the Charleston with their
playgirls, as on the flanking panels other flappers strut
past crippled war veterans begging on the street. Dadaist
attempts such as *Seaman Fritz Müller of Pieschen* (1919;
Turin, Museo Civico) also belong in this context. As
Otto Conzelmann justifiably points out in his otherwise
resentment-biased book *Der andere Dix* (The Other
Dix), the merciless anatomist of war, painter of eroti-
cized Old Testament stories and recorder of the violent

sexism of the period, as exemplified in *The Rape-Murderer,* escapes classification in terms of any philosophy or ideology.

Dix himself, in an interview in 1965, laconically remarked that he and his friends in Dresden in 1919 were "all nihilists." He viewed the war as an inexorable natural catastrophe, experienced all its horror on the front lines, and depicted it with an almost terrifying mixture of fascination and cruelty, a mixture that is as closely allied to the Nietzschean will to power as it is to Ernst Jünger's *Stahlgewitter* (Storms of Steel). In his war diary Dix wrote, "War, too, must be seen as a natural occurrence." The images of unmitigated horror, whose dynamic quality gave way in later depictions to an almost monumental statuesqueness, as in the triptych *War* (1929-32; Dresden, Gemäldegalerie) and the battlefield landscape of *Flanders* (1936; Berlin, Nationalgalerie), encompassed the dialectic of creation and destruction, growth and decay. Although Dix's approach followed in the footsteps of a Goya or Callot, his execution, as Paul Ferdinand Schmidt notes, was characterized by a "fanatical cold-bloodedness." His paintings also bear obvious affinities with the apocalyptic poetry of the period, with Georg Trakl (whose suffering under human cruelty, unlike Dix's, led to self-annihilation), with Georg Heym and Gottfried Benn. Stylistically, the art of these years is marked by an unprecedented combination of hyper-real precision of detail with comprehensive, coherent composition, and a palette that is morbidly manneristic in atmosphere.

It is no wonder that Dix's work rankled the National Socialists no end, as they had the conservative, nationalistic critics before them. Yet it is precisely the unsentimental detachment of his technically superb and largely emotionless style that contributed to lending the major works of Dix a permanence that his later paintings by no means achieved.

### The Skewered Philistine

To "skewer" the philistine on his pencil-point – that was what George Grosz envisaged as he transmuted his early, metaphysical scenes into radically verist depictions. By means of exaggeration to the point of razor-sharp cari-

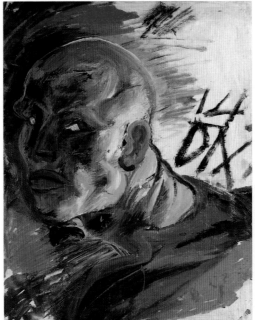

**Otto Dix**
Self-Portrait as a Soldier, 1914
Oil on paper, 68 x 53.5 cm
Stuttgart, Galerie der Stadt
Stuttgart

**Otto Dix**
Portrait of the Journalist Sylvia
von Harden, 1926
Oil and tempera on wood,
121 x 89 cm
Paris, Musée National d'Art Moderne, Centre Georges Pompidou

**Otto Dix**
Portrait of the Artist's Parents II,
1924
Oil on canvas, 118 x 130.5 cm
Hannover, Niedersächsische
Landesgalerie

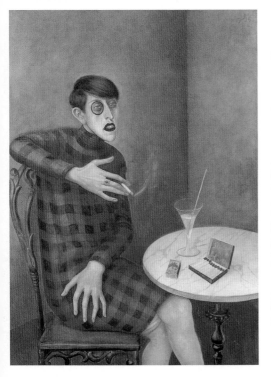

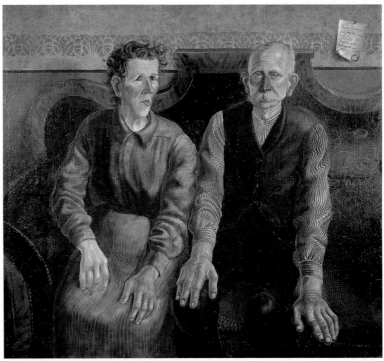

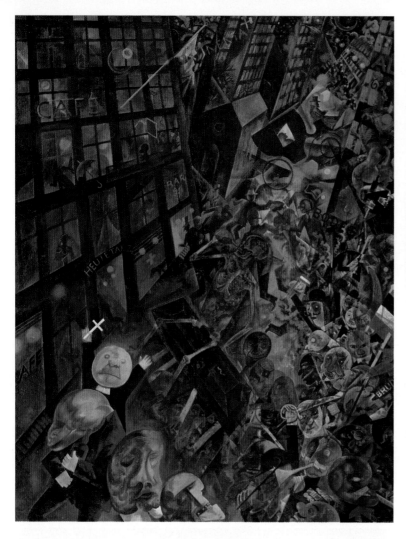

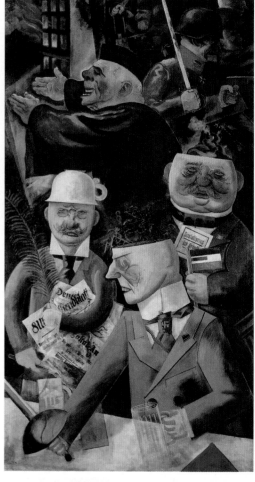

*"I see the future development of
painting taking place in workshops,
in pure craftsmanship, not in any
holy temple of the arts. Painting
is manual labor, no different from
any other; it can be done well or
poorly."*
GEORGE GROSZ

cature, Grosz pilloried the hopeless state of the post-war world. He succeeded so well in this bitter task that average Germans were soon characterizing the unscrupulous legislators, businessmen, and military men among them, with their stiff collars, bull necks, and helmets, simply as "Grosz types". His pictures and person accordingly became the target of virulent attacks, not excluding attempts on his life.

Even in his oil paintings, Grosz remained a draftsman foremost. The means he used to simultaneously depict various aspects of the urban inferno were derived not only from the anonymous "artists" of public lavatories but from Futurism and Dadaism. After his early period, Grosz continued to create significant oils, one of the finest of which was his eerie and anarchistic *To Oskar Panizza* (ill. above). It shows a ghostly procession seemingly tumbling downwards through a canyon of toppling buildings, rendered with Futurist dynamism and a Futurist simultaneity of chronological events. As Death crouches on the coffin, downing a shot of schnapps, a moon-faced preacher waves a crucifix, ill-boding masqueraders stumble past, and in the background a carriage passes across and over the pandemonium. Like this

canvas, Grosz's portraits, exemplified by the moving depiction of the writer Max Herrmann-Neisse (Mannheim, Städtische Kunsthalle), have survived the period of their making. Grosz must be credited with the historical achievement of having confronted the legend of the Golden Twenties with the reality of Weimar, that so unstable and jeopardized republic.

## Max Beckmann's Masks

Important as the artists just discussed were, they were outshone by a contemporary who was one of the century's greatest: Max Beckmann (pp. 191–195). Recognized early in his career, after leaving the Berlin Secession group, Beckmann for a time pursued similar thematic and stylistic paths to Dix and Grosz, but as the years passed he attained to a depth they could not reach. Beckmann was a lone wolf who belonged to no group or trend, a man who began to employ the stylistic means of Expressionism long after Expressionism, as a project, was over. More, he ceased to indulge in the self-analysis, the psychic exhibitionism of the Expressionist painters after once mercilessly evoking, in his 1917 *Self-Portrait with Red Scarf* (p. 194), the shock and consequent ner-

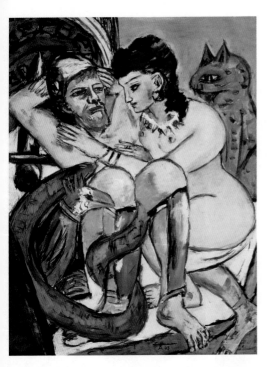

vous breakdown to which his experience of the brutality of war had led.

Later Beckmann concealed his mental torment behind impenetrable masks, be it the tragic mask of the visionary in *Self-Portrait with a Crystal Ball* (1936; private collection), the self-confident one of the *grand seigneur* in *Self-Portrait in a Tuxedo* (1927; Cambridge, MA, Busch-Reisinger Museum), the aloof and self-critical mask of the performer in the circus of the world in *Self-Portrait with Horn* (1930; private collection), or the symbolically enigmatic mask of the ancient Greek hero in *Odysseus and Calypso* (1943; ill. above).

Increasingly, reality was translated into mythical ciphers, despite the fact that Beckmann always took actual experience, moments of vision, as his point of departure. He painted what he saw; but as his early, long under-rated, grandiose and pathos-filled visions of veritably Baroque drama already showed, Beckmann was anything but a naturalistic artist. Late in his career he would caution his students against the mere imitation of nature, saying that it was a wonderful chaos, and that it was the artist's task and duty to lend order to it. The translation of reality into color and form, the transposition of space onto the two-dimensional plane, were in Beckmann's eyes the only "true abstraction" in art. Abstraction for its own sake, the sheer play of non-signifying form, he considered inadmissible.

The older Beckmann became, the less importance he attached to the particular experience that led to a painting. What counted more was the working through of a subject once chosen to lend it historical depth. This power to transform a subject was a gift that revealed itself early in his career. It already appeared full blown in the still quite realistic vision of terror and aggression

*The Night* (p. 195). Murderous thugs have broken into the attic apartment of a family, where they coolly perform their grisly work in front of a black, gaping void, silent, indifferent, inescapable. That the scene plays in a postwar city is apparent only from the style of dress; it might just as well be set in ancient Rome, in the Middle Ages, in a Nazi concentration camp, on the Congo, in Cambodia, Chile, or the Balkans. Horror at the demoniac and destructive side of human nature, including the artist's and our own, takes on oppressive presence in this image.

Beckmann's triptych *The Departure* of 1932/33 (p. 192) contains autobiographical references. It reflects the artist's own role and his view of the relationship between the sexes, but it also can be seen as a premonition of Beckmann's own destiny, his emigration from Germany when the Nazis came to power. At the same time the painting, as always with Beckmann, alludes to contexts of a much wider nature. In one study, by Friedhelm W. Fischer, *The Departure* is interpreted as a re-staging of the myth of the Flood as a purifying and renewing force. On the middle panel, against the backdrop of Beckmann's so beloved sea, a group of people stands in a boat, preparing to cast off: a veiled, super-human female figure in a mythical mask; a human woman holding a child in her arms; a ferryman, his face half hidden; and the crowned figure of a king, who releases fish from his net. The two flanking panels contain images of cruelty:

**Max Beckmann**
Odysseus and Calypso, 1943
Oil on canvas, 150 x 115.5 cm
Hamburg, Hamburger Kunsthalle

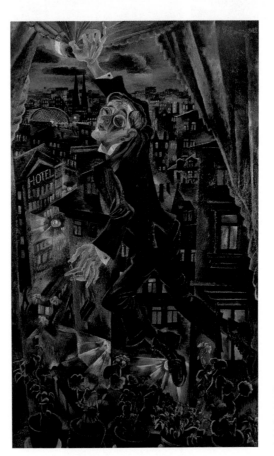

**Conrad Felixmüller**
Death of the Poet Walter
Rheiner, 1925
Oil on canvas, 185 x 129 cm
Los Angeles (CA), Los Angeles
County Museum of Art

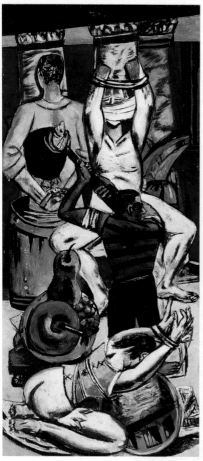
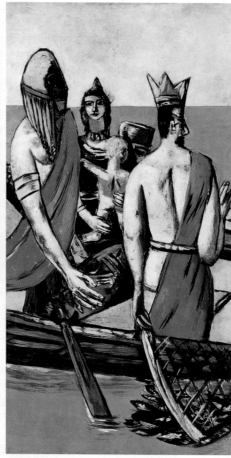

**Max Beckmann**
The Departure (Triptych), 1932/33
Oil on canvas, wing panels
215.1 x 99.5 cm,
central panel 215.5 x 115 cm
New York, The Museum of
Modern Art

*"Departure. Yes, departure from the
deceptive appearance of life to the
things themselves that matter,
behind the appearances. But, in the
final analysis this applies to my pic-
tures…"* MAX BECKMANN

executioners and their victims, situations and places one
leaves without ever being able to forget them. World and
anti-world, the noble and the base, darkness and light,
brutal reality and mythical transfiguration, all are given
compellingly concrete form in these three images.

Another triptych, *The Argonauts* (ill. right), defini-
tively completed only a day before the artist's death
("Not a single brushstroke more," Beckmann wrote),
likewise shows a group of people preparing to depart.
On a platform above the ocean stand two adolescent fig-
ures: Orpheus, crowned with a wreath, his lyre at his
feet, and Jason, on his arm the wryneck, the bird given
him by Aphrodite, whose cries would send Medea into a
passion of love. Behind the youths, an old man clambers
up a ladder out of the sea, pointing out the direction to
be taken by the heroes of the legendary ship "Argo." On
the left panel we see a painter, whose gestures suggest
Beckmann but whose physiognomy resembles van
Gogh, standing at an easel and depicting the sword-
bearing, voluptuous Medea. She is seated on a mask
that bears Beckmann's features. On the right is a group
of girls playing music, very contemporary-looking girls
whose beauty corresponds to the American ideal, which
intrigued Beckmann. These are modern representatives
of the antique choir. Jason, too, is a 20th-century ado-
lescent, classically noble of feature but with the athletic

physique of a football player. His hair is ruffled by the
wind, a wind which, according to the artist's friend
Erhard Göpel, represented "the cooling breeze of the
plateaus of the Beyond" to Beckmann. Göpel has also
pointed out that *The Argonauts*, like many major works
of this outstanding artist, is so multifarious in meaning
that it permits of any number of other interpretations.
Moreover, it includes messages that can only be
expressed through color and form, messages which, like
the content of all great painting, cannot be translated
into verbal terms.

The most intriguing thing about Beckmann's paint-
ings is the way present, past and future flow into one
another and interpentrate. Yet every scene in the artist's
universal theater was based on a real situation. In the
case of *The Night* it was the horror of the post-war
period in Germany; in that of *The Departure* it was the
artist's personal fate; and even *The Argonauts* played a
role in Beckmann's own life – they were the group of
friends who shared his exile in Amsterdam. In Beck-
mann's work the present is rendered permeable to the
winds that blow from the underworld and the world
beyond; each painting, the triptychs above all, becomes
a universal metaphor. Precisely by taking a biographical
or historical situation and transcending it, rendering it
timeless, Beckmann permits time to permeate the

image. This is the fourth dimension, of time past, lost, then remembered, recovered again. Beckmann himself described what he felt in the process of painting as follows: "For me, translating three into two dimensions is a magical experience, in the course of which I momentarily capture that fourth dimension after which my entire being seeks."

What is incomparable about these symbol-laden compositions is that they are neither painted literature nor are they burdened by that fatal profundity which is the besetting sin of German art. The key to understanding them, accordingly, is not speculation but precise observation and knowledge of their background. Beckmann's paintings amount to an exact if mythically transformed record of the state of human affairs during a particular period of history, a deeply penetrating and illusionless interpretation of human behavior in situations of extremity.

Beckmann's portraits, not only of himself but of others, are taciturn as well. The sitters wear masks, which conceal their inner-most thoughts instead of revealing them. The loneliness of man in society, or, again, the isolation of humans within the cage of the self, finds expression in many of Beckmann's works. It is there in the hopeless attempt of Calypso to prevent, with melancholy tenderness, the departure of Odysseus,

whose thoughts are already far from her (*Odysseus and Calypso*); it is there in *Apache Dance* (1938; Bremen, Kunsthalle), where the man, his eyes flashing victory, carries off the half-willing, half-violated woman, much as Perseus does Andromache in the *Perseus* triptych of 1941 (Essen, Museum Folkwang).

Executioners and their victims, persecution and escape, despair and new-found hope, the dereliction of man in an infinite space "whose foregrounds one continually has to fill up with a little rubbish so one cannot see their terrifying depths so clearly.... This endless lostness in eternity. This aloneness" – all of these Beckmann depicted, and thus gave his own sense of life and of the reality of the century and its historical and mythical background a visual expression as precise and compelling as that of Picasso.

Along with Picasso, Beckmann is one of the greatest expressive realists of the modern age, a painter who spoke in parables, a moralist and metaphysician who, despite the fact that the people in many of his pictures appear captive, imprisoned, believed that art could play the role of helper and liberator of humanity, that through form, the many ambiguities of life could be resolved, as Beckmann told his students a few months before his death. An idealist without illusions, in other words, who let neither the chaos of the century nor of

**Max Beckmann**
The Argonauts (Triptych), 1950
Oil on canvas, wing panels
189 x 84 cm,
central panel 203 x 122 cm
Washington, National Gallery of
Art, Gift of Mrs. Quappi-Mathilde
Beckmann

*"The old man in the center panel
who is climbing out of the sea on a
ladder is a god who shows the young
men the way to a better world – the
way to a higher level of conscious-
ness, above earthly life. There is a
strong wind; sun and moon are
darkened, two new planets are just
being created."*

MAX BECKMANN

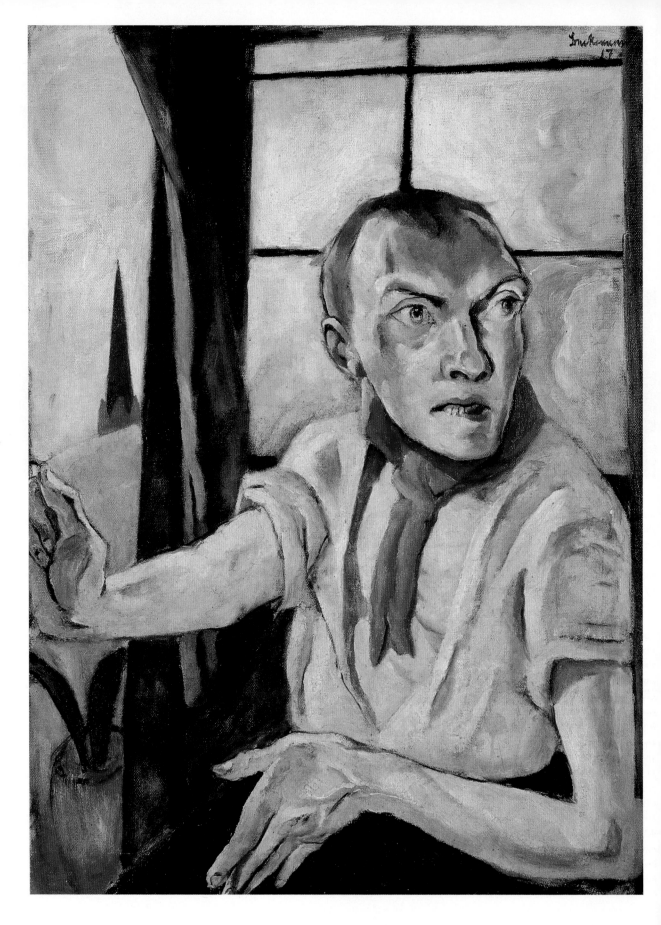

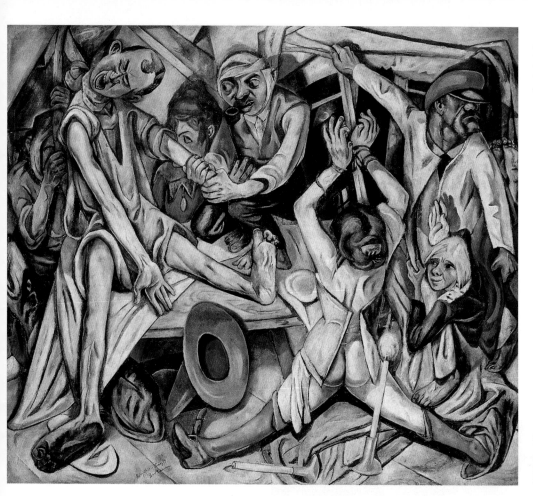

**Max Beckmann**
The Night, 1918/19
Oil on canvas, 133 x 154 cm
Düsseldorf, Kunstsammlung
Nordrhein-Westfalen

human history, nor hateful persecution at the hands of sub-human supermen, deter him from fulfilling his mission.

## Metaphysics and Painting

As fascinating as is the existential background of Beckmann's art, we must not forget its technical side, the mastery of which cost him a great struggle. Beckmann was born in Leipzig, Saxony, to parents who had moved there from Lower Saxony. His early paintings were characterized by Baroque theatricality and a certain allegorical overloading. By learning to discipline these tendencies and to place his virtuosity in the service of concentrated expression, Beckmann became the dominant figure in German art of the 20th century. This fact was only belatedly recognized in the United States, and only recently in France, the classic land of *bonne peinture*. That Beckmann holds a position of prominence among the very greatest painters of the century, of whatever nationality, can no longer be gainsaid. Although his major works still reflect a graphic tendency, the heavy, containing contours are not only entirely integrated into the painterly whole but have become a painterly element *sui generis*. Their expressive force corresponds perfectly with the sonorous color chords of Beckmann's palette.

## Joyless Silence

Another lone wolf among German artists, if for entirely different reasons, was Karl Hofer (p. 196). He was a truly tragic figure. Hofer spent three years in a French internment camp during World War I, and during World War II, a single night's air raid on Berlin cost him the major part of his life's work, which he subsequently attempted, despairingly and not always successfully, to reconstruct. Hofer finally died during – not to say of – one of those embittered debates on the primacy of abstract or objective art which were such a depressing feature of the postwar decades.

The decisive aesthetic experiences for Hofer were the idealizing figurative painting of Hans von Marées and the constructively logical painting of Cézanne. The classicist among modern German artists, Hofer was an idealist disillusioned by bitter experience. His subject matter was influenced by a journey to India, where he was deeply moved by the sight of girls whose gentle, awkward grace was apparently entirely unselfconscious.

Hofer's figures, both his young men and his young women, live in a world that has turned inwards, alone and self-contained, melancholy and joyless, as if musing on their own isolation and mortality. A note of sentimentality sometimes creeps in, whether the subject be the silent suffering of the creaturely or of the intellectu-

**Max Beckmann**
Self-Portrait with Red Scarf, 1917
Oil on canvas, 80 x 60 cm
Stuttgart, Staatsgalerie Stuttgart

**Marcel Gromaire**
Sailor in Clear Grey, 1930
Oil on canvas, 55.5 x 46 cm
Private collection

ally aware life. *The Poet* (1942; destroyed by fire), hand raised in a gesture of warning and invocation, gliding in a boat over dark water before an empty, nocturnal horizon, was one of Hofer's most compelling images. His poet was brother to Charon, ferryman of the underworld, fearlessly traversing the terrible void.

Hofer's landscapes are as forlorn as his figures. In the finest of them, done in Tessin, his otherwise dry, matte color begins to shine. The stringently harmonious compositions, like a few of the still lifes, reveal an affinity to the principles of Cézanne, although considerable variations in quality appear across the œuvre as a whole.

Mention has been made of the return to realism of French artists such as Léger and Derain. But this return, as with the Italians and some of the Germans, was not to the classical Renaissance. Derain, for instance, took his point of departure in the Gothic art of Avignon. A less important expressive realist, Marcel Gromaire (ill. right), was influenced by Léger, his socialist outlook and themes from the life of workers and peasants, rendered in a toned-down Cubist style. In general, post-World War I French realism exhibited a stronger reaction than elsewhere in Europe to current historical events, which led to a defusing of Cubist formal ideas. This development gained significance in Europe only when it began

**Karl Hofer**
Circus People, c. 1921
Oil on canvas, 148 x 118.5 cm
Essen, Museum Folkwang

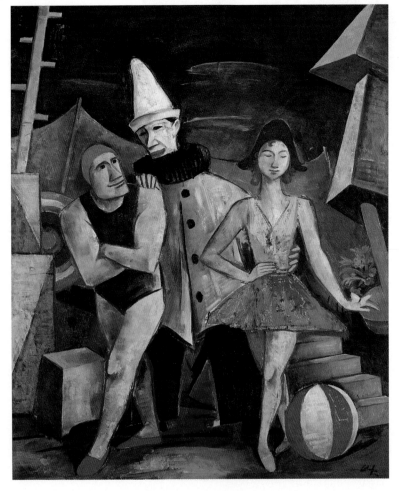

to be reflected in Picasso's neoclassical phase. Paris – or better, the Paris Abstract International of the post-World War II years – put not only all realist art but all figurative art out of the running for years, because every artist who considered himself progressive was convinced that abstraction represented the epitome of art, an epitome which, illogically, they thought would last to Kingdom Come. The course of history, as it almost always does, has impressively proven the prophets wrong.

## Groups and Individuals

Neorealist tendencies were noted, if still only in passing, at Harald Szeemann's documenta 5, held in Kassel in 1972. "Art is returning to itself," announced the imaginative exhibition curator with a sure instinct for current issues and emergent trends. What he meant by this was artists' reaction to their disappointment over the abortive political commitments of 1968, their return to a new brand of *l'art pour l'art*, to more personal concerns, even to a new ivory tower, as a result of the painful insight that art, by itself, is not capable of changing the world.

Another key if long underrated exhibition date was more significant than the documenta in this context. This was "22 Realists," shown in 1970 at the Whitney Museum in New York, a hodgepodge of diverse streams within an over-arching development which had little more in common than a programmatic advocacy of figuration. At the very least, this neorealism had the beneficial effect of leading to a rediscovery and re-evaluation of earlier realist painting in the orbit of Neue Sachlichkeit and Magic Realism in Europe. In the United States, artists began to recall their own realist heritage of the 1930s and 1940s, the American Scene in all its variants, from the admired Edward Hopper to the socially critical Ben Shahn.

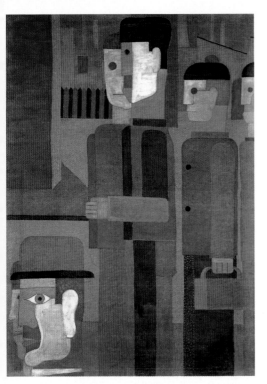

young artists, who, as socialists, envisioned an art for the urban masses. Accordingly, Hoerle's and Seiwert's key scenarios and *dramatis personae* were taken from the industrial world of manufacturing plants and laborers. The paintings of these two combine in a highly idiosyncratic way realistic and constructivist elements, derived both from Neue Sachlichkeit and from Constructivism and Léger. The figures are impersonal, indeed de-personalized, standing for entire social strata or human types – male and female workers, farmers, disabled war veterans. In Seiwert's case, religious motives initially entered the picture as well. In 1922 he painted an image of *Christ in the Ruhrgebiet* (Cologne, private collection).

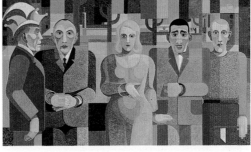

In Germany, whose realist scene was not without influence on the Americans, artists realized that Neue Sachlichkeit was not represented by Dix and Grosz, nor even Kanoldt and Schrimpf alone. Salient rediscoveries were made among the group of Cologne "Progressives," Heinrich Hoerle (ill. above right), his friend Franz-Wilhelm Seiwert (ill. above left), and Anton Räderscheidt. These artists had separated from the Cologne Dada group around Ernst and Baargeld, as we have seen, because their antics appeared too bourgeois to the

On a wall in the background of the painting was inscribed, "What you have done to the lowliest of my brethren, that you have done to me." In front of the wall stood a gnomelike figure with protruding eyes and a steel helmet and – already at this early date – a swastika, blood-spattered symbol of the still-preventable rise of "Arturo Ui" alias Adolf Hitler. The warnings of Hoerle and Seiwert, who died young, proved to be as vain as their attempts to make themselves understood to those whose cause they championed.

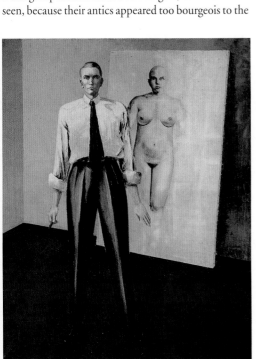

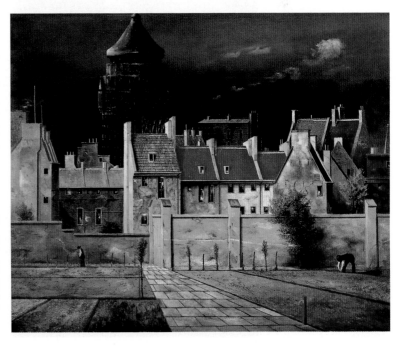

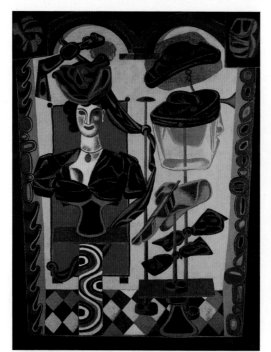

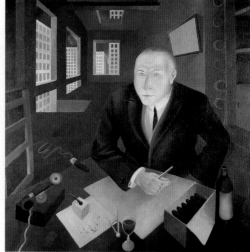

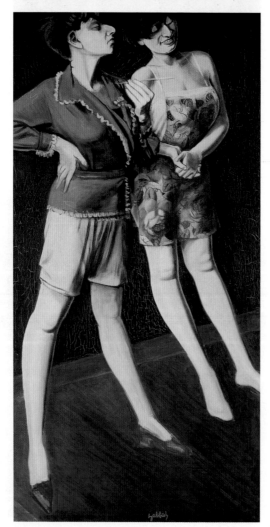

Räderscheidt's theme was the loneliness of the individual in a collectivized society, for which he found memorable formulations in depictions of elongated figures in urban settings of forbidding emptiness (p. 197 below left).

Realist groups formed everywhere in Central Europe at this period, not only in Germany but in the Scandinavian countries, in Austria and Switzerland, and within Germany, not only in Cologne but in Berlin and Munich, Hannover and Dresden, where first tentative steps were taken in the direction of a socialist realism untrammeled by party discipline. There were also loners like Franz Radziwill (p. 197 below right), who lived in the North Sea hamlet of Dangast. Though he temporarily fell under the spell of fascism, Radziwill depicted eerily abandoned cityscapes overflown by insect-like aircraft which almost prophetically predicted the imminent disaster of World War II. The rediscovery of such artists began in 1961, sparked by a show at Haus am Waldsee, Berlin. Eberhard Marx, sensing the deflation of the "wild" painting of the 1950s, L'art informel and Tachism, mounted a retrospective of realism under the same title Hartlaub had chosen almost 35 years previously in Munich: Neue Sachlichkeit. Since this time, artists of the second echelon have also been given their due: Gustav Wunderwald, known as "Berlin's Utrillo," who was also much in demand as a stage designer; the social critic Karl Hubbuch (ill. left); Heinrich Maria Davringhausen of Munich (ill. above right); Carlo Mense, later active in the Rheinland; Dresden artists Hans and Lea Grundig and Wilhelm Rudolph; Carl Barth of Düsseldorf; and the Swiss Niklaus Stoecklin, to name only a few. Other realists such as Oelze, Höch, or Julius Bissier (p. 199 below) soon turned to other concerns, to

create œuvres of great individuality beyond Neue Sach-lichkeit and Magic Realism.

Links with these styles are also evident in the work of Bruno Goller, a Düsseldorf original who, like his student Konrad Klapheck, went far beyond these 1920s sources. The son of a milliner, Goller succumbed to the magic of objects early on. The things in his initially soft-contoured, then increasingly harsh and flat compositions – ladies' hats above all, but also dresses, parasols, ribbons, bows and jewellery – unfold a strange inner vitality of compelling charm that is tempered by a bizarre, ironic humor. Goller's people and accessories tell stories, or their own personal story, like the coquet-tishly smiling hat mannequin surrounded by hats and ribbons in *Large Show Window* (p. 198 above left). Quite real props of everyday life, these things seem far removed from reality in Goller's art. His treatment of banal objects – umbrellas, jackets, armchairs, hatstands, or even numerals and monumental ears – anticipated

the more pragmatic approach of Pop, whose protago-nists in Germany accordingly admired the self-effacing old gentleman as one of their forerunners.

A cool, ironically sparkling humor also suffuses the paintings of Klapheck. He loves the well-ordered, light-flooded interiors of Vermeer, the classicism of Poussin, but also admires – apart from his mentor, Goller – the Surrealists and Dadaists. With painstaking accuracy Klapheck depicts banal things, transforming and alien-ating them in the process into actors in the human comedy, by placing them in unfamiliar situations or combinations, or raising them to the plane of the super-real. An old-fashioned typewriter, monumentalized, becomes *The Weapon of Earnestness* (Essen, collection Ruhnau) and a masculine sex symbol in one. Bicycle bells without caps sound a silent *Memento Mori* (Essen, private collection). A sewing machine embodies *Female Logic* (Estate of the Artist). A *Sex Bomb and Her Com-panion* (Wuppertal, Von der Heydt-Museum) are incar-nate in a curvaceous hand-shower fixture and a static, vise-like object that wonderfully persiflages empty-headed machismo. Metallically gleaming drill-presses, marching like robots toward the viewer out of a lurid background, proclaim *The War* (ill. above). Unim-pressed by the more or less dominant abstract streams of the period, Klapheck has continued to follow the highly individual path he chose for himself early in his career.

Precision is also the salient trait of the work of Domenico Gnoli (p. 200 above left), an Italian artist whose life was prematurely cut short. Gnoli's detail-obsessed, ornamentalized banal objects occupy an inter-mediate zone between Magic Realism and Surrealism. The things he paints are items of apparel, like shoes and shirts, suits and ties, things closely related to the human beings who either do not appear at all in the picture or are shown from the back, and thus rendered anony-mous. By isolating these things and blowing them up to large scale, Gnoli reveals their covert and threatening

**Konrad Klapheck**
The War, 1965
Oil on canvas, 145 x 200 cm
Düsseldorf, Kunstsammlung
Nordrhein-Westfalen

*"I do not use objects as symbols, but instead I paint them as well as I can and then see what they say to me. In the end, paintings are cleverer than their creator and exceed his expecta-tions."* KONRAD KLAPHECK

**Konrad Klapheck**
The Logic of Women, 1965
Oil on canvas, 110 x 90 cm
Humblebæk (Denmark), Louisiana
Museum of Modern Art

**Julius Bissier**
22nd May 61, 1961
Egg-oil tempera on canvas,
43.5 x 48.5 cm
Düsseldorf, Kunstsammlung
Nordrhein-Westfalen

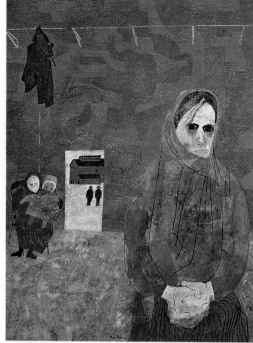

**Domenico Gnoli**
Man with Two Elevations, 1964
Oil and sand on canvas, two parts,
149 x 72 cm each
Cologne, Museum Ludwig,
Ludwig Donation

**Ben Shahn**
Miners' Wives, 1968
Tempera on cardboard,
122 x 91.5 cm
Philadelphia (PA), Philadelphia
Museum of Art

enigmatic quality. In their immediacy of presence,
Gnoli's works are symbols of the emptiness and imper-
sonality of modern life.

## The American Scene

After the First World War artists in the United States
became painfully aware of their dependence on Europe.
Amidst the political outcry to "dump Wilson," who had
not been able to gain acceptance for his "Fourteen
Points" in the Treaty of Versailles, America rediscovered
the benefits of "splendid isolation". Its artists began to
gain a new self-confidence based on an appreciation of
their national identity. After Black Friday in 1929 and the
ensuing Great Depression, many of them turned to
socially critical themes. The American Way of Life,
whether idealized or in its unsensational aspects as
reflected in the existences of commonplace people, the
poor and dispossessed, the black minority – Barbara
Rose has spoken in this context of the boredom and
emptiness of life in democracy – became fit subjects for
art. From the first significant attempts of American
artists to emancipate themselves from the European tra-
dition, embodied in the Ashcan School of the turn of
the century, this development led to Precisionism and
Regionalism, and finally culminated in the work of
Edward Hopper. After learning a mastery of color and
light in Paris, Hopper returned home to apply his skills
to the American Scene, depicting the countryside but
above all the loneliness of the big city in works of a
stature unique to that point in American art.

The Ashcan School, composed of John Sloan,
George Luks, George Bellows and others, made the first
attempt to introduce the subject of the metropolis into

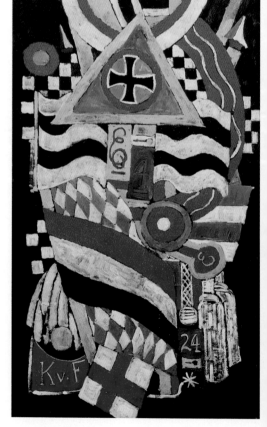

**Marsden Hartley**
Portrait of a German Officer, 1914
Oil on canvas, 173 x 105 cm
New York, The Metropolitan
Museum of Art, Alfred Stieglitz
Collection

the short history of American art. Ben Shahn (p. 200), born in Lithuania, brought to the United States at the age of eight, was an admirer of Dix and Grosz who, apart from working as a photographer, was assistant to the great Mexican revolutionary painter Diego Rivera. This background is evident in both the subject matter and the style of Shahn's paintings, which consciously departed from the then-dominant hedonism of Paris. Shahn was the most committed social critic among the American artists of the day and continued the tradition of the Ashcan School. He achieved fame through a cycle devoted to the life and death of the Italian-American anarchists Sacco and Vanzetti, who, based on a scandalous verdict were executed for murder on insufficient evidence – a macabre foreshadowing of the persecutions for "un-American activities" at the hands of Senator Joseph McCarthy in the 1950s, at the onset of the Cold War.

Shahn, like Grosz, basically remained a graphic artist foremost. His colors, in accordance with the theme, were initially subdued, and later took on a lighter brilliance. His precision was certainly influenced by photography, but in later years Shahn relinquished detail for a more generous, if occasionally somewhat decorative treatment of form. His paintings derived their suspense from a contrast between relatively small-scale figures and expansive backgrounds, while the aggressive mood of the earlier compositions gradually made way for a more elegaic atmosphere.

Charles Sheeler (p. 202 below right), leading light among the Precisionists, who included Charles Demuth (p. 202 above right) and Ralson Crawford, was likewise a photographer, an excellent one, whose prints now hang in many museums. The flat, reduced forms in his compositions were surely derived more from photography than from Cubism, the influence of which many American critics see as seminal to the Precisionist approach. More important to the group, astonishing as it might seem, was Duchamp. His unaltered "ready-mades" pointed up the covert magic of the simplest, most unprepossessing objects, of the very type that Sheeler, Demuth and their friends depicted in simplified, planar terms and in strong color. As Horst Richter notes, there is little connection with Cubism to be seen here, but all the more with Pop Art (if not with latter-day neo-realism), whose protagonists not incidentally had Duchamp's sympathy.

The celebrators of the American Scene – of provincial America, far from New York and the East Coast – were at home in the South, West and Midwest. Their protest against the dominance of the "European Babylon" of New York would bear fruit decades later in West Coast art, but also in the highly original work of artists from Edward Kienholz to Bruce Nauman, or the light-modulating styles of Robert Irwin, Doug Wheeler, and Ron Cooper (of whom Irwin, best known in Europe, has probably the most complex œuvre to his credit). Yet in the case of almost all the isolationist painters of the

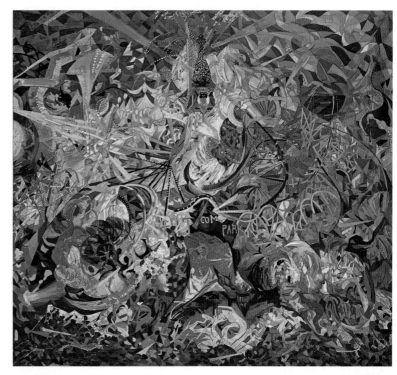

**Joseph Stella**
Battle of Lights, Coney Island, 1913
Oil on canvas, 192.5 x 213.5 cm
New Haven (CT), Yale University
Art Gallery

**Thomas Hart Benton**
People of Chilmark, 1920
Oil on canvas, 166.5 x 197.3 cm
Washington, Hirshhorn Museum and Sculpture
Garden, Smithsonian Institution

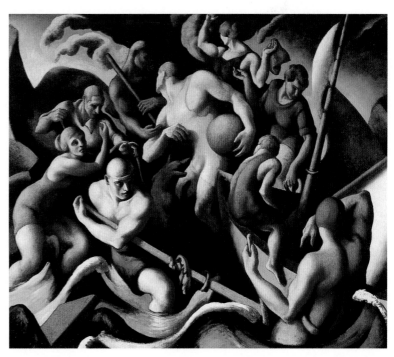

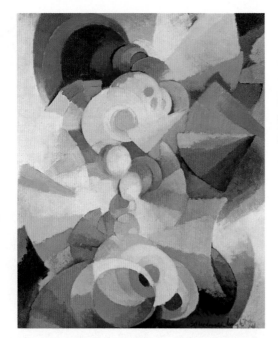

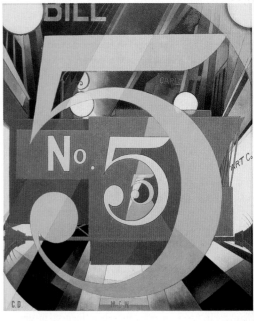

**Stanton Macdonald-Wright**
Conception Synchromy, 1914
Oil on canvas, 91.3 x 76.5 cm
Washington, Hirshhorn Museum
and Sculpture Garden,
Smithsonian Institution

**Charles Demuth**
I Saw the Figure 5 in Gold, 1928
Oil on composition board,
90 x 76 cm
New York, The Metropolitan
Museum of Art, Alfred Stieglitz
Collection

*Below:*
**Edward Hopper**
Gas, 1940
Oil on canvas, 66.7 x 102.2 cm
New York, The Museum of
Modern Art, Mrs. Simon
Guggenheim Fund

*Below right:*
**Charles Sheeler**
Upper Deck, 1929
Oil on canvas, 74 x 56.5 cm
Cambridge (MA), Fogg Art
Museum, Harvard University,
Louise Bettens Fund

rural life back then, their regional limitation led to artistic narrow-mindedness. Only the *American Gothic* of Grant Wood (p. 203 above) – the title of a double portrait of elderly Babbitts in front of a neo-Gothic wooden chapel, rendered in an ironically tinged style schooled on the precisionism of Flemish masters – or occasionally the rustic power of Thomas Hart Benton (p. 201), Pollock's teacher, still deserve serious interest.

In the work of Edward Hopper, however (ill. below and p. 203), American realist painting achieved a level before World War II which justifies placing Hopper and

his work beside the best Europe had to offer in the field in the 1920s. It is no exaggeration to say, as does Wieland Schmied, that Hopper's art was the painterly equivalent of the major American literature of the period, from John Dos Passos to Theodore Dreiser, Sinclair Lewis, or William Faulkner. Hopper's evocations of the isolation of big-city dwellers in bars, diners, trains, even in the theater or cinema, at railroad stations, gas stations, in their own humble front yards and homes in the country or suburbs, reveal a superb execution, mastery of the effects of light and shade, and great coloristic quality, derived from the artist's thorough study of French paint-

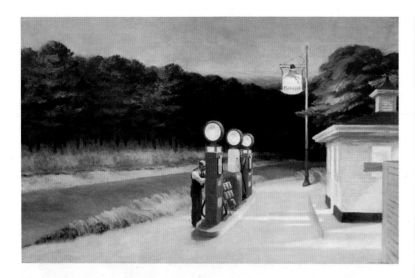

*Page 203 above:*
**Grant Wood**
American Gothic, 1930
Oil on canvas, 75.9 x 63.2 cm
Chicago (IL), The Art Institute
of Chicago

*Page 203 below:*
**Edward Hopper**
Nighthawks, 1942
Oil on canvas, 76.2 x 152.4 cm
Chicago (IL), The Art Institute
of Chicago

ing. Even more, the theme of isolation, loneliness, and lack of purpose in life, sometimes mitigated by an evocation of life's small joys, is distilled into memorable pictorial symbols, and occasionally even into legends. His mastery of the craft permitted Hopper to simplify his compositions and waive all merely anecdotal detail. What speaks to us from his works is compassion, empathy with the fates of normal, commonplace people, with life in a mass society, which ultimately throws the individual back upon himself or herself.

A key if stylistically unclassifiable position in the American Scene, and indeed in 20th-century painting as whole, is held by the work of Georgia O'Keeffe (p. 204 above right), who died at the age of almost 100 at her lonely residence in rural New Mexico. Hers' is a position between abstraction and realism, between America and Europe. Married to Alfred Stieglitz, photographer and promotor of avant-garde art in New York, O'Keeffe doubtless drew much inspiration from European art, not least from Kandinsky, but she nevertheless always remained herself and indubitably American. The organic, biomorphic shapes in her work, derived from plants, landscapes, even human faces, combine a concentration on symmetry with the painterly effects of loosely brushed passages, ornamental spiral forms, and pastel gradations. It is enough to compare a rigorously stylized seashell of 1926 with a spirally rotating, constructive "Abstraction" of the same year, to become aware of the strangely intermediate position of O'Keeffe's art between autonomous abstraction and what has been termed "relativizing realism."

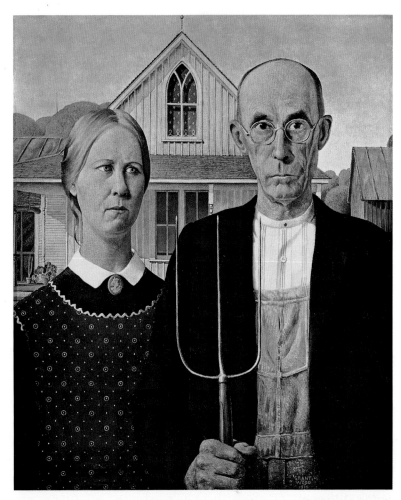

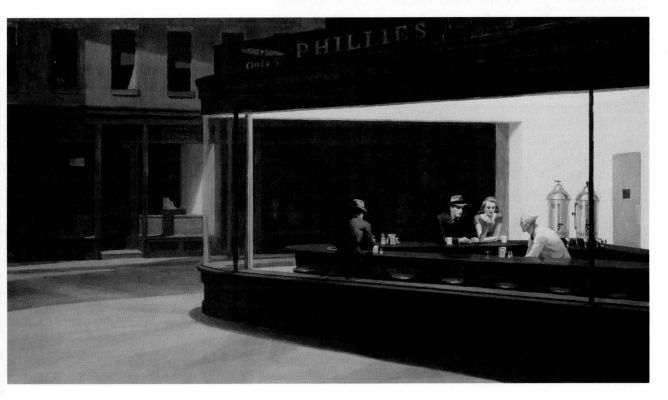

### Art of Revolutionary Fervor

A special case, which outstripped the American Scene in terms of drama and monumentality, which indeed represented a diametrically opposed approach, was the expressive realism, or better, the realistic expressionism, of the Mexican revolutionary painters José Clemente Orozco, Diego Rivera, and David Alfaro Siqueiros. The list could be extended by an artist who shared their tradition but did not reach the pitch of their political com-

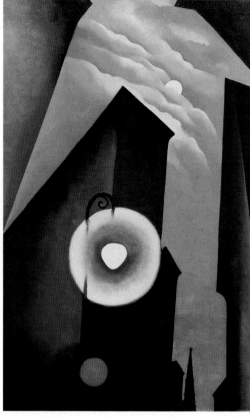

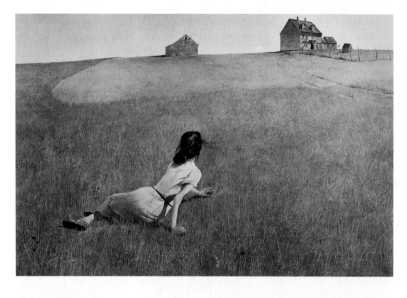

mitment, Rufino Tamayo, the author of a mural on the UNESCO building in Paris (ill. below left).

The starkest form of this "transcendent realism" is found in the work of Orozco, a Creole who had lost an arm, was frequently ill-humored, but always effaced himself in favor of his art. As early as 1926, his collaborator, Rivera, called Orozco Mexico's greatest artist (p. 205). He was also, despite certain affinities with

Picasso, the most original painter of the group, a man who, though well-versed in European painting, came down most clearly on the side of the art of his own country, from the Mayas to colonial Baroque, and lent it an inimitable identity. Orozco's panels, and above all his murals on the struggles and passions of his people, on the battles and victories of the Mexican revolution, are a rare example of the fact that monumental history paint-

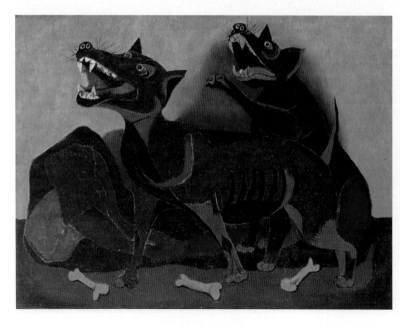

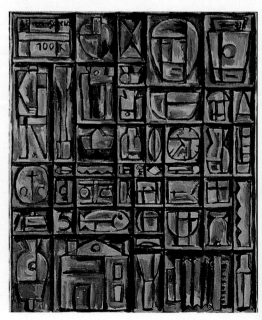

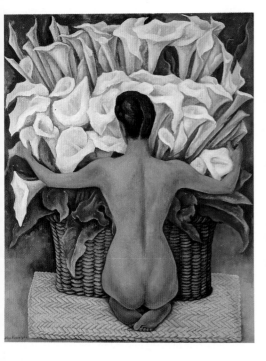

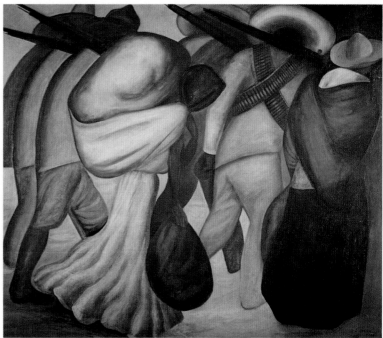

ing of a clearly revolutionary bent is still possible in the 20th century. His multiple-figure compositions are filled with tumultuous drama, doubtless derived not only from Mexican traditions but from an awareness of Expressionism and the expressive realism of a Picasso. But these influences are transmogrified into an aggressive, obsessive style with an inimitable, personal stamp. Orozco is not afraid of pathos, even of sentimentality on occasion, courageously taking risks that lesser artists would avoid.

Rivera's painting, dynamic if formally more tranquil by comparison to Orozco's furor, is likewise at its monumental best in the fresco medium. It reveals the European influences, from the orbit of Modigliani and Apollinaire, of Picasso, Braque, and Gris, even of the frescoes of Giotto, which Rivera overcame by an enormous act of will without ever quite being able to forget them.

Siqueiros (p. 207 below), the third in the league of painting revolutionaries, stood even more decisively on the side of the wretched and the poor, especially of the Indians. To "socialize artistic expression with the aim of eliminating individualism" was his express intention. Like his friends Orozco and Rivera, the latter of whom he met in Paris in 1921, Siqueiros took his point of departure in the aesthetic and ideological doctrines of the revolutionary graphic artist Posada and the founder of

the "Indian Renaissance," Dr. Atl (alias Gerardo Murillo). But unlike them, he wholeheartedly accepted the role of political propagandist, activist, and educator of the people. Despite his many commissions, Siqueiros even occasionally relinquished artistic activity entirely in favor of grassroots political work. Nevertheless, he managed to introduce a number of technical innovations, such as the systematic use of new tools like the airgun. These he put in the service of a rapid, propagandistically effective, "current" painting which was capable of keeping pace with the political developments of the day.

**Diego Rivera**
Nude with Calla Lilies, 1944
Oil on hardboard, 157 x 124 cm
Mexico City, Emilia Gussy de
Gálvez Collection

**José Clemente Orozco**
The Soldiers' Wives, 1926
Oil on canvas, 70 x 100 cm
Mexico City, Museo de Arte
Moderno

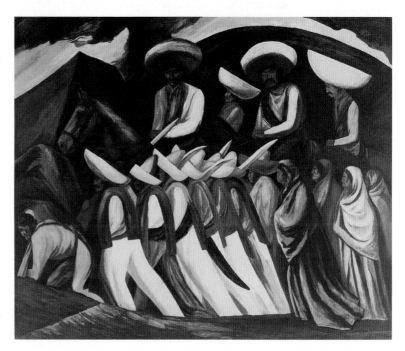

**José Clemente Orozco**
Zapatistas, 1931
Oil on canvas, 114.3 x 139.7 cm
New York, The Museum of
Modern Art

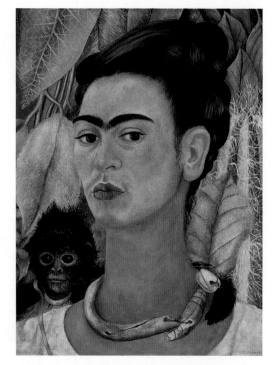

**Frida Kahlo**
Self-Portrait with Monkey, 1938
Oil on hardboard, 40.6 x 30.5 cm
Buffalo (NY), Albright-Knox
Art Gallery, Bequest of A. Conger
Goodyear

**Diego Rivera**
The Arsenal – Frida Kahlo
Distributes Arms, 1928
From the cycle: "Political Vision
of the Mexican People" (detail)
Fresco, 203 x 398 cm
Mexico City, Secretaría de
Educación Pública

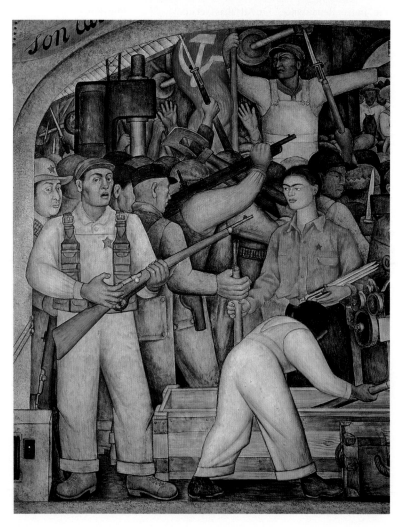

The confrontation at the Düsseldorf Kunsthalle in 1995 of 50 each drawings and paintings by Siqueiros and Pollock, who worked together in New York in 1936, shed a new light on both artists. In the engaged realist's laboratory, the later painter of "drip" abstractions learned the technique of letting paint drip from a stick while moving around the canvas lying on the floor.

An important rediscovery was the work of Frida Kahlo, Rivera's wife, who long stood in the shadow of her dominating husband (ill. left). The moving paintings of this long-suffering artist are socially critical without being aggressive. They are images of compassion, documents of human warmth, in which a merciless frankness obviates every tendency to sentimentalism.

The flowering of Mexican mural painting, which was not without influence on North American art, began in 1922 with the execution of murals for the Escuela Nacional Preparatoria by the trio of Siqueiros, Rivera and Orozco. These were followed by many other frescoes which are now the pride of Mexico City. Unlike many like-minded European artists, the Mexicans had the satisfaction of being understood by those to whom their art was addressed – and sometimes even by their artistic and political opponents, which involved them in a great deal of trouble despite their popularity. Although they were political artists and convinced of their mission, they never subordinated themselves to any party line, not even Siqueiros, who was a convinced communist. That saved them from compromise, not to mention those acts of submission which watered down or even ruined the work of so many of their colleagues. The later, often embarrassing concessions of the erstwhile Russian revolutionary painter Alexander Deineka to the Stalinist version of Socialist Realism may stand as an example.

Concessions of a less drastic nature are seen in the work of the Sicilian artist Renato Guttuso. Like the Mexicans, he too remained a convinced socialist, if of the Italian stamp – a Eurocommunist, in other words, even holding the position of senator from 1976 onwards. And like them, Guttuso was one of the major realists of the years before and after mid-century. A certain insecurity, engendered by his attempts to conform to the doctrines of Socialist Realism, which he basically accepted, is reflected in the irritating inconsistency in the quality of Guttuso's work over long periods. Nevertheless, despite a verism that shows parallels to the work of neorealistic film directors like Roberto Rossellini, Guttuso never descended to shallow naturalism. For that he was too widely travelled, and involved in too lively an exchange with the best in the art of the period.

The pictures which brought him first fame reflect, apart from an innate expressive tendency, a continual coming to terms with a range of contemporary styles, on the basis of a schooling in the Italian tradition. This is impressively attested by one of Guttuso's major canvases, *Caffè Greco* (pp. 207, 208), a scene in which the

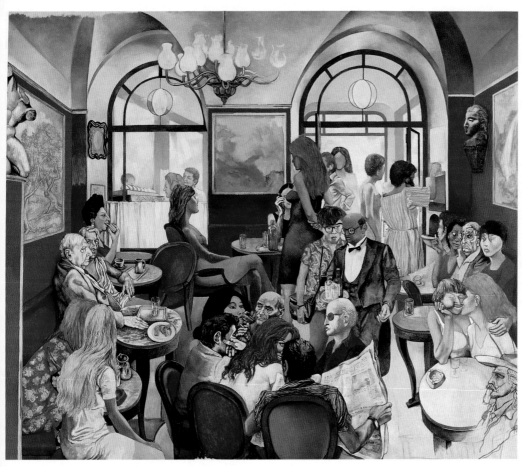

**Renato Guttuso**
Caffè Greco, 1976
Oil on canvas, 282 x 333 cm
Cologne, Museum Ludwig,
Ludwig Collection

**David Alfaro Siqueiros**
Death and Funeral of Cain, 1947
Acrylic on wood, 76 x 96 cm
Mexico City, Museo de Arte
Alvar y Carmen T. de Carillo Gil

worlds of the living and the dead mingle. De Chirico and André Gide, Duchamp and Buffalo Bill, lesbian girls and Japanese tourists, a female head by Picasso and the Apollo of Belvedere, hold a rendesvous in this realistic phantasmagoria related to an actual place and conceived at that place. Beyond this, a key historical event that altered world consciousness, the Paris revolt of May 1968, which very nearly led to Charles de Gaulle's demise, found its most compelling artistic formulation in a work by Guttuso.

Guttuso's achievement notwithstanding, political-critical realism in the West produced no works that in terms of artistic rank could be set beside the best of Futurism prior to World War I and of Verism in its wake – not to speak of the prostituted productions that were churned out in such masses in Stalin's Soviet Union and Hitler's Germany. Even the Paris May had few artistic consequences, although its manifestations profited greatly from new, spontaneous forms of art and theater such as the Happening and the Living Theater. In West Germany, the most effective contribution to a politically engaged critical realism has been that of a Heidelberg attorney-at-law, Klaus Staeck, with his photograph-based posters and postcard series.

It is surely no coincidence that a relatively critical postwar realism should have emerged in Spain. There, artists were largely in agreement in their protest against

**Renato Guttuso**
The Takeover of Land by Sicilian
Peasants, 1949/50
Oil on canvas, 265 x 344 cm
Dresden, Gemäldegalerie Neue
Meister, on loan from the
Akademie der Künste

**Eduardo Arroyo**
Blind Painters, 1975
Oil on canvas, 221 x 180 cm
Zurich, Crex Collection

the Franco regime, even though many of them – if not most, such as Antoni Tapiès, for instance – set themselves goals in which their political conviction played little part. One is reminded of Herbert Marcuse's reply to students clamoring for an agitprop art during the unquiet late 1960s and early 1970s: Though Courbet, as a political man, participated in the razing of the Vendôme Column, said Marcuse, you couldn't tell this from his pictures.

Among the critical realists of Spain, Juan Genovés and Rafael Canogar hold places of prominence, Genovés with compelling figurative symbols of political vio-

**Erró**
Venus, 1975
Oil on canvas, 130 x 97 cm
Aachen, Ludwig Forum für
Internationale Kunst

lence and persecution, often set in stark contrast to empty spaces, and Canogar with photocollages and later three-dimensional figures (often headless torsos) representing anonymous victims of political persecution and torture, demonstratively placed before empty walls. "Equipo Cronica", founded by Manuel Valdes and Rafael Solbes in 1964 – four years before the Paris May – employs overpaintings of reproductions of famous historical works from Goya to Picasso and Lichtenstein and uses the collage technique to update these images and place them in the service of the current political debate.

A special niche on the Spanish scene is occupied by Eduardo Arroyo, a writer and journalist who lives in Paris. In his graphic and painterly work the actual is blended with the unreal, the real with the surreal, primitivistic simplification with intellectual metaphor. In one painting a man in a suit hops on his head down the stairs, his face a palette, indicating his role as painter. A dog and cat, in the form of a rubber collage, lie on the pavement in Berlin-Kreuzberg. "The Last Optimist" represents Julio Alvares del Vayo, minister of state of the Spanish Republic before the advent of Franco, his *Shoes of Exile* multiplied to five, the broad smile in the circular portrait he holds like a shield in front of his face in the full-figure depiction fixed in a grimace. Flecks of color hover before the eyes of Arroyo's *Blind Painters* (ill. above right), and he depicts himself as *Robinson Crusoe* (1965), clad in skins and a feathered hat, seated in a chair that, while comfortable, is obviously located on a desert island. In a three-panel picture, Janek Walczak, the boxer, though apparently beyond his prime and looking apprehensive, strikes a fighting pose in the center, while at the left a skinny black opponent raises his guard and at the right, a pair of gloves and a deflated punching ball hang on the familiar nail. As one can see, a telling, liter-

ary wit, not unlike Magritte's but more related to current events and concerns, is one of the prime tools of Arroyo's unacademic painting. "Panama," his biography of the boxer Al "Panama" Brown, long held a place on the non-fiction bestseller list.

Political commitment is expressed more directly and without literary trappings in the work of the Icelandic artist Erró, who distills his equally straightforward and sarcastic political vocabulary from comic books and posters, and recombines the elements by means of painted collage (p. 208 below).

The work of the Swedish-American artist Öyvind Fahlström, though it likewise relies on comic-strip clichés, is more ambiguous, indirect, and allusion-charged than that undertaken by Erró. Hovering in an area between Pop and New Realism, Fahlström's compositions give pointed intellectual expression to an enigmatic humor rooted in the Dadaist and Surrealist tradition (ill. right). Taking a convinced pacifist position during the Vietnam War, the artist waived the expression of the emotions it aroused in him, instead he marshalled facts and data that were intended to attack the war-mongers and educate the viewer. Those he criti-

cized and those effected by the inhumanity of government, Fahlström hoped, would both "understand and be injured" by his imagery. In a few cases he certainly succeeded in this; but for the masses Fahlström's work remained a message that did not reach them.

A completely different approach to a critique of social conditions is evident in the work of Columbian artist Fernando Botero (ill. left). Botero reveals the "discrete charm of the bourgoisie," of ecclesiastical and political leaders, by means of fine painting and the device of the blow-up. Masterpieces of art history from Raphael to Peter Paul Rubens are as little immune from this process as presidents and cardinals. Admittedly, however, the sometimes frivolous, if ultimately gentle humor of Botero's depictions of this literally inflated society, along with the brilliance of their execution, do blunt the point of his attack.

**Öyvind Fahlström**
Roulette, Variable Painting, 1966
Oil on photograph, paper, vinyl, cardboard, magnets, 152.5 x 166 cm
Cologne, Museum Ludwig, Ludwig Donation

**Fernando Botero**
The President, 1969
Oil on canvas, 267 x 135 cm
Munich, Bayerische Staats-gemäldesammlungen, Staatsgalerie moderner Kunst

# The Face of the Century

## Painting as a Dramatic Act
## Pablo Picasso: an Artist and his Legend

It is no easy task to become a monument to oneself during one's lifetime. For many artists who do so, it leads to ossification and a decline in their creative powers. If there was one painter of our times who was an exception to this rule, it was Pablo Picasso. Born in Málaga, Andalusia, Pablo was the son of Doña Maria Picasso y Lopez and Don José Ruiz Blasco, an academy instructor and later professor in Barcelona. Even far into his eighties, this small, great man with the blazing eyes continued to excite controversy. It is common knowledge that at an advanced age, Picasso married the beautiful young Jacqueline Roque, who later was unable to get over his death, and that before and between his two marriages he had several mistresses. It is also common knowledge that Picasso distorted the human anatomy in his work, occasionally deforming the human image to the point of monstrosity; that he was able to paint and draw quite realistically, even classically, and yet seldom chose to. In the meantime the experts have declared Picasso a Proteus, comparing him to the ever self-transforming, oracular "sea-ancient" of antiquity. For some a god, for others Picasso was the symbol incarnate of Hans Sedlmayr's *Der Verlust der Mitte* (Loss of the Center) – thus the title of the conservative art historian's influential book – and his diagnosis that the melancholy of the modern artist was due to his having lost touch with God.

Although Picasso never had a private student, he did unwittingly found a school that has incomparably affected art in our century, whether by acceptance or rejection of his work. The number of his followers and imitators is legion. Even the violence with which many painters attacked their father-figure after 1945, especially during the 1950s, only goes to show how difficult they found it to emerge from his shadow. The greatness of Picasso, someone aptly said back then, could be measured by the number of debates he was capable of triggering. Most of the doubters, though, have long since turned from Sauls to Pauls, a conversion that was encouraged by the gradual revelation of the scope and diversity of Picasso's œuvre, in sculpture as well as in painting and graphic art.

One of the most important exhibitions of the early 1990s was "Picasso. Die Zeit nach Guernica" (The Period After Guernica). This presentation convincingly disproved the legend of the late Picasso's faltering imagination, a legend to which even William S. Rubin, a friend of the artist and curator of the otherwise breathtaking retrospective held in 1980 at the Museum of Modern Art, New York, in honor of Picasso's 100th birthday, still paid tribute. Rubin, as if embarrassed by the late work, discussed it only in passing. How erroneous this was became entirely obvious in 1992, at the exhibition named above. Shown in Berlin, Munich and Hamburg, it began with the year 1937, when Picasso painted *Guernica* (p. 217) for the Spanish Pavilion at the Paris World Fair – the epoch-making canvas that remained homeless in Franco's Spain, enjoyed a refuge in New York, and now has found its final place, unavailable for loan, in Madrid. Post-modernism, which has relativized the concepts of innovation and the avant-garde, has confirmed the re-evaluation of Picasso's late work from the standpoint of the present day.

It is truly exciting to watch the aging Picasso, entirely oblivious of avant-garde ambitions, in full control of his incomparable painterly means, doing what he will with colors and forms, unashamedly quoting himself and the greats of art history as the whim takes him. As if providing a running commentary on his own career, the old painter spreads out before our eyes his decades of experience with a dazzling abundance matched by no other artist of the era. The best of these late and latest works possess a freshness of invention, a precision of execution, and a brilliancy of attack which attest to the unbroken force of an imagination of unbounded scope. Compelling evidence is found in paintings such as *Le Déjeuner sur l'herbe* after Manet (1961; Paris, Musée Picasso), *Great Profile* (1963; Düsseldorf, Kunstsammlung Nordrhein-Westfalen), the lovely, tenderly melancholy *Portrait of Jacqueline* (1964; heirs of Jacqueline Picasso), the bucolic *L'Aubade* (p. 218), the ironically insouciant double portrait *Musketeer and Cupid* (1969; Cologne, Museum Ludwig), or the *Musketeer with Pipe* (p. 218).

### The Human Drama
Beneath the artist's stylistic leaps and masquerades one can detect a basically quite logical development, driven by a sensibility that reacted seismographically to changes in the world around it, and with a dramatic vehemence intended to be immediately effective. Picasso once scoffed at the aestheticism of Impressionist landscapes

*"I deal with painting as I deal with things, I paint a window just as I look out of a window. If an open window looks wrong in a picture, I draw the curtain and shut it, just as I would in my own room. In painting, as in life, you must act directly."*
PABLO PICASSO

**Pablo Picasso**
Acrobat and Young Harlequin,
1905
Gouache on cardboard, 105 x 76 cm
Private collection

and their subtle records of changing light, calling them mere "weather reports." In every transformation he went through, Picasso remained a great realist. His sense of reality was Spanish in origin. Instead of being satisfied with beautiful appearances, he painted to get under people's skin. As his friend, Eluard, once said, Picasso was after the truth hidden beneath the surface. He never painted for the sake of painting alone. Picasso aimed to depict the adventure of life, the human drama. This is why, as close to abstraction as some of his works came, he rejected abstract painting in the narrower sense.

"Abstract art is nothing but painting. Where is the drama in that?" Picasso asked Christian Zervos, editor of *Cahiers d'Art*, in 1935. With this in mind it is no wonder that Picasso gave up Analytic Cubism when he decided the style had become too scientific, too hermetic. Picasso was no pure artist; he wanted his pictures to have an effect. "Some day we should be able to paint pictures that are capable of curing a person's toothache," he once said, in a wonderful understatement that aptly described what moved him to paint. Although he was capable of painting, and above all of drawing, not only as correctly but as beautifully as any Old Master, Picasso's art is not slick or facile; it is rough, disquieting, harsh, dramatic, and often provokingly grotesque and sarcastic.

The restlessness that drove him and determined the course of his life was also the agent that moved his art.

**Pablo Picasso**
Harlequin, 1915
Oil on canvas, 183.5 x 105.1 cm
New York, The Museum of
Modern Art

Hardly any other painter gave himself over so completely to the adventure of art, to working without the benefit of the safety-net of convention, and that to a ripe old age. This was the source of Picasso's incessant stylistic changes. Master of every skill and artistic means, he was capable of transforming himself from year to year, even from month to month, week to week, day to day. Picasso shifted effortlessly from the dramatic to the lyrical mode, from the classic to the expressionistic, from realism to symbolism, Cubism to Surrealism. He continually altered his standpoint and point of view, uncovering ever-new aspects of his motifs. Picasso knew that an artist, due to the fast rhythm of the modern age, could not put all of himself into a single masterpiece, but had to express his vision in terms of series. This is why he did 15 versions of *The Women of Algiers* after Delacroix, and a full 58 versions of *Las Meninas* after Velázquez (Barcelona, Museu Picasso).

Rather than proceeding on the basis of a pre-considered plan, Picasso let himself be led by intuition. "I never know what will come up next," he said, and admitted that he sometimes made a hundred studies in a single day. The rapidity of his production was predicated on a somnambulistically sure hand. This entailed an unbelievable concentration, a meditative process of painting in which the external world was completely shut out. No one dared to disturb Picasso at his work. The few people he permitted to watch, such as the English painter and collector Ronald Penrose, report that he worked in absolute silence.

Picasso thought with his hands; his experiments were seldom or never a testing of pre-conceived theories, but unconscious practice. Reflection came later. As intelligent as he was, Picasso left theorizing to others. He did not set much store in explanations. And if something remained obscure, all the better. "Everybody wants to understand art," he told Zervos. "Why don't people try to understand the songs of a bird? Why do people love the night, flowers, everything around us, without needing to understand them?"

In his œuvre Picasso traversed the entire range of expression and form in modern painting, discovering countless new provinces. But he never sacrificed reality to pure, aesthetic form or self-satisfied revellings in color. His manner of working immediately and entirely from the promptings of his unconscious was a sign of his freedom of spirit and ultimately of a great tolerance, which touchingly expressed itself in Picasso's enthusiasm for the work of other artists, especially younger talents, even if they were no more than mediocre. Throughout his life, Picasso encouraged young artists and never discouraged them. This attitude reveals the apparent arbitrariness and inconsistency of his continual stylistic changes to have actually been a logical process, independent of fashion and fleeting period styles. The only thing that was capable of making Picasso feel insecure was his self-doubt, which, after all, is a sign of the critical, creative mind.

For all his transformations, Picasso remained true to himself. Even later, when rich and living in luxury, he continued to surround himself with the disorder he needed as a stimulus to creativity. He never forgot the terrible, wonderful years in Montmartre, for his lifelong motto was to "live like a poor man, but with money." Nor did he forget the cold night when – like the hero of some cheap Bohemian novel – he had to burn his drawings in the stove to keep warm, or that his girlfriend at the time, the "delightful slattern" Fernande Olivier, had to make do with two francs a day for food money.

Already at the age of sixteen Picasso's talent put his teachers, including his thoughtful father, to shame. The early drawings and paintings had a perfection, a sureness of handling even the large format, that soon made further academic study seem pointless. The young artist employed Impressionistic techniques with the same skill as the earlier academic, Old Masterly ones. For a time Picasso delved seriously into the theories of the scholarly Seurat and his Neo-Impressionism. But he only came into his own with the first works of the Blue Period, which were begun during an early stay in Barcelona. Their pervading dark blue, melancholy and occasionally verging on the sentimental, resulted from an instinctive affinity for the color. In formal terms, the pictures of this period show the influence of Gothic elongation, and of the mannerisms of El Greco and Toulouse-Lautrec. Their socially critical impulse, by comparison, for instance, to the detachment of Degas's absinthe drinkers or café scenes, is quite obvious. Picasso was always a virtuoso in adopting others' styles, styles which he subjected to the logic of his own personality and expressive vision. The list of those to whom he paid homage is long and diverse: from the Gothic of Avignon to the Egyptians, from the pre-classical and classical Greeks and the Phonecians to Cranach, Michelangelo, Goya, Velázquez, El Greco, Poussin, Ingres, and Delacroix, all the way down to Courbet, Toulouse-Lautrec, van Gogh, Cézanne, and Degas – and, as a sculptor, to his great compatriot and friend Julio González (pp. 470–472), in collaboration with whom he invented welded iron sculpture. But whatever the stimulus Picasso took up, the resulting work was inimitably his own.

This great revolutionary and disturber of the artistic peace had strong ties with tradition, if not with the ubiquitous Italian Renaissance. By copying and transforming masterpieces of past eras Picasso laid the groundwork for his personal mastery. His lifetime achievement, formally and aesthetically, was to have married the realistic, dramatic expressive power of Spanish art with the painting culture of his host country, France. This fusion already became apparent in the various phases of the Rose Period. The world evoked in these paintings is no longer marked by the crushing desolation of the Blue Period; it is brighter, more joyful, less sentimental, if not without a shadow of sadness that passes across the faces of its clowns, harlequins, and groups of artistes. Loneliness within a community, a lack of communication, a con-

sciousness of the transience of life, unallayed by faith in a better life to come – feelings which tormented Picasso to the end of his days, all found moving expression in the pictures of the Rose Period. They are suffused with autobiographical hints, some overt, some covert. Picasso assumed the harlequin's mask just as readily as, later, he would slip into the role of the Minotaur, of the aging artist with his young model, the lover, the child with a candle, bull, stallion, owl or dove.

Merely to list the figures in the Rose Period works is to show that Picasso had turned to a new range of themes, derived from the circus world. By about 1905/06 he was producing figurative compositions of a classical harmony of line and plane which already anticipated the Classical Period of the early 1920s. By 1906 the young artist had already achieved public recognition in the country in which he lived, without ever entirely overcoming his homesickness for Spain. Thus he was hurt all the more by the rejection of the great canvas in which he had invested so much work, the composition that harshly and demoniacally heralded the advent of Cubism: *Les Demoiselles d'Avignon* (p. 69). The result was a bout of depression, and it would not be Picasso's last. His secretary and biographer Jaime Sabartés reports that in 1936, a year before *Guernica*, the artist informed him in writing that he was going to give up "painting, sculpting, engraving and poetry" and devote himself from then on "exclusively to singing." Though this eccentric plan was soon abandoned, the episode shows that Picasso's self-doubts were not allayed by success. He declined to visit exhibitions of his own work. He knew

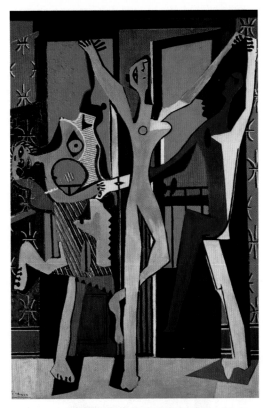

**Pablo Picasso**
Dance, 1925
Oil on canvas, 215 x 142 cm
London, Tate Gallery

*"I object to the idea that there should be three or four or thousand ways of interpreting my pictures. There ought to be no more than one. And within this interpretation it should be possible, to some extent, to see nature, which after all is nothing but a kind of struggle between my inner being and the outer world."*
PABLO PICASSO

the pictures, he had made them himself, so why should he go, Picasso asked. The question might have been Duchamp's. Picasso had no talent for playing the role of the misunderstood genius. The moment anyone could have convinced him that his paintings left his contemporaries cold, he would have changed his profession. As it was, he only changed his style.

Picasso took Cubism to a much more radical and ambitious level than Braque, who retired into a realm that, while still intellectually demanding, was consciously limited, tranquil, sophisticated. Compared to those of his former friend, Picasso's later endeavors appear positively daredevil. Cubist means heightened to the utmost are found not only in the *Harlequin* of 1915 (p. 212), with its radically, its hard-edged, superimposed colored planes that verge on geometric abstraction; they

**Pablo Picasso**
Portrait of Dora Maar, 1937
Oil on canvas, 92 x 65 cm
Paris, Musée Picasso

are also found in a key work of six years later, the rigorous, idol-like *Three Musicians* (New York, The Museum of Modern Art). In its crystalline precision and mystical depth this canvas represents the summing-up of the artist's experiences with Synthetic Cubism. Employing its vocabulary in a composition with three figures is something no one but Picasso would have dared, let alone managed to bring off.

The same artistic mastery is seen in the realistic imagery with which the Spaniard replied to the slogan, "Back to Raphael!" The wave of realism that swept a painter like Beckmann to the surface, carried Picasso along as well. How close the connection was between life and art in his work is indicated by the fact that many

of his monumental, statuesque female portraits, partaking of archaic myth or embodying the fecundity of Mother Earth, emerged during the months in which Picasso's first wife, the Russian dancer Olga Koklova, was pregnant. The vital female principle in its mythical ordinariness, which in pre-historical times had found expression in the Venus of Willendorf, was now lent monumental presence in Picasso's maternal idols.

## Prophetic Monsters

The incredible and the monstrous are also part of reality. Although Picasso never belonged to the Surrealist movement, it did encourage him to address the evil, diabolical and ridiculous traits inherent in human nature. Such tendencies were pre-figured in the bacchic *Dance* (p. 213) of two women and a man; they peaked in a brutal metamorphosis of the female body into threatening, polyplike configurations or birds of death. The concurrent portraits, on the other hand, were gentler in mood and more brilliant in color, and combined frontal and profile views in a way that indicated a recapitulation of Cubist experience.

If the portraits revealed an attempt to depict the human essence in its entirety, rather than in selected aspects, the monstrously distorted, eerie or grotesque figures of the period seemed prophetic of things to come. They anticipated the works in which speechless horror at the atrocities of the Spanish Civil War, which were still largely ignored by world public opinion but would soon lead to the orgies of cruelty of the Second World War, were lent immediate presence. Picasso's paintings of these years are witnesses to his own suffering in face of the unspeakable suffering endured by his fellow-men. The truth and reality of his monsters was horrifyingly confirmed, and continues to be confirmed daily.

## "Guernica"

That modern art is still capable of producing an impassioned accusation, triggered by a current historical event, that far transcends mere social criticism to document the destructive side of human nature, was irrefutably proven by Picasso's most famous painting, *Guernica* (pp. 216/217). The event was the German bombardment, without military necessity, of the small Basque village of that name by aircraft of the Legion Condor, which sowed death and destruction over the town as its inhabitants were gathered in the marketplace. This was a dress-rehearsal for the total war of six years later, prelude to its campaigns against the civilian population, to its killing out of sheer indifference and cruelty.

Picasso describes not the German attack but its consequences. The colors he employs are few: black, white, grey. The compositional framework is a flat, obtuse-angled triangle, into which eight figures, not so much acting as acted upon, are inscribed: in the middle, a fatally injured "apocalyptic" horse, its neck stretched out in agony; on the ground below it, the shrapnel-torn rider; a woman rushing towards the center; another

"I keep doing my best to lose sight of nature. I want to aim at similarity, a profound similarity which is more real than reality, thus becoming surrealist."
PABLO PICASSO

**Pablo Picasso**
Weeping Woman, 1937
Oil on canvas, 60 x 49 cm
London, Tate Gallery

whose arm, stretched out over her head and into the picture, holds a candle that illuminates the grisly scene, while to the right another woman collapses screaming, and at the left a fourth woman holds her dead child in her arms: a terrible 20th-century Pietà. Over this figure appears a bull, unapproachable and proud, its eyes wide open – perhaps a symbol of invincible Spain, or of indifference in face of the triumph of evil. The flames over the house in the right half of the picture are depicted schematically, as in a child's drawing, as is the "sunlight" ironically streaming from a light-bulb. The torn bodies, according to Picasso's own interpretation, have a symbolic, allegorical meaning. They are models, representing suffering humanity in "the sweeping-out of the white race," as Friedrich Dürrenmatt sarcastically described the self-destruction of mankind. The enemy is not shown; he remains anonymous, invisible. This too is a prophetic premonition of the total anonymity of war in the era of those bombing operations the military frightfully terms "surgical."

In Picasso's dramatic gestures and dismembered figures, the tragic mode, which long seemed inaccessible to modern art, again found compelling formulation. In *Guernica* the artist achieved a complete equilibrium

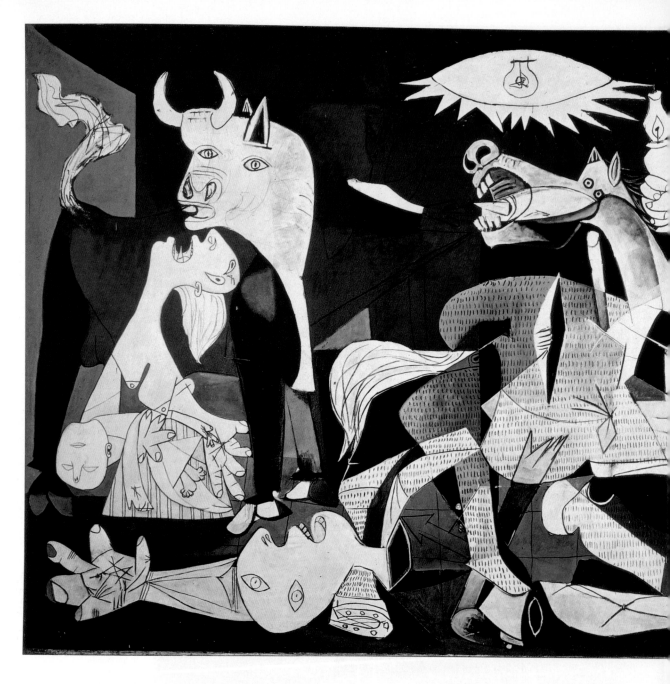

between form and expression. The monumental work is
the most significant history painting of the epoch. Tran-
scending the event that occasioned it and less cryptic
than Beckmann's triptychs, *Guernica* represents a time-
less metaphor of overwhelming force, more convincing
and memorable than the polemic *Massacre in Korea* (1951;
Paris, Musée Picasso).

In the orbit of *Guernica* a number of studies and sep-
arate depictions were made, the most compelling of
which, apart from many drawings on the same theme,
are the oil studies of *Weeping Woman*. These were
inspired by the famous scene of crying and screaming
women in Eisenstein's classic revolutionary film *Battle-
ship Potemkin*. The version of October 26, 1937 (p. 215) is

an especially moving example. The splintered face, in
whose eyes silhouettes of two bombers are reflected, is
literally "torn with sobs" – a memento of cruelty and of
compassion with tormented humanity. Picasso the
dramatist, the pathos-loving Spanish realist, the expres-
sionist whose force of expression far outstripped that of
most of the Expressionists proper and their camp-fol-
lowers, achieved the apex of his mastery in *Guernica*.
The combination of painted symbol and historical real-
ity was Picasso's own, inimitable variant of symbolism.
It was the "evidence," as Werner Spies wrote, with the
aid of which "a repressed historical reality was brought
to light," just as Géricault did in his *Raft of the Medusa*
(Paris, Musée du Louvre).

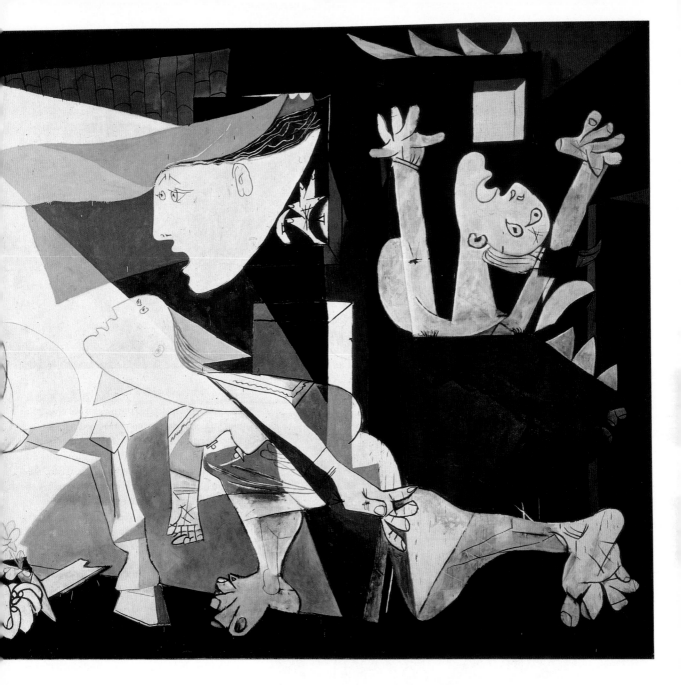

## Master of the Line

Yet the Spaniard could also be as gentle as a Rococo painter, as enamored of decor and ornament, in love with the beauty of human beings and landscapes untouched by strife and conflict. Many still lifes, Mediterranean scenes, bucolic drawings, but above all the series of female portraits, glowing with gem-like color, document Picasso's artistic mastery in this field (p. 214). They show him looking upon the bright side of life, which he continually needed to compensate his sense of the omnipresence of death, so compellingly and terrifyingly embodied in his depictions of bare animal skulls. The clowning, faun-like side of Picasso's nature also had its source in this struggle with darkness. That

Eros and Death, joy and tragedy are siblings, is more clearly revealed in Picasso's work than in that of any other artist of our times.

"In modern painting, every brushstroke has become precision work," the great draughtsman once said. Despite his brilliant facility, Picasso had to struggle over and over again for decades to achieve this precision anew. The drawings and prints illustrate the scope of his accomplishment. Like Kirchner's woodcuts, Picasso's etchings and lithographs stand on an artistic par with the oils. Many of them, like the drawings, possess the quality of originals, since rather than representing pre-liminary studies to larger works, they are autonomous works of art in their own right. There are very few paint-

**Pablo Picasso**
Guernica, 1937
Oil on canvas, 349.3 x 776.6 cm
Madrid, Centro de Arte
Reina Sofía

**Pablo Picasso**
L'Aubade, 1967
Oil on plywood, 161.7 x 122 cm
Lucerne, Galerie Rosengart

ings in Picasso's œuvre that were done on the basis of an existing drawing. More often, drawings were "copied" after paintings. However, there were numerous reciprocal relationships between the two media as regards the artist's stylistic development, although their various phases did not always coincide in time. The "naturalism" that appeared in the paintings in about 1918 was already pre-figured in the drawings of 1914-15; the influence of Ingres vanished from the paintings in 1923-24, while remaining evident in the drawings and prints thereafter.

The idiosyncrasies of the artist's personality and working process are just as clearly evident in the graphic work as in the painterly. Picasso always worked spontaneously, letting technique and style of treatment be prompted by the subject at hand. "A picture is not conceived and determined in advance; while you're doing it, it follows the changeability of the idea," is how he himself once put it.

"I'm no pessimist, I don't abhor art," Picasso bravely stated during a period of deep self-abhorrence, "because I couldn't live without devoting all my time to it. I love it as my sole purpose in life. Everything I do in connection with art gives me the greatest pleasure." A Mediter-

**Pablo Picasso**
Musketeer with Pipe, 1968
Oil on canvas, 162 x 130 cm
Paris, Galerie Louise Leiris

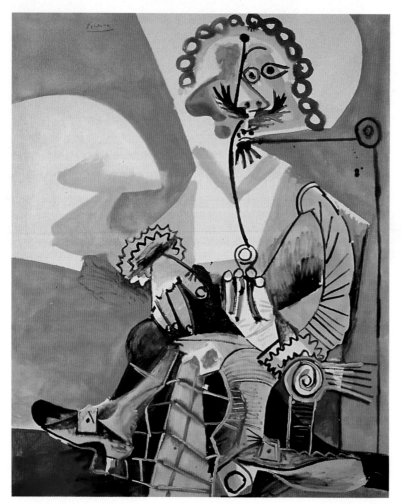

ranean enjoyment of everything life has to offer, a heathen optimism and love of the pleasure of creation, found immediate expression in Picasso's graphic art. But neither did Goya's countryman suppress the night side of life, struggle and death, when addressing the copper plate, lithographic stone, or – in later years – the linoleum block. It is truly the whole Picasso that one encounters in the graphic œuvre. Concentration and infallible sureness of line, sovereign mastery of every technique, the intensity of expression already familiar from his painting, the sense of the decorative that lent charm to his not always practical but invariably original ceramics – all these made Picasso one of the most significant draughtsmen and printmakers of all times.

His sculptural work was no less inventive than his graphic art. In this field, too, the Spaniard was a pioneer. Not his compatriot, González, first used iron as sculptural material, but the friend whom González had agreed to help in his experiments. And when Picasso decided to make a ready-made, the results, thanks to his boundless imagination, far surpassed those of his Dadaist-Surrealist models. Not satisfied with a mere gesture or a demonstration that existing banal things could be art, he transformed them into true works of art, quite unlike Duchamp's fetishes. Picasso would take a bicycle saddle, turn it point downwards, attach handlebars to the broad end – and there was a *Bull's Head* with horns (p. 479). A configuration of this kind witnesses to the probity of Picasso's insight that the decisive factor for his art was not seeking, but finding.

"In the distorting mirror of art, reality appears undistorted." Kafka's famous statement applies perfectly to Picasso. It is the face of the century that looks out at us from the lifework of this great artist.

# 10
# Between Revolt and Acceptance

## The Unknown in Art
### The New Realities of Abstract Painting

Abstract art has survived any number of obituaries. True, abstraction is no longer considered the only viable style of painting, as it still was in the 1950s. But if a so unconventional and independent-minded abstract artist as Gerhard Richter can state, "Abstract paintings are fictitious models, because they illustrate a reality which we can neither see nor describe, but the existence of which we may deduce," this insight shows that the paths of abstract painting have yet to be travelled to the end.

Born around the year 1910, abstraction passed through an adolescence that was uneventful as far as broad public resonance was concerned, then, in the mid-1940s, celebrated a belated post-revolutionary triumph. Starting from its headquarters, Paris, where it had been imported by Dutch, Russian, and German emigrés, abstraction conquered not only Europe but the entire Western world. For twenty years it reigned undisputed. The innate internationalism of abstract art, ignoring all national borders to overleap oceans and continents, seemed at the time to justify the concept of world art. Yet in hindsight, now that its dominance has waned, abstraction can be seen to have encompassed an enormous range of signs and symbols that reflected a changing, and still changing, world – despite the time-honored veracity of Hugo von St. Viktor's dictum, "The sign cannot be the truth, even though it be a sign of the truth." That entire legions of abstract camp-followers and *bons vivants* have disappeared into the void of oblivion, and that what seemed meaningful yesterday is meaningless today, is part of the painful process of "becoming classical" which every era of art history must go through.

The bias of the arguments advanced against non-objective painting over the decades becomes quite obvious in hindsight, now that the smoke has settled over the battlefield and we can play the role of detached observer. Abstraction was neither levelling nor productive of uniformity, it neither eliminated individuality nor abolished beauty, neither destroyed the human image nor caused the "death of ornament" or lost contact with reality. It led neither to fundamentalistic stultification nor to anarchistic excess. To judge the enormous scope of expressive possibilities inherent in abstraction it is enough to set the crosses and squares of a Malevich beside the revellings in paint of a Pollock, the piously

decorative painting of an Alfred Manessier beside the despairing rages of a Wols. A tension like that between the representatives of the various brands of "abstract", "non-objective", "non-figurative", "absolute", or "concrete" art – or whatever the inadequate category may be – such polar, mutually exclusive oppositions like those between Platonic geometry and the controlled chance of gestural paint orgies, have been exhibited by no other stream in 20th-century art, neither by Fauvism nor Expressionism, Cubism nor Realism, not even by Surrealism.

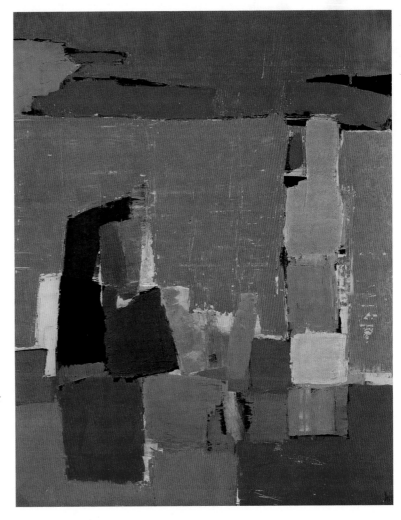

**Nicolas de Staël**
Figure on the Beach, 1952
Oil on canvas, 161.5 x 129.5 cm
Düsseldorf, Kunstsammlung
Nordrhein-Westfalen

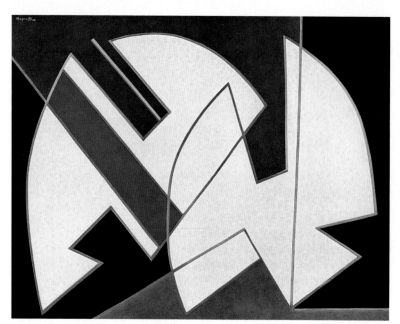

**Alberto Magnelli**
Dialogue, 1956
Oil on canvas, 130 x 162 cm
Rome, Galleria Nazionale
d'Arte Moderna

**Auguste Herbin**
Midnight, 1953
Oil on canvas, 161.5 x 114 cm
Zurich, Kunsthaus Zürich,
Association of Zurich Friends
of Art

The same distance separates the whirling, atomized forms of the early Kandinsky from Mondrian's right angles as separates Classicism from Romanticism, Apollo from Dionysus. Every direction in modern art temporarily issued in abstraction, and every one returned on a higher revolution of the spiral to transcend itself: Impressionism and Expressionism, Cubism and Surrealism, Dada and, for a time, even Verism in its harshest, most brutal form: solipsistic *l'art pour l'art* with an impassioned social commitment. It would almost seem as if in the years after 1945, European art of the first half of the century, in its post-revolutionary, as it were already "post-modern" phase, had attempted to marshal all its powers once again before temporarily abandoning the field to its American student, in whose hands it had for decades placed the means of self-realization with which he then proceeded to overcome his mentors and make New York instead of Paris the world capital of art.

### The Second Modern Movement

The change of scene – or rather, preparations for it – came during the period of the Second World War. The shifting of props on the avant-garde stage was merely an external sign of a profound transformation that took place in the minds of artists and their audience. With the outbreak of war, the classical epoch of modern art came to an end; a second modern movement, which is still underway, began. The 1940s marked the watershed. In 1937 the notorious "Entartete Kunst" (Degenerate Art) exhibition took place in Munich, and in 1939 the works of the defamed artists were sold for a pittance at an auction in Lucerne. The great emigration began, first within Europe, then to the United States. The era of utopias and closed systems, which despite trenchant criticism and unmistakable signs of the approaching catastrophe still retained an idealistic belief in the improve-

ment of man and his world, came irrevocably to an end. Now, art, whether abstract or figurative, is always a reply to reality. It is no wonder that in a confused, agitated, brutalized world the reply should have been ambivalent. Out of the chaos of the "incubation period," as art critic Laszlo Glozer has characterized the years between 1939 and 1945, emerged the radical propositions of a new art, in the face of which one can no longer allege that all of the decisive arguments in the 20th-century art discourse were advanced by 1910, and that what came after 1914 was merely repetition or, at best, variation.

For the avant-garde, "the Second World War... cannot be considered a divide," says Glozer, but represented a "hinge-point." And he adds, "The collision of modernity with current history surely had one effect: the motif of liberty was made public, became a leitmotif of reception.... Thus began a new phase in the history of effect – that of perceived, received modernity."

The "revolution of modern art," in Sedlmayr's phrase, no longer played itself out within the aesthetic realm alone, but advanced into society. Just short of a decade later the 1968 Paris May revolt would signal changes in political and social consciousness whose effects can still be felt today. After 1945 the avant-garde emerged "from the phase of limited experiments, out of private circles and initiatives, into the exposed status of public attention; out of isolation into what may not have amounted to general popularity, but did represent a solemnly underwritten legality."

Another point Glozer makes is the "internal alteration in the framework of avant-garde art" that took place during the war years and the years of crisis that

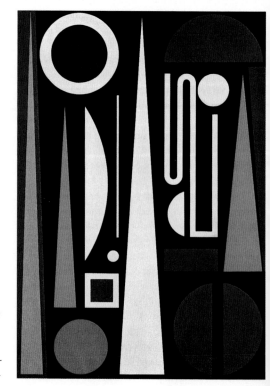

preceded them: "The new art which emerged from this as early as the 1940s, while it was rooted in the epoch-making achievement of the avant-garde, actually resulted from immediate concern," reflected artists' experience of the shock-waves that shook "the value systems of civilization, culture and art."

The work of Wols in Europe, and of Pollock in America, seismographically recorded these shock-waves, as different as their intellectual positions and their results may have been. Such is the background, along with the sense of a new-found freedom and a belief that art could overcome all national barriers to embrace the globe, against which the temporary triumph of post-war abstract art should be seen.

### Beginnings in Silence

The abstract tidal wave gathered force in silence, in part even in underground exile. Stalinist, Nazi, and – in lesser degree – Italian fascist terror, which had degraded art to an instrument of state propaganda, had interrupted a development in full flow, initially in Russia, then in Germany. In Italy the caesura was not so grave, because Mussolini not only understood nothing about L'art brut – unlike the artist and architect *manqué* Hitler – to an extent admitted this failing. How dependent art is on liberty is indicated by the astonishing fact that the decades of Stalinist and fascist tyranny, despite immense official support for conformist art, produced not a single painting or sculpture that has remained in the awareness of the cultured world.

Writing in Germany today, one cannot emphasize this fact enough, because a dangerously simplifying, ostensibly "objectifying" historiography is in the process of reducing the unparalleled brutality of the National Socialists to a "normal" level by pointing out atrocities committed by others elsewhere. In this connection belongs the attempt to convince today's public, especially young people, that, since we all know "anything goes", something in the nature of substantial art existed in Nazi Germany. The only reply to this is to state, categorically, that it did *not* exist. German art between 1933 and 1945 was produced in exile, or, to a lesser extent, in the "inner emigration." Klee, Kirchner, and Beckmann, to name only three, were driven from the country. Max Ernst lived in France from the 1920s onwards and later was compelled to emigrate a second time, to the United States. Schlemmer's *Window Pictures*, Willi Baumeister's *Eidos* series, and finally Nolde's *Unpainted Pictures*, all were executed under the protection of courageous friends and out of the public eye. Ernst Wilhelm Nay's *Lofoten* canvases were done in Norway. Artists such as Otto Freundlich, who fell into the hands of Hitler's henchmen, were murdered.

The works of the persecuted and suppressed are now very much in the public eye, hanging in museums all over the world, not lastly in Germany. German art of the period between Hitler's takeover of power and his demise is thus fully represented. The art that was offi-

**Otto Freundlich**
Composition, 1932
Oil on canvas, 161.5 x 130 cm
Basel, Öffentliche Kunstsammlung
Basel, Kunstmuseum

**Bram van Velde**
Painting, 1960
Oil on canvas, 130 x 195 cm
Private collection

cially tolerated and furthered during the Third Reich falls into the category of kitsch. These paintings (and writings) exhibit those "contradictory elements" which Saul Friedländer has unmistakably called by name in his essay *Kitsch und Tod* (Kitsch and Death): "… support of the existing order of things on the one hand, and of death and destruction on the other…. Here the visions of harmony, there the firestorms of the apocalypse; here the flower-wreathed girls and snow-capped peaks of the Bavarian Alps, there the heroes' dirge of the Feldherrn-halle, the ecstasy of the twilight of the gods, and the visions of the end of the world."

Unlike the field of literature, that of the visual arts produced no artist of rank under Nazism or fascism. Not even Hitler himself was satisfied with the results of his policies. And when a gifted young artist like Arno Breker submitted himself to the reigning ideology, artistic decline was the price he paid.

In the former Eastern Bloc, too, only Krushchev's *Thaw* brought remarkable talents back to light, in Poland, then-Yugoslavia, then-Czechoslovakia, and elsewhere. Many of these artists linked up with dormant traditions, or with dominating tendencies in the West; some adopted abstraction, others, like Strzemiński and Stazewski, even provided impulses to the Western van-guard ("Zero"). Their formal idiom had often been developed in the underground, and not without danger to themselves.

In France, abstraction remained a relatively weak tendency during the years between 1920 and 1940. At least it presented no serious rival to the great masters Picasso, Braque, Léger, or the Surrealists, especially as Delaunay, painter of the Eiffel Tower and *Views from a Window*, who had not only approached the frontier of abstraction but crossed it several times, returned in later years – like Villon and, temporarily, Herbin – to a more or less definite objectivity. What was on view in Paris at that period in the way of abstract painting was a weak reflection of things that were happening outside France – something for connoisseurs and adepts, and for a few artist-colleagues who even tried their hand at it for a time, before hesitating and returning to the objective world.

The French sense of reality long resisted the infiltration of utopian universal harmonies à la De Stijl and Slavic romanticism à la Kandinsky. Malraux, once a Marxist author, later a conservative and minister of culture under de Gaulle, long successfully hindered the acquisition of a Mondrian for the Musée National d'Art Modern in Paris. French artists eschewed abstract painting until they saw that *bonne peinture* in the French tra-

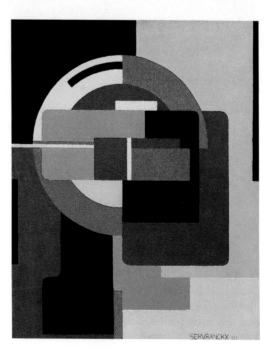 

Günter Fruhtrunk
Staccato, 1970
Oil on canvas, 140 x 141 cm
Munich, Bayerische Staats-
gemäldesammlungen, Staatsgalerie
moderner Kunst

**Richard Paul Lohse**
Nine Vertical Systematic Color
Sequences with Horizontally and
Vertically Increasing Density,
1955–1969
Oil on canvas, 120 x 120 cm
Napa (CA), Hess Collection

dition was possible even using non-objective forms, and that abstraction was not only, as they somewhat one-sidedly imagined, either frenetic, uncontrolled action or a drawing-board art that extolled the benefits of technology, the submission of the individual to the mass, of man to the machine, of painting to architecture. The Parisian individualists either rejected the idea of painting with a function, as industrial design or applied art or advertising, or they remained initially distrustful and aloof. After all, the metropolis of modern art had long courageously hindered the penetration of functionalist architecture – apart from a few Art Nouveau arabesques and that giant tinker-toy, the Eiffel Tower – into its grand 18th-century design. Saint-Ouen and La Défense were still undreamt-of.

## The "Liberation"

Credit for the emergence of an independent abstract painting in France must ultimately be given not so much to Kandinsky and Mondrian as, astonishingly, to Klee, the "level-headed Romantic" from Germany. Roger Bissière, teacher of Manessier and Jean Bazaine, in his maturity an "abstract intimiste", admired Klee, as his paintings clearly indicate. Bissière also published a portion of Klee's theoretical writings in French translation, which is to say, shorn of myth and mystery, he picked brilliance and grace notes out of the nocturnal obscurity. Manessier, in turn, placed these transformed elements in the service of his Christian symbolism. What preceded this development was abstract painting at second-hand, post-revolutionary exploitation of revolutionary ideas, not comparable in terms of formal power or intellectual intensity to the pioneering works of a Kandinsky, Mondrian, or Malevich.

The gradual subversion of the objective Ecole de Paris continued without much ado, but with consequences that were all the more far-reaching. In 1924 the energetic van Doesburg organized the first Paris exhibition of the De Stijl group. In 1930, shortly before his

death, he began editing the programmatic journal *Art Concret*. As mentioned, the Dutch artists rejected the adjective "abstract." They spoke of "concrete" art, explaining that color, form and plane were quite concrete values which represented a reality in themselves. In 1929 the first comprehensive show of Kandinsky's works went on display in Paris, followed a year later by the first international exhibition of abstract art. With it, the discussion on the aims of the new painting got officially underway in the world capital of art of the first half of the 20th century.

A group called "Abstraction-Création" was formed, laying the foundation for the international abstract Ecole de Paris. Developments were considerably advanced by the move to Paris of the Russian sculptor-brothers Pevsner and Gabo, by Kandinsky's flight there

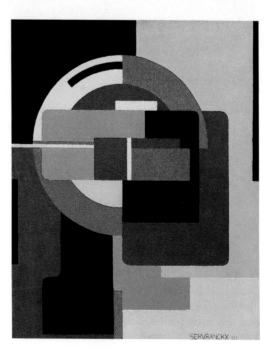

**Victor Servranckx**
Red Rotation, 1922
Oil on canvas, 72.5 x 57.5 cm
Paris, Musée National d'Art
Moderne, Centre Georges
Pompidou

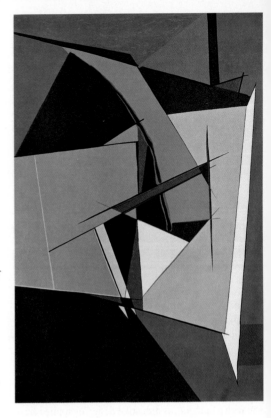

from Nazi Germany, and also by Mondrian's activity, the presence of Arp and several Surrealists, and finally by the infiltration of Russian Constructivist and Bauhaus ideas.

The fascination exerted by these ideas proved to be extraordinarily strong. "Liberation" was the operational word, as it had been for the revolutionaries around 1910. Color and form were at last given full autonomy as values in themselves; "purity of means" became an axiom. It was not until the 1940s that the concept of Nouvelles Réalités, or new realities, cropped up, and was subsequently applied to literature as well.

### "Loss of the Center" and "Atomization"

But the new art had many opponents. Their oft-reiterated arguments were that its purism was "inhumane" and "despairing," and that it would lead to sheer, chaotic anarchy. This led to the hypothesis of the "loss of the center," of the "rootlessness" of abstraction or the "empty void" in which it floated. Critics accused abstract art of being an obscure affair addressed only to experts, called its concepts arrogant, arcane, and self-serving, said it aimed at disintegrating the visible world, called it a conspiracy of the intelligentsia against the poor, helpless public. As one can see, the defaming arguments remained the same, while the object – or lack of

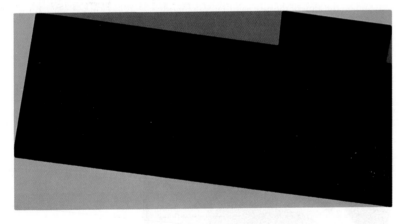

*"Art for me has always been abstract motion. Abstract motion excels over physical or naturalistic motion in its speed and feeling of exhaltation. Everything is motion, everything moves. There is no fixed point in the universe."* OLLE BAERTLING

an object – to which they were addressed, changed. The Jeremiads and pamphlets could just as well have been directed against later styles, such as L'art informel, Action Painting, Minimal and Conceptual Art – and in fact, although the vocabulary was different, this is exactly what came to pass.

The title of Sedlmayr's book, *Loss of the Center*, became just as much of a slogan as that of Max Picard's essay, "Atomization in Modern Art". In the eyes of these cultural pessimists, the key artists of the first half of the century and their predecessors were, roughly speaking, not diagnosticians of the despairing or hopeless state of the world, but themselves partly responsible for it. In other words, not those who created the situation were guilty, but those who described it or drew critical conclusions from it – who supposedly fouled

their own nest. Then as now, the conservative critics called for a return to lost values, not realizing that a return was impossible because the clock cannot be turned back.

Rarely has a stream in art triggered so much debate, embittered on both sides, as has abstract art. Instead of concentrating on the visual evidence, the colors, forms, and rhythms of the pictures involved, the opponents of abstraction mounted polemics and issued pamphlets, which its advocates answered with the provocative exaggerations of a camp fighting against prejudice. Both sides fell into an error that has long been avoided in discussions of music: They asked about the meaning of abstract painting and attempted to explain it in verbal terms, forgetting that painting, like music, is a non-verbal language.

"The work of art is an independent organism, on a par with nature and in its deepest inner essence without connection with it... insofar as nature is taken to be the visible surface" of things, wrote Wilhelm Worringer at the beginning of the century in his book *Abstraktion und Einfühlung* (Abstraction and Empathy, 1908), clairvoyantly written – as a dissertation – before abstract art in the narrow sense even existed. The debate for and against abstract art that set in after 1945 was unparalleled in terms of obstinacy and duration, even our so eminently polemical century.

From the vantage point of the present day this seems all the more surprising because of the fact that as the abstract wave subsided, it grew increasingly obvious that while the non-objective painting of mid-century may

have had an evolutionary character, it was certainly not revolutionary any more. The occasional cry of "Dump Picasso!" or "Down with geometry!" was harmless by comparison to the revolt against the Academy, the aesthetic revolution, that took place at the start of the century.

## Cosmopolitans of Art

The story of the emergence of the Ecole de Paris was not an exciting, suspenseful drama; it was the story of a gradual, hesitant, as it were "trans-avant-garde" digestion of impulses that came from outside. Slavic influences mixed with Germanic and Latin ones; currents from all over Europe flowed into the city on the Seine. There was formed the type – later to be so bitterly criticized – of the "cosmopolitan of art," for whom national traits and ties ceased to be of importance, who absorbed stimuli wherever he found them, for whom the concepts of "blood" and "soil" had been emptied of meaning.

Indicatively the pioneers of the School of Paris were not French. Vordemberge-Gildewart, heir of De Stijl and Constructivism, was a German, as was the painter-sculptor Otto Freundlich (p. 221). Freundlich, born in Stolp, Pomerania, in 1878, was discovered by the Nazis in his hiding-place in the Pyrenees in March 1943, deported to Poland, and died a short time later as an

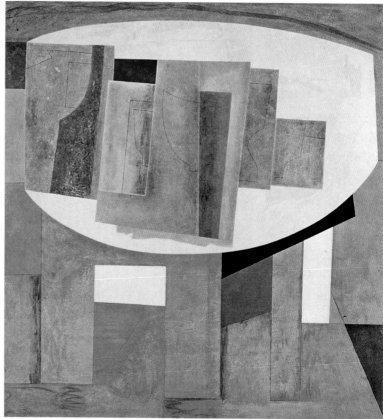

inmate in Maidanek. Stylistically, Freundlich was influenced by Delaunay and his chromatic colors. The De Stijl followers Félix Del Marle and César Domela (p. 172) came to Paris from Belgium and Holland. Alberto Magnelli was an Italian, more precisely a Florentine. As his Cubist-derived, architecturally rigorous compositions indicate, not even abstract art can exist in a void, cut off from every relationship to history. In Magnelli's somewhat dry paintings, links with the Renaissance architects Leon Battista Alberti and Filippo Brunelleschi, with Uccello and Piero della Francesca, are clearly evident (p. 220 above).

## With Ruler and Compass

Among French painters, Auguste Herbin was the first to seriously adopt a rigorous abstraction in which he expunged every memory of the visible world seen in his earlier work (p. 220 below). Herbin practiced pure geometry, establishing relationships between the elementary, flat forms of triangle, rectangle, circle, and arc segment. There were no half-tones, gradations, or gradual transitions in Herbin's compositions. Though they represented an interesting and highly skilled beginning, they already contained the end of strict geometrical abstraction, that intellectual glass bead game aimed at plumbing the secrets of proportion and number – facile, perfectionistic shapes of poster-like two-dimensionality which, in the hands of lesser talents, stiffened into dry-as-dust academicism.

**Ben Nicholson**
February 1959 (Half Moon), 1959
Oil on canvas, 160 x 149 cm
Private collection

*"After all, every movement of human life is affected by form and color; everything we see, touch, think and feel is linked up with it, so that when an artist can use these elements freely and creatively it can be a tremendously potent influence in our lives."* BEN NICHOLSON

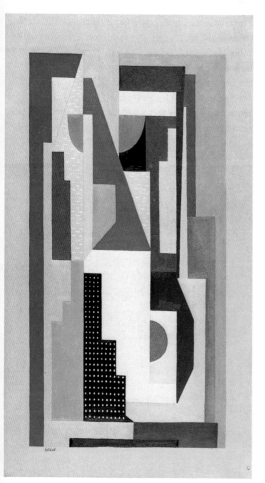

**Atanasio Soldati**
Composition, 1934
Oil on canvas, 103.5 x 57 cm
Milan, Civico Museo
d'Arte Contemporanea

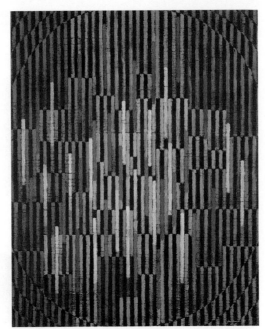

Herbin's approach, like the later one of Vasarely, not only inspired Op Art, it also set off a new wave of concrete painting, along the lines of the concept of "concretion" coined by van Doesburg and Arp. In this context mention should be made of a later group, the "Zurich Concretes," which included Max Bill, Paul Lohse, and Camille Graeser. For Bill (p. 222), first rector of the Ulm School of Design in the 1950s, there was no hard and fast line between fine and applied art. In his eyes the design of a chair, a folding table, or an electric socket was just as significant a task as composing a painting or sculpture. Bill approached every task with the same sense of

responsibility, the same thoroughness, and the same striving for truth, devoid of all bravado, that underlay his service as a national councillor. In all his œuvre – whether in painting, sculpture, or industrial design – one finds nothing half-hearted. Everything is right, everything fits, everything is as intelligent as it is precisely calculated. Bill's work was inspired by a fascination with numbers. Its aesthetic appeal derived from the harmony of exactly balanced relationships of form and color. For him, an aesthetic configuration was the result of mathematical, verifiable thinking, a brain-game. Bill took the ideas of the Bauhaus to their logical conclusion. Whether painting or sculpture, in which he was perhaps more successful (p. 456), art for Bill was no longer the creative act of an individual but a means to the super-ordinate end of designing a more humane environment.

Precise construction of a painting based on geometric principles was likewise the guiding idea of Camille Graeser (p. 222). For him the painting was a *creatio ex nihilo*, a configuration without relation to the world of objects, but shaped in analogy to the laws of musical composition. Like Kandinsky, Graeser spoke of the "musical sound" of a painting, which could be achieved solely through proportion, and the values of color, form, and line.

Richard Paul Lohse (p. 223), who since 1942 has concentrated exclusively on perpendicularly oriented color fields, is the most rigorous of the concrete artists in the wake of Constructivism. His visual thinking is marked by considerations of a social nature, for he envisions the concrete utopia of a harmony between man and his environment. Like Bill's, Lohse's variation-rich sequences and arrangements of colored forms are based on numerical relationships, which determine both the

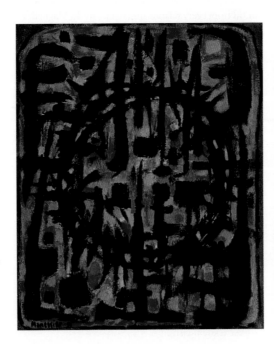

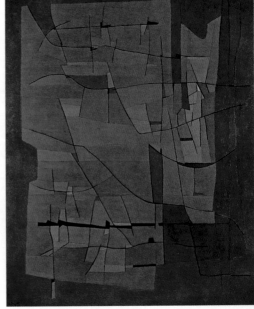

relation of the fields and color groups to one another, and their relation to the format as a whole. Despite this veritably ascetic formal discipline, which is surpassed only by Albers's *Homages to the Square* (p. 179), Lohse's rigorous compositions appear to push beyond the edges of the canvas. And despite the waiver of any trace of individual touch, the brilliancy of their colors lends them a vibrant, quasi musical lyricism.

The Belgian Victor Servranckx (p. 223) moved the orbit of the Paris group "Abstraction-Création" centered on Ozenfant and Le Corbusier. He was also intrigued by Léger. Contacts with Eastern European Constructivism and even to Dutch De Stijl, on the other hand, were scant. Still, Servranckx's thinking was dominated by the Constructivist ideals of an elimination of the border-line between fine and applied art, and a linking of art and life. More strongly than other concrete artists he was fascinated by the world of machinery, to whose functional precision he attempted to create an equivalent in painting – pictures in whose autonomous color-shapes it is difficult to detect their source of inspiration.

A different case is that of Ben Nicholson, a British painter whose second wife was the sculptress Barbara Hepworth. Both of Nicholson's parents were artists. His father, Sir William Nicholson, was a very highly regarded Post-Impressionist in his day. Out of opposition to his parents the young Nicholson soon defected to Cubism, to Braque and above all Gris, whose cool, structural thinking deeply impressed him. At the age of 40 Nicholson met Mondrian, a meeting that determined his subsequent development.

Nicholson (p. 225) attempted to combine the De Stijl idea of a universal harmony with the structural principles of Cubism, within an autonomous, non-illusionistic pictorial space. In his sensitive drawings, sparing line is used to trace the mystery of cathedral portals, the complicated structure of vaulting, and the beautiful forms of commonplace things. From this point Nicholson's path led him to abstract compositions in which occasional reminiscences of objects appear, what Her-

bert Read calls "last vestiges of reality." The motifs are reduced to a few, basic shapes: rectangle, circle, and sometimes the abbreviated form of a lovely pitcher or jug. Nicholson's "geometric lyricism" draws sustenance from a formal tension between straight line and curve, between abstract, artificial configuration and fragment of the visible world. His palette is subdued; Nicholson's compositions, inspired by musical and architectural forms, are not seldom executed white in white or grey in grey. Occasionally he raises the picture plane into low relief, and emphasizes the play of light and shade.

Geometric painting of every variety was disseminated all over the world. It found adherents in Italy (Atanasio Soldati; p. 225), in Sweden (Olle Baertling; p. 224), in Germany (Adolf Fleischmann; p. 226), in Brazil (Almir Mavignier). Yet few of its later proponents were able to match, let alone surpass, the innovative force of its pioneers and classical representatives. But one thing should not be forgotten: The intellectual effort and rigorous focus of the Platonists of modern art, by harking back to the Egyptians, the early Greeks, the Early Renaissance, to Chardin's and Poussin's well-considered pictorial frameworks, as well as to ancient human symbols such as the labyrinth, zigzag, plait, spiral, etc., liberated these artistic means from the yoke of non-aesthetic, anecdotal encumberments. As Thomas Mann said in *Doktor Faustus* with regard to the twelve-tone scale in music, geometric abstraction "reinstated [composition] in its mean." In another place Mann wrote,

**Pierre Tal-Coat**
Passage to the Bottom of the Canyon, 1956
Oil on canvas, 190 x 195 cm
Paris, Musée National d'Art Moderne, Centre Georges Pompidou

**Jean Le Moal**
Autumn, 1958–1960
Oil on canvas, 130 x 81 cm
Paris, private collection

**Roger Bissière**
Grey, 1958
Oil on canvas, 116 x 89 cm
Paris, private collection

**Maurice Estève**
Vermuse, 1958
Oil on canvas, 100 x 81 cm
Private collection

"Organization is everything. Without it there is absolutely nothing, least of all art." This might have been the credo of the geometric abstractionists. Their art was the expression of a revolt of European rationality against uncontrolled emotion, of cool objectivity against factitious sentimentality, of order against anarchy. The perfect form they sought for, to speak with Plato, seemed to represent "that which always is." Against the backdrop of the rampant irrationality that led to the second world catastrophe, this attitude surely had its historical significance. Franz Marc would probably have shared it.

Yet what the geometricians of modern art ended up designing was the construction plan for an abstract-utopian world, hermetically sealed, without direct connection with nature or with the social reality of the era. In the long run, this purist ivory tower naturally proved uninhabitable. The alternative nature *or* abstraction was too dogmatic and absolute to be viable. Artists remembered that art, realistic or not, could never be pure repre-

**Jean Bazaine**
The Clearing, 1951
Oil on canvas, 120 x 96 cm
Private collection

**Gérard Schneider**
Opus 87 B, 1955
Oil on canvas, 116 x 89 cm
Paris, private collection

sentation, that its aim and essence was not quotation but transformation and formal design. Back then Bazaine, soon to become one of the leading figures in the *tradition française* movement, pointed out that even Jan van Eyck was a great abstract artist in so far as it was not verisimilitude that determined the rank of his work but the quality of its form and color.

## "Inventing the World"

Perhaps it speaks for itself that the Fronde against Platonism in painting first gathered force in France. It was there that the notion of Nouvelles Réalités first began to circulate. Artists realized that what one cannot see can nevertheless be real – as, in our own day, Gerhard Richter has once again expressly pointed out. It was physics that served to open artists' eyes to the complex structure of matter and its ambivalent nature. Perpetual truths were relativized, and two world wars did their part to once and for all destroy the naive trust in traditional, immutable values.

According to the proponents of the New Realities, conventional, realistic painting only represented the appearance and surface of things, not their essence or core. Out of this negative insight they drew the positive conclusion that it must be possible to "invent a world," a pictorial world which, on the one hand, was both more true than illusory appearance, and on the other, not so far removed from reality as was geometric abstraction. This world of imagery would be based in equal measure on the visual and mental experience of the artist, which, freely translated and independently of "natural" colors and forms, would take shape in paint on canvas as the artist's own creation, a Nouvelle Réalité .

The artist would no longer depict an immediate impression but the echo or resonance it set up in his mind and imagination. Klee had already progressed far in this direction: *Flora on Sand* (1927) was the title of a watercolor composed of irregular squares and a few rectangles in luminous hues.

Thus the retreat of art from reality, its escape into utopia, was at least partially reversed, for a critique of contemporary conditions was not attempted. The

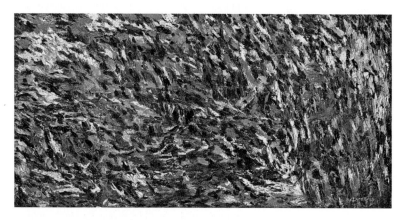

horrors of the Second World War and its aftermath, artists believed, were simply too monstrous to allow for direct depiction in art. These were the years in which Theodor W. Adorno's proclamation that after Auschwitz, no more poems could be written, was considered an incontrovertible truth. Until poets, not least one who had been immediately involved in the Holocaust, Paul Celan, proved the invalidity of yet another absolute statement.

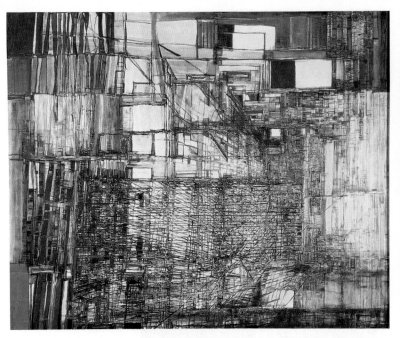

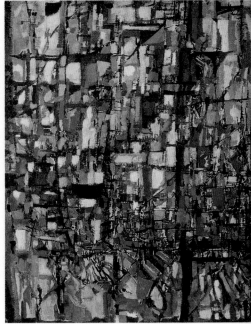

**Maria Elena Vieira da Silva**
Theatre of Gérard Philipe, 1975
Oil on canvas, 162 x 130 cm
Colmar, Musée d'Unterlinden

**Maria Elena Vieira da Silva**
Breton Festival, 1952
Oil on burlap, 92 x 72.5 cm
Private collection

*"When I am in front of my painting and palette, there is a constant effort; a little more white, a little more green, it is too cold, too warm, lines that ascend, that descend, that meet, that part. This means so much in painting and so little in words."*
MARIA ELENA VIEIRA DA SILVA

## French Tradition

In 1941, Jean Bazaine mounted in Paris an exhibition titled "Twenty Painters in the French Tradition." Apart from the initiator, the participants included Alfred Manessier, Léon Gischia, Maurice Estève, Edouard Pignon, and Jean Le Moal (p. 227). The express reference to their national tradition could be understood as a gesture of resistance in several respects: firstly, as resistance to the military occupation of France by a foreign power, Germany; secondly, to the domination of foreigners in the abstract Ecole de Paris; and thirdly, as resistance to the geometric abstractionists' "un-French" disdain of *bonne peinture.*

Roger Bissière (p. 228) had paved the way for the traditionalists. The paintings of Bazaine reflected a closer affinity to the landscapes of Impressionism (pp. 228, 229) than to the influence of Cubism or to certain Klee-inspired paintings by Bissière himself. As he himself put it, he let "the subject disappear as an object" in order to "justify it as form." In other words, an impression of nature was replaced by a painterly system of chromatic and formal rapports or correspondences. Bazaine did not work on the basis of any pre-conceived plan; he let his hand follow his inspiration. The fundamental element was always color, which for him possessed space-creating and atmospheric qualities in one. Bazaine's sophisticated palette reveals the influence of Bonnard, while the atmosphere in his canvases was Impressionist in origin.

"The potential today seems to me to lie in non-objective art, because through it the painter can best find his way back to reality and to an awareness of that which is essential in it." The words are Manessier's, and they precisely express the mood of those post-war years in which abstract art triumphed, with an exclusiveness which it is nowadays difficult to grasp.

For the Christian artist Manessier (p. 226), the regaining of a lost reality represented the certainty of salvation in the midst of a transient world. The form this reality took was the pictorial symbol. Painting thus became an act of meditation, a path to an awareness of self and of man's position in the world. Manessier depicted the *Passion* as a solemn arrangement of abstract symbolic black configurations against a red ground, signs representing the instruments of martyrdom against a hue that underscored the deep seriousness of the theme. But unfortunately Manessier's artistic skills were not always up to the profundity of the task he set himself.

The work of Maurice Estève has proven more lasting (p. 228). A series of brilliantly colored still lifes and interiors, executed with bravado and daring in the choice of unconventional croppings, was the first culmination of his career. The second was a series of ornamental and architectonic abstractions in luminous, sometimes somewhat garish colors – blue, red, green, yellow. Estève's work, too, is based on actual visual experiences, memories and recollections of which appear in the compositions. Reality is transformed and rearranged into islands, continents, fields, and bars of color.

A position between abstraction and objectivity is occupied by the free figuration of Charles Lapicque, who has produced a number of interesting paintings employing abrupt changes in perspective and graphically structured autonomous color (p. 229). Later Lapicque let his compositions be dominated by pure color, and waived the integration of color configuration and motif – with highly varying success, it must be admitted.

The tension between abstraction and objectivity reaches a peak in the œuvre of Nicolas de Staël, who was born in St. Petersburg, Russia, in 1914 and ended his life in 1955 by jumping from a window in Antibes. Instead of

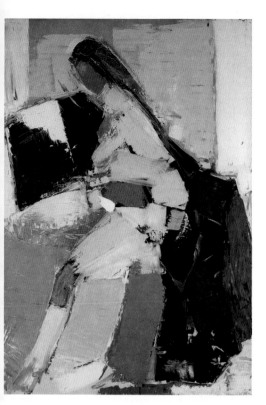

would not be mistaken to see a connection between the weave of her transparent architectural visions and the figures enmeshed in imaginary spaces in Alberto Giacometti's paintings (ill. below), although these admittedly far surpass da Silva's in terms of force of vision and pictorial realization. Yet her filigree imagery likewise expresses a fundamental feeling of the epoch: the anxiety of modern man, his fear of being caught in the labyrinth of a world over which he has lost control, the prime symbol of which is the big city, New Babylon.

## Expressionist Art in the Abstract Mode

The development of abstract art after the war led from puristic objectification based on mathematically calculated form, through an autonomous realm of signs suffused with memories of nature, to issue finally in a depiction of subjective feelings and sensations, mental reflections of artists' experiences of reality – an abstract expressionist art, in a word, which culminated in L'art informel in Europe and Action Painting in the United States.

At the beginning of this new development stood the work of a German artist, Hans Hartung, a native of Leipzig (p. 232). His checkered biography reflected the notorious restlessness of the period. Like every truly

addressing the issue of "objective or non-objective" in his painting, De Staël attempted to overcome this unproductive alternative and re-create a lost unity. His work accordingly unfolded between the poles of abstraction and objectivity, tending first more to the one, then to the other, before the dialogue was interrupted in mid-sentence by his suicide on the Côte d'Azur. De Staël had by no means spoken the last word in his art. His late works were no longer as powerful and encrusted with spatula passages as the earlier canvases, as seen in the *Football Players* (done in various versions), which is painted in more fluent, lighter strokes of the brush and palette knife, larger in format, and indicative of the artist's return to an emphasis on the subject (ill. above and p. 219). But the late works also show that De Staël was not able to solve his self-posed problem, which Werner Schmalenbach defines as "measuring the boundless with the dimensions of painting." The artist apparently must have felt that he had arrived at a dead end, despite the fact that the sophisticated beauty of his relaxed, free, quite unconventional compositions would suggest that, on the contrary, he was on the verge of developing innovative pictorial possibilities.

The enormous range of approaches covered by the generic term abstract painting is illustrated by a comparison between the apparently so dynamic work of De Staël and the labyrinthine urban visions of the Portuguese artist Maria Elena Vieira da Silva (p. 230). If the paintings of the unhappy Russian seem like a transmutation of the intellectual principles of Cubism into a vitalistic, almost barbarian emotionalism, the hallucinatory world of da Silva is rooted in Surrealism. Perhaps it

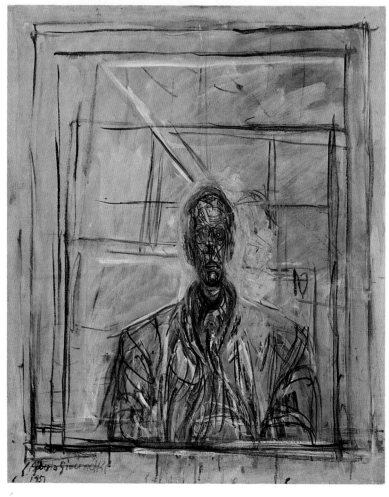

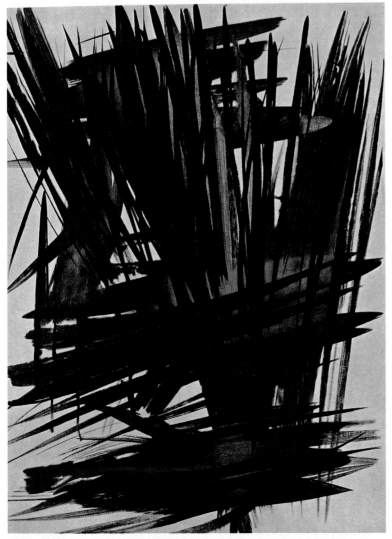

investigations Hartung's innate musicality, his intensive scientific interests, and his feeling for poetry served as curbs on his emotionality. As early as 1922 he was already working in an abstract idiom. What especially intrigued him about these studies was the personal touch, the "handwriting" of the artist, as an immediate expression of his temperament. "The deeper we immerse ourselves in our own personality," Hartung said, "the more clear and convincing will be the image we can give of our inmost selves, but also, the more comprehensive our expression will be." This remark amounts to a credo, a dedication to self-imaging. Hartung found a method to achieve this which was very much his own: the psychograph in painting, the spontaneous record of emotional and mental states ranging from euphoria to depression. A polished technique enabled Hartung to retain differentiation and precision even when working under extreme emotional tension.

Against usually light, loosely brushed backgrounds the artist set sheaves of dark, linear, agitated strokes that recorded an existential moment. Hartung painted these psychographs with great energy and sometimes as if in a trance. The procedure, by analogy to Surrealist theory and practice, was automatic in nature. Complex experiences, desires, and ideas flowed together under Hartung's hand to congeal into a pictorial sign. Dramatic accumulations, collisions, overlappings, and corrections resulted, concentric force-fields alternated with nervous lineatures, heavy paint passages with graphic inter-

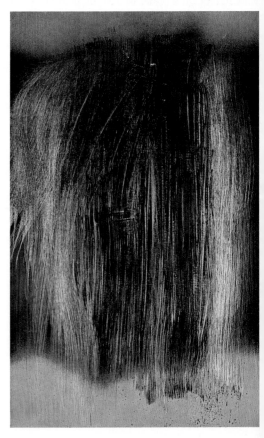

**Hans Hartung**
T 1956-9, 1956
Oil on canvas, 180 x 137 cm
Paris, private collection

original German artist, Hartung, who had his first public exposure in Dresden in 1931, soon ran into trouble with the Gestapo after Hitler came to power. The critics Will Grohmann and Christian Zervos, in a memorable German-French collaboration involving some very clever maneuvering, assisted Hartung in leaving the country. Like many others before him, Hartung too became a Parisian painter. His identification with his host country went so far that he volunteered for the Foreign Legion in 1939 and subsequently fought with de Gaulle in Africa. In 1944 Hartung lost a leg in fighting near Belfort, and the year after he was awarded French citizenship. That a man who lived so uncompromising a life should have adopted an expressive approach to painting is no wonder, particularly as Hartung stemmed from a country in which expressionism of one kind or another was not only a period style but a fundamental artistic tendency.

Accordingly, after initially exploring the mysteries of Rembrandt, Hartung gravitated to Kokoschka, Nolde, Marc, and not least, to Kandinsky. In the course of his

**Hans Hartung**
T 1962-U 4, 1962
Oil on canvas, 180 x 111 cm
Private collection

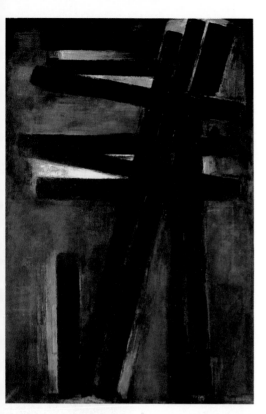

ships of asymmetrical color fields. The palette, at first subdued and tone-in-tone, over the years unfolded a stronger, sometimes festive brilliance in passages effectively contrasted to darker color fields. Though the minor key is sometimes sounded, it is rarer than a brilliant major chord. What distinguishes Poliakoff's paintings from those of his Cubist predecessors, apart from their generally intense palette, is the unclassical treatment of forms, which often appear to virtually extend beyond the canvas edge or penetrate into the plane from outside, the way the forms interlock, and their limitation to a comparatively narrow range of shapes. In recent years Poliakoff's accomplished painting has again been accorded the respect it deserves, as indeed the entire abstract Ecole de Paris has come in for a juster appraisal, after having been first over-rated, then under-rated, during its heyday.

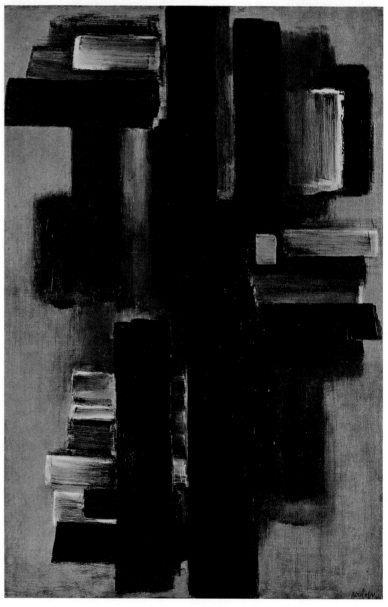

weaves. In these dynamic hieroglyphs the artist's personality was laid bare.

Later Hartung's approach grew calmer, the pictorial signs lighter, more graceful. His fan-like configurations, when successful, had something of the spiritual charm of Far Eastern calligraphy. Brushstrokes were incised into the surface as negative shapes, and with the aid of a new spray technique, dark clouds of color expanded across the canvas – the image became a meditational panel.

Perhaps even more compelling is the earnest and powerful expressive abstraction of Pierre Soulages, whose work has recently come in for a re-evaluation (ill. above and right). Early on in his career, Soulages began to concern himself with archaic and early Romanistic art, and some of the dignity of that era has accordingly entered his dynamic abstractions. Using a special spatula, the artist set monumental swathes of a shimmering black derived from Manet against monochrome, often light backgrounds which suggest boundless space, achieving impressive effects of contrast. "The waiver of the loquaciousness of line," Soulages formulated his artistic credo, "corresponds to a waiver of the loquaciousness of color.... I was always of the opinion that the more limited the means are, the stronger the expression will be."

The Russian artist Serge Poliakoff (p. 234) set out to develop the principles of Cubism and De Stijl into an original idiom. While graphic networks initially were employed to lend stability to the compositions, soon they began to rely solely on sophisticated inter-relation-

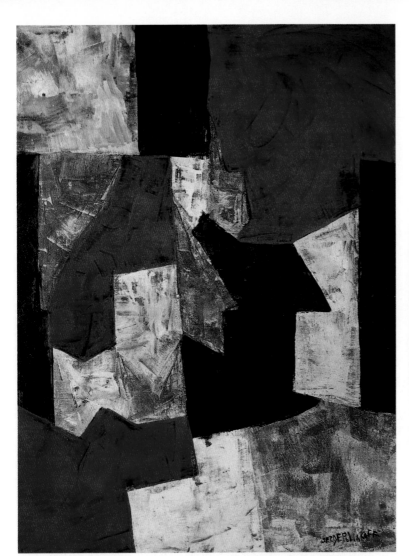

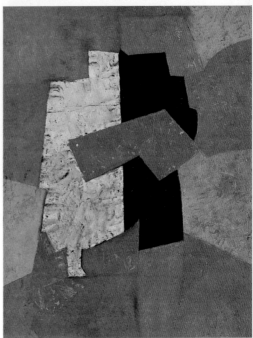

**Serge Poliakoff**
Red, Blue and Black – Abstract
Composition, 1957
Oil on canvas, 115 x 89 cm
Saarbrücken, Saarland Museum

**Serge Poliakoff**
Composition, 1950
Oil on wood, 130.5 x 97.2 cm
New York, Solomon
R. Guggenheim Museum

# Farewell to Subject Matter
## Abstract Art in Germany

In Eastern Europe, even in the former Soviet Union after the final enthronement by Stalin in the early 1930s of Socialist Realism as the sole officially sanctioned style, painters and sculptors continued to work in an abstract vein, despite the fact that it could cost them their career or even their liberty. One of the key groups that has since come to Western attention is "Movement," headed by kinetic and performance artist Lew Nusberg. The existence of this group alone disproves the orthodox Marxist hypothesis that abstract art of whatever variety can flourish only in a capitalist climate. No one continues to believe such hypotheses now that "actually existing" pseudo-socialism has crumbled, especially as Socialist Realism, in its shallow, doctrinaire form, had long since discredited itself as absolutely petty-bourgeois. The Hungarian communist Vasarely and the Hungarian

socialist Schöffer, who both lived in France and were leading representatives of abstract painting, have since had museums devoted to their work in their native country. In Russia, too, the realization is growing that Suprematism and Constructivism represented the truly revolutionary art. In Poland, the Muzeum Sztuki in Lódz has long since become one of the most significant international centers of classical and contemporary modernism.

That abstract art can signal resistance against an all-powerful tradition grown stultified in academicism, resistance against empty conventions and normative aesthetics, but also against political bullying, became evident in Germany between 1933 and 1945. When the war ended, a non-objective art came to light which stood on a par with European developments on all sides – a small cultural miracle that the world registered with

some bafflement. To many people at the time in Germany, abstract art seemed like a beacon light of freedom in a period of total repression. This position was taken at one of the first of the subsequently famous Darmstadt Talks in 1950 by the artist Willi Baumeister, during a debate with the orthodox art historian Sedlmayr on the topic of *The Human Image in Our Era*. At that period, heated debates between representatives of figurative and abstract art became an international phenomenon.

## Romantic Idealism

The path of Willi Baumeister (ill. right) to what he termed "absolute painting" was a long one. Born in Stuttgart, Baumeister was no child prodigy, as little as was his ideal, Cézanne, with whom he shared in common a sedentary and superficially uneventful life. In terms of his visual thinking Baumeister had an affinity with Klee, whom he admired as much as he did Miró. What ultimately concerned him was the unknown, the never-before-seen, the unheard-of. To his mind, these could take on material shape only in abstract painting. "Abstract forms," said Baumeister, "can contain, retain or absorb real forces.... Non-objective manifestations of the human spirit are open to the transcendental. Objective depictions are always more or less burdened by the earth's gravity, and their pinions are not free." This metaphysical, romantically tinged idealism was anchored in Baumeister's work by a formal discipline which he owed to an intensive study of Seurat, Cézanne, Cubism and Constructivism, as well as by an emotional reserve which consciously kept its distance from the fervors of Expressionism. In every phase of his diverse career, clarity and harmony were Baumeister's foremost concerns.

Baumeister was a fellow-student of Schlemmer, and his most important teacher was Hoelzel, who addressed himself to the problem of abstract rhythms and color chords at an early date. Baumeister's early figurative works were related, in terms of spirit and aesthetic, to Hans von Marées and Cézanne. After the First World War, searching for a new order in the face of general chaos – as Marc had written in his war letters – Baumeister came to Constructivism, to Le Corbusier's and Ozenfant's Purism, and especially to Léger. While his theme remained the human figure, he subjected it to a harsh, stringent geometric, mechanical order. Thereafter the artist abandoned traditional brushwork, adding sand to the oil paint to produce rough, low-relief surfaces. The painting, Baumeister believed, must become a solid, constructed, final entity. The *Wall Pictures* of those years can be described as designs for an as yet non-existent architecture.

But these rigorous montages did not remain Baumeister's last word. Elements of the fantastic, the surreal entered the compositions of the – still figurative – *Sport Pictures*. As this theme itself suggests, static pictorial frameworks were now superseded by painterly evocations of movement. The final turn to "The Unknown in Art," as Baumeister titled a manifesto written

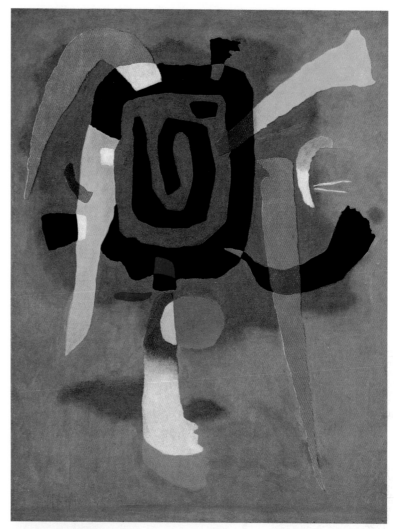

**Willi Baumeister**
Bluxao V, 1955
Oil on cardboard, 130 x 100 cm
Hamburg, Hamburger Kunsthalle

**Willi Baumeister**
Safer, 1953
Oil on canvas, 65 x 54 cm
Stuttgart, Archiv Baumeister

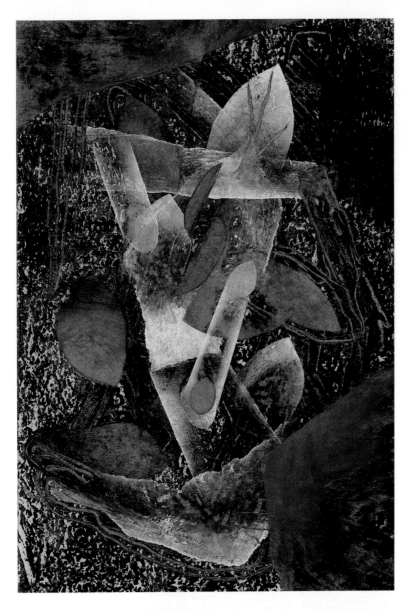

**Fritz Winter**
Motive Forces of the Earth, 1944
Oil on paper, 29.5 x 21 cm
Ahlen, Fritz-Winter-Haus

*"My art does not legitimize itself
through elements that lie outside the
realm of art. Its meaning can be
comprehended – experienced – by
looking at the elemental painting."*
ERNST WILHELM NAY

age-old messages in terms of a very contemporary, invented visual language.

Towards the end of the artist's career came the *Montaru* and *Monturi* canvases, usually dark in hue and dominated by deep black, more rarely colorful and carefree in mood. With these works, at the zenith of his maturity, Baumeister created his own, personal, pictorial myths. In the course of time black came increasingly to dominate the compositions, like an ominous pall. No one can say whether a premonition of death was manifested here. Perhaps not even the artist himself knew, for concurrently with the dark compositions he produced many of a festive, sometimes even brash joyousness of color. In Baumeister's œuvre as in so many others, a love of life and melancholy went hand in hand.

In contrast to the works Baumeister produced during his emigration within his own land, the paintings Schlemmer did in the same situation – *Views from a Window into a Neighbor's Window*, he called them – record a turn to reality and a waiver of what he sarcastically termed the "picassible abstract." Yet reality, only a slice of which was accessible to the persecuted artist, was mystified, spiritualized, drawn inwards. Everything, Schlemmer declared, boiled down to the old question, "... what is truth? The truth of art – the truth of nature." A turn to the spiritual, to the transcendental in art becomes just as obvious in Schlemmer's attitude as the rejection of superficial reality in the case of Baumeister.

An intermediate position in this context was occupied by Fritz Winter. Although his early abstract compositions of the 1930s were still "burdened by life," Winter's dark, somber formulations strove beyond the finite and earthbound towards the infinite and universal. A romantic mystique of nature and a longing for transcendence were the sources of Winter's art. His best-known series, the *Motive Forces of the Earth* (ill. left), comprising forty small oils on paper, was, like Schlemmer's "window pictures", done during the period of worst persecution. The "degenerate" artist, who nevertheless was inducted into the army, was taken prisoner of war by the Russians, and not released until 1949, did the *Motive Forces* in 1944, during a home leave to recover from a wound. The travails of a life spent first as a coal miner, then as a frontline soldier, entered into these unusually condensed works. They nonetheless maintain a balance between emotional tension and spiritualized form, to become compelling visual symbols of the immutability of motive forces that emerge from the depths into the light, as the seething colors emerge from dark, earthy brown.

### Color as a Formative Element

The art of Ernst Wilhelm Nay, the first German abstract painter to achieve international recognition after 1945, was rooted in Expressionism. That Nay began with a semi-abstract realism in subdued tones, toyed with Surrealism, then was influenced by Kirchner and Munch, who took Nay under his wing in Norway, is hardly evident from the works of his maturity. Their spiritual atti-

towards the end of the war and published in 1947, indicatively began during the period of his persecution.

In the footsteps of Malevich, Baumeister produced figurations floating free in space, which he called "ideographs". From here the artist's path led to the series of *Eidos* paintings, in which amoeba-like configurations hover in front of abstract pictorial spaces. These works document the last possible step in the process of the reduction of natural phenomena to abstract forms. After this, Baumeister developed a personal hieroglyphic picture-writing which was inspired by pre-historical and early historical art, by paleolithic rock paintings, by the art of indigenous peoples, of early Babylon and Egypt, archaic Greece and the Far East. "Memories" of lost cultures and their magical symbolism, rising from the unconscious mind, were freely translated into new pictorial signs. The Gilgamesh Epic and the Old Testament inspired Baumeister to an abstract re-formulation of

tude and palette are no longer introverted and Nordic, but definitely marked by a Western optimism (ill. right).

Nay began emphasizing the dynamic aspect of painting early on. In his landscapes and figures he favored the general over the individual. The *Lofoten* canvases, based on the life and environment of Norwegian fishermen, stood at odds with the officially ordained naturalistic style in 1930s Germany. The compositions combine an expressively nervous rhythm, recalling Kirchner's hieroglyphics, with a concise reduction of form to essentials. Over the following years, particularly shortly before and after the end of the war, Nay heightened his palette to orchestral brilliance. There emerged incredibly rich compositions in which the subject was detectable only in alienated form, as mythical memory or inspiring stimulus. These works of the so-called "Hecate" period are among the finest Nay ever produced. This imagery creates the impression of an exquisite ornamental tapestry, shot through with dreamlike eyes, rare butterflies, and precious fans. Ellipses and discs also appear, but these forms do not yet play the dominating role they would in Nay's later paintings. At this point the artist still based his compositions on an underlying, supporting graphic grid. Subsequently he would set the color discs free, to hover and dance, interlocked or overlapping, across the pictorial plane.

The freedom with which Nay handles purely painterly means in his mature work, his openness to all their possibilities, up to and including the decorative, are rare in German art. The element of the musical, of the dance, plays an essential role here. The dynamic shapes convey no mental associations; the colors and rhythms of Nay's compositions do not signify anything beyond what is contained in their wonderfully differentiated chromatics. Here, color is no longer used as a means of expression but as an autonomous pictorial value. Color also determines the non-perspective space

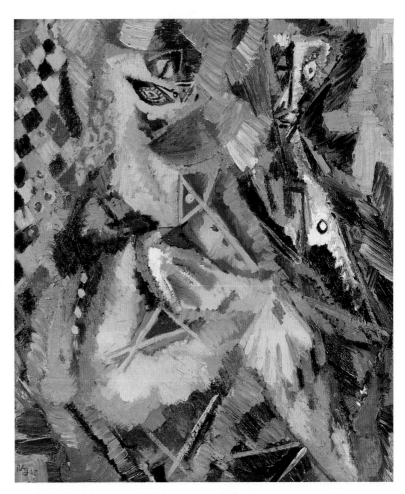

of the image. The colored shapes appear to advance and recede, descend and ascend; cool and warm hues, heavy and light configurations, are counterpointed with great refinement. The temptation into which this "pure" painting runs the risk of falling is evident: repetition,

**Ernst Wilhelm Nay**
Daughter of Hecate I, 1945
Oil on canvas, 98 x 85 cm
Private collection

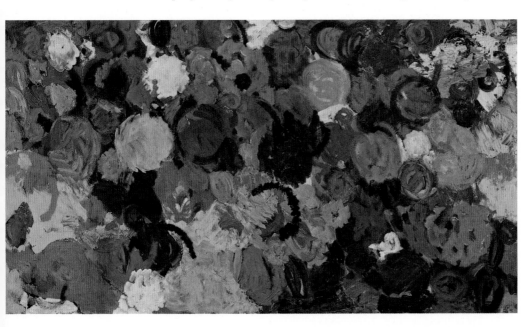

**Ernst Wilhelm Nay**
Blue Flood, 1960
Oil on canvas, 190 x 340 cm
Cologne, Museum Ludwig,
Donation Peill

**Hann Trier**
Staccato, 1959
Oil on canvas, 130 x 162 cm
Düsseldorf, Mannesmann A.G.

**Georg Meistermann**
Being Torn, 1952/53
Oil on canvas, 150 x 220 cm
Germany, private collection

ing- board, "space-plans", "ground-plans", and "scaffoldings" – imagery that reveals an impetuous personality subjecting itself to intellectual control.

Hann Trier (ill. left) is one of the few German and European abstractionists of the early post-war period whose work has lost none of its drive. The theme of his early canvases was motion, including the mechanical variety. "Sewing", "typewriting", "talking of the devil", "writing in the wind", but also the flustered fluttering of wings in a dovecote, were evoked in painterly and graphic abbreviations of dynamic rhythm and explosive force. The nervous clattering of typewriter keys, the zig-zag lines of hems, the strokes of the needle were translated into a visual code in which objective references were still detectable. Trier's sparkling irony had little in common with the existentialist end-of-the-world mood of Tachism, with which his work was roughly concurrent. Trier's path led him from what, speaking flippantly, one might call life's little dramas to true poetry in painting. Although the rhythmic articulation of the picture plane and the blending of graphic structure and

colored form remained characteristic of his art, the motion and machine pictures were followed by word, script, and dance paintings, which from 1955 onwards were executed with both hands simultaneously, tracing the rhythms of the artist's body movements. Here the theme of the labyrinth, crucial to Trier as to many of his contemporaries, already made its appearance. Trier was also an influential teacher, one of whose students was Georg Baselitz.

routine, mere tasteful arrangement. Nay occasionally succumbed to this temptation. Perhaps this explains why he subsequently introduced more ruggedness and unpredictability into his compositions by breaking up the disc form, before, towards the end of his life, surprisingly turning to a decidedly two-dimensional, generously simplified ornamental approach.

Like that of Nay, the painting of Georg Meistermann (ill. right) established a point of orientation for contemporary German art in the immediate post-war years. In addition, Meistermann brought new life into secular and ecclesiastical glass painting, and was an eloquent advocate of the rights of art and artists. The visible world, ensconced in his early work behind harsh graphic grids, was later translated into signs and symbols, hieroglyphic messages from a world the in process of becoming. Ovid's *Metamorphoses* took on a visual presence. *Fish Wants to Become Bird* (1952; Cologne, Museum Ludwig) is a typical work of this period. In a subsequent phase Meistermann showed himself to be a rigorous architect of the picture, who designed, as if on a draw-

# The Abstract International
## Non-Objective Painting around the World

The first and decisive phases of the 20th-century revolution in art can be connected with particular nations: Fauvism and Cubism with France, Futurism with Italy, Expressionism with Germany, Suprematism and Constructivism with Russia, De Stijl with Holland, and so forth. The only exact statement one can make about the second great wave, that of abstraction after 1945, is that it originated in Paris. After that, non-objective painting immediately burgeoned into an international phenomenon. Its principles were adopted and put into practice for some time to come by the finest talents around the world, whether in Paris or Berlin, Rome or Cologne, Milan or Copenhagen, London or New York, Tokyo or Rio de Janeiro.

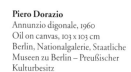

The phenomenon cannot be explained solely by reference to the advantages and disadvantages of the unprecedented dissemination of information through exhibitions, world trade, newspapers, radio and television, or tourism. Nor is it enough to cite the effects of clever marketing and the adaptability of dealers, as little as their not always beneficial influence can be denied. The vocabulary of abstract painting was taken up by artists around the world as if the salvation of their soul depended on it. Let us recall that prior to 1914, experiments in abstraction were going on at various places in Europe almost concurrently, without the mutual knowledge of the artists involved – Kandinsky, Čiurlionis, Kupka, and Malevich, to name only a few. And after the harshest phase of the Cold War, when the Iron Curtain began to lift, the world realized that even in the countries of Eastern Europe, abstract art had continued to exist despite its ostensibly "subversive character" and its "capitalist formalism".

Even the quintessential land of the classical tradition, Italy, fell under the sway of abstraction and, for the first time since the heyday of Futurism, it re-entered the European art discourse. That Italian artists too were concerned not with *l'art pour l'art* but with *l'art pour l'homme* is indicated by the association of artists working in highly diverse styles into a "New Front of the Arts," which was formed in 1947. Abstract painters such as Renato Birolli, Giuseppe Santomaso, and the vehemently expressive Emilio Vedova, temporarily rubbed shoulders with dyed-in-the-wool realists like Renato

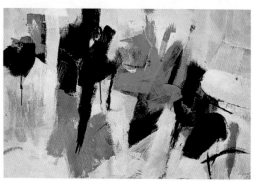

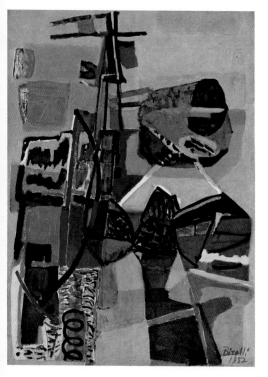

Guttuso. The ambitious, indeed utopian goal of the group was nothing less than to bring about an unprecedented synthesis of the opposing streams. That, in view of the extreme individualism of the artists involved, simply could not work in the long run. Their idealistic initiative was doomed to failure like so many others in art and politics which attempt to set signposts for a new beginning by sloughing off the burden of the past.

In 1951 an exhibition took place that struck European art critics as an absolute sensation: "astratta e concreta." Birolli, in politics a socialist, was among the leading fig-

**Emilio Vedova**
Non dove '87 (Tondo –1–), 1987
Oil on wood, diameter 280 cm
Napa (CA), Hess Collection

**Emilio Vedova**
Cosmic Vision, 1953
Tempera on plywood,
82.8 x 55.5 cm
New York, The Museum
of Modern Art, Blanchette
Rockefeller Fund

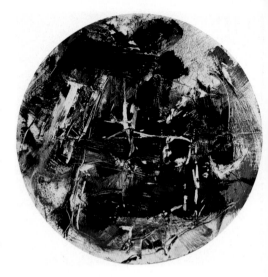

ures (p. 239). Birolli rejected the doctrinaire ideology of communism with the same fervor as he had previously protested against the narrow-minded art policies of fascism. By way of landscapes and figurative paintings Birolli gradually approached free abstraction, but even here, his passionate temperament prevented him from losing touch with nature and humanity. He remained an expressive, dramatic realist whose art always took its point of departure in experience.

The same is true of the more reserved painting of Giuseppe Santomaso (p. 239 above right). The palette of his early, abstract landscapes was suffused with the light of Venice, while the paint handling revealed the influence of the Ecole de Paris, especially of Hartung. Later Santomaso would blunder into the well-worn paths of an "informal art", grown fashionable and facile. Antonio Corpora, too, envisaged a revival of the "dialogue with

nature," before he, too, succumbed to the superficial charm of amorphous, non-referential paint structures (p. 241 above left).

A quite different case is the art of Vedova. The Venetian is a painter of enormous force, matched by his imposing stature, who has made by far the greatest Italian contribution to Abstract Expressionism (ill. above and left). In the 1950s Vedova was celebrated as the star among the Tachist and L'art informel artists, although this label was always misleading. "My works are full of structures", he says. "These structures are the structures of my consciousness." This confessional tendency is an integral part of Vedova's personality and work, which has never drifted into the merely aesthetically pleasing and has retained its committed character.

**Painting as an Adventure**

For Vedova, painting is an adventure, which includes a willingness to take risks. He sets out to depict the problems of human beings who, in Heidegger's memorable term, are "thrown" into existence as a dog throws its young, and to protest against the absurdity and cruelty of contemporary life. Vedova's pictorial space possesses a Baroque depth (he knows his Venetian art from Tintoretto to Tiepolo very well). It is a space without beginning or end, into which break vibrating, ecstatic rhythms of black swaths set against the empty white of the canvas. Although the dynamism of his compositions recalls Futurism, Vedova will have nothing of this. He insists that he does not illustrate movement. The movement in his paintings emerges from himself, from the gestures of his arms and the movements of his body – which, by the way, determines the scale of his canvases – in a word, from his passionate temperament.

When Vedova transgressed the borders not only of the easel painting but of painting per se, using primitive means – paint on unprocessed rough wood or particle board – to produce large-scale objects titled *Plurimi di Berlino* which were shown in 1964 in the hallowed halls of the documenta, both the art trade and a large part of

the public and critics withdrew their support. For many years thereafter the official art discussion passed over Vedova in silence. Then, with the expressionist tendencies of the 1980s, the realization spread that Vedova's work had set standards in the field of gestural painting. The *Plurimi* have since become incunabula of an unconventional, innovative object art.

Another, half-forgotten Italian artist was remembered in the context of subsequent developments: Giuseppe Capogrossi (ill. above). His work is characterized by an ornamental picture-writing consisting of simple signs, some invented, others derived from pre-historic models. It was the New Ornamentation or Pattern Painting of some years ago that led to a rehabilitation of Capogrossi.

Just as the Italians must bear the sweet burden of their Renaissance and Baroque painting, so must the Dutch cope with the glory of their 17th-century middle-class art. Rembrandt and Vermeer, van Gogh and Mondrian mark the poles of the great arena in which Dutch art has moved down to the present day. The feeling of liberation that suffused the entire nation after 1945 communicated itself to the first post-war art of Holland, which was principally expressive in thrust. This is seen in the Dutch members of the "Cobra" group (a name composed of the first two letters of Copenhagen, Brussels,

and Amsterdam), which exhibited in 1949 at the Stedelijk Museum in Amsterdam. Their tendency to free, occasionally rough-and-ready action painting came out most clearly in the work of Karel Appel (p. 243 above right). Appel's compositions in brilliantly colored, thickly applied impasto, inspired by Surrealist automatism, were initially populated with hybrid figures derived from folk art, primitive art, or the naive and grotesque L'art brut of the early Jean Dubuffet. In their racy way, Appel's figures even occasionally recall the more spirited *dramatis personae* in the dream landscapes of Paul Klee, and particularly of Joan Miró. Connections to the mythical Nordic realm of trolls and poltergeists are also evident. In the course of time Appel turned to an increasingly abstract expressionistic approach, but without ever entirely eliminating objective allusions. For years now Appel's work has sadly been declining in substance.

More reserved and controlled than Appel's is the work of Corneille (p. 241). The convoluted formal structure of his labyrinths and the rudimentary, emblematic, parcelled character of his architectural and landscape

compositions perfectly embody the linking of abstraction with figuration for which the Cobra artists initially strove. It was not until the advent of Tachism, L'art informel, and Action Painting that they made the step to total abstraction.

The Belgian member of "Cobra" was Pierre Alechinsky (p. 241). Alechinsky's early compositions teemed with abstract symbols that recalled vegetation, earth and rock formations, held within a structural framework. But gradually, under the influence of his friends, the artist's gestural brushwork grew increasingly free, expressive, and agitated. Ghosts and spirits, demons large and small, began to populate a picture plane covered with energetic swaths of paint and scurrilous graphic ciphers. But Alechinsky's expressionist phase lasted only a few years. Influenced by Japanese calligraphy his painting grew more tranquil, yet the oscillation between abstraction, non-naturalistic objectivity, and fantastic, sometimes ornamental figuration has remained characteristic of the artist's approach down to the much more facile work of recent years.

### Impassioned Expression

The outstanding member of "Cobra" was Asger Jorn, a Dane (pp. 243, 244). Jorn received his first strong impressions from Munch and Nolde, and like that of the German artist, Jorn's iconography was drawn to a large extent from the realm of Nordic myth, with its legendary creatures, its trolls and gnomes. But perhaps even more important was Jorn's confrontation with the imagery of Max Ernst and Paul Klee. What he learned from Surrealism was above all the spontaneity of *écriture automatique*, or automatic writing (which also concurrently influenced American Action Painting), as well as the blending of the worlds of day and night, reality and

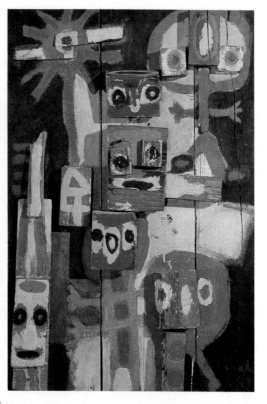

dream. The vehemence of Jorn's attack, the frenzy of his gestures, and the visionary imagination that flows into his imagery, all set his work above that of his friends. His impulse to destroy form arises from an ingrained disgust with the perfectionism of a merely aesthetic, tasteful art lacking in all critical thrust, and with the self-satisfied complacency of art-lovers who demand no more. The aggressively satirical element in Jorn's art is not to be overlooked.

Yet despite the wildness of his brushwork, Jorn's explosions of form and color never lead to amorphousness. His work is marked by a characteristic balance

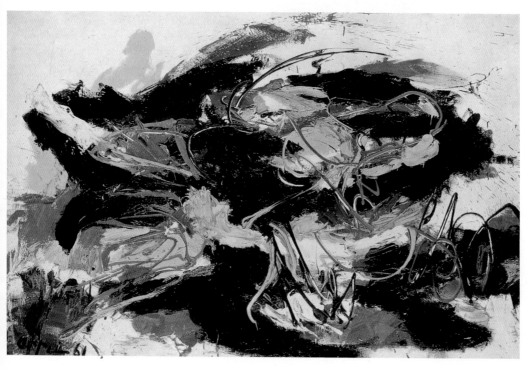

*"Let's suppose that the first colour I apply to the canvas is red. Now, that action determines everything else that happens to the painting. After that I could put yellow on it, and some blue; then I might perhaps obliterate the red with black, and the blue would perhaps become yellow, and the yellow purple, while the black changes to white. Obviously anything can happen. But the whole fascinating process began with that first red, and if I hadn't begun with red, the whole painting would have been different. Is there a system, is there order, in this chaos?"*

KAREL APPEL

**Asger Jorn**
Loss of the Mean, 1958
Oil on canvas, 114 x 146 cm
Ghent, Museum van Hedendaagse
Kunst

*"True realism, materialist realism,
lies in the search for the expression of
forms faithful to their content. But
there is no content detached from
human interest."* ASGER JORN

**Carl-Henning Pedersen**
The Flying Red Horse, 1941
Oil on canvas, 84 x 101 cm
Herning (Denmark),
Herning Kunstmuseum

between abstraction and objectivity, whereby the objective reference was more strongly emphasized in the earlier work than in the later, in which free form and unleashed gesture dominate. As the artist says, "No work of art can emerge that does not represent, in and of itself, an alienation with respect to the existing 'real' or 'normal' exterior world." The figures that emerge from Jorn's agitated color fields are imaginary figures which are held up to the superficial "reality" of visible appearances. The levels of reality are shifted here – the visible world grows unreal, while the unreal world of dream is revealed to be the reality "behind things."

This impassioned expressiveness represents the diametrical opposite to "concrete" art. For the politically committed Jorn, art must have an immediate effect on life, not by attempting to enlist scientific rationalism to its own ends, but by projecting an imaginative counterworld to the existing one. This attitude led to an embittered dispute with Max Bill, and to Jorn's temporary participation in the provocative actions of the "Situationists," a politically extreme left-wing group whose German headquarters was then in Munich, where a group called *Spur* (Trace) formed around Heimrad Prem, Lothar Fischer, and H.P. Zimmer. Prem, who ultimately lost faith in a renaissance of painting out of the spirit of spontaneity, and Uwe Lausen, who was also involved in the group's activities, ended by taking their own lives.

The outstanding figure in British painting of the period was Ben Nicholson. But the pioneer of pure abstraction in that country was Victor Pasmore (p. 245 below). After following in the footsteps of Bonnard by cultivating a sophisticated style *à la française*, Pasmore came for a time under the influence of Piet Mondrian. Robin Denny, Richard Lin, Roy Ascot, and Mary

Martin in her later phase, all rang changes on Pasmore's images of a right-angled, ideal world. But geometric abstraction never became entirely acclimatized in Great Britain. The then-influential, formally stringent canvases of the Scottish artist William Scott, with their symbolic signs and vibrant, sophisticated palette, already anticipated Action Painting, while Alan Davie's work (ill. right) pointed at this early date in the direction of a new figuration and neo-Expressionist tendencies to come.

Quite a different case was that of Stuart Davis, the leading figure among the few abstract painters in the United States who worked in a more geometric than Surrealism-derived style (p. 246). Davis's work has only recently begun to attract greater attention in Europe. He began his career as a realist and a successful one, having already been represented in the renowned Armory Show of 1913. In thematic terms Davis was attracted by the everyday situations and trappings of modern life, and he accordingly worked as a cartoonist for various periodicals. Stylistically, he came by way of an involvement with Matisse to Cubism, whose ascetic palette, however, he did not adopt.

From there Davis's development led logically to geometric, structurally oriented abstraction. Yet references to the visible world remained present in the allusive pictorial signs that enlivened his landscapes and still lifes. A tendency to schematize was just as evident here as the artist's love of the contemporary urban scene with all its bright and garish color and syncopated rhythms. Impulses from Davis's work spread in various directions. In formal terms, they led via Cubism – particularly in Léger's version – to the American abstraction of the late 1930s onwards. And in terms of content, Davis's use of trivial subject-matter and bright colors had an influence on Pop Art (which in turn owed much to the late Léger).

In the classical painters' land, Spain, a progressive, free art remained viable even during the period of the Franco dictatorship. Though Picasso – not only an artistic revolutionary but a member of the French Communist Party – Gris, Miró, and González carried little weight in their home country, and the decades between the two world wars passed rather uneventfully in artistic terms, immediately after 1945 the situation changed radically. Influenced not lastly by remarkable art journals, developments that had taken place in the rest of Europe were rapidly disseminated in Spain, for the Franco government made no concerted attempt to intervene. The first abstract artists' group was founded in 1948, in Saragossa, and only a few years later Constructivism and "Magic Abstraction" had triumphed across a broad front. When in 1957 the group "El Paso" formed in Madrid and dedicated itself to *pitura informal*, the Spanish version of L'art informel, artists of European rank came on the scene. With the likes of Tàpies and Antonio Saura, Spain again had a voice in the European art discourse.

Alan Davie
Entrance for a Red Temple
No. 1, 1960
Oil on canvas, 84 x 68 cm
London, Tate Gallery

## The Omnipresence of Tradition

"The present, for an Austrian, is his tradition," writes the Austrian critic Wieland Schmied. "He feeds on it like Hundertwasser, dissects it like Hausner, attempts to expunge it like Rainer... Austrians occupy themselves with themselves, not with the world." This omnipresence of tradition, especially the Baroque tradition, a cult of the past revolving around the glory of the Austro-Hungarian Empire, plus the massive attacks of the erst-

Victor Pasmore
Transparent Construction,
1959/60
Plexiglass and wood, 76 x 81 cm
Vienna, Museum moderner Kunst

**Stuart Davis**
Swing Landscape, 1938
Oil on canvas, 217 x 440.5 cm
Bloomington (IN), Indiana
University Art Museum

while revolutionary, Kokoschka, on abstract art, did not create a climate conducive to the development of abstraction in Austria. Nor has it ever come to play the dominating role there that it did in other European countries. Yet it existed nonetheless. The diverse and varied work of Arnulf Rainer and action painters like Markus Prachensky will be discussed in another context. Josef Mikl initially oriented himself to Mondrian, but then developed squares and rectangles into elaborate labyrinths and gestural configurations in a range of modulated colors, without sacrificing the link to the constructive, architectural basis of his work. Mention must also be made in this connection of the work in painting and sculpture of artist-friends Herbert Boeckl (ill. below) and Fritz Wotruba (p. 491), whose influence

**Herbert Boeckl**
Blue Jay, 1922
Oil on canvas, 53 x 60 cm
Vienna, Estate of Herbert Boeckl

as teachers has been especially great, contributing substantially to the receptiveness of the Austrian scene to contemporary developments in painting and sculpture. Boeckl's "coded idiom," especially in the early work, was embodied in a painterly form both sensitive and expressive, and his "color islands," as W. Hofmann has said, "can be read as metaphors for spatio-physical energies." Boeckl's late work stands under the spell of Cézanne, to whose art he opened his students' eyes, thus fostering the spread of abstraction in the Alpine republic.

The transition from Klimt's Jugendstil arabesque to the episodic "New Ornamentation," which had a brief revival in American "Pattern Art," is recorded in the work of Friedensreich Hundertwasser, especially in his early work. Hundertwasser was probably the first environmentalist and Green among the artists of our era (p. 247). With his "mould manifesto", he protested against the monotony of soulless functionalist architecture and its "walls with holes," proclaiming individual "window rights" and propagating the benefits of cows grazing on planted roofs. Now that the friend of the Dalai Lama has become a successful party-lion and has been able to put his architectural suggestions into arguably successful practice, it is difficult to recall the scandal caused by Hundertwasser's early projects, such as the transformation of the interior of the Hamburg School of Art into a thread-like labyrinth. In his relevant works, based on the spiral as a perpetually recurring fundamental form, the world metamorphoses into a fairytale garden and at the same time into a critically ironic mirror of the times, and Klimt's celebration of the vamp takes on the character of a morbidly erotic mythology not without sarcastic, self-ironic, and eroto-manic traits.

The cultural link between Poland and Western Europe goes far back in history, and it has never entirely broken. In comparison to other Eastern Bloc countries, Poland has enjoyed a relatively great cultural liberty, even at the height of political repression. In the 1920s, as mentioned above, the "Blok" and "Praesens" groups –

founded by Berlevi, Stazewski, and Strzemeński, and materially influenced by progressive architects – maintained contacts with Malevich and Mondrian, and fought to keep abstract art viable, even into the years after 1945.

Polish artistic thinking might be briefly described as extremely volatile, imaginative, and ready to resist ideological and aesthetic doctrines at all times. These characteristics are reflected in the diverse œuvre of Tadeusz Kantor (ill. below right), as they were in that of his universalist like-minded predecessor, Stanislaw Witkiewicz (ill. below left). From an early date Kantor was equally intrigued by art and theater. In 1943 he participated in the establishment of an illegal underground theater in

Cracow. In 1945 he became a member of the "Young Sculpture" group. In 1947 Kantor even became an academy professor, though he was fired just two years later. After that began a collaboration with an artist he admired, Maria Jerema, with whom he worked more or less out of the public eye.

Kantor was the vanguard artist par excellence, unceasingly changing, always on the move. His relatively brief phase of painting in a L'art informel vein was already over by the mid-1960s. But everything Kantor did thereafter – producing his own *musée imaginaire*, creating assemblages, *emballages* and objects, organizing happenings, but above all working in the field of theater – had its source in this abstract, gestural approach. In his

**Friedensreich Hundertwasser**
The Great Way, 1955
Polyvinyl acetate on two joined strips of canvas primed with chalk and zinc white, 162 x 160 cm
Vienna, Österreichische Galerie im Belvedere

**Friedensreich Hundertwasser**
Grass for Those Who Cry, 1975
Mixed media, 65 x 92 cm
New York, private collection

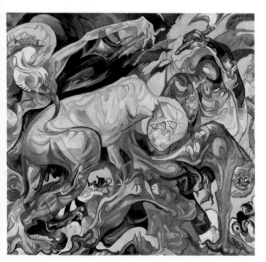

**Stanislaw Witkiewicz**
The Struggle, 1921/22
Oil on canvas, 99 x 106 cm
Lódz, Muzeum Sztuki

**Tadeusz Kantor**
Painting, 1959
Oil on canvas, 86 x 99.5 cm
Warsaw, Muzeum Narodowe

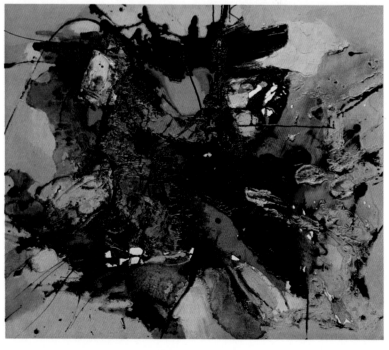

pictures as in his theater work Kantor rendered visible his idea of "hot abstraction," as a process, a departure into a new freedom. To this extent he was one of the most consequential representatives of gestural abstraction in either East or West.

In the former Czechoslovakia, where visual art has always had close ties with Surrealism and Fantastic Realism, abstract painting did not come to play a dominant role despite the great Czech model of Kupka. In addition, tentative artistic connections with the outside world were brutally severed in 1948. It was not until the 1960s that representatives of tendencies opposed to official Socialist Realism were able to dare public exposure. None of the later abstractionists has enjoyed a world acclaim like that of the poet and collage-maker Jiří Kolář. Yet although Kolář's visual alphabet-poems, related to concrete poetry, occasionally verge on abstraction, they constitute only a small portion of his œuvre.

In Hungary there was, and is, a continuation of the Constructivist stream initiated by Moholy-Nagy, Kassák, Vilmos Huszár (p. 173), and Sándor Bortnyik. The influence of Vasarely and Schöffer is likewise evident. Constructivist links are apparent in the various

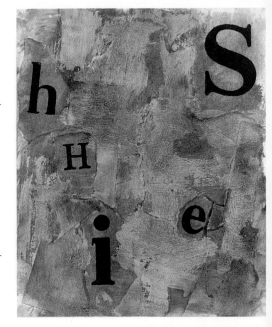

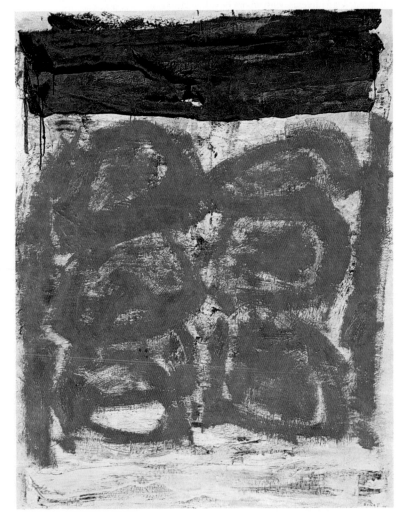

phases of the work of László Lakner, who now lives and teaches in Western Europe (ill. above). While Lakner's early style was a critical realism with Surrealist overtones, his current reputation is based on "Script Portraits" of famous and anonymous people from past and present, executed in rich and delicate nuances on canvases and unstretched fabric. The series was largely inspired by illegible scrawls on building walls and subway graffiti seen during a stay in America. In the meantime, Lakner has considerably advanced his combination of highly cultivated painting and script or calligraphy. In his works sensibility and intelligence, autonomous form and allusive, ambiguous message merge into a compelling pictorial unity.

### Geometry as Grammar

The dissemination of the international language of abstraction did not remain limited to Europe and the United States. Japanese artists, for instance, were influenced by it as well. During the heyday of the Ecole de Paris it was Koumi Sugaï who attracted particular attention, with Far Eastern pictographs monumentalized in a Western manner (ill. left).

Even in the Soviet Union abstract tendencies were not entirely suppressed, as the skilled and very original painting of Vladimir Weisberg indicates. Beginning with Cézanne, Weisberg came by way of analyses of coloration and structure to an incomparably sensitive transparency of barely detectable transitions, a veritably "invisible," metaphysical painting in which all objectivity is dissolved in a hovering, unreal space. Unlike many of his colleagues, Weisberg did not succumb to a Western-influenced eclecticism despite – or perhaps because of – his opposition to official art doctrine.

The abstract wave also inundated Latin America, South Africa, the Philippines, India, Egypt, Syria and

Israel. This was not necessarily always positive, because it tempted many artists in these areas to forsake their tradition, deny their identity, and become mere imitators of a foreign art which they practiced at second-hand. It is not unjustified to view this process as a reflection of cultural colonialism, which led to an unfortunate loss of originality. Luckily many artists of the younger generation have since become conscious of their own roots.

"Geometry," said Apollinaire, who had an infallible sense of emerging new developments, "geometry is to visual art what grammar is to the writer." The mastery of this grammar and the development of ever more liberated forms, all the way down to Abstract Expressionism, has given artists complete freedom in dealing with their medium. That is perhaps the most significant gain which the great epoch of the Abstract International brought to art.

# The Gentle Anarchist
## Wolfgang Schulze: a German Artist in Paris

"A life-changing decision of the kind made by Rimbaud or Gauguin is no longer feasible in the present and future; the character of the era precludes it," wrote the conservative sociologist Arnold Gehlen in his book *Zeitbilder* (Pictures of an Era). The author should have known better. A few years prior to the publication of his reactionary commentary on contemporary art, a destiny had run its course in Paris that was comparable to Rimbaud's, indeed comparable to any of the artists' fates in that city's "heroic" period. Admittedly the protagonist was no revolutionary, no angry young man in the Romantic style who, disgusted with civilization, set out to find an earthly paradise in India or the South Seas. He was a negative hero who, rather than challenging fate, suffered it: escape, persecution, hunger, loneliness, and finally, self-destruction.

Carl Jakob Burckhardt, deeply impressed by the first "exhibition of the works of a certain Wols" in late May 1947, at Galerie Drouin, Paris – a show that went practically unnoticed by critics and public – understood the "quality of the era" much better than Gehlen. "Under what tensions an era must stand," Burckhardt wrote to the Swiss critic and essayist Max Rychner, "in which something of this nature is possible...!"

Indeed, something of the nature of Wols's mature work would have been impossible in any other era. Attacking the canvas or sheet with the brush, scratching through the paint with its handle, working at the highest emotional and physical pitch, this artist produced in the mid-1940s a series of images whose dynamic sheaths of line and nervous, filigree strokes, as Werner Haftmann recognized, established "a completely new brand of painting at one fell swoop." Preceded and paralleled by Hartung's psychographs and Jean Fautrier's *Otages* (Hostages), Wols's paintings introduced to Europe the second wave of uncompromising and illusionless modernity, as Pollock's paint frenzies did to the United States. Georges Mathieu, himself later a successful Tachist who made spectacular public demonstrations of his calligraphic rapidity, immediately recognized the significance of the forty oils on display at Drouin. "Forty

masterpieces!" Mathieu wrote. "Every one more shattering, thrilling, sanguine than the next – an event, without a doubt the most important one since the works of van Gogh.... It was like forty moments from a man's crucifixion...."

Alfred Otto Wolfgang Schulze, alias Wols, born in 1913 in Berlin, came of an upper-middle-class public servant's family. His father, a cultivated man who loved music above all else, was president of the State Chancellery in Saxony. Wolfgang inherited his father's musical gift, but not his practical sense. Restlessly on the move, he studied one subject, then another, tried his hand at fish-farming, photography, the violin. Schulze enrolled at the Frobenius Institute in Frankfurt to study ethnology, then applied to the Bauhaus, which was then located in Berlin and entering its final phase. Moholy-Nagy advised him against enrolling, and suggested he go to Paris instead, which he eventually did. Schulze was so accomplished a violinist that Fritz Busch, the German conductor who later emigrated to England, said he would find him a position as concert master. And after Hugo Erfurth had seen the photographs done by the

*"The image can be in rapport with nature like the Bach fugue with Christ; such a case is not a re-copy but an analogous creation."*
WOLS

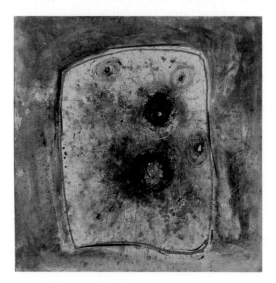

**Wols**
Painting, 1944/45
Oil on canvas, 79.7 x 80 cm
New York, The Museum of Modern Art, Gift of Dominique and John de Menil

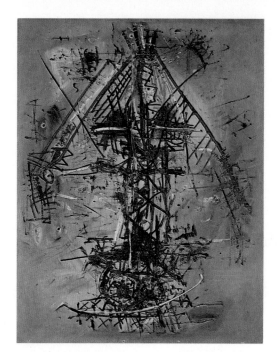

**Wols**
Le Bateau ivre, c. 1945
Oil on canvas, 90 x 73 cm
Zurich, Kunsthaus Zürich

*"Klee is an angel, Wols is a poor devil. The one creates the wonders of this world or comprehends them, the other experiences their amazing terrors. The only unhappiness for the former arises from his happy nature. Happiness draws a line, the only happiness of the latter is given to him out of the wealth of his misfortune. Unhappiness is without borders... As a human being and, at the same time, as an inhabitant of Mars, Wols tries to see the world through disaffected eyes. In his opinion, this is the only way to give our experiences an universal value. He would surely not refer to the unfamiliar, all-too familiar things that now appear in his pictures as as 'abstract' objects. For him they are just as concrete as those that he rendered when he first started painting. This is not surprising, for they are the same, only reversed."*
JEAN-PAUL SARTRE

eighteen-year-old, he told Schulze he had nothing more to learn. He earned a meager living as a photographer in Paris before becoming the official photographer for the 1937 World Fair. It was at this period that the artist adopted his pseudonym. As his wife, Gréty, recalls, a telephone operator who did not understand her husband's unfamiliar German name, simplified it to Wols. And Wols it remained.

Quiet, friendly, and highly sensitive, lost in musings and meditations, reading Meister Ekkehard and the Chinese philosophers, Novalis and Kafka, Poe and Rimbaud, Shelley and Lautréamont – when he didn't happen to be playing the violin – Wols soon found many friends despite the distance he felt between himself and other people. Among these friends were Miró, Max Ernst, Calder, Tzara, and Simone de Beauvoir, but above all her life companion, Jean-Paul Sartre, who to the end continued to help Wols where he could, when others had forgotten him or given him up. As long as he could afford it, Wols was a generous host, giving what he had without a thought for tomorrow. His love of the exquisite extended to fine dining. It was a terrible irony of fate that in the end, weakened by alcohol and the rigors of withdrawal treatment, Wols died of food poisoning.

### "For a Painting You don't buy Hamburger"
Under the pressure of internment in various camps – uwanted in Germany, Wols was suspect in France as an "enemy alien" – he began to drink heavily in 1940. Eventually he needed alcohol as a stimulant when recording his confessional autobiography in paint, his hopes and despairs, his desires and privations. "We had no wood and could not make a fire," Wols's widow recalled. "So he sat down and painted both, the wood and the fire. He

always painted his dreams like this, the good ones and the bad." As his situation grew worse and worse, Wols's œuvre developed as it were in private. He had never wanted to be a professional artist. He would rather have kept all his paintings himself. "For a painting you don't buy hamburger," Wols said.

Despite his unusual intelligence and many talents Wols tended to follow the promptings of emotion first. The necessity of some order in his life, some planned career, had no appeal for him. He remained a stranger in the world of realities, a homeless and rootless vagrant in the spirit of François Villon, the type of the vagabond reborn in the 20th century.

This young man, who aged early, unwittingly triggered the most violent change in the history of modern art, which was surely not lacking in revolts and protests. Wolfgang Schulze was the father of Tachism (French la tache = spot, mark) in the narrower sense, and of L'art informel in the wider sense – that style of gestural or action painting which revolted against the formalism of the abstract academy, brought sensuousness back into art by letting the paint run free, splashing and dribbling it onto the canvas. Tachism openly embraced chance, the irrational, the unpredictable, and the urges of the subconscious mind. It was the protest of passionate human feeling against the supposed objectivity of constructed, calculated art, of spontaneity against routine, of a romantic against a classical frame of mind.

Yet Wols's works signalled more than an art-historical watershed. They showed the artist turning his inmost feelings outwards, bringing his entire personality into play, revealing the plight of a man alone, reliant only on himself, and – in the Existentialist phrase – thrown into existence, as a representative of, witness to, and victim of the times. This could not have been done with the aid of traditional forms or styles. These had to be swept aside, to make way for the emergence of a new, unprecedented pictorial structure. The new structure went far beyond Surrealist *écriture automatique*. It was Wols' role as a witness, his abandonment of himself to the painted image, that gave his late work an exemplary significance beyond all purely aesthetic categories.

### Filigree Dream Cities
After Expressionist beginnings, Wols produced expressive works that were sited on the permeable border-line between non-objective painting and Surrealism. "Everything I dreamed took place in a big and very beautiful unknown city," the artist once said. The works on paper of the 1930s still contained many literary references. Filigree dream cities and landscapes evoked Kafkaesque realms, in which Baudelaire's *Fleurs du mal* flourished as well. Ghostly figures, humans and zoomorphic creatures in process of dissolution, populated streets and squares depicted with a fragile, microscopically precise lineature and in nuances of sometimes morbid color. The real mingled with the surreal, the organic with the constructive, in paradoxical combination.

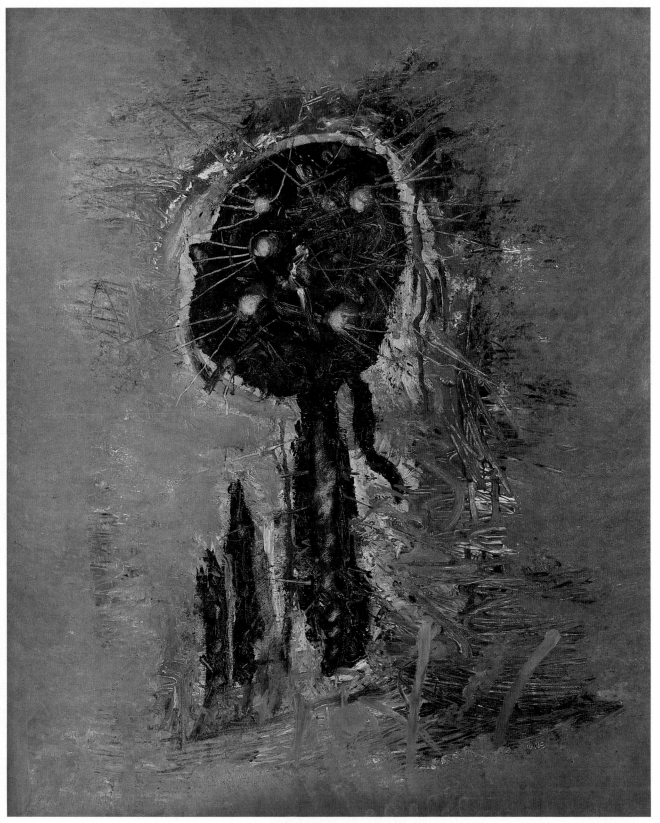

**Wols**
The Blue Phantom, 1951
Oil on canvas, 73 x 60 cm
Cologne, Museum Ludwig

BETWEEN REVOLT AND ACCEPTANCE

As time went on, the world of appearances grew increasingly vague. As the elements in Wols's compositions became ever more autonomous, there emerged "interior worlds," images of eerie and enchanting fantasy. Parallel lines, overlappings, rotations, and interweaves were combined into configurations that distantly recalled natural phenomena. Vortexes, spirals, branchings, sinuousities, proliferations and growths called microscopic enlargements of animal and vegetable structures to mind. Many Wols' paintings were in fact inspired by photographs of biological micro- and macro-structures, as well as by telescopic photographs, of spiral nebulae, for instance. His own photographs of animal cadavers, which had already influenced a number of fantastic drawings, also entered the work in oil.

Wols's photographic œuvre, done between 1932 and 1941, holds an independent position alongside his watercolors, drawings, and oils.

In his little more than 80 paintings Wols tirelessly experimented with unusual techniques. For instance, he would let several layers of thinned paint flow into one another and congeal, producing a dense interweave of textures, then would scratch or score the paint with a brush or sharp tool to reveal the ground beneath. At this period, the night side of life assumed compelling presence in these spontaneous, feverishly nervous paintings. Occasionally, anxiety and a sense of threat took on fantastic, surrealist shape, as in *Blue Phantom* (p. 251), done during the last year of the artist's life. The scoriated, martyred skin of his paintings was Wols's own.

# Painting as a Voyage of Discovery
## Tachism, L'art informel, L'art autre

Art-historical labels seldom sit comfortably. They are convenient tokens we use when talking about art, simply because they have become widely accepted. Cases in point are the names given to the records of a revolt against the Platonism of the Abstract International: Tachisme, L'art informel, Abstract Expressionism, Action Painting, or simply, *un art autre*, a different art. The gestural painting and sculpture so designated can look very diverse, but it appeared at about the same time and out of the same impulse in Europe and America, without the mutual knowledge of the artists involved.

Here again, the operative term was "liberation." Liberation from rules, liberation from the traps of formalism, from conformity in abstract disguise, but also from the burden of the tradition that even the classical modernism of the first half of the century had since formed.

Artists said farewell to the illusion that art could contribute to changing and improving the world. Put positively, this implied a new, ideologically resistant liberty on the part of the self-reliant individual, which in artistic terms took the form of a trust in vital, flowing paint, impulsive line, spontaneous gesture, and raw, unaesthetic materials.

The link between gestural abstraction and Surrealism, above all its automatic writing, is obvious. But the influence should not be overrated, because spontaneous painting based on the promptings of the subconscious mind involved primarily process and technique, and only secondarily the content and substance of the works. The gestural approach can be traced far back into the past, not only back to Dada and the abstract expressionism of the early Kandinsky, but even back to the *Haystacks* and *Water Lilies* of the late Monet, to Turner's watercolors, to the topographical drawings of Leonardo da Vinci, and finally – among the Germans – to Romanticism, to Albrecht Altdorfer, to the Danube School. Also discernable in the broad range of gestural abstraction is a renewed search for an unsullied innocence beyond the sophistications and strictures of the civilized world. This attitude led to a recourse to the authenticity of the visual symbols of pre-historical cultures. It also led to a new approach to landscape, in which artists penetrated beneath the surface to create a sort of structural geology in paint and other, unconventional materials, applied in heavy layers to the point of three-dimensional relief. "It used to be we came from nature to art," said the German gestural painter Bernard Schultze back then: "Now we come from art to nature." In this context also belong the "mental landscapes" of many L'art informel painters, which had an early fore-runner in the remarkably atmospheric, if sometimes sentimental

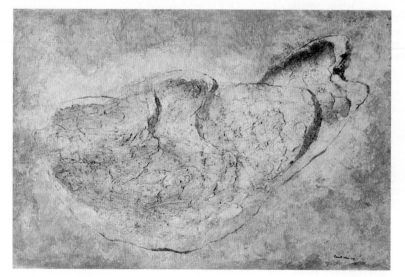

**Jean Fautrier**
The Gentle Woman, 1946
Oil, pastel and India ink on paper, mounted on canvas,
97 x 145 cm
Paris, Musée National d'Art Moderne, Centre Georges Pompidou

**Jean Fautrier**
Tormented Man, 1942
Oil on paper, 80 x 115 cm
Paris, private collection

paintings of August Strindberg, playwright and amateur artist.

Seldom before in art history have painters so frankly expressed their personality, their anger, joy, or sadness. Jean Paulhan, chief editor of the glorious *Nouvelle Revue Française,* in an early "Eulogy to Non-formal Art," not only acknowledged its great seriousness but declared that it possessed the dignity of the tragic. Other interpreters, in contrast, spoke of a moral neutralization of art, of an escape from the "compulsion to make a statement." The paradox of these contrary readings is resolved when we realize that the best works of the protagonists of gestural abstraction, from Wols to Tàpies, stood firmly in a definite historical context. They were in part dramatic, in part silent painterly records of a damaged life, of human dereliction and despair, and of the widespread speechlessness of the period.

L'art informel was the last European artistic current to have had its inception in Paris, and it was soon to be joined by a massive influx from America. Immediately after the liberation of France, Galerie René Drouin, on the narrow Rue de Visconti, showed paintings by Wols, Fautrier, and Dubuffet. There followed, in 1948 to 1950, exhibitions at Galerie Facchetti of the Americans Pollock, Mark Tobey, Clyfford Still, and Robert Motherwell. It was above all Pollock, and his method of dripping paint from a can onto a canvas on the floor, who confirmed the French artists in their approach. The tendency was soon adopted in Germany by the Munich "Zen" group, the short-lived "Quadriga" group in Frankfurt, and by "Gruppe 53" in Düsseldorf. It Italy it was represented by "Movimento Arte Nucleare."

## Art without Consolation

Like the painting of the emigré Wols, that of Jean Fautrier is well described by Jean Paulhan's reference to the tragic dignity of L'art informel (pp. 252–254). In Fautrier's case, it was not so much his own personal suffering as that of others that stood in the forefront. *Les Otages* (The Hostages) was the collective title of a series of thirty paintings done between 1943 and 1945 which made Fautrier famous. They are heads with vaguely suggested features formed of plastic material (*hautes pâtes*) and lightly worked over in oil.

The artist and his friends always put great store in the statement that *informel* tendencies had been anticipated in Fautrier's work as early as 1928, which, indicatively, was a year before he interrupted his artistic activity for all of a decade. Thirty at the time, Fautrier made illustrations for Dante's *Inferno,* images in the "black manner" and white "glaciers" in a free-flowing, form-dissolving approach whose surfaces were suffused with sinuous lineatures. "The Fautrier of 1928 already had within himself the visionary force, the innovative technique of the Fautrier of 1943," wrote André Verdet. At any rate, the gestural and expressive elements of later works were clearly present at this time.

More important than the question of priority – which Fautrier claimed over Dubuffet with respect to the relief-like, built-up surface as well – is the question of artistic substance. In Fautrier's case, this has been given its due only in recent years. This significant painter had been forgotten twice over, once in the 1930s, and again after L'art informel had lost its dominant position. Fautrier himself remained a lone wolf, but his work

*"No form of art can depict feelings if a piece of reality is not included in it. No matter how tiny, how imperceptible this suggestion may be, this irreducible part is like the key to the work. It makes it readable, it illuminates its meaning, it opens the deep, essential reality of the aesthetic perception, which is true intelligence."*
JEAN FAUTRIER

**Jean Fautrier**
Head of a Hostage, 1945
Oil on paper on canvas,
35.5 x 26.5 cm
Private collection

*"Painting operates through signs
which are not abstract and in-
corporeal like words. The signs of
painting are much closer to the
objects themselves. Further, paint-
ing manipulates materials which
are themselves living substances.
That is why painting allows one to
go much further than words do, in
approaching things and conjuring
them."* JEAN DUBUFFET

**Jean Dubuffet**
Road with Men, 1944
Oil on canvas, 129 x 96 cm
Cologne, Museum Ludwig,
Ludwig Donation

set an example and proved highly influential, even
across the Atlantic – Jackson Pollock and Willem De
Kooning were deeply impressed by the *Otages*. Fautrier's
œuvre is rebellious, disquieting, and at the same time
hermetic, not easily accessible and discouraging to
those who think abstract art can be taken in at a glance.
Not only a committed artist but a difficult, hot-tem-
pered man, Fautrier prompted Paulhan to dub him
*l'enragé*.

The consistency with which Fautrier broke with tra-
ditional forms and techniques was quite unmatched.
His skepticism was radical. He was not only one of the
earliest but one of the most significant representatives of
that disillusioned second wave of modernity that began
to sweep away classical modernism just before mid-cen-
tury. The *Otages* are a key case in point. Done under the
impression of war atrocities, they show tormented, tor-
tured, deformed heads, and in the images of the series of
*Objects* and *Naked Ones* the remains of dismembered,
decaying bodies as well.

It is precisely the anonymity of the victims, the
waiver of a direct reference to visual appearances in
favor of vague suggestion, that lends these images their
dignity and authenticity. Form and color combine into
a sign, a shockingly grisly if sometimes sardonically
grotesque, alienated symbol of reality. In the following
years, as the shock subsided, Fautrier again began tenta-
tively to try a more aesthetic approach. The dense mate-
rial of the paintings developed into relief, the palette
grew lighter, more buoyant.

Unlike the forms in the works of most of the other
French gestural painters, the color forms in Fautrier's
paintings do not appear to extend beyond the canvas
edge. His rectangles, squares, and spontaneous,

whiplash lines are set against an indeterminate back-
ground and are certainly irregular in character, but not
amorphous. Some paintings even have titles like *Small
Construction* or *Perpendicular Lines*. But Fautrier's most
far-reaching contributions were the use of compact,
plastic materials and the introduction of an open pictor-
ial structure. What is not found in his work is the free
fluxes of paint, raised to autonomous formal and expres-
sive values, seen in Wols and other L'art informel artists.

### Poetry of the Commonplace

Dubuffet (pp. 255, 256) became famous much more
rapidly than Fautrier. After a checkered life he finally
decided, in 1942, to give up his business career and
devote himself to art. This was a year before Fautrier
began painting his *Otages*. Prior to his decision Dubuffet
had already discovered a new and unspoiled originality
and authenticity in the picture-making of the mentally
ill, of naive artists and children, which he collectively
called L'art brut, or raw art. Such impressions con-
tributed materially to his nevertheless highly conscious
and intellectually considered neo-primitive works of the
1940s and 1950s, with which Dubuffet ironically
protested against elegant *peinture* and traditional, sup-
posedly eternal values in art. He discovered the poetry
contained in plain materials, in the commonplace
things of everyday life, in the banal existences of human
beings, animals, and plants.

Initially perfectionism of any sort seemed suspect to
Dubuffet. Nor was he interested in the unusual. Banal
things, seen wherever you look – chalk scribblings made
by children on the pavement, rough-surfaced stones,
muddy soil, dried and cracked – sufficed Dubuffet
entirely. In the pseudo-naive, carefree and ironic style
developed from such impressions the artist in 1947
portrayed a series of contemporary intellectual heroes,
including Fautrier, Michaux, the critic Michel Tapié,
and Pierre, the son of Henri Matisse, under the collec-
tive title *Lovelier Than You Think*.

Dubuffet rehabilitated the trivial in a way quite
different from the later Pop artists, many of whom, such
as Claes Oldenburg and Eduardo Paolozzi, greatly
admired him. Instead of deriding the commonplace, he
attempted to discover its hidden poetry, and to arrange
"rich and sublime festivities." He did so without the
aid of exquisite colors or sophisticated forms. The pic-
turesque seemed equally suspect to Dubuffet as good
taste and culture did as a whole. He did not believe in
the *homo aestheticus*, saying "As far as the superiority of
the scholar or the precious sophisticate over the next
best farmhand is concerned, I have my doubts."

For the Dubuffet of the early and probably most sig-
nificant phases, there was no color, but only matter: "I
am thinking of paintings," he said, "that are quite simply
made of the original, monochrome ooze, without varia-
tion of any kind, neither in tone nor in hues, not even
in gloss or arrangement, and whose effect would derive
solely from the many types of sign, trace, and vital

**Jean Dubuffet**
Smeared On Man, 1955
Oil on canvas, 116 x 89 cm
Private collection

**Jean Dubuffet**
Amorous Propositions, 1967
Vinyl on canvas, 130 x 162 cm
Private collection

intermittently, it continually turns, going off into empti-ness, taking and giving and taking, and it incessantly emits its filament, which breaks off and is reknotted and whose ends dangle down all over the place. – And you can paint this filament. It's marvellous!"

Dubuffet's painting seems suspended between real-ity and dream, actual and mental experience, and his figures are wittily ambiguous. Accordingly, his art holds an intermediate position between abstraction and objectivity. Dubuffet has created his own fantastic real-ity out of a belief, as one commentator says, in "the magic miracles of materiality," which for him is true nature. He is a primitive who uses the advancement of the chemical industry for his atavistic incantations, and who announces that art is meant not for the eye but for the mind alone.

As early as the 1950s Dubuffet turned to other, more graphically oriented techniques. By combining litho-graph and ink impressions in their negative form, con-crete details from reality were alienated through surpris-ing juxtapositions. The graphic elements of these assem-blages of printed material also found entry into the oil medium, determining the texture of the *Legends*. By comparison to the rawness of Dubuffet's early L'art brut, these images appear more gentle, even almost decora-tive, in terms of theme, color and style. Yet in compari-son to the *Landscape Tables*, the *Landscapes of the Mind*, the *Philosophical Stones*, the amorphous, practically unstructured *Textures* and *Topographies*, the absurd plant collages, and not lastly the *Materiologies*, Dubuffet's *Leg-ends* and the ensuing *L'Hourloupe* series have lost some-thing of the latent demonology and especially the tactile character of the early works, while becoming more light-hearted and carefree in character.

In a word, Dubuffet's pictorial idiom gradually became more puzzle-like, more ornamental. This orna-mental rhythm of cellular signs was then applied to sculptural and architectural projects (such as the group of trees on Chase Manhattan Plaza, the enamel garden in Otterlo, the "Villa Falbala" in Périgny-sur-Yerres). From abandoned works on paper, finally, Dubuffet composed his *Théâtre de mémoire* (Theater of Memory), assemblages intended to capture moments of thought, made in the belief, as the artist says, that "visual memory is more vivid than merely cognitive memory." It was "rich and sublime festivities" that Dubuffet celebrated in his late work. It had little more to do with the earlier "ecstasies of commonness." The sworn enemy of the culture business had become a brilliant arranger of form, an aesthete.

### Painting as an Actionistic Show

As Dubuffet's example indicates, only those practition-ers of L'art informel could hope to survive the period who retained the capacity for change and further devel-opment. One of them, Georges Mathieu, recognized the problem early on. "The so-called avant-garde," he said, "is basically only a working-out and statement of

impression which the hand leaves when it works pulp." Employing tar, cement, plaster and stones, Dubuffet produced ambiguous, insouciantly ironic imagery in which tables might double as landscapes, textures meta-morphose into tiny idols, gnomes or demons, animals or people, into a *Tumult in the Sky* or a *Metaphysical Landscape*.

There lives on in such pictures a memory of forgot-ten things which we pass by without noticing. "The glance is very mobile," the painter says, "it leaps quickly from one object to the next, flares up and goes out a thousand times a second, stops and begins again. Then,

new forms, a short time before these become part of a tradition." Yet Mathieu's insight could not save his paintings, not to mention his spectacular, and surely also speculative actions as a quick-sketch artist, from oblivion. As a showman who knew how to beguile an audience, Mathieu briefly seemed to have stepped into the shoes of Dalí, whose irrationalism, however, the intelligent and well-educated Frenchman eschewed. Like a fencer, Mathieu threw his whole body into the process of painting (p. 258). His extremely effective and telegenic demonstrations sometimes recalled circus performances. Moustachioed and clad in bizarre costumes, Mathieu attacked canvases of often huge proportions. The act of painting itself was so "interesting and exciting," he thought, that it deserved to be demonstrated for all to see.

What Mathieu publicly demonstrated was action painting in pure form. His virtuoso performances, though perhaps only superficially brilliant, did make entirely clear what was at the bottom of L'art informel of the Tachist variety and the Action Painting concurrently developing in the United States: painting itself had become the subject of painting, the strokes and flows of paint had become its "content."

In Mathieu's case these configurations consisted of dynamic, as if electrified, signs with a calligraphic character. Yet unlike Chinese or Japanese calligraphy these pictographs, which naturally had their source in Surrealist automatic writing, did not communicate content or encourage meditation but were purely dramatic, even theatrical in nature. This was not changed when Mathieu, using the title of an exhibition he organized in 1947, said he wished his painting to be understood as "lyrical abstraction."

Jean-Paul Riopelle (p. 259), a Canadian artist in Paris, likewise began as an "automatic" painter in the footsteps of the Surrealists and Expressionists. Soon, however, he turned to a more controlled, if still vivid style, using spatula and palette-knife to apply thick impasto over paint brushed or dripped on the canvas to produce textured, mosaic-like surfaces. The pictorial order was based on serial procedures and the interlocking of color fields. The canvases exhibited no composition in the narrower sense, having no center of interest, no beginning nor end. The paint textures seemed arbitrarily cut off at the canvas edge, as if they would other-

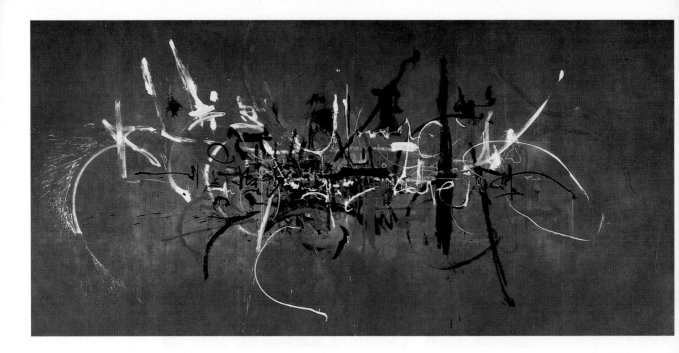

**Georges Mathieu**
Capetians Everywhere, 1954
Oil on canvas, 295 x 600 cm
Paris, Musée National d'Art
Moderne, Centre Georges
Pompidou

*"Evolution in art is produced by the
saturation of the means of expression
(significations) and their replace-
ment by new means, of which the
efficacy is unknown at the moment
of use. The significance of these new
means assumes a necessity, a struc-
turing of the pictorial material, such
as that realized to a lesser degree in
psychical or biological facts."*
GEORGES MATHIEU

**Henri Michaux**
Untitled, 1970
Watercolor on paper, 50 x 31.5 cm
Private collection

wise continue into infinity. Riopelle's approach was
based not on the laws of harmony but on the principle of
the series. Just as, in Monet's late *Water Lilies*, the sub-
ject almost vanishes behind the veils of paint, Riopelle's
non-objective imagery inadvertantly calls up memories
of objects. The picture becomes a landscape of paint
whose finely articulated textures recall the earth seen
from the air. Yet rather than abstracting from an experi-
ence of nature, Riopelle too came back to nature
through art. The impasto application and the furrows
separating the color fields give many of his paintings a
rough, relief-like surface. Not surprisingly, the artist
later made attempts in sculpture. The dynamic charac-
ter of mutually opposed energies and color gradations
lends Riopelle's canvases a high degree of gestural
expressiveness, and his mastery of color placement lends
them an unusual coloristic quality.

Although the Belgian painter-writer Henri Michaux
(ill. left) belonged to the Paris scene, he was not a Tachist
in the narrower sense. However, the contemporary ten-
dency drew much attention to his drawings and paint-
ings. For the poet, who was self-taught as a painter,
painting and drawing were a means to overcome speech-
lessness, to make visible what could not be expressed in
words: "Can't they see," he asked, "that I paint in order
to leave words behind...?" Another thing Michaux, the
great traveller, wanted to leave behind was the visible
world, and the laws of logic as well. What interested him
were "the spaces within," the inner man, to the explo-
ration of which he devoted a lifetime of work, untiringly
investigating the dialectic of word and image, both
of which he understood as writing, script. Michaux
attempted to expand his consciousness with the aid of
drugs, such as mescaline, and to record the visions he
experienced. For him, free will was "the death of art."

*"My conception is not that of abstracting: it is going toward it with a free gesture (I'm not talking about automatism) to try to understand what nature is, departing not from the destruction of nature but rather towards the world."*
JEAN-PAUL RIOPELLE

**Jean-Paul Riopelle**
Composition, 1954
Oil on canvas, 97 x 162.5 cm
Berlin, Nationalgalerie,
Staatliche Museen zu Berlin –
Preußischer Kulturbesitz

## Construction and Destruction

Another "anti-artist" like Dubuffet, at least in terms of the use of unconventional materials, was Alberto Burri (p. 260). But after abandoning abstract painting in 1948, the Italian artist took a quite different path. A former physician, who did not begin to paint until his internment in an American prisoner-of-war camp, Burri made pictures out of burlap bags, sheets of wood and iron, and various plastics, which he crumpled and folded and burned with a torch. The results were compositions of both rustic force and great sensibility, whereby the charm of the rough surface was consciously included in a play with materials inspired by Schwitters. Above all,

the burlap images accentuated with color, which possessed a latent classicism in which Constructivist, and especially Cubist influences were clearly apparent, brought Burri rapid success. Their raw, material nature was consciously opposed to the perfection of "fine painting." The expressive force of the compositions was increased by the roughly stitched textiles, their apparently random folds and wrinkles, and by the shadows cast by loosely dangling ends. The "wounds," "scars," and "sutures" may contain reminiscences of the artist's earlier profession, but they without doubt represent an attempt to come to terms with his experiences as a medic during the war.

**Simon Hantaï**
Untitled, 1973
Acrylic on canvas, 243 x 232 cm
Paris, private collection

**Jean-Paul Riopelle**
Virevolte, 1953
Oil on canvas, 81 x 65 cm
Private collection

The burning red in many of the burlap pictures evokes the idea of festering wounds, just as the black craters in other works – including some executed in plastics – call up strong associations with the smell of burning and decay, apart from the immediate association with the moon's surface. When Burri built picture-objects of boards, the impression of a boarded-up world was inescapable, despite the fact that the artist would not hear of such interpretations. Perhaps his most compelling works were those in which the picture surface was hermetically sealed off with pieces of sheet iron. These somber, often almost pathetically serious works – picture, relief, and object in one – had a great influence on Jannis Kounellis.

**Alberto Burri**
Sack 5P, 1953
Mixed media and collage, 150 x 130 cm
Città di Castello, Fondazione Palazzo
Albizzini, Collezione Burri

*Right:*
**Alberto Burri**
Sacking and Red, 1954
Burlap, glue and vinyl on canvas,
86 x 100 cm, London, Tate Gallery

The factor that proved seminal for the following generation of artists was above all the suspenseful dialectic in Burri's art between constructive form and destructive dissolution of form. This combination completely transcended the principles of L'art informel. Not only Kounellis (pp. 362, 558 f) and Arte Povera, but a number of American image- and object-makers, profited from this step forward.

Burri's compatriot Roberto Crippa (ill. left) initially involved himself with an action painting in which wild, whirling spirals predominated, before attaining to a new classicism in relief paintings, collages of wood, iron, canvas, and paper.

## Tellurian Landscapes

Perhaps the most significant representative of L'art informel in the wake of Wols, as well as of material-oriented painting, is Antoni Tàpies of Spain (pp. 261, 262). Tàpies' works are informed by a great, organizing artistic intelligence. The emotions that enter them tend to be of the quiet and meditative nature, rather than of the volcanic so characteristic of other gestural abstractionists. Instead of acting out his inmost urges in the arena of the picture, Tàpies consciously orders the plane in terms of expansive, often empty passages and simple, generous forms, that have been given an ordered structure.

**Roberto Crippa**
Untitled, 1962
Collage on wood, 200 x 200 cm
Private collection

The impulses he received from his great compatriots Picasso and Miró, from Klee and the Surrealists, declined in importance as his career progressed. Tàpies creates his own personal reality – pictorial landscapes whose formal tension derives from a contrast between empty, silent spaces and shaped configurations, between positive and negative, between projections and depressions, between chance and order, freedom and control. Some of the artist's works put one in mind of crumbling walls, inscribed with enigmatic markings reminiscent of Assyrian or Egyptian pictographs, which elude rational explanation but nonetheless seem to bear witness to lives once lived in some distant past. Others reveal primeval landscapes, lost continents, the ground plans of buried fortifications, craters and sand dunes, blown by winds off the ocean.

These are not metaphysical but tellurian landscapes, very much of the earth in that they point far back in time to forms of pre-existence on our planet. Often dark, dun, apparently monochrome but actually shot through with an extraordinarily subtle range of color, Tàpies's paintings seem removed from the context of current time. They possess a strange dignity and serenity, and suggest a positive reaction to the enigmas of the universe, which we know are insoluble despite nuclear fission, space travel, gene technology, and futurological predictions. Tàpies creates "counter-images," the replies of a thinking artist, on the one hand, to the restlessness and high-tech euphoria from which we both suffer and know to be our future, and on the other to the permanently lurking threat of nothingness.

As with Fautrier and the early Dubuffet, materials – plaster, cement, sand, clay, paint mass – play a key role in the Catalan artist's work. While human beings may not appear in the form of figures, the human presence is there, in the form of traces left by the hand, inscribed or impressed on the surface. Tàpies thus might be called an early forerunner of *Spurensicherung*, trace or clue-finding art, which later emerged particularly in Germany. He also has had an unmistakable influence on the purism of Minimal Art, on Arte Povera and its approach to materials, and finally on Process Art.

Tàpies's compatriot, Antonio Saura, also began in a Surrealist style (p. 263). But in contrast to Tàpies, the son of a Jewish mother and an Arabian father is a radical socialist and abstract expressionist. He lets his convictions and sufferings flow untrammelled into stark black and white imagery composed of ragged forms in which demons seem to lurk. "The canvas is a battlefield without limits," says Saura, and his early pictures looked the part. Later the forms grew simpler, and an earthy brown supplemented the black and white. Yet the expressive energy, the directness of the painterly statement of protest against an unjust world order remained.

Discovering the poetry in previously overlooked materials has been the concern of Jaap Wagemaker, a Dutch artist and outsider who has stood somewhat in the shadow of the Cobra group (p. 263 below). His

*Above:*
**Antoni Tàpies**
Grey Relief in Four Parts, 1963
Mixed media, with sand, on canvas,
150 x 217 cm
Cologne, Museum Ludwig

*Below:*
**Antoni Tàpies**
Matter on Wood and Oval, 1979
Mixed media on wood,
270 x 220 cm
Private collection

paintings, built like masonry into painted reliefs, evoke a world in process of transformation. Wagemaker cements stones and twine onto canvas, sometimes supplementing them with unprepossessing materials such as rags, textile scraps, stucco, and base metals. The structures of the artist's "primeval landscapes" are less spiritual, more earthy and secular than those of Tàpies. The colors tend to remain in the range of earth tones, but like so many of his colleagues of this period, Wagemaker also investigated the expressive potential of a silent black. Viewing his works one is put in mind of lakes, mountain chains, great plains, deserts, and volcanic craters in a planetary – or more rarely, inter-planetary landscape. Forms penetrate into the picture plane from outside, strive beyond its edges, or describe labyrinthine circles. A forceful sense of design holds the often harsh contrasts in equilibrium.

The leading German representatives of Tachism and L'art informel have survived better than most of their French counterparts. This is probably largely due to the fact that they recognized the pitfalls of spontaneous gestural painting early on. The oldest of these artists, Emil Schumacher, combines a thoughtful intelligence with painterly energy and a vulnerable sensibility. Schumacher's canvases (pp. 263, 264) are "landscapes" without direct reference to the visually perceived world, tellurian "landscapes of the inward man." The artist veritably digs into the paint as if it were a matter of opening the earth's crust to discover what the injury to matter will bring to light.

Schumacher's art is disillusioned, but not despairing. As he himself says, his pictures are those of a "happy painter" who has wrest them out of a struggle with his own doubts. They are serious, inquiring, and skeptical, in keeping with the experience of a generation of

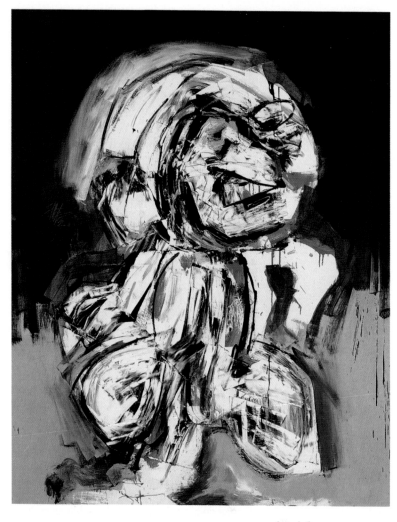

Antonio Saura
Tani, 1962
Oil on canvas, 162 x 130 cm
Private collection

*Below left:*
**Emil Schumacher**
For Berlin, 1957
Oil on canvas, 170 x 131 cm
Frankfurt/Main, Deutsche Bank Collection

*Below right:*
**Jaap Wagemaker**
The Living Desert, 1957
Mixed media, with sand, on canvas, 90 x 75 cm
Germany, private collection

*Page 262:*
**Antoni Tàpies**
Brick-Colored Relief, 1963
Mixed media, with sand, on canvas, 260 x 195 cm
Düsseldorf, Kunstsammlung Nordrhein-Westfalen

**Emil Schumacher**
Terrano XII, 1990
Oil on wood, 170 x 125 cm
Private collection

**Jean Miotte**
Deliverance, 1960
Oil on canvas, 73 x 92 cm
Cologne, Museum Ludwig,
Haubrich Collection

**Karl Otto Götz**
Painting of 8. 2. 1953, 1953
Mixed media on canvas,
175 x 145 cm
Saarbrücken, Saarland Museum

of deep black or earthy brown, applied over the paint layer or shining through from the ground. Schumacher works at full pitch, both physically and mentally. A dialectic of painterly surface and masterfully distributed graphic accents, of shapes and negative shapes, lends the artist's work an extraordinary tension and concision. The process of painting itself, as a decidedly unliterary theme of visual thinking and acting, becomes an existential symbol in this vital imagery. "The measure of the picture," says Schumacher, "is the force that dictates the path of the line."

This corresponds to French painter Jean Miotte's statement that "painting is an act, a sequence of movements one bears within oneself, whose source is one's inner being." This emphasis on the active, immediate nature of the painting process well characterizes Miotte's approach, a free-form lyrical abstraction beholding to the Ecole de Paris, Tachism, Abstract Expressionism – in a word, to L'art autre. The artist is just as familiar with the American scene as with the European. In this regard his highly original work, which since the mid-1990s has exhibited a marked reduction of color accompanied by a sense of expanding space, mediates between streams on either side of the Atlantic (ill. below).

## Labyrinths

With his tendency to philosophical musing and introspection, Bernard Schultze is a quintessentially German artist (p. 265 right). An excellent draftsman whose graphic skill remains evident in his painting, Schultze traces his roots back through Surrealism to German Romanticism, all the way back to Grünewald, the Danube School, and late Gothic. As the eye roams through his allusive, richly configured landscapes in two or three dimensions, it is confronted with *Les fleurs du mal* in

painters whose relevant work began only after 1945 and who, unlike their predecessors after 1918, felt no temptation to exorcise chaos by means of signs and emblems of a new order. The younger generation lived in *Sodom* (Hagen, Karl-Ernst-Osthaus-Museum), as one of Schumacher's early encrusted landscapes is titled, a landscape in fiery reds that emerge from the heavy integument of paint as if secreted from a wound.

Not all of the artist's images are so marked by pain. Many are dominated by a wonderful, subtly glowing, spiritualized blue, which, however – as in other cases the red and orange – is shot through with darker gradations,

poisonous hues. Not coincidentally, the French Symbolists and the German apocalyptic poet Georg Trakl are amongst Schultze's favourite writers, who himself writes poems. His visionary, labyrinthine landscapes, though populated with demons and horrors, are shot through with irony and a sometimes Chaplinesque humor that create detachment. The ancient Vanitas motif is re-interpreted out of the chiliastic consciousness of a late

culture and the hallucinatory vision of a belated Alexandrine, the aesthetics of the ugly re-formulated in modern terms. As regards palette, green and red in all variations and nuances dominate. These do not have the brilliance seen in Italian, English, and above all French painting; they are greyed, more morbid, sometimes to the point of evoking decay. Many Schultze paintings are nocturnal pieces, phantasmagorias without beginning or end, visionary landscapes that exist on a level beyond the real.

The flowing paint not only soon penetrated beyond the canvas edge, it burgeoned into full three dimensions. The next step was the emergence from the tangle of proliferating lineatures and flux of color of hidden figures – Schultze's *Migofs*. In these figures the eerie and ominous threat lurking in the darkness of the human unconscious was brought to light. They confront us with the leering mask of man stripped naked, reduced to a creature. Yet the crippled, decaying appearance of Schultze's figures is mitigated by signs of new, proliferating growth. In his rich and very fresh late work the color chords become surprisingly light, proving that the

artist is no pessimist with regard to the world's future. He describes his attitude as that of "existential optimism." "I am certain," Schultze says, "that nature will go on, it will grow and proliferate as it does in my paintings, even if someday humans should have ceased to exist."

In the fairy-tale world of Ursula, Schultze's wife, dangers lurk just beneath the carefree surface (ill. above left). Her work is more strongly beholding to Surrealism than her husband's. In stippled brushwork and inked line she relates tales of glory and mystery that emerge from subconscious depths and play themselves out in a twilight realm populated by good and bad fairies, humans, animals, plants, and strange legendary creatures. Painterly sophistication and a love of storytelling combine, not without sarcasm, in images whose precious shimmer occasionally recalls medieval miniatures.

Gerhard Hoehme (p. 266 below) is perhaps the most meditative figure among the German gestural abstractionists. He has also travelled the longest road. Hoehme intends his pictures – and not only the "Roman Letters"

**Ursula**
It's me. So what?, 1995
Oil on canvas, 147 x 98 cm
Hamburg, private collection

**Bernard Schultze**
Apparition, 1990
Oil on canvas, 120 x 90 cm
Private collection

– to be *read*. Despite his early revolt against the "tyranny of the rectangle," despite his triumphal discovery of color as energy, as a simultaneously mental and material principle, Hoehme has remained an introverted artist to the point of self-flagellation. He allows line literally to emerge from the painted surface or painted object, as a "feeler" extending from the imaginary pictorial space into the actual, surrounding space. Hoehme has altered himself, his thinking and imagery more visibly and more frequently than other German artists of the period, exposing himself and his work to the highest risks. His imagery demands that the viewer complete it in the process of viewing. "Paintings are not on canvas," Hoehme states, "they are in the human" who makes and sees them.

### Early Action Painting

If the label of "action painter" fits any German artist in the L'art informel orbit, then it is Fred Thieler (ill. right). After a late start due to political discrimination in the Third Reich, Thieler became an influential mentor and respected role-model for entire student generations at the Berlin School of Art. In keeping with his belief that painting is his only way of life, he concentrates on the

dynamic painting process, using a limited range of color and occasional admixtures of rough-and-ready collage. Everything he experiences, victories and defeats, euphoria and depression, finds immediate entry into Thieler's imagery. Marked by a difficult life, he chose gestural abstraction because, as he says, "You can't live with ideologies."

Karl Otto Götz paints with even more rapidity than Thieler, sometimes even finishing a canvas in a matter of minutes (p. 264 below right). The process has been frequently described. First "the initial strokes are quickly set with thin, dark paint on a light ground, as pattern and ground." Then new textures are created by drawing a rubber scraper across the wet paint. Finally Götz uses a dry brush to inscribe linear skeins into the wet surface. The imagery is the result of long and intensive premeditation, followed by a rapid execution that balances on the razor's edge between success and failure. Götz's action painting is based on a Surrealist concept: "Use psychic automatism and paroxysm to catch the miracle by the tail!" The work demands extreme concentration on the artist's part. The high risk involved determines an acceptance/rejection ratio of about 1:15 or 1:20. Götz has been able to derive continually new and interesting formulations by patiently exploring this dynamic process.

According to K.R.H. (Kurt Rudolf Hoffmann) Sonderborg, who was born in the Danish town of that name (p. 267), the ecstatic rhythms in his work reflect a spiritual longing, an artistic transformation of personal experience, an answer to realities seen and heard – in a jazz cellar, at Hamburg harbor, in prison, on Stromboli, or in Rome. His pictorial means are emblems of his own

Tachism and L'art informel was Winfried Gaul, whose Tachist works were extraordinarily sensitive in terms of palette and a structure that had the effect of being potentially unbounded.

Despite post-war deprivations, the period was one of abundance in painting, in France as well as Spain, in Italy and especially in Germany. If one were to name the smallest common denominator of L'art informel and gestural abstraction, it would probably be the artists emphasis on color and its expressive potentials, which reflected a faith in the continuing meaning of painting. What characterized the "young wild painters" of the 1950s, immediately in the wake of the calamity of the Second World War, was the compelling intensity of their pictorial structure and a high degree of existential concern and thoughtful skepticism, accompanied by a waiver of myth, self-assertive posing, and nationalistic and religious attitudes.

While the effects of European gestural abstraction on the whole were enormous, as regards its influence on and exchange of ideas with the American scene, its German representatives played only a modest role. Not even Wols was duly recognized across the Atlantic until the mid-1980s. The revolt against the academy which opened new roads to art was only one manifestation of the extraordinary intellectual ferment of a period dominated by restless spirits in every field.

**K. R. H. Sonderborg**
Composition, 1959
Oil on cardboard, on canvas,
107.5 x 70.5 cm
Bonn, Kunstmuseum Bonn

existence, and at the same time something entirely different. There is a Sonderborg painting of 1980 in which, far transcending current gestural tendencies, the diagonally or horizontally rotating strokes seem to come to rest, condensing into a stringent sign. The image is "trace art" of a very special brand. Its title: *Trace of Andreas Baader* (later abbreviated by the artist to *Trace A.B.*). We see the contour of the damaged ceiling molding in the terrorist's cell in Stammheim Prison; an irregular triangle marks the position of his body under the bedsheet. Sonderborg has projected into the image his shock at the mysterious circumstances surrounding Baader's death, and his sympathy for the prisoner's plight. It is a painting of compassion as well as of impassioned commitment, a political painting of compelling force, but without the slightest trace of propagandistic bias or hate.

To render emotions visible in which the temperament and personality of the artist were expressed, was also the goal of Peter Brüning, who died young (ill. right). Brüning employed color with great reserve and delicacy. In his early paintings it served primarily to convey impulsive, spontaneous, yet intellectually controlled gestures that embodied Brüning's characteristic lyrical and dramatic sensibility. During his L'art informel phase, his procedure was related to the serial music of the period, with whose composers and interpreters he maintained close contacts. Later Brüning turned to other themes: street scenes and a painterly cartography. Another German artist who soon left the orbit of

**Peter Brüning**
Untitled, 1961
Oil on canvas, 129 x 97 cm
Private collection

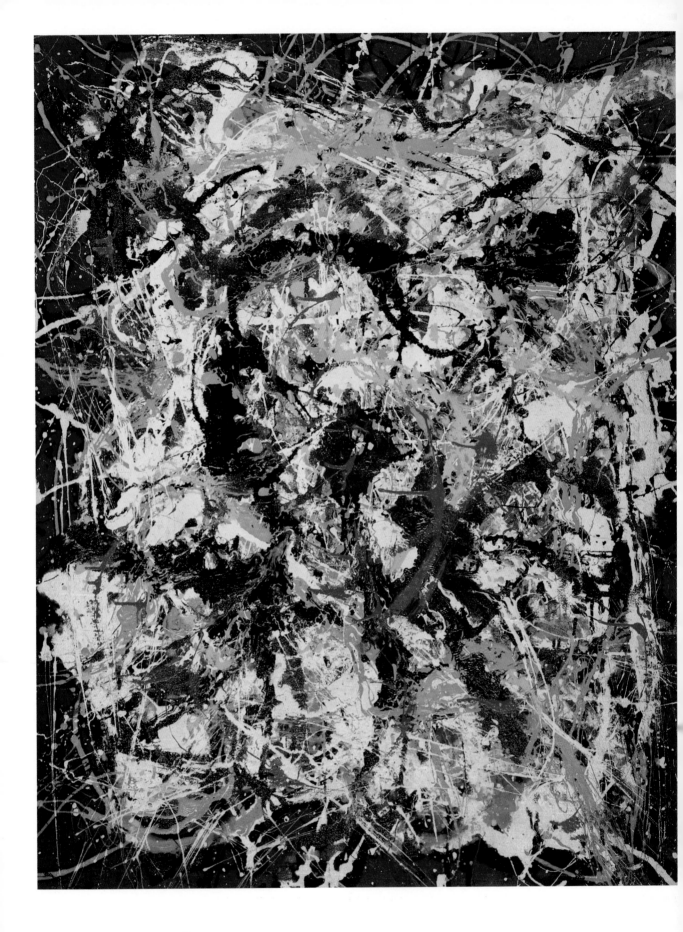

# II
# The Paris-New York Shift

## America Overcomes Europe
### Mid-Century Painting in the USA

The years around mid-century were important not only chronologically but stylistically, for they marked a profound shift in the development of visual art. This process, in contrast to the period preceding World War One, took place in a rather more evolutionary than revolutionary way. Nevertheless, the art being done around the world after mid-century differed fundamentally from that which had gone before. The outbreak of World War Two and the subsequent war years marked a fissure between the end of the first modern movement and the beginning of its successor.

The disillusion that artists felt in the face of total war, a disillusion that had often led them to abandon their last remaining ideals, long ruled out a naive enthusiasm of any sort in art. After 1945, we look in vain for high-sounding programs, and find only very few optimistic manifestos. The metaphysical idealism of the Zero movement and its initiators, Yves Klein and Lucio Fontana, was the exception that proved the rule. Except during an interim period in the late 1960s, hardly any artist still dared to conceive of art as a vehicle of ideology. Few wished to emulate the results of the more or less strict government regulation of art in the Eastern Bloc countries and Maoist China. Liberty of artistic practice became the fundamental tenet.

As economic prosperity returned to the post-war world, the demand for art increased. In the West the consumption of art, in all its positive and negative aspects, soon reached a level no one could have predicted. Modern art became a public, and popular, affair. The improvement of printing and reproduction methods, up to and including the dubious advance of producing art works in series, brought contemporary art to strata of the population which it had never before reached. The museums and exhibition venues began to attract undreamed-of numbers of visitors, a tendency that is still on the upswing at this writing.

The circle of collectors, connoisseurs, and afficionados of contemporary art grew ever larger. Governments, churches, and communities began, if hesitantly and not always sure of their aesthetic ground, to make contacts with artists and to award commissions. These institutions were joined by banks and businesses which recognized the image-promoting potentials of art. There commenced a process of integration that has continued

*"The modern artist, it seems to me, is expressing an inner world – in other words – expressing the energy, the motion, and other inner forces."*
JACKSON POLLOCK

**Jackson Pollock**
Black and White, Number Five, 1952
Automotive lacquer on canvas, 142 x 80 cm
Private collection

and grown stronger to this day, but which has also brought problems of a different and perhaps unexpected kind along with it. What successful artists have had to fear most, since the 1980s at the lastest, is a benevolent embrace that threatens to crush creativity, since it entails adaptation to market mechanisms and something most people, not only artists, find hard to resist – the temptation to make a quick buck.

Now that America has once again begun looking to Europe, and the German-Italian "trans-avant-garde" has had a spectacular success both in New York and London, it has become easier than in previous years to imagine the dominant influence which Europe once exerted over American art before its emancipation.

**Jackson Pollock**
Number 4, 1950
Oil, enamel paint and aluminum paint on canvas, 124.1 x 94.3 cm
Pittsburgh (PA), The Carnegie Museum of Art, Gift of Frank S. Kaplan

**Jackson Pollock**
Guardians of the Secret, 1943
Oil on canvas, 122.8 x 191.3 cm
San Francisco (CA),
San Francisco Museum of Art,
Albert M. Bender Collection

*"My painting does not come from
the easel. I hardly ever stretch my
canvas before painting. I prefer to
tack the unstretched canvas to the
hard wall or the floor. I need the
resistance of hard surface. On the
floor I am more at ease. I feel nearer,
more a part of the painting, since this
way I can walk around it, work
from the four sides and literally be in
the painting. This is akin to the
method of the Indian sand painters
of the West.
When I am in my painting, I'm not
aware of what I'm doing. It is only
after a sort of get acquainted' period
that I see what I have been about.
I have no fears about making
changes, destroying the image, etc.,
because the painting has a life of its
own. I try to let it come through.
It is only when I lose contact with
the painting that the result is a mess.
Otherwise there is pure harmony, an
easy give and take, and the painting
comes out well."*
JACKSON POLLOCK

Since the 19th century, masterpieces of European art had
continually flowed to America, thanks to the unparal-
leled financial resources of collectors who wished to
embellish their business empires with culture. The
influence of Europe on American artists was equally
strong, and it continued well beyond the 19th century
and far into the twentieth. Many of them, such as Hop-
per, studied in Europe, above all in Paris. What resulted
artistically from this confrontation of the New World
with the Old was for the most part eclectic, if not imita-
tive. Many Americans in Paris, beginning with Symbol-
ism, Fauvism, or Cubism, launched into their own more
or less convincing variants of tendencies current on the
Paris scene.

This changed fundamentally in the course of the
1940s, as artists in America, especially in New York, grew
increasingly confident of their own powers. The next
decade brought a growing awareness in Europe that an
exchange of roles had taken place. There was no denying
that American artists had shaken off European tutelage.
The overwhelming vitality of the huge canvases of the
Action and Color Field painters made the pictures of
the abstract Ecole de Paris seem tasteful but substan-
tially modest products of an aging culture.

The superb exhibition "Fifty Years of Modern Art,"
shown at the Brussels World Fair of 1958, passed the
European development in review once again; but in the
American pavilion, Europeans saw themselves con-
fronted with an independent new art, above all with
painting of compelling power and undoubted original-
ity. Previously, the Basel Kunsthalle had shown, for the
first time in Europe, "The New American Painting," an
exhibition compiled by the Museum of Modern Art.
What announced itself here became a reality with

breathtaking speed. Within the next few years New
York had supplanted Paris as the world center of the
arts.

### Beginnings in 1913

The long road to the emancipation of American art from
Europe began in 1913, with the legendary Armory Show.
As in Paris with the Impressionists, it was a photogra-
pher who took the initiative in the art world of New York
after the turn of the century. Just as Nadar had mounted
the first exhibition of Impressionist paintings at his stu-
dio on Boulevard des Capuchines, Alfred Stieglitz pre-
sented the first shows of avant-garde art in America at his
studio at 291 Fifth Avenue. Stieglitz showed Rodin's
drawings, causing a great scandal, then works by
Cézanne, Matisse, Rousseau, Picabia, and Constantin
Brancusi. His studio became the focus of New York
Dada. Yet the reactions of American audiences and
critics, despite their freedom from overweening tradition,
were every bit as biased as those of their European
counterparts. Instead of calling avant-garde artists
"Hottentots in starched shirts" or "paint-spattering
monkeys" as in Paris, they were termed a "black gang"
or, in the case of a group of socially critical painters,
the Ashcan School.

As Herbert Frank has pointed out, the situation of
the American artist attempting to cast off the fetters of
an inflexible tradition was even more difficult than that
of his Old World colleagues: "Even though the young
Impressionists felt like 'pariahs' because the official
Salon remained closed to them, they nevertheless lived
in an educated society that revered art as a high cultural
good ... In a nation that had battled to escape its colo-
nial past, on the other hand ... all that counted was

**Jackson Pollock**
Search, 1955
Oil and enamel paint on canvas,
146 x 228.6 cm
Private collection

efficiency of action and hard-headed, practical think-
ing. While science, in so far as it served progress and
furthered industrial development, enjoyed high esteem,
the significance of art and literature had not even
entered the average American's field of vision."

But there were above-average Americans as well,
such as unbiased and impassioned collectors of the type
embodied by the Stein family, especially the poet
Gertrude and her brother Leo. The significance of these
men and women cannot be over-estimated, for in Amer-
ica, as initially in Europe, it was neither public institu-
tions nor government departments that interested
themselves in modern art, but private citizens.

Arthur B. Davis, president of the Association of
American Painters and Sculptors, founded in 1912 and
comprising 25 members, saw the *Sonderbund* exhibition
held in Cologne, Germany, that same year. Together
with his friend, Walt Kuhn, he went through consider-
able organizational and diplomatic effort to bring a
selection of 500 works of art to the United States. In
order not to confront visitors with entirely unfamiliar
art straight off, the selection began with Ingres and
Delacroix. It was by no means without gaps and
revealed Davis's predilection for Symbolism. Then too,
tactical considerations made it necessary to include a
further 500 works, by more or less traditionalistic Amer-
ican artists. The resulting show caused a scandal
nonetheless. Davis had expected this, even hoping it
would boost interest in his project. By the time it
ended, the "International Exhibition of Modern Art"
had attracted 75,000 visitors to the Armory building in
New York City, and in Chicago it even drew 200,000.
Only in conservative Boston did the public stay politely
aloof.

The critics wailed once again about the "end of art,"
but visitors bought pictures nonetheless. A total of 200
European paintings from the show remained in the
United States. The taboo that had previously been
attached to modern art was broken, even though some
time was still to pass before the seeds sown by Davis
would sprout in artistic practice. The First World War
and its aftermath then interrupted this development.

## Influence of the Museum

Sixteen years after the Armory Show, in 1929, the
Museum of Modern Art was founded in New York.
Once again, the initiative had come from the private
sector. Although according to its statutes, the museum
was to accept only certified and proven works of art, it
revolutionized museum practice in a manner similar to
the Hannover Museum headed by Alexander Dorner,
who was subsequently driven from Germany by the
Nazis. In addition to fine arts, the so-called applied
arts, including photography, film, architecture, and
design, were given their own departments at the
Museum of Modern Art. The traditional ideal of the
museum as a treasury for the benefit of connoisseurs
and scholars was replaced from the very start by the idea
of a vital, democratic art institution. At the Museum of
Modern Art, works of art were not understood to be
rare and precious objects but reflections and examples
of real life.

According to its founding director, Alfred H. Barr,
the museum's two supporting pillars were Paris and the
Bauhaus. The expansion of the collection, down to the
immediate present, was conducted on the basis of Barr's
motto that the museum man must be right up front, but
still one step behind. In other words, he should follow

*"I approach painting the same way I
approach drawing, that is direct –
with no preliminary studies."*
JACKSON POLLOCK

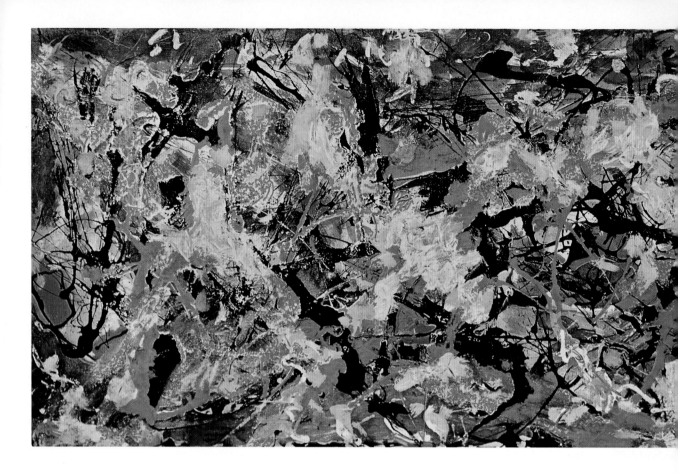

current developments with great attention, without suc-
cumbing to the temptation of making the collection
into a bazaar of novelties. The "MOMA" has fared
quite well under Barr's principles, even though acquisi-
tion policy in the field of contemporary art, including
American contemporary art, may have been initially
somewhat hesitant. At any rate, the influence of the
museum and its incomparable collections, as well as
that of its associated or succeeding institutions, has
materially furthered the appreciation and acceptance
of 20th-century art in the United States.

As collecting activities continued to burgeon in
America, the revolutionary development of a painting
independent of and surpassing European models
unfolded in relative obscurity. Though the beginnings of
the "Pacific School" in the Northwest – a school, by the
way, which its revered mentor, Mark Tobey, called an
"invention of the critics" – went back to the year 1930,
the final breakthrough of emancipated American art on
a national, and soon international level had to wait until
1952. This was the year in which the Museum of Modern
Art introduced the New York School, including Pol-
lock, Rothko, Still, and others, in an exhibition titled
"15 Americans."

## New York Becomes a Capital of Art

In the following period American painting, with irre-
pressible elan and brash self-confidence, began to play
the leading role in world art it would continue to hold
until the 1970s. A Paris art dealer of the rank of Daniel
Cordier, furtherer of Surrealist and post-Surrealist art,
closed his gallery at the time, saying the French capital
had become an amusement park for tourists and its art
scene had declined into insignificance. In the mean-
time, people interested in art registered everything that
was happening in the New World, especially in New
York, but later also on the West Coast, with the same
eagerness they had previously reserved for Paris. Not
only European artists but European collectors, dealers,
and museums began to increasingly orientate them-
selves towards developments in America.

As the abstract Ecole de Paris produced ever more
aesthetic variations on earlier pioneering achievements,
the Americans disproved the still widely held hypothesis
that abstraction was a uniform, monotonous style. The
contrasts between the delicate picture-writing  Mark
Tobey derived from East Asian calligraphy and the
explosive gestures of a Willem De Kooning, between
Pollock's frenzied Action Painting and Rothko's or Bar-
nett Newman's serenely meditative panels, could not
have been greater. But despite their differences, the
American artists of these formative years all shared key
things in common: a mixture of vitality and sensibility
unprecedented in the art of this century, the ability to
lend their works, even the meditative abstractions, the
character of immediate reality, and a democratic sense

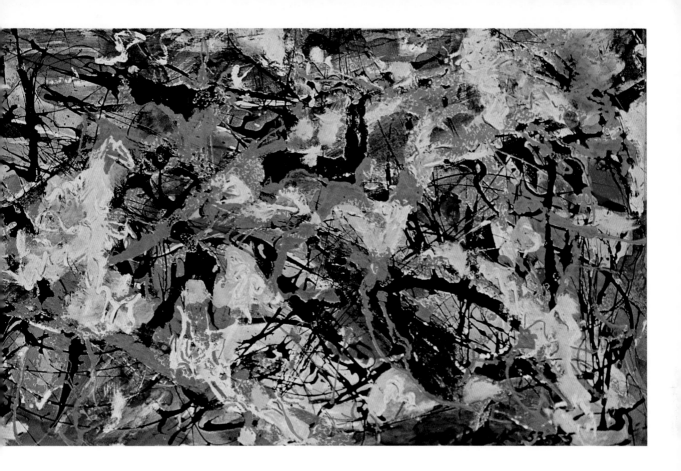

of the social mission of an art which, by definition, was meant for all. The notion of an esoteric existence in an ivory tower would have seemed absurd to most of these artists. Only the late Ad Reinhardt (p. 293) of the *Black Paintings* represents a certain exception, though it should not be forgotten that their creator was also an art theoretician and a political man whose polemics could be scathing.

## Painting as a Process

All the artists later labelled Abstract Expressionists shared the need to express themselves through the immediate, spontaneous act of painting. The old idea of the artist as a representative of his contemporaries took on a new, pragmatic meaning in their works, a meaning entirely devoid of the neo-mystical pathos that would reappear in the mature phases of a Rothko and especially a Newman. In Action Painting the gesture and resulting brushstroke express themselves rather than any extraneous meaning; the process of painting represents the content of the picture. In such works the temperament and character of the artist, his joys and despairs, are revealed immediately, without recourse to the intermediary steps of developing a motif. This is especially true of Jackson Pollock.

Pollock once said that he did not want to *illustrate* feelings but to *express* them, spontaneously and immediately, without obfuscating technique. One is put in mind of van Gogh, who likewise wanted to "forget" technique and cause "people to flock together and swear by everything sacred that we have no technique." Pollock's paintings, in which chance and principle converge, in which the vital recklessness of the frontier pioneer meets the neurotic vulnerability of civilized man, are not projections but manifestations of life (pp. 269–274).

The works of Pollock's early phase are done in a livid and somber semi-expressionist style with manneristic traits, recalling El Greco. For a time, the artist was excited by the bright-hued art of the American Indians and their picture-writing, then by the monumental expressiveness of the Mexican revolutionary muralists Rivera, Orozco, and Siqueiros. Surrealism, at least Miró's version, and the quasi-Surrealist phase in Picasso's œuvre left their traces on Pollock's approach as well.

Pollock's painting is a dramatic art of expression. Even where Cubist formal elements still play a role and an ornamental planar arrangement is still strived for, in every square inch of the canvas covered with thick impasto to the point of low relief one senses the artist's impassioned attempts to express his inmost self, to find pictorial signs for a sense of life that oscillated between exuberance and anxiety. In place of the ancient myths we find archetypal symbols from the psycho-analysis of C.G. Jung. (Due to alcohol problems Pollock was under

**Jackson Pollock**
Frieze, 1953–1955
Oil and aluminum paint on canvas,
66 x 218 cm
Merion (CT), private collection

*"The modern artist is living in a mechanical age and we have … mechanical means of representing objects in nature such as the camera and the photograph. The modern artist, it seems to me, is working and expressing an inner world – in other words, expressing the energy, the motion, and other inner forces … the modern artist is working with space and time, and expressing his feelings rather than illustrating …"*
JACKSON POLLOCK

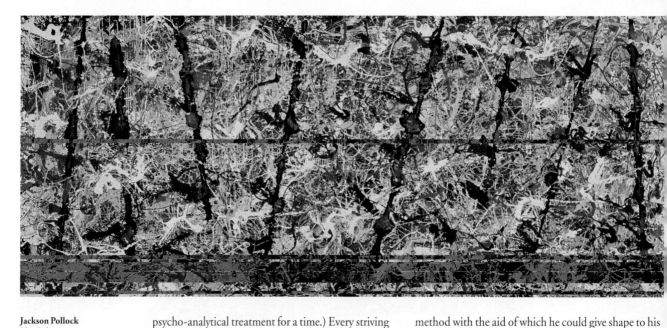

**Jackson Pollock**
Blue Poles, 1953
Oil, automotive lacquer and
aluminum paint on canvas,
210.8 x 488.9 cm
Canberra, Australian National
Gallery

psycho-analytical treatment for a time.) Every striving for objectifying distance gave way to untrammelled subjectivity. Yet when Pollock attempted to give form to his personal despairs, visions, and neurotic fears, he was acting in proxy for America and an entire epoch. When he launched out in "search of a symbol" with the aid of daring abbreviations, one can see a parallel with related attempts in Europe. In a similar way as for the Surrealists, mythology was equated with the unconscious mind, what Lawrence Alloway has called the embodiment of the buried life.

The highroads and detours Pollock took in search of himself, of an art original and without parallel, are paved with pictures of greatly varying quality. His obsession with finding true originality in the midst of an over-civilized, perfected, and regimented environment led in 1947 to a momentous decision. He decided to use a

method with the aid of which he could give shape to his inmost nature without recourse to conscious design. As he had seen Siqueiros do, Pollock spread a length of canvas on the floor and let paint drip onto it from the brush or straight out of a tin can. The principle of "dripping" was born, permitting the direct transmission of the artist's thought and act into painting, by means of what Max Ernst had called "controlled chance." Pollock himself explained that working on the floor gave him a sense of being closer to the painting, more a part of it. He could walk around it, work on it from all four sides, and literally "be in the picture." The Indians in the West, he added, worked in a similar way on their sand paintings. The logical consequence of Pollock's approach, by the way, was not appreciated by Siqueiros.

With immense concentration, precise observation of the paint trails, and a series of rapid decisions, there emerged the "web of paint" which came to be Pollock's trademark. Many paintings were done as if in a trance. The results have an astonishing density and an often baffling logic. The crucial factor is the artist's ability to combine spontaneity with a sense of form, to make "a lyrical statement of the highest subtlety" even using extremely robust means on enormous formats. This singular ability is just as evident in the brightly colored works in which the surface is covered with dense layers and textures, as it is in the more sparing black and white images, in the small formats as in the monumental canvases.

The contradictions contained in the American character, tensed between the brute force of the pioneer and the neurotic wavering of the modern city-dweller, become a visual event in Pollock's imagery, as does the contrast between the tradition-laden Old World and a New World struggling for cultural self-definition. This contrast is well illustrated by comparing the chamber music in painting of a Wols with the explosive fortissimos of Pollock's Abstract Expressionism.

**Willem De Kooning**
Merrit Parkway, 1959
Oil on canvas, 228 x 204 cm
Private collection

*Page 275:*
**Willem De Kooning**
Woman I, 1950–1952
Oil on canvas, 192.7 x 147.3 cm
New York, The Museum
of Modern Art

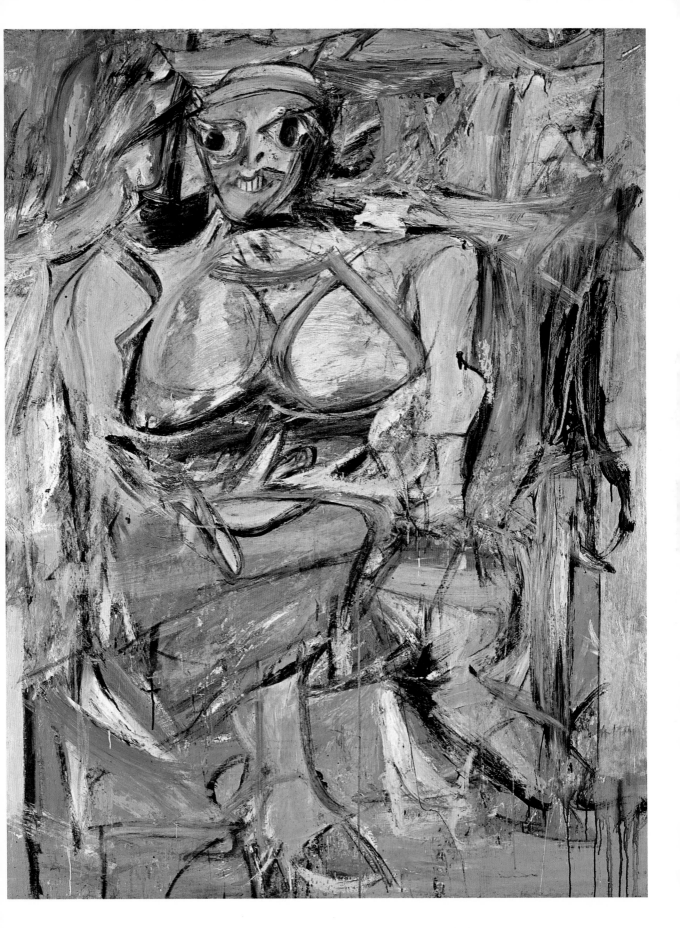

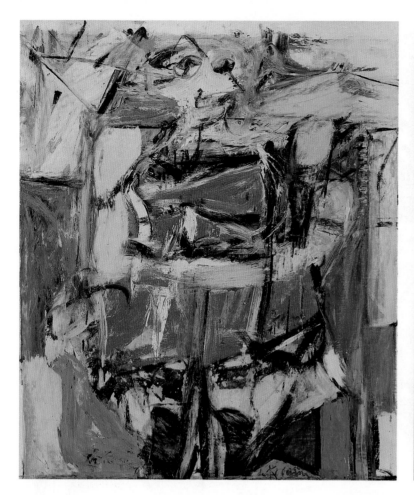

*"The attitude that nature is chaotic
and that the artist puts order into it
is a very absurd point of view, I
think. All that we can hope for is to
put some order into ourselves. When
a man ploughs his field at the right
time, it means just that."*
WILLEM DE KOONING

## Unity of Life and Work

An at least equally important representative of Action
Painting, with whom Pollock exhibited as early as 1942,
and who even surpassed him in terms of the multifarity
and intellectual depth of his rich œuvre, was Willem De
Kooning. Eight years younger than Pollock, De Koon-
ing was born in Rotterdam. After an apprenticeship in
Holland and Belgium, he decided he wanted to go to
America, and arrived there without papers after a fantas-
tic odyssey as a ship's machinist and seaman. After
beginnings in a figurative style, De Kooning came under
the influence of Miró and his friend, Arshile Gorky, and
began to depict an inner, pre-existent world, indepen-
dent of historical reference and external experience. But
the more mastery he gained over his means, the more
this "landscape of the soul" receded into the back-
ground.

The realistic allusions vanished, and expressive color
came to determine the non-perspectival pictorial space.
The shapes broke up and appeared to shoot beyond the
canvas edge. The content of such paintings lay in the
making visible of the painting process, the artist's
actions themselves, although the series of *Women*, com-
plex, idol-like or demonic female figures, and such
painting titles as *Suburb in Havana* or *Merrit Parkway*
(p. 274), indicate that references to things seen and expe-

rienced were never entirely expunged from De Koon-
ing's abstractions.

Indeed De Kooning always retained the right of
artistic decision and resisted being labelled an Abstract
Expressionist by producing obviously figurative works,
unconcerned by the confusion his *Women* caused
among experts (pp. 275, 276). This open-endedness of
artistic stance corresponded to the openness of de
Kooning's gestures, the unfinished look of his forms.
His paintings are metamorphoses of the visible world
and, at the same time, of his own mental and emotional
world. Since these realities changed as incessantly as the
artist's relation to them, his art eludes all stylistic classifi-
cation. Transformation and change are the dominant
factors in the imagery of this eminently gifted painter.
These were the source of the amazing richness of form
and expressive gesture in his work, which encompasses
the poles of explosive drama and free-flowing, serene,
comparatively sparing movements, as seen in his late
work. De Kooning's style is incredibly vital, and holds a
tense equilibrium between unleashed expression and
compositional precision. Perhaps this is due to his hav-
ing learned a lesson from the Cubists, before – at the
suggestion of Gorky – letting himself be inspired by
Surrealist automatism. Basically there are only two
themes in De Kooning's work, of which he made free

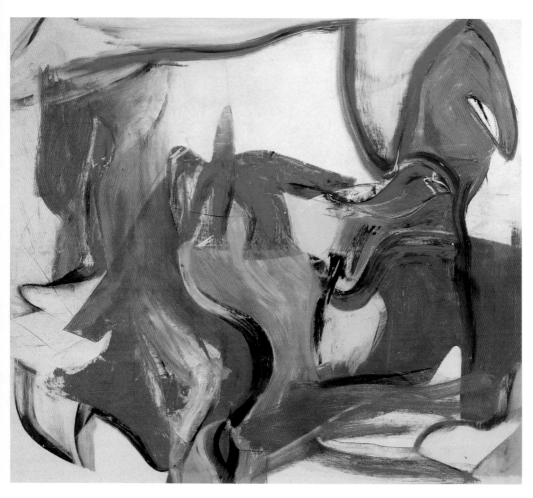

"Nothing is positive about art except that it is a word. Right from there to here all art became literary. We are not yet living in a world where everything is self-evident. It is very interesting to notice that a lot of people who want to take the talking out of painting, for instance, do nothing else but talk about it. That is no contradiction, however. The art in it is the forever mute part you can talk about forever."

WILLEM DE KOONING

**Willem De Kooning**
Untitled XII, 1982
Oil on canvas, 177.8 x 203.2 cm
Private collection

variations between abstraction and objectivity in numerous series: landscape and figure. Yet his life's work, which includes remarkable, grotesquely demonic sculptures inspired by Auguste Rodin and Matisse, is perhaps richer in metamorphoses and contrasts than that of any other artist working in the latter half of the 20th century.

The œuvre of Philip Guston, whom Gerhard Mack has called "the studio painter among the Abstract Expressionists who has probably the deepest roots in the Western painting tradition," oscillates between abstraction and figuration. In 1968, after a show at the Jewish Museum, New York, Guston decided to deal solely with concrete objects from that point onwards. The combi-

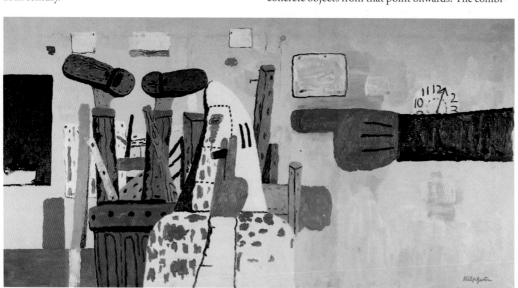

**Philip Guston**
Courtroom, 1970
Oil on canvas, 170.2 x 327.6 cm
Private collection

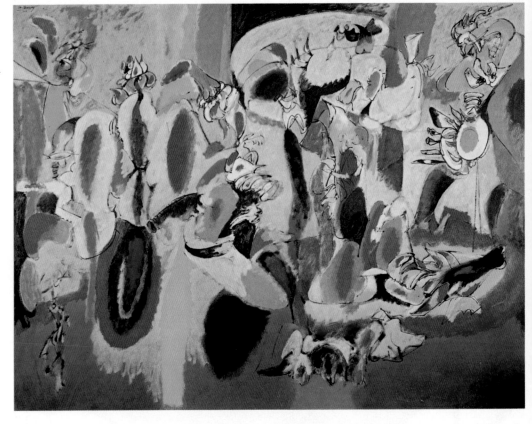

**Arshile Gorky**
The Liver is the Cock's Comb, 1944
Oil on canvas, 183 x 249 cm
Buffalo (NY), Albright-Knox Art Gallery, Seymour H. Knox Foundation

nation of social critique and caricatural elements in his later work is more than obvious. A good example is the threateningly extended index finger pointing at a hooded Ku Klux Klan member and an amalgam of painter's easel and painter's feet in *Courtroom* (p. 277).

Bradley Walker Tomlin arrived by way of an involvement with Cubism, Surrealism, and calligraphy at a specific variant of Abstract Expressionism that occasionally recalls the work of Mark Tobey. His painting style is not as vehement as Pollock's, to whose circle he belonged. Tomlin's rhythmically repeated, sometimes interwoven colored points, lines, and cross-configurations in subdued hues have the weightlessness of a dance and a lyrical atmosphere (p. 279 above left).

The Surrealist tendency remained stronger in the imagery of De Kooning's friend and contemporary Arshile Gorky (ill. above and left), who committed suicide in his mid-forties after a cancer operation and an automobile accident. Initially influenced by Miró, Picasso, and Léger (who had temporarily emigrated to the United States), and later by Matta and Tanguy, Gorky arrived at his personal style in the early 1940s – a biomorphic abstraction with Surrealist reminiscences. It was only quite late in his career that the native Armenian managed to slough off a certain symbolic overloading and begin treating colors and forms in a freer manner. The canvases done after this transition, with their exquisite, European-influenced coloration and wonderfully vital configurations that emerged in the process of painting, are among the finest and most influential examples of American painting during the period of its emancipation. In Europe, Gorky's significance still remains to be discovered.

The great vitality of Action Painting, its drama and pathos, come out full-blown in the large-format black and white paintings of Franz Kline (p. 279). The theme of his art is the direct and immediate record of power-

**Arshile Gorky**
The Betrothal, 1947
Oil on canvas, 127.5 x 100 cm
New Haven (CT), Yale University Art Gallery, Katherine Ordway Collection

fully sweeping gestures, broad bands of force emerging from nodes of energy to meet and clash across the pictorial field. Unlike Pollock, Kline tended to control the painting process rather than yielding to the promptings of his unconscious. His decision to limit himself to black and white, which were again supplemented by colors towards the end of his career, had its source in parallels between drawing and painting. Kline made numer-

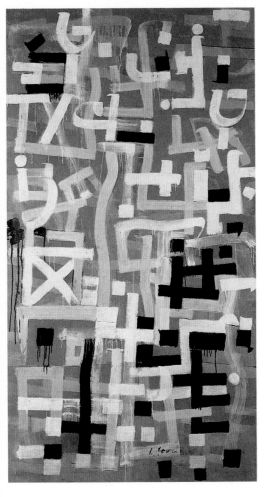

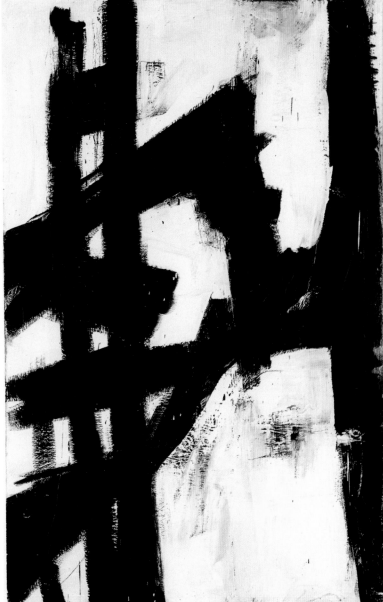

ous brush drawings whose elements he then frequently transferred to canvas. His monumental signs are neither symbolistically encoded references to covert content, nor are they based directly on things seen or experienced, despite the fact that Kline began in an objective style in which allusions, say, to bridges or cityscapes were still detectable. Kline's mature painting takes place, if you will, in the present moment; it is an event arising from the artist's act. The resulting configurations bear their meaning within themselves. Kline's vehement strokes, a far cry from the delicacy of East Asian calligraphy and more closely related in terms of color and gesture to Goya, Daumier, Toulouse-Lautrec, or Picasso, have an expressiveness of sometimes archaic force. Whether limited to black and white or, as in the late work, containing incursions of harsh blue, red, or green,

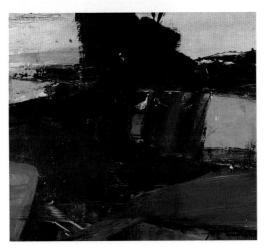

*Above left:*
**Bradley Walker Tomlin**
Number 5, 1949
Oil on canvas, 177.5 x 96.2 cm
USA, private collection

*Above right:*
**Franz Kline**
New York, N.Y., 1953
Oil on canvas, 201 x 128.5 cm
Buffalo (NY), Albright-Knox
Art Gallery, Gift of Seymor
H. Knox

**Franz Kline**
Untitled, 1957
Oil on wood, 46 x 53.5 cm
Private collection

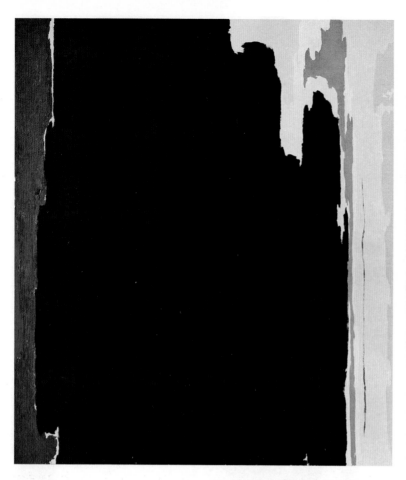

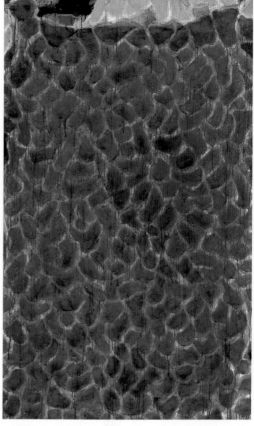

**Clyfford Still**
Painting, 1951
Oil on canvas, 237 x 192.5 cm
Detroit (MI), Detroit Institute
of Arts

**Sam Francis**
Blue, 1954
Oil on canvas, 144 x 89 cm
Hannover, Niedersächsische
Landesgalerie

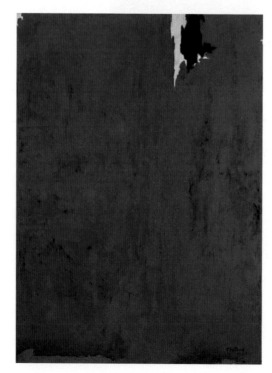

**Clyfford Still**
Untitled, 1953
Oil on canvas, 236 x 174 cm
London, Tate Gallery

the paintings seem to contain the artist's personality in essence. Kline's canvases represent seminal contributions to America's self-image.

The ethical claims of American painting prior to the advent of Pop Art come out very clearly in a letter of Clyfford Still. American painters were now obligated to take unprecedented action, Still wrote, not to illustrating worn-out myths or contemporary alibis. They must assume full responsibility for what they did, and greatness would lie in the depth of insight and the courage with which they realized their own ideas. Questions of communication were presumptuous and secondary, Still added. Only when the viewer ceased looking at a painting as into a mirror, searching there for his own fears and hopes, would he be able to recognize and participate in the problems of the work.

Still's painting (ill. left and above) derives its tension from a contrast between large surfaces of textured dark paint into which narrow, tapering wedges of lighter color are inserted. The drama of his large-format canvases is lower in key than that of other Action Painters. The drama withdraws into the image with the restrained gestures. These nevertheless convey an exciting energy, manifested in an impasto paint application which lends Still's paintings a vibration, an emotionally charged vitality. As with the other Action Painters, Still's theme is the painting process itself.

Less problematic, apparently, are the methods and results of Action Painting in the work of the almost twenty years younger Sam Francis (ill. left and below). In his painting, too, which initially stood under Pollock's influence, the act of translating emotion into color becomes a painterly event. Francis's paintings, too, have no other content than the paint configurations themselves. At first the artist favored a reserved palette, tending to monochromy. White or black islands or clouds of paint, interspersed with stimulating passages of color, covered the expansive surfaces in an irregular arrangement full of visual sensations which were a source of continual surprise. Meditative calm spoke from this imagery as much as an ebullience that revelled in its own vitality.

In the course of the years France steadily heightened the brilliance of his colors to the point where they obtained what amounted to a luminosity. Transparent blue, red or yellow announced that life, and painting, were a sheer joy. The sweepingness of the gestures was reined in by the artist's sensibility and his sophisticated sense of color. Francis has repeatedly lived and worked in Paris, and he is perhaps the most French of the American Action Painters. The latent threat to his art lies in the temptation to succumb to a luminous, Fauve-inspired palette whose jewel-like exquisiteness occasionally verges on the all-too lovely and decorative. This threat is happily avoided in the late, meditative images, inspired by Far Eastern thought, in which sparing but focused color passages stand in contrast to expansive, empty spaces.

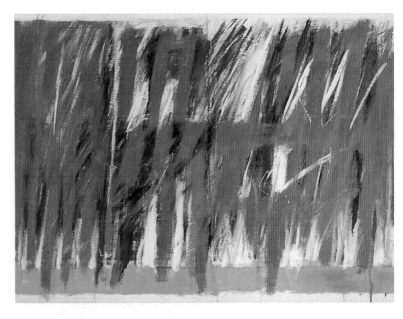

**Jack Tworkov**
West 23rd, 1963
Oil on canvas, 152.7 x 203.2 cm
New York, The Museum of Modern Art

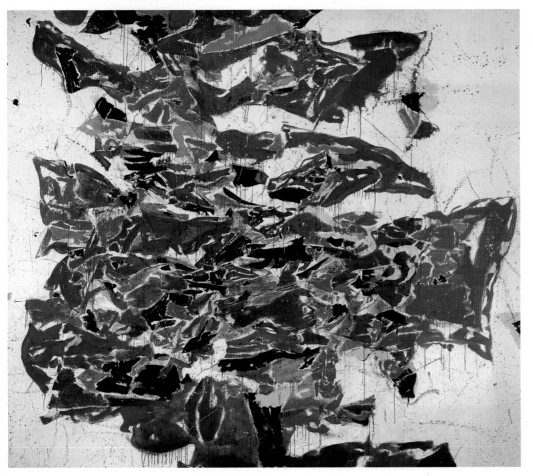

*"I live in a paradise of hellish blue balls – merely floating, everything floats, everything floats – where I carry this unique mathematics of my imagination through the succession of days toward a nameless tomorrow."* SAM FRANCIS

**Sam Francis**
Round the World, 1958/59
Oil on canvas, 274.3 x 321.3 cm
Private collection

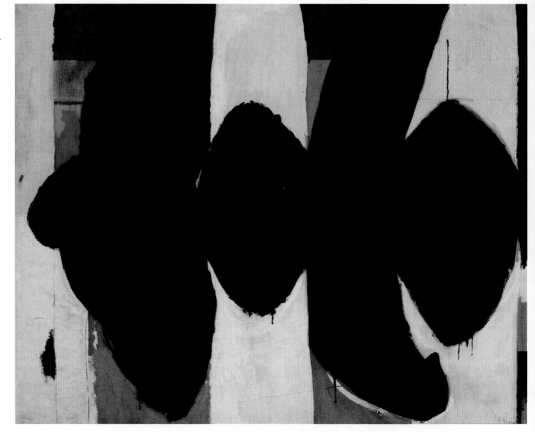

**Robert Motherwell**
Elegy to the Spanish Republic
No. 34, 1953/54
Oil on canvas, 203 x 254 cm
Buffalo (NY), Albright-Knox
Art Gallery, Gift of Seymour
H. Knox

**Robert Motherwell**
Titanium Man, 1977
Collage and acrylic on canvas,
91.4 x 61 cm
London, Paul McCartney
Collection

The attempt of American artists to jettison the burden of the European heritage and develop their own expressive potential began during the 1940s, initially without much hope of attracting the attention or support of their countrymen. For ten years, reports Robert Motherwell, American artists went their own lonely way without the participation of the art public.

## European Influences

This situation was not easy to bear, particularly for the highly educated and cultivated Robert Motherwell (ill. above and left), who had been deeply impressed by European art. Picasso and Matisse, Surrealism and Dada cast their spell over him – Kurt Schwitters and Hans Arp more strongly than Max Ernst or Dalí. Motherwell's cultivated treatment of color, as in the subtle monochromy of the *Open* pictures, was French in origin. Soft-spoken and reserved, Motherwell generally held aloof from the loudly proclaimed neo-primitivism of his colleagues. But to find his own way, he too first had to forget Paris. The moral impulse of American painting was especially strongly embodied in Motherwell's personality and work. As he once said, he thought the laws of painting were in the first place ethical, and only then aesthetic in character.

The artist involved himself with the human issues of the era in more than philosophical terms. Motherwell's long and impressive series of *Spanish Elegies* were dedicated to the Spanish Republic destroyed by Franco. The

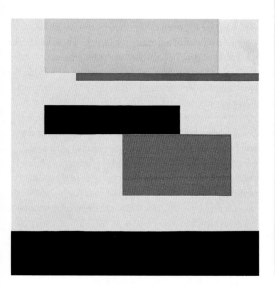

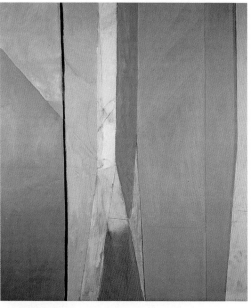

highly reduced formal idiom of these compositions combines symbolic force with the subjective decisions of Action Painting. Their author, who also made significant and original contributions to the art of collage, possessed a sensibility and power of imagination, a critical eloquence and a sureness of judgement that made him one of the major artistic intermediaries between America and Europe.

Action Painting in the United States has repeatedly been classified under the rubric of Abstract Expressionism. Although the term is not entirely false, it is not quite correct either. There was nevertheless one bridge,

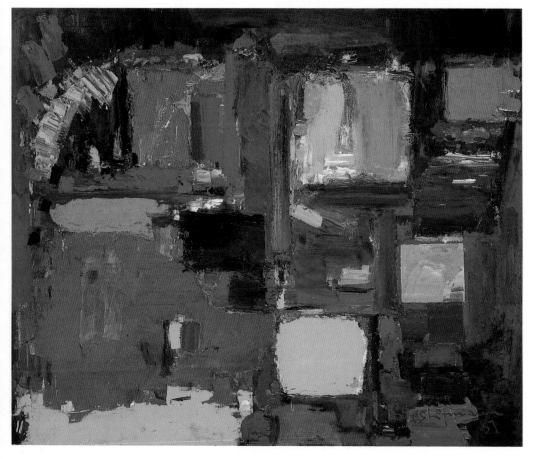

*"Art is not only the eye; it is not the result of intellectual considerations. Art is strictly bound to inherent laws dictated by the medium in which it comes to expression. In other words, painting is painting, sculpture is sculpture, architecture is architecture."* HANS HOFMANN

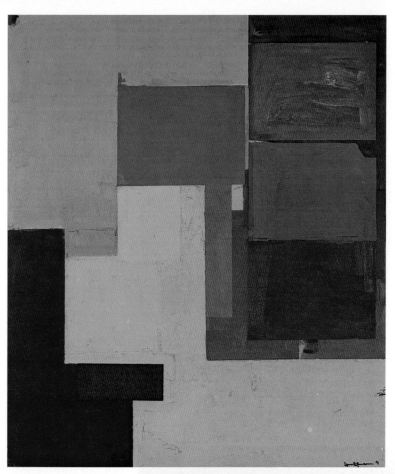

one direct link between European and American expressionism, in the person and œuvre of Hans Hofmann, a native of Bavaria (ill. left and p. 283). Hofmann's reputation had already been established by 1915, when he opened a school of painting in Munich. There he taught a number of American artists, including the later famous sculptress, Louise Nevelson. In 1930 Hofmann was a guest instructor at the University of California at Berkeley, whose museum now holds an extensive collection of his works. The following year he settled permanently in the United States. As an original artist and a teacher Hofmann contributed decisively to the emergence and spread of a self-confident American art, and pointed the way for many students who subsequently became prominent. His School of Fine Art in New York has justifiably been termed the "cradle of contemporay American art."

The sources of Hofmann's mature style, after Impressionist beginnings, lay in the aesthetic revolution that swept Paris from 1905 to the First World War. Picasso and Braque, Matisse and Delaunay, were his great models. Later, after Hofmann's return to Germany, strong impulses came from Expressionism, especially from the Blauer Reiter group. It was in coming to terms with Matisse and above all with Kandinsky that Hofmann found his own, personal style, which culminated in what he termed the "push and pull" of colors, the ability of juxtaposed colored shapes to evoke space, and the currents of energy that emerged from them to virtually overcome the picture boundaries. The daring

**Hans Hofmann**
Veluti in Speculum, 1962
Oil on canvas, 216 x 188 cm
New York, The Metropolitan
Museum of Art, Gift of Mr. and
Mrs. Richard Rodgers

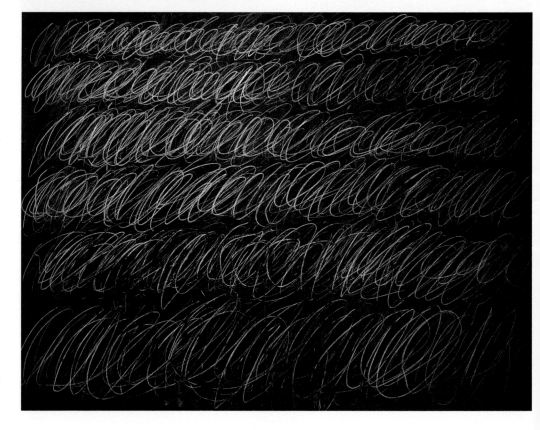

**Cy Twombly**
Untitled, 1968
Oil, crayon and pencil on canvas,
172.2 x 228.5 cm
Formerly Saatchi Collection,
London

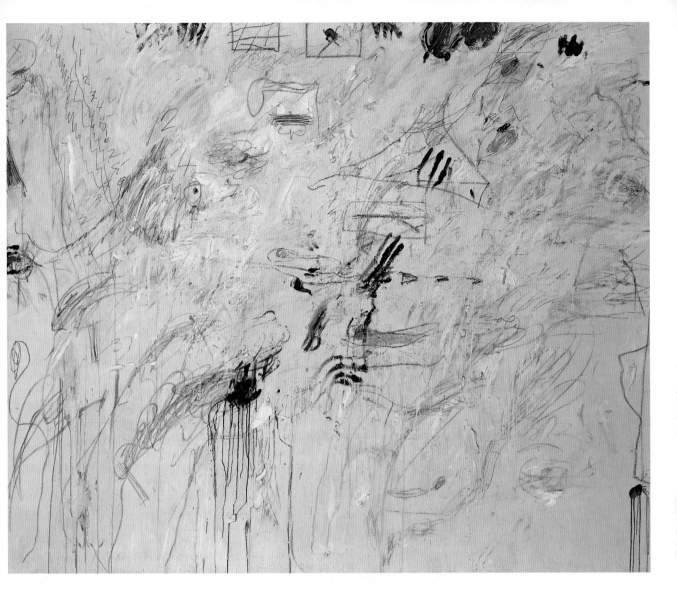

and self-confidence with which Hofmann overcame European painting without ever entirely losing touch with it, was a source of enormous encouragement to American artists. His compositions are equally marked by what one commentator terms "the tension between boundless space and sign-like shape," and by the generative capacity of color to determine form.

The art of Cy Twombly, who lives in Italy, is extremely complex, and full of allusions and associations and references that are not easily deciphered (ill. above). Twombly, too, comes from Action Painting, but over the years he has developed both formally and substantially away from its robust vitalism and drama. The nervousness of his idiom, inspired by grafitti, recalls the linear networks of Alberto Giacometti's paintings, while the compositional device of strewing or dispersing signs and marks across the surface bears a debt to Jackson Pollock's all-over approach. Using references from mythology and literature, from Marquis de Sade to John Keats and the writings of Goethe in Italy, the European-

influenced "primitive of a new path" exemplifies the dominant themes of Eros and death, sexuality and violence, in an allusive graphic-painterly code which tends to conceal more than it reveals. Twombly's sensitive, calligraphic touch ties the loose weave of the compositions into a unity. Again, as occasionally during the early period of L'art informel, a significant artist understands painting as a kind of writing or script, if a largely hermetic one.

## Color as Visual Theme

Helen Frankenthaler comes from the sphere of influence of Hans Hoffman, and like the great abstract expressionist mentor, she holds an intermediate position, if of a different kind (p. 286 below). Beginning with the early Kandinsky, but also with Pollock, Gorky, and of course Hoffman, Frankenthaler developed a very personal version of Action Painting which was less dramatic than that of her predecessors. A lyrical tendency, as well as hints of things seen, especially landscapes, have suf-

**Cy Twombly**
Untitled (Roma), 1962
Oil, crayon and pencil on canvas,
199 x 240.5 cm
Private collection

*"Every line is thus the actual experience with its unique story. It does not illustrate; it is the perception of its own realization."*
CY TWOMBLY

fused her work from the start. Frankenthaler also invented a technique that proved seminal for American painting beyond Abstract Expressionism – the soak stain technique, in which thin paint is used on unprimed canvas. This permitted the artist to unify

color and support, content and form, in strict two-dimensionality.

Morris Louis (ill. above and p. 287) and Kenneth Noland adopted Frankenthaler's technique and developed it into styles variously known as Color Field Painting and Post-Painterly Abstraction. In these, the oil medium takes on a surprising diaphanousness, flowing almost as freely as watercolor and appearing light-suffused and immaterial even on the large format. The two painters may additionally have been inspired by the especially beautiful light over the city of Washington, D.C., where they both worked for a considerable period. Open space, suggested by the unprimed canvas surface, plays just as important a role in their approach as the painted configuration. With his *Veil* paintings, in which thin acrylic paint seems almost to blossom across the surface, Louis showed himself a master of the new technique, occasionally employing the principle of controlled chance to determine the paint flow.

During the final years of his life, in allusion to American Indian motifs, Louis created arrow-shaped paint configurations running parallel from top to bottom of the canvas, and above all the "Unfurlings," enormous horizontal formats in which the paint bands flow diagonally across the unprimed canvas, leaving either the center or the edges free. The unique technique and the huge formats of these works give rise to the impression that the images hover between materiality and immateriality, between two-dimensional extension and three-dimensional depth.

The painting of Albers-student Kenneth Noland is more rigorous and geometrical than Louis' (p. 287 above). Initially Noland concentrated on symmetrical configurations – circles, crosses, V- and X-shapes. The treatment of the basic elements, involving subtle irregu-

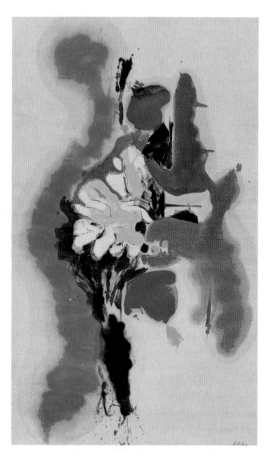

**Morris Louis**
No. 180, 1961
Acrylic on canvas, 226 x 186 cm
Pasadena (CA), Pasadena Art
Museum

(p. 286). Jensen's strong-hued, finely articulated color fields combine painting with intellectual games and numerological principles. Among the younger painters who have been influenced by the Color Field approach, Al Held stands out particularly (p. 290). After initial *Signal Paintings* inspired by American Indian ornament and employing bright, almost garish color, Held turned to large-format canvases in which architectural or constructivist shapes were rendered in stringent black and white.

### Meditation not Action

The sensibility of which American painting is capable comes out most clearly in the work of Mark Tobey (p. 288). In many respects Tobey's painting is the diametrical opposite to the expressive frenzy so typical of the Action Painters. The experience of the First World War ingrained in him a deep abhorrence of the destructive cruelty of which Western man is capable. Tobey turned to the wisdom of Asia, and travelled extensively in the Near and Far East. He spent a long period in a Zen Buddhist monastery, but resisted the temptation to identify completely with the doctrines taught there. The experience of Chinese and Japanese art, gained in collaboration with a Chinese artist-friend, revealed to Tobey the expressive potentials of line, as an autonomous force independent of, and indeed opposed to, the element of

larities and barely perceptible gradations of hue, created the impression of rotating, vertical or horizontal motion. Later works tended to strictly parallel, linear bands extending across cinemascope-like formats, apparently

**Kenneth Noland**
Via Blues, 1967
Oil on canvas, 229 x 671 cm
Pasadena (CA), private collection

without beginning or end, and creating an inextricable bond between painted motif and support. Noland's subject was, and remains, color itself – hence the absolute neutrality, or non-referentiality, of the parallel bands. The important thing in painting, says Noland, is to find a means to express color without destroying it, by retaining its value independently of the pictorial systems, be they supra-real, Cubist, or structualist.

The achievements of the Color Field painters in going beyond Abstract Expressionism have brought the work of many other, previously little-known artists to light. Prime among the older of these is Alfred Jensen, who was born in Guatemala and grew up in Denmark

volume. Practice in ink drawing, calligraphy, and Sumi painting confirmed and ramified Tobey's approach.

As early as the middle of the 1930s he produced his first *White Writings*, which were likely Tobey's most significant and personal contribution to contemporary art. Their densely interwoven lineatures, their infinitely varied graphic textures and patterns, combine stylistic characteristics of East Asian calligraphy with Western content and form. Tobey's works are gestural abstractions in the sense of possessing a form-dissolving tendency and relying on the aleatory principle, that is, on a play with controlled chance. Finely articulated, rhythmical compositions built up of – mathematically speaking – infini-

**Mark Tobey**
Harvest, 1958
Oil on canvas, 91.4 x 61.6 cm
New York, private collection

**Mark Tobey**
Radiant City, 1944
Oil on canvas, 49.2 x 36.1 cm
New York, private collection

tesimal strokes replaced compositional arrangements intended to be taken in at a glance. These images challenge us to stop and consider – to contemplate, in the full sense of the word. As the artist himself said, they are "more Oriental than American."

The reference to reality comes out more clearly in Tobey's city pictures. The flickering of neon signs, the termite-like swarming of traffic and pedestrians, the hum and sparkle of life in the urban jungle are all evoked in the linear webs of these compositions. Tobey did not like big cities; he disdained the arrogance of their inhabitants and feared that one day the United States would be "gradually swallowed up by New York" like France was by Paris. Accordingly the artist retired in later years to Basel, Switzerland, where he died.

"We may well realize," wrote Konrad Fiedler at the end of the last century, "that the eye is there not only to furnish us with images of things present outside ourselves, but that with the act of perception, something emerges within ourselves which is capable of independent development by ourselves." Applied to art, this implies that a painted image which exists in the finite world can communicate something infinite, when we as viewers mentally and perceptually enter into the space of the image. This insight informed the mature work of Rothko and Newman, the major artists among the American Color Field painters. Both of them came of an Eastern Jewish background, and both went through a Surrealist and an Abstract Expressionist phase before arriving at a meditative form of image which corresponded to the profundity of their thinking and feeling.

**Alfred Jensen**
Sphinx of the South, 1960
Oil on canvas, 183 x 117 cm
Napa (CA), Hess Collection

To counter a sense of dissatisfaction with the world by advancing an optimistic utopia aimed at improving the world, as Mondrian did with his notion of "universal harmony," seemed to Newman not very productive. In his eyes, the art of his European father-figure, flat, geometric, right-angled, was ultimately a secular, non-transcendental "untragic" art. Consequently it remained impermeable to the "sublime," which Newman attempted to evoke in his canvases. For him, Mondrian's painting was a derivative rather than a direct, primary art, because it still contained too much "natural reference," even the right angle being a "natural form." The transcendental experience for which Mondrian strove, according to Newman, was no longer possible of realization in a Europe burdened by the weariness of old nations.

This explains Newman's intensive involvement with the "primitive" art of the American Indians, and also his emphasis on content over and above form. By attempting to achieve a sort of second naivety, Newman hoped to regain ritual magic and dignity for art. As for many of his colleagues, Robert Goldwater's book *Primitivism in Modern Art* (1938) was of similar significance for him as Wilhelm Worringer's *Abstraction and Empathy* was for German artists prior to the First World War.

Abstraction, for Newman, had nothing to do with geometry (pp. 289, 290). His categorical demands on art were that, first, its language had to be abstract; secondly, its dynamic had to be ritual will; and thirdly, its goal must be vision and enlightenment. In place of beauty as a reference to the known and visible, Newman, influenced by the philosophy of Baruch de Spinoza and Edmund Burke, truth and the sublime. In place of mediated effect, immediate experience became the goal of his painting. The picture would thus became a conveyor of a perceptually experienced, materially graspable idea, the result of a pictorial thinking that was both radi-cal and deeply emotional. This thinking manifested itself primarily through color, in the color *field* which would become a color *space* when, as the artist stipulated, the viewer approached closely enough to the picture and, forgetting traditional, habitual perception, entered into the luminous color plane produced by applying layer upon layer of thin paint. The viewer's willingness to enter the picture, believed Newman, must be complete and uncompromising. He should have no

**Barnett Newman**
Vir Heroicus Sublimis, 1950/51
Oil on canvas, 242.2 x 513.6 cm
New York, The Museum of
Modern Art, Gift of Mr. and Mrs.
Ben Heller

*"What is the explanation of the seemingly insane drive of man to be painter and poet if it is not an act of defiance against man's fall and an assertion that he return to the Adam of the Garden of Eden? For the artists are the first men."*
BARNETT NEWMAN

**Barnett Newman**
Who's Afraid of Red, Yellow and
Blue I, 1966
Oil on canvas, 190 x 122 cm
New York, private collection

possibility to orientate himself within actual space, and, in the case of the large formats, no chance to see the whole image at once, for the sublime required no compositional order. Still, Newman's compositions do have an ordering factor. Instead of Mondrian's right angle we find the "zip," a linear, sometimes vaguely contoured vertical, like a section of an endless ribbon.

### Working with the Entire Space

Only pure idea had meaning, declared Newman. Yet this Platonic notion was translated into art with the aid of the materiality of painting, if admittedly, unlike the much younger Frank Stella, Newman did manage to deprive the painting of its concrete, objective character. Communicating signs and symbols were entirely excluded. The reality of secular and transcendental experience merged into a third quality – the painted image. What Newman strove for was to make the experience of the painter coincide with the experience of the viewer. Reflection outside the painting would be

**Barnett Newman**
Chartres, 1969
Oil on canvas, 305 x 290 cm
New York, private collection

**Al Held**
Untitled, 1960
Oil on canvas, 152.3 x 106.7 cm
Private collection

replaced by direct participation within the painting's own space. And the painting would contain no references to anything that had gone before. It would be its own, self-contained message. As Newman put it, instead of working with the remainders of space, he would work with the entire space. And concerning the sublime, he believed that we create it outside of ourselves, outside our feelings.

Mark Rothko pursued similar goals (pp. 291, 292). Unlike Beckmann, who attempted to "make the invisi-

ble visible through reality," Rothko attempted to make space visible through color, and without reference to external reality. Like Newman, he believed that the "tragic experience" was the only source of art. Yet in contrast to Newman, Rothko did not emphasize the flat plane to convey the space-evoking effects of color. He employed rectangular bands or blocks, blurred at the edges, and seemingly floating in an indeterminate space. Rothko's sense of space had its origin in actual experience, that of the expanses of the open countryside in America, more particularly in Oregon, where the artist was confronted with a seemingly endless space which gave him the sense that his own ego had vanished. From a high vantage point Rothko looked out over an empty landscape covered with white fog. In the milky veil that spread out through space, in this void of earth and mist, there suddenly appeared a tiny dot – a car. Rothko was overcome by a feeling of his own meaninglessness. He never forgot this experience and this feeling. And accordingly, his works represent variations on the theme of infinity. His paintings can be mentally continued beyond the edges of the canvas; what the endless vertical was for Newman, color virtually flowing over and beyond the canvas edge was for Rothko. Like Newman's, his "abstract icons" with their veiled appearance that recedes from the inquisitive eye, that conceals more than it reveals, are counter-images to reality, the result of "transcendental experiences." In their serene, silent way they draw the viewer into spaces that appear suffused with light from some hidden source. This light refers to the artist's "transcendental experiences". The colors are an emanation of light, rising up, as Cézanne said, "from the roots of the world."

Believing in the metaphysical properties of color as he did, Rothko, though he admired Matisse, grew angry when anyone called him a "brilliant colorist." Like the paintings of many Jewish artists, Rothko's may well contain a covert image of the invisible God of whom the religion forbade images to be made, not even if one were

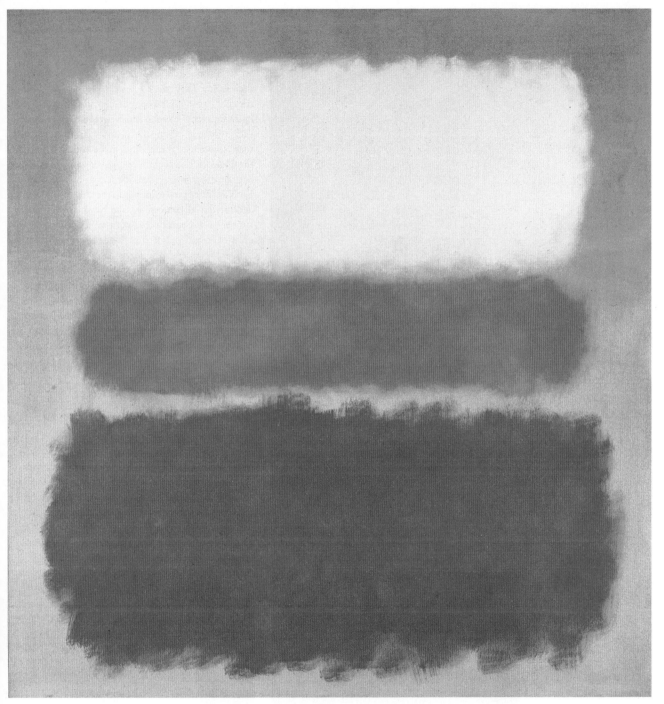

**Mark Rothko**
White Cloud over Purple, 1957
Oil on canvas, 143 x 158 cm
Private collection

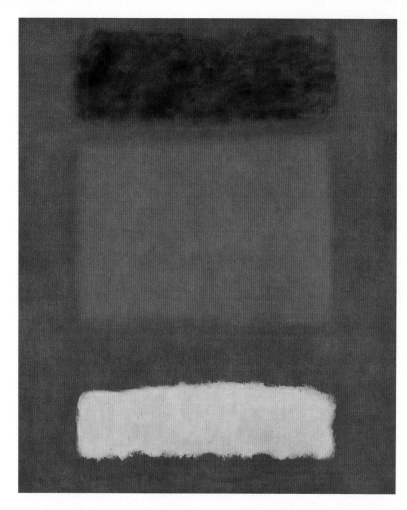

**Mark Rothko**
Red, White and Brown, 1957
Oil on canvas, 252.5 x 207.5 cm
Basel, Öffentliche Kunstsamm-
lung Basel, Kunstmuseum

**Mark Rothko**
Untitled
(Seagram Mural), 1959
Oil and acrylic on canvas,
183 x 153 cm
Washington, National Gallery of
Art, Gift of the Mark Rothko
Foundation

**Theodoros Stamos**
Infinity Field Cretan Riztika
Series, 1983
Acrylic on cotton wool,
167.6 x 152.4 cm
Napa (CA), Hess Collection

overcome by the "fear of nothingness." It would seem to be just this fear which Rothko's hovering forms conceal like the curtains in a synagogue – for void and infinity go hand in hand.

Beuys once said, "Humans must learn to transcend their reality. They have to create a spiritual vehicle with which they can reach a completely different standpoint in the universe." Rothko and Newman both created just such a "vehicle." Using the means of painting on canvas they transcended the medium just as much as they did the dogmatic tenets of the religion of their fathers. Perhaps the most impressive evidence of this is seen in Rothko's nocturnal paintings in the chapel in Houston, dedicated to all confessions, and Newman's sculpture *Broken Obelisk* outside (p. 497), a wonderfully moving unity of art and architecture flooded with the brilliant light of the American Southwest.

More opaque by comparison to Rothko's transparencies are the colors in the paintings of his friend, Theodoros Stamos (ill. below). Stamos's art is less metaphysically oriented, and unlike the dissolved contours and gradual transitions in Rothko's paintings, Stamos employs forms that despite their irregularity are more decisively articulated.

## The Black Monk

Ad Reinhardt (p. 293), author of the *Black Paintings*, which he intended to be the last paintings anyone could make, was an outspoken opponent of all mystification in art. This brought him into conflict with Newman, who was just as acute an analyst and sharp-tongued debater as Reinhardt. Reinhardt's painting is conceivable only as the product of a late culture. Yet despite its high degree of objectification and elimination of all personal touch, despite the artist's rigorous rationality and cool control, his puristic works lead back in an inim-

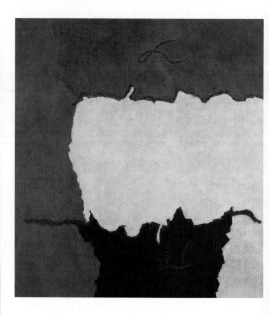

**Ad Reinhardt**
Abstract Painting, Blue, 1952
Oil on canvas, 190.5 x 71.1 cm
Pittsburgh (PA), The Carnegie
Museum of Art

**Ad Reinhardt**
Abstract Painting, 1958
Oil on canvas, 274.5 x 101.6 cm
Fukuoka (Japan), Fukuoka
Museum of Modern Art

itable, irresistably logical, and highly individual way to something extremely elementary – to black, a color or non-color whose capacity of evoking depth is concealed beneath the flat, impenetrable surface.

The late paintings of the "black monk," as someone dubbed the artist, whose combativeness also came out in acerbic caricatures, approach the zero point, the borderline to the no-longer-visible. In this regard Reinhardt's works can be seen in the context of other contemporary developments both in America and Europe, developments that led to the founding of the "Zero" group in Germany, of "Nul" in the Netherlands, and of "gruppo t" in Italy; to the *Homages to the Square* by Josef Albers (whom Reinhardt admired); to Yves Klein's monochrome blue, red or gold canvases and "invisible paintings"; and finally, to Rothko's and Newman's color field canvases. Links can also be traced back into the past, to the classical rigor of Cubism (which for Reinhardt

**Adolph Gottlieb**
Blast # 1, 1957
Oil on canvas, 228 x 114 cm
New York, The Museum of
Modern Art

**William Baziotes**
The Web, 1946
Oil on canvas, 76.2 x 71.1 cm
Ithaca (NY), Herbert F. Johnson
Museum of Art, Cornell University

*because* it is negative. In the words of the Protestant philosopher Paul Tillich, "The negative lives from the positive it negates."

Looking at the *Black Paintings,* which much to Reinhardt's pleasure are not reproducible, requires concentration and a specific sensibility. As late as 1971 a well-known art scholar could still maintain that Reinhardt's minimal tone gradations over-taxed the eye's ability to adapt. Opposed to this stands the simple experience that viewers, especially younger viewers, are inexorably drawn to the silent black panels. Reinhardt's rigorous rejection of everything non-classical, of the mystical and sentimental, his absolute purism, were uncompromising. Abstract art, he declared, had its own integrity, not some kind of "integration" with something else. Every combination, mixture, addition, vulgarization, or popularization robbed abstract art of its essence and compromised artistic conscience. Art was free, Reinhardt said, but "not a free-for-all." In his anachronistic opinion, art could not gain the world without doing harm to its own soul.

Thus Reinhardt proceeded systematically, through the rigor of his aesthetic as through his uncompromising rejection of the art business, to block his own path to success. He was not to experience it until shortly before his death, in 1965, when younger artists discovered Reinhardt as one of the few older artists who were important to them. The Conceptual artist Joseph Kosuth (p. 535) took Reinhardt's "art-as-art" ideology beyond the confines of painting with his doctrine of "art as idea as idea." Although Reinhardt himself knew that the younger generation of Minimal and Conceptual artists had started "from the same point" from which he once had, he soberly realized that they had not begun directly with his work and theory.

represented the major aesthetic event of the century), to Piet Mondrian and De Stijl, to Malevich and his Suprematism.

Black – capable of infinite variation even without the cold-warm distinctions produced by adding primary colors – Reinhardt's black is not a phenomenon of the dark-light contrast. Rather, it is a phenomenon of light itself (whereby the opposite, white as a source of darkness, does not hold). Light is an immanent quality in the *Black Paintings.* They have absorbed it. Their light does not impinge from some hidden external source, as in Rothko's works. Reinhardt's black has extinguished all form. The internal cross-shaped or tripartite divisions occasionally detectable in the compositions – more clearly in earlier ones than in later – have no formal, let alone symbolic, meaning. Reinhardt was greatly amused by attempts to read into the cross shape, which long predates Christianity, something in the nature of a nihilistic Christian view. He used the sparing interior forms only as aids to articulating and differentiating the black field. Black includes all colors; it means *everything* precisely

The world as darkness, Reinhardt noted in his lapidary diction; hidden, meaning beyond. It was in 1966 that he made his famous remark that he was doing "the last painting which anyone can make." Nevertheless, Reinhardt at no time ever postulated the end of art. So might his œuvre represent a concrete utopia, the "principle of hope" – or does it stand for its negation? With Reinhardt, many questions remain open.

# Meditation and Motion
## European Reactions to Abstract Expressionism

A reaction to unleashed gestural abstraction, in this case of the Cobra group and Tachism, was as inevitable in Europe, as it had been in the United States. Weary of the existential skepticism of the post-war years, artists drew their conclusions from the altered situation, the new economic and political optimism of the late 1950s and early 1960s. The role of the neglected genius lost its attraction. Instead of trusting posterity for recognition, artists turned to the living, sought success in the here and now. In contrast to American Action Painting and its vital, outgoing expression of liberation from the past, Tachism, for all its gestural frenzy, had taken the European path inwards, a path that led it back through Expressionism all the way to the Romantic period in art.

The flagging spontaneity and drama of orthodox Tachism were now confronted with a primarily lyrical painting, serene and optimistic, sustained entirely by light and color. Young artists began to distrust the emotionally charged gesture; yet neither did they turn to the opposite, Constructivist pole, because an art of well-ordered stasis, they believed, could do justice neither to the flexible, continually changing environment nor to the relaxed attitude to life in the early 1960s. The excited dynamism of yesterday was sublimated to a vibrato of color. A limitation to a single hue, either clearly dominating or used in a range of gradations, set a painterly counterpoint to the garishness of the consumer world. The inundation with visual stimuli, the visual pollution of the contemporary environment, was beginning to make itself felt even back then, and the idea of countering it with "pure," sensitive artistic formulations was a not unimportant motive. But instead of the world-weariness and nausea that informed Tachism, the paintings of the monochrome artists showed a fine sense of the beauty of color and its enlivening, encouraging qualities, whether they defined color, like Otto Piene, as "light and energy" or as "sensibilized matter" like Yves Klein. "The nuances," proclaimed Piene, then head ideologue of the Düsseldorf "Zero" group, with all the pathos of his new-found faith in light, "the nuances stimulate our breathing and heighten the force of our colors."

In place of seething cataracts of paint there came a new order based on reduction as an artistic principle; in place of dramatic coloristic effects there came a limitation to subtle effects of light and dark, light and shade, or to a gradual differentiation of one and the same tone, or even to black and white. The geometrically constructed, hierarchic composition was replaced by an egalitarian structuring of color fields, without a center of interest, arranged by means of regular modules, facets, grids, or screens, whose regularity might be enlivened by condensation or relaxation, rhythmical displacements, color syncopations, points of calm, delay, or acceleration. The center of this movement was a group of three artists in Düsseldorf called "Zero": Otto Piene, Heinz Mack, and Günther Uecker. They were encouraged by the Frenchman Yves Klein, confirmed by the Italian Lucio Fontana, and inspired by the Munich group "Zen" around Rupprecht Geiger (ill. below), Willi Baumeister, Fritz Winter, Rolf Cavael, and Theodor Werner.

The protest against Tachism began in 1957, with exhibitions lasting only a single evening in Piene's and Mack's studios. The first Zero manifesto was published the following year. Although these artists respected the *élan vital* of a Pollock and the existential mysticism of a Wols, they defended themselves zealously against the claim that art must be an expression of the age. If it were, stated Piene, an artist would be no more than a

*"Red is 'the' color. Red is beautiful. Red is life, energy, potency, power, love, warmth, strength. Red gives you a high."*
RUPPRECHT GEIGER

**Rupprecht Geiger**
Red Painting 1961, 1961
Oil on canvas, 190 x 145 cm
Munich, Städtische Galerie
im Lenbachhaus

Back then color was celebrated as an emanation of light. What next step could have been more obvious than to paint monochrome pictures, stage light ballets, and – more philosophically – to understand art as "an articulation of natural forces: light, fire, smoke, wind," as Wieland Schmied said? One night in a Düsseldorf artists' pub, Piene asked the rhetorical question, "Why shouldn't a painting have just one single color? Why not paint a red picture?" Well, over the years Piene painted not only red but yellow, white, and brown pictures, introduced the grid structure into art, worked with smoke and fire, and, in the footsteps of Moholy-Nagy, he made light dance, before shifting to work in three dimensions (ill. left).

Mack very early on attempted to escape from simultaneously flat and illusionistic two-dimensionality and make the picture plane vibrate with life. The result was a series of extremely sensitive and painterly *Vibrations*, done during the pioneer years of the Zero group (p. 297 above). But once he had discovered the charm of reflected light, after having stepped on a thin metal sheet that lay on a carpet and picked up an impression of its texture, Mack was bound to abandon painting, at least for a time. Already in 1963, four years before differences among its members led to Zero's dissolution, Mack painted what he thought would be his last picture, and became a sculptor and creator of light-suffused and illuminated objects. In the meantime Mack has in fact

"reporter." Zero frankly and, at the time, quite anachronistically believed that, "the Platonic ideal, that the beautiful is also true and good, is not forgotten." On the other hand, the "dullness" of L'art informel color was "a sign of the dullness of the person, the dullness of his consciousness." Zero's path thus logically led from subjective gesture to a practically anonymous objectivity, from Existentialism to Structuralism, from post-war pessimism to the more buoyant visions of the Kennedy era. There was no place in Zero's program for the brooding melancholy which Sedlmayr had supposed to be an essential trait of the modern artist. It was only in the later works of Uecker, with their silent earnestness, that the shadow side of life once again came into its own.

### The Medium of Light

For the time being, the three artists agreed among themselves that an art of subjective confession, of suffering under the ills of the world and under one's own frailties and failings, must be supplanted by an art of affirmation, an art that vibrated in sympathy with the rhythms of the universe – and with those of modern civilization. This fundamental attitude corresponded to a turn to life-giving light as a new medium of art.

The "New Idealism" derived from this attitude, Piene's and Mack's romantization of light, was something Uecker, who had joined the group in 1958, could not accept. Yet in the beginning he, too, dreamed of a new, "empty man", a human being without history and therefore without prejudices, capable of liberating himself from the Western trauma of war and holocaust, "prepared to go to another planet". The depressing unimaginativeness of the subsequent real-life astronauts, which was a far cry from the cosmic visions of a Yves Klein, was quite as unpredictable back then as the insane notion of making space a theater for military confrontations.

returned to painting, and that in intense colors; but he still holds fast to his aim of producing concrete sculptural and architectural examples of a better and more sensible design of the human environment, in both the secular and ecclesiastical domain (ill. above). The opti-

mism and belief in the future of the early Zero years continued to inform such all-encompassing projects, as they did works that embraced space like Mack's Sahara project and Piene's famous rainbow over the Olympic Park in Munich.

Uecker was born in Mecklenburg, in north-eastern Germany. Before emigrating to the West he received strong impulses from the Eastern European avantgarde, which was tolerated in communist Germany until 1951. Kasimir Malevich and his Polish student, Vladislav Strzemiński, impressed Uecker especially, while the Expressionists appealed to him mainly for their uncompromising stance and absolute personal dedication to their art.

The emergence of Uecker's mature visual approach (ill. right) came in the mid-1950s, when he rejected content in painting in reaction to the ideological illustrations of Socialist Realism. Reflecting his personal situation, Uecker painted *Dirt Pictures* using his fingers. Subject matter was replaced by the texture of impasto paint, the covert poetry of a mundane material. To intensify the low-relief texture and the vibration of the surface Uecker began to incorporate various everyday objects into the paint. One of these objects was the nail – the principal medium of Uecker's future art was discovered. Initially he used nails no differently than paint, as one working material among others. Then the medium became the message, a means to create sensitive, pictorially structured plays of light and shadow which inexorably draw the viewer's eye to them. By means of the color white, which includes all other colors of the spectrum, the nail was virtually dematerialized, to finally become a fetish, tool, and vehicle of an idea at once. It also became the cross Uecker has to bear, because the process of driving thousands of nails puts enormous demands on his physical and mental energy. Corrections are out of the question. If a mistake is made, the work is ruined.

This high degree of risk and Uecker's acceptance of it lends his work a profound seriousness and the character of a perpetual self-experiment, whether he makes two-dimensional paintings or static and kinetic objects, whether he modulates light by means of sinuous rows of nails, metal rods, or *Plantations*, designs temporary installations related to a specific site, or paints meditative watercolors. The initial, rather naive optimism of the Zero manifesto: "Zero is silence, Zero is the beginning, Zero is round, Zero rotates," soon dissipated, and for Uecker, it never returned. Reality caught up with him. "A post-war generation is becoming a pre-war generation," he wrote in a proclamation against war. This disillusioned insight helps us remember that Uecker's fundamental subject is "not art and life, but life and death." This can only imply that in the incessant transformation of the eternally same – time, which does not flow, but *is* – Uecker's artistic rituals place the human being opposite the picture or object, in an imagined center, not as image but as measure of all things.

## Yves "Le Monochrome"

Though he was no older than his German friends, Yves Klein must be considered the father-figure of the Zero movement (pp. 298–300). In the eyes of the enthusiastic Otto Piene, he was even the "present incarnation of the saint, prophet, messiah." Had "Yves le Monochrome" lived longer, he would almost certainly have been accorded a special status and been venerated as an idol, like the later Joseph Beuys.

**Yves Klein**
ANT 63 (Anthropométrie), 1961
Pigment and synthethic resin on paper on canvas, 153 x 209 cm
Private collection

*"What is blue? Blue is the invisible becoming visible... Blue has no dimensions. It 'is' beyond the dimensions of which other colors partake."*
YVES KLEIN

Klein was a fascinating personality: a not very tall, rather chunky man with dark, melancholy eyes, a visionary and manager, a showman and mystic, an activist and a philosopher. Before he appeared on the scene most people believed that Mondrian's universal geometric harmony and Malevich's *Black Square* marked the extreme borderline of what painting was capable of formulating (Reinhardt's *Black Paintings* were as yet unknown in Europe), but Klein by far transcended this belief. Together with a chemist-friend he tirelessly experimented to find that deep, matte, luminous ultramarine blue that would enable the artist to simultaneously make visible the material and spiritual qualities of color and to make these accessible to the contemplative viewer. Klein's monochrome panels, initially flat, later built up in relief with the aid of sponges, covered with brushed or rolled-on layers of "IKB" (International Klein Blue), and later with gold and more rarely, red, divided the art world into two camps, Klein believers and scoffers. The former considered him a genius, the latter a charlatan. From his exhibition of "sensibilized matter," consisting of blue pigment in a special fixative, one of the many paths of the imaginative artist logically led to the "invisible painting." In 1958, at the Iris Clert gallery in Paris, in whose empty, white rooms there was nothing to see, Klein exhibited the principle of immateriality, of the increment of undefinability that is always present in painting even if it cannot be seen. This was more than an artist's prank. The show represented a formulation in "painting" of the silence of the unutterable which was such a salient trait of the current historical situation.

Eventually Klein painted with fire and light, making images that flared up, guttered out, and sank back into silence. He and his friends Arman and Pascal divided up the world among themselves; Klein signed the sky; in collaboration with the architect Werner Ruhnau he conceived of air-conditioning for great geographic territories of the planet. Klein composed a *Monotone Symphony* using a single note, and sold *The Immaterial* for a specified amount of gold leaf, half of which he threw in the Seine. From 1960 onwards, after his meeting with the Nouveaux Réalistes around critic Pierre Restany, Klein made impressions on paper in metaphysical blue of nude, quite physical female bodies, or created negative images using a spray gun.

It may be going too far to view these *Anthropometries* as a "sanctification of the flesh", as a knowledgeable admirer of Klein has done. There is no overlooking the element of heathen mysticism in the romantic and idealistic thought and actions of the artist, who was influenced by Zen Buddhism and the occult doctrines of the Rosicrucians. Beyond doubt, however, is the significance of this restless spirit, whose influence has continued far beyond his short life to extend even to the Conceptual Art of our own day. Klein's cooperation with the New Realists, with the sculptors Jean Tinguely and César, with object-maker Daniel Spoerri, "accumulator" Arman, packaging artist Christo, and décollage-artist Raymond Hains, was not as surprising as it might appear on first sight. For just as Klein worked with real pigments, all of these artists worked with real things from everyday life, from eyeglass frames through typewriters all the way to the remains of a meal on an artist's table. They, too, were ultimately concerned with reinstating the dignity of the commonplace, with a synthesis of the material and the immaterial, if without the metaphysical sublimation which Klein alone strove for, and which led him to hope that, with the aid of art, "a new and grand world civilization of the beautiful" could be realized.

## Space Brought to Light

If Yves Klein was a father-figure to his same-age Zero friends, the Argentine-born, thirty year older former sculptor Lucio Fontana (pp. 300, 301) was more like a close relative whom they admired from a respectful distance. It is to him the German group owed its finest collaborative work, the kinetic light-in-space installation *Hommage à Fontana*, which was among the sensations at documenta 3 in 1964. Founder in the 1930s of the Italian branch of Abstraction-Création in Paris, Fontana in 1946 authored a *Manifesto blanco* (White Manifesto), in which he developed synaesthetic ideas that only much later would become an artistic reality, in his own work

**Yves Klein**
Blue Sponge Relief (RE 19), 1958
Pigment in synthetic resin on sponges, gravel,
and composition board, 200 x 165 cm
Cologne, Museum Ludwig, Ludwig Donation

**Yves Klein**
Monochrome Blue IKB 48, 1956
Oil on wood, 150 x 125 cm
Stockholm, Moderna Museet

*"To sense the soul, without explanation, without words, and to depict this situation – this, I believe, is what led me to monochrome painting."*
YVES KLEIN

and others', if not to the extent and with the impact Fontana had envisioned. The manifesto demanded that color and space, light, motion, and sound, be brought into correspondence. Taking the first step of letting space penetrate the two-dimensional picture, or of opening it out to the surrounding space, Fontana – who was already fifty at the time – simply punched a hole in the canvas (*Buchi*) or slit it with a knife (*Tagli*). In his eyes, this seemingly rough-and-ready solution of the problem of space was no act of destruction, but rather an act of liberation. The material surface had to be violated in order literally to make room, to create space, for the visualization of an idea.

Evidently, like that of Yves Klein, Fontana's art is a conceptual art, in which the idea is more important than the way in which it is put into practice. This is reflected in the titles of the works: *Concetto Spaziale* (Spatial Concept) for the paintings, *Scultura Spaziale* (Spatial Sculpture) for the sculptures. The object, whether painting or sculpture, has a merely mediating function. For the artist, the color of the canvas and the aesthetic arrangement of incisions or holes in it, and the perforations in the sculpture, serve in the first place as "aesthetic explanations" of his ideas to the public. The consistency of these ideas is well illustrated by Fontana's flat sculptures, which instead of displacing space allow

it to enter the piece through its openings. And as early as 1951 he used fluorescent tubing to create a sign in space which already anticipated things to come – the new art genre of the environment, the interior space designed to function as an image, as well as the employment of new, industrial materials.

## The Dream of the *Gesamtkunstwerk*

Zero was more than a group of German artists and their French and Italian friends and relations. In accordance with their cosmopolitan attitude, the movement soon burgeoned into an international phenomenon, sending out branches as far as Japan. The "Nul" group in the Netherlands, "gruppo t" in Milan, the French "Groupe de la Recherche d'Art Visuel" around kinetic artist Julio Le Parc – none would have existed without Zero, and naturally without Yves Klein. The 1960s were a period, as Jürgen Claus has said, of an "expansion of the arts", a period of border crossings among the classical genres of painting, sculpture, and print-making, of an inclusion of light and motion, word and sound, in works of art which, borrowing a term from science, came to be called interdisciplinary. Material contributions to this development were made by Zero and its predecessors in continuing and expanding upon historical attempts – among them some of the Futurists, Dadaists, Constructivists, and a few of the Bauhaus masters, such as Kandinsky, Schlemmer, Moholy-Nagy. It was no coincidence that Piene, Mack, and Uecker, like Fontana, penetrated into the third dimension, or that Klein, in his ideas and activities, even went a step farther to advance into the domain of the imaginary. Behind all these experiments stood the old artists' dream of the Gesamtkunstwerk, the work of art that would embrace and reconcile mind and matter, include the world and at the same time transcend it.

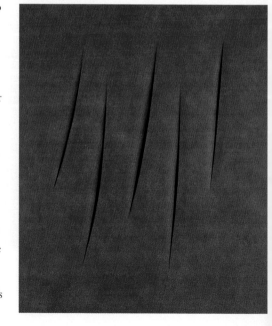

**Lucio Fontana**
Concetto spaziale – Attese, 1965
Watercolor on canvas, five
incisions, 100 x 81 cm
Private collection

In the course of his short, restless life, Italian artist Piero Manzoni (ill. below) came by way of late L'art informel, Tàpies and Dubuffet and the New Realists, to the white, actually colorless works he accordingly titled *Achromes*. These pieces go beyond Klein's cosmological monochrome blue works to the extent that every reference to anything outside them is eliminated, and the white canvases, wads of cotton wool or plastic balls, sheets of glass or fiberglass, rounds of rabbit fur or cubes of straw, signify nothing but themselves. The minimalistic forms occasionally even arise from the innate characteristics of the materials. "Infinity," says Manzoni, "is strictly speaking monochrome, or, better still, destitute of color…"

Similarly to Yves Klein, Manzoni then stepped beyond the confines of the picture frame to put his signature on human bodies, eggshells, or the notorious tin cans containing *Merda d'Artista* (Artist's Shit). He declared the air in a balloon to be *Artist's Breath*, called a balloon, a stand, and an air pump in a wooden box a *Body of Air*, drew a line 7200 meters long and proclaimed – in a less mystical, more neo-Dadaistic way than Beuys – the border-line between life and art nonexistent. In 1961 Manzoni erected the *Pedestal of the World* (p. 509). In its radicality his œuvre belongs only partially and conditionally to the painting medium; basically, it eludes all classification. During his brief career Manzoni approach passed through the way-stations of L'art informel, Nouveau Réalisme, Neo-Dada, Happening, and Fluxus and Zero.

The most significant representative of the European Zero movement in Holland, Jan Schoonhoven (p. 302 below), was a deserter from L'art informel. In keeping with Dutch level-headedness, he tended more to the concrete than to the utopian. And unlike the sensitive Belgian monochrome painter, Jef Verheyen, Schoon-

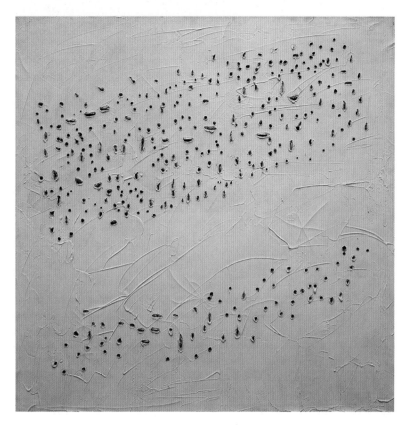

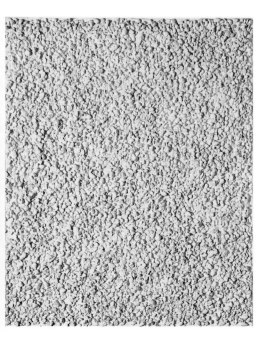

hoven had absolutely no interest in color. The objectification of the work of art was the main aim of this intelligent purist. "Zero," Schoonhoven said, "is above all a new conception of reality, in which the role of the artist is reduced to a minimum. The absence of any preference for certain places and points in the work is important for Zero, and necessary in order to bring the isolated reality into evidence. In practice this means a serial edifice, arranged in ranks, an order that avoids preferences."

Schoonhoven's stringent œuvre developed without breaks or leaps, because he remained true to the principles he had once found correct. The changes in his exact, geometric idiom based on the effects of light and shade and intermediate between painting and sculpture, took place gradually and step by step, reflecting a great intellectual and aesthetic discipline. This procedure explains the richness of detail in Schoonhoven's work, which is thus never boring despite its rigorous logic.

If color does not exist for Schoonhoven, for Gotthard Graubner it is the paramount theme (p. 302 above). In early years he was erroneously classified as a monochrome painter and associated with Zero, with whose members he had friendly contacts. Actually Graubner's palette was more polychrome, more rich in gradations, than that of perhaps any other painter of the

**Lucio Fontana**
Spatial Concept: Marriage in Venice, 1960/61
Oil on canvas, 152 x 154 cm
Cologne, Museum Ludwig, Ludwig Donation

*"The subconscious molds the individual; it completes and transforms him, giving him the guidance which it receives from the world and which he from time to time adopts."*
LUCIO FONTANA

**Piero Manzoni**
Achrome, 1962
Stones and white color on canvas, 75 x 60 cm
Private collection

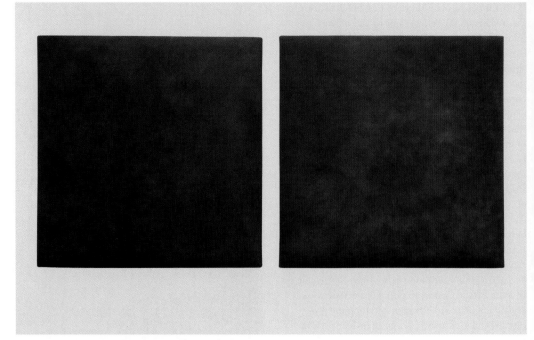

**Gotthard Graubner**
Color-Space Body, Diptych, 1977
Oil on canvas over synthetic wool,
248 x 248 x 15 cm (each)
Cologne, Museum Ludwig

day. What linked him with Zero was an understanding
of color as an emanation of light. In an early phase of his
career he described his paintings with a striking simile,
calling them "trampolines of light."

The two-dimensional *Color Spaces* of the young
Graubner were followed by canvases titled *Color Bodies*
(or *Cushion Paintings*) that were lent a haptic quality by
means of padding. Then the artist combined the two
approaches to produce *Color-Space Bodies*, manifesta-
tions in color of the infinite, which confronts the viewer
of the painting, surrounds him, and into which he men-
tally and meditatively enters. In a different way than
Yves Klein – much more painterly and less conceptually
– Graubner lends physical presence to the metaphysical,
visibility to the invisible. "My paintings expand as the
illumination increases," the artist says, and "when it is
extinguished, so are they. Beginning and end are inter-
changeable. They do not describe a condition; they are
transition." In the process of painting Graubner
attempts to "forget, make quiet, fall silent, exclude the
self."

In the *Color-Space Bodies* the diaphanous flux of
modulated color gradations, rich in nuances and values,
is itself the space-creating element. The paint relies on
the body of the canvas only as a support, not as a plastic
volume in its own right. It was only logical that Graub-
ner also produced works on folded or combed paper in
which the play of light and shadow is a key element.
Under the impression of the light and atmosphere over
Venice, where he represented Germany in the 1982
Bienale, the artist's colors have grown lighter and more
luminous, and the contrasts stronger. The interactions
of color, made visible with great sensibility, continue to
be the salient theme of Graubner's mature work. He is
one of the few German painters who is a major colorist.

**Jan Schoonhoven**
R 72–27, 1972
Cardboard, paper and distemper
on wood, 200 x 130 cm
Düsseldorf, Kunstmuseum
Düsseldorf im Ehrenhof

# The Fascination of the Trivial
## Pop Art and Nouveau Réalisme

No other designation of a stream in 20th-century art has entered common usage to the extent that Pop Art has. Daily experience seldom offers a chance to describe something or someone as "expressionistic" or "cubistic." True, a situation or joke might be called "surrealist," but this is rare, and tends to be an in-group usage. The term "pop," in contrast, has become a byword. It is applied to anything from music to hairstyles, from fashion to appliance design, from film to advertising, all of which owe a great deal to Pop Art.

The whole range of American trivial culture is present in a collage by British artist Richard Hamilton, titled *Just What Is It That Makes Today's Homes so Different, so Appealing?* (ill. right). Done in 1956 for the legendary London exhibition "This is Tomorrow," the image includes a body-builder and a pin-up girl, television set and tape recorder, Ford emblem and canned ham, comic poster and ancestral portrait, vacuum cleaner and movie-ad, a huge all-day sucker brandished like a tennis racket (and bearing the inscription "Pop"), and a photo enlargement of a crowded beach, all beneath a ceiling formed by a section of the globe. Like the exhibition itself, this work emerged at a time when the first string of Pop Art in England, the "Independent Group," initiated by sculptor Eduardo Paolozzi and Hamilton himself, had long since disbanded. Nevertheless Hamilton's collage became the programmatic image of British Pop.

The collage reveals three things: first, a mixture of fascination and irony with respect to the symbols of American affluence; second, the significance of collage as a typical Pop technique, derived from Cubist, Dadaist, and Surrealist practice; and third, the intelligence and sophistication of a composition rife with allusions and ambiguities. These stand in crass contrast to the banality of the theme. The ongoing debate about the origin of the term "Pop Art," which is generally ascribed to the critic Lawrence Alloway, need not concern us here. The fact is that the young Paolozzi, who lived in Paris at the time and was as impressed by Dada as by variants of Surrealism all the way to Dubuffet, already used the term "Pop" in 1947, in one of his early collages.

But even more important than the influence of Dada or Surrealism on Pop was that of Duchamp, who was the first to exhibit ordinary, "ready-made" objects in the gallery and museum context, and who irreverently drew a moustache on the sacred symbol of Western art, the Mona Lisa. Other sources of inspiration were the collages and "Merz" constructions of Schwitters, and the late Léger of the "Proletarian Olympus" with its accompanying, everyday attributes. Pop Art not only made trivial subject-matter worthy of aesthetic treatment and – especially in America – monumentalized it through the device of the blow-up, it also increasingly

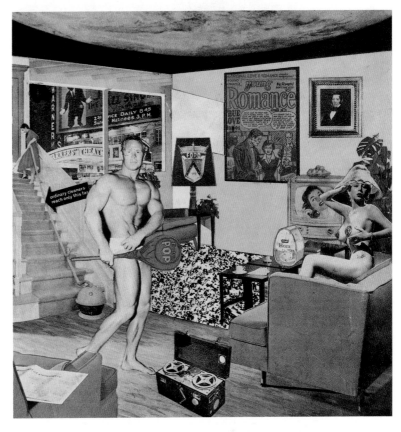

**Richard Hamilton**
"Just What Is It That Makes Today's Homes so Different, so Appealing?", 1956
Collage on paper, 26 x 25 cm
Tübingen, Kunsthalle Tübingen,
Prof. Dr. Georg Zundel Collection

**Richard Hamilton**
Trafalgar Square, 1965–1967
Oil and photograph on wood,
80 x 120 cm
Cologne, Museum Ludwig,
Ludwig Donation

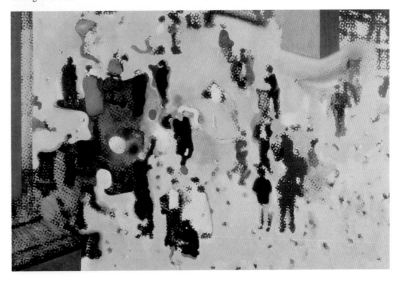

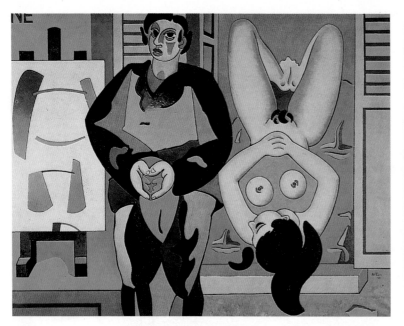

**Jean Hélion**
The Wrong Way, 1947
Oil on canvas, 113.5 x 146 cm
Paris, Musée National d'Art
Moderne, Centre Georges
Pompidou

**Peter Phillips**
Purple Flag, 1960
Oil, collage and wax on canvas,
213 x 184 cm
London, private collection

reflected on the icons of mass culture in an intelligent and critical way.

Thus the term Pop Art, unlike its source, the popular or folk art of vernacular culture, is basically a misnomer. Nor, despite its continuing interest for young artists, does Pop retain much vitality today. No doubt the then-young artists who conceived Pop intended it as a style that would appeal to wider audiences. And, after long years of dominance on the part of abstract art of all brands, Pop was received with a kind of relief when the initial shock had subsided. (The reaction to the Neo-Expressionism of the 1980s would be similar.)

Still, the revolutionary changes in form and theme that Pop introduced into painting and, later, into sculpture – its revival of subject-matter, its intrusion of the commonplace into the hermetic realm of abstract art after 1945 – ultimately did not bring about an integration of fine art into mass society. Pop's addressees, like those of Léger's proletarian realism, did not respond as expected to the style's negation of compositional and thematic hierarchies, the egalitarian, as it were democratic tendency of its original, non-derivative imagery. Despite its enormous indirect effect on mass culture, Pop Art never stood a chance of becoming as truly pop-

**Patrick Caulfield**
Pottery, 1969
Oil on canvas, 213.5 x 152.5 cm
London, Tate Gallery

**Joe Tilson**
OH!, 1963
Oil on canvas, 125.5 x 94 cm
Boston (MA), The 180 Beacon
Collection

ular as pop music or pop fashion design. And when a large German town, Hannover, put Niki de Saint Phalle's fat and happy *Nanas* on its streets (p. 520), a loud popular outcry was the result. In other words, the direct effect of art, as so often in the past, initially remained limited to a circle of connoisseurs and experts – even though this circle had considerably expanded in the meantime.

## Banal Subject-Matter – Sophisticated Means

The elitist appeal of Pop becomes understandable as soon as we realize that despite its populistic thrust, the style ultimately oriented itself to Duchamp's demand that art be intelligent first and foremost. Thus although Pop subject-matter was banal, its aesthetic means were generally not. Pop was a style in keeping with the level of consciousness of a late culture; its apparent simplicity was actually artificial to the highest degree. In this case, the medium was not the message at all, contrary to the then widely accepted theory of Canadian popular philosopher Marshall McLuhan. Pop Art, too, was an art of critical, detached reflection, not only on the part of the artist producing it but on the part of the audience contemplating it. This is clearly evident in the British version of the style, which emerged almost simultaneously on both sides of the Atlantic, and initially without mutual influence.

While the more pragmatic American Pop artists drew much direct inspiration from advertising, where many of them had originally made a living, in England a revolutionary new theory of art preceded its practice by many years. There, also, the term Pop Art did not so much refer to the style itself as to what it depicted: the symbols of mass production and consumption, from Mickey Mouse to the cult of packaging, from Hollywood movies to science fiction novels. The protagonists of British Pop envisioned a contemporary art that would be as vital and diverse as contemporary life itself, including its banalities. They threw open the doors between art and everyday living, between art and kitsch, hoping to create a new unity in diversity, an art accessible to everyone, beyond the barriers of education and class.

At the beginning of developments in Britain stood two, basically opposing influences. On the one hand, artists there were intrigued by the intellectual ideas of Duchamp and the Surrealistic mind-games of Magritte, as mediated by Paolozzi and Hamilton. On the other, they were filled with naive admiration at the "American way of life", its promise of Frigidaires and swimming pools for all. This ambivalence ran through the works of early British Pop, whether by Hamilton or David Hockney, Ronald B. Kitaj or Peter Phillips (p. 304), all of whom oscillated between acceptance and rejection of the things they depicted. Then too, since they were in revolt against the mainstream art of a Henry Moore or a Graham Sutherland, young British artists as it were began with a clean slate. In the United States, in contrast, direct links existed with Duchamp, who was living

*"I don't mind a picture having a story as long as the beginning and the end exist within the four edges of the canvas. A picture is only finished when it is self-sufficient. The title should not be a synopsis."*
ALLEN JONES

**Allen Jones**
Perfect Match, 1966/67
Oil on canvas, three parts, 280 x 93 cm
Cologne, Museum Ludwig,
Ludwig Donation

in New York, and with Action Painting, from which the great predecessors of Pop, Jasper Johns and Robert Rauschenberg, emerged.

The brash unconcern of the Americans was beyond the British, who felt the weight of tradition on their shoulders. Their initial enthusiasm was soon and increasingly supplanted by thoughtful reflection. The œuvre of Hamilton reveals this development very clearly. Even his icon of British Pop mentioned above, with its conglomeration of status symbols of affluence, already shows the artist's ironic detachment from his theme, and from the means employed to depict it. This critical attitude grew more pronounced over the years, culminating in Hamilton's contrast of an ultra-hip but brutal "swingeing" London to the "swinging" London of popular cliché, illustrated by the arrest of Mick Jagger and his gallerist-friend Robert Fraser in 1968.

In Hamilton's imagery, the collage technique is developed to perfection, combining traditional materials with the latest from the field of plastics and synthetics. But unlike the statements of his American counterparts, Hamilton's are usually not straightforward but ambiguous and encoded. Mass society and its idols, from movie star to astronaut, are criticized by means of alienation. The range of emotions in Hamilton's work extends from empathy with the fate of stars who, victims of their own artificial personae, cancel themselves out on press photos like Marilyn Monroe (*My Marilyn*, 1964; Cologne, Museum Ludwig), to sheer derision of sophisticated and hypocritical advertising methods in a pastel-hued image of two models in a *Soft Pink Landscape* (1972; Budapest, Magyar Nemzeti Múzeum). In this invocation of springtime the voyeuristic view, and the seductive quality of the toilet paper in the foreground, play the key role.

In contrast to Hamilton, the sculptor Paolozzi (p. 518), whose *Bunk* collages, films, and neo-Dadaist word-puzzles made him a forerunner of Pop, soon turned to concerns beyond the style. The younger Peter Blake, in *On the Balcony* (ill. left), a depiction of four children surrounded by emblems of high and low culture rendered with dead-pan seriousness, created a key image of British Pop. These kids are representatives of a society being confronted, as it were in a state of innocence, by the phenomenon of mass production of both physical and cultural goods. Blake's painting also bafflingly makes us conscious of the problem of original versus imitation, for instead of being an actual collage, it is a painted one. Blake, moreover, was the first Pop artist, far in advance of Andy Warhol, to depict the idols of young people at the time, idols whose unprecedented popularity was mediated to the extent that it would not have been possible without the techniques of mass visual reproduction represented by the new media of film and television. It is indicative that Blake never saw in person the star he depicted so many times, Elvis Presley, for, as the artist admitted, he was more a fan of the legend than of the person.

**Peter Blake**
On the Balcony, 1955–1957
Oil on canvas, 121.3 x 90.8 cm
London, Tate Gallery

**David Hockney**
Le Parc des Sources, Vichy, 1970
Acrylic on canvas, 214 x 305 cm
Paris, private collection

**Ronald B. Kitaj**
The Ohio Gang, 1964
Oil and oil crayon on canvas,
183.1 x 183.5 cm
New York, The Museum of
Modern Art, Philip C. Johnson
Fund

*"There will always be skylarks; even
a few nightingales. But arts are not
only the human equivalent of the
song of the singing birds."*
RONALD B. KITAJ

*Below:*
**Sidney Nolan**
Glenrowan, 1956/57
Ripolin on hardboard,
91.4 x 122 cm
London, Tate Gallery

## Profundity and Playfulness

An intellectual opposite pole to Blake's "popular art" is
seen in the painting of Ronald B. Kitaj (ill. above), an
admirer of Ezra Pound who was born in Cleveland,
Ohio. Unlike the other artists of British Pop, Kitaj was
familiar when he came to London with American
Action Painting and the intermediary styles of
Rauschenberg and Johns. His imagery, instead of taking
its point of departure from the mass media, has its roots
in history. This is indicated by subjects such as *Rosa
Luxemburg's Assassins* (1960) with its allusive visual quote
of the features of German Field Marshal Helmuth von
Moltke; *Isaak Babel Riding with Budjonny* (1962); or
*Austro-Hungarian Foot Soldier* (1961; Cologne, Museum
Ludwig). Without a knowledge of the historical context,
these images remain largely cryptic.

Kitaj's style, derived from Abstract Expressionism,
has a technical refinement that surpasses that of his
friends. It is only his occasional use of vertical or hori-
zontal series of disconnected images, the combination
of image with typography, or the collage principle trans-

**David Hockney**
Pearblossom Highway,
11–18 April, 1986
(second version)
Photographic collage, 198 x 282 cm
Los Angeles,
The J. Paul Getty Museum

*"Best of all I like handmade pictures; consequently, I paint them myself. They always have a subject and a little bit of form. Balancing the two makes me, I suppose, a traditional painter."*
DAVID HOCKNEY

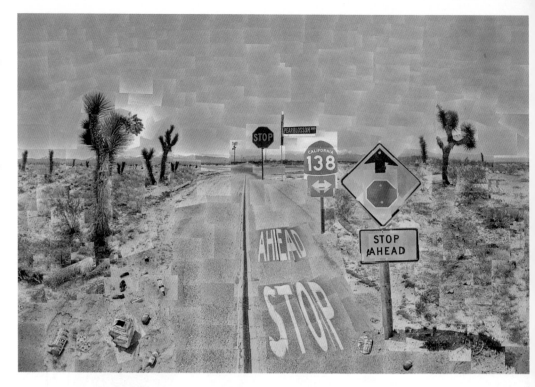

**Alain Jacquet**
Le Déjeuner sur l'herbe, 1964/65
Silk print on canvas, two parts,
175 x 195 cm
Canberra, Australian National
Gallery

**Martial Raysse**
She, 1962
Fluorescent paint on cardboard
and photograph, 182.5 x 132.2 cm
Cologne, Museum Ludwig,
Ludwig Donation

lated into painting, that link Kitaj's work loosely with Pop, making it hard to contradict him when he says he is not really a Pop artist. His basically arcane, difficult paintings with their abundance of literary allusions and covert references give free play to mental associations. They are certainly not naive, let alone easy to understand.

Understanding comes easier with David Hockney, the clever golden boy of the movement (ill. above and p. 306). Stylistically, especially in his early work, Hockney owed a great deal to Kitaj. Yet as his often-quoted statement shows, "I paint what I like, when I like, and where I like," the problem-laden, historical themes of his older friend, despite Hockney's intelligence, were not for him. In this respect, Hockney considers himself a traditionalist. One of his prime concerns is an understandable visual idiom in the context of a new figuration. Still, Hockney's approach is not illusionistic. The

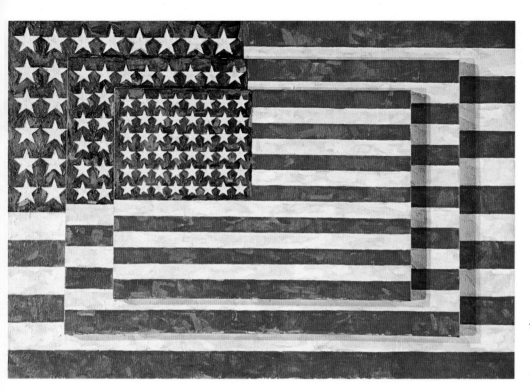

**Jasper Johns**
Three Flags, 1958
Encaustic on canvas,
76.2 x 115.6 x 12.7 cm
New York, Whitney Museum
of American Art

figures are abbreviated, sometimes ironically caricature-like pictorial signs.

Also characteristic of his early work is a combination of painting and script, a contrast of painted passages to the primed or unprimed canvas, and an obvious enjoyment of storytelling. *Flight into Italy – Swiss Landscape* (London, private collection) tells of an automobile trip with friends that was over much too soon for the artist's taste; *A Man Thinking* (London, The Arts Council of Great Britain) shows thoughts materializing like clouds above the figure's head; *We Two Boys Together Clinging* (London, The Arts Council of Great Britain) is fully explained by the title (all works 1961/62).

That Hockney is an excellent draughtsman becomes obvious from a glance at his early drawings and prints. In the mid-1960s his painting style began to grow more realistic, and the comparatively harsh contrasts and juxtapositions of the earlier compositions became rare. Hockney's approach and attitude are equally at home in the homo-erotic and high society coteries of California. His work proclaims that it's great to be alive, if your life is anything like his. Still, his style is suffused by a very British, subdued irony, which for a time prevented the sun-drenched images from slipping into superficiality. This sadly cannot be said of all the paintings of Hockney's most recent period.

Allen Jones (p. 305) developed his style out of a free play of form and color inspired by De Kooning, producing polychrome configurations that bore only oblique references to objective reality. His intention, as Jones once wrote to critic and curator Uwe M. Schneede, was to show that the surface of the picture was primarily a reflection of the artist's ideas. Jones later diverged radically from this conception, which was quite incompatible with Pop principles, to create a series of obsessive painted and sculpted depictions of his high-breasted, long-legged wife as a sex symbol. These cannot be said to have advanced his art.

Schneede has repeatedly pointed to the fact that, the British Pop artists subjected the means of painting to intensive investigation and questioning, thereby employed combinations of disparate images in a way reminiscent of Surrealism, and included a conceptual factor that was inspired by Duchamp. This penetrating, questioning thoughtfulness is also characteristic of the work of the American artist Jasper Johns.

### Johns and Rauschenberg – The Pathfinders

Jasper Johns (pp. 309–312) fits into the category of Pop no better than does Robert Rauschenberg. Yet both paved the way for Pop Art, producing in the process a body of painted and graphic masterworks whose outstanding quality was matched by no other artist of their generation, nor even by older artists such as Roy Lichtenstein. They perhaps found a near-equal in the object-maker Claes Oldenburg, who, like Johns and Rauschenberg, came from Action Painting and had little more in common with Pop than a raising of the trivial to aesthetic status (following cues from Cubist collage and Dadaism), a negation of hierarchic orders in art, and a Surrealism-derived simultaneous presentation of disparate, mutually contradictory imagery. Particularly in Oldenburg's early work, the borderline between painting and sculpture was still permeable, but as his career proceeded, the three-dimensional object came increasingly to the fore (pp. 515, 516).

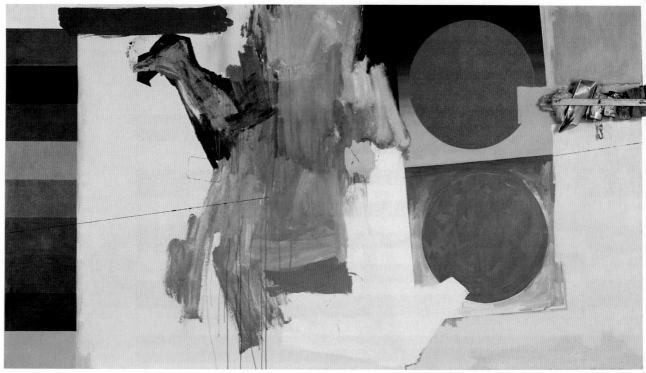

**Jasper Johns**
Edingsville, 1965
Oil on canvas with objects,
173 x 311 cm
Cologne, Museum Ludwig,
Ludwig Donation

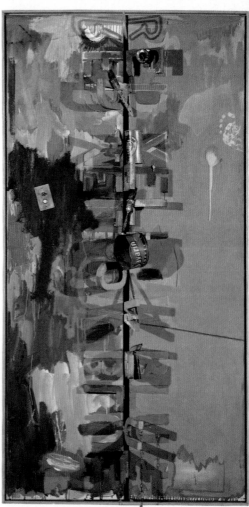

With Johns, too, a neo-Dadaist inclusion of actual, everyday things and utensils (newspapers, rulers, wire, forks, shovels) plays a key role. External reality disturbingly intrudes into the reality of the painted surface. Sublime themes and pleasing visual illusions produced by tricks of perspective are entirely absent from Johns's work. The border-line between the reality of the thing depicted and the reality of the depiction blurs; the picture becomes an object in its own right. The artist's subject-matter is taken exclusively from the context of the conventional, the mundane, with which we are all familiar and to which we therefore pay hardly any attention. The motifs are meaningless patterns, as it were. If they again become capable of rousing our interest, it is because of the alienation Johns subjects them to. This process runs counter to every received scale of values, whether thematic or aesthetic. Johns is concerned only with value-free facts, and commonplace things have the inestimable advantage of being impersonal and neutral. And since they already exist, there is no need to invent them – numerals and letters of the alphabet, targets, maps, wooden slats, banal patterns on building walls or the sides of delivery vans. It is in keeping with the banality of such motifs that the human figure hardly occurs in Johns's imagery at all, unless it be in the form of fragmentary casts or – even rarer – summarily painted contours of human limbs.

All of this sounds very pragmatic, and surely reflects a no-nonsense approach to reality that is perhaps typically American. Yet it is what Johns does with his superficially banal themes that lends his art its unquestionable rank. For instance, the American flag remains the

**Jasper Johns**
Field Painting, 1963/64
Oil on canvas with objects,
183 x 93.3 cm
New York, collection of the artist

Stars and Stripes (even though the number of stars may be wrong) when it is transferred to canvas. It contains no deeper, metaphorical meaning beyond that which it already conveys. Yet at the same time, the flag becomes part of an abstract painting. When provocatively asked, "Is it a flag or a painting?" Johns quite logically declined to reply. He was concerned with the issue of a new vantage point on commonplace things, or, in his own words, "with a thing's not being what it was, with its becoming something other than what it is, with any moment in which one identifies a thing precisely and with the slipping away of that moment...." In the end, Johns addresses the question of the reliability and substance of our subjective, frequently one-sided and fleeting perception of reality, investigates the relationship of percepts and ideas to real phenomena. A radical skepticism that takes nothing for granted is the motive force behind Johns's creativity.

Like a great painter of still life, like Manet when he depicts a bundle of asparagus, Johns confirms in a new and very personal way the age-old truth that great art does not depend on the significance or loftiness of the

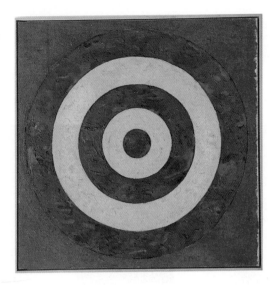

**Jasper Johns**
Target, 1958
Oil and collage on canvas,
91.5 x 91.5 cm
Washington, National Gallery
of Art (on loan from the artist)

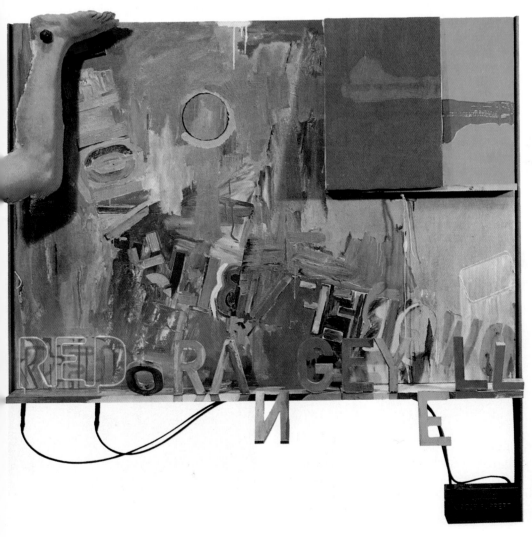

*"I'm interested in things which suggest the world rather than suggest the personality. I'm interested in things which suggest things which are, rather than in judgments. The most conventional thing, the most ordinary thing – it seems to me that those things can be dealt with without having to judge them; they seem to me to exist as clear facts, not involving aesthetic hierarchy."*
JASPER JOHNS

**Jasper Johns**
Passage II, 1966
Oil and objects on canvas,
151.8 x 158.8 cm
New York, private collection

**Jasper Johns**
Map, 1967–1971
Encaustic, pastel and collage on
canvas, 22 parts, 500 x 1000 cm
Cologne, Museum Ludwig,
Ludwig Donation

**Robert Rauschenberg**
Charlene, 1954
Mixed media, four parts,
225 x 321 cm
Amsterdam, Stedelijk Museum

**Allan d'Arcangelo**
Full Moon, 1963
Oil on canvas, 162.6 x 155 cm
Colorado (TX), Kimiko and John
Powers Collection

subject. On the contrary: one might even say that the more humble the subject, the more at liberty we as viewers are to concentrate on the quality of the painting itself. Many of Johns's works were done in the encaustic technique, a mixture of pigment and hot wax, derived from the procedure used in ancient Coptic mummy portraits. This technique permits rapid execution, and facilitates the application of layer upon paint layer which Johns often uses and which lends the picture the character of an object, even when actual objects are not included.

Yet that he is a painter foremost rather than an object-maker, is indicated by Johns's palette and mastery of composition. The colors are of such richness and subtle differentiation of values, and the serial or non-serial structure of his paintings with their multiple focuses of interest is so cogent and the variety of inter-relationships and harmonies so cohesive, that Johns's works can be placed beside the best in French art.

This cannot be said of the pictures of Edward Ruscha (p. 313), despite the fact that, as he once admitted, Johns's *Target* paintings had the effect of an atomic bomb on his training. Ruscha's works, combining painting with typography and lettering, and occasionally employing cinematic elements, are a great deal cooler in mood than Johns's. Always carefully planned, they seemingly purposely avoid revealing any trace of emotion with respect to the subject in hand.

Robert Rauschenberg, five years Johns's senior, shared a house with him for a time in the 1950s and prof-

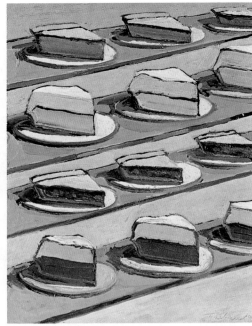

**Mel Ramos**
Lucky Lulu Blonde, 1965
Oil on canvas, 122 x 101.6 cm
Private collection

**Wayne Thiebaud**
Refrigerator Pies, 1962
Oil on canvas, 51 x 41 cm
Pasadena (CA), Pasadena Art
Museum, Gift of Paul Beckmann

ited a great deal from his friend's suggestions. Like Johns's work, Rauschenberg's evinces a blend of Action Painting elements with Neo-Dadaism, especially echoes of Kurt Schwitters's collages of diverse materials and Duchamp's ready-mades. It also reveals Surrealist influences in the use of existing things (*objets trouvés*) and the exploitation of absurd confrontations à la Lautréamont's famous "meeting of an umbrella and a sewing machine on a dissecting table."

Classical examples of Rauschenberg's so unclassical *Combine Paintings*, in which painting, collage, and objects mix, are *Monogram* (p. 510), a mixed-media painting lying on the floor and "monogrammed" by a stuffed goat with a tire around its body, and *Odalisque* (p. 511), which refers to Ingres's picture of that title.

Admittedly the reference is quite indirect, consisting only in a pillow bearing a column on which is perched an illuminated box with reproductions of erotic Old Master paintings. On top of the box struts a stuffed rooster, symbol of overweening masculinity.

Such works, like the shelf with three winged Coca Cola bottles of 1958 or Johns's painted Ballantine beer bronzes (p. 510), were landmarks of American Neo-Dada, and at the same time, anticipated characteristic Pop Art themes to come: the triumph of the trivial over the sublime – as in Duchamp's Mona Lisa with a moustache – the breaking down of the barrier between painting and object, the depiction and employment of mass-produced, mundane materials and images, and the intermingling of original with reproduction. The affin-

*"I think photography is dead as a fine art; its only place is in the commercial world, for technical or information purposes. I don't mean cinema photography, but still photography, that is, limited edition, individual, hand-processed photos. Mine are simply reproductions of photos."*
EDWARD RUSCHA

**Edward Ruscha**
Large Trademark with Eight
Spotlights, 1962
Oil on canvas, 170 x 339 cm
New York, Whitney Museum of
American Art

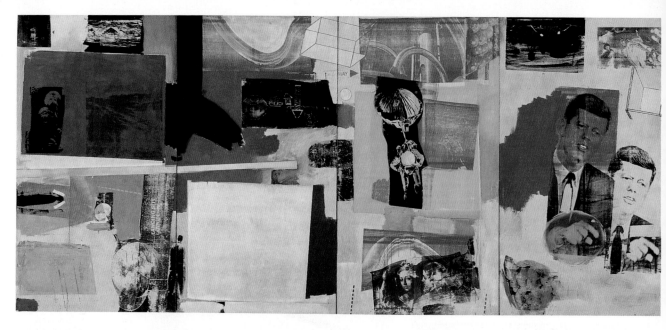

**Robert Rauschenberg**
Axle, 1964
Oil and silkscreen on canvas,
four parts, 274 x 610 cm
Cologne, Museum Ludwig,
Ludwig Donation

*"Painting relates to both art and life.
Neither can be made. (I try to act in
that gap between the two.) A pair of
socks is no less suitable to make a
painting with than wood, nails,
turpentine, oil, and fabric. A canvas
is never empty."*
ROBERT RAUSCHENBERG

**Robert Rauschenberg**
Black Market, 1961
Combine Painting: canvas,
wood, metal, oil paint,
152 x 127 cm
Cologne, Museum Ludwig,
Ludwig Donation

ity to Schwitters is unmistakable. Yet the American
artist goes far beyond his European idol in terms of the
radicality of his additive procedure and waiver of a com-
positional center of interest, in a starkness of means
which does entirely without harmony in the traditional
sense, and finally in the expansive, monumental formats
of his works. By comparison to Duchamp's witty,
nihilistic statements, in turn, Rauschenberg's works
have much more sensuous, perceptual appeal.

### History Paintings for the Contemporary Age

Rauschenberg's origins in Abstract Expressionism
remain visible even in the combine paintings. The
brushwork of the painted passages is more vehement
than Johns', and it remains clearly legible as such, even
in the context of the montages of fragments of reality
which stand by proxy for some general motif. Examples
are *Wall Street* (1961; Cologne, Museum Ludwig), where
the financial district is represented by a Corinthian capi-
tal, a barrier, and a firehose; and *First Landing Jump*
(New York, The Museum of Modern Art), of the same
year, with its evocative clothing parts, electrical equip-
ment, cable, car tire, wooden beam, and leather and
metal elements.

The break between two generations of American
artists had its historic hour in Rauschenberg's biogra-
phy. In 1953 he erased a drawing by Willem De Kooning
which had been given to him by his older friend, and
gave the empty sheet the deadpan title, *Erased De Koon-
ing Drawing*. Of course De Kooning was initially an idol
to Rauschenberg, who owed a great deal to him. Evi-
dence of intensive involvement is seen especially in
Rauschenberg's works of the 1950s, with their unprece-
dented mediation between image and object, reality and
art, original and reproduction, series and one-off work.
So the young artist's attack with the eraser surely repre-
sented an act of liberation, but also a gesture of farewell

– from Abstract Expressionism and its cult of self and
subjectivity, from traditional painting in general, and
naturally also from traditional composition of any
variety.

From then on Rauschenberg's intention was to com-
bine art and life. Painting always involved both, as far as
he was concerned, and then as now, if with a different
accentuation, he attempted to work in the gap between
them. He did not want a painting to look like something
it was not, Rauschenberg once stated, and his words
became famous. He believed that a painting would be
more real when it was made of parts of reality.

While the various phases of Johns's development
were characterized by concentration and increasing
focus above all, Rauschenberg much more frequently
changed his motifs, forms, and materials. It is a far cry
from the harsh, rough works of the early period to the
combine paintings, the elegant silk prints, the concep-
tual assemblages, objects, and cardboards, and the
installations of the late 1960s and early 1970s, which
include space and audio effects as constituitive ele-
ments. In works like *Soundings* of 1968 (Cologne,
Museum Ludwig), the art is altered by the viewer's
behavior. When you speak or clap your hands, the plexi-
glass box reacts by projecting various video sequences
representing chairs.

In the case of combine paintings like *Black Market*
(ill. right), the viewer was invited to exchange the suit-
case which was part of the work for some mundane
utensil of his own, to stamp this with the number of the
object removed, and to record the exchange on one of
four notepads. The idea, however, did not work,
because viewers followed only the first step in the
instructions and neglected to replace the components
removed by others. At any rate, the thrust of the piece,
what Armin Zweite has called a "continual change of
perspectives," was typical of Rauschenberg's approach.

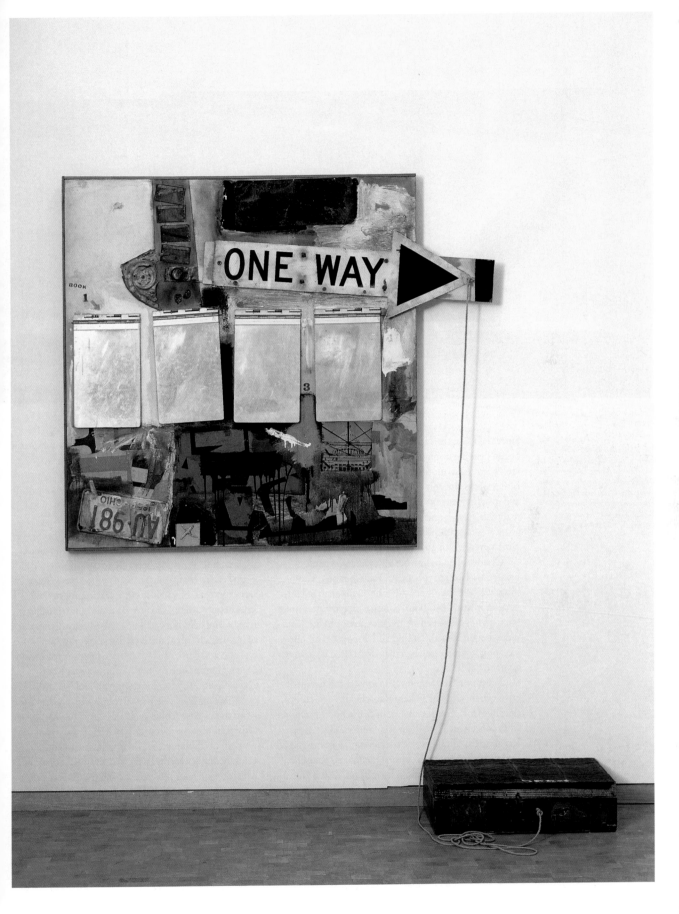

Since the 1980s, similarly to the late Picasso, he has begun deriving inspiration from his own previous oeuvre, returning to motifs, techniques, and materials of earlier works and combining these with new experiences and insights gained from an involvement with space and materials, history and current events. Naturally in an artist of such great productivity as Rauschenberg, a certain unevenness of quality is unavoidable.

His love of quotation has always been complemented by a joy in experiment. Rauschenberg's optimism was admittedly considerably dampened in connection with an ambitious, naively visionary attempt to build a bridge between art and technology in the "EAT" series, begun in 1966. The industrial sponsors of the project soon lost interest when they discovered it was not going to pay.

The immediate result was an artistic and personal crisis which, although it kept Rauschenberg out of the headlines for a considerable period, did not prevent him from conceiving, in 1984, an even more ambitious project aimed at nothing less than facilitating international understanding through cultural exchange: "Rauschenberg Overseas Culture Interchange," or "ROCI" for short. The artist invested all of his money in this project, and when the monster travelling exhibition and associated trips to Chile, Mexico, Cuba, China, Japan, the former Soviet Union, and to Berlin immediately after the Wall came down, threatened to exhaust his funds, Rauschenberg broke with his long-time dealer Leo Castelli and sought aid from the equally legendary and

controversial billionaire Armand Hammer and from the Knoedler Gallery.

ROCI proved that Rauschenberg's maintenance of artistic detachment, his demonstrative waiver of pathos and the grand gesture, had nothing to do with moral indifference, let alone with the cynicism – real or feigned – of the work of his friend, Warhol. Though he was unable to cure the world's ills with his courageous undertaking, Rauschenberg did do the utmost one individual can to bring diverse and divergent people and cultures together. His artistic ethos was manifested not least in his waiver of the use-value of things, recalling that of Tinguely, but without going to the other extreme of making a fetish of the everyday and commonplace. It was also and particularly manifested in the multiplicity of meaning and the openness of an art which critic David Galloway has termed "polyphonal."

There may have been greater inventors in the history of art than Rauschenberg. He was never an avant-garde artist in the long over-rated, post-modern sense of the term. In his thinking, love of experiment and quotation, Rauschenberg was, precisely, a "combiner," someone who retained his independence and freedom of movement in an era dominated by the specialist. He always remained a loner, who was able to combine great sensitivity to the realities of the day with visionary imagination – a utopian without illusions. In his late paintings and objects Rauschenberg drew the sum of a long and rich visual experience. Yet though still vital and not without inventiveness, they reveal a shift of emphasis

towards aesthetic appeal and elegance of execution, while not denying or falsifying the real world in which we live.

## Fragments of Reality

James Rosenquist (ill. above) is still another example of an American artist whose roots were in Abstract Expressionism. Yet for him a quite different and more mundane experience proved crucial – making his living as a painter of movie billboards. Perched high above the New York streets on a rickety scaffold, the expanse of surface to be covered right in front of his nose, Rosenquist mechanically filled it in with garish colors, often working as if in a trance. The realistic depiction, seen in extreme close-up, turned into an abstract pattern. This was the insight Rosenquist exploited in his own work in painting. The resulting visual irritation, seen in the large-format later paintings and environments, was intentional.

Rosenquist presented fragments of reality, outsized, often larger than life, clearly defined. Yet instead of being isolated and mutually independent as with Rauschenberg, each fragment was always interlinked with those surrounding it. One and the same excerpt from reality – a paintbrush, an automobile grille, a hair dryer, a mountain of spaghetti, a movie star, a jet fighter – can simultaneously function as the central motif in one field of the painting and as the transitional context in another. Every passage of Rosenquist's compositions, unlike those of his Pop colleagues, is related to the next,

interlocked, interdependent. The things represented do not stand for themselves alone, but are part of a general context of meaning. Indicatively, Rosenquist's closest friends during the heyday of Pop included abstractionist Ellsworth Kelly, but none of his fellow practitioners of Pop.

Unlike his great forerunner, Rauschenberg, Rosenquist had no intention of bridging the gap between art and life. He drew a clear dividing line between them.

**James Rosenquist**
Horse Blinders (detail), 1968/69
Oil and fluorescent paint
on canvas and aluminum,
23 parts, 275 x 2530 cm
Cologne, Museum Ludwig,
Ludwig Donation

**James Rosenquist**
Look Alive
(Blue Feet, Look Alive), 1961
Oil on canvas, 170.2 x 148.6 cm
Private collection

**Larry Rivers**
Africa I, 1961/62
Oil on canvas, 184.2 x 163.8 cm
Private collection

**Jim Dine**
Five Feet of Colored Tools, 1962
Oil on canvas with objects, 141.2 x 152.9 x 11 cm
New York, The Museum of Modern Art,
The Sidney and Harriet Janis Collection

Instead of setting out to depict existential experiences, Rosenquist attempted to convey a new brand of experience to be had within the artificial domain of advertising and consumerism. When he depicted a cigarette ad with Joan Crawford – again, in a monumentalized excerpt – he produced not a portrait of the famous movie star but a reproduction of her image as manipulated for advertising purposes. Such pictures function on several levels of meaning, showing a woman who, already stylized into a mass idol, is in turn manipulated and degraded into a marketing motif aimed at increasing sales.

What Rosenquist painted during his most prolific years did not reflect the rapprochement between political and artistic intelligence that seemed possible during the brief Kennedy era. Rosenquist's skepticism remained unaffected by wishful thinking of this kind.

Larry Rivers (ill. left) is a lone wolf who eludes the category of Pop. His artistic activities began not in the field of painting but as a jazz saxophonist. Rivers went on to study music at the renowned Julliard School in New York, before, intrigued by the portrait of a cellist by Braque, he spontaneously decided to become an artist. This was in 1945, when Rivers was twenty-two. He also admired Richard Lindner, and repeatedly referred to his inspiring influence, saying that he felt a spiritual relationship to the older painter. Although he also respected Oldenburg, Rauschenberg, and Warhol, Rivers always remained an outsider on the scence and went his own way. As even his earliest paintings of the 1970s reveal, the artist drew sustenance from the imagery of commercial art, out of whose clichéd depictions he developed his own, personal visual ideas. What distinguishes Rivers from the protagonists of Pop Art is a close and continuing link with the wellsprings of Abstract Expressionism as manifested in the energetic gestures of a De Kooning. One might say that Rivers's work eludes all stylistic or art-historical labels.

## Is Pop Art a Brand of Genre Painting?

Jim Dine (ill. left and p. 319 above), who left the United States in 1967 for London, said just a year later that he thought a great part of what went by the name of Pop Art in America was really genre painting – a pretty facile show-business-type thing. Not that he would deny anything he himself or others had done, Dine added, it was just that Blake and Hockney did this sort of genre painting much better. Like most of his colleagues and friends, Dine came from Action Painting. With Allan Kaprow (p. 319 below), Oldenburg, and others he was involved in the expansion of this actionistic, gestural art form into the actual, public space, that improvised, borderline-transcending art and artists' theater that, as the "Happening", not only went down in history but, like "Pop", became a household word. The happening, moreover, provided the spark that set off the still more improvisational Fluxus movement, the occasionally self-flagellating tendency known as Body Art, the black masses of

the Viennese Actionists, and the more disciplined and ritualized "performance." These later developments deserve emphasis when discussing Dine, because the enormous enthusiasm with which he threw himself into the New York art scene would later give way to a profound skepticism.

This doubt with respect to excesses of earlier days led Dine to a creative involvement with the art of the Old World, all the way back to the Egyptians, and away from what Wieland Schmied has termed the "rustical directness of America." But before this came to pass, Dine's irrepressible enjoyment of whatever he was doing – whether painting or making objects or both in one – found expression in a blithely bright palette and especially in his favorite and often-varied motif, the heart. For a time Dine seemed to be the most carefree of Pop artists, and his paintings and objects possessed a degree of concreteness lacking in those of the others. This lay in Dine's respect for craftsmanship, and a lifelong love of simple, basic tools, a love he had inherited from his Polish grandfather. It was to him that Dine ascribed the greatest influence on his work – before, in 1959, he met Kaprow, Oldenburg, Johns, Rauschenberg, and Robert Whitman in New York.

Like that of many American artists, Dine's work frequently reveals an interplay between actual and painted objects. This device had a certain tradition in the United States, going back historically to the *trompe-l'œil* painting of John Frederick Peto and William Harnett in the 19th century (which Johns also admired). For Dine, the canvas was a final point of connection with unreality, while the object – whether shovel, saw, or bathrobe, or, later, the torsos and statues of antiquity, up to the Hellenistic period – generally remained an actual, concrete thing. The tension in Dine's very personal variant of Pop Art long derived from a visualization of this dichotomy. Then a new motif appeared: the landscape. But despite the painterly emphasis of this more conventional imagery, the concrete object still played a role. Hammer, axe, brush, or spatula kept the memory of the artist's grandfather's workshop alive.

Tom Wesselmann (p. 320) perhaps risked more than most Pop artists from the start. He put all his money, if you will, on a single, limited theme: the clichés of advertising, personified by woman as a secularized Eve, equipped with the corresponding attributes: invitingly open mouth, dazzlingly white teeth, swelling breasts, supplemented by ripe oranges and a filter cigarette conveying the dual meaning of phallic symbol and secular *memento mori*. The blatant sexuality of Wesselmann's imagery is ice-cold; his females are merely anonymous, sales-boosting sex objects, whether the inticement be to take up smoking, use paper tissues, or buy a bathtub with shower. This viewpoint also makes itself apparent elsewhere. Other status symbols like the automobile appear in a monumentalized form and spirited into an artificial world in which everything natural seems turned to plastic, even a summer landscape with living people.

**Jim Dine**
Pleasure Palette, 1969
Oil, glass, paper on canvas,
152 x 102 cm
Cologne, Museum Ludwig,
Ludwig Donation

**Allan Kaprow**
Baby, 1957
Assemblage: composition board,
linen strips, paper, metal foils,
synthetic paints, India ink,
282 x 306 x 97 cm
Vienna, Museum moderner Kunst

**Tom Wesselmann**
Bathtub No. 3, 1963
Oil on canvas, plastic, objects
(bathroom door, towel, laundry
basket), 213 x 270 x 45 cm
Cologne, Museum Ludwig,
Ludwig Donation

Wesselmann's subject-matter is less complex than
that of his Pop colleagues. Perhaps it was too limited to
provide a long-term yield. Also, the decorative tendency
in his work was always strong, and the irony not always
sharp enough, to prevent the border-line between
detachment and affirmation from becoming blurred.
The *Outcuts* of later years, their palette saccharine sweet
and their schematized figuration stale, provide sad evi-
dence of the fact that no one can produce Pop Art on an
assembly-line basis for an entire career without detri-
ment to his own better talents.

The case is different with Roy Lichtenstein (pp.
321–323). The oldest of the American Pop artists, he also,
with Warhol, was one of the most influential, his
approach affecting both sub-cultural and mainstream
visual thinking in his own country, in Europe, and even
here and there in the Middle and Far East. A glance at

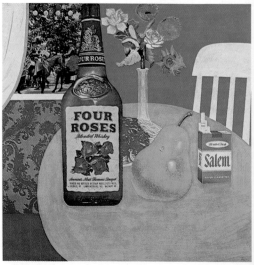

**Tom Wesselmann**
Great American
Still Life No. 2, 1961
Oil on canvas, 120 x 120 cm
Pasadena (CA), Pasadena Art
Museum, Gift of Fred Heim

the billboards of most any city, or into the display windows of its boutiques, supermarkets, drugstores, even banks, will suffice to show what I mean. What advertising once provided to Pop Art in the way of inspiration, it has long since harvested many times over. Basically, this conversion process took the same course it did earlier, when Picasso and Mondrian were trivialized and introduced on the popular level, in the design of home interiors, in advertising, or in printed dress patterns. But the feedback of a style whose principal theme was already the banal and mundane was much more strikingly evident than the subliminal influence of Mondrian or the De Stijl group.

Lichtenstein contributed as much as Warhol to this feedback effect. He monumentalized the comic strip and, with the mixture of fascination and irony so typical of Pop Art, lent comic-book heroes and heroines the same visual dignity that his great idol, Léger, had lent to the world of the anonymous working-man. Yet Lichtenstein also turned the tables on high art, stripping the mythical trappings from the sublime and sacred icons of Western culture, from the Greek temple to Monet's *Rouen Cathedral*, from Picasso and Mondrian to the brushstrokes of Abstract Expressionism, by dis-solving them all into the sterile dot patterns of commercial printing methods.

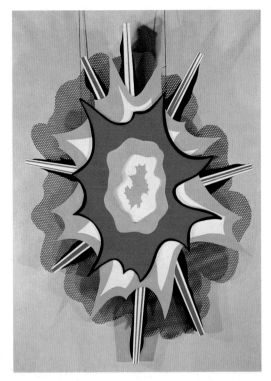

**Roy Lichtenstein**
Explosion No. 1, 1965
Lacquered metal, 251 x 160 cm
Cologne, Museum Ludwig,
Ludwig Donation

## The Covert Classicist

Still, it was no coincidence when the American art historian Diane Waldman mentioned the name of Ingres in connection with Lichtenstein, even before the allusive and no longer so revolutionary work of his mature period had emerged. Lichtenstein is in fact a covert classicist, with a highly developed sense of form. His pictures combine a concise, pointed simplicity with "elegant sophistication and intellectual precision," as Waldman notes. To characterize the American artist's œuvre in a single word, one could do worse than choose the

title of an 18th-century book by Comtesse de Noailles, *Exactitudes*. This term fits Lichtenstein's work from the beginnings to recent years, when his approach began to show a certain expressive relaxation.

It is in keeping with this penchant for precision that, besides Ingres, Dutch artists Mondrian and van Doesburg, leaders of De Stijl, have played as important a role in Lichtenstein's artistic thinking as the Cubists in general, and Picasso and Léger in particular. Naturally his thoughts reach back even further, to Cézanne and his rigorous pictorial structure. And it is surely no coincidence that Egyptian pyramids and Greek temples are

**Roy Lichtenstein**
Whaam!, 1963
Oil and magna on canvas,
two parts, 172.7 x 421.6 cm
London, Tate Gallery

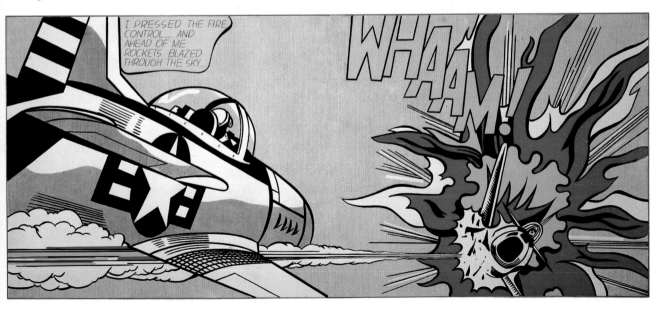

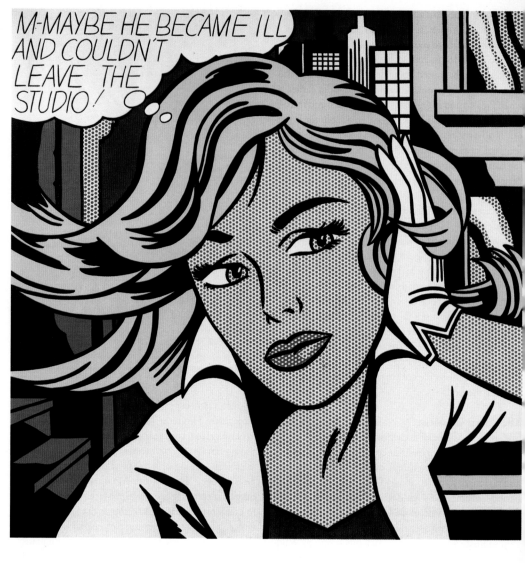

**Roy Lichtenstein**
M-Maybe (A Girl's Picture), 1965
Magna on canvas, 152 x 152 cm
Cologne, Museum Ludwig,
Ludwig Donation

*Page 323 above:*
**Roy Lichtenstein**
Figures in a Landscape, 1985
Oil and magna on canvas,
243.8 x 279.4 cm
Private collection

*Page 323 below:*
**Andy Warhol**
Do it Yourself (Landscape), 1962
Acrylic on canvas, 178 x 137 cm
Cologne, Museum Ludwig,
Ludwig Donation

submitted to the same Ben Day process as barns, hot dogs, or balls of twine. Even when the subject is expressionistic art – by Marc or Heckel, even Picasso – Lichtenstein reduces it to apparently straightforward but actually highly sophisticated configurations full of irony, and rife with a multiplicity of allusions and covert homages.

Since the 1970s at the latest, Lichtenstein's art has been an "art about art", an art for connoisseurs – and for artists. The quiet, distinguished gentleman from Long Island celebrates a timeless, detached classicism.

### An Art of Conformity

Pop Art, decreed veteran Dadaist Hans Richter, was not an art or anti-art of protest like Dada, but a record of artists' acceptance of and conformity with contemporary consumerism. In Richter's view, Pop Art was nothing more than a derivative, neo-Dada style. Yet criticism of existing social and political conditions, let alone the notion of improving them through artistic protest, was far from the minds of the protagonists of Pop. Thus

Richter decried a lack of commitment where none was intended.

Let us list some of the characteristics of genuine Pop Art: the blow-up; an isolation or serial presentation of motifs; a waiver of expressiveness and individual touch in favor of an impersonal style; a limitation of subject-matter to actual commercial commodities and mass media imagery; a congruity of motif and style; a preference, as in advertising, for brand-new objects (as opposed to the worn and used ones employed by Johns and Rauschenberg); a waiver of all ideology, critique, and metaphorical reference; and finally, a favoring of technical reproduction processes. In view of these factors, Richter was correct to speak of Pop as an art of conformity or affirmation. Its characteristics are reflected in the purest and most radical form in the work of the man whose name has become a synonym of Pop Art, even among people who could care less about art in general: Andy Warhol (pp. 323–326).

Warhol went beyond even the "completely mechanical and removed style" of which Lichtenstein spoke, a

style in which complicated manipulations led to a translation of the original motif into an autonomous image. Warhol proceeded differently. His piles of Brillo boxes, for instance, were not manipulated but simply left in their original state, without alteration on the artist's part. The only sign of his personal choice was the arrangement of the pyramid, with the largest box on top. There is an evident similarity here with the activity of the decorator or designer, and hence with advertising, in which Warhol began his career. Here the object – unlike, say, Johns' bronze beer cans – was not alienated by transposition into another material or by painterly treatment.

Johns, who was two years Warhol's senior, once stated that when you made one object out of another, there was no change, just two objects. Now this no longer held. With Warhol, a Brillo box remained a Brillo box, and a pyramid of Campbell soup cans remained just that. Even in his silkscreen prints of a single or a hundred soup cans, their identity remained intact, apart from slight irregularities in printing. But above all, the factor of mass production and interchangeability was made visible, with an added ironic twist when Warhol used the same serial reproduction process to banalize the Mona Lisa under the title *Thirty are Better Than One* as he did to portray Jackie Kennedy or Marilyn Monroe.

Everything, in other words, could be mechanically produced and repeated *ad infinitum*. The idea of gratuitous beauty was reduced by Warhol to the cool statement that "An artist is somebody who produces things that people don't need to have but that he – for some reason – thinks it would be a good idea to give them." The marketing of art was wholeheartedly accepted: "Business art is the step that comes after Art. I started as a commercial artist, and I want to finish as a business artist ... and good business is the best art." In this state of affairs memory and history naturally had no place. "I have no memory," stated Warhol. "Every day is a new day, because I can't remember the day before. Every minute is like the first minute in my life." He tried to remember, but couldn't, which was why he was married to his cassette deck. Like it, Warhol stated, his memory had a button marked "erase."

### Reporter of the Era – Portraitist of Society

Values, feelings, seemed not to exist for Warhol. He registered race riots, suicides, airplane crashes, the atomic bomb, the electric chair with the same cool detachment that he brought to registering soup cans, revolvers, flowers and Brillo boxes. The medium was either newsprint or photography, which for Warhol, who occasionally saw himself in the role of a camera even when he was not using one, was just as important as film. This held true even in cases where a photo transferred to canvas was used as only one of several compositional elements.

There has been much debate about whether Warhol was truly the detached, cold-blooded reporter he made

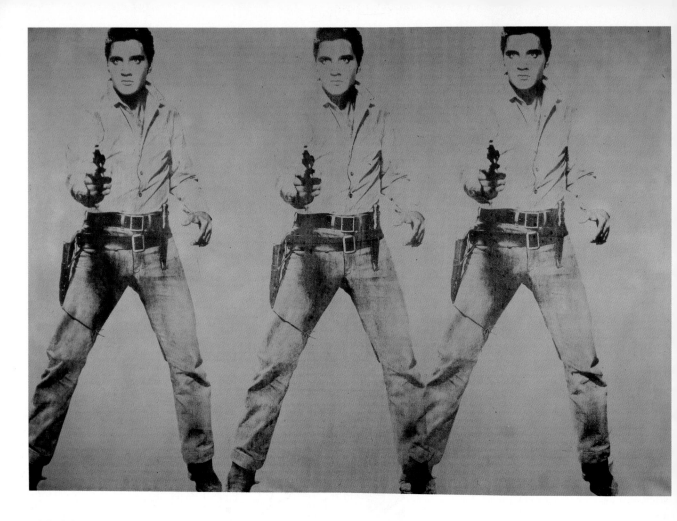

**Andy Warhol**
Triple Elvis, 1962
Silkscreen print on canvas,
208.3 x 299.7 cm
Formerly Saatchi Collection,
London

**Andy Warhol**
Silver Disaster, 1963
Acrylic and silkscreen
on canvas, 203 x 203 cm
Zurich, Galerie Bruno
Bischofberger

*Page 325:*
**Andy Warhol**
Twenty-Five Colored
Marilyns, 1962
Acrylic on canvas, 209 x 170 cm
Fort Worth (TX), Modern Art
Museum of Fort Worth,
The Benjamin J. Tillar

himself out to be, or whether his show of emotionlessness concealed a fundamentally moralistic attitude. The issue becomes irrelevant in view of what the intelligent cynic and eccentric jet-set favorite did during the last years before his unexpected death. Now not only were his motifs banal, but so was their slapdash and careless execution. It was as if Warhol felt tempted to see how much a consumption-oriented, snobbish art scene would accept from its undisputed star without ruining his reputation. This was his parting shot.

Or perhaps not, in view of the last paintings Warhol left behind. These are not only done with virtuoso technique, they reveal a well-considered conception which is perfectly suited to the motif (such as the head of Lenin). This elusive eccentric, who concealed his true self and real intentions behind a – naturally equally well-considered – silence and a series of masks, down to the white wig of his final years, never revealed his secret. So with respect to Warhol's work and personality, we are forced to rely on speculation to a greater degree than in the case of almost any other 20th-century artist. But one thing does stand out clearly: his significance as an innovator who provided fresh impulses to practically every field of visual art, and, especially, his importance as a portraitist of late-capitalist society. The cool, seemingly

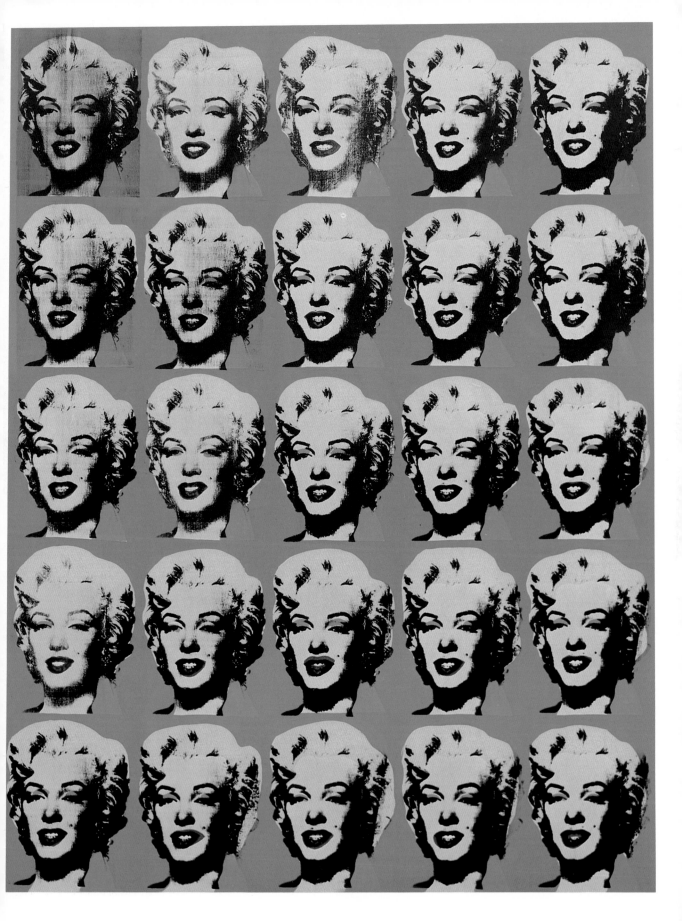

"With silkscreening, you pick a photograph, blow it up, transfer it in glue onto silk, and then roll ink across it so the ink goes through the silk but not through the glue. That way you get the same image, slightly different each time. It was all so simple – quick and chancy. I was thrilled with it." ANDY WARHOL

**Richard Lindner**
The Meeting, 1953
Oil on canvas, 152.4 x 182.9 cm
New York, The Museum
of Modern Art

merciless detachment with which Warhol saw behind its masks, particularly in the high society photo series, lends his oeuvre the character of a dispassioned and disinterested stock-taking of our era. In his imagery, future archaeologists digging into the 20th century will find a rich yield.

## Fascinated by a New Babylon

The opposite tack to the serial methods of Lichtenstein or Warhol is represented by the painstaking technique of Richard Lindner, a German-Jewish painter born in Hamburg in 1901 (ill. above and p. 328). Lindner experienced the escalation of racism and anti-Semitic violence in Munich and Nuremberg, and was able to escape at the last moment by way of Paris to New York.

His style and technique were beholding to the Neue Sachlichkeit of Otto Dix, Christian Schad, or – to a lesser degree – of the early Balthus, while the aggressiveness of a George Grosz remained foreign to Lindner. The themes of his imagery were initially inspired by the writings of Frank Wedekind and Bertolt Brecht. But then the life and times, the desires and dangers of New Babylon cast their spell over Lindner. As obvious as his European origins remained, this circumstance brought him into proximity with Pop Art. In terms of subject-matter, this proximity was reflected in an emphasis on the trivial (targets, slot machines, and toys, which

recalled the artist's Nuremberg period), in a brash palette (Lindner, too, worked in advertising), and in a coolly detached depiction not only of things but of human beings. Lindner's figures, often derived from the milieu of prostitutes and gangsters, seem emotionally isolated from one another. They act like marionettes, yet they also symbolize certain fundamental human traits. To woman, the artist ascribes the dual role of demon and mother, goddess and whore. In any case the females in Lindner's visual world are superior to the males, in keeping with his belief that in fact women are the strong sex, and not the "pitiable" men.

What fundamentally distinguishes Lindner's paintings from those of the Pop artists is an alienation of reality by means of distortion and a collage-like dissection of objects and figures, an interpretative symbolism, and a painstaking, precise, and patient execution which recalls the Old Masters. Lindner's painting, in a word, is American art shaped by Europe.

## Radical Realism in Paris

The use of "components of reality" to produce art, advocated by Rauschenberg, was ramified by a group founded in Paris in 1960 on the initiative of critic Pierre Restany: the Nouveaux Réalistes. The most logical development of this approach over the years took place in the work of Arman (p. 328 below). After starting as a

**Andy Warhol**
Big Torn Campbell's Soup
Can (Black Bean), 1962
Acrylic on canvas, 183 x 137 cm
Düsseldorf, Kunstsammlung
Nordrhein-Westfalen

without a certain painterly effect. But when he enclosed a number of plastic hands in a polyester torso, he not only transcended the border-line of sculpture, but evoked a symbolic message reminiscent of Surrealism (hands penetrating into a body). Perhaps in reaction, Arman then began to limit himself to a simple presentation of accumulations of real, mundane, sometimes discarded objects (eyeglass frames, paint tubes, water pitchers) which evinced no recognizable incursion on the artist's part. The representation and the thing represented were identical; reality itself became image; the borderline between external reality and aesthetic reality was rendered permeable. Existing things became aesthetic objects.

Daniel Spoerri (ill. below), author of a *Topography of Chance*, fixes traces of life at a certain moment, by attaching, say, the remains of a meal or a party to a board, producing *Trap Pictures* that brought time to a standstill. A table top became a memento; one fleeting second between life and death took on the quality of permanence. Spoerri also is a collector of situations, including verbal ones, considering words to be excerpts of biographical processes. Found objects that fall into his hands by chance continually inspire the artist to new, original, and profoundly witty arrangements, which he sometimes expands into ironic and critical environments like his famous *Musées sentimentaux*. In the meantime Spoerri has ceased to make *Museums* or *Traps*, having recently begun to cast his tables in bronze. He had "now reached an age when an artist has to work in

gestural, Tachist painter, the high-strung artist soon began to make three-dimensional objects out of unaltered, everyday things, which he called *Accumulations*. This eventually led to an involvement with prefabricated industrial parts (*Accumulations Renault*). When Arman collected items of daily use and embedded them in clear fiberglass resin to create a portrait of their owner and his habits, the resulting non-formal arrangement was not

bronze if he wants to be taken seriously," Spoerri self-ironically replied to the question whether Dadaist gestures were now to become museum-worthy art. Nor were such perennial themes as death any longer taboo. Yet as Hans Peter Schwerfel remarks, Spoerri relegates even this theme to "the curiosity cabinet of life, to prevent art from becoming deadly boring."

Raymond Hains (ill. above left), Jacques de la Villeglé (ill. above right), and Mimmo Rotella (ill. below), reversed the principle of collage by tearing off the top layers of billboard posters to reveal the "new realities" concealed beneath. These *décollages*, in Hains's case at least, were concerned not so much with art as with a critique of hypocritical advertising methods. The same

WRAPPED REICHSTAG (PROJECT FOR BERLIN) PLATZ DER REPUBLIK, REICHSTAG PLATZ, BRANDENBURGER TOR, UNTER DEN LINDEN

**Christo**
Wrapped Reichstag, Berlin, 1993
Collage: pencil, fabric, twine,
photo by Wolfgang Volz, pastel,
charcoal, crayon, technical data,
tape, 30.5 x 77.5 and 66.7 x 77.5 cm
New York, Cyril Christo Collection
© Christo 1993

not follow the American tendency to value-free depiction but mercilessly pilloried the ills of consumer society, of war and inhumanity. Even though he occasionally returned to pure painting, Vostell's commitment remained strong and obvious.

In this connection mention must be made of two artists who like no other took art out of the museum into the open air, be it a stretch of countryside or an urban site: Christo & Jeanne-Claude (ill. left). Although Christo initially earned his living as a portraitist, he is not primarily a painter but a superb draughtsman and collage-maker. The artist began to alienate commonplace objects of daily use by wrapping them in paper or fabric, which lent them a strangely poetic aura. The ambitiousness of Christo and Jeanne-Claude's ideas already became apparent in 1962, one year after the Berlin Wall was built, when they erected a barricade of brightly colored barrels across the Rue Visconti in Paris. In 1995, six years after the German-German border was opened, Christo and Jeanne-Claude were finally able to realize an idea they had tirelessly pursued for almost a quarter century – their dream of wrapping the Reichstag Building in Berlin (p. 550).

Never before had artists encouraged so many people to think about contemporary art and its meaning, in an entirely relaxed and unpretentious way, than Christo and Jeanne-Claude. This is why they cannot be passed over in this chapter on painting. At first sight it may seem surprising that apart from Christo, Yves Klein, the painter of sheer blueness and the void, should have been one of the leading figures of the group. Yet he, too, in an œuvre that combined the material and the immaterial in an inimitably personal way, in his emphasis on the pure, physical presence of color, and in the impressions of living human figures on paper or canvas, the *Anthropometries* (p. 298), made a crucial contribution to the application of the theory of reality, if for Klein reality always included the transcendental.

method was used for similar reasons for a time by German artist Wolf Vostell (p. 329), who became the European father of the happening. In his work in a Pop vein and his major, socially critical environments, Vostell did

## The Damaged Life
### The Realism of Francis Bacon

The œuvre of Francis Bacon, who was born in 1909 to English parents in Dublin and lived in London until his death in 1992, holds a special place in 20th-century art. Self-taught, Bacon began to paint in the 1930s, like his countryman, Graham Sutherland, under the influence of Surrealism and the distorted figuration of Picasso. Yet since he destroyed most of this early work, it was only after the Second World War that Bacon began to find international recognition. Immune to the various modernist isms and fads, he remained true to figurative painting for over half a century, to be become arguably

the most significant and complex realist of the period. What Kafka once said about Picasso applies perfectly to Bacon's work: "In the distorting mirror of art, reality appears undistorted."

Bacon was an admirer of the pioneers of photography and film, Muybridge and Eisenstein. Muybridge's experimental photo sequences on the movements of humans and animals, and above all the close-up image of a woman screaming in Eisenstein's film, *Battleship Potemkin,* left clear traces in his work. These influences are apparent in the inter-twined male figures of many

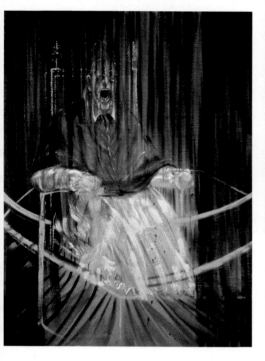

paintings, as they are in the series devoted to Popes, mouths agape and enclosed as if in a cage. These went back to the superb portrait of Pope Innocent X by Velázquez (Rome, Galleria Doria Pamphilj), a picture Bacon never wanted to see in the original because he felt he could never hope to match such an achievement (ill. below). The artist often worked from photographs, but considered that painting possessed the great advantage of a texture that was much more direct and intensive in effect than that of photography.

Bacon obstinately insisted, despite his polemics against abstraction, that his art was devoted to primarily aesthetic aims. Yet the imagery itself and the often unconventional means used to make it – throwing paint or paint-soaked rags, scrubbing brushes, or whisk brooms at the canvas – reveal an underlying theme: the precariousness of the human condition. "I think art is an obsession with life," said Bacon, "and after all, as we are human beings, our greatest obsession is with ourselves. Then possibly with animals, and then with land-

scapes." Seen thus, Bacon's Popes, and even the crucified Christ, become our contemporaries. Since according to Bacon there are no new myths, an artist must continually reinterpret the old ones – far from all traditional religiosity.

Like Picasso, Bacon employed the device of distortion, of both visible aspect and hidden essence, in his figurative and portrait works. But unlike Picasso, he used distortion not for dramatic ends but presented it as the frightening result of his diagnosis of reality. His pictures, beyond their outstanding artistic quality and extraordinarily disciplined form and composition, are compelling, precisely observed documents of an era as reflected in an immensely fertile imagination. Bacon did not moralize; he merely pointed out the state of humanity, provided an "image of the phenomenon."

His conscious waiver of commentary, interpretation, and any deeper meaning we as viewers may read into his work reflected Bacon's laconic objectivity and his rejection of storytelling and what he called "illustrational"

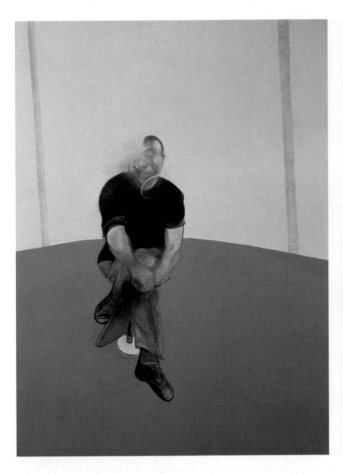
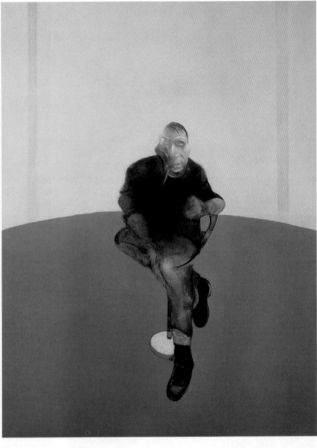

**Francis Bacon**
Study for Self-Portrait (Triptych),
1985/86
Oil on canvas, 198 x 147.5 cm (each)
London, Marlborough
International Fine Art

*"In my case all painting – and the
older I get, the more it becomes so –
is accident. So I foresee it in my
mind, I foresee it, and yet I hardly
ever carry it out as I foresee it. It
transforms itself by the actual paint.
I use very large brushes, and in the
way I work I don't in fact know very
often what the paint will do, and it
does many things which are very
much better than I could make it do.
Is that an accident? Perhaps one
could say it's not an accident,
because it becomes a selective process
which part of this accident one
chooses to preserve. One is attempt-
ing, of course, to keep the vitality of
the accident and yet preserve a con-
tinuity."* FRANCIS BACON

painting. The damaged life, damaged existence, are
evoked by purely painterly means. Terror and horror,
destruction and the destroyed, tortured human and gut-
ted animal are presented not sadistically but dispassion-
ately, for if Bacon's imagery is tormented, so is the reality
it reflects. The anxieties and fears given shape on canvas
are our own, and were those of the artist. The precari-
ousness of life and reality are invoked by means of his-
torical and contemporary figures – including Bacon
himself and many of his friends – whose contours blur
and dissolve, whose faces are distorted or obscured by
shadows. Equally at home in the upper and the under-
world, Bacon always told the truth about what he saw.

From this point of view, Bacon's involvement with
van Gogh as a prime example of the isolated man and
artist becomes clear. Although he later distanced him-
self from his many variations on van Gogh's *Painter on
the Way to Work* (formerly Magdeburg, Kaiser-Friedrich-
Museum; destroyed in World War II), as he did from his
portraits of the Popes, Bacon must have felt van Gogh to
be a kindred spirit. The series, brilliant in color and exe-
cuted with an expressive gesture unusual in Bacon, rep-
resent stations of the cross in an everyday setting. The
third study (p. 331) shows the lonely painter as a ghostly,
shadowy figure in the landscape, pausing under a tree
on his way to work to escape the burning sun. Even in
this static pose, the figure appears restless and unsettled,

the face barely recognizable and the body seemingly on
the verge of dissolution.

In later years Bacon repeatedly painted triptychs and
series of variations on a theme. He himself explained the
reason, saying "...in the series one picture reflects on the
other continuously and sometimes they're better in
series than they are separately because, unfortunately,
I've never yet been able to make the one image that sums
up all the others." It is perhaps a phenomenon typical of
our troubled century in which the whole has disap-
peared from view, that the substance of an artist's life-
work can no longer be distilled into a single work, but
only revealed through a series of works. In this regard,
too, Bacon was a child of our times.

Lucian Freud (p. 335 above right), grandson of Sig-
mund Freud, once portrayed Bacon. His predominant
theme, like Bacon's, is the human being, male and
female – their anatomy and physiognomy, including his
own. Refusing to work with professional models, Freud
depicts only people to whom he has a personal relation-
ship, not least his daughters, because they, he says, need
be ashamed of nothing. Freud's canvases bear an affinity
with Bacon's, not so much in terms of painterly
approach and composition as in terms of existential atti-
tude. In this regard, his Jewish descent and emigré's
experiences surely played a role that should not be
underestimated.

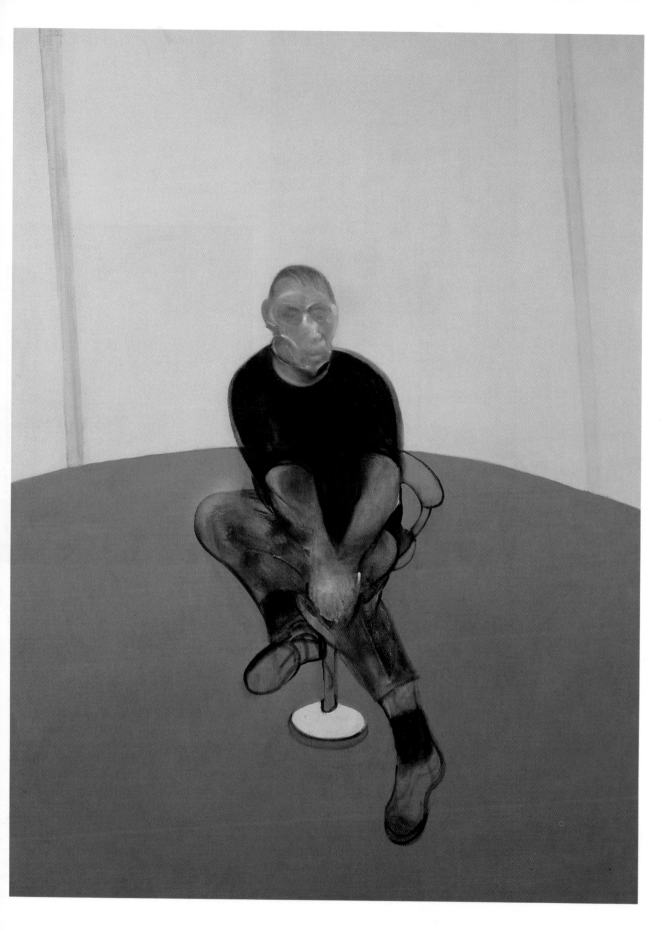

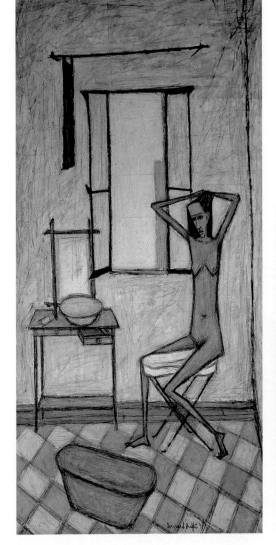

**Bernard Buffet**
Woman with Bathtub, 1947
Oil on canvas, 209 x 109 cm
Private collection

**Francis Gruber**
Female Nude in a Red Cardigan, 1944
Oil on canvas, 115 x 89 cm
Paris, Musée d'Art Moderne
de la Ville de Paris

*Page 335 below:*
**Philip Pearlstein**
Female Nude in an Armchair, 1977/78
Oil on canvas, 182 x 244 cm
New York, Brooklyn Museum,
J. B. Woodward Fund

## Investigation into Reality
### Aspects of Neo-Realism

The discussion about realist tendencies in post-war art is still in its beginnings. The range and obvious differences in approach and quality of the works shown in 1970 at the Whitney Museum's "22 Realists", mentioned above, already suggested that realism and naturalism were different things. Yet instead of attempting to define the fundamental differences in terms of form and content, methods and results, in the approaches of painters and sculptors working in a realistic vein, most critics continued to lump them together, and do so still. But what do the early portraits of American artist Chuck Close, with their naturalistic reference alienated by means of format, camera focus, and painterly alteration, have in common with the European sensibility and covert romanticism of Franz Gertsch's figure paintings,

which capture an entirely new lifestyle? What links the homogeneous sharp focus and frozen immobility of the urban scene as depicted by photo-realist Richard Estes with the cool, manneristic nudes of Philip Pearlstein (p. 335 below)? What relationship can be established between the overpainted photos of the early and middle periods of German artist Gerhard Richter, who was never a photo-realist, and the archetypical, mundane, Joycean situations depicted in a superbly complex technique by Canadian artist Alex Colville? The melancholy nudes of Stanley Spencer have as little to do with photo-realism as Pearlstein's canvases. They are painterly documents of resignation and human alienation (p. 335 above left). The same can be said of the expressive tristesse of Frenchman Bernard Buffet's images of suffering (which,

however, soon declined into mannerism), or of the emaciated nudes of his countryman, Francis Gruber, done as early as the 1940s and 1950s (p. 334 right).

If we were concerned with a simple copying of photographs without formal or interpretative alteration, Neo-Realism would truly be easy to pigeonhole. But its major protagonists make the task difficult, even those for whom the photograph – or photo series – is as important a tool as the sketchbook is for other painters. Accordingly, their creative work already begins with the choice of motif, their selection from photographs they have usually made themselves, sometimes with a manipulated camera. Naturally these artists have profited from the achievements of professional photography, which, like modern painting, tenaciously fought for aesthetic autonomy, a struggle in which many visual artists served as pacemakers. The development of color photography also played a key role in this process. In discussing the issue of artists' reliance on photography, we should recall that the Impressionists already drew inspiration from the static, black and white daguerrotypes of the day, and translated them into something entirely different. The influence of technically and thematically expanded photography on Duchamp and Dadaism is also a matter of record. So there is nothing amiss in a painter's employment of the new medium in choosing and preparing his motifs. And this holds not only for realistic painters, when we consider the reciprocal influences between "subjective" photography and abstract art.

## The Magic of the Real

The paintings of Richard Estes (p. 336) have a hyper-real effect which is beyond the capacity of the naked eye, and even of the camera, no matter how sharply focused. This is achieved by means of distributing the focal points of various photographs over the entire canvas surface, and rendering every square inch of it with equal precision. Nearby and distant things are seen with equal clarity. A combination of the blow-up, derived from Pop Art,

**Richard Estes**
Downtown, 1978
Oil on canvas, 122 x 152 cm
Vienna, Museum moderner Kunst,
on loan from Ludwig Collection

**Richard Estes**
Victory Theater, 1968
Oil on wood, 82.6 x 61 cm
Boston (MA), private collection

with a painstaking depiction of natural and artificial illumination and reflections, lends a soundless stasis to the everyday scene of food shops and glitzy entrances, automobiles and reflecting glass facades. Estes's imagery has a timeless magic that distantly recalls Metaphysical Painting. In face of many of his works one is inadvertently put in mind of the provocative statement of the "black monk," Ad Reinhardt, that "art is always dead" – that is, exists in a vacuum, beyond life. As so often, the extremes meet; two diametrically opposed positions tacitly coincide.

In accordance with his stance as an artist, Estes considers photography a preparatory, auxiliary means. Instead of providing a subject, the photograph, as he says, merely gives the best pointers to the theme he wants to paint. For all their apparent faithfulness, Estes's motifs undergo a degree of imaginative transformation unmatched by most other photo-realists employing related subject-matter. This holds for the California artists Richard McLean, Don Eddy (p. 337 above), and Ralph Goings (p. 337 middle), as it does for Brooklyn-born Robert Cottingham (p. 337 below). Cottingham, who, like Rosenquist, began his career in commercial art, transposes the Pop principles of close-up and fragmentary excerpt of reality into the terms of a Pop-inspired neo-realism.

The case is different with Malcolm Morley (p. 338). Morley divides the photographic image into a grid pattern of small rectangles, and rotates it, with the canvas,

through 180 degrees. In other words, if in a different way than the later Baselitz, he turns the picture upside down and makes it illegible in order better to concentrate on the painterly detail. Unlike Estes, Morley works in thick, heavily textured impasto, which serves to alienate the mundane subject, be it telephone book or picture postcard. The thing reproduced and its reproduction are no longer identical, the quotations are ambivalent, as indicated by the devices of crossing out, crumpling, or ripping Morley occasionally uses. His concern is not with an illusionistic representation of the visible, but with with an analysis of it, what the artist himself terms "the anatomy of illusion." What this in turn implies is that Morley's true theme – again, like Baselitz's – is painting per se. The more or less arbitrary motif is merely the occasion for painting. Or, as Morley puts it, his intention is to "paint painting." As one can see, this has as good as nothing more to do with photo-realism as pure, straightforward representation – though the artist's later paintings seemingly indicate a certain insecurity, if not a crisis, in his development.

Howard Kanovitz points out that the term "realism," introduced into the discussion on visual art by Courbet, has yet to be adequately defined. As he justifiably adds, there is neither a realist school nor group in the present period. For Kanovitz, realism in painting consists in recognizing something we have never really seen, a shocking piece of visible and psychological reality which cannot simply be limited by the wish to paint things as one sees them.

Kanovitz employs photographs and drawings as preliminary studies for his pictures. The photo serves primarily as an aid to memory, rather than as a conveyor of the visual idea. The decisive thing is the selection of the thematic elements which are to enter the painting. Kanovitz convincingly points out the external and underlying similarities of Neo-Realism with a concurrent stream whose aims were quite different: Conceptual Art. Both, he says, often employ photographs, both are concerned with processes, with "how something is done and expressed."

As with Morley, Kanovitz's central theme is the relationship of reality to illusion, their points of convergence and divergence, even though he approaches the theme by means of a quite different technique and conception. That like all the relevant Neo-Realists he is not concerned with mere illustration is indicated by Kanovitz's express reference to Baroque illusionism, the "illusion of an illusion." Although a painting such as his famous *Vernissage* (p. 338) is still clearly influenced by Pop Art in terms of palette and characterization of figures, and possesses ironic, socially critical aspects including a metaphorical evocation of the emptiness of the people's talk by means of a diffuse background, it also contains elements of the unreal, which would play an increasing role in the artist's work.

*Trompe-l'œil* painting soon no longer sufficed Kanovitz. But he did turn his experience in this field to

**Don Eddy**
Private Parking III, 1971
Acrylic on canvas, 122 x 167.5 cm
Private collection

**Ralph Goings**
Plumbing-Heating Pick-Up, 1969
Oil on canvas, 114.5 x 162.5 cm
Private collection

**Robert Cottingham**
Carl's, 1975
Oil on canvas, 198 x 198 cm
Aachen, Ludwig Forum für Internationale Kunst

points out, "provides only the mode of perception and conditions" for such works. Painting, in contrast, provides "the aesthetic means of transforming the protocol of the photographic method" – which, in Close's case, supplants the natural vision of the eye – "point by point into a quasi-abstract image, which maintains its autonomy between the color-field painting of Ryman and the media absolutism of Warhol."

That the painting process was the basis of Close's portrait series became ever more obvious, sometimes blantantly so, during the 1980s. The resolution of the faces into small, equal-sized color fields of varying texture was occasionally achieved at the expense of internal cohesion and compositional logic, and thus of quality. The brief phase of *Finger Paintings*, in which Close worked with blurring effects, carried more conviction than the finely articulated monumentality of the subsequent oils.

### The Strangeness of the Everyday

At this juncture we should take a brief look at the sculptors working in a hyper-realist style. John De Andrea, who depicts friends in highly intimate situations, expressly says that photographs do not suffice him in representing his sole theme, the absolute individuality of every human being. As he is concerned with immediacy foremost, de Andrea feels that any intervening medium would destroy it.

Duane Hanson, too (p. 514), requires the presence of living models for his work. His theme, says Tilman Osterwold, is "the strange everyday," or, in the artist's own words, "just that fixed moment." Where movement ceases, time stands still. It has entered the painted figures with their utensils that are always the same. Their faces and bodies, silent, motionless, contain their entire life's story. Psychological reality is revealed to view through the physical presence of the sculpture. For Hanson, art is at once an aesthetic product and a document. In contrast to the great environment-maker

good use in expanding the flat image into three dimensions, by combining painting and object, linking the concrete with the imaginary, as for instance by framing a romantic landscape in an actual French door. Even more compelling was an interlinking of transparent visual levels, a combination of the disparate recalling Magritte, consisting of an open grand piano and seat in front of window-wall casting a shadow and standing in water: *The Grandiose Piano* (1987; Berlin, private collection). Here the mythology of everyday life entered a poetic phase in Kanovitz's work.

The extremely enlarged, manipulated photo-portraits on canvas by Chuck Close (p. 339 above) likewise evince surprising links between the radical photo-realism he practiced for 25 years and conceptual, analytical painting. "Photography," as Manfred Schneckenburger

*"I am now making paintings and sculptural works which involve my interest in appearance, illusion, and character. I use a precisionist approach, crystallizing my images so that they go beyond realism into an area that is similar to trompe-l'œil. I use my own photography as the source of my painted images."*
HOWARD KANOVITZ

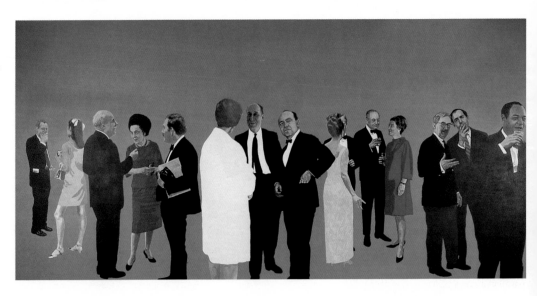

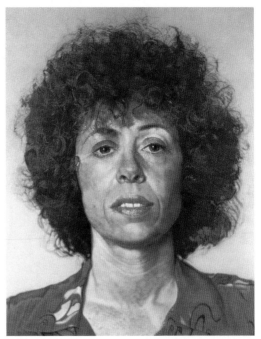

*"The only way that I can accomplish what I want, is to understand not the reality of what I am dealing with, but the artificiality of what it is. So perhaps I would feel more comfortable with 'new artificialist' than with 'new realist'."*

CHUCK CLOSE

**Chuck Close**
Self-Portrait, 1968
Acrylic on canvas, 274 x 213 cm
Minneapolis (MN), Walter Art
Center, Art Center Acquisition
Fund

**Chuck Close**
Linda, 1975/76
Acrylic on canvas, 273.5 x 212.5 cm
Akron (OH), Akron Art Museum

Edward Kienholz (pp. 511, 512), Hanson resorts neither to surrealistic or symbolic reference, nor to anonymity. The painting of his figures, clothed in their personal attire, and the photographic precision of their detail, place his work in an intermediate position between painterly and sculptural Neo-Realism.

The pictures of Canadian artist Alex Colville (ill. below) bear more affinity to the American Precisionists of the 1930s than to photo-realism. His perfect compositions are based on an abundance of sketches and studies, which are first brought into an abstract, geometric scheme before drawings are made from the live model and proportioned according to the planned format. Only then does the slow and patient process of painting begin. Layer upon layer of thinned paint is applied to a primed wooden panel, and the opaque surface finally sealed with transparent lacquer. The process can often take months.

Colville has devoted intensive study to European painting. According to him, it took him many years to digest the impressions gained during two days spent in the Louvre. Yet he has also been deeply impressed by the American Luminists, and not least by Hopper. Colville's paintings are proof of the fact that a realism of content need have nothing in common with naturalism, that the serious realist does not unthinkingly reflect reality, but analyzes it. It is this analytical cast of mind, Colville is convinced, that permits him to discover "myths of mundanity" – on the banks of the River Spree, by the seaside, in the circus, at sports events, on a boat or a highway, in a meadow or a swimming pool, in a telephone booth or a bedroom. Colville insists that the mythical aspect of everyday life is not reserved for authors of the secular rank of a James Joyce, but that the contemporary painter can have access to it as well.

## "The Saga of Man"

Colville's silent images are static. Yet practically all of them tell a story, in a brief, concise plot that does not always have a resolution. Fundamental human situations are their both simple and complex themes: loneliness, isolation, parting, work, leisure, estrangement, love. The only subliminally dramatic, often melancholy laconism of content corresponds to the absolute precision of form by which it is conveyed. Like hardly another artist, Colville maintains the difficult balance between imagination and sober calculation, formal interest and social commitment. Behind the realistic surface of his imagery lurks the surreal – but a surreal that lacks every trace of theatrical staging or borrowing from psychoanalysis, whose new myths Colville deeply mistrusts.

**Alex Colville**
Truck Stop, 1966
Acrylic on composition board,
91.5 x 91.5 cm
Cologne, Museum Ludwig,
Ludwig Donation

**Franz Gertsch**
Medici, 1971
Dispersion on canvas,
400 x 600 cm
Vienna, Museum moderner Kunst,
on loan from Ludwig Collection

**Franz Gertsch**
Johanna II, 1986
Tempera on unprimed cotton,
330 x 290 cm
Napa (CA), Hess Collection

**Michelangelo Pistoletto**
Demonstration No. 2, 1965
Collage on polished steel,
215 x 120 cm
Cologne, Museum Ludwig,
Ludwig Donation

*Page 341 above:*
**Jacques Monory**
Murder No. 10/1, 1968
Acrylic on canvas,
195 x 315 cm
Humblebæk (Denmark),
Louisiana Museum of Modern Art

*Page 341 below:*
**Gerhard Richter**
Ema – Nude on a Stairway, 1966
Oil on canvas, 200 x 130 cm
Cologne, Museum Ludwig,
Ludwig Donation

Harald Szeemann once spoke of "exaggerated American realism" as opposed to the "more humane European" variety, as manifested in the work of Swiss artist Franz Gertsch. With Colville, engagement and detachment hold a balance. With Gertsch, something else enters the equation – a romantic outlook like that reflected in the contemporary new lifestyles of young people and artists in particular. Everyday situations in their lives are Gertsch's predominant theme. Like De Andrea and Hanson in their own way, Gertsch needs

human proximity, a closeness and familiarity with those he depicts. This sense of nearness is underscored by his, as it were, pointillistic technique, which discloses two different types of experience, depending on whether one views the painting from a close or a distant vantage point. Seen close up, the surface offers the aesthetic experience of a masterful, sumptuous *peinture*, while from a distance, it congeals into a figurative scene of amazing vitality.

## Pictures of Pictures

According to Gertsch (p. 340 below left), what he paints are "pictures of pictures," in which "the something (the realistic image) should be as immaculately present as the nothing (the white canvas)." This, indicatively, is followed by a reference to the immaculateness of the ultramarine blue sky of Yves Klein. Gertsch's painting derives its tension from the dichotomy between idea and reality. Even in his later, large-format woodcuts, begun in 1986, reality is always the theme, even though the immediate visual experience has given way to memory, and the main role is no longer played by human figures, individuals or groups, but by landscape and nature.

To integrate external reality, the viewer's surroundings, into the reality of the image, and ultimately to negate the borderline between life and art, was the aim of the early *Mirror Paintings* of Michelangelo Pistoletto – photographed figures applied in a collage manner to a polished steel plate (p. 340 below right). The Italian artist has continued to pursue these aims in his later sculptures and environments.

In contrast, French artist Jacques Monory (ill. above) spirits his semi-naturalistic pictorial sequences to a dreamlike realm by means of monochrome blue grounds, while his countryman Jean-Olivier Hucleux paints his enigmatic pictures of human and automobile cemeteries from projected slides.

If we now turn to the work of Gerhard Richter (pp. 341–343), it is with the hope that no one will be tempted to classify his work as realism in the narrower sense. The German artist's painting is many-sided, many-layered, and functions on multiple levels of meaning. In order to at least suggest the complexity of Richter's work, let me quote a comment of Georg Schmidt, the eminent Swiss museum curator, to the effect that for him, Mondrian was a great realist.

And Richter himself, in an interview, stated pointedly, "Don't you understand? That which we flippantly call reality is not there and not real for as long as it has not become reality through art. In other words, art never makes a statement about reality, but is itself the only reality which is there." Some years later, in connection with his more recent gestural abstractions, the artist formulated his expanded definition of reality thus: "Abstract paintings are fictitious models, because they visualize a reality which we can neither see nor describe but which we may nevertheless conclude to exist. We attach negative names to this reality: the un-known, the

**Gerhard Richter**
Sea Piece, 1975
Oil on canvas, 200 x 300 cm
Private collection

**Gerhard Richter**
Swimmers, 1965
Oil on canvas, 200 x 160 cm
Stuttgart, Froehlich Collection

un-graspable, the in-finite, and for thousands of years we have depicted it in terms of substitute images like heaven and hell, gods and devils. With abstract painting we created a better means of approaching what can be neither seen nor understood, because abstract painting illustrates with the greatest clarity, that is to say, with all the means at the disposal of art, 'nothing.' ... This ist not an artful game, it is a necessity; and since everything unknown frightens us and fills us with hope at the same time, we take these images as a possible explanation of the inexplicable or at least as a way of dealing with it."

These words give us a sense of the higher unity in which Richter's work is contained, despite its undeniable diversity and its real or apparent contradictions. In all its reflections and refractions, from the involvement with Socialist Realism at the beginning to the monumental products emerging from Richter's studio today, his oeuvre revolves around the inexhaustible theme of "reality," a reality that is never ultimately comprehensible – unless in the form of the reality of art itself, which Richter calls the "highest form of hope."

Thus painting is the Archimedian fulcrum of this born painter. In it is reflected his entire experience of reality, positive and negative, general and personal. Richter's reply to experience always takes the form of a painted image – whether a conceptual one like his minimalistic color panels or grey-in-grey paintings, an ironically romantic one like the landscapes of the late 1960s and early 1970s, or an expressive one in the black, white and grey cityscapes or the grandiose *Alpine Panorama* of 1968. These were followed by overpainted photographs, which introduced Richter's relevant work after his move to Western Germany, by a vehemently gestural

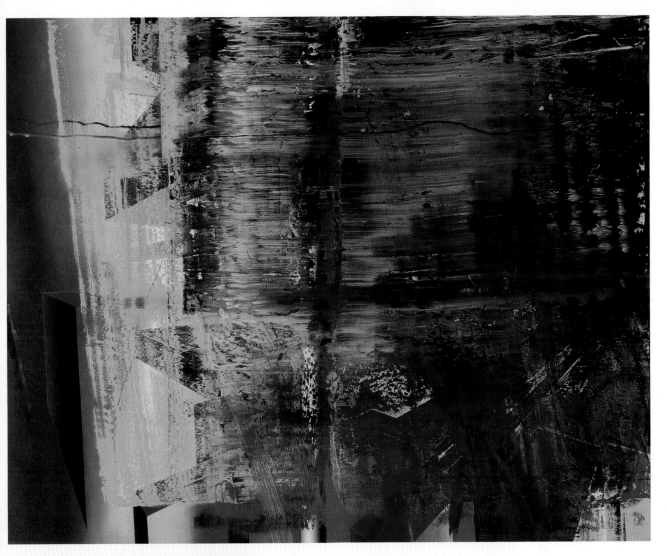

approach in the recent works, or by the structurally more reserved movement of the abstract *London Paintings* of the late 1980s. Richter forsakes none of these painterly positions, reserving the right to return to them at will.

His work is the work of an artist who is always on the move, searching, he is continually inquiring into reality and calling it into question. In Richter's work the disquiet and insecurity that marks an Alexandrine, late culture, as well as skepticism and doubt, and the artist's ironically tinged melancholy and moments of subdued happiness, have been turned to creative ends.

**Gerhard Richter**
S. D. I., 1986
Oil on canvas, two parts,
320 x 400 cm
Napa (CA), Hess Collection

**Gerhard Richter**
Facade, 1997
Oil on Alucobond, 100 x 90 cm
Private collection

# Painting as a Mind-Game

## Provoking the Eye
### Op Art and the Crossing of Borderlines

The simultaneity of oppositions in the field of art-making is no new phenomenon. It is met with in almost every epoch of art history. Thanks to today's pluralistic thinking, the number of diverse and sometimes mutually exclusive tendencies co-existing on the scene is especially great. Pop Art and Neo-Realism, too, were paralleled by a movement with quite different aims. As their representatives were developing an art determined by life and the outside world, including all its banality,

there were other artists devoting themselves, put simply, to issues inherent to art.

The opposite pole to Pop Art is marked by Optical, or Op Art, which drew inspiration from Albers and, farther back in time, from the Pointillism of Seurat and the Orphism of Delaunay. We recall that Seurat's dot patterns in the colors of the spectrum had compelled the viewer's eye to pull them together, to condense the dots into a composite color and form. This was a complex

*"I draw from nature, I work with nature, although in completely new terms. For me nature is not landscape, but the dynamism of visual forces — an event rather than an appearance."* BRIDGET RILEY

**Bridget Riley**
Current, 1964
Emulsion paint on canvas,
135 x 150 cm
New York, The Museum of
Modern Art, Philip Johnson Fund

**Victor Vasarely**
Vega 200, 1968
Acrylic on canvas, 200 x 200 cm
Private collection

and demanding perceptual experience, especially as Seurat's pictures evinced a dichotomy between a surface composed of finite paint particles and a linear composition of veritably classical harmony. Delaunay then went one step farther, with his "simultaneous contrasts" of color, and with a simultaneity of static and dynamic forms, whose "synchronous motion" for him represented the "drama of the universe."

The extreme demands made on the eye by Seurat and Delaunay were taken by representatives of Op Art, in various ways, to the verge of the bearable, and sometimes even beyond. It was Albers who pointed the way. Habitual perception, he realized, could be upset by forcing the eye to take in two contradictory, normally mutually exclusive perceptions at once, by relying on what he termed the "interaction of color." In Albers's paintings and colored prints this effect took the form of a continual oscillation between spatial and planar perception; in the black and white drawings and prints it took the form of a continual flipping back and forth between positive and negative, convex and concave.

Albers's imagery gives the eye no respite. The colors and shapes resist every attempt to definitively fix them. Moreover, as the artist realized, a color will change in intensity or hue depending on the neighboring color. This is what lends the seemingly so simple forms in his painting, including the square, their flickering, ambiguous appearance. This effect is basically the theme of Albers's painting. What it makes visible is the contradiction between the physical fact and the psychological effect. If we are willing to enter Albers's work, we find it capable of inducing doubt as to the dependability of our entire perceptual experience.

## Optical Bafflement

This attack on perceptual habits was mounted with even greater force by the London artist Bridget Riley (p. 344). Her concept, Riley once said, in a seeming contradiction in terms, was the open, planar space, a multi-focal space of the kind found, for instance, in Pollock. What this implied was a space without a compositional or perspective focus or center. It took the form of "all-over"

**Victor Vasarely**
PAUK-SP, 1968/69
Oil on canvas, 150 x 150 cm
Private collection

**Richard Anuszkiewicz**
Luminous, 1965
Acrylic on canvas, 61 x 61 cm
Los Angeles (CA), Mr. and Mrs.
Melvin Hirsch Collection

**Yaacov Agam**
Life is a Passing Shadow, 1969/70
Painted relief, 81 x 117 cm
Private collection

compositions inspired by Pollock's, but entirely lacking in Pollock's dramatically emotional gesture. The optical irritation or unrest caused by Riley's pictures is purely visual in nature. Admittedly, changes in tempo, condensation or relaxation of the patterns of stripes, dots, wavy lines, triangular or rectangular shapes, the virtual movements and countermovements and stasis or dynamics of the pictorial elements, evoke a suspenseful if non-relational expressiveness, which, however is always kept under formal control. Riley understands the counterpoint and polarization in her imagery to represent formal parallels "to our emotional life."

Apart from drawing inspiration from the Pointillists and Impressionists (especially Monet), and admiring the universal harmony of Mondrian, Riley has been influenced by van Gogh and the Futurists. Every one of her paintings has its own specific character, despite the fact that all individual touch has been expunged in an effort to make her art as objective as humanly possible. The perceptual irritation it causes, and the pictorial energies

with which it is suffused, demand great, unflagging concentration on the part of the viewer. Riley's imagery requires no interpretation, because the message is all there on the surface, challenging us as viewers to analyze its effect upon our perception.

Victor Vasarely (ill. above left and p. 345) studied with Bortnyik at the Budapest Bauhaus. Unlike Riley, he strove to give his artistic experiences, which ultimately derive from Constructivism, an exact, scientific and theoretical basis. From early on Vasarely was intrigued by networks, webs, and weaves of all types, all the way from isobathic maps of the earth to looms and "patterns of the kind used for many printing processes, also railway nets, lines of force, circuits and their complex systems – all of them coordinates of fascination," in the artist's own words.

This early fascination was the source of Vasarely's attempts to overcome individualistic painting dominated by the artist's personal touch, his rejection of the original work and its aura in favor of reproducible models based on the *unité plastique*, Vasarely's endlessly changeable and interchangeable fundamental form of the "work of art in the age of technical reproduction." The use of serial procedures reflects Vasarely's conviction that a work of art must be repeatable and capable of being produced in as many copies as required, whether it be in two dimensions or three, or even a kinetic work. "If the art product," he says, "does not break through the constrictions of an elite of connoisseurs, art is doomed to death by suffocation." The means to ward off this danger, Vasarely believes, is the mass production and dissemination of art.

This conviction also made Vasarely one of the key pacemakers of multiple art. In the late 1960s and early 1970s, when widespread political and social change seemed imminent, the reproduction of art and concomitant reduction in price, as Günther Gerken notes, promised a "broader and more direct effectiveness than that of the one-off museum piece.... In the work of art

which has lost its character as a prestige object, true intellectual values, not influenced by market value, prevail." As we now know, this wonderful hope was illusory. The masses did not cooperate. The aura, originality, and exclusiveness of a work continue to determine its market value.

The approaches of Riley and Vasarely mark the poles of Op Art and its possibilities: the former cleaving to two-dimensionality and to the importance of the original work despite all attempts at "objectivity," the latter striving to produce the "democratic" multiple and to negate the border-lines between genres in an attempt to create a social art for all.

Intermediate positions were held by artists such as the Venezuelans Jesús Rafael Soto and Carlos Cruz-Diez, by Israeli painter and sculptor Yaacov Agam, by the American Richard Anuszkiewicz, by Wojciech Fangor of Poland or Almir Mavignier of Brazil. Soto's work (ill. right), according to his own testimony, had its source in the desire to "make Mondrian's works appear to be in motion." In front of monochrome, usually low-relief surfaces Soto mounted thin metal rods attached to nylon filaments, which were set in motion by the slightest air currents. The intersection of the sometimes parallel, sometimes opposing lines created a visually irritating effect known as Poggendorf's Illusion – a line that meets another at an acute angle appears interrupted in its course.

Soto's mixture of flat painting with relief already anticipated the three-dimensional kinetic art of a Schöffer, in its – likewise Mondrian-influenced – constructivistic form, or the art of a Jean Tinguely, with its ironic, "black" romanticism. Agam's paintings (p. 346 below) are divided by angular lamella. Their colored shapes change in appearance as the viewer moves back and forth in front of the picture. They become broader, then narrower, until the image either opens out to reveal its multi-colored aspect, or condenses into a black, textured plane.

Changes in the vantage point of the viewer and in the impinging light are employed in a similar way by Cruz-Diez from Venezuela (ill. right), a former designer. In the case of Anuszkiewicz (p. 346 above right), optical bafflement is induced by juxtaposing straight with radiating lines, which appear to cause the former to curve. Mavignier sets the picture plane in vibration by means of a permutation and the progression of equidistant sequences of elements of various size and hue. The former industrialist François Morellet (p. 348) employs the means of painting, relief, sculpture, and occasionally blends of all three, combined into simple, fundamental structures, to produce his precisionistic works, which are sometimes conceived for the architectural context. Constructivist elements are combined here with elements of Minimalism and Conceptual Art.

What all Op artists share in common is a relinquishment of any fixed vantage point on the part of the viewer, which, together with a multi-focal composition, compells the eye to ever-fresh perception. This is underscored by an elimination of the artist's personal touch, in an attempt to concentrate solely on the objective, optical event taking place on the surface. The visual unrest of Op Art reflects an urge not only to keep the eye moving but to set the work of art itself in motion. This process, which led to Kinetic Art, can be seen to good effect in the development of Heinz Mack's work. From the early, still painstakingly rendered serial *Vibrations* it led by way of *Light Columns* in the Sahara Desert to plastic, kinetic pieces, which integrate the aleatory factor and the effects of light interference in an aesthetic play of light seemingly infinite in variation.

**Jesús Rafael Soto**
Large Vibrating Panorama Wall, 1966
Rome, Galleria Nazionale d'Arte Moderna

**Carlos Cruz-Diez**
Physichromie No. 326, 1967
Wood, plastic and oil paint,
120 x 180 cm
Cologne, Museum Ludwig

During the latter half of the 1980s, triggered by Mikhail Gorbachev's ultimately abortive attempt to reform the Soviet Union's ossified sociopolitical system, there suddenly came to light works of art of an originality and diversity, and occasional radicality, which Western observers would not have thought possible under the circumstances. Though it had been obvious for years that orthodox Socialist Realism was on the defensive, the high level of knowledge of Western trends on the part of younger Russian artists in particular came as a great surprise. Under quite different political conditions, these beginnings have continued to bear fruit to the present day.

# A Painting is a Painting is a Painting
## Minimalist and Conceptual Painting

According to conventional wisdom, every significant proposal in 20th-century art was not only advanced but put into practice during the early modernist period, and every subsequent development was merely imitative, repetitive, or, at best, an eclectic variation on previous achievements. If this were true, every innovative tendency that preceded today's Post-modernism and the "politically correct" statements of the final days before the millennium would have to be judged uncreative and derivative, and be stamped with that mark of Cain, the

*"I chose geometry because of its neutrality, the system, that would make me restrict the arbitrary nature of my decisions."*
FRANÇOIS MORELLET

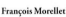

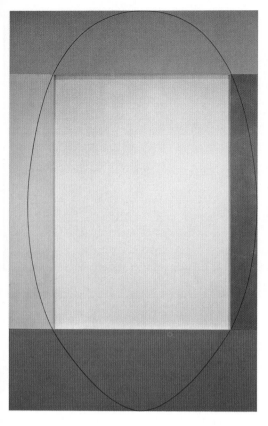

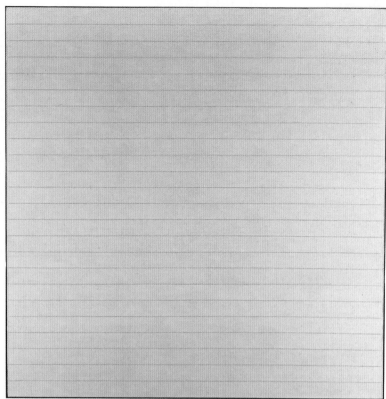

prefix "post." In that case Wols and Jackson Pollock would be Post-Expressionists, the Pop artists Post-Dadaists, Gotthard Graubner's color-spaces Post-Romantic.

But things are not that simple, for as George Kubler has said, "No formal sequence is ever truly completed in an exhaustion of all its possibilities in a consistent series of solutions. A re-evaluation of all problems under new conditions is always possible, and sometimes indeed topical."

F. N. Mennemeier's statement that "deconstruction is always, or should always be, a construction as well," applies to those tendencies that revived long-forgotten Constructivist ideas and considerations. Among these were Hard Edge Abstraction, Minimal Art, and certain aspects of Conceptual Art and the analytic, conceptual

**Robert Mangold**
Four Color Frame Painting
No. 3 (pink, yellow green, red, green), 1983
Acrylic and pencil on canvas, 335.3 x 213.4 cm
Formerly Saatchi Collection, London

**Agnes Martin**
Untitled VIII, 1981
Acrylic and graphite on canvas, 183 x 183 cm
Formerly Saatchi Collection, London

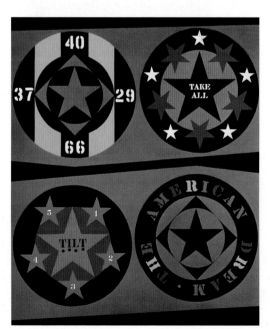

**Richard Artschwager**
Untitled, 1970
Liquitex on Celotex with aluminum frame, 72 x 62 cm
Private collection

**Robert Indiana**
The American Dream I, 1961
Oil on canvas, 183 x 152.7 cm
New York, The Museum of Modern Art, Larry Aldrich Foundation Fund

**Ellsworth Kelly**
Blue Red, 1965
Oil on canvas, 165 x 381 cm
Private collection

**Ellsworth Kelly**
Red Blue Green Yellow, 1965
Oil on canvas (floor section on
composition board), 222 x 137 x 222 cm
USA, private collection

painting associated with it. An outstanding representative of the latter is Agnes Martin (p. 349 above right). Her sensitive paintings and drawings, in which abstract forms were increasingly reduced to serial, horizontal or vertical grid schemes, not only had a great influence on the younger generation but anticipated Minimalist and Conceptual tendencies to come.

American artist Ellsworth Kelly (ill. above and below), who, like his countrymen Robert Indiana (pp. 348, 349) and James Rosenquist, was a friend and student of Martin's, was painting similarly "minimalistic-concrete" pictures long before the terms were coined to describe a style. A key trait of Kelly's painting is its waiver of all referential content. The picture, reduced to a painted surface and its support, stands only for itself. Painting and subject are one. The support determines the shape and extent of the paint surface; painted contours are replaced by the edges of the various numbers of smaller canvases joined together into a whole.

The simplicity of the late Matisse' cut-outs, and occasionally the brilliance of their color, were at the back of Kelly's lapidary statements. Yet the stark contrast between deep black and intense white has also intrigued him. The stringency of his pictorial structure is occasionally mitigated by irregular, geometric apertures. In their object-like character and format, particularly in the case of the *Shaped Canvases*, many of Kelly's works transcend the borderline between painting and sculpture. Kenneth Noland's later paintings, in which parallel bands of color merge completely with the picture support, also belong in the context of Hard Edge Abstraction.

### From Purism to Baroque

Frank Stella, too (pp. 351, 352), considers his paintings to be objects, saying that "only that which can be seen there is really there." In the early 1950s he began making

"black paintings" whose surface was articulated by series of narrow, parallel lines in which the light color of the canvas shone through. The stringency of this lineature was toned down by a visual effect of vibration, caused by the varying degree of lightness of the lines and an occasional blurring over by black pigment. For all the objectivity of his approach and methodicalness of the painting process, this feature revealed the artist's emotional involvement in his work. Then came, in the 1960s, Stella's black *Shaped Canvases*, followed by paintings in vivid color employing matte and glossy fluorescent paint to produce an interplay of surface effects. A certain link with tradition is evident even in Stella's minimalistic work, despite his own disclaimers. At this period he still insisted that there was no going back, and asked why any artist would involve himself with things that were "over and done with". Yet subsequently Stella would involve himself, very intensively, with Matisse, for whose sumptuous and sensous painting he expressed a clear admiration that ran very much counter to current trends. His main interest, Stella coolly admitted, was to do what is popularly known as decorative painting, really close to life, if under "unequivocally abstract premises." Decorative, that is, in the sense as it applies to Matisse. Delaunay's disks of color and Oriental art also left a deep impression on Stella, although his color range of the late 1960s, by comparison to that of the *Concentric Squares* and *Labyrinths* of preceding years, extended to include broken and subdued hues.

The covert Baroque tendencies in Stella's thinking, only suggested in the early, black canvases, emerged full-blown in a series of works begun in the 1970s. These were aluminum reliefs whose basic elements derived from the curved templates used by Danish shipbuilders, followed by more finely articulated, tightly interwoven ornamental pieces with an even stronger emphasis on three-dimensionality and painted surfaces inspired by

**Frank Stella**
Ctesiphon III, 1968
Fluorescent acrylic on canvas,
300 x 600 cm
Cologne, Museum Ludwig,
Ludwig Donation

American Indian art. Then Stella launched into painted montages of a veritably Baroque vitality and abundance, diametrically opposed to the purism of the early work. Reminiscences of primitive and native American art, which Stella collects, were combined here with quotations from and references to Western European models. Occasionally these three-dimensional paintings – or rather, painted objects – burgeon out into theatrical spaces complete with painted sets and wings. Within

this compilatory, quotation-rife art and its blend, so typical of a late culture, of apparent naivety with a high degree of historical awareness, a certain gradient in quality is evident. In view of some of Stella's works one inadvertantly thinks of Pattern Art, that decorative style which, in the hands of its lesser representatives, so strongly recalls lengths of printed dress fabric. Exceptions are talented artists like Robert Kushner (p. 353 above) and Miriam Schapiro (p. 353 middle).

*"My painting is based on the fact that only what can be seen there is there. It really is an object. Any painting is an object and anyone who gets involved enough in this finally has to face up to the 'objectness' of whatever it is that he's doing."* FRANK STELLA

**Jules Olitski**
Strip Heresy, 1964
Magna on canvas, 266 x 207 cm
Private collection

**Larry Poons**
Untitled P26, 1974
Oil on canvas, 197 x 155 cm
Private collection

**Robert Kushner**
Sail Away, 1983
Various fabrics and acrylic on
canvas, 221 x 523.2 cm
Courtesy Holly Solomon Gallery,
New York

**Miriam Schapiro**
I am Dancing as Fast
as I Can, 1985
Acrylic and fabric on canvas,
228.6 x 365.8 cm
New York, private collection

**Rosemarie Trockel**
Hammer and Sickle, 1986
Wool, 130 x 150 cm
Stuttgart, Collection Südwest LB

## The Painting as Object

The attempt to transform the painting into an object, by
radically reducing the element of form and expunging
personal touch, leaving only an opaque surface as
smooth as a mirror, takes on extreme form in the per-
fectly executed works of Robert Mangold (p. 349). Man-
gold's unusually shaped panels, divided into regular seg-
ments, combine highly sensitive painting with precisely
delineated graphic elements, recently usually elliptical
in form.

The first comprehensive exhibition of Minimal Art
to be seen in Europe took place at The Hague, Düssel-
dorf, and Berlin in 1968/69. The catalogue listed ten
sculptors and object-makers – Carl Andre, Ronald
Bladen, Dan Flavin, Robert Grosvenor, Donald Judd,
Sol LeWitt, Robert Morris, Tony Smith, Robert Smith-
son, and Michael Steiner – but not a single painter. The
work of these artists, which extends into space, defines
it, and requires the environment, whether architecture
or landscape, for its effect, likewise evinces lines of con-
nection with Conceptual Art (Andre, LeWitt) and with
Land Art, which took art out of the museum and into
the open spaces.

The death of painting, was a simplistic hypothesis
very much in vogue during the 1960s and early 1970s and
continues to be pronounced, against all odds, even
today. Still, there is no denying that many of the most
spectacular events in art since that time have taken place
outside the field of painting. And the painting of that
period was not exactly popular. This would have its con-
sequences.

Yet even during the heyday of forbidding Minimal
sculptural monuments, of Land Art and "Individual
Mythologies", of the tumultuous celebration of the sup-
posedly new media of photography, film, television and
video, the period of Body Art and the Happening and
Fluxus movement and its offshoot, the Performance, of
Beuys's expanded definition of art, and of naive
attempts to break out of the vicious circle of studio-
gallery-museum – even during those years in which
"Attitudes Became Form", paint continued to be
applied to canvas.

**Robert Ryman**
Director, 1983
Oil on fiberglass with aluminum
holders, 235.6 x 213.4 cm
Formerly Saatchi Collection,
London

**Raimund Girke**
Contrast, 1992
Oil on canvas, 200 x 220 cm
Essen, Museum Folkwang

## Analytical Paintings

The common denominator of "non-relational" painting
is the artist's reflective attitude, a profound questioning
of his own medium, and a strict refusal to countenance
subject-matter or content extraneous to the image per
se. This analytical, conceptual approach to painting was
based, on the one hand, on Duchamp's example and
theories, and, on the other, on the puristic attitude rep-
resented by Barnett Newman, Ad Reinhardt, and Yves
Klein, whose conceptualism the non-relational painters
even surpassed.

While Jules Olitski's lyrical canvases (p. 352), spray-
painted layer upon layer, have earned him the sobriquet
of the "first Abstract Impressionist," Robert Ryman's
works (ill. left) have proven to be the most highly logical
among those of analytical painters. As early as the late
1950s Ryman was already producing white paintings,
which, seen in isolation, was not all that sensational,
considering the fact that even representatives of L'art
informel, such as Tàpies, had worked in a similar vein.
Yet thereafter Ryman began to make use of the painter's
basic materials. The effect of the canvas texture was
included in the effect of the white painted surface.
Materials such as steel, aluminum, copper, fiberglass, or
cardboard, used as supports, emphasized the object-
character of the works. The paint application, however,
continued to be highly variable. Dense textures alter-
nated with loose, regular or irregular ones, thick
impasto alternated with smooth application, opaque
surfaces with transparent. Yet the term "planned paint-
ing" is only conditionally applicable to Ryman's
approach, because despite continual intellectual control
his temperament and moods do become evident in the
final image. Ryman relies a great deal on his emotions,
he once said in an interview, doing the things he consid-
ers right, preferring to follow his intuition rather than
relying on preliminary testing.

Raimund Girke (ill. left) is not an analytical thinker
like Ryman, nor is he a mystic of chromatic abstraction,
as Brice Marden, following in Newman's footsteps, was
at least for a time. Girke illustrates no theories, saying
that he does not intend to "sacrifice painting for an
idea." "The material remains the determining factor," he
adds, and not merely a means to demonstrate a concept.
Everything Girke paints appeals to the senses, and bears
the unique, personal mark of his hand. Although as
tenacious in his use of the color white as Reinhardt was
in his adherence to black, the German artist's works
have none of the hermetic quality of the American's
*Black Paintings.* Reinhardt's black seals off the colors it
contains. In contrast, Girke's white seems to expand and
contract, appears open, continually changing. In a
word, it appears to breathe.

English artist Alan Green (p. 355 above) takes a stance
exactly opposite to that of Rauschenberg. While the
American heightens the real character of the image by
integrating actual elements of reality, Green believes
that a picture done by purely painterly means has a bet-

ter chance of belonging to the real world than a repro-
duction of external reality. He, too, considers the
painted image to be a concrete, autonomous object. The
minimal means he employs are contemporary to the
extent, he says, that they correspond to the "minimal
radius of action" of human beings in an endangered
world marked by dependencies and compulsions.

### Art About Art

Unlike Green and the representatives of Shaped Canvas
painting, Jerry Zeniuk (p. 356 below), an American born
in Hamburg, does not wish his paintings to be thought
of as objects. His work records the return of art to its

achieved the color value and sense of diffuse space
which correspond to his idea of painting. The result is a
contemplative, subtly nuanced color-space which
appeals immediately to the eye, and has no need of theo-
retical underpinning. In later works this rigorous purism
would give way to a stronger emphasis on agitated sur-
faces and forms. The contemplative panels of Alan
Charlton (ill. below) are radical abstractions untainted
by academicism, which struck exhibition organizer
Christos M. Joachimides as being suffused by a
"Beckett-like loneliness."

The chromatic color-field paintings of American
artist Brice Marden (p. 356 above), whose surfaces

roots, after the failure of the campus revolt, in the wake
of Vietnam and Watergate. He has set himself the task,
Zeniuk says, of finding out what painting really is. There
could be no clearer statement of the intention to recall
the fundamental premises of art, and to return to its
basic elements. This reflective attitude on the artist's
part, this making of "art about art," not only entails a
slow, patient process of painting. With an intensity that
takes nothing for granted and sometimes verges on
masochism, Zeniuk applies, without a pre-conceived
plan, layer upon layer of paint until he believes to have

absorb rather than reflect light, are a different case
entirely. The thinking of Barnett Newman has left clear
traces in Marden's work. Like Newman, Marden strives
for an imageless religiosity. The rhythm of the propor-
tionally related rectangular fields, diagonal or parallel
structures, and anthropomorphic curvatures, and the
alternation of color values between light and dark in his
work, are seen by the artist as corresponding to human
emotionality. What he paints, Marden says, has nothing
to do with things existing in real space, though it does
with illusion – illusion understood as the realization of

the abstract character of the perceptions we have of real things. He does not paint "trees and flowers," says Marden, though he does employ a "landscape image." Marden considers the artist's role to be that of a mediator between man and the invisible, mystical forces behind all things. Rational calculation and religious sensibility blend in his thinking and his work.

**Jerry Zeniuk**
Untitled Number 193, 1996
Oil on canvas, 188 x 233 cm
Bonn, Kunstmuseum Bonn

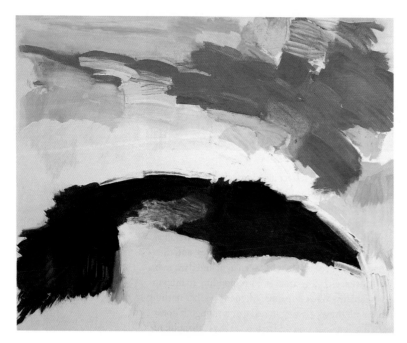

## Color and Space

The œuvre of the Beuys student "Blinky" Palermo (p. 357 below) remained only a fragment, due to his premature death. Like many artists working in a minimalistic vein, Palermo was impressed by Constructivism. It speaks for the broad-mindedness of his teachers, Bruno Goller and above all for that of Beuys, that they did not attempt to suppress this then quite unopportune preference, but encouraged its further development. Palermo's approach combined a treatment of the painting as an autonomous object, manifested especially in the series of metal paintings begun in 1972, with a sensitivity to the surrounding space, to which his works – apart from the sketches and miniatures – almost always related. It is unfortunate that none of the pieces realized and installed in actual spaces has survived, although reconstructions do exist.

In a process of logical reduction, every allusion to the human figure vanished from Palermo's paintings as they grew increasingly simple and more concentrated. In the end neither composition nor surface texture remained – only clearly defined, stark color fields, as if made one with the support. These were the result of a painstaking and ingenious painting process in which layer after layer was applied over a white ground, in the course of which the original conception was intuitively revised again and again. The aim of his work, according to Palermo, was to arrive at a sequence or chord of color which he could neither have conceived nor imagined when beginning work.

Page 356 above left:
**Brice Marden**
Red Yellow Blue, 1974
Oil and wax on canvas,
three parts, 188 x 183 cm
Formerly Saatchi Collection,
London

Page 356 above right:
**Imi Knoebel**
Untitled, 1987
Acrylic on screw-mounted wood
panels, 250 x 170 cm
Private collection

**Shusaku Arakawa**
Untitled, 1964/65
Mixed media on canvas, two parts,
247 x 161 cm (each)
Cologne, Museum Ludwig,
Ludwig Donation

For another student of Beuys, Imi Knoebel (p. 356 above), the eye-opening experience was Malevich's Suprematism, particularly his *Black Square*. As for his friend Palermo, both the object-character of the painting and the establishment of a relationship between it and the surrounding space are constitutive for Knoebel. Compellingly manifested in his environment-related

evinces a blend of the minimalist structures of the early works with a strong, if controlled, palette, as he continues to transgress the borderlines between the genres.

An even higher degree of such conceptualism is seen in the work of Shusaku Arakawa (ill. above), a Japanese artist living in New York. The painting in the above illustration belongs to a series entitled *Diagrams*.

installations, these factors already became evident in the constructive, minimalist phase of Knoebel's work, which culminated in a first installation at the Düsseldorf Kunsthalle (now in the Museum Ludwig, Cologne). Subsequently the artist's sensitive purism occasionally made way for a brilliant coloration inspired by Matisse, irregular formats, and especially for the expressive, gestural approach seen in the installations and a few of the paintings. Knoebel's most recent phase

Arakawa's allusive imagery combines graphic and painterly elements with literary and philosophical references on the basis of an abbreviated, evocative sign language. The open character of his paintings is consciously fragmentary, and eludes final definition, for the "mechanism of meaning" is inconstant and continually changing. It permits of numerous, sometimes mutually contradictory interpretations, to the point of logical inversion. The viewer is challenged to participate in the

**Blinky Palermo**
Points of the Compass I, 1976
Acrylic on aluminum, four parts;
26.7 x 21 cm (each)
Cologne, Museum Ludwig,
Ludwig Donation

unravelling of Arakawas's pictorial codes, which, suggesting an awareness of the provisional nature of all knowledge, allow great latitude for mental association. The use of various sign systems (words and images, plans, photographs, and real objects) increases this effect still further. All identity between the things depicted and the depiction itself is negated. Behind such pictorial mind-games the shades of Duchamp and Magritte are detectable. The step from Arakawa's work to Conceptual Art is a small one.

Roman Opalka (ill. right), a Polish artist who lives in France, since 1965 has been painting rows of numerals in acrylic on canvases of identical format, beginning with one and now far into the millions. These traces of his own life, diaries in paint, he calls "details." Day by day, week by week, month by month, and year by year, they mark the stages of a silent drama, the drama of the artist's own existence, whose vicissitudes are subtly reflected in the character of the brushwork. In addition, since 1972 has been recording a litany of numbers on tape, and making a daily self-portrait photograph. Even when he is on a trip, the sequence of literally existential numerals is not interrupted, though here the medium is drawing. Opalka's numerals are painted in white on grey, a grey that is lightened from canvas to canvas by adding one percent more white. Dieter Honisch has pointed out a link between this unprecedented attempt to bring a life of isolation in the studio into a pictorial unity and the *unism* of Strzemiński, the Polish Constructivist who – going beyond Malevich – posited a

unity of structure and image, figure and ground, form and color. Opalka has devoted himself entirely to a unity of art and life, expressed in the form of a work in progress.

On Kawara (p. 358 above), a countryman of Arakawa's who likewise makes his home in New York, has also made his own life the theme of his art, which far transcends the borderline of painting to enter the field of Conceptual Art. Kawara records the places he goes to, what he reads, the people he meets, and current events both public and private such as "Sit-in on Times Square" or "Taeko Kissed Me". He telegraphs his friends telling them what time he got up and that "I'm still alive." Time and space are Kawara's theme. In a multi-volume work he noted down "A Million Years", the painterly yield of which exercise were works on identical formats to each of which Kawara devoted six or seven hours a day. Despite the difficulty of his work of recent decades, it should not be forgotten that the Japanese artist was among the few of any nationality who, in the early 1950s, reacted immediately and compellingly to the horrors of the Second World War, especially the terrible consequences of the atomic bomb attacks on Hiroshima and Nagasaki. The destruction and deformation of the human face found shocking and visionary expression in Kawara's *Death Masks*.

German artist Hanne Darboven (ill. below) produces non-linguistic writings, serially arranged in lines and columns of numbers, letters, and calligraphic motions. Johannes Cladders has aptly described this imagery as "antedating the computer" and as issuing from a "programming office... in which the material is, so to speak, made palatable to electronics." Darboven's endless theme is the course of time, which she treats not only in terms of abstract, encoded formulations which require an index to understand, but in terms of references to actual current events. The works of this major representative of Conceptual Art ascetically radicalize our understanding of painting as writing. In Darboven's oeuvre time is not only represented but subjected to critical commentary by means of enciphered abbreviations, occasionally interspersed with documentary, actual figures and events.

The work of French artist Daniel Buren (ill. above), actually conceptual in thrust, has sparked debates on whether he is really a painter or not. In 1967, on the occasion of the "Salon de la Jeune Peinture", Buren and his friends Olivier Mosset, Michel Parmentier, and Niele Toroni, issued a flyer that listed all the characteristics of painting as traditionally defined. Then, in conclusion, they stated, "...since painting means painting with reference to aestheticism, flowers, women, eroticism, daily milieu, art, dada, psychoanalysis, war in Vietnam, WE ARE NOT PAINTERS." This total rejection corresponded, in positive terms, to a reduction of painting to basic structures. Buren employs alternating bands of color and white, set in regular, impersonal sequences on awning material, plastic sheet, paper or sailcloth.

**Daniel Buren**
Untitled, 1972
Dispersion on striped fabric,
150 x 140 cm
Private collection

**Hanne Darboven**
Request Concert – 144 Poems, 1984
Ink and offset printing on paper, greeting cards (collage),
1008 sheets, each 29.7 x 21 cm (detail). Berlin, Busche Galerie

**Günther Förg**
Untitled (Lead Painting), 1986
Acrylic on sheet lead on wood,
three parts, 120 x 90 cm (each)
Germany, private collection

From a regatta with striped sails on Lake Wannsee in Berlin to a presentation in the museum or the public domain, such works aim at altering and artistically accentuating the environment by means of "painterly" incursions. Buren's space at the 1986 Venice Biennale, like that of his German colleague, Sigmar Polke, justifiably won an award, for it was one of the few highpoints of this artistic miscellany.

A quite different approach is seen in the conceptual painting of Gerhard Merz. The reality of monochrome paint is confronted with the reality of the experience of other peoples and times, lending visual presence to a cultural climate. This is manifested, for instance, in

Merz's provocative juxtaposition of a color chart with popular and frequently cloying images of the Zeitgeist, such as an eagle, nude, flower, or tango dancers. In more recent years the artist has turned to paintings and installations whose rigor recalls Malevich and Mondrian, and occasionally Futurist architecture.

In a similar spirit, if with different aims, Günter Förg (ill. above) contrasts color fields of strict two-dimensionality to reproductions evoking spatial experiences, in works that combine the media of painting, drawing, and photography. Förg also addresses actual spaces, producing installations that reflect the influence of Palermo.

## Purists and Prophets
### Painting by Sculptors and Object-Makers

*"The depiction as illusion – in my opinion this is one of the achievements of European painting, at least in this century."* MARIO MERZ

We should now take a glance at a few important artists who, though they have not devoted themselves primarily to painting, have provided crucial impulses to the medium, and have moreover expanded the border-lines of art itself.

Michael Heizer, with Walter De Maria and Robert Smithson (who died young in an airplane crash), is one of the major representatives of Land Art. This movement, bringing art out of the museum, has left human traces on environments of every description, but preferably desolate, remote places. Examples are De Maria's *Lightning Field* (p. 547), Heizer's *Earthworks* (p. 545), Smithson's *Spiral Jetty* (p. 546), and James Turrell's *Light Crater* in the American Southwest. Heizer is also an excellent draughtsman. As a painter, he admires Matisse and Bonnard. He works on carefully primed canvases using napped rollers to achieve a vibrant interplay of

dense and attenuated textures. Even though Heizer's paintings are done in a city studio, the light and expanse of the landscapes in which he creates his earthworks remain present in them.

Nancy Graves (p. 568) began her artistic activity as a painter before turning to sculpture and objects. Since the 1970s Graves has been painting again. While her three-dimensional works are devoted to discovering and presenting traces of pre-historical eras and lost cultures of the earth, her paintings deal, on the basis of scientific documentation and satellite photographs, with interplanetary spaces. Graves's imagery is a composite of free variations in which topographical elements mingle with abstract passages and graphic improvisations.

Sol LeWitt (pp. 528, 529) is not only one of the major representatives of Minimal Art, but a forerunner of Conceptual Art. In keeping with his realization that

when the idea for a work has formed in the artist's mind and its final configuration is determined, the execution happens blindly, LeWitt has his *Wall Drawings* carried out by assistants. Their work is admittedly checked by reference to the artist's ink drawings, which, as plans, have the same value for him as the finished works.

These linear black and white drawings consist basically of horizontals, verticals, and forty-five degree diagonals, rendered with varying pressure and composed to produce varying densities of surface. The black is supplemented by color variations achieved by systematically mixing the elementary colors of yellow, red and blue, as used in printing processes. Both the colored and black and white drawings are transferred directly to the wall, whose material character, dimensions, and architectural design the artist accepts as integral parts of the image. On the other hand, he is disturbed by the fact of being beholding to the architect, and being dependent to a great extent on the givens of the site.

The work of American Minimalist Richard Tuttle (ill. right), who might be termed a contemporary Precisionist between abstraction and objectivity, draws on elements of painting, sculpture, and object, sometimes in a single work. Plain, unprepossessing materials are employed to produce radically simple yet poetic configurations, a highly abbreviated shorthand for landscape, script, and objects which frequently has humorous overtones. These configurations are attached to the wall or placed on the floor, without frame or pedestal, in arrangements that may appear arbitrary but are actually carefully planned. Formal and substantial correspondences play just as important a role in the arrangement as the precise distance of the objects from one another, their relationship, and finally their composition in space by the artist or according to his instructions.

**Richard Tuttle**
Mountain, 1965
Acrylic on canvas and wood,
116 x 119 cm
Cologne, Museum Ludwig,
Ludwig Donation

## Prophet of a New Sensibility

The dialectical pictorial thinking of Mario Merz (ill. above) is even greater in range. A native of Turin, Italy, Merz became famous as one of the key protagonists of Arte Povera, an art employing common materials whose ordinariness stands in inverse relationship to the intellectual richness of the works. Merz first attracted attention to himself with transparent igloo-shaped constructions whose configuration established a link between exterior form and interior space or content. These pieces had been preceded by intensive early experiments in painting, attempts to go beyond Picasso and beyond the realism-abstraction dichotomy.

Arte Povera, announced Merz, represented an entirely new possibility of creating art. Certain links with Minimal and Conceptual Art were nonetheless evident. Also, Harald Szeemann was justified in including Merz, at documenta 5 in 1972, among those artists who attempt, in highly diverse ways, to establish a link between past and present by creating new myths – what

**Mario Merz**
Painter in Africa, c. 1981
Dispersion and oil on canvas,
neon tubes, 240 x 940 cm
Cologne, Museum Ludwig,
gift of Dr. Reiner Speck

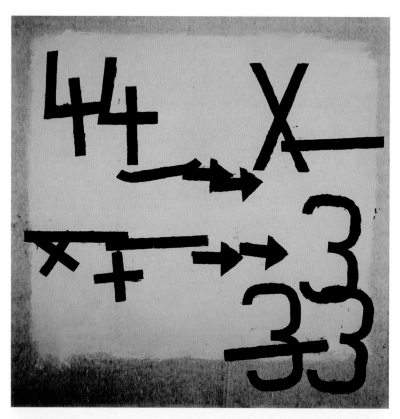

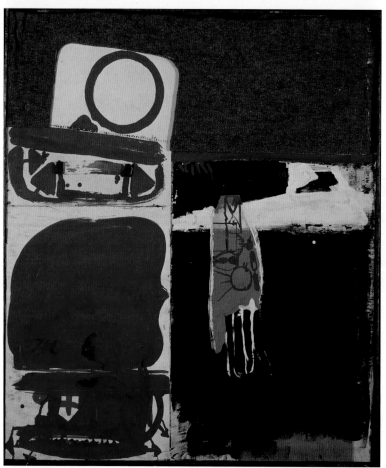

Szeemann termed "Individual Mythologies". But it is only at the point where Merz's work crosses the borderlines of current trends that the intellectual and aesthetic depth of his imagery and objects, based on an invocation of buried, archetypal life forms and forgotten primal imagery, becomes evident.

Merz does not understand avant-garde thinking as a faith in aesthetic progress which is blind to all that has gone before. For him it involves a rediscovery and re-evaluation, in the context of contemporary awareness, of buried myths and insights. These are the building blocks for the artist's models of a new and more humane world in which the powers of the imagination, as opposed to sterile rationality, are again given their due. This existential approach and his belief in the concrete utopia of a liberated society make Merz a kindred spirit with Beuys. They also give him the right to call himself and his confreres the "true Futurists."

Merz's element is not what is dead in the past but what remains vital. This is manifested, for instance, in the numerical progressions of Pisan mathematician Fibonacci (c. 1180–1240), and in the artist's employment of materials such as neon, fruit, and bundles of brushwood. Merz emphasizes that everything he does, including objects and installations, has its source in painting. Just as interior and exterior merge in the igloos, his painting activity, resumed in the mid-1970s, encompasses history and current events, myth and reality, rational thought and vision – but also life and death ("Memento mori," states Merz, "is always ever-present in life"). For him Fibonacci's spiral becomes Ariadne's thread, capable of leading us out of the labyrinth of our social and personal constrictions.

This existential optimism is foreign to the paintings, objects, and static installations of Jannis Kounellis (ill. above), a Greek artist who since 1956 has lived in Rome. Although determined by memory and history like Merz's work, Kounellis's hermetically seals off any path to, or view of, the future. Considering himself a painter foremost, Kounellis is concerned with finding out what images are still possible at this point in time. He attempts to point out the lack of binding values caused, in his view, by the demise of the bourgeoisie and the standards and order it once represented and maintained.

In view of Kounellis's multifarious and ambiguous œuvre – from the painted letters and musical notes to the blind masks, maskings, and montages employing fire, smoke, and lead – it becomes obvious that the theory of the avant-garde as a blithe and optimistic project no longer holds as our century approaches its end. Kounellis's concern takes on visual shape in enigmatic, associative symbolic forms that elude all definition, forms that oscillate between fleetingness and permanence, between being and nothingness. With these Italian artists, political – and poetic – commentary is not merely a footnote to their oeuvre but an integral part of it.

## The Last Utopian

This is true, in an even more fundamental way, of the most outspoken advocate of an expanded definition of art, Joseph Beuys (p. 362 below), who died in 1986. Beuys's personality and work exhibited an exemplary congruence between life and art that was singular in the present period. It resulted from the holistic, evolutionary thinking and feeling of a man who united all the contradictions of our era within himself in an attempt to overcome them, to reconcile reason with imagination, myth with reality, enlightenment with magic, history with the present day.

Space does not permit us to more than touch on the unparalleled career of this draughtsman and painter, sculptor, object-maker, environment, Happening, Fluxus and Action artist, co-founder with Heinrich Böll of the "Free International College of Creativity," this both deeply political and religious man. Beuys's profound, melancholy yet optimistic, very complex and very German artistic activities, whose roots can be traced back to the magic symbolism of pre-history, go far beyond his often-cited predilection for the Gesamtkunstwerk. Beuys envisioned a society, as Peter Iden notes, "in which art would enter a synthesis with and be borne up" by society, "society as a sculpture of humane potentials," just as earlier, Christian thinkers envisioned a community in which art would enter a synthesis with and be borne up by faith.

Beuys's incredibly sensitive work in drawing and painting, straightforward, consciously avoiding virtuosity and sophistication, combining the chthonic with the cosmic, already contained the visual thinking and the design of this "possible world" in a nutshell. Beuys's teacher at the academy, Ewald Mataré, who neither could nor would accept the path his master-student took, once imagined Beuys declaring, "I've had enough of the aesthetic work of art; I'm going to make a fetish." This applies not only to Beuys' sculptures and objects, from *Eurasian Staff* to *Queen Bee*, but to the majority of his drawings and marvellously beautiful watercolors as well. Restrained, with lineatures of hypersensitive fragility traced on commonplace, sometimes scrap papers, these indeed often recall a "footprint in the sand," as Mataré said.

The results of Beuys' study of natural history, his marshalling of totemistic animals (hare, stag, elk, wild goat, raven, bee), nomadic legends, rose and cross, heathen and Christian figures and symbols, anthroposophical astral figurations, shamanistic accoutrements, heat machines, sleds, women in the moors and very contemporaneous demonstrators – all appeared in the drawings, which seemed like preliminary exercises for subsequent work in three dimensions and actions in the public domain, in so far as they were not actually dispassionate, precise notations of intellectual and formal considerations.

The romantically visionary, magically evocative art of Beuys, his charismatic personality and face marked by a war wound and intellectual effort, the logic of all his actions, not only inspired and influenced many of his students and colleagues, but shaped the image of the contemporary German artist in the world's mind.

The traditional border-lines between the genres of art which Beuys broke through, are unlikely ever to grow impermeable again. In a television program after his death, one of the panel members asked what would remain of "Beuys after Beuys," of the transitory portion of his œuvre, which naturally could not be reduced to static pictures or objects.

Beuys himself gave the answer during his lifetime, when he shed doubt on the much-touted "eternal value" of works of art, including his own. In his view, every work he did was a model, a model of an idea. "Because these products," Beuys said, "are really just records, documents, outgrowths of this process of becoming conscious, just as I consider products in general to be outgrowths of thoughts."

A contrast to Beuys's critical faith in the future is seen in the deeply pessimistic formulations of Dieter Roth (ill. above), a painter, graphic artist, object-maker, film-maker, and poet who invokes the transience and insignificance of earthly things. Roth's "Collected Works" comprise many volumes, to some of which he applies the period's favorite four-letter word and its meaning: *Early Writings and Typical Shit, Still More Shit,* etc. The artist's chiliastic mood is also reflected in his choice, for many paintings and objects, of perishable materials (sausage, cheese, chocolate), which are enclosed in glass, plexiglass, or plastic sheet. Unlike Beuys, Roth advances a radical critique of the era and its art which contains no hope for the future. This radical skepticism, however, is implicitly countered by an excellent graphic and painterly œuvre that reveals only little of the melancholy which lurks behind the veil of Roth's sarcasm.

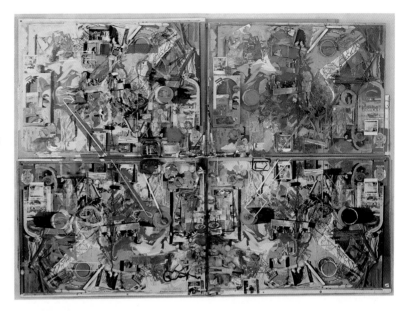

**Dieter Roth**
Untitled, 1976/77
Photograph and mixed media on canvas, 177 x 241 cm
Stuttgart, Galerie der Stadt Stuttgart, Courtesy Galerie Buchmann, Basel

*Page 362 above:*
**Jannis Kounellis**
Untitled, 1959
Oil on canvas, 200 x 200 cm
Munich, Goetz Collection

*Page 362 below:*
**Joseph Beuys**
King's Daughter Sees Iceland, 1960
Watercolor and oil on paper, on felt, under glass, in metal frame, 114 x 98.5 cm
Cologne, Museum Ludwig, Ludwig Donation

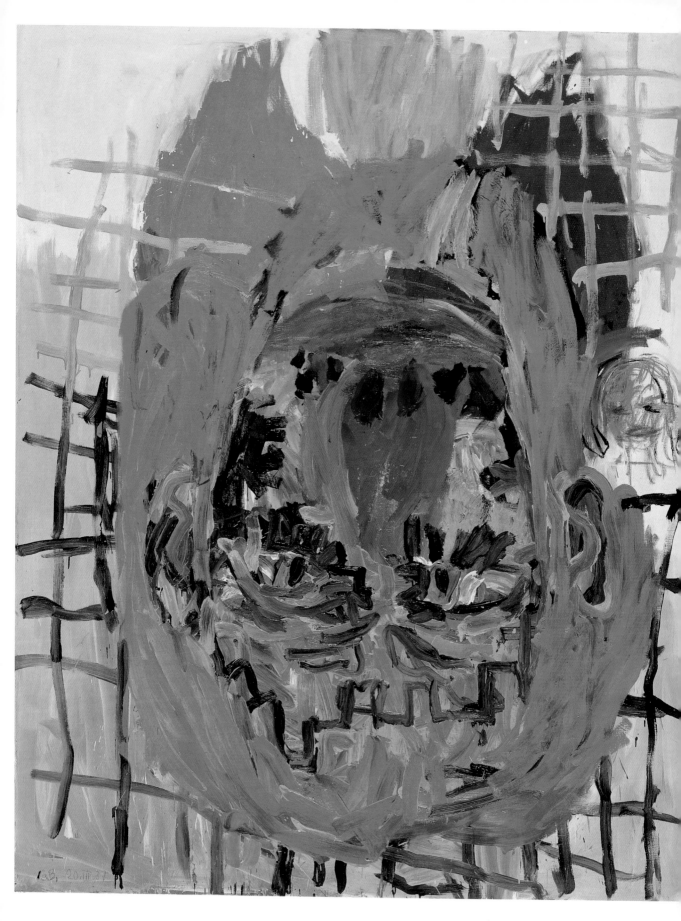

# 13 Beyond Utopia

## Between Vanguard and Reaction
### Painting on the Verge of the Millennium

Beuys was the last utopian in contemporary art, at least for the time being. His visionary thinking reflected an unshakeable idealism which no clash with reality was able to quell. A traditionalist and avant-gardist in one, Beuys both invoked the distant past and prophesied a future determined by artistic sensibility. The barriers have since been rebuilt along the frontiers of utopia; the future is a book with seven seals.

pass was not a rebirth but a rediscovery and further development. Traditional painting found many and talented adherents among the younger generation of artists. In the meantime, the new media have become generally accepted, and the work being done in them has grown a great deal more professional thanks to the example of outstanding artists such as Nam June Paik, Vito Acconci, Jürgen Klauke, Rebecca Horn, Nancy

*"Each work is a whiteness; the conscious recognition of the simultaneous state of a moment filled with longing, anxiety, curiosity, fear, death, the remembrance of every pertinent impetus nameable and unnameable. Friends living and dead, friends I used to know. The disillusionment with their loss."*
JULIAN SCHNABEL

**Julian Schnabel**
L'Heroïne, 1987
Gesso on tarpaulin, 259 x 457 cm
Germany, private collection

In America, liberal and socialist minds have metamorphosed into conservatives. This is a period of adaptation, in which Herbert Marcuse's conception of "repressive tolerance" has taken on new currency under circumstances quite different from the late 1960s. "Wild" gestures, whether understood as such by their authors or not, no longer excite anyone, unless Richard Serra's austere, silent monuments (pp. 541–543) or, in a different key, Jeff Koons's kitsch sculptures (p. 571) can be said to have temporarily disturbed the peace in America or Europe.

The 1980s have been widely described as having witnessed a rebirth of painting. The term is badly chosen, because painting never died. What actually came to

Hoover, Dan Graham, Ulrike Rosenbach, Bill Viola, and many more (pp. 576–619). A naive fascination by the technological trappings of the new media has given way to familiarity, and their employment no longer seems sensational. Film, video, and performance have long since been accepted as welcome enrichments of the artist's methods and tools. No reasonable person would now consider playing them off against painting or sculpture, especially since many performance, video, and film artists also paint and draw with accomplishment (Klauke, Johannes Bernhard Blume) or create objects or environments (Horn, Paik), or like Astrid Klein or Katharina Sieverding are outstanding photographers who incorporate painterly elements in their

**Georg Baselitz**
Self-Portrait Disaster, 1987
Oil and pastel on canvas,
250 x 200 cm
Napa (CA), Hess Collection

**Jürgen Klauke**
Stutter + Stammer/Oblong, 1992
24 parts
Watercolor on paper,
41.5 x 55.5 cm (each)
Düsseldorf, Galerie Bugdahn
und Kaimer

work. By the way, it is striking how great a role women play in the field of the new media.

There was also a further, quite obvious reason for the return to painting mentioned above. This was a certain weariness of the austere purism of Minimal Art and of the intangibility and rarification of the projects of Conceptual Art, with which, incidentally, some of the later wild or neo-expressionist painters had been intensively involved. As in other epochs of art history, this weariness was provoked not so much by the major protagonists of these styles as by the sheer unoriginality and boringness of the work of their countless camp-followers. The story of spontaneous, gestural painting took no different course.

As in the field of the new media, in that of the supposedly new painting the sheep had been separated from the goats by the middle of the 1980s. Whether their work had a neo-expressionist, gestural, or meditative thrust, the best of the young artists ceased to follow well-worn paths, being just as little willing to sacrifice

their intellects to the god of sensuousness as to accept an ideology of progress that degraded avant-gardism to "avant-garditis." The conservative, retrospective character of the dominant tendencies in painting until just a few years ago – from the Italians' new myths to Anselm Kiefer's ambivalent coming to terms with the German past, from Julian Schnabel's decoratively elegant exploitation of variously textured materials (velvet, burlap, carpets, even animal skins) to the banalities of "free figuration" (p. 365) – apparently did not dazzle young artists to the point of forgetting that inertia and endless repetition are the death of art.

### Dead End or New Freedom?

Manfred Schneckenburger, two-time head of the documenta, has aptly described the situation of painting (and its offshoots in sculpture) in the past decade. Speaking in an interview, he said, "Free disposal over every style, or the waiver of style, though weakly evident throughout the 20th century, is now penetrating into uncharted territory … . What we call 'modernism' was essentially determined by two ideas: On the one hand, by the notion of art finding its way back to itself – culminating in [American critic and theoretician] Clement Greenberg's puritan teleology of painting as the self-critique of painting. On the other, by the perpetual opening of art into non-art (slogan: 'art as/is life'), Peter Bürger's leftist theory of the avant-garde. The one path ran linearly and evolutionarily; the other repeatedly subjected art to revolutions. Both paths made it meaningful to speak for 120 years of an avant-garde, both made art appear dynamic and innovative. And both have issued in the static eclecticism of post-modernism – in a dead end, or a new freedom? It is too early to give a diagnosis, let alone a prognosis. But it would also be wrong to overlook the sharpness of the caesura."

A good example of the development is Jürgen Klauke, a definitely vanguard artist whose obsessive drawings, as Werner Lippert notes, express "a mental world interested in findings of sexual identity and their

**Raimer Jochims**
In Memory of Kandinsky,
1991/92
Acrylic on composition board,
96 x 135 cm
Bonn, Kunstmuseum Bonn

communication phenomena," and whose sometimes ironic (*Post-Modernism, Please Like Me, Zweitgeist*), sometimes existentially concerned performances, photo sequences, and paintings represent a salient contribution to an expansion of artistic possibilities. Even an artist with such credentials could say of himself, "I am a classical artist, a traditional artist."

The story of the new expressiveness in art after the Second World War did not begin with the new myths of the Italian "Trans-Avant-Garde," as its prophet, Achille Bonito Oliva dubbed it, or Arte Cifra, as it is otherwise known. Nor did the story begin with the "Wild Painting" of the Berliners or the "Bad Painting" by the bad boys of Mülheimer Freiheit in Cologne, nor even with their idols, Baselitz and Penck. The new expressiveness emerged much earlier, with European and especially German L'art informel of the Tachist brand, and with American Abstract Expressionism or Action Painting.

The Germans in particular – Schultze, Schumacher, Hoehme – never denied their recourse to Romanticism and Expressionism. It must be recalled that in the 1950s, historical Expressionism, all the way to Beckmann, was considered a German aberration on both sides of the Atlantic. Then the formerly so denigrated traits of savagery and irrationalism were rediscovered, and for a time extolled, from Paris to New York and Los Angeles, from Tokyo to Moscow. And again, the pendulum swung back.

There can be no doubt that the magic of Beuys's personality and work helped lead to a revision of prejudices with regard to German art and artists, despite the fact that Beuys was certainly no eclecticist or Neo-Expressionist, let alone a Neo-Fauve or Wild Painter. Still, his œuvre could hardly have emerged anywhere other than in Germany, perhaps nowhere else than in the Lower Rhine region near the Dutch border, a region that has produced many profound minds.

Nor is it perhaps a coincidence that Baselitz and Penck, the two pioneers of the new German expressively gestural painting, like Richter, Polke, Graubner, Uecker, Hoehme and others, came from the former German Democratic Republic. It was there that Willi Sitte, with his Baroque super-abundance, and the earnest Silesian-born Bernhard Heisig (ill. above), with his teeming figurations, not only continued the Expressionist tradition but ramified it in a very personal, individual way. After

**Werner Tübke**
Portrait of a Sicilian Landowner
with Marionettes, 1972
Oil on canvas, 80 x 190 cm
Dresden, Gemäldegalerie
Neue Meister

all, the memory of Expressionism was never entirely expunged during the years after 1945, not even during the period of political regimentation.

Yet Expressionism was taboo in East Germany when Georg Kern from the town of Deutsch-Baselitz (thence his assumed name) came to West Germany in the late 1950s. It was not until the early 1960s that those who toed the political line, Sitte, Heisig, and also Wolfgang Mattheuer (p. 367), the painter of intellectually reflected, mildly surrealist daydreams, and the virtuoso

**Gerhard Altenbourg**
Now Concealed, Now Revealed:
Great Leeway, undated
Mixed media on Bristol board,
97 x 67 cm
Berlin, private collection.
Courtesy Galerie Brusberg, Berlin

neo-mannerist Werner Tübke (ill. above), whose social criticism was schooled on Bosch, Dürer, Mantegna, and Rubens, gained courage and began undermining the ossified principles of Socialist Realism.

This also holds, under quite different artistic premises, for the outstanding painter-draughtsman Gerhard Altenbourg (ill. below), who took his point of departure in Klee. All of these artists – including Penck, who was long influential in Dresden – paved the way for a younger, ambitious generation of East German artists.

When Baselitz arrived in then West Berlin, his teacher became Hann Trier, the Rhineland abstractionist who worked with both hands simultaneously. Baselitz's earlier idols were Corinth and Heckel, but also Ferdinand von Rayski, the great 19th-century portraitist. This list was not a bad basis for the artist who – apart from being a superb draughtsman and printmaker – was to become the prime representative of a gestural, expressive, ostensibly new painting which had strong and never-denied roots in tradition.

### In the Beginning was Scandal

Yet before he became prominent, Baselitz first had to cause a bit of a scandal. In 1961, together with his artist-friend Eugen Schönebeck, he issued a first "Pandämonium" manifesto, followed by a second a year later, and proclaimed the advent of the age of "Pathetic Realism." At this period emerged truly savage paintings in an expressive and provocative semi-realist style, blasphemous and frankly obscene: *The Big Night Flushed* (1961; Cologne, Museum Ludwig), *Christmas* (1964; Cologne, Museum Ludwig), *The Hand of God* (1964/65; Bonn, Kunstmuseum). These violent works were done in protest against an abstraction grown sterile and academic, but even more, they pilloried the pride and prudery of Germans under the Economic Miracle. The moral reaction was not long in coming. *The Naked Man* (Berlin, Kleihues Collection) and *The Big Night Flushed* – a grotesquely deformed depiction of an adolescent with oversized head and monumental penis – were confiscated by the police, who released them only after a two-year long court case. It is unfortunate that Baselitz later distanced himself from his early, explosive paintings, saying he considered them "too pubescent."

**Georg Baselitz**
Night Meal in Dresden, 1983
Oil on canvas, 280 x 450 cm
Zurich, Kunsthaus Zürich

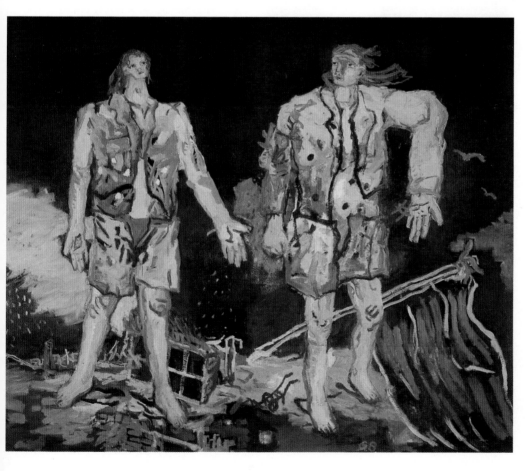

*"The art-work comes into being in
the artist's head, and it stays in the
artist's head. There is no communi-
cation with any public whatsoever.
The artist can ask no questions, and
he makes no statement; he offers no
informaion, message or opinion. He
gives no help to anyone, and his
work cannot be used. No social or
personal situation will govern,
influence, prevent or make
inevitable, the end product."*
GEORG BASELITZ

**Georg Baselitz**
The Great Friends, 1965
Oil on canvas, 250 x 300 cm
Cologne, Museum Ludwig,
Ludwig Donation

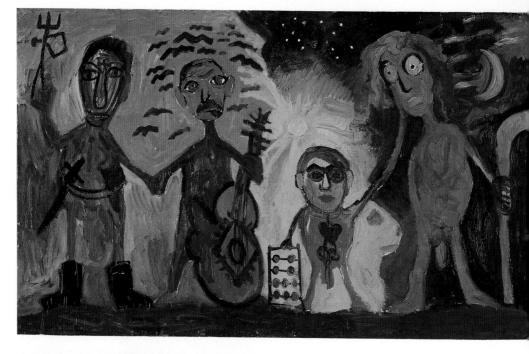

**A. R. Penck**
Untitled (Group of Friends),
1964/65
Oil on composition board,
170 x 275 cm
Cologne, Museum Ludwig,
Ludwig Collection

**Georg Baselitz**
The Forest Upside-down, 1969
Oil on canvas, 250 x 190 cm
Cologne, Museum Ludwig,
Ludwig Donation

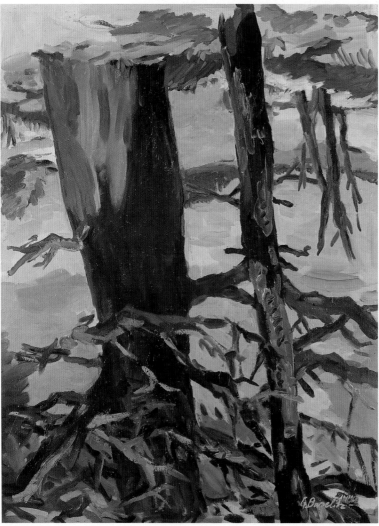

Yet of course the rebelliousness and spontaneous anger of youth cannot be conserved. It is understandable that the artist ultimately made painting for its own sake, regardless of motif, his principal theme. In order to prove that a well-painted picture remains just that even if you rotate it through 90 or 180 degrees, Baselitz, as everyone knows, began to turn his figures and landscapes upside down. But what was initially a baffling move, a programmatic demonstration, in the long run became rather routine, not always to the advantage of an on the whole impressive œuvre. Baselitz is a superb technician, a master of differentiation and variation, based on an alternation of cool and warm colors, condensed and loosely rendered passages, painterly drama and tranquillity. The key difference between his imagery and abstraction consists in his retention of subject-matter, as a structural element and as a means of control, to prevent the image from slipping into a mere, arbitrary pattern. In the meantime, Baselitz has tried doing without the spectacular headstands of his figurative and abstract elements. The experiment has produced a number of compelling images which seem to indicate that he has no intention of resting on the laurels of his international fame.

A.R. Penck emigrated from East Germany twenty years after Baselitz. Influenced by Rembrandt and van Gogh, Penck also came under the spell of Expressionism early on. This is seen in his ghostly and ironic depiction of a group of friends (ill. above), including Wolf Biermann, Jürgen Böttcher, Baselitz as a specter, and the artist himself, with Picasso's head on a gnomish body. Apart from the obviously Expressionistic features of brilliant coloration and grotesquely distorted figures, forms that would become characteristic of Penck's subsequent work already appear – anticipations of a picto-

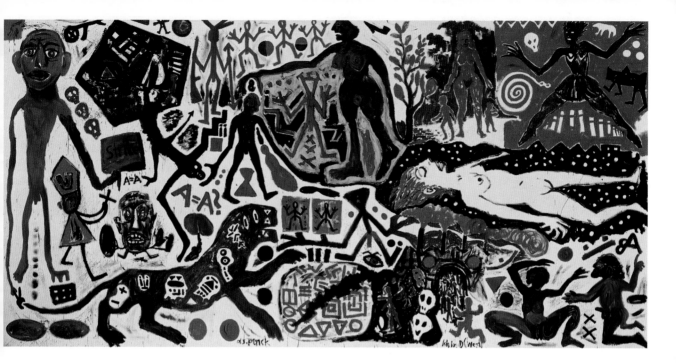

graphic idiom of a part pre-historical and archetypal, part technological nature. These reflect the autobiographical references so important to Penck (a pseudonym adopted from the name of a 19th-century scientist), as well as the diversity of his interests, from philosophy, poetry, theater, dance and music to technology and its information systems. Not least, the symbols embody Penck's ambitious endeavor to create a symbiosis of rationality and irrationality, logic and imagination, which would find expression in the following, analytical "System" and "World" paintings, and especially in the artist's attempts to set objective "Standards." In 1978, looking back on his own development – and probably on that of his namesake – Penck, writing under still another in a series of pseudonyms, Ypsilon, declared the attempt to create a universal language of signs a failure. Yet the validity of the steps on the path towards his unreachable goal was not denied. For Penck, as for many of today's artists, there is no one, definitive style, nor does he have any qualms about eclectically exploiting history and art history. In this sense his work is clearly the product of a late culture and its existential doubts. The pitfall Penck faces is the tendency, seen in recent years, for his enigmatic pictographs to slip into mere decorativeness, patterns on the wall.

Jörg Immendorff, who met Penck in 1977 and launched German-German art activities in collaboration with him, has long developed beyond the one-dimensional, narrowly leftist ideology conveyed by the neo-primitivism of his early years. Yet this has deprived his work of none of its polemical force, having only added to the substance of Immendorff's critical involvement with German history and its oscillation between hope and despair. Combining a narration of personal experiences with references to historical situations and events, the artist's paintings and sculptures link anecdote with symbolism and allusion in a graphic and immediately appealing style in which even grotesque exaggeration is wholeheartedly accepted. One of Immendorff's major projects, a momentous series on the theme of *Café Deutschland* (ill. below), while inspired by Guttuso's *Caffè Greco* (p. 207), expands its theme and applies it in a bitter and disillusioned way to the division of Germany, and by allusion to the division of the world into East and West, and the deformation of thinking to which it led.

**A. R. Penck**
Me, in Germany (West), 1984
Dispersion on cotton,
600 x 1200 cm
Cologne, Museum Ludwig,
Ludwig Collection

**Jörg Immendorff**
Café Deutschland I, 1978
Acrylic on canvas, 282 x 320 cm
Cologne, Museum Ludwig,
Ludwig Collection

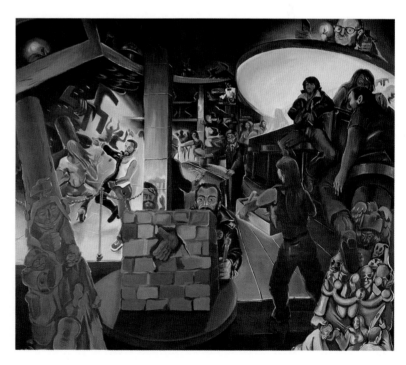

**Anselm Kiefer**
Eco Niches, 1992
Plants, clay and emulsion on
canvas in glazed steel frame,
170 x 520 cm
Cologne, Museum Ludwig,
Ludwig Collection

*"All of painting, but also literature
and all that goes with it, is merely a
process of going round and round
something inexpressible, round a
black hole or a crater whose center
one cannot penetrate. And those
things one seizes on as subject matter,
they have merely the character of
pebbles at the foot of the crater - they
mark out a circle which, one hopes,
draws ever closer to the center."*
ANSELM KIEFER

### Nibelungs Never Die...

Anselm Kiefer, too, concerns himself intensively with
recent German history and its fallacious myths. Yet for
him, this history reveals aspects very different from
those addressed by Immendorff. It is rooted in myth,
based on a diffuse ideology derived from realms far dis-
tant in space and time, and marked by their irrational
invocation. Kiefer does not rely on eye-witnesses or
records, but attempts to come to terms with the fascina-
tion of the evil and irrational, including their sources, by
conducting his own personal investigation, in which a
capacity for empathy plays a key role.

In 1970 Kiefer began a series of heroic landscapes
and heroically symbolic subjects, followed by studies
devoted to Richard Wagner, the Nibelungs, and Parsifal.
These complex themes were translated into imagery of
a compelling and evocative pathos whose ambivalence
and open-endedness left much room for the viewer's
own personal associations. Ultimately these canvases
evoked the intextricable bond between positive and
negative, good and evil. Kiefer's series on the theme of
*Scorched Earth*, his heroic interiors (*Parsifal*; London,
Tate Gallery), and countrysides infused with history like
*Sand of the Marches* of Brandenburg (ill. below), have a
symbolically charged subjectivity that permits of various
interpretations. Only rarely in recent art has an immedi-
ate, historical reference been stated so clearly as in the
artist's depiction of *Operation Sea Lion*, the planned but
never implemented German invasion of Great Britain,
preparations for which Kiefer has take place in a bath-
tub.

One cannot always be certain about what dominates
in Kiefer's work – whether he is more overwhelmed by
pity and regret, or by the power of myth and the irra-
tional. His paintings, incredibly dense in texture and
executed in unconventional combinations of materials
(emulsion, oil, acrylic, shellac, epoxy, sand and straw),
are thus subject to misunderstanding, especially in the
current climate of a simplistic historical revisionism in
Germany.

**Anselm Kiefer**
Sand of the Marches, 1982
Sand and oil paint on paper,
330 x 556 cm
Amsterdam, Stedelijk Museum

**Anselm Kiefer**
Margarethe, 1981
Oil and straw on canvas,
280 x 380 cm
Formerly Saatchi Collection,
London

The seriousness of Kiefer's deeply thoughtful, complex, and very German painting, and the outstanding quality of his œuvre as a whole, cannot be doubted. Nevertheless, in face of his imagery, one is inadvertently put in mind of playwright Heiner Müller's laconic and hardly controvertible statement, "Germany is still playing the Nibelungs."

A quite different thrust, if one not without its own evocative magic, is seen in the work of Horst Antes (ill. right), who is six years Kiefer's senior. Antes's reputation was established by his "cephalopods," human figures condensed into heads and feet, which he depicted in a long series of variations. Like his subsequent, formally and technically much more stringent gabled houses of the 1960s, Antes's figures convey an underlying, subtly stated metaphysical message. His detachment from figurative realism, among whose first representatives in Germany Antes was in younger years, became obvious at the latest in the strange, dwarfish creatures with usually super-posed eyes in over-large heads, which he depicted until the early 1980s.

These figures have since vanished from Antes's work, despite his later, very intensive involvement with the magical, spiritualized heads of Javlensky. Yet he does reply, as if in counterpoint, to the Russian artist's imagery, with reduced, geometric shapes derived from house walls and roofs. Antes's intellectual and aesthetic stance is also reflected in his collecting activity, which ranges from mundane objects like school primers and milk jugs to the art of the indigenous peoples of America and Australia.

## "I am the People that Paints!"

Even before the 1970s were out, Berlin artists organized a "Biennale" exhibition to protest against the lack of attention their work was receiving, because it ran counter to the mainstream trends on the German and international art scene. Their eloquent spokesman was Markus Lüpertz (p. 374 below). Those politically if not artistically wild years witnessed a debate at the academy

*"I have always been interested in surfaces – once could call them synonyms for something. … Reality never interested me. I put my expressiveness into my painting and made a specific fantasy visible. I aim for meaningless, cold painting."*
MARKUS LÜPERTZ

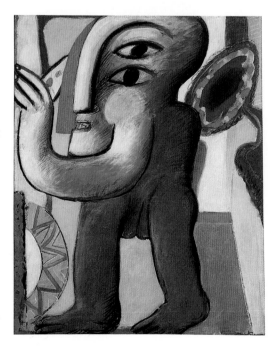

**Horst Antes**
Blue Figure: St. Francis of Assisi,
1961–1964
Oil on canvas, 100 x 80 cm
Private collection

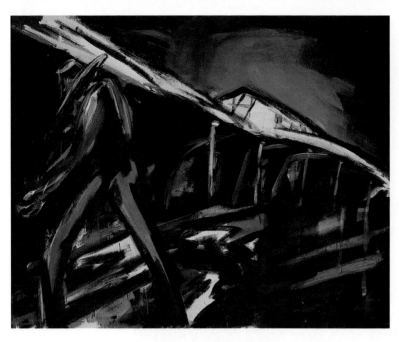

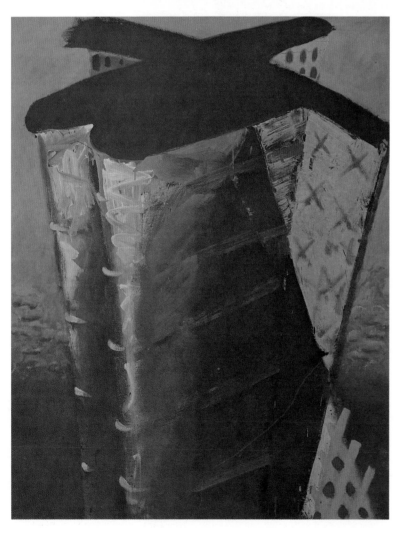

in which Lüpertz' colleagues, styling themselves representatives of the people, polemicized against the ostensible "crypticness" and "elitism" of contemporary art. Lüpertz replied with the unanswerable declaration, "I am the people that paints!" Shortly thereafter Lüpertz's work began to receive national and international acclaim.

Lüpertz' statement reflects the fact that he has worked as a miner, streetsweeper, wrestler, and soccer player. His self-confidence is unmistakably reflected in his style, which he terms "dithyrambic." Though not wild – Lüpertz dislikes being described as a prominent forerunner of the Berlin "vehement" painters or Neo-Fauves – his painting is suffused by an untragic, euphemistic pathos and a great vitality of attack, and yet it also shows an amazing sense of compositional balance and differentiation of color values. For Lüpertz art takes place on the surface without the aid of materials other than paint, which only load down the image. This is why he will have no truck with Kiefer's straw or Schnabel's crockery sherds. Nor do particular motifs have any intrinsic meaning for Lüpertz. They merely provide him with an occasion for the act of painting, which is basically his sole theme, despite his occasional quotation of events in history or art history. Though a brilliant speaker and debater who has no qualms about extolling himself and being extolled as a "master," Lüpertz is equally candid about his debts to other artists, such as the retiring Werner Gilles, about whom Lüpertz has written a book.

Karl Horst Hödicke (ill. right)) had an enormous personal and aesthetic influence on the development of "vehement" painting in Berlin. He worked intensively in the drawing medium, made films, involved himself with Dada, Neo-Dada, Décollage, Pop Art, and Neo-Realism before deciding to concentrate on expressive painting. Hödicke's artistic intelligence, and a mastery of craft gained through tireless experimentation, have proven to be immensely stimulating to younger artists. Despite certain weaknesses in the primitivistic paintings of recent years, his work, both topical and retrospectively involved with history and myth, represents an outstanding contribution to German contemporary art.

It cannot be denied that most of the Berlin painters around Hödicke were politically abstinent by comparison to their immediate predecessors, the critical "Berlin Realists." A more aggressive and cynical approach, far from political utopianism if not without overtones of Bloch's principle of hope, is seen in the work of the brothers Albert and Markus Oehlen (ill. right), Werner Büttner, and Martin Kippenberger ( ill. right). The former band musicians, who also share literary ambitions and witty, acerbic painting titles in common, reject autonomous painting as an end in itself, and address topical subjects and issues of contemporary society. They thus continue a tradition that extends from William Hogarth and Goya to Beckmann's ambiguous pictorial parables.

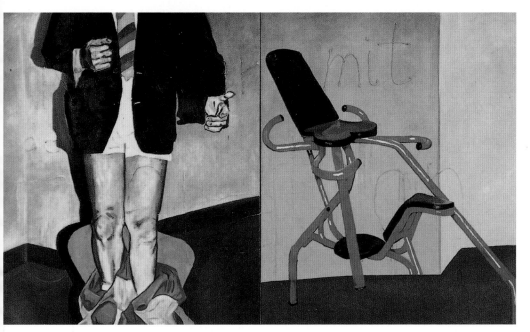

*Page 374 above:*
**Rainer Fetting**
Van Gogh and El Train, 1978–1981
Acrylic on canvas, 200 x 250 cm
Collection of the artist

*Page 374 below:*
**Markus Lüpertz**
Babylon Dithyrambic I, 1975
Oil on canvas, 162 x 130 cm
Eindhoven, Stedelijk van Abbe
Museum

**Martin Kippenberger**
Down with Inflation, 1984
Mixed media on canvas,
160 x 266 cm
Germany, private collection

"Truth is Labor" was the illuminating title of a joint exhibition mounted by Büttner, Kippenberger, and Albert Oehlen in the mid 1980s. Though they still fundamentally adhere to this attitude, the improved quality of their painting in recent years indicates that craft no longer plays a subordinate role.

Among the former members of the Cologne group "Mühlheimer Freiheit," Czech artist Jiri Dokoupil was long the most fascinating figure before withdrawing from the limelight. A good soldier Schweik with a paintbrush, Dokoupil has a chamelionlike ability to change his palette, forms, and media seemingly overnight. Walter Dahn, another member of the group, has shown more consistency. His breakthrough with vehemently painted if sometimes rather obvious imagery was followed by a much more considered phase marked by intense, frequently experimental investigation into the means of painting and its themes. Increasingly sensitive and variable, Dahn's work indicates that for all its modernity, it stands in the Romantic tradition which reached its aesthetic and intellectual culmination in Caspar David Friedrich.

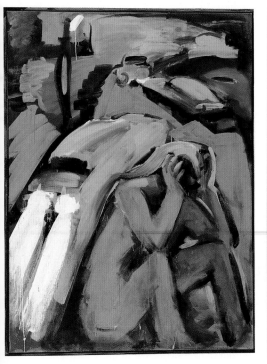

**K. H. Hödicke**
Melancholy, 1983
Synthetic polymer on canvas,
230 x 170 cm
Nuremberg, Kunsthalle Nürnberg

**Albert Oehlen**
Untitled, 1988
Oil on canvas, 187 x 137 cm
Germany, private collection

*"I need something to paint about.
I can't paint from nothing."*
PER KIRKEBY

**Per Kirkeby**
Untitled, 1983
Oil on canvas, 200 x 350 cm
Napa (CA), Hess Collection

**Sandro Chia**
L'Ammazzapreti, 1983
Oil on canvas, 160.6 x 180.3 cm
Private collection

More significant on the international scene, and more typical of the oscillation of contemporary art between skepticism and an utopian, spiritual vision, are the work and personality of Danish artist Per Kirkeby (ill. above). Not only a painter and sculptor, Kirkeby is also an essayist, novelist, film-maker, and even Arctic explorer – the quintessence of a late Alexandrian personality. The remarkable thing about his painting œuvre is that Kirkeby's admiration for great masters of the past such as Turner, Poussin, and Monet provides a catalyst for his painting without leading to eclecticism. "Paint-ings are always a strange reproduction of other paint-ings," he says, and one might add, on a higher turn of the spiral. It is astonishing to see how Kirkeby's coloris-tically sophisticated, light-flooded, structurally highly differentiated mature approach engenders a sort of "sec-ondary nature," suffused with nature's extreme, chang-ing moods yet nonetheless highly artificial in the best sense of the term.

## Stylelessness as a Principle

The Italian movement known as Arte Cifra was likewise a reaction to the previous phase, in more than one sense of the word. One of its leading representatives, Sandro Chia (ill. below), summed up the process as follows: "From 1972 to mid 1975 I did something different – magic conceptualism, an attempt to get to the roots of the creative phenomenon. I wanted to find the zero point at the bottom of the creative process. But zero doesn't exist. Zero is a fiction.... When I started to paint again in 1975, it was a complete new beginning. I felt like someone recuperating from an illness." Similarly, Enzo Cucchi (p. 377 below) definitively renounced a belief in artistic progress when he stated, "We are pre-historical."

Cucchi distanced himself from what he called the "conceptualistic approach" of German artists and their "problem of historical retrospection," as seen in Kiefer's work. Yet he also distanced himself from America, say-ing it was "still much too young" to possess a memory, which for Cucchi is a necessary part of the process of image-making. As he sees it, history is "a memory. Memory comprises recollections.... This does not nec-essarily mean we have to take history literally.... I prefer legend.... Yet I understand what is behind this devotion to myth and history [on the part of artists such as Kiefer]: it's Europe.... The last word on painting will not be spoken by America, but by the 'Old World'..."

If we add a clear affirmation of subjective feeling, a dislike of "too much intellect" in painting, and finally the rejection of a consistent or binding style –"Inconsistency, your style is art," says Chia – we have pretty much listed the motives behind post-modernism. History becomes a grab-bag to dip into, eclecticism a principle. Art with a moral message, such as Arte Povera, is considered repressive and masochistic. The sensations experienced in the labyrinth of one's own inner being, and a subjective, private interpretation of history and mythology, become the central theme of the trans-avant-garde. Painting is sufficient unto itself.

It need no longer justify either itself or the new symbolism of its idiom: "The fall of the sacred social [orientation] corresponded to a rise of the ego...," states Germano Celant. "The 'correct' place becomes the private realm, the privileged precinct of an inner monologue, where needs become facts."

The conservative thrust of this change in attitude is obvious. Artist's replies to the visual pollution of our environment are no longer formulated in rigorous, aesthetic terms but in imagery of a highly personal and enigmatic nature. "This painting," wrote Ingo F. Walther about a *Picture sans Title* by Francesco Clemente (p. 378 above), "seeks no link with the external world; rather, it reflects the painter's inner realities." The pitfall of this neo-expressionist approach, which achieved rapid success, consists in its banalization of what is by definition significant, which occasionally takes it over the border into the superficially decorative.

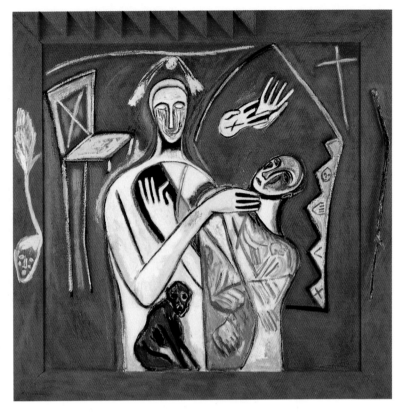

**Mimmo Paladino**
Tango, 1983
Oil on canvas, with painted frame
and assemblage, 143 x 143 cm
Private collection

*"Every day a painting explodes over the earth and on the shore a feeling rises and falls with the waves flows onwards and breaks upon the land."*
ENZO CUCCHI

**Enzo Cucchi**
Un sospiro di un onda, 1983
Oil on canvas, 300 x 400 cm
Courtesy Galerie Bruno
Bischofberger, Zurich

**Francesco Clemente**
Untitled, 1984
Oil on canvas, 274 x 477 cm
Private collection

Mimmo Paladino (p. 377 above) and Nicola De Maria do not deny their experience in abstract and conceptual art in their paintings, objects, and installations. De Maria's sensitive works and Paladino's intelligent play with metaphors are based on a much more complex and controlled conception than the approach of their countrymen. Their multifarious, highly associative imagery, combining references to concrete situations with fantastic, sometimes archaic formulas and mystical

**Miquel Barceló**
El Paseillo, 1990
Mixed media on canvas,
203 x 303 cm
Private collection. Courtesy
Galerie Bruno Bischofberger,
Zurich

recollections, is not readily classifiable in stylistic or substantial terms.

This statement also holds, if in a different way, for the neo-expressionist painting of the younger generation of Spanish artists. The death of Franco occasioned a turn to a specifically Spanish version of international trends, but not to a denial of national traditions. The majority of younger Spanish painters share a tendency

to figurative expressionism, and to multi-layered painting grounds fraught with symbolic signs and mythical allusions. The influence of Miró and Tàpies is evident in terms of style and themes, while in terms of approach, Pollock's gestures and the materials of Arte Povera play a key role. The pictures of Frederic Amat, Miquel Barceló (ill. below), and the abstractionist José Maria Sicilia are marked by energetic attack, while Chema Cobol practices a rather overladen expressive surrealism, and signs and figures dominate in the canvases of artists such as Victor Mira, García Sevilla, Guillermo Paneque, and – in a more reserved, somewhat ennervated way – in those of María Gomez.

Unlike the Italians, Spanish and Germans, Frank Auerbach, a Berlin-born artist who lives in London, was not an initiator of the neo-expressionist wave. Rather, his work was overtaken by this development, which finally opened the eyes of people outside England to the specific qualities of Auerbach's painting. Inspired by late Expressionism, his landscapes, portraits, and figurative compositions are executed in heavy impasto, in a limited range of subtle gradations occasionally punctuated by more brilliant, even searing tones, applied with sweeping, spontaneous strokes of palette knife or broad brush. "Painting," says Auerbach, "is... a moral act."

In his early paintings an affinity with American Action Painting, above all with De Kooning, was just as evident as the influence of Auerbach's great idol, Soutine, his admiration for de Staël, and his involvement with Giacometti and, not lastly, with Francis Bacon. Auerbach's paintings are based on impassioned, thoroughly worked-out drawings, whose black lines, he says, signal the colors to be used in the ensuing painting.

In terms of attitude and attack, the work of Leon Kossoff (p. 379 above), the son of Russian emigrés living in London, bears similarities with that of Auerbach. Places in the British capital are among Kossoff's themes,

as are pictures of people which, at first glance, recall
those of the Expressionists. Yet on closer scrutiny we
realize that the figures, as David Sylvester notes, do not
play a role assigned them by the artist. For instead of
being characters, they are creatures that are there only to
be looked at, painted in matte, opaque colors suffused,
here and there, by an accent of illumination.

## Aggression and Self-Exploration

Quite different sources from the subjective mythologies
of the Italians and the process-oriented gestural
approach of Scottish artist Bruce McLean (p. 380) are
tapped by Maria Lassnig (ill. below). Devoted to an
exploration of self, and the body which is its vessel, the
Austrian artist's very original work has run counter to
current tendencies and only recently been accorded the
attention it deserves. Lassnig's specific form of "body
art" has nothing in common with happening or Fluxus,
performance, or Body Art per se. She has never been
tempted to abandon painting for one or the other cur-
rent trend or fad. (The relatively realistic phase she
passed through during a stay in America was a tempo-
rary exception.) Lassnig's approach, long rather restric-
tively defined by her own term "body awareness," can-
not be called egocentric in the popular meaning of the
word, despite, or perhaps because of the fact that she
makes herself an object of study. Lassnig's special ego
trip is undergone by proxy, because her profound explo-
ration of self is designed to communicate what she dis-
covers to others. Her personal experiments are simulta-
neously investigations into the issues of painting, espe-

**Leon Kossoff**
School Building, Willesden,
Spring 1981, 1981
Oil on hard board, 136 x 166.4 cm
Formerly Saatchi Collection,
London

cially into the complex question of how mental and
emotional experience can be conveyed in visual terms.

Lassnig's palette continually tends towards grey, the
universal color that contains all others. Yet paradoxi-
cally, her figures appear not precarious and complex, but
forceful and evocatively symbolic. The chain of tradition
that extends from the self-confident self-portraits of
Velázquez, Munch, and van Gogh, through van Gogh's

**Maria Lassnig**
Samson, 1983
Oil on canvas, 200 x 133 cm
Private collection

**Frank Auerbach**
The Studios, 1996
Oil on canvas, 50.8 x 61.3 cm
London, Marlborough Fine Art

tormented self-portrait with severed ear, to Lassnig's own crouching, grotesquely distorted figure, is no imaginary ancestral gallery. It is an indication of spiritual affinities, and as such, gives ironic, hybrid evidence of the artist's own – female – self-confidence. Although long befriended with Arnulf Rainer and closely associated with the early Austrian avant-garde around the legendary Monsignore Mauer, Lassnig has inspired no school, though she has provided crucial stimulus to younger Austrian artists like Hubert Schmalix, Siegfried Anzinger, and Erwin Bohatsch. In Herbert Brandl's work, the spontaneous painting act and a detachment from his own activity blend in an intelligent way which is without direct predecessors.

### The Dialectics of Life and Death

The work of Arnulf Rainer holds a special place not only within Austrian art but within European art as a whole. It has repeatedly been directly linked with L'art informel and Tachism, perhaps because of the "perspectives of destruction" which followed Rainer's beginnings in Fantastic Realism and which evinced a dissolution of

form and fine articulation of the picture plane reminiscent of these styles.

But there is a deeper layer in Rainer's work, represented by the gesturally expressive *Übermalungen*, or over-paintings, begun as early as the first years of the 1950s (p. 381 above). These set the thorough bass that runs through his œuvre: the dialectics of life and death. The image was obscured, destroyed, in order to bring to light something new. In the dark, sometimes jet black overpaintings, in which a deep blue occasionally seemed encaged, a narrow zone of light shone through – a source of illumination, or its last refuge? "Everything depends on this small remainder," the artist says.

The contained, masochistically restrained expressiveness of these formulations oscillates between a "burial" or "drowning" of painting (Rainer's words) and its rebirth in an awareness of death. The result is a mood of meditative calm, the complement of a deep-seated existential anxiety. Grünewald's *Isenheim Altarpiece* is the past work of art that has impressed Rainer most. The crucifix became one of his early basic forms, the cross understood as "an abbreviation for the human face," a theme that has fascinated 20th-century artists from Javlensky and Mondrian all the way down to Newman and Rothko. Faces, both his own and the grotesque heads of neoclassical sculptor Franz Xaver Messerschmidt, the demonic masks of Hieronymus Bosch, the distorted faces of Goya's victims and madmen, the merciless self-portrayals of Rembrandt and van Gogh, the grimaces of the mentally ill, even death masks, have followed Rainer throughout his career. His obsessive gri-

mace paintings compellingly evoke a despairing expressiveness, an existential anxiety which has frequently, if mistakenly, been religiously over-interpreted in terms of a negative theology.

Rainer's expressiveness has little in common with gestural abstraction or Action Painting, for he never entirely reveals his inmost self. The over-paintings and *Zumalungen*, or total over-paintings, he says, "are not abstractions, but my disguises, or, as it were, a psychophysical reproduction." Rainer's œuvre spans the poles of resignation and aggression, sadness and anger, concealment and disclosure, ranges from the self-castigating control of a passionate temperament seen in the early monochrome imagery to the unleashed, explosive gesturalism of the brightly hued, if not always entirely convincing recent work. As Armin Zweite points out, this is an artist who articulates "the problem of the individual in contemporary society, his lack of ties, his helplessness and despair."

The Viennese movement known as "Actionism," especially the *Orgy Mystery Theater* of Hermann Nitsch (p. 380 above and p. 585), is ultimately rooted in Austrian Catholicism. Its celebration of black masses, with their suspenseful combination of heathen and Christian elements, perhaps represent Austria's most important contribution to contemporary art, second only to Rainer's work. It should be noted that Nitsch, author and director of his highly individual Gesamtkunstwerk, also considers himself a painter, and the relics of his activities to be paintings in their own right.

When we recall that Dionysus was not only the god of ecstasy and revelling, but the god of tragedy and death, we might be justified in calling Swiss artist Mar-

tin Disler a Dionysian painter (p. 382). Disler works at night, listening to music. His gestural approach owes much to Pollock and to European Tachism, "due to its structure, its frenzy, and perhaps also due to *one* of its roots, which lies in psychoanalytic symbolism," as Dieter Koepplin points out. In Disler's paintings and drawings love and death mingle. Despite the artist's reflective detachment, certain autobiographical references do appear. The frenzy of his brushwork is a painterly expression of deep existential unrest.

Like Rainer's work, the drawings and paintings of Walter Stöhrer (p. 382) have been associated with Tachism and L'art informel. At the most this holds only for his early style, which was inspired by the gesturalism of Schultze, Brüning, or Götz. What distinguishes Stöhrer from the majority of his contemporaries who work in an expressive, spontaneous vein is a combination of sweeping brushwork with graphic precision, explosiveness with control, temperament with a fine sense of form. This combination is the result of an unusual capacity for concentration, trained by the Grieshaber student's practice in the dry-point tech-

**Arnulf Rainer**
Michelangelo, 1967
Oil on synthetic sheet, 118 x 88 cm
Napa (CA), Hess Collection

**Arnulf Rainer**
Macrocosm, 1994/95
Oil and appliqués on textured
cardboard, 102 x 73 cm
Courtesy Galerie Ulysses,
Vienna

LITTER AND BIN

**Martin Disler**
Untitled, 1980
Acrylic on cotton, 172 x 256 cm
Private collection

**Neil Jenney**
Litter and Bin, 1970
Acrylic and pencil on canvas,
155.6 x 159.4 cm
USA, private collection

nique, which permits of no corrections or second thoughts. Stöhrer's work evinces a quite unique counterpoint between dynamic swaths of paint, graphic lineatures, and quotes from texts in which painting becomes calligraphy. Series and cycles of canvases are the underlying principle of his oeuvre, for, as the artist says, "I see paintings, too, in terms of sequences. I think that you cannot even view one painting independently of the next."

The gestural art of French painter Eugène Leroy (p. 383 above), which was only very belatedly discovered, reflects none of the obsession with self-exploration seen in the work of younger artists. Leroy, born in 1910, has spent most of his life in Lille. It was not until 1992, at

documenta 9, that the world became aware of the mastery of his apparently gestural abstractions. Though it is going too far to maintain, as Jan Hoet did, that Leroy's work is "painting in the sense of a Titian or Giorgione," his gestural expressionism is truly not an end in itself. Rather, it is always based on some real subject, be it figure or landscape. The real is mingled with the unreal frequently to the point of indistinguishability, with an emphasis on the paint material itself and its dynamic movement which has increased as Leroy's career has progressed. Still, the subject remains a concern even in his late work, which includes self-portraits admired by many younger artists such as Baselitz.

**Walter Stöhrer**
Untitled, 1984
Mixed media on paper,
78 x 54.5 cm
Germany, private collection

**Susan Rothenberg**
Untitled, 1979
Acrylic and glossy enamel on paper, 107.3 x 76.8 cm
Private collection

**Jonathan Borofsky**
Canoe Painting at 2.491.537,
1978
Acrylic on composition board,
two parts, 235 x 150 cm
Formerly Saatchi Collection,
London

**Eugène Leroy**
Green, 1963
Oil on canvas, 161.5 x 129.5 cm
Private collection

## Critique and Submission

There is more than one way to make art, more than one way to live and be happy, says American artist Jonathan Borofsky (ill. above left). Known for his early paintings, but even more for his monumental and ironic installations and figures, Borofsky's ideology is undogmatic openness. He takes ideas wherever they offer themselves, in Magritte or Fellini, Dalí or Disney, Pop or Conceptual Art, reality or dream, childhood experi-

Neil Jenney (p. 382 above) began, as one of the first representatives of American "New Image Painting," to translate real and Pop Art elements, and an as yet sparing figurative iconography, into a highly charged painterly approach. This set the stage for the expressively symbolic and metaphoric style of Louisa Chase, the pictorial signs of Susan Rothenberg, and the enigmatic picture-narratives of David Salle with their multifarious mixtures of styles and moods.

**Nancy Spero**
The Black and the Red III, 1994
Handprint and collage on paper,
panel 15 and 16 (of 22),
49.5 x 245 cm (each)
Munich, Barbara Gross Galerie

ences or adult confrontations with mass society. An intelligent, virtuoso eclectic, Borofsky believes that borrowing something from other people means learning something from them. His work, rich in figures and allusions and stories, has long since broken through the boundaries of painting and expanded into an effectively staged, as it were static theater, which the artist associates with a "magic circus." His sometimes surreal phantasmagorias are based as much on actual experience as on the projection of inner sensations outwards.

Rothenberg's paintings and drawings (p. 382 below) hold an ambiguous balance between personal expression and objectified form, between Cézanne, to whom she owes the spontaneity of her notations, and the Expressionists, whose concise, agitated lineatures she subjects to intellectual control – a woman artist exploring the potential of diverse styles and epochs.

The key theme of David Salle (p. 384 above), who is a few years younger than Rothenberg, is the human, especially the female, figure. In the footsteps of Picabia and

**David Salle**
Pink Teacup, 1995
Oil and acrylic on canvas,
183 x 245 cm
Zurich, Galerie Bruno
Bischofberger

Polke, employing projections, black and white photos, film, translucent paint layers, and many other techniques, Salle investigates the body as a vessel of human existence. In terms of technique, content and form, his work holds a strange and quite original balance between history and contemporaneity, psychological and physiological reality, between high and trivial art, eroticism and pornography, historicist pathos and banality. Salle's imagery is suffused with the skepticism of a culture of surfeit, as well as with a covert yearning to overcome it.

A belated but all the more radical turn to fundamental feminism was reflected in the mature work of Nancy Spero (p. 383). Born in 1926, as late as the early 1970s Spero could still devote two painting sequences to Antonin Artaud, father of absurd theater and known misogynist (*Artaud Paintings* and *Codex Artaud*). But for over twenty years now, men have been entirely absent from the panel-like series – paper bands with collaged figures and text fragments – of the wife of artist Leon Golub and mother of several children. The dominant theme of Spero's recent work is the body of the self-confident, active woman, independent and sexually self-determined.

Men may not have vanished from Leon Golub's work (ill. below), which combines pure painting with script, usually inspired by graffiti and slogans scribbled on city walls. But his male figures tend to be gross urban characters of the type the artist says he observes with growing dismay. The anonymous figures of Golub's anti-war paintings of the 1970s have increasingly taken on personal features. Instead of Vietnam, he now addresses the brutality of surburban life, an issue most of us are reluctant to face.

Eric Fischl (p. 385 above) was a co-student of Salle's at the California Institute of the Arts, in Valencia near Los Angeles, which is known for its experimental atmosphere. Fischl's theme is the deadly boredom endemic to affluent Western societies, Baudelaire's *ennui* brought up to date. In scenes of life on the beach, in front of a television set, or in the midst of the monotony of the

**Leon Golub**
Mercenaries V, 1984
Acrylic on cotton, 305 x 437 cm
Formerly Saatchi Collection,
London

American suburbs, Fischl shows how human beings come to treat themselves as objects. The relationship of the figures to the pictorial space signals isolation, lives lived in parallel to one another instead of with one another. Even in the orgiastic, obscene scenes, immobility prevails, recalling a movie still.

While Fischl unmasks the middle-class monotony he for a time attempted to escape as a hippie, most representatives of "Free Figuration" in France raise monotony to a principle (and thus inadvertently reveal the limits of their freedom). The statement of painter and performer Jürgen Klauke to the effect that now, for the first time in history, serious art is being sold and marketed like entertainment, applies to many of the young French artists.

Going beyond certain affirmative tendencies in the work of camp followers of the Neo-Expressionist scene, Free Figuration in part signals an uncritical submission to the laws of the entertainment industry. A defector from the avant-garde cause, Jean Clair, has made himself the prophet of this counter-movement. Hervé de Rosa announced his "total rejection of the intellectual and critical discourse," in favor of painting as "fun rock." François Boisrond says, "I have the impression that I learn more when I watch bad films or see bad painting," and is ostensibly proud of "accepting a stupid culture that is fascinating."

Not only comics and science-fiction but gruesome war movies have become the source of intelligent young people's technicolor dazes. Rejecting unrealistic dreams of a New Human in an earthly paradise, they have instead become fanatics of resignation. This represents, writes Marie-Luise Syring, "a trivialization of the so-called *modern myths.*"

The art of Jean-Charles Blais leaves the vulgar, programmatic infantilism of many of his generation behind (ill. below). His unconventional treatment of familiar commonplace material – Blais paints over torn posters –

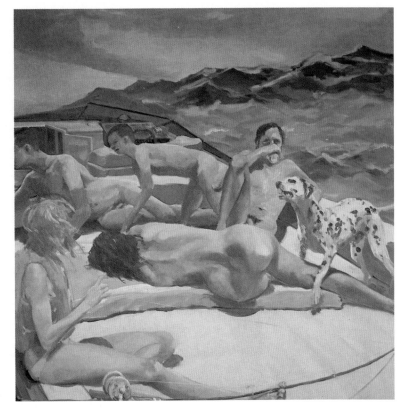

avoids the cliché by being formally coherent and skilled in execution. The works were evidently stimulated by the figures of the early Malevich, and perhaps also by the later, post-Suprematist ones. Other possible influences are van Gogh, and, very likely, Léger and his "Proletarian Olympus," whose optimism about the future, however, is tempered by skepticism with Blais. Blais's heavily contoured, super-individual, monumental figures suggest a humanity made insecure by the complexity of the modern world.

**Eric Fischl**
The Old Man's Boat and the Old Man's Dog, 1982
Oil on canvas, 213.4 x 213.4 cm
Formerly Saatchi Collection, London

**Jean-Charles Blais**
Untitled, 1986
Paint on torn poster, 173 x 238 cm
Courtesy Galerie Yvon Lambert, Paris

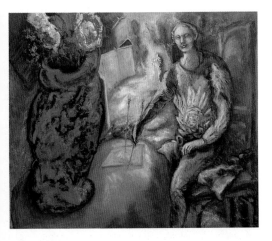

**Gérard Garouste**
Columbia, 1981
Oil on canvas, 250.8 x 294.6 cm
New York, Leo Castelli Gallery

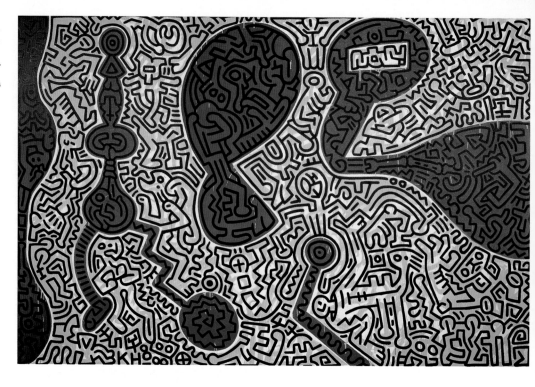

**Keith Haring**
Toledo, 1987
Acrylic on canvas, 244 x 376 cm
Düsseldorf, Galerie Hans
Mayer

Even more complex, allusive, and ambivalent is the work of Gérard Garouste (p. 385 below left). The French artist's approach to painting is characterized by a blend of unleashed temperament and skeptical intelligence, a blend very close to that of Romantic irony. Garouste's expressive paintings reflect the consciousness of a late epoch, a disillusioned, fragmented reality devoid of myths, as well as a certain nostalgic melancholy. This comes through despite the Baroque verve of the brushwork, for the imagery teems with figures and associations and barely concealed historical reminiscences. Anyone familiar with history knows that premonitions of the world's end were not foreign even to an epoch as vital as the Baroque.

## Pictures from the Underground

One of the most salient contributions made to fine art by representatives of a sub-culture is that of grafitti. Dubuffet and others began at an early date to collect and adapt the figures and inscriptions in which outsiders and underdogs, children and the mentally ill, found a means of self-expression. But it was not until the 1970s that the attention of the public and the art trade was drawn to grafitti as an art form in its own right. The development was spearheaded by the "pieces" sprayed by young "writers" on New York subway cars, in which an untamed, under-class creativity found explosive expression. In the meantime, mass, puerile imitation in America and Europe has undermined the cre-

**Hervé Télémaque**
Port-au-Prince, the Rose, 1988
Acrylic on canvas, 200 x 310 cm
France, private collection

**Keith Haring**
Untitled, 1988
Acrylic on canvas,
152 x 152 cm
Private collection

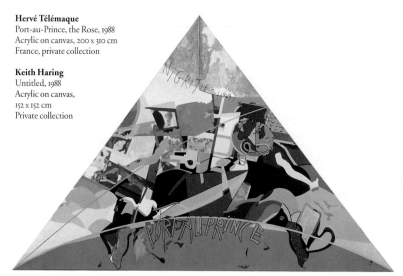

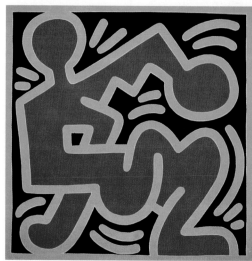

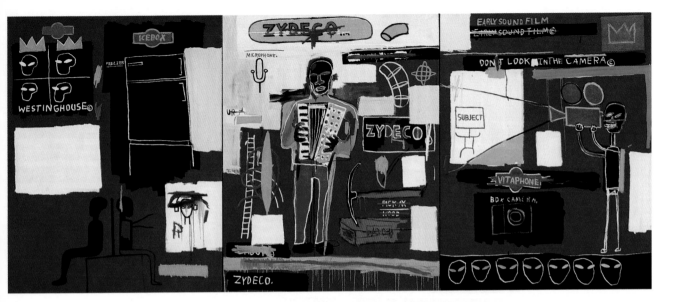

ative potential of such work and reduced it to hollow gesturing.

A quite different impetus lay behind the pointed critique of civilization and culture mounted by the "Sprayer of Zurich," Harald Nägeli, a trained psychologist. Nägeli's stick-men raised the ire of the philistines, who immediately – and of course successfully – appealed to the authorities to do something about this desecration. After Nägeli was tracked down by Interpol and spent several terms in jail, his subversive activities were gradually legalized, which could not help but rob them of their force.

The work of New York artist Keith Haring, in contrast (p. 386 above and below right), raised grafitti to the status of fine art, without sacrificing its freshness and impact. Haring, who would later succumb to Aids, was honored by inclusion in the documenta, which immediately caused the prices of his paintings to skyrocket. This was in the mid-1980s, as, grotesquely, the city of New York was spending four million dollars to destroy the then still very original imagery of the "writers," from whose ranks Haring himself had so rapidly risen to prominence.

The Hispanic-American artist Jean-Michel Basquiat (ill. above) died in 1988 not of Aids, like Haring, but from an overdose of heroin. He too began as a grafitti painter in New York, but developed beyond it to transfer to canvas his critical, often macabre, graphic picture stories about the situation of underdogs and under-privileged minorities.

Haring also depicted himself in these narratives, in bizarrely expressive, near-portrait likenesses, playing the role of an acutely endangered wanderer along the thin line between life and death. Nor did he gloss over his adaptation and submission to the rituals of the elite who lionized him, the self-denying, prostituting strategies of survival which were nonetheless unable to prevent his premature death at the age of 27.

## Explorations into High and Low Culture

Perhaps the most prolific, restless, humorous, and at the same time most enigmatic contemporary artist is – or at least was, for a considerable period of time – Sigmar Polke (pp. 387–389). The rational and the irrational, irony and magic, combine in his key works with an employment of highly original, experimental techniques, pointedly expressed ideas, and aesthetic concision.

In Polke's imagery, elements of the real are confronted with elements of fantasy and pure idea, and all take their place in a holistic pictorial reality which

**Jean-Michel Basquiat**
Zydeco, 1984
Acrylic and oil crayon on canvas, three parts, 219 x 518 cm
Private collection. Courtesy Galerie Bruno Bischofberger, Zurich

*"I wanted to be a star not a gallery mascot."*
JEAN-MICHEL BASQUIAT

**Sigmar Polke**
Bunnies, 1966
Oil on canvas, 150 x 100 cm
Washington, Hirshhorn Museum and Sculpture Garden

**Sigmar Polke**
The Raven, 1966
Dispersion on textile,
190 x 200 cm
Bad Münstereifel, Galerie Klein

encompasses both what can be experienced through the senses and what can only be mentally conceived. Polke's procedure is not analytic but synthetic in character. When he painted screen-dot pictures in the 1960s, instead of mechanically resolving a given image into a system of dots like Lichtenstein, Polke began with the dots themselves, consciously arranging them to form a vital, visually vibrating image based on intrinsic aesthetic laws.

Polke's explorations are devoted as much to the mass media and the trivialities of mass culture as they are to received artistic traditions and techniques. He also delves into physical and chemical processes, such as the changes caused in specially sensitized paint layers and the changes in their appearance due to the effects of light, heat, humidity – or even the viewers' reactions to the work. Thanks to these unpredictable changes in the materials and their fragile nature, the factor of time enters into Polke's open-ended imagery.

It is very much in character when the artist states that his untraditional and anti-traditional pictures were done under the supervision of a "higher being." Such are the risks he takes in exploring unexplored territory, so

innovative is his creative process, that they can lead to trance-like moments in which the sense of being a mere tool of the universal spirit can overcome even an ironic and skeptical mind. But masquerade or not, Polke's statement reveals the seriousness of his untiring attempts to pin down and capture both visible and invisible realities, in the frustrating knowledge of their ultimate elusiveness.

Encompassing both high and low culture, Polke's oeuvre paradigmatically illustrates that an uncompromising openness of artistic practice, beyond all conventions and ideologies, need not necessarily lead to conformity, affirmation, or an escape into arbitrariness. Polke stands as an example of the fact that an artist, even on today's scene, need not sacrifice his intelligence in order to be successful. Admittedly, in recent years some of the artist's work has shown a certain discrepancy between effort and result, between a huge format and relatively unexciting ideas and composition. In this regard the work of even this ingenious but inconsistent artist reflects the insecurity of a period of crisis in which everything has become *questionable* – in both the literal and figurative sense.

**Sigmar Polke**
Lovers II, 1965
Oil and lacquer on canvas,
200 x 140 cm
Private collection

# At this Writing

## Artistic Issues at the Turn of the Millennium
### Painting in the Age of Electronic Media

**Peter Halley**
CUSeeMe, 1995
Acrylic, Day-Glo and Roll-a-Tex on canvas, 274.5 x 280 cm
Munich, Goetz Collection

Art always reacts to the period in which it is made, and to the problems and issues of that period. Hence, strictly speaking, there is no such thing as "timeless" art. There never was. Any artist who refuses to accept this insight and attempts to escape from the present day, risks artistic failure. This was recently illustrated by the short-lived phenomenon of post-modernism. In a period of upheaval and insecurity like our own, which has thrown overboard every universal scheme and system, art can no longer hope to proclaim indubitable truths. Even the border between "high and low" – the title of a 1990 exhibition at the Museum of Modern Art, New York – begins to blur.

Thus the painting of the final decade before the year 2000 has evinced no predominating tendency, no forward-looking avant-garde theory, no standard-setting group, not even a dominant artistic personality, comparable to a Pollock or a Bacon – not to mention a Picasso – around mid-century. Though Warhol's part cynical, part melancholy prognosis that everyone would be famous for at least a quarter of an hour has not been fulfilled, it no longer seems as as naive during our own increasingly fast-paced period as it did during the artist's lifetime.

All rules have gone out of force. Even the most ambitious theories of art have an individualistic tinge nowadays, and can hardly claim universal validity. Intellectual reflection, an essential component of contemporary artistic activity, is frequently indulged in at the cost of creativity. Sometimes the gap between the philosophical and theoretical ambitiousness of a work of art and the banality of its statement grows so large that it takes itself ad absurdum.

Among younger artists, apart from a few exceptions, the idea of "immediacy" is no longer a concern. Today's art no longer establishes guidelines, it seeks orientation; it no longer makes statements, it asks questions – questions about a reality growing ever more complex, and about the role of art itself within this reality. Wherever it sets its sights on that ominous "social relevance" so central to the generation of Vietnam and campus revolts, even in an honorable commitment to the marginal groups of society, art generally flips over into propaganda whose social effectiveness tends to be null.

An awareness of these problems is shared by serious artists everywhere, not only in the Western world but in Eastern Europe, Latin America, and China, countries where critical reflection was long present under the surface but only recently gained the opportunity for public expression. This basic, shared awareness could contribute to an overcoming of deep-seated prejudices, and to that "decolonialization of the mind" promoted by Edward W. Said. Yet in the course of such efforts, we must beware of succumbing to the old illusion of an all-encompassing "world art" or, indeed, "world culture." Because that would entail confusing a beneficial and stimulating cultural permeability with that sterile sameness which is just as fatal in the artistic and cultural domain as it is in the political. As Hans Belting says, "There is no universal conceptual scheme to cover the diversity of world cultures." The defects of large-scale projects such as "Magiciens de la Terre" at Centre Pompidou, Paris, in 1989, and documenta 9 in Kassel three

years later, resulted from just such misunderstandings, as reflected in the idealistic but diffuse conceptions on which they were based. In the case of documenta this idealism, paradoxically, was paired with a bias against the art of Eastern nations.

Yet these are not the only reasons for skepticism with regard to the question whether something in the nature of a global exhibition of the arts is possible in our time (or ever was). In view of the enormous variety of positions, a superhuman effort of coordination would be required to prevent such an exhibition from becoming a mere congeries of more or less unrelated works – unless one set out from the start to illustrate the "New Unmethodicalness."

In painting today, anything goes, from a rigorously conceptual or even "radical" painting all the way to elementary paint-for-paint's-sake. The issue of abstraction versus objectivity has become anachronistic. As Gerhard Finckh notes, the crux of the matter is "determining where one stands, making an analysis, and building a basis…. The 'Cry, Art, Cry' [of Lucas Moser, early 15th century] is something other media now lay claim to…. Bruce Nauman's documenta 9 video-audio installation 'Help Me' is one of the few successful examples of this."

**Allan McCollum**
Plaster Surrogates, 1982–1990
Plaster and email, 10 parts,
51 x 410 cm
Haigerloch, Sabine Schwenk
Collection

*"I want my paintings to attempt a belief and sincerity which I, as an artist, don't necessarily feel, and certainly don't feel continuously. I want them to have a relationship to the world, to know how the world works and, nevertheless, to retain an optimism."* Ross Bleckner

**Ross Bleckner**
Wreath, 1986
Oil on canvas, 274 x 183 cm
Private collection

Artistic investigations can lead to highly divagating results even within the œuvre of a single artist, as indicated by the paintings of Ross Bleckner (p. 391 below). The American artist produced, almost concurrently, compositions of abstract bands in vibrant colors (*The Arrangement of Things*, 1982–1985), and surreal, universalistic visions (*In Memory*, 1987). If such works have a common denominator, it is the Vanitas motif. Yet even a motif of this kind, says the painter, has the situation of the artist as its theme, and concerns itself with this self-reflection.

Bleckner's friend Peter Halley (p. 390) paints imagery whose great color sensibility and precise formal geometry recall both Albers and the Bauhaus and Barnett Newman. Though Halley accepts Bleckner's approach, he considers it to involve a critique of the "diverse idealisms of Plato, Descartes, and Mies [van der Rohe]." For his own part Halley attempts to reduce Constructivism, Minimalism, and Color Field Painting to their fundamental source, their "sociological basis" – the square as a symbol of the prison cell, the color red as an allusion to the dangers of technology. Luckily the pictures bear up well under the philosophical weight, derived from French savants Jean Baudrillard and Michel Foucault, they are made to carry.

In sharp contrast to Halley's approach stands that of Philip Taaffe (ill. above), as well as that of Christopher Wool (ill. below), with its employment of stencils and illegible sequences of letters. Taaffe, who lives in New York and on the Gulf of Naples, considers his paintings a contribution to mass culture, filtered through critical choice. In their continuation of the "New Ornamentation" on a higher twist of the spiral, Taaffe's works combine substantial and formal elements from two cultures, Arabian and European past and present, whereby the decorative merges with the aesthetic in an effective way.

Objective configurations floating free across the pictorial plane are the theme of Terry Winter's painting, which in the 1980s held an intermediate position between abstraction and figuration. His more recent work, with its graphic and calligraphic networks, tends to non-objectivity despite the suggestions of organic forms it contains (p. 393 above right).

A tension between spontaneously notated and planned, stringent, and dissolved forms, between color fields and linear sheaves, characterizes the compositions of Jonathan Lasker (p. 394 below left). They might be described as a late version of Mannerism, especially as the artist consciously employs historical quotations from a variety of periods and climes. David Reed's painting (p. 394 above) is inspired by the movies, and accordingly uses the wide-screen format. As in the case of Newman, whom Reed admires, his paintings cannot be taken in at a single glance. The viewer, Reed hopes, will make the effort to visually construct "a whole out of parts" – a statement that might have come from Newman. Yet Newman's theme was the sublime, whereas Reed addresses the fantastic, as illustrated by the agi-

**Joseph Marioni**
Blue Painting, 1994
Acrylic on cotton, 56 x 51 cm
Vienna, Rosemarie Schwarzwalder Collection

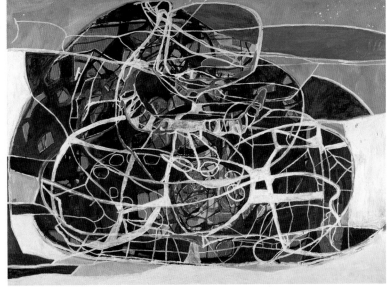

tated shapes in which mundane things are monumentalized and surrealistically alienated, if not always entirely convincingly.

Similarly, the long series of *Surrogates* produced by Allan McCollum (p. 391), plaster casts of various sizes painted black and framed in various colors, articulate a critique of society and its institutions, as well as of the "elitist," exclusive original work of art. Another instance, that is, of art directed against art, against the "fiction" of the autonomy of the arts and their authenticity, in the footsteps of the ubiquitous Baudrillard. Whether and to what extent the messages of McCollum's "contextual painting" (Peter Weibel) reach the addressee are questions that, as so often in art, remain open.

A different case entirely is the theoretically founded yet ideologically unburdened *Radical Painting* of American artist Joseph Marioni (ill. above left) or his compatriot Frederic Thursz (ill. left). Both share a conviction that a painting should represent nothing other than itself. A painting cannot resolve the internal contradiction of attempting to be something it is not, says Marioni. The result of his considerations are subtly nuanced monochrome images in changing colors. Thursz, in contrast, restricts himself to a black whose differentiated texture becomes perceptible only on patient observation. Unlike Ad Reinhardt, the artist does not expunge every last trace of the personal hand. Rather, as Hannelore Kesting notes, the "physical texture" of his works "becomes a substantial component," that is, serves to convey content.

Much the same holds for the monochrome works of Jürgen Meyer with their impasto paint application. The formally disciplined, precisely executed painting series and painting-sculpture combinations of Heinrich Dunst are convincing enough in their own right to do without the theories with which they are encumbered.

**Terry Winters**
Phase Plane Portrait, 1994
Oil on cotton, 274.3 x 365.8 cm
New York, collection of the artist

*Left:*
**Frederic Thursz**
Vixen, 1989
Oil on canvas, 146 x 73 x 5 cm
Private collection

*Page 392 above:*
**Philip Taaffe**
Bad Seed, 1996
Mixed media on canvas,
262 x 282 cm
Germany, private collection

*Page 392 below:*
**Christopher Wool**
Untitled, 1993
Enamel paint and aluminum,
230 x 172 cm
Germany, private collection

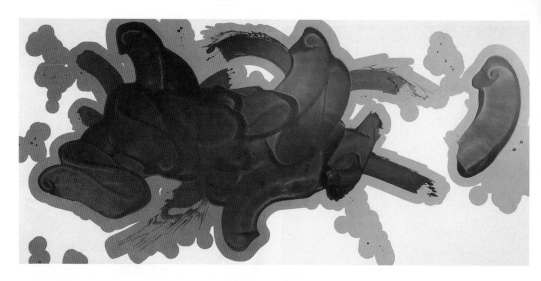

**David Reed**
# 349, 1996
Oil and alkyd resin on canvas,
137 x 300 cm
Cologne, Galerie Rolf Ricke

As little as Ad Reinhardt brought to canvas the last painting anyone would ever be able to do, just as little has "art & language" exhausted the theme of image and language. Richard Prince (ill. below), who earlier worked in a surrealist style, used the media as ready-mades, and combined imagery with typography, now paints jokes in acrylic on canvas, precisely lettered and in carefully chosen color combinations. According to Prince, his intention is to make paintings in which there is nothing to interpret, nothing to speculate about – another method, if a rather obvious one, of reacting against visual pollution.

The intellectually more challenging paintings of French artist Bernard Frize (p. 395 below right), with their multifarious layerings, abrupt caesuras, and exchange of figure and ground, and the ambivalent, as it were diagnostic works of the Belgian artist Luc Tuymans (p. 395 below left) with their austere coloration, both illustrate in different ways the attempts of young artists to explore the potentials still available to painting in this late modernist age, without resorting to substantial or formal borrowings or making historical compromises.

Painting in Russia and China is likewise marked by a

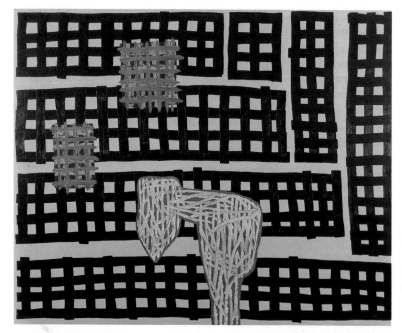

**Jonathan Lasker**
Reasonable Painting, 1990
Oil on cotton, 162.5 x 203 cm
Private collection

**Richard Prince**
Untitled, 1996
Acrylic and silkscreen on canvas,
221 x 147.3 cm
Courtesy Jablonka Galerie, Cologne

**Ilya Kabakov**
Holidays No. 9, 1987
Oil and rosettes on canvas,
100 x 160 cm
Private collection

skepticism that takes nothing for granted. In the mean-time, artists in these nations have begun to ask the same questions as their Western counterparts. But their questions have a stronger political and socio-critical thrust, and are concerned less with issues immanent to art. The reasons for this are obvious. In the periods of dictator-ship and isolation, inofficial art understood itself largely as a weapon in the battle against an unloved political system imposed upon the people from above. Its ammu-nition consisted above all in irony, as seen even in the

*Below:*
**Bernard Frize**
Spitz, 1991
Acrylic and resin on canvas,
254 x 361 cm
London, Tate Gallery. Courtesy
Frith Stret Gallery, London

still dictatorially governed China, whose economic opening to the West has started to bring sand into the totalitarian machinery.

Not only current Chinese but Russian art still shows evidence of the intellectual and emotional sources from which it arose, whether it be the persiflage of Socialist Realism conducted by "Soz Art" or the conceptual work

*Left:*
**Luc Tuymans**
Dildo, 1996
Oil on canvas, 69,5 x 43.7 cm
Munich, Goetz Collection

**Dimitri Prigov**
Nietzsche with Hitler
on His Hip, 1994
India ink and acrylic on paper,
130 x 190 cm
Aachen, Ludwig Forum für
Internationale Kunst

now being done in Moscow. This holds despite the fact that important Russian protagonists such as Vitali Komar and Alexander Melamit, or Ilya Kabakov, now live in the United States.

Kabakov's works (pp. 395 and 575), the earlier paintings as well as the later installations that brought him fame, have a narrative character. His style is accordingly realistic to naturalistic. Kabakov's subject is human loneliness in general, and that of the regimented Soviet citizen in particular. His more recent works demonstrate with dramatic pointedness the jeopardy in which culture, East and West, now finds itself, and the struggle for survival of humane values.

A quite different thrust is seen in the painterly and formal problems addressed by the twenty-year younger Nikolai Filatov (p. 397 above). His expressive paintings have a bold coloration and reveal a spiritual attitude that definitely recall the mythologically founded hopes for the future of the German Expressionists, Franz Marc foremost. The realistic imagery of Alexander Petrov, in contrast (ill. below right), takes affirmative Socialist Realism ad absurdum, in terms of both style and content. The suggestive force of Petrov's paintings occasionally recalls Hopper.

Erik Bulatov (ill. below left) mixes linguistic and painterly, realistic and symbolic, aesthetic and literary elements with ironic intentions, whether to show up the contradiction between private atmosphere and state deprivatization or to allude to the insecurity of a crumbling empire in an image of a simultaneously rising and setting sun, combined with Soviet emblems with hammer and sickle, hovering over a globe (*Sunrise or Sunset*, 1989; Aachen, Ludwig Forum für Internationale Kunst). Whether Georgi Pusenkoff (p. 397 below) paints large-format abstract stripe canvases with indeterminate upper and lower edges or quotes famous colleagues past and present – from Bronzino through Malevich and Kabakov to Lichtenstein – the focus of his imaginative variations is always the pictorial space. For as Bulatov says, "space is what counts."

The end of political and social illusions is even more compellingly evoked by the pictorial and calligraphic signs of Dimitri Prigov (ill. above) whose work provides evidence of the fact that the Russian Conceptualists extended their radically pessimistic critique to the period after the fall of the Soviet Empire. Also concep-

**Erik Bulatov**
Ne Prislonjazja, 1987
Oil on canvas, 240 x 170 cm
Basel, Öffentliche Kunstsamm-
lung Basel, Kunstmuseum

**Alexander Petrov**
The House by the Railway, 1981
Oil on canvas, 150 x 120 cm
Beijing, Ludwig Museum of
International Art

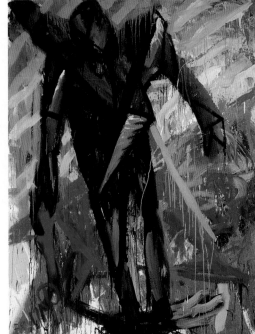

tually oriented in their ambiguity are the paintings and installations of Komar and Melamit. After being deprived of their work permits and even prohibited from visiting art exhibitions, the two went to Israel in 1977, and the year after to New York. Their dual experiences in East and West provide the basis for sarcastic and ironic works which point up the interchangeability of personalities and systems, and blithely employ a range of past and contemporary styles and techniques. Komar and Melamit's unmasking of phraseology, personality cult, and false myths is merciless, yet not embittered. A humorous detachment, with undertones of nostalgia, makes their work convincing.

Mention should be made of an outsider of great originality who was born in Russia and now makes his home in New York. Grigori Bruskin (ill. above left) creates cyclical depictions combining image with script in which Jewish spirituality and religiosity take on a compelling form for which there is no comparison in contemporary art.

No review of the art of our era would be complete without a reference to a critical style of painting in China which, as Dieter Ronte says, "does not conform to the Chinese cultural authorities' definition of art." Practiced largely by younger artists between 30 and 40 working in oils, this approach developed with extreme rapidity in a country where the oil medium was unknown just over a century ago.

Though Western influences are taken up, these are reformulated and blended with elements of the Chinese tradition to produce imagery of an amazing originality and great diversity. Abundant evidence of this was provided by the first comprehensive review shown in Germany, at the Kunstmuseum Bonn in 1996. The quality of

the work now going on in China corresponds to the growing number of Chinese collectors of contemporary art, a phenomenon long overlooked in the West. Several European and American galleries immediately drew their conclusions and opened branches in the Middle Kingdom.

Despite certain realistic and formalistic developments in Chinese art of the late 1970s and early 1980s,

hardly anyone would have predicted what has come about in the years following Mao's cultural revolution and the 1989 massacre on the Square of Heavenly Peace. There can be no doubt that the development is still in its beginnings. It is being carried forward not so much by the expatriates among Chinese artists as by those who live and work in their own country, despite the fact that

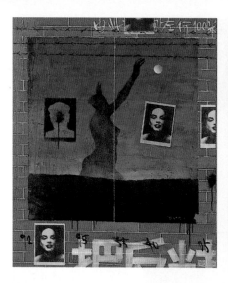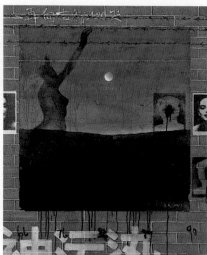

**Dai Guangyu**
Wall Landscape, 1993
Oil on canvas, three parts,
105 x 125 cm (each)

they rely to a large extent on foreign customers, as the frequent employment of Latin characters as typographical elements in their paintings indicates.

Contemporary Chinese painting evinces an astonishing stylistic range, from realism to serial abstraction, from surrealism to approaches verging on strict monochromy. In terms of subject matter, amazingly frank or ironically tinged criticism of living conditions (and hence of the regime) is accompanied by a focus on the human body and sexuality which surpasses even that of American and European art. As an example of the former category let us take Zhang Xiaogang's three-part *Large Family* of 1995 (p. 399 above). Picture no. 1 represents a couple, no. 3 depicts two young men, and only picture no. 2 shows a wife and husband with a child – a boy, of course. True large families with several children

are just as undesired by the Chinese authorities as are girls.

Dai Guangyu uses different means to break taboos, because the obscene, as he says, is not permitted despite the ancient and wonderfully beautiful erotic depictions of Chinese art. This is precisely why Dai makes it his theme. In his *Wall Landscape* (ill. above) – the title itself is ambiguous – the artist inserts several overpainted portraits of Chairman Mao into a series of Marilyn Monroe photos. "Two great figures in history merged on a Chinese wall for the purpose of making a public-relations statement," explains the artist. No further comment necessary. A juxtaposition of a Chinese girl in a tanga and a copulating couple with an erotic scene in the traditional style is titled *Sensual Misunderstanding* by artist Wei Guangqing (ill. below left). Liu Wei's *Bathing*

**Wei Guangqing**
Sensual Misunderstanding,
Chapter 83, 1994
Oil on canvas, 160 x 120 cm

**Liu Wei**
Bathing Beauty, 1994
Oil on canvas, 200 x 150 cm

*Beauty* (p. 398 below right) is ogled by panting men in the water around her. As these examples indicate, despite official prudery, contemporary Chinese painting addresses the theme of sexuality with great frankness.

Such depictions stand in contrast to the painted collages of newspaper reports made by Wang Cheng, such as *Reports from the Insane Asylum* (ill. below), to the practically monochrome paintings of the older Qiu Shihua, who describes them as "soul landscapes," or – as an antithesis – to the musical portraits and landscapes of Chen Yifei, who divides his time between Shanghai and America, where his blend of Western influences with Chinese realism has proven especially successful. The list of examples could go on and and on. What they illustrate is that contemporary Chinese painting has found its own, unique language. It has digested Western influences and can hardly be called eclectic any longer, let alone derivative.

In sum, we can say that final, definitive answers can no longer be given, in no field of human affairs, neither in the West nor the East. In art, such answers never existed anyway. Doubt has always been a stimulus to creativity. An artist like Marcel Broodthaers provided an exemplary illustration of this, both in his art and his life. His colleagues of today are even more certain than he that there are no absolute certainties. To this extent the insistent questioning and inquiry of many young artists who no longer accept anything at face value, past or present, is an encouraging sign. Because their doubt is just as opposed to the misunderstanding of art as a status symbol and mere ornament to life, as it is to the superficiality of the art business, with its market leaders who are not always the right ones, its immoralism which, blind to quality, equates *world* rankings with *price* rankings, and its widespread, uncritical, conformist political correctness.

Nor does young artists' critique stop at the "bias and hypocrisy" involved in the organization of great exhibitions, and the lack of courage to risk "comparison with significant old artists" of which Baselitz, himself one of the great public stars in contemporary art, so bitterly complains. As long as young artists remain aware of the fact that it is one of the functions of art to engender knowledge and insight, as Friedrich von Schiller stated and Joseph Beuys demonstrated, there is no reason for skepticism or indeed pessimism about the future of art, all the prophets of doom to the contrary. Art, and not least painting, so frequently pronounced dead, have survived every ominous prediction until now, and will continue to survive even in the age of the electronic media. We should put our trust in the viability of art and, with Georg Christoph Lichtenberg, "leave the metaphysical cogitations to those who are incapable of doing anything better."

**Zhang Xiaogang**
Great Family, No. 2, 1995
Oil on canvas, 170 x 210 cm

**Wang Cheng**
Reports from the Insane
Asylum, 1995
Oil on canvas, 153 x 180 cm